Rainer W. Schlegelmilch

Hartmut Lehbrink

Jochen von Osterroth

h.f.ullmann

Contents
Inhalt
Sommaire

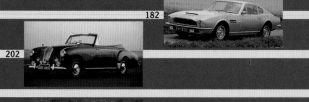

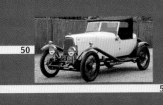
50

58

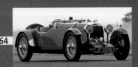
64

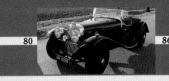
80

86

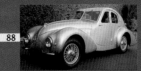
88

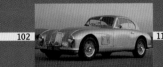
102

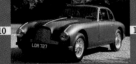
110

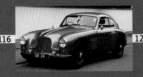
112

116

122

138

144

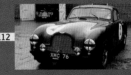
148

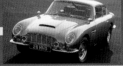
156

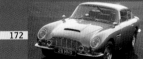

160

172

176

190

194

198

208

210

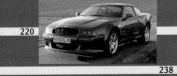
220

224

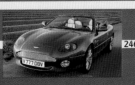
238

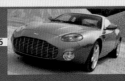
246

252

256

Foreword
Vorwort
Préface

by Roy Salvadori

I am pleased to be offered the opportunity to write the foreword to this magnificent Aston Martin book by authors Rainer Schlegelmilch and Hartmut Lehbrink.
I drove for the Aston Martin racing team from 1953 to the end of 1963 and during this period I became close friends with John Wyer, the Aston Martin team manager, and with David, later Sir David Brown. In fact I spent many years in close contact with him as we both eventually retired to Monaco. Not only did I race his cars but I was an Aston Martin agent in Surrey as well.
They created one of the world's finest racing teams from scratch at a time when, Jaguar apart, Britain was not considered as a serious contender in international motor racing. Works Aston Martins finished second at Le Mans in both 1955 and 1956, won there in 1959, won at the Nürburgring three years in succession and won the Sports Car World Championship in 1959.
The success of the Aston Martin operation was brought about by David Brown's and John Wyer's meticulous choice of personnel: designers, engineers, mechanics, team staff, and racing drivers. With the incomparable Stirling Moss as lead driver the full potential of the cars and team organisation was ably demonstrated.
When the DB4 was introduced the racing team developed both sports and GT cars that used a larger capacity engine with considerable success. Some of the team drivers were offered production cars at

reduced prices on condition that they passed information on to the racing department about any shortcomings or improvements they thought could be made to these standard cars. As an aside that should not be taken too seriously: one of the team drivers, who shall remain nameless, complained that the interior dimensions of the car were confining and greatly interfering with his social activities ...
The Aston Martin racing team was considered to be an elite enterprise. Not only was it one of the best organised, but it had created in addition a team spirit and camaraderie second to none, with the happy atmosphere of an informal club to which it was a privilege to belong, just as it is a privilege to possess and to drive a road car of the marque. Problems within the team were resolved with a firm but paternal hand and new drivers were treated with the same consideration and respect as was accorded to Stirling Moss.
In the course of its history the Aston Martin Company has been through difficult periods but, thanks to its illustrious name and the beauty and the quality of its products, has found saviours time and again, in particular with David Brown and more recently the combination of Victor Gauntlett and Peter Livanos. It is good to know and immensely satisfying to me that now that the Ford Motor Company has acquired control the future of this great marque is solidly ensured in the capable hands of Bob Dover.

Auf den Wunsch, zu diesem prächtigen Buch des Autorenteams Rainer Schlegelmilch und Hartmut Lehbrink über Aston Martin das Vorwort zu schreiben, gehe ich gerne ein. Ich fuhr von 1953 bis Ende 1963 für den Aston-Martin-Rennstall. In dieser Zeit wurden Team-Manager John Wyer und David (später Sir David) Brown gute Freunde von mir. Mit Brown blieb der Kontakt auch weiterhin sehr eng, weil wir uns beide in Monaco zur Ruhe setzten. Ich startete nicht nur auf seinen Autos, sondern war auch Aston-Martin-Händler in Surrey.
Damals schufen die zwei aus dem Nichts einen der bedeutendsten Rennställe der Welt. Dies geschah zu einer Zeit, als England, einmal abgesehen von Jaguar, im internationalen Rennsport nicht viel

zu bieten hatte. 1955 und 1956 endeten Werkswagen in Le Mans auf Rang 2, siegten 1959, siegten am Nürburgring dreimal hintereinander und gewannen 1959 die Weltmeisterschaft der Marken. Der Erfolg der Aston-Martin-Mission wurde ermöglicht durch John Wyers und David Browns sorgfältige Auswahl ihres Personals: Designer, Ingenieure, Mechaniker, Teamkader und Fahrer. Da sich uns der unvergleichliche Stirling Moss als Nummer eins zugesellte, wurde das volle Potential der Wagen und des Team-Managements ausgeschöpft.
Mit der Einführung des DB4 entwickelte die Rennabteilung Sport- und Granturismowagen, durch die sich ein hubraumstärkeres Triebwerk in erheblichen Erfolg ummünzen ließ. Einigen Teamfahrern wurden zu reduzierten Preisen

Roy Salvadori (left) and Jim Clark.
The pair drove for Aston Martin in
Le Mans in 1960.

Wider den tierischen Ernst:
Roy Salvadori (links) und Jim Clark,
mit dem er 1960 für Aston Martin
in Le Mans startete.

Nous, sérieux ? Allons donc !
Roy Salvadori (à gauche) et Jim Clark,
avec lequel il a disputé pour Aston
Martin les 24 Heures du Mans en 1960.

Produktionswagen unter der Bedingung angeboten, dass sie die Rennabteilung über deren Schwächen und Stärken auf dem Laufenden hielten und Vorschläge zur Verbesserung dieser Serienfahrzeuge einbrachten. Eine Randbemerkung, der man nicht allzu viel Gewicht beimessen sollte: Einer der Piloten, dessen Name lieber unerwähnt bleiben sollte, beschwerte sich, die beengten Raumverhältnisse der Coupés behinderten ihn bei gewissen sozialen Aktivitäten …
Das Aston-Martin-Team wurde allgemein als Eliteaufgebot angesehen. Es war nicht nur eine der am besten organisierten Equipen, sondern zeichnete sich auch aus wie kein zweites durch Teamgeist und ein Gefühl der Verbundenheit. In seiner ungezwungenen Atmosphäre kam man sich vor wie in einem informellen Club

und ich empfand es als ein Privileg dabei zu sein, wie es ein Privileg ist, einen Straßenwagen der Marke zu lenken. Probleme wurden mit fester, aber väterlicher Hand geregelt und neuen Fahrern wurde die gleiche Aufmerksamkeit und der gleiche Respekt gezollt wie Stirling Moss.
Im Laufe seiner Geschichte hat Aston Martin schwere Zeiten durchgestanden. Aber wegen seines guten Namens und der Schönheit und Qualität seiner Produkte fanden sich immer wieder Retter. Ich möchte hier David Brown hervorheben und in jüngerer Zeit das Duo Victor Gauntlett und Peter Livanos. Es ist gut zu wissen und ungemein beruhigend, dass heute die Geschicke der Marke der Ford Motor Company anvertraut sind und die Zukunft des Unternehmens in den fähigen Händen von Bob Dover ruht.

C'est avec enthousiasme que j'ai accepté d'écrire la préface de ce magnifique ouvrage de Rainer Schlegelmilch et Hartmut Lehbrink consacré à Aston Martin. De 1953 à la fin de 1963, j'ai piloté pour l'écurie de compétition d'Aston Martin. Au cours de cette période, le chef d'équipe John Wyer, David Brown et moi-même sommes devenus bons amis. J'ai continué d'entretenir des liens très étroits avec David Brown. D'ailleurs, je ne me suis pas contenté de courir sur ses voitures puisque j'ai aussi été concessionnaire Aston Martin dans le Surrey.
John Wyer et David Brown venaient de créer l'une des écuries de course les plus importantes du monde. Abstraction faite de Jaguar, l'Angleterre n'avait alors pratiquement pas voix au chapitre dans la compétition internationale. En 1955–1956, les Aston Martin ont terminé deuxièmes au Mans, course qu'elles ont remportée en 1959 avant de décrocher trois victoires consécutives au Nürburgring et d'accéder, en 1959, au titre de championne du monde des marques. Le succès de la mission Aston Martin a été rendu possible par le très grand soin avec lequel John Wyer et David Brown ont choisi leur équipe, qu'il s'agisse des designers, ingénieurs, mécaniciens, cadres de l'écurie ou des pilotes. À partir du moment où Stirling Moss nous a rejoints avec le statut de numéro 1, il a été possible d'exploiter le potentiel des voitures.
Après l'introduction de la DB4, le département Compétition a mis au point des

voitures de sport et de Grand Tourisme dont le moteur de plus grosse cylindrée a permis de remporter des succès qui ont fait date. Quelques pilotes de l'écurie se sont vus proposer des voitures de production à prix réduit à la condition qu'ils informent en permanence le département Compétition des faiblesses et des points forts de la voiture. Une anecdote au passage: l'un des pilotes, dont nous préférons ne pas citer le nom, s'est plaint que l'étroitesse du cockpit des coupés constituait un handicap pour l'exercice de certaines activités sociales …
L'écurie Aston Martin a généralement été considérée comme une troupe d'élite. Ce n'était pas seulement l'une des équipes les mieux organisées, elle se distinguait aussi par son esprit d'équipe et sa solidarité. Les problèmes étaient réglés d'une main de fer, mais avec une bienveillance paternelle, et les nouveaux pilotes bénéficiaient de la même attention et du même respect que Stirling Moss.
Au cours de son histoire, Aston Martin a connu des périodes difficiles. Mais, en raison de sa notoriété ainsi que de la beauté et de la qualité de ses produits, elle a toujours trouvé des sauveteurs. Je tiens à citer parmi ces derniers David Brown et, plus tard, le duo Victor Gauntlett et Peter Livanos. Je suis heureux de savoir que, aujourd'hui, le destin de la marque est confié à la Ford Motor Company et que l'avenir de l'entreprise repose entre les mains de Bob Dover, homme compétent entre tous.

Coal Scuttles, Cannon Fodder and Regal Cars

The History of Aston Martin Lagonda

Von Kohlenkästen, Kanonenfutter und königlichen Automobilen

Die Geschichte des Hauses Aston Martin Lagonda

Histoires de caisses à charbon, de chair à canon et d'automobiles royales

L'histoire de la maison Aston Martin Lagonda

Brothers in spirit
Robert Bamford and Lionel Martin

As so often in the history of great companies, the story of Aston Martin Lagonda Limited began with a friendship between two men. On the one hand there was Robert Bamford, born in 1883, son of a clergyman and a Briton to a T, looking alertly and confidently out at the world with his waxed moustache and clear eyes. Bamford had a knack for things mechanical and also a solid grounding as an engineer. His burgeoning ambition led him to create a curious prototype machine, a small car he had designed himself and then put together using a variety of odds and ends. The conditions Bamford was working in were anything but promising: a tiny dilapidated shed which scarcely provided him with space to shape his developing vision.

And on the other hand there was Lionel Walker Birch Martin, born in 1878, scion of a family that had made its fortune in the mining industry. Martin was a mild-mannered man, an old Etonian who always looked spick and span. However, once he was behind the wheel of one of his cars he underwent a Jekyll-and-Hyde transformation, treating the machine with positive brutality, whether engaged in hill climbing or long-distance trials, generally over rough terrain. A typical episode: on one such occasion, a hill test on Beggars Roost, the unmistakable sounds of engine failure emanated from the depths of the machinery. Before setting off for the nearest garage, however, Martin first made sure he was well groomed, changing his socks, putting on his Eton tie and scrupulously removing every last trace of dust from his suit with the brush he had taken along for that purpose.

Motorsport was both the thing that brought the two together, and what set the seal on their affinity. In contrast to such long-standing compound names as Daimler-Benz or Rolls-Royce, Bamford & Martin Limited, founded on 15th January 1913, was not destined to have a long life as a company name. The small firm, based in Callow Street, off the Fulham Road in West London, sold Singer cars throughout most of southern England. They came as a standard model boasting ten horsepower and a top speed of 45 mph (72 kph), and as a tuned version capable of a giddy 70 mph (112 kph). Clearly business was booming: a contemporary newspaper advertisement exhorts respected patrons to hurry while stocks last, demand allegedly being frenetic. These machines, despite their fragility, were also put to use by Messrs Martin and Bamford for multifarious motorsport activities.

However, both men wanted more: to create their own product, one which shared the merits of the Singer but not its defects. The name had already been decided. On its origins, a few words from Lionel will suffice: "After reviewing all the flowers, beasts, birds and fishes that we knew, we got to place names, and as my Singer had recently scored a point or two at the Aston Clinton Hill Climb, the first part of that name was adopted with acclamation and my simple cognomen

Brüder im Geiste
Robert Bamford und Lionel Martin

Wie so häufig im Lebenslauf von Unternehmen steht am Beginn der Geschichte der Aston Martin Lagonda Limited eine Männerfreundschaft. Da ist Robert Bamford, Jahrgang 1883, Sohn eines Geistlichen und Brite wie aus dem Bilderbuch mit gepflegtem Schnäuzer und Kirschenaugen, die wach und krisp in die Welt schauen. Bamford hat ein Händchen für Mechanisches und verfügt darüber hinaus über eine solide Grundausbildung als Ingenieur. Von einer knospenden Ambition zeugt ein kurioser Prototyp, ein Kleinwagen, den er selbst entworfen und dann aus lauter Fremdteilen zusammengebaut hat. Die Rahmenbedingungen sind ungemein dürftig: eine winzige Klitsche, die Bamfords Blütenträume eher einzwängt, als dass sie Spielraum für ihre Entfaltung bietet.

Und da ist Lionel Walker Birch Martin, geboren 1878, Spross einer Familie, die sich im Bergbau einen Namen gemacht hat. Martin ist ein Mann von milden Manieren, Eton-Schüler und stets wie aus dem Ei gepellt. Seine Autos aber behandelt der Gentleman mit ausgesuchter Rohheit, sei es auf Bergrennen, sei es bei Langstreckenprüfungen, meist durch raues Gelände. Eine typische Episode: Bei einer solchen Gelegenheit, einer Bergprüfung am Beggars Roost, kündigt sich in hörbarer Infarkt aus den Tiefen seines Triebwerks an. Bevor Martin jedoch den Weg zur nächstgelegenen Werkstatt antritt, sorgt er für ein gepflegtes Erscheinungsbild, wechselt die Socken, legt seinen Eton-Schlips an und entfernt mit einer ebenfalls mitgeführten Bürste penibel die Stäubchen von seinem Anzug.

Der Motorsport, das ist die Basis, auf der sich diese beiden begegnen, zugleich der Stoff, aus dem ihre Wahlverwandtschaft gemacht ist. Im Gegensatz zu stabilen Namensverbindungen wie Daimler-Benz oder Rolls-Royce bringt es die Bamford & Martin Limited, die sie am 15. Januar 1913 ins Leben rufen, nur zu zeitweiser Unverbrüchlichkeit. Die kleine Firma, ansässig Callow Street, Fulham Road im Londoner Westen, vertreibt Automobile der Marke Singer fast im ganzen englischen Süden, ein Standardmodell mit zehn Pferdestärken und 72 Stundenkilometern Spitze sowie eine getunte Version, die sich zu 112 Stundenkilometern aufschwingt. Offensichtlich floriert das Geschäft: In einem zeitgenössischen Inserat wird die verehrte Kundschaft aufgefordert, doch möglichst rasch zuzugreifen, die Nachfrage sei regelrecht stürmisch. Von fragiler Konstitution, werden die solchermaßen angepriesenen Wägelchen auch von den Herren Martin und Bamford mannigfaltigen sportlichen Betätigungen zugeführt.

Ihnen steht gleichwohl der Sinn nach mehr: ein eigenes Produkt zu schaffen, das die Meriten, nicht aber die Macken der Singer aufweist. Der Name steht auch schon fest. Was seine Ursprünge anbelangt, ist ein autobiografisches Zitat Lionel Martins überliefert: »Nachdem wir alle Blumen, Vierbeiner, Vögel und

Frères spirituels
Robert Bamford et Lionel Martin

Comme c'est souvent le cas, l'histoire d'Aston Martin Lagonda Limited a débuté par une amitié entre deux hommes. Le premier est Robert Bamford: né en 1883, fils de pasteur et Britannique jusqu'au bout des ongles, il arbore une moustache soigneusement entretenue et des yeux perçants qui scrutent le monde d'un regard sans cesse en éveil. Bamford est un surdoué de la mécanique qui peut, en outre, se prévaloir d'avoir reçu une excellente formation d'ingénieur. Un curieux prototype témoigne de son ambition bourgeonnante: il s'agit d'une petite voiture qu'il a dessinée lui-même et construite à partir d'innombrables pièces prises à gauche et à droite. Le creuset de sa passion est des plus primitifs: c'est un modeste hangar qui bride plus les rêves d'expansion de Bamford qu'il ne laisse libre cours à son épanouissement.

Le deuxième larron est Lionel Walker Birch Martin, né en 1878 dans une famille aisée, qui s'est fait un nom dans le secteur minier. Martin est un homme aux manières sauvages, élève d'Eton et toujours sur son trente et un. Mais le gentleman traite ses voitures avec une brutalité sans pareille, qu'il participe à une course de côte, à une épreuve d'endurance ou, le plus souvent, à une éprouvante course de trial. En voici une anecdote typique: lors d'une manifestation de ce genre, la course de côte de Beggars Roost, un infarctus irréversible s'annonce des profondeurs de son moteur. Mais, au lieu de chercher à atteindre le garage le plus proche, Martin inspecte de pied en cap sa tenue, change de socquettes, noue sa cravate d'Eton et enlève ensuite, avec une brosse qu'il a toujours sur lui, jusqu'au dernier grain de poussière sur son costume.

La compétition automobile, voilà le théâtre sur lequel vont se rencontrer ces deux hommes et où se cristallisera leur affinité élective. Contrairement à des binômes qui survivront à l'histoire comme Daimler-Benz ou Rolls-Royce, la société Bamford & Martin Limited, que les deux hommes fondent le 15 janvier 1913, ne connaîtra pas la pérennité. La petite société, qui a son siège dans Callow Street, Fulham Road, dans l'ouest de Londres, distribue dans presque tout le sud de l'Angleterre des automobiles de marque Singer, un modèle standard de 10 ch dont la vitesse culmine à 72 km/h ainsi qu'une version plus sophistiquée capable d'atteindre 112 km/h. Il semblerait que les affaires marchent bien puis que, dans une annonce publiée dans un journal de l'époque, l'honorée clientèle se voit invitée à passer commande le plus rapidement possible, car on s'arrache ces voitures. Bien que de constitution fragile, les voiturettes qui font l'objet de tant d'éloges doivent aussi faire la preuve de leur fiabilité dans les compétitions les plus diverses avec Messieurs Martin et Bamford au volant.

Mais les deux hommes ont une tout autre ambition: construire leur propre voiture, une voiture qui possède les qualités, mais non les tares de la Singer. Son nom est d'ailleurs déjà choisi. Quant à son origine, il faut se fier à une déclaration autobiographique de Lionel Martin: «Après

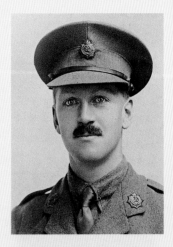

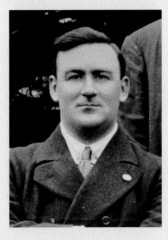

Forefathers: Robert Bamford (top), around 1916, and Lionel Martin photographed in 1906.

Die Ahnen: Robert Bamford (oben), um 1916 aufgenommen, und Lionel Martin. Das Bild stammt von 1906.

Les ancêtres: Robert Bamford (en haut), photographié ici vers 1916, et Lionel Martin (photo prise en 1906).

appended to it." An early declaration of intent has also been preserved: an Aston Martin must always be a quality car, with good performance and a pleasing appearance, a car for the demanding owner who likes to get a move on. As regards design, development and manufacture, it must stand out from the rest through its high degree of individuality. To this day nothing needs to be added to the above. The acquisition of new premises at Henniker Place, West Kensington, clearly demonstrates that their plan was in earnest, and their first opus was soon taking shape. First to be ready was the engine, a modified Coventry-Simplex

Lionel Martin's second wife Katherine at the wheel of the Coal Scuttle.

Lionel Martins zweite Frau Katherine am Lenkrad des Coal Scuttle.

Katherine, la seconde épouse de Lionel Martin, au volant de la Coal Scuttle.

machine with side valves and a modest 1389 cc. It was test driven in a 1908 Isotta-Fraschini chassis before being united with the rest of the very first Aston Martin, a two-seater which was registered on 16th March 1915 by Wiltshire County Council under the number AM 4656. This first Aston Martin soon acquired the nickname "Coal Scuttle", one of a range of monikers including "Green Pea" which survives from those days. Over the ensuing four years the "Coal Scuttle" was to experience all manner of difficulties and deliberate rough treatment. A far more important landmark in the history of Aston Martin, though, was the second prototype, which took to the road from their new premises in Abingdon Road, Kensington, at the end of 1920. Now with an engine capacity of 1487 cc and fitted with front wheel brakes, it was the forerunner of the first, tentative attempts at a production car from 1923 onwards.

By now founding father Robert Bamford, who had never really warmed to the idea of mass production, had left the fledgling company. In his place, Count Louis Vorow Zborowski was steadily gaining in influence and had also invested a fair amount of his own money in the

Fische in Erwägung gezogen hatten, die wir kannten, wendeten wir uns geografischen Begriffen zu. Und da mein Singer unlängst ein oder zwei Punkte beim Bergrennen von Aston Clinton (in der Grafschaft Herefordshire) ergattert hatte, machten wir uns unter allgemeinem Beifall den ersten Teil jenes Namens zu Eigen und hängten meinen bescheidenen Nachnamen einfach dran.« (O-Ton: »*After reviewing all the flowers, beasts, birds and fishes that we knew, we got to place names, and as my Singer had recently scored a point or two at the Aston Clinton Hill Climb, the first part of that name was adopted with acclamation and my simple cognomen appended to it.*«) Eine frühe programmatische Äußerung ist ebenfalls erhalten: Ein Aston Martin müsse ein Qualitätsauto sein, von guter Leistung und von gefälligem Aussehen, ein Fahrzeug für den anspruchsvollen Besitzer, der gerne zügig reise. Hinsichtlich seiner Konzeption, Entwicklung und Herstellung habe es sich durch hohe Individualität von anderen zu unterscheiden. Dem ist, wie man weiß, bis auf den heutigen Tag nichts hinzuzufügen.

Der Erwerb eines neuen Anwesens am Henniker Place, West Kensington, belegt unmissverständlich, dass es den beiden ernst ist mit ihrem Plan, und Opus 1 nimmt in der Tat zügig Gestalt an. Zuerst ist der Motor fertig, eine modifizierte Coventry-Simplex-Maschine mit Seitenventilen und bescheidenen 1389 Kubikzentimetern. Sie absolviert eine Probezeit in einem Isotta-Fraschini-Chassis von 1908 und wird dann mit dem Rest des ersten Aston Martin vereint, eines Zweisitzers, der am 16. März 1915 beim Wiltshire County Council mit dem Kennzeichen AM 4656 zugelassen wird. Der Volksmund tauft den Erstling liebevoll »Coal Scuttle«, den »Kohlenkasten«, wie überhaupt aus jener Zeit eine Reihe von Spitznamen überliefert ist wie etwa »Green Pea«. In den folgenden vier Jahren steht dem »Kohlenkasten« ein schweres Autoschicksal bevor, da er schikaniert und gepiesackt wird wie ein Erlkönig von heute. Ein viel wichtigeres Leitfossil in der Historie der Marke ist indessen der zweite Prototyp, Ende 1920 bereits unter ihrer neuen Adresse in der Abingdon Road in Kensington auf die schmalen Räder gestellt. Mit nunmehr 1487 Kubikzentimetern und Vorderradbremsen wird er zum Stammvater eines ersten, schwachen Schubes von Produktionsautos ab 1923. Inzwischen hat Gründervater Robert Bamford, der sich für die Idee einer Serienfertigung nie sonderlich erwärmt hat, die kleine Firma verlassen. An seiner statt hat Graf Louis Vorow Zborowski immer mehr an Einfluss gewonnen und auch das eine oder andere Pfund Sterling investiert. Eton-Zögling wie Lionel Martin selbst, ist Zborowski ein Paradiesvogel von charismatischer Ausstrahlung. Schon sein Vater Elliott, gebürtig in Elizabeth, New Jersey, ist eine höchst ungewöhnliche Erscheinung. Geld ist in Hülle und Fülle vorhanden: Elliott Zborowski erspekuliert ein Vermögen an der Wall Street und heiratet die schwerreiche Margaret Astor Carey. Da

avoir passé en revue tous les noms de fleurs, de quadrupèdes, d'oiseaux et de poissons que nous connaissions, nous nous sommes tournés vers les termes géographiques. Et comme, tout récemment, ma Singer avait remporté un ou deux points lors de la course de côte d'Aston Clinton (dans le comté du Herefordshire), nous avons décidé, à l'unanimité, d'opter pour la première partie de ce nom et d'y ajouter tout simplement mon modeste nom de famille. » Un des postulats de l'époque, qui prendrait valeur de programme, vaut aujourd'hui encore : une Aston Martin doit être une voiture de qualité, au moteur puissant, aux lignes séduisantes, convenant à un propriétaire exigeant et qui apprécie de voyager à un rythme rapide. Sur le plan de sa conception, de son développement et de sa fabrication, elle doit se distinguer des autres par sa forte personnalité. Et tout cela est encore valable aujourd'hui même.

L'acquisition d'une nouvelle propriété sise dans Henniker Place, West Kensington, prouve sans ambiguïté possible que les deux hommes sont bien déterminés et leur première réalisation prend bel et bien rapidement forme. Le premier élément achevé est le moteur, un Coventry-Simplex modifié à soupapes latérales de la modeste cylindrée de 1389 cm³. Il fait ses premières armes sur un châssis d'Isotta Fraschini de 1908 et est ensuite marié aux restes de la première Aston Martin, une biplace, homologuée le 16 mars 1915 auprès du Wiltshire County Council, et qui arbore la plaque minéralogique AM 4656. Le public surnomme affectueusement cette nouvelle voiture « Coal Scuttle », caisse à charbon, surnom qui s'ajoute à nombre d'autres de cette époque, par exemple « petit pois ». Pendant les quatre années qui suivront, la « caisse à charbon » aura une dure vie de voiture, car on s'acharnera sur elle comme sur tous ces prototypes traqués par les paparazzi d'aujourd'hui. Mais le second prototype est une étape autrement plus importante dans l'histoire de la marque. Il fait ses premiers tours de roues, étroites, dès la fin de 1920 à sa nouvelle adresse d'Abingdon Road, à Kensington. Avec désormais une cylindrée de 1487 cm³ et des freins sur les roues avant, elle est l'ancêtre d'une première lignée de voitures un peu lymphatiques produites en série à partir de 1923.

Entre-temps, Robert Bamford, l'un des deux fondateurs, qui n'a jamais été particulièrement enthousiasmé par l'idée d'une fabrication en série, a quitté la petite firme. À sa place, le comte Louis Vorow Zborowski a pris de plus en plus d'influence, n'hésitant pas, à cette occasion, à investir ses deniers personnels. Élève d'Eton comme Lionel Martin lui-même, Zborowski est un oiseau de paradis au charisme irrésistible. Son père Elliott, qui est né à Elizabeth, dans le New Jersey, est aussi un personnage comme on en rencontre rarement. L'argent coule à flots : Elliott Zborowski a fait fortune en spéculant à Wall Street et a épousé la richissime Margaret Astor Carey. Comme la noblesse de l'argent a une attirance pour la noblesse de sang, cet authentique Américain de naissance se donne, après avoir déménagé en Angleterre, l'identité

enterprise. An old Etonian like Lionel Martin, Zborowski was a charismatic and flamboyant character. His father Elliott Zborowski, born in Elizabeth, New Jersey, was himself a larger-than-life figure who made a fortune speculating on Wall Street and married the wealthy heiress Margaret Astor Carey. Zborowski was an American through-and-through, but a snob as well, so once in England he took on the persona of a Polish aristocrat, and his son Louis was happy to carry on the pretence.

Everything about him had to be on a grand scale. His notorious special, "Chitty-Bang-Bang", taken from the chorus of a rude song, bore eloquent witness to this, its onomatopoeic name reflecting the noise that emanated from its 23 liter Maybach aviation engine, which his accomplice Clive Gallop had bolted on to a prewar Mercedes chassis. Zborowski's wild parties at his country seat in Higham near Canterbury were legendary, as was his little foible of having small houses built on Higham's rolling parkland, then filling them with explosives and blowing them sky high. His striking black and white check linen caps were a familiar sight on European race circuits. He perished on 19th October 1924, when just 29 years old, in the Italian Grand Prix at Monza, bringing to an end a boisterous and extravagant life in an entirely fitting fashion.

When on 24th May 1922 an Aston Martin with the deceptively peaceable name "Bunny" was sent to Brooklands to attempt various records, the young pseudo-aristocrat was along for the ride. Brooklands was a three-mile oval circuit ideal for that purpose, and together with his team comprising Bertie Kensington Moir, Clive Gallop and Sammy Davis, he broke ten world records in 16½ hours, at an impressive average speed of 76 mph, not a bad premiere for such a small car. Suddenly Aston Martin was a household name, although an expedition to that year's French Grand Prix in Strasbourg, and the exploits of another record-seeking Aston Martin by the name of "Razor Blade" did little to add to the firm's reputation. However, the Razor Blade did make one contribution to British motorsport by providing the model for the emblem of the renowned British Racing Drivers' Club.

In the meantime Lionel Martin was getting into ever deeper economic difficulties: too many races and record attempts and too few sales – no more than 50 or so over a two year period, not enough, despite the exorbitant £700 to £750 price-tag of the Aston Martins. Even the largesse of Lord Charnwood could not long stave off the inevitable, and in 1925 the young company went into receivership for the first time.

At this point a disheartened Lionel Martin resigned from the company to devote the rest of his life to his second great passion: bicycles. And on 14th October 1945 it was in fact a tricycle that proved his undoing, as he suffered fatal injuries in an accident incurred as he rode peacefully down the Kingston Gloucester Road. But 20 years previously he had already bequeathed his most priceless asset: his good name.

sich Geldadel am liebsten mit richtigem Adel schmückt, gefällt sich der waschechte Amerikaner nach seinem Umzug nach England in der Identität eines polnischen Aristokraten, eine Würde, in der sich auch Sohn Louis durchaus wohl fühlt.

Alles Mickrige ist ihm ein Gräuel. Ein beredtes Zeugnis davon legt sein berühmt-berüchtigter Special »Chitty-Bang-Bang« ab. Sein Kriegername ist dem Refrain eines obszönen Liedchens entlehnt und gibt lautmalerisch die Lebensäußerungen seines 23-Liter-Flugmotors von Maybach wieder, den sein Helfershelfer Clive Gallop auf ein Mercedes-Chassis aus der Vorkriegszeit geschraubt hat. Zborowskis ausgelassene Parties in seinem Herrensitz zu Higham bei Canterbury sind Legende wie auch seine Marotte, in dessen weitläufigen Parkanlagen kleine Häuser zu errichten, um sie anschließend mit Sprengstoff zu füllen und zur Explosion zu bringen. Seine schrillen Kappen aus schwarzweiß kariertem Leinen kennt man auf den Pisten des Kontinents. Am 19. Oktober 1924 kommt er, gerade 29 Jahre alt, beim Großen Preis von Italien in Monza ums Leben, so wie die wüste Existenz des Don Giovanni von seiner Höllenfahrt angemessen beendet wird.

Als am 24. Mai 1922 ein Aston-Martin-Rekordwagen mit dem friedfertigen Namen »Bunny« nach Brooklands verfrachtet wird, einem 4,8 Kilometer langen Betonoval, das sich für diese Zwecke hervorragend eignet, ist der junge Wahl-Adlige mit von der Partie. Zusammen mit der Mannschaft Bertie Kensington Moir, Clive Gallop und Sammy Davis bricht er innerhalb von 16½ Stunden zehn Weltrekorde mit dem bemerkenswerten Schnitt von 122 Stundenkilometern, eine echte Premiere für ein kleines Auto. Plötzlich ist der Begriff Aston Martin in aller Munde, während eine Expedition zum Großen Preis von Frankreich jenes Jahres in Straßburg sowie die Eskapaden eines weiteren Rekordwagens namens »Razor Blade« kaum zu ihrem Renommee beitragen. Immerhin macht sich die »Rasierklinge« um den englischen Rennsport verdient, da sie als Vorlage zum Emblem des renommierten British Racing Drivers' Club dient.

Lionel Martin indessen rutscht immer mehr ab in eine qualvolle wirtschaftliche Schieflage: zu viele Rennen und Rekorde, zu wenige Verkäufe, nur etwa 50 in zwei Jahren, auch wenn ein Aston Martin mit 700 bis 750 Pfund sündhaft teuer ist. Da fruchten selbst die Zuwendungen der Adelsdynastie Charnwood nichts mehr. 1925 muss sich das junge Unternehmen zum ersten Mal eine Konkursverwaltung gefallen lassen.

Zugleich zieht sich Lionel Martin verstimmt zurück, bewahrt sich indessen zeitlebens seine zweite große Passion: Fahrräder. Am 14. Oktober 1945 wird sie ihm zum Verhängnis werden: Friedlich auf einem Dreirad thronend, wird er bei einem Verkehrsunfall in der Gloucester Road zu Kingston letal verletzt. Bereits bei seinem Abgang 20 Jahre zuvor hat er ein schier unbezahlbares Erbstück hinterlassen: seinen guten Namen.

d'un aristocrate polonais, un statut qui convient également tout à fait à son fils Louis.

La médiocrité lui fait horreur. Sa célèbre et redoutée « Chitty-Bang-Bang » spéciale en livre un témoignage éloquent. Son nom de guerre reproduit de manière pittoresque les borborygmes de son moteur d'avion, un Maybach de 23 litres de cylindrée, que son auxiliaire Clive Gallop a monté sur un châssis de Mercedes d'avant-guerre. Les somptueuses fêtes qu'organise Zborowski dans sa propriété de Higham, près de Canterbury, sont entrées dans la légende, tout comme sa marotte, qui consiste à faire édifier dans son immense parc de petites maisons qu'il remplit ensuite de dynamite avant de les faire exploser. On connaît sur tous les circuits du continent sa spectaculaire casquette en lin à carreaux noirs et blancs. Il trouvera la mort lors du Grand Prix d'Italie à Monza, le 19 octobre 1924, alors qu'il est tout juste âgé de 29 ans, à l'instar de Don Juan, dont la vie débridée semble avoir été stoppée net par sa descente aux enfers.

Le jeune noble d'adoption est aussi de la partie lorsque, le 24 mai 1922, une Aston Martin de record affublée du pacifique surnom de « Bunny » est envoyée à Brooklands, un circuit ovale en béton de 4,8 km de développement idéal pour les tentatives de record. Avec l'équipage se composant de Bertie Kensington Moir, Clive Gallop et Sammy Davis, il bat, en 16 heures et demie, dix records du monde à la moyenne remarquable de 122 km/h, une authentique première pour une petite voiture. Soudain, le nom d'Aston Martin est sur toutes les lèvres et ce malgré une expédition au Grand Prix de France de cette année-là, à Strasbourg, où la prestation d'une autre voiture de record de l'écurie Aston Martin, baptisée « Razor Blade », ne contribue pas particulièrement à sa renommée. La « lame de rasoir » aura tout de même apporté quelque chose à la compétition automobile britannique, car elle a servi de modèle pour l'emblème du réputé British Racing Drivers' Club.

Lionel Martin, quant à lui, a la douleur de voir sa situation économique péricliter de plus en plus : trop de courses et de records, trop peu de ventes – une cinquantaine seulement en deux ans – même si une Aston Martin coûte le prix astronomique de 700 à 750 livres, cela ne suffit pas. Même les subventions de la dynastie des lords Charnwood ne pourront le sauver du désastre. En 1925, la jeune entreprise est placée pour la première fois sous syndic.

Dépité, Lionel Martin profite de cette occasion pour se retirer et se consacrer à la seconde grande passion de sa vie, les cycles. Le 14 octobre 1945, cette passion lui sera fatale : roulant tranquillement sur un tricycle, il est mortellement blessé dans un accident de la circulation sur Gloucester Road, à Kingston. Mais il avait déjà, vingt ans auparavant, en quittant l'entreprise, laissé un héritage qui n'a pas de prix : son nom.

Count Lou Zborowski in imperial pose behind the wheel of his Higham Special.

Graf Lou Zborowski in imperialer Pose am Volant seines Higham Special.

Le comte Lou Zborowski, l'air impérial, au volant de sa Higham Special.

"Our Bert"
The Bertelli Era

It was this same name that would provide for continuity, both now and in the future. Returning to 1926, Aston Martin experienced a rapid renaissance as Lord Charnwood and John Benson took on the ailing company. Together with Domenico Augustus Cesare Bertelli and William Somerville Renwick, in October 1926 they renamed the company Aston Martin Motors and also moved to new premises in Victoria Road, Feltham, Middlesex. Two years previously Renwick and Bertelli had set up a factory in Birmingham with the modest ambition of building the best car in the world. The concrete product of this enterprise to date had been an elaborate power train, a 1.5 liter four cylinder engine with an overhead camshaft and dry sump lubrication. Installed in a vehicle which survives to this day, it was to be the prototype for all Aston Martin engines up until 1936.

Cesare Bertelli, known affectionately to his friends as "Our Bert", now increasingly became the heart and soul of the company. "Our Bert" could look back on an illustrious past as the co-driver and mechanic of Italian racing ace Felice Nazzaro, a highly popular figure in England. Bertelli's profound technical knowledge and shrewd judgment of character meant he brought not only plenty of heart but also some highly

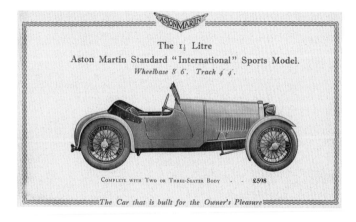

ASTONMARTIN

The 1½ Litre
Aston Martin Standard "International" Sports Model.
Wheelbase 8' 6". Track 4' 4".

COMPLETE WITH TWO OR THREE-SEATER BODY - £598

The Car that is built for the Owner's Pleasure

Never at a loss for words: advertisement for the International from 1930.

Um flotte Sprüche nie verlegen: Werbung 1930 für den International.

Foin de la timidité: une publicité de 1930 pour l'International.

welcome and much-needed business sense to the enterprise. Chroniclers have nothing but good to say about a man who combined an alarming frankness with disarming charm. One instance of this was the occasion when he had the nerve to pick holes in the concept of a future legend, the Austin Seven, when Herbert Austin laid them innocently before him. Austin had the reputation of being an irascible and autocratic man, but he swallowed the unaccustomed criticism tamely and even quietly incorporated Bertelli's suggestions.

By 1929 the universally respected Aston Martin International had developed to the point where it was setting new standards in terms of handling and roadholding. However, money was still tight, and the company could not afford costly advertising campaigns, so Bertelli and his team

»Unser Bert«
Die Ära Bertelli

Dieser ist es denn auch, der diesmal und später immer wieder für Kontinuität sorgt. So kommt es 1926 zu einer raschen Renaissance, als sich Lord Charnwood und John Benson des maroden Betriebes annehmen. Gemeinsam mit Domenico Augustus Cesare Bertelli und William Somerville Renwick widmet man ihn im Oktober 1926 um in die Aston Martin Motors und bezieht auch gleich eine neue Garnison an der Victoria Road in Feltham, Middlesex. Renwick und Bertelli haben zwei Jahre zuvor in Birmingham eine Manufaktur gegründet mit der pompösen Zielsetzung, das beste Auto der Welt zu bauen. Konkret dabei herausgekommen ist bisher ein aufwändiges Triebwerk, ein Vierzylinder von 1,5 Litern mit oben liegender Nockenwelle und Trockensumpfschmierung. In ein Fahrzeug installiert, das bis heute überlebt hat, wird es zum Ahnherrn für die Aston-Martin-Maschinen bis 1936.

Als Herz und Seele des Unternehmens entpuppt sich immer mehr Cesare Bertelli, von Freunden liebevoll »unser Bert« geheißen. »Unser Bert« blickt auf eine illustre Vergangenheit als Beifahrer und Schrauber des italienischen Renn-Asses Felice Nazzaro zurück, der sich in England großer Popularität erfreute. Mit profunden technischen Kenntnissen sowie einem urgesunden Menschenverstand ausgestattet, bringt er viel Herz und einen höchst willkommenen Sinn für das Geschäftliche mit. Nur Gutes wissen die Chronisten auch sonst zu berichten: Bertelli sei von erschreckender Offenheit, aber verbindlich in der Methode gewesen. So habe er zum Beispiel die Stirn gehabt, an dem Entwurf der künftigen Legende Austin Seven herumzumäkeln, der ihm von Herbert Austin arglos vorgelegt worden sei. Austin gilt als jähzorniger Autokrat. Er schluckt gleichwohl die ungewohnte Kritik handzahm und bringt sogar die Vorschläge Bertellis klammheimlich in sein Konzept ein.

1929 hat das allseits geschätzte Modell International Gestalt angenommen, das neue Maßstäbe setzt hinsichtlich seiner Handlichkeit und Straßenlage. Immer knapp jedoch bleibt das Geld. Kostspielige Werbekampagnen kann man sich nicht leisten. Also bedienen sich Bertelli und die Männer um ihn in bester Tradition ihres Hauses des Rennsports, um die Idee Aston Martin in aller Welt unter die Leute zu bringen. Dabei streut man entsprechend weit: Die Produkte der Nobel-Firma zu Feltham finden sich durchaus nicht nur auf den Starterlisten von englischen Hochglanzveranstaltungen wie der Tourist Trophy, sondern auch bei der Mille Miglia sowie den 24-Stunden-Rennen von Spa und Le Mans. Schon aus Prinzip: »Racing improves the breed«, wissen die Aston-Martin-Macher, Rennen veredeln die Rasse. 1932 gewinnen Cesare Bertelli und Pat Driscoll auf dem Sarthe-Kurs den Rudge Whitworth Coupe Biennale, eine Handicapwertung, die das Volumen des Motors ins Verhältnis setzt zu den gefahrenen Kilometern. 1935 sorgen Charles Martin und Charles Brackenbury für eine Neuauflage dieses Erfolgs und eine Rekorddistanz für die Andert-

« Notre Bert »
L'ère Bertelli

C'est ce nom qui, cette fois-ci et plus tard encore, assurera toujours la continuité. Aussi la renaissance est-elle rapide lorsque, en 1926, Lord Charnwood et John Benson reprennent l'entreprise agonisante. Conjointement avec Domenico Augustus Cesare Bertelli et William Somerville Renwick, l'équipe de dirigeants la rebaptise Aston Martin Motors, en octobre 1926, et déménage par la même occasion pour Victoria Road, à Feltham, dans le Middlesex. Deux ans auparavant, Renwick et Bertelli ont fondé, à Birmingham, une manufacture qui s'était donné l'objectif ambitieux de construire la meilleure voiture du monde. Tout ce qu'elle a concrètement réalisé jusqu'alors est un moteur complexe, un quatre-cylindres de 1,5 litre avec un arbre à cames en tête et une lubrification à carter sec. Installé dans une voiture qui existe aujourd'hui encore, il sera l'ancêtre des moteurs d'Aston Martin jusqu'en 1936.

Et c'est toujours Cesare Bertelli, que ses amis surnomment affectueusement « notre Bert », qui est la cheville ouvrière de l'entreprise à laquelle il donne une âme. « Notre Bert » peut se prévaloir d'un illustre passé comme passager et mécanicien d'un grand pilote de course italien, Felice Nazzaro, qui jouit d'une grande popularité en Angleterre. Féru de mécanique et doté d'un solide bon sens, il est très chaleureux, et ce qui ne gâte rien, a le sens des affaires. Quoi qu'il en soit, les chroniqueurs ne parlent de lui qu'en termes élogieux : d'une franchise désarmante, Bertelli avait un jugement très sûr. Ainsi avait-il eu le courage de critiquer les esquisses de la future légendaire Austin Seven que Herbert Austin lui avait candidement présentées. Austin avait une réputation d'autocrate colérique. Contrairement à ses habitudes, il avala cette critique inhabituelle sans se vexer et tint même secrètement compte des propositions de Bertelli pour son projet.

1929 voit apparaître le modèle International qui remporte un grand succès et représente un progrès important en termes de maniabilité et de tenue de route. Mais l'argent est toujours aussi rare. Aston ne peut se permettre de coûteuses campagnes publicitaires. Dans la plus pure tradition de la maison, Bertelli et son équipe recourent donc à la compétition automobile pour propager la notoriété d'Aston Martin dans le monde entier. Et, pour cela, ils n'hésitent pas à ratisser large : on ne retrouve pas seulement les bolides de la prestigieuse firme de Feltham sur les grilles de départ de célèbres manifestations anglaises comme le Tourist Trophy, mais aussi aux Mille Miglia italiennes ainsi qu'aux 24 Heures de Spa et du Mans. C'est même devenu un principe : « Racing improves the breed » (la course anoblit la race), proclament les constructeurs d'Aston Martin. En 1932, Cesare Bertelli et Pat Driscoll remportent la Rudge Whitworth Coupe Biennale sur le circuit de la Sarthe, un classement avec handicap qui tient compte du rapport entre la cylindrée du moteur et le nombre de kilomètres parcourus. En 1935, Charles Martin et Charles Brackenbury rééditent cette performance et signent, dans la

fell back on the best motorsport traditions of the marque in order to bring the Aston Martin name to the world's attention. In line with the principle "racing improves the breed", efforts were spread far and wide. Aston Martin cars were entered not only for top English races like the Tourist Trophy but also for prestigious international events such as the Mille Miglia and the 24-hour races at Spa and Le Mans. In 1932 Cesare Bertelli and Pat Driscoll won the Rudge Whitworth Coupe Biennale on the Sarthe racetrack, an event based on the relationship between engine volume and miles covered. In 1935 Charles Martin and Charles Brackenbury repeated this success, winning the one and a half liter class with a distance record that was to stand until 1950. Le Mans played to the Aston Martins' strengths while mercifully concealing their weaknesses. The cars' weight meant that their acceleration out of the corners lacked punch, while their reliability and impressive top speed both very much came into play on the long straights. They were also able to surmount various hitches: before the two privateers Mortimer ("Mort") Morris-Goodall and Robert Hitchens won Aston Martin's third Coupe Biennale in 1937, there was a minor problem to overcome. At the end of the 23rd hour a valve from their two liter engine fell into a cylinder, and it was only after this was suspended in the pits that the pair were able to fulfil a clause in the rules stipulating that cars must cross the finishing line with the engine running at 4 pm on Sunday.

Meanwhile the company had undergone a number of significant changes. Towards the end of 1932 Aston Martin Motors had been taken over by Sir Arthur Sutherland, with his son Gordon becoming managing director. Under their auspices the renowned Le Mans, successor to the International, saw the light of day, to be followed in 1934 by the Mark II, in turn the forerunner of the Ulster, which was introduced that same year. The one and a half liter engine had remained an article of faith for 12 years, but now at the end of 1935 they started developing a two liter unit. The plan was for it to do service in a somewhat more middle-of-the-road vehicle than the cars that had hitherto emerged from the Feltham works. The result of this minor palace revolution was the 15/98, which – as was customary – came in three versions, a four-seater, a saloon, and a drophead coupé, meeting the needs of well-heeled customers in search of automotive individuality. An enthusiastic minority of said clientele gathered on 25th May 1935 at The Grafton Hotel in Tottenham Court Road, London, to found the Aston Martin Owners' Club. 66 Aston Martins were built in that year, one sixth of the total population of 400 in existence up to that point in time. Incidentally, by 2000 a total of just 17,000 had been built, while the club today has 4700 members.

As for motorsport, the works program had been cut back and privateers were taking the lead. Motorsport is an expensive business, and shortage of funds continued to plague the company and dominate discussions at board meetings. At the end of 1936 another chapter in the company's history sadly came to a close with the

halbliter-Klasse, die erst 1950 übertroffen wird. Le Mans kommt den Tugenden der Aston Martin entgegen und vertuscht gnädig ihre Schwächen: Nur behäbig beschleunigen sie wegen ihres hohen Gewichts aus den Kurven heraus, zum Vorteil hingegen gereichen ihnen ihre beachtliche Spitze und ihre Zuverlässigkeit. Sie stecken auch einiges weg: Bevor die beiden Privatfahrer Mortimer Morris-Goodall und Robert Hitchens 1937 den Coupe Biennale zum dritten Mal für Aston Martin gewinnen, gibt es eine kleine Schwierigkeit zu überwinden. Am Ende der 23. Stunde fällt ein Ventil ihres Zweiliters in einen Zylinder. Erst nachdem dieser an der Box still gelegt worden ist, können die beiden der Klausel im Reglement nachkommen, der Kandidat müsse am Sonntag um 16 Uhr mit laufendem Motor die Ziellinie überqueren.

Inzwischen haben sich Dinge von beträchtlicher Tragweite ereignet. Gegen Ende des Jahres 1932 gehen die Aston Martin Motors über in die Hände von Sir Arthur Sutherland, dessen Sohn Gordon das Management übernimmt. Unter dessen Ägide fällt das berühmte Modell Le Mans, Nachfolger des International. 1934 folgt ein Mark II, Vorläufer des Ulster aus dem gleichen Jahr. Nachdem ein Motorvolumen von anderthalb Litern zwölf Jahre lang zu den Glaubensartikeln gehört hat, beginnt man Ende 1935 mit dem Bau des Zweiliters. Er soll seinen

catégorie des 1500 cm³, un record qui ne sera battu qu'en 1950. Le Mans met en valeur les qualités des Aston Martin et masque leurs points faibles: en raison de leur poids élevé, elles n'accélèrent que lentement en sortie de virage, mais elles ont l'avantage d'une vitesse de pointe respectable et d'une grande fiabilité. Et elles savent aussi encaisser: avant que les deux pilotes privés Mortimer Morris-Goodall et Robert Hitchens gagnent, pour la troisième fois, la Coupe Biennale pour Aston Martin en 1937, il y a une petite difficulté à surmonter. À la fin de la 23e heure, une soupape de leur moteur de deux litres tombe dans un cylindre. Ce n'est qu'après que ce cylindre a été mis hors service aux stands que les deux hommes peuvent respecter la clause du règlement qui prévoit le passage de la ligne d'arrivée, moteur en marche, le dimanche à 16 heures.

Entre-temps, des événements d'une tout autre importance se sont produits. Vers la fin de 1932, Aston Martin Motors devient la possession de Sir Arthur Sutherland, dont le fils Gordon se charge de la direction. C'est sous sa férule que naît le célèbre modèle Le Mans. En 1934 paraît alors une Mark II, précurseur de la Ulster de la même année. Alors qu'un moteur de 1,5 litre de cylindrée a, pendant douze ans, été un dogme pour Aston Martin, on commence à dessiner un deux-litres à la fin de 1935. Il est appelé à exercer ses

Wide-ranging offer: the Aston Martin stand at the 1931 London Motor Show. From left: four-seater International, two-seater Le Mans, 4-door saloon.

Weit gefächertes Angebot: Aston-Martin-Stand auf der London Motor Show 1931. Von links: International 4-Seater, Le Mans 2-Seater, 4-Door Saloon.

Une offre déjà diversifiée: le stand d'Aston Martin au London Motor Show de 1931. De gauche à droite: International 4 places, Le Mans 2 places, berline 4 portes.

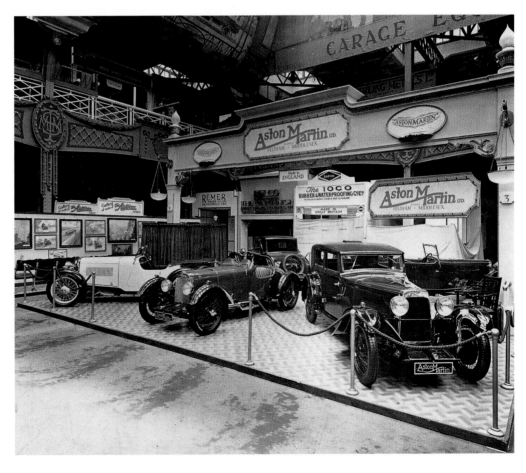

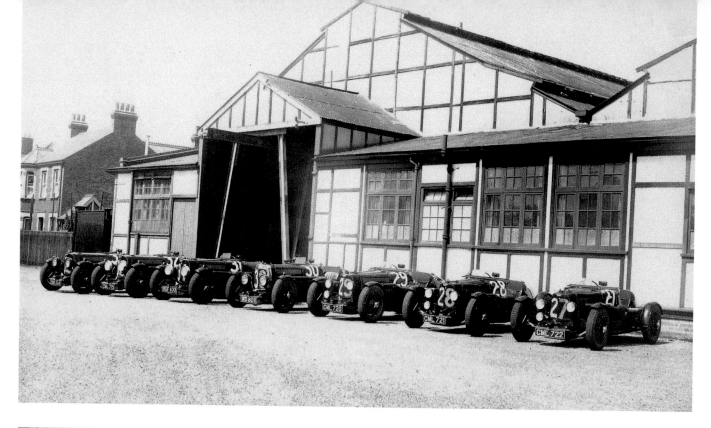

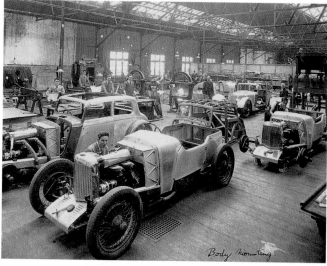

Top: *1935 Le Mans works cars LM18, LM19, LM20 and privately-owned vehicles.*
Above: *Assembly ca. 1935 with a Mark II Sports Saloon and an Ulster.*

Ganz oben: *Werksautos für Le Mans 1935: LM18, LM19, LM20 und diverse Privatwagen.*
Oben: *Montage eines Mark II Sports Saloon und eines Ulster, um 1935.*

En haut: *Voitures d'usine pour Le Mans 1935, LM18, LM19, LM20 et voitures privées.*
Ci-dessus: *Le hall de montage vers 1935; au premier plan, une Mark II Sports Saloon et une Ulster.*

departure of Cesare Bertelli. He had done much to foster the mystique and renown of Aston Martin and his name has an honored place in the company annals. But life goes on, and in the spring of 1939 came a prototype bursting with innovations: independent front suspension, an electric Cotal gearbox and a kind of tubular space frame, all clad in a slightly progressive take on the notions of streamlining prevalent at that time. This futuristic note was also mirrored by the name of this handsome one-off, dubbed the "Atom". This proved to be more than just a concept car, as it became the object to which Aston Martin pinned its hopes during the long years of the Second World War.

Dienst im Gewand eines etwas bürgerlicheren Autos aufnehmen, als man sie bislang aus Feltham gewohnt war. Das Ergebnis dieser kleinen Palastrevolution ist der 15/98, der wie üblich in den drei Varianten Viersitzer, Saloon und Drophead Coupé die Bedürfnisse einer gut betuchten und nach automobiler Individualität dürstenden Klientel abdeckt. Eine bekennende Minorität davon findet sich am 25. Mai 1935 in The Grafton Hotel in der Londoner Tottenham Court Road zusammen zwecks Gründung eines Markenclubs. 66 Aston Martin werden in jenem Jahr gebaut, ein Sechstel also der Population von insgesamt 400 bis zu diesem Zeitpunkt. Zum Vergleich: Knapp 17 000 werden bis zum Jahre 2000 unters fahrende Volk gebracht, über 4700 Mitglieder zählt der Club heute.

Was den Rennsport anbelangt, überlässt man den Privatfahrern die Initiative. Geldnot ist längst zum Leid-Motiv auf den Lagebesprechungen der Geschäftsleitung geworden. Ein weiteres Kapitel der Firmen-Saga ist abgeschlossen, unübersehbar die triste Symbolik von Cesare Bertellis Ausscheiden Ende 1936.

Man wird ihm ein ehrendes Angedenken bewahren, denn auch er hat etliches zum Mythos und zum Profil von Aston Martin beigetragen. Das Leben aber geht weiter. Im Frühjahr 1939 entsteht ein Prototyp, vollgestopft mit Innovation: unabhängige Aufhängung vorn, elektrische Cotal-Schaltung, eine Art Gitterrohrrahmen – eingekleidet in die zeitgenössische, wenn auch sanft futuristische Interpretation von Stromlinie. Vorbehaltlos fortschrittlich gibt sich selbst der Name des gefälligen Unikats: »Atom«. Es ist nicht nur ein technisches Paradestück, sondern soll Aston Martin zugleich als Hoffnungsträger über den Zweiten Weltkrieg geleiten.

fonctions sous le capot d'une voiture un peu plus bourgeoise que celles que l'on est habitué à voir sortir de Feltham. Le résultat de cette petite révolution de palais est la 15/98 qui est proposée dans trois variantes – quatre-places, Saloon et Drop head Coupé – pour satisfaire les besoins d'une clientèle aisée et éprise d'individualisme automobile. Une partie de cette clientèle enthousiaste se retrouve, le 25 mai 1935, au Grafton Hotel, Tottenham Court Road, à Londres, pour fonder un club de marque. Soixante-six Aston Martin sont construites cette année-là, un sixième, donc, de la production totale qui était de 400 à ce moment-là. À titre comparatif, près de 17 000 seront construites et vendues jusqu'en l'an 2000 et le club compte aujourd'hui plus de 4700 membres.

Côté compétition, l'usine laisse l'initiative aux pilotes privés. La pénurie d'argent est depuis longtemps devenue un leitmotiv lors des conférences régulières de direction. Un autre chapitre de la saga d'Aston Martin s'achève sur une note triste avec le départ de Cesare Bertelli à la fin de 1936.

Il laisse un souvenir ému, car lui aussi a largement contribué au mythe et au profil d'Aston Martin. Mais la vie continue et au printemps de 1939 est présenté un prototype truffé d'innovations: suspension à roues indépendantes à l'avant, boîte de vitesses électrique Cotal, une espèce de châssis tubulaire – correspondant à l'esthétique de l'époque contemporaine, mais avec une touche futuriste et des lignes aérodynamiques. Le nom même de ce séduisant spécimen unique témoigne d'une confiance aveugle dans le progrès: «Atom». Plus qu'une vitrine technologique, ce prototype représentera pour Aston Martin une lueur d'espoir pendant la Seconde Guerre mondiale.

Trophies, Tenacity and Tears

25 Years of David Brown

The following anecdote has proved difficult to verify, which is a pity as it has great charm: when reading *The Times* one morning in the autumn of 1946 David Brown, the Chairman of the David Brown Group, came upon a laconic small ad wedged in between the venerable newspaper's usual page one offerings of antiquarian books and military memorabilia from the recently ended conflict. Perhaps it was this one, published in the *Businesses for Sale* column: HIGH-CLASS MOTOR BUSINESS, established 25 years, 30,000 pounds, net profit last year 4000 pounds. – Write Box V. 1362, *The Times* E.C.4. Brown looked into the matter and somewhat to his surprise confirmed that the renowned marque Aston Martin had chosen this rather unusual way of seeking an end to its perennial financial difficulties. He got in touch with Gordon Sutherland, who had by now become owner of the company, and arranged a meeting with Claude Hill, the works designer. In February 1947 Brown purchased the ailing enterprise for £20,000. The tangible assets which he received in return for his investment did not exactly amount to a great deal: the lease on a dilapidated shed in Feltham, a few dog-eared work benches and drilling machines, a bare engine lying abandoned on the floor – and the time-honored Atom, rusting quietly in a corner. This the industrialist had taken back to his home town of Huddersfield to test drive. He was at least partially encouraged by what he found: the car proved to have excellent roadholding, but its 1970 cc pushrod unit proved somewhat feeble.

The future livelihoods of Sutherland and Hill, for many years Aston Martin's chief constructor, were secured by places on the board of the rejuvenated company.

In 1948 production of the new 2-litre Sports commenced. The car came as a 2/4-seater drophead coupé.

The best recommendation for a sports car is success on the racing circuit. Brown was entirely in agreement with this longstanding tenet of company philosophy, which was also, incidentally, very much an article of faith for their great rival of the future, Enzo Ferrari. And indeed Aston Martin soon got back down to business with an overall victory in the two liter class at the Spa 24 hour race for the driver pairing of "Jock" St. John Horsfall and Leslie Johnson. The Spa adventure was to prove of double significance. Not only was it important in helping Aston Martin find its feet after the upheavals of the Second World War, that rain-sodden weekend also marked the appearance on the scene of one John Wyer. Wyer was working then as manager of the Watford-based tuner Monaco Motors, which prepared racing cars for privateers. This time, though, they raced off their own bat, with his boss Dudley Folland teaming up on the Ardennes circuit with Ian Connell in an Aston Martin that had the distinction of having been driven before the war by Mercedes superstar Dick Seaman. This was very much a team

Trophäen, Trotz und Trübsal

Das Vierteljahrhundert unter David Brown

Die folgende Anekdote lässt sich nicht mehr eindeutig belegen. Dabei hat sie zweifellos Charme: Bei der morgendlichen Lektüre seiner geliebten *Times* entdeckt David Brown, Vorsitzender der David Brown Firmengruppe, im Herbst 1946 zwischen bibliophilen Raritäten und martialischen Souvenirs an die just beendeten Kampfhandlungen wie damals üblich auf der ersten Seite des altehrwürdigen Blatts eine lakonisch gehaltene chiffrierte Kleinanzeige. Vielleicht ist es diese vom 1. Oktober unter *Business for Sale*: HIGH-CLASS MOTOR BUSINESS, established 25 years, 30,000 pounds, net profit last year 4000 pounds. – Write Box V. 1362, *The Times* E.C.4. Brown geht der Sache nach und stellt überrascht fest, dass die renommierte Auto-Schmiede Aston Martin diesen durchaus ungewöhnlichen Weg beschritten hat, um ihre finanzielle Misere in den Griff zu bekommen. Er setzt sich mit Gordon Sutherland, mittlerweile zum Eigner der Fund-Sache aufgerückt, in Verbindung und arrangiert ein Treffen mit dem werkseigenen Designer Claude Hill. Im Februar 1947 erwirbt Brown den kränkelnden Betrieb für 20 000 Pfund. Mit dem, was er als realen Gegenwert erhält, ist wenig Staat zu machen: ein gepachteter Schuppen in Feltham, ein paar vergammelte Werkbänke und Bohrmaschinen, ein splitternackt herumliegender Motor und der in Ehren ergraute Atom, den der Industrielle im heimischen Huddersfield einer Probefahrt unterzieht. Sein Eindruck ist halbwegs ermutigend: Der Wagen wartet mit exzellenter Straßenlage auf, ist aber mit seinem 1970-ccm-Stoßstangentriebwerk etwas schwach auf der Brust. Für das weitere Auskommen von Sutherland und Hill, viele Jahre Chefkonstrukteur bei Aston Martin, ist gesorgt. Beide bleiben im Vorstand.

1948 nimmt man die Produktion des 2-litre Sports auf, in Gestalt eines 2/4-sitzigen Drophead Coupés.

Die beste Empfehlung für ein sportives Automobil ist die erfolgreiche Teilnahme an Rennen: Zumindest in diesem Punkt weiß sich Brown im Einklang mit der bisherigen Firmenphilosophie. Wie sich die Bilder gleichen: Dass die Piste Mutter von Rasse, Ruhm und Renommee sei, so lautet auch Artikel eins im Katechismus des künftigen Konkurrenten Enzo Ferrari. Gesagt, getan: Mit einem Gesamtsieg des Zweiliters beim 24-Stunden-Rennen von Spa unter der Pilotenriege »Jock« St. John Horsfall und Leslie Johnson setzt man umgehend einen energischen Akzent. Nicht nur als früher Paukenschlag bei der Selbstfindung und Eigendarstellung von Aston Martin nach dem Krieg indessen ist Spa von Bedeutung. Im strömenden Regen, der das ganze Wochenende anhalten wird, ist auch John Wyer angereist. Wyer arbeitet als Manager bei Monaco Motors in Watford, einem Tuner, der Rennwagen für private Kunden präpariert. Diesmal ist man in eigener Sache tätig: Sein Chef Dudley Folland tritt auf dem Ardennenkurs

Trophées, ténacité et tristesse

Un quart de siècle avec David Brown

Pour n'être pas forcément véridique, voici une anecdote qui ne manque certainement pas de charme. En automne 1946, lors de la lecture matinale de son cher *Times*, David Brown, président du groupe David Brown, fait une découverte tout à fait inattendue. En effet, à la page 1 de ce respectable journal se trouve, au milieu des publicités pour des livres anciens et des récits d'une guerre ayant tout juste pris fin, une petite annonce laconique. Peut-être s'agissait-il même de celle de la rubrique *Businesses for Sale* du 1er octobre : HIGH-CLASS MOTOR BUSINESS, established 25 years, 30,000 pounds, net profit last year 4000 pounds. – Write Box V. 1362, *The Times* E.C.4. Brown mène son enquête et découvre non sans surprise que la célèbre manufacture de voitures de sport Aston Martin a choisi cette méthode pour le moins inhabituelle pour se sortir de sa débâcle financière. Il prend contact avec Gordon Sutherland, devenu entretemps propriétaire de la firme et désireux de s'en débarrasser, puis arrange un rendez-vous avec le designer maison, Claude Hill.

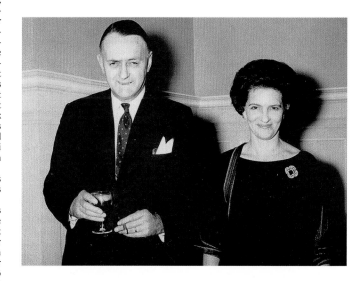

En février 1947, Brown acquiert l'entreprise à l'agonie pour 20 000 livres. Il n'y a pas de quoi pavoiser avec ce qu'il obtient en contrepartie : un hangar loué à Feltham, quelques machines-outils et perceuses en mauvais état, un moteur complètement nu et l'« Atom », qui a vieilli avec dignité et que l'industriel soumet à un essai à Huddersfield, où il réside. Le résultat est plutôt encourageant : la voiture possède une excellente tenue de route, mais, avec son moteur culbuté de 1970 cm³, elle manque un peu de puissance. La carrière de Sutherland et Hill – qui restera de nombreuses années constructeur en chef chez Aston Martin – est assurée. Tous les deux restent au directoire. En 1948 débute la production

Connoisseurs: John Wyer and his wife Tottie in the mid-fifties.

Stille Genießer: John Wyer und Gattin Tottie Mitte der Fünfziger.

Le charme discret de la bourgeoisie: John Wyer et son épouse Tottie, vers le milieu des années 1950.

Little Big Man

The guy was just bursting with vitality, and somehow seemed to be spared the usual processes of aging, of wear and tear. For David Brown, known universally as DB or as Sir David since the day in 1968 when Queen Elizabeth II knighted him for services to the crown, country and Aston Martin, there was no such thing as speeding up or slowing down: he spent his whole life in the fast lane, in overdrive and with his foot hard to the floorboards. Death eventually overtook him when his engine finally gave out, just eight months before his 90th birthday. Not a tall man, he was something of a Napoleon of the machine age, always looking for new conquests, but not immune from meeting the odd Waterloo along the way. And he never had a free ride.

Some scenes from a life in the fast lane: as the son of the boss of David Brown & Sons Limited of Huddersfield, the common view would have been that he had been born with a silver spoon in his mouth, but his youth or rather lack of it, was no picnic. The reality was a working day as a 17-year-old at his father's gearwheel factory that practically smacked of exploitation: up at five in the morning, a one-and-a-half mile walk to the railway station, followed by another one-and-a-half miles to the factory at the other end, where he clocked on at seven, then the same in reverse in the late afternoon, followed by evening classes twice a week as an intellectual counterbalance to the day's physical labors.

And a shrill inner voice was forever driving him on: faster, faster, faster. When David Brown senior gave him a Reading Standard motorbike for the journey to work, an 1100 cc of impressive sluggishness, he immediately got to work on the hulk, stripping it down, boring holes in the pistons and connecting rods, increasing the compression, lightening the flywheel, removing the fairing and going on to win various hill climbs in the machine.

A budding career on four wheels, in a Vauxhall which he had himself fitted with a compressor, came to an abrupt end in 1926. David Brown sensed a temptation to which he did not wish to succumb, besides which his father had suffered a stroke and was needed at the family firm. No half measures was one of his watchwords, and so he rethought his priorities, and in 1929 he became a director at the tender age of 25. By 1932 he was the boss.

He never lost his love of motorsport, however. Whenever Aston Martin raced at Le Mans, Brown was there to drive one of the cars back to Feltham, and never mind if there was only one gear left, the clutch was slipping and the vehicle was steering violently to the right. After the 1959 victory, he insisted on at least driving the DBR1 back to the team's headquarters in La Chartre sur-le-Loir. As he later proudly reported, the car was still fit as a fiddle and good for another thousand miles or even more. And even as an octogenarian, a denizen of that haven for senior English gentry, Monaco, residing in close proximity to his friend and one-time race star Roy Salvadori, he remained a welcome guest at the convivial and boozy meetings of the Club des Anciens Pilotes when the Grand Prix circus had arrived at the principality.

Of course, he did give up the problem child Aston Martin for adoption in 1972 due to dire economic circumstances. Agriculture was in a deep depression and a large portion of the weekly output of 1000 Brown tractors was remaining unsold.

However, new horizons always beckoned, and his addiction to speed never diminished, whether it be on land, water or even in the air. Sir David was the proud owner of eight yachts at one time or another, and the last of these caused a sensation. This was a fiberglass catamaran which he himself had designed on his dining table and had built in South Africa. It was 36 meters long, 9.8 meters wide and as fast as the wind: off the coast of Cape Town he reached a speed of 45 mph with it. But off Cannes on his Mediterranean home waters he had to content himself with 37 mph. That was not enough for the ambitious David Brown, so he had the two 2000 horsepower engines sent back to Germany to be pepped up a bit. The name of this catamaran racer was Chief Indian Sun II, Chief Indian Sun I being Brown himself, having been anointed a Chief by the Canadian Iroquois in thanks for his tractors. When the colors in his headdress faded, the Aston Martin Owners' Club of Canada sent him fresh eagles' feathers, and from then on the somewhat out-of-the-ordinary souvenir greeted visitors to the home of David Brown and his wife Paula.

Even as a sprightly old-timer DB literally knew no boundaries, as he traveled restlessly between his home in Monaco, his shipyards in Singapore and his farm in the English county of Buckinghamshire, where he continued herding straying cattle on horseback at the ripe old stage of 85.

The earnest enjoiner to "Buy British" merely brought a tired smile to his lips: he was interested only in the best, he would respond defiantly, and if the British automobile industry was unable to provide him with that, then he would simply have to look somewhere else. Finally, he even swapped his Mercedes for a Lexus on Roy Salvadori's advice.

Numerous Ferraris, Lamborghinis and Alfa Romeos adorned the driveways of Mr. Aston Martin, though he did admit to Walter Hayes in 1993 that he could certainly be tempted by a DB7. Hayes himself described David Brown as the epitome of engineering ingenuity and inventiveness, qualities that, in his view, were so sadly disparaged in contemporary Britain. Indeed, Brown's life proved an important point: even in the 20th century, the age of collectivism, characters of the stamp of Henry Ford, Ettore Bugatti, Enzo Ferrari or David Brown could make a real difference. Even Henry Ford II was not immune to Brown's charisma, declaring in 1987: "There's a man! If you get as much out of life as he has, you'll be a happy fellow."

Der Mann bebt und birst förmlich vor Vitalität, den üblichen Prozessen von Altern, Ermüdung und Verschleiß auf merkwürdige Weise enthoben. Für David Brown, den alle Welt bei seinen Initialen DB oder auch Sir David nennt, seitdem ihn Elizabeth II 1968 für seine Verdienste um Königin, Volk, Vaterland und Aston Martin in den Adelsstand erhoben hat, gibt es keinen Anlauf und keinen Abschwung: Das Leben setzt ihn gewissermaßen auf die Überholspur, fünfter Gang voll und immer am Begrenzer. Und der Tod holt ihn dort ab, als der Motor nicht mehr mitmacht, acht Monate vor seinem 90. Geburtstag. Er ist von kleinem Wuchs, ein wuseliger Napoleon des Industriezeitalters, der sich an Austerlitz orientiert und auch das eine oder andere Waterloo wegstecken muss. Geschenkt wird ihm nichts.

Szenen einer rasenden Existenz: Seine Jugend zum Beispiel, die eigentlich keine ist, obwohl er sich als Sohn vom Boss der David Brown & Sons Limited (Huddersfield) nach landläufigen Vorstellungen doch auf der Sonnenseite des Lebens aalen könnte. Der Werktag des 17-Jährigen riecht fatal nach Ausbeutung: Wecken um fünf, zweieinhalb Kilometer Anmarsch zum Bahnhof, noch einmal zweieinhalb Kilometer bis zur Firma, wo der Dienst um sieben anfängt, am späten Nachmittag das Gleiche, nur andersrum, dazu zweimal in der Woche Abendschule als intellektueller Lastenausgleich.

Da bläst es ihm diese penetrante innere Stimme bereits ein: schneller, schneller, schneller. Als ihm David Brown der Ältere für den Weg zur Arbeit eine Reading Standard spendiert, ein plumpes Reiterstandbild ohne Reiter mit 1100 grollenden Kubikzentimetern, macht sich der Junior umgehend über den Koloss her, bohrt Löcher in Kolben und Pleuel, erhöht die Kompression, erleichtert das Schwungrad, entfernt die Schutzbleche und fährt die schnellste Zeit des Tages bei diversen Bergrennen.

Eine keimende Karriere auch auf vier Rädern mit einem Vauxhall, dem ein von ihm selbst installierter Kompressor erst so richtig auf die Sprünge hilft, verplätschert 1926 im Sande. David Brown verspürt eine Lockung, der er nicht erliegen möchte, und überdies hat sein Vater einen Schlaganfall erlitten. Man braucht ihn. Nichts Halbherziges, lautet eine seiner Devisen, und so setzt er seine Prioritäten anders, ist 1929 im zarten Alter von 25 Jahren bereits Direktor und 1932 Chef.

Stets aber bleibt der Flirt mit dem Rennsport. Wann immer Aston Martin in Le Mans gestartet ist, Brown fährt eines der Autos zurück nach Feltham, und wenn nur noch ein Gang übrig ist, die Kupplung rutscht oder die Lenkung nach rechts zieht. Nach dem Sieg 1959 lässt er es sich nicht nehmen, den DBR1 wenigstens zurück zur Garnison des Teams nach La Chartre zu chauffieren. Der Wagen, berichtet er später voller Stolz, sei fit für weitere tausend Meilen oder mehr gewesen. Und noch hochbetagt ist er ein Bürger der englischen Nobel-Seniorenresidenz Monaco, wohnhaft ganz in der Nähe seines Freundes und ehemaligen Stars Roy Salvadori, ein gern gesehener Gast bei den feuchtfröhlichen Sitzungen des Club des Anciens Pilotes, wenn die Grand-Prix-Truppe im Fürstentum einfällt. Gewiss: Das Problemkind Aston Martin wird von ihm 1972 zur Adoption freigegeben, weil überall Not am Mann ist. Mit der Landwirtschaft geht es bergab und ein großer Teil der Wochenration von 1000 Brownschen Traktoren geht ins Leere wie das Öl aus einer geborstenen Pipeline. Aber es winken auch neue Ufer und immer lockt die Droge Tempo, sogar in der Luft, vor allem aber zu Lande und zu Wasser. Acht prächtige Yachten nennt Sir David im Laufe der Zeit sein Eigen. Bei der letzten handelt es sich schlichtweg um eine Sensation – ein Katamaran aus Fiberglas, von ihm selbst auf seinem Esstisch entworfen, in Südafrika gebaut, 36 Meter lang, 9,8 Meter breit und sauschnell: Vor der Küste von Kapstadt erreicht er damit 72 Stundenkilometer, vor Cannes im heimischen Mittelmeer nur noch 59. Das reicht nicht für den Ehrgeiz eines David Brown. Folglich verfrachtet er die beiden 2000-PS-Triebwerke zurück nach Deutschland, um sie dort noch ein bisschen aufpeppen zu lassen. Chief Indian Sun II heißt der Doppelrumpf-Renner, Chief Indian Sun I ist DB selber, zum Häuptling gesalbt von kanadischen Irokesen aus Dankbarkeit für seine Traktoren. Als sein Kopfschmuck ein wenig fahl geworden ist, steckt ihm der Aston Martin Owners' Club of Canada frische Adlerfedern auf und so empfängt er fortan den Besucher des Ehepaars David und Paula Brown als sanft unheimliches Souvenir.

Selbst als rüstiger Greis kennt DB keine Grenzen – buchstäblich –, er pendelt rastlos zwischen seinem Wohnsitz in Monaco, seinen Werften in Singapur und seiner Farm in der Grafschaft Buckinghamshire, wo er noch mit 85 Jahren hoch zu Ross das eine oder andere verirrte Rind wieder der Herde zuführt. Der beschwörende Imperativ »Buy British« nötigt ihm lediglich ein müdes Lächeln ab: Ihn interessiere nur das Beste, antwortet er widerborstig auf diesbezügliche Mahnungen. Wenn die englische Autoindustrie unfähig sei, ihm das Beste anzubieten, müsse er sich eben anderswo umsehen. Schließlich jedoch tauscht er auf den Ratschlag von Roy Salvadori seinen Mercedes gegen einen Lexus.

Etliche Ferrari, Lamborghini und Alfa Romeo haben den privaten Fuhrpark von Mister Aston Martin geziert. Indes: Der DB7 könne ihn echt in Versuchung führen, vertraut er Walter Hayes 1993 an. David Brown, sagt er anerkennend über ihn, sei der Inbegriff jener Ingenieurkunst und Erfindungsgabe, die im heutigen England zu Unrecht ins Gerede geraten sei.

In der Tat haftet der Vita des kleinen Unternehmers etwas Exemplarisches an: Selbst in diesem Jahrhundert noch, dem Zeitalter der Kollektive, können Charaktere vom Schlage eines Henry Ford, Ettore Bugatti, Enzo Ferrari oder David Brown eine Menge bewegen. Solch einem Charisma kann sich nicht einmal Henry Ford II entziehen: »Welch ein Mann!«, staunt er 1987. »Wer aus dem Leben so viel herausholt wie er, der kann von Glück sagen.«

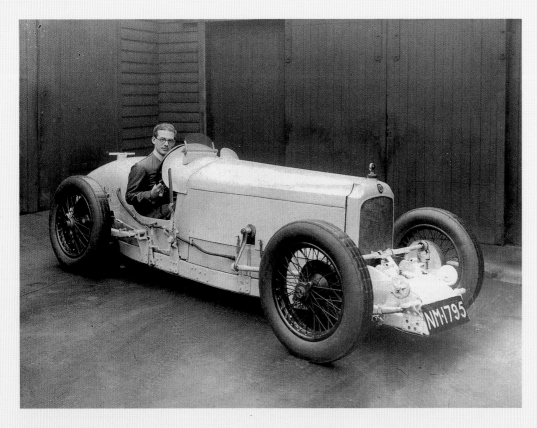

L'homme bouillonne littéralement de vitalité, échappant bizarrement au processus de vieillissement et à toute fatigue ou usure. David Brown, que le monde entier ne connaît que sous ses initiales DB ou, encore, sous le nom de Sir David depuis qu'Elizabeth II l'a anobli en 1968 pour ses mérites et les services rendus à la reine, au peuple, à la patrie et à Aston Martin, ne connaît ni accélération ni ralentissement : il a passé toute sa vie sur la voie rapide, en cinquième vitesse et le pied au plancher. Et c'est là que la mort passera le prendre lorsque son moteur ne fonctionnera plus, huit mois avant son 90e anniversaire. C'est un homme de petite taille, un Napoléon vibrionnant de l'ère industrielle qui ne pense qu'à Austerlitz même s'il doit, de temps à autre, subir un Waterloo. Car rien ni personne ne lui fait de cadeau.

Quelques anecdotes d'une existence à cent à l'heure, par exemple, qui n'en est pas une à proprement parler, bien que, en tant que fils du chef de la société David Brown & Sons Limited, à Huddersfield, il eusse pu, selon l'idée que l'on se fait couramment d'un fils à papa, se contenter de gaspiller son argent. La journée de travail de l'adolescent de 17 ans dans la fabrique d'engrenages de son père fait immédiatement penser à l'exploitation : réveil à cinq heures, deux kilomètres et demi à pied jusqu'à la gare, puis deux autres kilomètres et demi jusqu'à l'usine où le travail commence à sept heures et, en fin d'après-midi, le même trajet en sens inverse, plus, deux fois par semaine, des cours du soir en tant que compensation intellectuelle indispensable. Et cette voix intérieure qui lui souffle déjà : plus vite, plus vite, plus vite. Lorsque David

Brown senior offre à son rejeton une petite Reading Standard pour se rendre au travail, le fiston se jette comme un affamé sur cet engin informe au moteur ronronnant de 1100 cm³, le démonte complètement, s'attaque aux pistons et aux bielles, augmente le taux de compression, allège le volant masse, démonte les garde-boue et s'en va réaliser à son volant le meilleur chrono de la journée lors de diverses courses de côte.

Une future carrière de pilote de course au volant d'une Vauxhall à laquelle un compresseur qu'il a installé lui-même donne des ailes est étouffée dans l'œuf en 1926. David Brown est soumis à une tentation à laquelle il ne veut pas résister, d'autant plus que son père a été victime d'une attaque d'apoplexie. On a besoin de lui à l'usine. Ne faisant pas les choses à moitié – fidèle en cela à l'une de ses devises – il se fixe donc de nouvelles priorités : en 1929, alors qu'il est tout juste âgé de 25 ans, il est déjà directeur et, en 1932, président directeur-général.

Mais il ne cessera néanmoins jamais de flirter avec la course automobile. Chaque fois qu'Aston Martin s'aligne au Mans, David Brown prend le volant de l'une des voitures pour revenir à Feltham, même si elle n'a plus qu'une seule vitesse, que l'embrayage patine ou que la direction tire à droite. Après la victoire, en 1959, il ne se prive pas du plaisir de ramener lui-même la DBR1 jusqu'au quartier général de l'écurie à La Chartre-sur-le-Loir. La voiture, rapportera-t-il plus tard rayonnant de fierté, était en parfait état et aurait pu encore couvrir plusieurs milliers de kilomètres. Jusqu'à un âge très avancé, parmi tous les riches Anglais qui passent une retraite dorée dans leur prestigieuse

résidence de Monaco, il réside à un jet de pierre de son ami Roy Salvadori, l'ancien as du volant, et continue à participer aux rencontres animées et bien arrosées du Club des Anciens Pilotes, quand la troupe du Grand Prix envahit la Principauté.

Certes, en 1972, il préfère laisser à d'autres mains le navire Aston Martin qui prend l'eau. L'agriculture a connu des jours meilleurs et une grande partie de la production hebdomadaire de 1000 tracteurs Brown reste invendue, aussi inutilisable que le pétrole s'écoulant d'un pipeline qui fuit. Mais bien d'autres horizons sont, aussi, tentants et il ne peut toujours pas résister à l'ivresse de la vitesse, même dans les airs, mais surtout sur terre et sur l'eau. Au fil des années, Sir David aura possédé pas moins de huit magnifiques yachts. Le dernier est un véritable bijou – il s'agit d'un catamaran en fibre de verre qu'il a dessiné lui-même sur la table de sa salle à manger et fait construire en Afrique du Sud, une unité de 36 mètres de long sur 9,80 de large, rapide comme un dauphin : au large du Cap, il atteint à ses commandes la vitesse de 72 km/h, alors qu'au large de Cannes, près de son port d'attache, il ne parvient pas à dépasser les 59 km/h. Cela titille l'ambition de David Brown. Immédiatement, il fait renvoyer les deux moteurs de 2 000 ch en Allemagne pour leur faire suivre une cure de vitamines.

Chief Indian Sun II est le nom de ce bolide à double coque ; le Chief Indian Sun I n'est autre que DB lui-même, élevé au rang de chef de tribu par des Iroquois canadiens en guise de remerciements pour ses tracteurs. Lorsque sa chevelure s'éclaircit un peu, l'Aston Martin Owners' Club of Canada lui offre une nouvelle coiffe de plumes d'aigle et le couple David et

Paula Brown reçoit désormais ses visiteurs, avec ce souvenir un tantinet bizarre trônant dans le vestibule. Vieillard encore vert, DB ignore les frontières – au sens propre du mot – et fait inlassablement le va-et-vient entre son domicile de Monaco, ses chantiers navals de Singapour et son exploitation agricole du comté de Buckinghamshire où, même à 85 ans, à cheval, il est toujours capable de faire rejoindre le troupeau à un bovin égaré. À l'impérieuse recommandation « Buy British », il ne répond que par un sourire condescendant : seul le meilleur l'intéresse, réplique-t-il, récalcitrant à ce genre de recommandations. Si l'industrie automobile anglaise est incapable de lui offrir ce qui se fait de mieux, il n'a pas d'autre solution que d'aller voir ailleurs. Finalement, sur les conseils de Roy Salvadori, il échange sa Mercedes contre une Lexus.

D'innombrables Ferrari, Lamborghini et Alfa Romeo ont fait honneur à la flotte privée de Mr. Aston Martin. Mais, finalement, avoue-t-il à Walter Hayes en 1993, la DB7 le tente vraiment. David Brown, déclare Hayes plein d'admiration, est l'incarnation même de cet art de l'ingénierie et de ce génie inventif que, dans l'Angleterre d'aujourd'hui, on critique fréquemment à mauvais escient.

De fait, la vie de David Brown a vraiment quelque chose d'exemplaire ; même en ce siècle, à l'heure où le collectif règne en maître, des hommes de caractère de l'envergure d'un Henry Ford, Ettore Bugatti, Enzo Ferrari ou David Brown peuvent faire avancer bien des choses. Henry Ford II lui-même se déclara incapable d'échapper au charisme de Brown : « Quel homme ! s'exclame-t-il en 1987. Quiconque sait tirer autant de choses de la vie peut se déclarer béni des dieux. »

effort, with both the racing car itself and every member of the five-man team having to perform dual functions: the car also serving as transport to and from the event, while John Wyer, for example, was both chief mechanic and team manager. In this dual role he started to refine the tricks of the trade which would stand him in good stead for the next 25 years, marking him out as one of the most talented long-distance racing strategists on the scene. Under his intelligent direction their privateer Aston Martin held its own against the works car right up until midday on Sunday, when Connell spun off to the right on the ascent behind Eau Rouge, probably as a result of petrol from a ruptured tank spilling on to the rear wheels. However, David Brown had noticed John Wyer, and in 1950 put him in charge of worldwide racing operations. The drivers who raced for him gave him the nickname "Death Ray" because of the murderous glare he emitted whenever something met with his displeasure. This partnership

Bare facts: the basic bodywork of the DB4 in Newport Pagnell in 1961.

Nackte Tatsachen: Rohkarosserien des DB4 in Newport Pagnell im Jahre 1961.

Précieux écrins : carrosseries blanches de DB4 à Newport Pagnell en 1961.

between two tremendously powerful characters lasted until 1963. Halfway through this period Wyer was promoted to become General Manager of Aston Martin and Lagonda, but he remained involved with the motorsport side of things thereafter.
The turbulence unleashed by the Aston Martin deal had scarcely subsided before David Brown's telephone rang once again. This time it was Lagonda's Bradford dealer, calling to inform him that the company was about to go into liquidation, and inviting him to play the Good Samaritan once more. Brown was dubious. He had done the Aston Martin deal chiefly for the fun of it, and did not want to get too deeply involved in the car industry. However, Lagonda arranged a test drive for him in their prototype and he went along. Among the party present was the designer of the power unit, one William Owen Bentley, known to everyone as just plain "W.O." As Brown later noted in his report, the car's handling was gruesome but, in stark contrast, the six-cylinder engine was a revelation. This naturally led him to the idea that a combination of Aston Martin's

zusammen mit Ian Connell in einem Aston Martin an, den vor dem Krieg sogar einmal Mercedes-Superstar Dick Seaman gefahren hat. Nicht nur, dass das Einsatzauto schmählich als Reisewagen bar jeden Komforts herhalten muss: Auch jedermann in dem Fünf-Personen-Team aus Watford hat in Personalunion noch eine zweite Funktion wahrzunehmen. John Wyer wirkt als Chefmechaniker und Team-Manager zugleich. Und in dieser Eigenschaft probt er bereits die Kniffe und Finessen, die ihn 25 Jahre lang in den Rang eines begnadeten Strategen bei Langstreckenrennen erheben werden. Bis Sonntag Mittag schlägt sich der private Aston unter seiner klugen Regie wacker gegen den Werkswagen. Dann rutscht Connell rechts von dem Anstieg hinter Eau Rouge von der Strecke, vielleicht nur, weil Benzin aus einem geborstenen Tank auf die Hinterräder spritzte. David Brown aber ist auf John Wyer aufmerksam geworden und verpflichtet ihn 1950 als General, wann und wo immer seine Autos eine Renn-Schlacht schlagen. »Death Ray« nennen ihn ehrfürchtig die Piloten, die unter ihm Dienst tun, Todesstrahl, wegen der mörderischen Blicke, die Wyer aussenden kann, wenn ihm etwas gegen den Strich geht. Diese Liaison zwischen zwei ungemein ausgeprägten Charakteren dauert bis 1963. Bei Halbzeit im Jahre 1957 wird John Wyer eine höchst willkommene Beförderung zum General Manager für Aston Martin und Lagonda zuteil. Dem Rennsport aber wird er noch lange erhalten bleiben.
Die Turbulenzen, die der Aston-Martin-Deal auslöst, sind kaum abgeebbt, da klingelt bei David Brown erneut das Telefon. Der Lagondahändler in Bradford teilt ihm mit, die Firma gehe in Liquidation. Ob er nicht auch in diesem Fall als Samariter auftreten wolle? Brown zögert. Der Spaßfaktor stehe für ihn im Vordergrund, die Sache dürfe nicht ins allzu Ernsthafte ausarten. Aber dann arrangiert Lagonda für ihn einen Ausflug mit einem Prototyp. Mit von der Partie ist der Schöpfer des Triebwerks William Owen Bentley, den alle Welt nur bei seinen Initialen W.O. kürzelt. Das Handling des Wagens, gibt Brown später zu Protokoll, sei grauenvoll gewesen, sein Sechszylinder hingegen eine Offenbarung. Das bringt ihn auf eine Idee: Das Aston-Martin-Chassis müsste sich mit diesem Triebwerk zu einem vorzüglichen Automobil verquicken lassen.
Die Preisvorstellungen der in arge Bedrängnis geratenen Firmenväter nötigen ihm lediglich ein müdes Lächeln ab. Mit 50 000 Pfund sei er mit von der Partie, gibt er zu verstehen, keinem Penny mehr, und begibt sich auf einen Urlaub in Italien. Dort setzt man ihn binnen kurzem telefonisch darüber in Kenntnis, er besitze eine zweite Autofabrik. Erneut lässt sich mit dem, was Brown da soeben erstanden hat, am Stammtisch kaum prahlen: der Name Lagonda, die Projekte, die im Entstehen begriffen sind sowie Entwürfe für die Zukunft. Man erwirbt voluminöse Schuppen auf dem Flugfeld von Hanworth und krempelt die Ärmel hoch. Im April 1950 wird der DB2 angekündigt.
Erst in Opus 2 der gesammelten Werke

de la 2-litre Sports sous la forme d'un Drophead Coupé de quatre places.
La meilleure carte de visite pour une voiture de sport consiste à participer à des courses avec succès : sur ce point, au moins, David Brown est au diapason de la philosophie de la firme. Soit dit en passant, c'est aussi le credo de son futur concurrent, Enzo Ferrari... Le succès ne se fait pas attendre : la 2-litres remporte la victoire au classement général aux 24 Heures de Spa, pilotée par le tandem « Jock » St. John Horsfall et Leslie Johnson. Le ton est donné. Spa aura une importance primordiale dans l'histoire d'Aston Martin après la guerre, et pas seulement en raison de cette victoire encourageante qui est aussi un moyen de se faire connaître. John Wyer a aussi fait le déplacement sous une pluie diluvienne qui durera tout le week-end. Wyer est manager chez Monaco Motors, à Watford, un *tuner* qui prépare des voitures de course pour des clients privés. Cette fois, il travaille pour son propre compte : son chef Dudley Folland s'est inscrit pour la course dans les Ardennes avec Ian Connell au volant d'une Aston Martin qui a même été pilotée, avant la guerre, par Dick Seaman, la superstar de Mercedes-Benz. Une tâche bien ardue. Outre que la supposée voiture de course est en réalité une voiture de tourisme sans le moindre confort, chacun des cinq membres de l'équipe de Watford doit aussi assumer parallèlement une deuxième fonction. John Wyer est ainsi à la fois chef mécanicien et chef d'équipe. Et c'est à ce poste qu'il acquiert l'astuce et l'expérience qui feront de lui pendant 25 ans un stratège béni des dieux pour les courses d'endurance. Jusqu'au dimanche midi, l'Aston privée qu'il dirige avec talent se bat vaillamment contre les voitures d'usine. Mais, dans la montée de l'Eau Rouge, elle quitte la piste, peut-être tout simplement parce que de l'essence fuyant d'un réservoir éclaté a mouillé ses roues arrière. Toujours est-il que John Wyer attire ainsi l'attention de David Brown qui le recrute en 1950 comme directeur d'écurie pour toutes les courses auxquelles participent ses voitures. *Death Ray* (« le rayon de la mort ») est le surnom que lui donnent les pilotes qui courent sous ses ordres, en raison des regards assassins que lance Wyer quand quelque chose ne lui plaît pas. Cette alliance de deux caractères très affirmés durera jusqu'en 1963. Quelques années plus tard, en 1957, John Wyer aura le plaisir d'être promu Directeur général d'Aston Martin et Lagonda. Mais il restera longtemps présent au bord des circuits.
Le rachat d'Aston Martin est encore récent et, déjà, le téléphone sonne chez David Brown. Le concessionnaire Lagonda de Bradford l'informe que la firme est au bord de la faillite. Ne serait-il pas tenté de reprendre cette firme aussi ? lui demande-t-il. Brown hésite. Ce qui compte avant tout pour lui, c'est le plaisir. Et il ne faut pas que les choses dégénèrent en travail. Mais Lagonda arrange un rendez-vous et lui propose d'essayer un prototype. Le père

Against the Tide

In truth the Lagonda marque owed its existence to failure, for what the company's founding father, Wilbur Adams Gunn, born in 1859 in Springfield, Ohio, really wanted to be was an opera singer. And so it came to pass that, in pursuit of the dream of one day appearing at Covent Garden, he found himself around the turn of the century in Staines, on the outskirts of London not far from the spot where Heathrow Airport today stands. However, the painful truth was that, though he now had a place of residence in the promised land, he did not have the gifted voice to go with it. Accordingly he resigned himself to humdrum reality and latched on to a Gunn family tradition: back in Springfield his father had at one time set up the Lagonda Corporation, a business which manufactured tube cleaning equipment. The name Lagonda itself was borrowed from an American Indian language: it is the Shawnee's name for a river in the region with as many arms as the goddess Shiva. Without further ado, Gunn imported the fine-sounding word to Britain as the name of his own business. Soon he had launched the Giralda, the fastest steamboat on the Thames, but his first efforts at motorized travel on land were less impressive. In a greenhouse he fitted bicycles with tiny one-cylinder engines which compelled the rider to provide vigorous assistance when climbing hills. As we shall see, however, from these modest beginnings a legend was to grow. In a small factory that he threw up on his patch of land in Staines, Wilbur Gunn produced motorcycles and (from 1904) 70 motorized tricycles. Then in 1907 came his first fully-fledged motor car. It was small, but it had class. Like many pioneers of the motor industry he did not exactly have a great business sense. The market that he made his priority was czarist Russia, where in St. Petersburg and Moscow he found a clientele for his stately six-cylinder machine which, although it had plenty of spending power, was somewhat thin on the ground. For the domestic market he launched, in 1913, a lightweight two-seater coupé with an 11.1 horsepower engine. It sold at the substantial price of £135 and featured an early example of a kind of self-supporting body. Both this and a four-seater version introduced in 1914 continued to be developed until 1926, when they were swept away by the tide of Morrises and Clynos which then swamped the market.

During the First World War the Lagonda works was unceremoniously converted to the production of grenades. Wilbur Adams Gunn, meanwhile, who had always been a hopeless workaholic, literally worked himself to death, expiring in 1920 when his overworked body simply could not take any more. Others took over where he had left off, introducing a new production program, and by 1925 production passed the 7000 mark. However, as a stronghold of traditions of old-fashioned hand craftsmanship, Lagonda was never in a secure financial position, and in the aftermath of the Wall Street Crash the classy Staines manufacturer was soon on the skids. Eventually in April 1935 a liquidator was appointed, but then at the eleventh hour a consortium led by one Alan P. Good came to the rescue, preempting an illustrious rival, Rolls-Royce, who were keen to incorporate the ailing but prestigious rival.

Motorsport was always on the agenda too. For example, in 1921, Lagonda's sales director, Major Bill Oates, lapped the Brooklands oval in a Lagonda single-seater at an average speed of 79 mph (127 kph) and went on to set four further records for lightweight cars. Sadly for him though, the records were short-lived, as Aston Martin erased them from the books a scant week later.

Three privately-owned Lagondas were entered in the 1935 Le Mans 24 hour race. One of them, bearing the number plate BPK 202, won the race with privateers John Hindmarsh and Luis Fontes at the wheel. They did so with an impressive lead of 5.3 miles, having covered a total distance of 1865 miles at an average speed of 78 mph. Rudimentary comfort was provided by a small attachment to the dashboard which was filled with fresh chewing gum at each pitstop.

Alan Good appointed W. O. Bentley chief constructor. Bentley had ceased to feel comfortable at his own company after the takeover by Rolls-Royce. A man who always thought big, he was then planning a 4.5 liter V12 engine designed with the assistance of Stuart Tresilian. This engine was presented to a suitably impressed public at the Olympia Motor Show in London in October 1936 – fitted in a conservatively-designed car – and was rumored by some to be, at least in part, a mere dummy. Be that as it may, it would be another year before the Lagonda would be ready for launch. Britain's finest body builders were already working on the task of cladding the rolling chassis which had been supplied to them from the works in suitably refined fashion. The two-ton leviathan quickly became a byword for elegance and whispering discretion. Nor was there any doubting its power: in 1938 a wholly unmodified saloon with the 54-year old Lord Howe at the wheel covered 100 miles in one hour, despite having to change tires en route, and in 1939 two of the V12s, each fitted with four carburetors and generating 220 horsepower, came third and fourth at Le Mans, while on a test drive at Montlhéry W. O. Bentley himself covered five laps at an average speed of 125 mph, accompanied by three terrified passengers. When the rich and powerful were on the lookout for opulent status symbols, the car of preference was the Lagonda. The names of Maharajahs and Texan oil magnates filled the order books for the 300 or so V12s manufactured at Staines. One of the most beautiful of them, a V12 Sedanca de Ville, with bodywork designed by Frank Feeley, went for a cool £1870.

Then war broke out once again. Lagonda once more did its bit, dedicating itself to the manufacture of aircraft parts and 4½ million grenades. W. O. Bentley was of the opinion that a 12 cylinder car was not the way forward. In this his view was, incidentally, diametrically opposed to that of the up-and-coming Enzo Ferrari. His solution was ready in 1945, in the form of a model with independent suspension all round and the straight six 2580 cc LB6 engine with two overhead camshafts, built by William Watson and Donald Bastow under his guidance. The new product was originally dubbed the Lagonda Bentley, but Rolls-Royce, which possessed the rights to the name Bentley, took exception to this, and as a result Alan Good had to go through a costly lawsuit and remove the logo from the engine and body. Thus an emblem was erased. But the writing was on the wall: Lagonda's days as an independent manufacturer were numbered

Gegen den Strom

Genau genommen verdankt die Marke Lagonda ihr Dasein einem Scheitern. Denn eigentlich schwebt ihrem Gründervater Wilbur Adams Gunn, 1859 in Springfield geboren, Ohio, USA, eine Karriere als Opernsänger vor. Und so verschlägt ihn der kühne Wunsch, vielleicht einmal in Covent Garden aufzutreten, gegen Ende des Jahrhunderts nach Staines im Weichbild von London unweit des heutigen Flughafens Heathrow. Ihm bleibt allerdings die schmerzliche Erkenntnis nicht erspart, er verfüge nun zwar über einen Wohnsitz im gelobten Land, keineswegs aber über eine begnadete Stimme. Folglich wendet er sich prosaischeren Tätigkeiten zu und nimmt zugleich den Faden auf, der ihm von der Familientradition der Gunns vorgegeben wird.

Sein Vater hat einst in Springfield die Lagonda Corporation ins Leben gerufen, welche die Ausrüstung zum Reinigen von Röhren herstellt. Der Name Lagonda ist der Indianersprache entlehnt: So nennen die Shawnees ein Flüsschen ihrer Region mit so vielen Armen wie eine Shivafigur. Gunn importiert das wohlklingende Wort kurzerhand nach England und benennt damit sein eigenes Unternehmen. Zwar hat er bereits die Giralda vom Stapel gelassen, die schnellste Dampfjacht auf der Themse, seine ersten motorisierten Gehversuche zu Lande indessen sind eher zögerlich. In einem Gewächshaus versieht er Fahrräder mit winzigen Motoren, die aus einem Zylinder kläffen und ihre Benutzer bergauf durchaus zu energischer Mitarbeit

seine stattlichen Sechszylinder vorfindet. Für die heimische Kundschaft vorgesehen ist 1913 ein leichtes, zweisitziges Coupé mit 11,1 Pferdestärken, das um den deftigen Preis von 135 Pfund als gewissermaßen prähistorische Premiere mit einer Art selbst tragenden Karosserie aufwartet. Dieses sowie eine vierplätzige Variante von 1914 werden zwar bis 1926 kontinuierlich weiter entwickelt, erliegen indes dem Ansturm der Morris oder Clyno, die bereits in massenhafter Verbreitung auf den Markt geworfen werden.

Während des Ersten Weltkriegs wird das Lagonda-Werk schnöde umgewidmet zur Produktion von Granaten. Wilbur Adams Gunn jedoch, schon immer ein hingebungsvoller Workaholic, arbeitet sich zu Tode, buchstäblich: Er stirbt 1920, als sein geschundener Organismus einfach nicht mehr mitmacht. Andere führen mit Elan das neue Programm fort, was er begonnen hat. 1925 übersteigt die Produktion die Zahl 7000. Gleichwohl ist Lagonda als Hochburg altertümlichen Handwerks wie auf Rosen gebettet. Im Windschatten des Wall Street Crash gerät die Nobel-Werkstatt in Staines bedrohlich ins Schleudern. Im April 1935 verschafft sich der amtlich bestallte Liquidator Zutritt. Als Helfer in höchster Not stellt sich zum Glück ein Konsortium ein mit Alan P. Good an der Spitze. Er schlägt einen illustren weiteren Bewerber aus dem Felde, Rolls-Royce, der sich den maroden, aber ruhmreichen Rivalen gerne einverleibt hätte.

3000 Kilometer hat man am Ende zurückgelegt, das sind 125 pro Stunde. Für rudimentären Luxus sorgt eine kleine Halterung am Armaturenbrett, die bei jedem Boxenstopp mit frischem Kaugummi aufgefüllt wird. Als Chefkonstrukteur stellt Alan Good W. O. Bentley ein, dem das Klima in seiner eigenen Firma nach der Übernahme durch Rolls-Royce nicht mehr behagte. Bentley hat immer noch und schon wieder Großes im Sinn, einen V12 mit viereinhalb Litern, bei dessen Konzeption ihm Stuart Tresilian unter die Arme greift. Dieser Motor wird seinen gebührend beeindruckten Landsleuten bei der Olympia Motor Show in London im Oktober 1936 – umgeben von einem konservativ gewandeten Automobil – vorgestellt und ist, wie man munkelt, teilweise noch eine Attrappe. Bis der große Lagonda käuflich wird, muss man sich noch über ein Jahr gedulden. Schon reißen sich die besten Karosseriebauer Englands darum, das rollende Chassis, das ihnen vom Werk angeliefert wird, aufs Schönste einzukleiden. Eleganz und wispernde Diskretion des Zweitonners werden rasch sprichwörtlich. Aber auch hinsichtlich seiner Potenz möchte man keinen Zweifel aufkommen lassen: 1938 spult eine ganz normale Limousine mit dem 54-jährigen Lord Howe am Lenkrad in einer Stunde 162 Kilometer ab, ein Radwechsel inbegriffen. Und 1939 werden zwei V12 mit jeweils vier Vergasern und 220 PS in Le Mans Dritter und Vierter. Bei Versuchsfahrten in Montlhéry legt W. O. Bentley persönlich fünf Runden mit knapp 200 Stundenkilometern Durchschnittsgeschwindigkeit zurück, begleitet von drei verängstigten Passagieren. Wo Macht und Mammon nach prächtigen Statussymbolen verlangen, stellt man sich vorzugsweise einen oder zwei Lagonda in die Garage. Die Namen von Maharadschas und texanischen Ölmagnaten drängen sich in den Auftragsbüchern für die rund 300 Zwölfzylinder aus Staines. Einer von ihnen, ein V12 Sedanca de Ville mit einem Aufbau von Frank Feeley, schlägt mit 1870 Pfund zu Buche. Doch dann ist wieder Krieg. Lagonda macht sich erneut mit der Fertigung von Flugzeugteilen sowie viereinhalb Millionen Granaten um das britische Vaterland verdient. Für die Flaute danach, meint W. O. Bentley und befindet sich damit im diametralen Gegensatz zu dem aufstrebenden Enzo Ferrari, sei ein Zwölfzylinder kein geeignetes Fortbewegungsmittel. Seine Lösung steht 1945 bereit, ein Modell mit Einzelradaufhängung ringsum und dem Reihensechszylinder LB6 von 2580 ccm mit zwei oben liegenden Nockenwellen, den William Watson und Donald Bastow unter seiner Anleitung gebaut haben. Lagonda Bentley soll der Neue heißen. Dies jedoch erregt den Grimm von Rolls-Royce, die im Besitz der Namensrechte sind, und so muss Alan Good in einem kostspieligen Prozess das Logo von Motor und Karosserie entfernen.

Ein Schriftzug ist getilgt. Dafür erscheint eine andere Botschaft an der Wand. Denn die Tage von Lagonda als selbstständigem Hersteller sind gezählt.

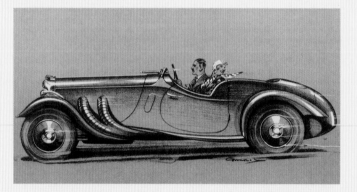

Eye-catching elegance: from a brochure for the 4.5 liter Special Rapide tourer. With Lagonda bodywork the car cost £1050.

Elegante Welt: Aus einer Broschüre für den 4,5 Liter Special Rapide Tourer. Das Auto kostet mit Lagonda-Aufbau 1050 Pfund.

Pour le monde des élégants : extrait d'un catalogue de la 4,5 Liter Special Rapide Tourer. Avec carrosserie de Lagonda, la voiture coûte 1050 livres.

zwingen. Aus diesen bescheidenen Anfängen erwächst, wie sich zeigen wird, eine Evolution ins Monumentale.

In einer kleinen Fabrik, die er flugs auf seinem Grundstück in Staines in die Höhe zieht, lässt Wilbur Gunn der Produktion von Motorrädern und (ab 1904) 70 motorisierten Dreirädern 1907 das erste ausgewachsene Auto folgen: klein, aber oho. Wie vielen Pionieren des Automobils eignet ihm nicht eben ein ausgeprägter Sinn fürs Geschäftliche. Der Markt, den er vorzugsweise erschließt, ist nämlich das zaristische Russland, wo er in St. Petersburg und Moskau eine kaufkräftige, aber überaus spärliche Klientel für

Immer ist da auch der Sport: 1921 etwa umkreist Lagonda-Verkaufsdirektor und Major der Reserve Bill Oates das Oval von Brooklands eine Stunde lang in einem Einsitzer der Marke mit Tempo 127 und stellt auch gleich noch vier weitere Rekorde für leichte Wagen auf, denen allesamt eine Woche später von Aston Martin das Lebenslicht ausgeblasen wird.

Für das 24-Stunden-Rennen von Le Mans 1935 aber sind drei private Lagonda gemeldet. Einer von ihnen, polizeiliches Kennzeichen BPK 202, gewinnt das Rennen mit John Hindmarsh und Luis Fontes am Volant mit einem Vorsprung von 8,5 Kilometern.

À contre-courant

Paradoxalement, c'est à un échec que la marque Lagonda doit son existence. En effet, à l'origine, son fondateur, Wilbur Adams Gunn, né en 1859 à Springfield, dans l'Ohio, aux États-Unis, aspirait à faire carrière comme chanteur d'opéra. Animé par le vœu ardent de monter un jour sur scène à Covent Garden, il franchit l'Atlantique et s'établit, vers la fin du siècle, à Staines, dans la banlieue de Londres, non loin de l'actuel aéroport de Heathrow. Mais le destin sera sans pitié pour lui : s'il a maintenant bel et bien son domicile sur la Terre promise, il ne possède toujours pas la voix d'un ténor. Contraint et forcé, il se consacre donc à des activités plus prosaïques et se tourne vers la mécanique, dans la plus pure tradition familiale des Gunn.

Son père avait en effet fondé jadis, à Springfield, la Lagonda Corporation, une firme spécialisée dans la fabrication d'équipements pour le nettoyage de tubes. Le nom Lagonda provient d'un dialecte indien : c'est ainsi que les Shawnees ont baptisé une petite rivière de leur région aux bras aussi nombreux que ceux du dieu Shiva. Gunn reprend sans hésiter ce nom ronflant pour baptiser l'entreprise qu'il crée en Angleterre. Il lance la Giralda, le yacht à vapeur le plus rapide de la Tamise, mais ses premières tentatives motorisées sur terre sont en revanche beaucoup plus incertaines. Dans une serre de jardin, il équipait des bicyclettes de minuscules moteurs monocylindres extrêmement bruyants qui obligeaient leurs passagers à pédaler comme des fous dès qu'une côte se présentait. Toutefois, ces débuts modestes ne l'empêcheront pas d'atteindre, comme nous allons le voir, des sommets.

Dans une petite usine qu'il fait édifier quelque temps plus tard sur son terrain de Staines, Wilbur Gunn se consacre à la production de motocyclettes. À partir de 1904, il fabrique 70 tricycles à moteur, puis, en 1907, la première voiture digne de ce nom : petite, mais non sans mérites. Comme pour beaucoup de pionniers de l'automobile, il ne se distingue pas par son sens des affaires. Le marché qu'il souhaite conquérir en premier lieu est en effet la Russie tsariste, où il trouve, à Saint-Pétersbourg et Moscou, une clientèle certes aisée, mais vraiment peu nombreuse pour ses imposants six-cylindres. Pour la clientèle locale, il prévoit, en 1913, un léger coupé biplace de 11,1 chevaux qui, pour un prix astronomique de 135 livres sterling, représente en quelque sorte une version primitive d'automobile dotée d'une carrosserie autoporteuse. Ce modèle ainsi qu'une version à quatre places apparue en 1914 seront perfectionnés régulièrement jusqu'en 1926, mais ils ne survivront pas au raz de marée des Morris ou Clyno, déjà produites à un rythme industriel, qui envahissent le marché. Durant la Première Guerre mondiale, l'usine Lagonda participe à l'effort de guerre et fabrique des grenades. Wilbur Adams Gunn, qui était un véritable bourreau de travail, travaille jusqu'à l'épuisement, et ce littéralement : il meurt en 1920 lorsque son organisme usé refuse de continuer à fonctionner.

D'autres poursuivent avec un nouveau programme ce que lui-même a commencé. En 1925, la production dépasse le seuil des 7000 exemplaires. Pourtant, le bastion de l'artisanat à l'ancienne qu'était Lagonda n'a jamais vraiment fait fortune. Après le krach de Wall Street en 1929, le prestigieux atelier de Staines menace de faire faillite. En avril 1935, l'entreprise est mise en liquidation. Mais, in extremis, un consortium avec Alan P. Good à sa tête se constitue pour reprendre la firme, prenant ainsi le pas sur un autre illustre candidat, Rolls-Royce, qui rêvait de s'approprier sa rivale agonisante, mais prestigieuse.

Le sport encore et toujours : en 1921, Bill Oates, directeur commercial de Lagonda et officier de réserve, couvre un tour de l'ovale de Brooklands au volant d'une monoplace de la marque à une moyenne de 127 km/h, battant ainsi par la même occasion quatre autres records pour voitures légères qui, tous, seront effacés des tablettes, tout juste une semaine plus tard, par Aston Martin.

Trois Lagonda privées sont inscrites pour la course des 24 Heures du Mans en 1935. L'une d'entre elles, avec la plaque minéralogique BPK202, gagne la course avec John Hindmarsh et Luis Fontes au volant, avec une avance de 8,5 km. À la fin, les deux hommes ont couvert 3000 kilomètres à une moyenne de 125 km/h. Leur seul luxe est un petit support ménagé sur le tableau de bord, qui voit son stock de chewing-gum renouvelé lors de chaque arrêt au stand.

Alan Good engage comme constructeur en chef un certain W.O. Bentley qui trouvait pesante l'atmosphère dans sa propre firme après la reprise de celle-ci par Rolls-Royce. Toujours enclin à la grandeur, Bentley avait déjà en tête une nouvelle idée ; il voulait lancer la fabrication d'un V12 de 4,5 litres de cylindrée pour la conception duquel Stuart Tresilian lui était venu en aide. Ce moteur est présenté à ses compatriotes, impressionnés comme il se doit, lors de l'Olympia Motor Show de Londres d'octobre 1936 – à côté d'une automobile aux lignes conservatrices – et se révèle en partie, tout au moins à en croire les rumeurs, un événement surfait. Il faudra encore patienter pendant un an avant de pouvoir acheter la grosse Lagonda.

Et déjà, les meilleurs carrossiers d'Angleterre se battent pour savoir qui habillera de la plus belle robe le châssis roulant que l'usine leur livre. L'élégance et le ronronnement discret de cette voiture de deux tonnes deviennent vite proverbiales. Mais elle ne laisse pas non plus place au moindre doute quant à sa puissance : en 1938, une limousine de série sans aucune modification, pilotée par Lord Howe, âgé de 54 ans, couvre en une heure 162 kilomètres, avec un changement de roue compris. En 1939, deux V12 à quatre carburateurs développant 220 ch terminent troisième et quatrième au Mans. Lors d'essais à Montlhéry, W.O. Bentley en personne couvre cinq tours à près de 200 km/h, accompagné de trois passagers pétrifiés de

peur. Dès lors, Lagonda devient la marque de prédilection des hommes riches et puissants qui souhaitent le manifester par des signes extérieurs. Les noms de maharadjahs et de magnats texans du pétrole se côtoient dans les carnets de commandes pour les quelque 300 douze-cylindres de Staines. L'une des plus belles, une V12 Sedanca de Ville avec une carrosserie de Frank Feeley, est facturée pour la coquette somme de 1870 livres.

Mais une nouvelle guerre éclate. Toujours patriote, Lagonda se consacre à la fabrication de pièces d'avion ainsi que de quatre millions et demi de grenades pour défendre sa patrie. Pour la période exsangue de l'après-guerre, W.O. Bentley – qui est ainsi d'un avis diamétralement opposé à celui de l'ambitieux Enzo Ferrari – pense qu'un douze-cylindres n'est pas un moyen de locomotion approprié. Il propose sa solution dès 1945, un modèle à suspension à quatre roues indépendantes et propulsé par le six-cylindres en ligne LB6 de 2580 cm³ avec deux arbres à cames en tête que William Watson et Donald Bastow ont construit sous son égide. Lagonda Bentley sera le nom de cette nouvelle voiture. Mais ce n'est pas du tout du goût de Rolls-Royce, qui détient les droits sur ce nom, et oblige Alan Good à faire ôter à grands frais le logo du moteur et de la carrosserie.

Un symbole est ainsi effacé. Mais il y a plus grave : la situation financière de Lagonda est précaire et ses jours comme constructeur indépendant sont comptés.

Detail of the Lagonda LM45 similar to the specimen which won the 24-hour race in 1935.

Detailaufnahme des Lagonda LM45, wie er 1935 das 24-Stunden-Rennen gewann.

Détail de la proue d'une Lagonda LM45 similaire à celle qui a remporté les 24 Heures du Mans en 1935.

excellent chassis and this engine would create a superb driving machine.

The imaginative price cited by Lagonda's management for a company in the direst of straits brought a tired smile to his lips, and an offer of £50,000, and not a penny more, if they wanted him along for the ride. Thereupon he disappeared to Italy on holiday. Not long after, the phone rang once again to let him know that he was now the owner of two automobile factories. Once again, the concrete assets that Brown had acquired were nothing to write home about: the name Lagonda, projects currently in progress and some designs for the future. So they acquired some spacious hangars at Hanworth Airfield, rolled their sleeves up and got down to work.

In April 1950 the DB2 was announced. This, the second opus to emerge from the newly-enlarged Aston Martin enterprise, was the first to immortalize the initials of new boss David Brown. Beneath its curvaceous hood the 2.6 liter Lagonda engine heralded the merger of the two firms. In typical Aston Martin fashion the new DB2 got off to a storming start, coming fifth overall in the Le Mans 24 hour race in June, and first in both the three liter class and the Index of Performance, driven by the team of George Abecassis and Lance Macklin. Two of the three cars used, which were serviced by a team of six mechanics, were production cars which had been just slightly modified for the race. The heavy coupés were thirsty beasts, consuming a gallon every 13 miles. From the practice results John Wyer then calculated an average lap time of five minutes and forty-five seconds. At the end of the race they were just three minutes and 17 seconds off this target – the result of an unplanned pitstop.

One pre-race dilemma ended up solving itself: David Brown, at the ripe old age of 47 and wholly without experience of top level motorsport, made Le Mans, so to speak, a top-level matter by declaring that he intended to drive the car himself. The list of English Le Mans entrants was always inspected and then passed on by the RAC. Thus it was that Colonel

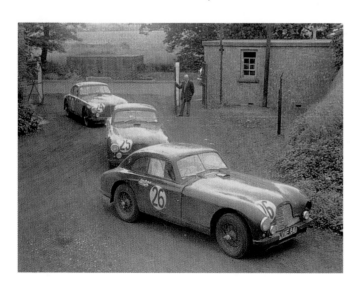

The three works DB2s of Macklin/Thompson, Abecassis/Shawn-Taylor and Parnell/Hampshire arriving at Le Mans in 1951.

Die drei Werks-DB2 von Macklin/Thompson, Abecassis/Shawn-Taylor und Parnell/Hampshire 1951 bei der Ankunft in Le Mans.

Les trois DB2 d'usine de Macklin/Thompson, Abecassis/Shawn-Taylor et Parnell/Hampshire, en 1951, à leur arrivée au Mans.

von Aston Martin nämlich verewigt sich der Chef zum ersten Mal mit den Anfangsbuchstaben seines Namens. Unter der rundlichen Haube kündet das 2,6-Liter-Lagonda-Triebwerk von der neuen Firmenehe. Die Räder sind vorn einzeln an Längslenkern aufgehängt. Nach Art des Hauses verschafft man sich einen furiosen Einstand: Beim 24-Stunden-Rennen von Le Mans im Juni jenes Jahres belegt ein DB2 mit der Piloten-Combo George Abecassis und Lance Macklin den fünften Rang und wird Erster in der Dreiliterklasse sowie im Index of Performance. Zwei der drei Einsatzwagen, die von insgesamt sechs Mechanikern betreut werden, sind der Serie entlehnt und nur behutsam für ihren besonderen Zweck abgeändert worden. Im Schnitt schlucken die gewichtigen Coupés 21 Liter je 100 Kilometer. John Wyer rechnet daher aus den Trainingsergebnissen einen Durchschnittswert von fünf Minuten und fünfundvierzig Sekunden pro Runde hoch. Am Ende liegt man drei Minuten und siebzehn Sekunden hinter der solchermaßen als Richtschnur vorgegebenen Zeit – Ergebnis eines nicht eingeplanten Boxenstopps.

Ein Dilemma im Vorfeld des Rennens löst sich von alleine: David Brown, bereits reife 47 Jahre alt und im großen Rennsport reichlich unbewandert, macht Le Mans gewissermaßen zur Chefsache und erklärt kategorisch, er wolle selber fahren. Zum Glück werden die englischen Nennungen vom Royal Automobile Club gesichtet und weitergeleitet. Als Colonel Stanley Barnes, Direktor des Competition Departments, britisch-zurückhaltend sein Befremden zum Ausdruck bringt und listig die Unentbehrlichkeit Browns für die heimische Industrie herausstreicht, befreit er zugleich Wyer aus einer peinlichen Klemme: Er hätte seinen Boss am Pilotieren eines seiner eigenen Autos hindern müssen. Der aber schluckt die Kröte arglos und gutmütig, und das Thema ist in Zukunft erledigt.

Die zweite Auflage dieses Erfolgs zwölf Monate später verklärt den DB2 zum Kultobjekt. Drei Exemplare führen die Wertung bei den Dreilitern an, an ihrer Spitze wie schon 1950 der Wagen mit dem polizeilichen Kennzeichen VMF 64. Das beweist zweierlei: Bei Aston Martin geht man haushälterisch um mit seinem Fahrzeugmaterial. Und immer auch dienen die Rennautos der An- und Abreise und müssen daher für den Verkehr auf öffentlichen Straßen zugelassen sein. In den folgenden fünf Jahren indessen wird die Geduld der Männer um John Wyer auf eine harte Probe gestellt. Erste Plätze bleiben im Wesentlichen den Mercedes, Ferrari, Maserati und Jaguar vorbehalten. Dann aber, zwischen 1957 und 1959, gewinnt die Marke sechs Weltmeisterschaftsläufe, dreimal das 1000-Kilometer-Rennen am Nürburgring, zweimal (1958 und 1959) die Tourist Trophy in Goodwood, einmal Le Mans. Das geschieht 1959, als sich Aston Martin auch die Markenweltmeisterschaft holt mit 24 Punkten vor Ferrari mit 22 und Porsche mit 21. Die DBR1 erweisen sich dabei als Muster an Langlebigkeit: In jenen drei Jahren der Glorie kommt man mit vier

de son moteur, William Owen Bentley, que le monde entier n'appelle que par ses initiales W.O., est également de la partie. La tenue de route de la voiture, dira plus tard David Brown en aparté, était horrible, mais son six-cylindres, en revanche, était remarquable. Et cela lui donna une idée: combiné à un tel moteur, le châssis d'Aston Martin devrait donner une voiture de tout premier ordre.

Les prétentions des fondateurs de la firme au bord de la faillite ne suscitent chez lui qu'un sourire condescendant. Pour 50 000 livres, laisse-t-il entendre, il serait preneur, mais pas pour un penny de plus. Il part ensuite en vacances en Italie, où, un peu plus tard, on lui annonce qu'il est devenu propriétaire d'une deuxième usine automobile. Une fois de plus, ce que Brown vient d'acheter n'a pas beaucoup de valeur pour les non-initiés: le nom Lagonda, quelques projets en gestation ainsi que des croquis pour l'avenir. Brown est désormais propriétaire de vastes hangars sur l'aérodrome de Hanworth; il ne reste qu'à retrousser ses manches.

En avril 1950, Aston annonce l'arrivée de la DB2. C'est seulement avec la deuxième voiture de la lignée des œuvres complètes d'Aston Martin que le chef s'immortalise pour la première fois en y gravant ses initiales. Sous le capot tout en galbes, le moteur de 2,6 litres de Lagonda est le témoignage de la nouvelle alliance. Les roues avant sont à suspension indépendante et guidées par des bras longitudinaux. Dans le plus pur style de la maison, elle prend un départ sur les chapeaux de roues: lors des 24 Heures du Mans, en juin de cette année-là, une DB2 pilotée par George Abecassis et Lance Macklin termine cinquième au classement général, mais première de la catégorie 3-litres ainsi qu'à l'Indice de performances. Parmi les trois voitures engagées, entre tenues par une équipe de six mécaniciens, deux sont proches de la série et n'ont reçu que très peu de modifications. Ces lourds coupés consomment en moyenne 21 litres aux 100 km. À la lumière des résultats des essais, John Wyer table sur une moyenne de 5 minutes 45 secondes au tour pour sa voiture vedette. À la fin, celle-ci accuse un retard de 3 minutes et 17 secondes sur ce temps idéal – résultat d'un arrêt imprévu aux stands.

Un problème en amont de la course trouve sa solution de lui-même: David Brown, déjà âgé de 47 ans et sans la moindre expérience en compétition, déclare que Le Mans est en quelque sorte l'affaire de la direction et annonce son intention catégorique de piloter lui-même. Par bonheur, les inscriptions anglaises sont contrôlées par le Royal Automobile Club, qui les retransmet à l'Automobile Club de l'Ouest (ACO). Lorsque le colonel Stanley Barnes, directeur du département Compétition, fait part de son étonnement avec un tact purement britannique et fait astucieusement comprendre à David Brown qu'il est indispensable à l'industrie autochtone, il décharge par la même occasion les épaules de John Wyer d'un lourd poids: il aurait dû empêcher son patron de piloter l'une de ses propres voitures.

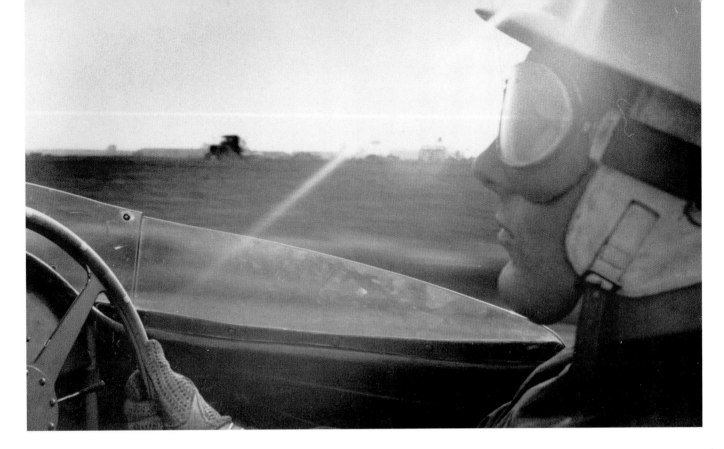

Stanley Barnes, director of the Competition Department, found, to his alarm, that Brown's name was on the list. In his reserved manner he expressed his concern, craftily stressing Brown's indispensability for the domestic motor industry, thus sparing John Wyer the embarrassing task of having to persuade his boss not to drive his own car. Brown took the bait and the problem was solved for the future.

When the DB2 succeeded in capping this Le Mans triumph twelve months later it was assured of cult status. Aston Martin occupied the first three places in the three liter class, with first place being taken, as in 1950, by the car with the VMF 64 number plate, bearing witness both to the fact that Aston Martin adopted a thrifty policy as regards the use of competition vehicles, and also that the racing cars still served as transport to and from races, and accordingly had to be registered for use on public roads. Over the next five years, however, John Wyer and his men had to curb their impatience, as overall first place seemed to be eternally reserved for the big four of Mercedes, Ferrari, Maserati and Jaguar. But then, between 1957 and 1959, came the breakthrough, as they won a total of six world championship races, winning the Nürburgring 1000 kilometer race three times, the Tourist Trophy at Goodwood twice (in 1958 and 1959), and Le Mans once. That was in 1959, when Aston Martin also won the constructor's championship with a total of 24 points to Ferrari's 22 and Porsche's 21. The DBR1 had proved itself to be a model of endurance and reliability. During the three glory years a mere four works cars and five engines were all they needed.

Werkswagen und fünf Triebwerken aus. Und das ist nur der Anfang von wahrhaft erfüllten Auto-Viten: Bis auf den heutigen Tag stehen die Protagonisten von damals auf historischen Rennen ihren Mann. Winzig ist auch das Budget: Das Unternehmen Nürburgring 1959, rechnet John Wyer penibel aus, kostet das Team 558 Pfund.

Inzwischen sind Wettbewerbswagen und Straßenautos zu zwei verschiedenen Spezies mutiert. Bereits beim DB2/4, eingeführt 1953, handelt es sich um eine Offerte an die Adresse des aufstrebenden Familienvaters. Er gewährt ungewöhnlich zierlich gewachsenen Kindern bis ins Grundschulalter hinein eine Mitfahrgelegenheit auf winzigen hinteren Notsitzen. Die Karosserie wird bei H. J. Mulliner in Birmingham hergestellt. Mitte 1954 rüstet man das Motorvolumen auf 2,9 Liter nach. Beide Marken sind nun unter der Anschrift Hanworth Park, Feltham erreichbar. Im Übrigen herrscht ein gemäßigter Polyzentrismus: Motoren, Chassis und Fahrwerk werden aus einer anderen Fabrik David Browns in Farsley in der Nähe von Huddersfield in Yorkshire angeliefert. Im gleichen Jahr kauft Brown die Karosseriefabrik Tickford Motor Bodies, bis heute Garnison der Aston Martin Lagonda Limited. Die Liegenschaft ist gewissermaßen mit historischem Edelrost überzogen. Das Grundstück gehört ursprünglich (seit 1820) der Sozietät Salmon & Sons, die sich mit dem Epitheton »Coachbuilders to the Nobility« zierte. Während des Zweiten Weltkriegs wird Tickford-Manager Ian Boswell Chef der Firma, zu deren Auftraggebern seit 1951 auch Lagonda zählt. 1957 tritt der DB Mark III als weitere Variation eines erfolgreichen

Ne se doutant de rien, David Brown se soumet et la question est réglée pour l'avenir.

La réédition de ce succès, douze mois plus tard, élève la DB2 au rang d'objet de culte. Trois exemplaires arrivent en tête du classement en catégorie 3-litres avec, à la première place comme en 1950 déjà, la voiture immatriculée VMF 64. Cela prouve deux choses: que, chez Aston Martin, on sait ménager son matériel et que les voitures de course doivent se rendre au circuit et en repartir par la route, comme des véhicules ordinaires, et donc être immatriculées. Les cinq années suivantes, la patience de John Wyer et de son équipe sera mise à rude épreuve. Mercedes, Ferrari, Maserati et Jaguar se disputeront toutes les premières places. Mais entre 1957 et 1959, la marque remportera six manches du championnat du monde, gagnera trois fois la course des 1 000 Kilomètres du Nürburgring, deux fois le Tourist Trophy à Goodwood (en 1958 et 1959) et une fois Le Mans. En 1959, Aston Martin remportera aussi le titre de championne du monde des marques avec 24 points devant Ferrari (22) et Porsche (21). La DBR1 se révélera à cette occasion un modèle de fiabilité. Pendant ces trois années glorieuses, Aston peut se contenter de quatre voitures d'usine et de cinq moteurs. Et ce n'est que le début d'une longévité automobile devenue légendaire: aujourd'hui encore, les véhicules de jadis ont toujours bon pied bon œil lors des courses de voitures de collection. Comme l'écurie, le budget est lilliputien: la comptabilité de John Wyer nous révèle que la participation aux

Stirling Moss in the DBR1 as seen by photographer Louis Klemantaski, who also accompanied the drivers in races such as the Mille Miglia.

Stirling Moss im DBR1 aus der Sicht des Fotografen Louis Klemantaski, der die Piloten auch auf Rennen wie der Mille Miglia begleitete.

Stirling Moss au volant de la DBR1 vu par le photographe Louis Klemantaski, qui accompagnait aussi les pilotes lors de courses comme les Mille Miglia.

Racing for Aston Martin

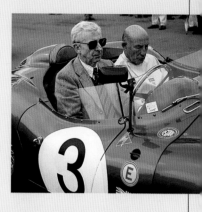

What I especially liked about racing with Aston Martin was the team spirit. There were wonderful guys and we really could have fun when not actually behind the steering wheel. There was a tremendous amount of leg-pulling and practical jokes and many a riotous time when we for instance were at La Chartre for Le Mans with people like Dennis Poore, Roy Salvadori, Reg Parnell and Peter Collins about. Unfortunately I have a terrible memory so I do not remember any particular incidents. That's also the reason why I have never written the book so many people have asked me to write. It was the camaraderie that I really indulged in and I would have been astonished if there had been a racing stable with more team spirit, the more so as we were involved in a very dangerous sport at that time. John Wyer was a very good team manager and had a dry sense of humor. But he was very much his own man and nobody dared to contradict him. If he had not been that good the team might have easily got out of hand with all these strong individuals about. As John Wyer writes in his book (The Certain Sound) I took part in driver trials at the end of 1954. We had two trials one being snowed off, both on aerodromes. There were three or four other drivers, among them Pat Griffith. Roy Parnell, Reg's cousin, was the Aston Martin test driver and quite a useful one as well. He took the car round on a circuit marked with barrels to give John Wyer an idea what times might be like. Then we were given a certain amount of laps with consistency as well as the actual times being of interest to him. As a result I was invited to join the team in 1955. We all drove the same car, a DB3S. My first race was Le Mans in 1955 which became notorious because of the disaster triggered off by [Pierre] Levegh in the Mercedes. I would leave Aston Martin after the 1958 season, as I did not have an ongoing contract with them, to join Ferrari for sports cars as well as Formula 1. My last race for them was the Tourist Trophy on Sep. 13 1958, which I won in the DBR1/300 together with Stirling Moss. My first really big success with them was winning a sports car race in Spa in May 1957 in the first outing of the DBR1/300 and then, of course, the Nürburgring 1000 Ks a fortnight later, with Noel Cunningham-Reid. Then there was another victory at Spa in the so-called Belgian Grand Prix in August. So I won three major races with the Aston Martin that year.

Both the Nürburgring and Spa, which I was happy to excel on, were fantastic circuits. They were of course quite different. Spa was really poetry in motion with all those fast sweeping corners driven in a four-wheel-drift which means controlling the slide of the car with the accelerator, just caressing the steering-wheel. It is such an essential as well as a delicate thing balancing the car on the limit of adhesion. Of course you had to have a really fast car. In the one-and-a-half liter Formula One from 1961 you were virtually flat out there everywhere apart from the La Source hairpin. With a car with excess power, driving there was really essentially satisfying.

The Nürburgring was quite similar, although the corners were not of such a high-speed caliber, full of those medium-speed and fast bends that give the driver most satisfaction. The vicious thing about both circuits was that it could be dry in one part and raining somewhere else. They were tremendous drivers' challenges. I don't know what it is like to be addicted to heroin but it must be a similar kick.

As to the strengths and weaknesses of the DBR1: its roadholding and brakes were superb but in 1957 it was significantly down on power compared to the competition, Jaguar, Ferrari and for instance the 4.5-liter Maseratis we were up against. All of them really had more power than the Aston. But with the qualities of the DBR1 you could compensate for the lack of power on circuits like the Ring. The same goes for Spa to a certain degree. I remember Olivier Gendebien going there extremely quickly in the big Ferrari but he had some tire trouble which prevented him from finishing in front of us. The gearbox sometimes gave us trouble and spoiled the 1957 Le Mans race. Cunningham-Reid brought the car which we shared into the pits at about three o'clock in the morning, stuck in fourth gear. We were second at that time and I didn't fancy driving the car in that plight for another 13 hours. So I tried to pull the gear out after accelerating hard and taking the power off and I did what you are not supposed to do in your first driving lesson: I looked down at the gearlever and, in doing so, passed my braking point at Tertre Rouge. That was my first mistake. My second one was that I almost got round the corner throwing the car into a broad drift that led to my hitting the sandwall at the end of the corner; the car flipped burying and trapping me underneath. Of course it was pitch dark at that time of the night. Since I had passed the apex of the corner the drivers behind me could not see that my car was lying there with me under it. So I was wondering if I would be burned to death or crushed to death. The first man to arrive was Umberto Maglioli and he knocked the car off me so I was able to leave the place in spite of my injuries. Mine was not a driver's error as such but just sheer stupidity. So I was not fit for the British Grand Prix at Aintree and arranged for Stirling [Moss] to have my Vanwall. He turned out to be a worthy substitute, winning the race. I only got out of my sickbed on the first day of practice. Driving for Vanwall in Formula 1 and for Aston Martin in sports cars was no problem because Colin Vanderwell built Grand Prix cars only so there was no clash of interests although David Brown did have his own Formula 1 car, the problem as usual being that it had a good chassis but insufficient power. Unfortunately I never took part in the Mille Miglia. They did not want to send me there as a new boy as Peter Collins and Reg Parnell had already worn out so many cars there the year before. It must have been great fun particularly while practicing for a week or so all over Italy with all that tremendous hospitality and good food. Those certainly were the days. But I did start in the Targa Florio and enjoyed that a great deal, although it was a rally-like affair unlike Spa or the Nürburgring. Aston Martin was not a deliberately British effort although the driver choice seemed to suggest this. At that time a lot of very good British drivers happened to be about. After all, people like Texan Carroll Shelby and Frenchman Maurice Trintignant drove for the team so there certainly was no "no-foreigners" attitude. I once owned an Aston Martin road car, in 1957, a beautiful black DB Mark III with a silver top and the registration number 59 LMT. But of course I had to pay for it although they made me a good price. My first contract for 1955 was honored with a retainer of £50 and afterwards it was not much more, peanuts as compared to today, always hundreds and never thousands. They covered your hotel and travel expenses. You got your share of the prize money and the bonuses but that was it. You were certainly not driving for the money and even Stirling did not earn more than £30,000 in his best year and he competed in more races than anybody else. He treated it as a business from very early on. What stands out for me from that time is that I met my wife through Aston Martin. We were racing in Rouen in 1956 and stayed with one of the organizers in a chateau named Alizay. Pina was a friend of the daughter's and on her way from Italy to England where she wanted to further her English studies. I met her at the chateau. That was by far the best thing that ever came out of racing with Aston Martin and motor racing as a whole as far as I am concerned.

Tony Brooks, born in 1932, pictured here with Stirling Moss at the 1999 Goodwood Revival, is one of the most underrated racing drivers of the postwar period. He won six of his 38 Grands Prix.

Tony Brooks, Jahrgang 1932, hier zusammen mit Stirling Moss beim Goodwood Revival 1999, gilt als einer der am meisten unterschätzten Rennfahrer der Nachkriegszeit. Er gewann sechs seiner 38 Grands Prix.

Tony Brooks, né en 1932, ici en compagnie de Stirling Moss lors du Goodwood Revival 1999, est considéré comme l'un des pilotes de course les plus sous-estimés de l'après-guerre. Il a gagné six des trente-huit Grands Prix auxquels il a participé.

Am Start für Aston Martin

Was mir während meiner Dienstzeit bei Aston Martin am besten gefiel, war der Teamgeist. Es gab dort prächtige Leute und wir hatten eine Menge Spaß, wenn wir nicht gerade hinter dem Lenkrad saßen. Sowie Männer wie Dennis Poore, Roy Salvadori, Reg Parnell und Peter Collins aufeinander trafen, waren einfach handfeste Streiche und Neckereien angesagt. Es ging so manches Mal hoch her, vor allem im Umfeld von Le Mans, wenn wir in La Chartre abgestiegen waren. Leider habe ich ein schreckliches Gedächtnis und kann mich an keine Einzelheiten mehr entsinnen, einer der Gründe, weshalb ich nie die Autobiographie geschrieben habe, um die mich so viele Leute gebeten haben. Eine bessere Kameradschaft hätte ich mir nicht vorstellen können und es gab in dieser Hinsicht wohl keinen vergleichbaren Rennstall, zumal unser Sport zu jener Zeit eine höchst gefährliche Angelegenheit war. John Wyer war ein exzellenter Teammanager und zeichnete sich darüber hinaus durch seinen trockenen Sinn für Humor aus. Aber er war auch eine sehr eigenwillige Persönlichkeit, der niemand zu widersprechen wagte. Hätte er die Dinge nicht so fest im Griff gehabt, wäre das Team gewiss so manches Mal über die Stränge geschlagen, da es seinerseits aus starken Individuen bestand.

Wie Wyer in seinem Buch (The Certain Sound) schreibt, nahm ich Ende 1954 an Versuchsfahrten für Aston Martin teil. Man gab uns zwei Mal eine Chance, in beiden Fällen auf Flugfeldern. Das erste Mal endete vorzeitig wegen Schneefalls. Außer mir nahmen noch drei oder vier Fahrer teil, unter anderem Pat Griffith. Roy Parnell, Regs Vetter, war damals Testpilot für Aston Martin und kein schlechter. Er drehte ein paar Runden über einen Parcours, der mit Fässern markiert worden war, und gab damit Zeiten vor, an denen sich John Wyer orientieren konnte. Dann wurden wir auf den Kurs losgelassen, wobei es sowohl auf Beständigkeit als auch auf die tatsächlichen Zeiten ankam. Das Auto war immer das gleiche, ein DB3S. Am Ende wurde ich eingeladen, 1955 für das Team zu starten. Mein erstes Rennen war jenes 24-Stunden-Rennen von Le Mans, das sich einen so traurigen Ruhm erwerben sollte – wegen der Katastrophe, die (Pierre) Levegh mit einem Mercedes auslöste. Nach dem Ende der Saison 1958 verließ ich Aston Martin, weil mein Vertrag ohnehin auslief, und schloss mich Ferrari an, in der Sportwagen wie in der Formel 1. Mein letztes Rennen für Feltham war die Tourist Trophy am 13. September 1958, die ich zusammen mit Stirling Moss

im DBR1/300 gewann. Mein erster wirklich bedeutender Erfolg für Aston Martin war der Sieg in einem Sportwagenrennen in Spa im Mai 1957 beim Debüt des gleichen Modells und dann natürlich beim 1000-km-Rennen auf dem Nürburgring 14 Tage später, gemeinsam mit Noel Cunningham-Reid. Darauf folgte ein weiterer Sieg in Spa beim so genannten Grand Prix von Belgien im August. Folglich gewann ich in jenem Jahr drei große Veranstaltungen im Aston Martin.

Beide Strecken, der Nürburgring und Spa, waren fantastisch und ich bin glücklich über meine Leistungen auf ihnen. Sie unterschieden sich gleichwohl erheblich voneinander. Spa bedeutete für mich Poesie in der Bewegung wegen der schnellen Kurven, die man im Four-Wheel-Drift fuhr, indem man den Wagen per Gaspedal kontrollierte und das Lenkrad lediglich streichelte. Ein Fahrzeug derartig im Grenzbereich zu bewegen war etwas Elementares, das sehr viel Finger- und Fußspitzengefühl erforderte. Dies setzte natürlich ein sehr schnelles Auto voraus. Ab 1961 wurden die Grand Prix ja nach der Anderthalbliterformel ausgetragen, und mit diesen Wagen fuhr man in Spa überall voll – mit Ausnahme der Haarnadel zu La Source. Das gab einem Piloten gewiss nicht halb so viel Befriedigung wie die Arbeit mit einem Fahrzeug voller überschüssiger Kraft.

Der Nürburgring bot eine ähnliche Herausforderung, obwohl seine Kurven nicht solche Vollgasorgien darstellten, sondern mittelschnell bis schnell waren, von der Sorte, die einem ihrerseits ein sinnliches Vergnügen bereiten. Eine Tücke war beiden Kursen gemeinsam: Es konnte an manchen Stellen regnen, während es an anderen noch trocken war. Beide stellten erhebliche Anforderungen an die Piloten. Ich habe keinerlei Sucherfahrungen mit Heroin, aber das muss einem einen ganz ähnlichen Kick geben.

Was die Stärken und Schwächen des DBR1 anbelangt: Seine Straßenlage und seine Bremsen waren superb, aber 1957 war er viel schwächer als seine Konkurrenten Jaguar, Ferrari und etwa die 4,5-Liter-Maserati, gegen die wir antreten mussten. Aber mit seinen Qualitäten konnte man dieses Defizit auf Strecken wie dem Ring austarieren. Das Gleiche gilt mit ein paar Einschränkungen für Spa. Ich erinnere mich, wie Olivier Gendebien dort mit dem dicken Ferrari superschnell war. Aber zum Glück hatte er Reifenprobleme und die hielten ihn davon ab, vor uns zu landen. Auch ging unser Getriebe manchmal kaputt, was uns zum Beispiel in Le Mans 1957 einen Strich durch die Rechnung machte. Cunning-

ham-Reid lief mit unserem Wagen gegen drei Uhr früh die Box an, da nur noch der vierte Gang funktionierte. Zu diesem Zeitpunkt lagen wir auf Rang zwei und ich war nicht erpicht auf weitere 13 Stunden Fahrt in dieser Verfassung. So beschleunigte ich voll, nahm das Gas weg und versuchte den Gang herauszureißen. Dabei jedoch machte ich einen Fehler, der einem nicht einmal in der ersten Fahrstunde unterlaufen sollte: Ich schaute herunter auf den Schalthebel und verpasste meinen Bremspunkt für Tertre Rouge. Das war mein erster Schnitzer. Der zweite war, das Auto so quer zu stellen, dass ich am Ende der Kurve in den Sandwall geraten musste, der sie begrenzte. So überschlug sich der Wagen und ich lag hilflos unter ihm. Um diese Zeit war es natürlich stockfinster. Ich befand mich hinter dem Scheitelpunkt von Tertre Rouge. Jemand, der nach mir kam, konnte mein Auto mit mir darunter also nicht sehen. Ich stand also vor der unattraktiven Alternative, zu verbrennen oder von einem anderen Fahrzeug ins Jenseits befördert zu werden. Als Erster traf Umberto Maglioli ein und entfernte krachend den Aston zu meinen Häupten, so dass ich mich trotz meiner Verletzungen in Sicherheit bringen konnte. Eines war mir klar: Das war nicht auf Grund eines Fahrfehlers passiert, sondern das Ergebnis reiner Dummheit. Jedenfalls war ich für den Großen Preis von England am 20. Juli in Aintree noch nicht wieder fit und arrangierte, dass Stirling (Moss) meinen Vanwall dort fahren konnte. Er entpuppte sich als ein würdiger Vertreter und gewann, während ich mich erst am ersten Trainingstag vom Krankenlager erheben konnte. Für Vanwall in der Formel 1 und für Aston Martin bei den Sportwagen zu starten stellte kein Problem dar, da Colin Vanderwell lediglich Grand-Prix-Wagen baute und somit kein Interessenkonflikt entstand. David Brown hatte allerdings selber ein Formel-1-Auto mit dem üblichen Problem: ein gutes Chassis, nicht genug Kraft.

Leider nahm ich nie bei der Mille Miglia teil. Man wollte mich als Neuling dort partout nicht hinschicken, nachdem Reg Parnell und Peter Collins im Vorjahr bei dieser Gelegenheit so viele Fahrzeuge verschlissen hatten. Das Rennen muss ein echtes Vergnügen gewesen sein – vor allem eine ganze Woche auf dieser Strecke quer durch Italien zu fahren und zu trainieren – mit den vielen gesellschaftlichen und kulinarischen Annehmlichkeiten, die das mit sich brachte. Das waren schon tolle Jahre damals! Aber bei der Targa Florio fuhr ich mit und das mit größtem Vergnügen, obwohl die Veranstaltung eher

einer Rallye ähnelte als die Läufe in Spa und auf dem Nürburgring.

Die Renneinsätze von Aston Martin hatten keinen chauvinistischen Beigeschmack, obwohl die Auswahl der Fahrer dies nahe zu legen schien. Zu jener Zeit gab es einfach eine Menge wirklich guter englischer Piloten. Schließlich fuhren auch der Franzose Maurice Trintignant und der Texaner Carroll Shelby für das Team, was irgendeine »Ausländer raus«-Haltung widerlegt. Ich besaß einmal ein Straßenauto von Aston Martin, einen bildschönen DB Mark III in Schwarz mit silbernem Dach und der Zulassung 59 LMT, an die ich mich merkwürdigerweise noch erinnere. Ich musste natürlich für ihn bezahlen, obwohl man mir einen guten Preis machte. Mein erster Vertrag wurde mir 1955 mit 50 Pfund Sterling honoriert und später kam nicht viel mehr, Peanuts im Vergleich zu heute, ein paar Hunderter vielleicht und niemals Tausender. Man bezahlte uns die Hotel- und Reisespesen. Auch bekamen wir etwas vom Preisgeld und den Bonussen, aber das war's. Man muss dazu sagen, dass er den Rennsport von Anbeginn an als geschäftliche Angelegenheit betrachtete.

Was mir aus jener Zeit am lebhaftesten im Gedächtnis geblieben ist: dass ich meine Frau durch meine Tätigkeit für Aston Martin kennen lernte. Wir fuhren 1956 in Rouen und wohnten zusammen mit einem der Veranstalter in einem Schloss namens Alizay. Pina war eine Freundin der Tochter des Hausherrn und machte Station auf ihrem Wege von Italien nach England, wo sie etwas für ihr Englisch tun wollte. Ich traf sie im Schloss. Das war das Schönste, was meine Zeit mit Aston Martin und überhaupt im Rennsport mir geschenkt hat.

Défendre les couleurs d'Aston Martin

Ce qui me plaisait le plus, lorsque j'étais pilote officiel chez Aston Martin, c'était l'esprit d'équipe. Il y avait là des gens remarquables et nous nous amusions énormément, sauf lorsque nous nous trouvions derrière le volant. Dès que des hommes comme Dennis Poore, Roy Salvadori, Reg Parnell et Peter Collins se retrouvaient, on pouvait s'attendre à tous les tours et plaisanteries imaginables. Il y avait parfois vraiment de l'ambiance, notamment à l'occasion des 24 Heures du Mans, lorsque nous descendions à La Chartre. J'ai malheureusement une mémoire déplorable et je ne me rappelle plus aucun détail, ce qui est l'une des raisons pour lesquelles je n'ai jamais écrit d'autobiographie. Et pourtant, Dieu sait si bien des gens me l'ont conseillé. Je n'aurais jamais pu imaginer un meilleur esprit de camaraderie et, à ce point de vue, il n'y avait sans aucun doute aucune écurie comparable, d'autant plus que notre sport était, à cette époque-là, vraiment très dangereux. John Wyer était un excellent team manager, qui se distinguait en outre par son humour pince-sans-rire. Mais il avait aussi une personnalité très affirmée et personne n'osait le contredire. S'il n'avait pas tenu si solidement les rênes, l'écurie aurait pu partir en débandade, car elle se composait, à ce moment-là, d'individus qui avaient, eux aussi, une très forte personnalité.

Comme John Wyer l'a écrit dans son livre [The Certain Sound], j'ai reçu une invitation à participer, fin 1954, à des essais pour Aston Martin. On nous a donné deux fois notre chance, sur des aéroports dans les deux cas. La première fois, des chutes de neige ont fait tourner court la sélection.

À part moi, trois ou quatre autres pilotes y ont participé, dont Pat Griffith. Roy Parnell, le neveu de Reg, était, à cette époque-là, pilote d'essai pour Aston Martin et il ne manquait pas de talent. Il fit quelques tours d'un tracé symbolisé par des fûts et établit des temps destinés à servir de référence à John Wyer. Puis ce fut à nous de nous lancer sur ce circuit improvisé, la régularité étant aussi importante que les temps réalisés.

La voiture était toujours la même, une DB3S. À la fin de l'essai, on m'a donc proposé un contrat pour courir pour l'écurie en 1955. Ma première course a été les 24 Heures du Mans, une course qui devait entrer bien tristement dans l'histoire en raison de la catastrophique sortie de route de Pierre Levegh avec sa Mercedes. J'ai quitté Aston Martin à la fin de la saison 1958 parce que mon contrat arrivait de toute façon à expiration et j'ai rejoint Ferrari, où j'ai piloté aussi bien des voitures de sport que des Formule 1. Ma dernière course pour Feltham a été le Tourist Trophy, le 13 septembre 1958,

que j'ai gagné avec Stirling Moss comme coéquipier au volant d'une DBR1/300. Mon premier succès vraiment important pour Aston Martin a été la victoire à une course de voitures de sport à Spa, en mai 1957, lors des débuts du même modèle, le deuxième ayant naturellement été la victoire aux 1000 Kilomètres du Nürburgring, 15 jours plus tard, avec Noel Cunningham-Reid. J'ai ensuite de nouveau terminé premier à Spa, lors du Grand Prix de Belgique, en août. Par conséquent, cette année-là, j'ai remporté la victoire sur Aston Martin lors de trois grandes manifestations.

Les deux circuits, le Nürburgring et Spa, étaient fantastiques, et je suis heureux des résultats que j'y ai obtenus. Et pourtant, les deux pistes sont complètement différentes l'une de l'autre. Pour moi, Spa est synonyme de poésie dans le mouvement avec tous les virages rapides que l'on franchissait en glissant des quatre roues, en contrôlant la voiture à petits coups d'accélérateur et en se contentant de caresser le volant. Maîtriser une voiture de cette façon-là à la limite d'adhérence était quelque chose d'élémentaire, mais qui demandait énormément de doigté et beaucoup de sensibilité avec les pédales. Mais cela présupposait naturellement aussi une voiture très rapide. À partir de 1961, les Grands Prix ont, comme chacun sait, été disputés selon la formule 1,5 litre et, avec cette voiture, on prenait tous les virages à fond à Spa, à l'exception de l'épingle de La Source. Mais c'était loin de donner au pilote la satisfaction qu'il ressentait au volant d'une voiture beaucoup plus puissante.

Le Nürburgring représentait un défi similaire bien que l'on n'ait pas à franchir à fond tous ses virages, dont certains étaient moyennement rapides ou rapides, mais d'un genre qui donne beaucoup de plaisir au conducteur. Les deux circuits avaient un point commun, un piège qu'ils pouvaient vous tendre : il pouvait pleuvoir à certains endroits alors que, à d'autres, la piste était encore sèche. Tous deux exigeaient des pilotes un sacré coup de volant. Je n'ai jamais essayé l'héroïne, mais cela doit donner une poussée d'adrénaline tout à fait comparable.

Quant aux points forts et aux points faibles de la DBR1... Eh bien, sa tenue de route et ses freins étaient exceptionnels, mais, en 1957, elle était beaucoup moins puissante que ses concurrentes les Jaguar, Ferrari ou, par exemple, les Maserati de 4,5 litres, contre lesquelles nous devions nous aligner. Mais, avec ses qualités, nous pouvions combler ce déficit sur des circuits comme le Nürburgring. Cela vaut aussi, mais avec certaines restrictions, pour Spa. Je me rappelle comment

Olivier Gendebien y était d'une extrême rapidité avec les grosses Ferrari. Mais, par bonheur, il a rencontré des problèmes de pneumatiques qui l'ont empêché de se retrouver devant nous. Parfois, il arrivait aussi que notre boîte de vitesses connaisse une défaillance, ce qui a été le cas au Mans en 1957, par exemple, et a réduit tous nos espoirs à néant. Avec notre voiture, Cunningham-Reid dut rallier les stands vers trois heures du matin parce qu'il n'y avait plus que la quatrième qui fonctionnait. À ce moment-là, nous étions deuxièmes et je n'avais vraiment pas envie de rouler encore pendant 13 heures avec une voiture dans un tel état. J'ai donc accéléré à fond, levé le pied de l'accélérateur et tenté de rétrograder de force. Par la même occasion, j'ai commis une erreur que ne devrait même pas commettre un conducteur débutant : j'ai regardé le levier de changement de vitesses et raté mon point de freinage pour le Tertre Rouge. Ce fut ma première faute. La seconde a été de mettre la voiture tellement en travers qu'elle a fini par percuter, à la sortie du virage, le mur de sable qui servait de délimitation.

La voiture a alors fait un tonneau et je me suis retrouvé prisonnier sous elle. Or, à cette heure-là, l'obscurité était, naturellement, totale. Je me trouvais derrière le point de corde du Tertre Rouge. Les pilotes qui me suivaient ne pouvaient donc pas voir ma voiture, ni moi prisonnier en dessous. J'étais donc confronté à une alternative qui n'avait rien d'attrayant : brûler ou être envoyé dans l'au-delà par quiconque percuterait ma voiture. Le premier qui arriva était Umberto Maglioli, qui, dans un bruit effroyable, frappa de plein fouet l'Aston au-dessus de moi. Finalement, sous l'effet du choc, celle-ci se déplaça et, malgré mes blessures, je pus me mettre en sécurité. Une chose était claire : cela ne s'était pas produit en raison d'une faute de conduite, c'était seulement le résultat d'une pure imbécillité. Quoi qu'il en soit, je n'étais pas rétabli pour participer au Grand Prix d'Angleterre, le 20 juillet, à Aintree, et je me suis arrangé pour que Stirling (Moss) puisse y piloter ma Vanwall. Comme vous le savez, il me représenta dignement puisqu'il remporta la victoire. Quant à moi, je ne pus quitter mon lit d'hôpital que lors des premiers essais. Piloter pour Vanwall en Formule 1 et pour Aston Martin en courses de voitures de sport n'était pas un problème, car Colin Vanderwell ne construisait que des voitures de Grand Prix, raison pour laquelle il n'y avait pas de conflits d'intérêts. David Brown avait toutefois lui-même une voiture de Formule 1, mais il se heurtait à l'éternel problème habituel : un bon châssis, mais un moteur pas assez puissant.

Malheureusement, je n'ai jamais participé aux Mille Miglia. En tant que néophyte, on refusa catégoriquement de m'y envoyer après que Reg Parnell et Peter Collins, l'année précédente, eurent détruit tant de voitures à cette occasion. La course devait être fantastique, d'autant plus qu'on avait l'occasion de s'entraîner une semaine entière sur ce trajet qui traverse tout le centre de l'Italie, avec les nombreux à-côtés mondains et culinaires agréables que cela implique. C'était quand même une époque fantastique ! En Italie, j'ai tout de même participé à la Targa Florio, avec le plus grand plaisir, même si cette manifestation ressemblait davantage à un rallye que les manches courues à Spa et sur le Nürburgring.

Courir pour Aston Martin n'avait rien de chauvin, même si le choix des pilotes incite à le penser à première vue. À cette époque, il y avait tout simplement une quantité de pilotes anglais vraiment bons. Et, finalement, le Français Maurice Trintignant ainsi que le Texan Carroll Shelby ont aussi couru pour l'écurie, ce qui réfute toute philosophie xénophobe. J'ai un jour possédé une Aston Martin de route, une magnifique DB Mark III noire au toit argenté, immatriculée 59LMT, plaque minéralogique dont bizarrement je me souviens encore. J'ai naturellement dû la payer, mais on m'a fait un prix intéressant. En 1955, mon premier contrat portait sur 50 livres sterling et, plus tard, je n'ai jamais gagné beaucoup plus, une aumône par rapport à aujourd'hui, quelques centaines de francs, peut-être, mais jamais des milliers. On nous payait les frais d'hôtel et de voyage. De même, nous recevions une partie des primes et des bonifications, mais c'était tout. Nous ne pilotions tout simplement pas par amour de l'argent. Durant sa meilleure année de compétition, un homme comme Stirling Moss a gagné 30 000 livres et il a participé à beaucoup plus de courses qu'aucun d'entre nous. Il faut préciser qu'il a dès le début considéré la compétition automobile comme une affaire commerciale.

Le souvenir le plus vivant qui me reste de cette époque est d'avoir fait la connaissance de ma femme grâce à mes activités pour Aston Martin. En 1956, nous courions à Rouen et nous habitions, en compagnie de l'un des organisateurs, au château d'Alizay. Pina était une amie de la fille du maître de céans et elle avait fait étape au château lors de son voyage à beaucoup plus de courses qu'aucun voyage d'Italie en Angleterre, où elle voulait améliorer son anglais. C'est ainsi que nous nous sommes rencontrés. C'est le plus beau cadeau que l'on m'ait jamais fait lorsque je pilotais pour Aston Martin et, d'ailleurs, le plus beau cadeau que m'ait jamais fait la course automobile.

And that proved to be only the beginning of the story, for these historic machines continue to hold their own to this day in classic car races. The budget was also tiny: the 1959 Nürburgring operation, for example, cost the team precisely £558 according to John Wyer's painstaking calculations.

By now racing cars and road cars had evolved into two totally different species. The DB2/4, launched in 1953, already offered additional rear space, preferably to children pre-primary school age. The bodywork was built by H. J. Mulliner of Birmingham. In mid-1954 the engine volume was increased to 2.9 liters. Both makes now shared the Hanworth Park, Feltham address. But in other respects this was a fairly decentralized operation, with the engine, chassis and gearbox being manufactured at another of David Brown's factories at Farsley near Huddersfield in Yorkshire. That same year Brown purchased the Newport Pagnell bodywork factory Tickford Motor Bodies, which to this day remains the headquarters of Aston Martin Lagonda Limited. This piece of real estate had a long history, having started life in 1820 as the premises of the firm of Salmon & Sons, which enjoyed the grand title of "Coachbuilders to the Nobility". During the Second World War Tickford's manager Ian Boswell was company boss, and from 1951 onwards Lagonda counted among their clients.

In 1957 the DB Mark III was launched as the successor to the highly successful DB2-4 Mark II. Though designated somewhat confusingly Aston Martin products were in the meantime attracting a growing band of devotees. The disc brakes of the Mark III, now prevailingly manufactured in Newport Pagnell, betrayed its closeness to the racing car. The model helped its makers to weather another crisis during the long wait for the DB4, the car with which Aston Martin was finally to make the grade and gain access to the highly exclusive club of supercar manufacturers. In the meantime, the bad news for Aston Martin was that David Brown's most beautiful daughter was

Grundkonzepts die Nachfolge des DB2-4 Mark II an. Mit der konfusen Namensgebung für ihre Lieblinge findet sich eine wachsende Schar von bekennenden Aston-Martin-Jüngern gerne ab. Die Nähe zum Rennwagen verraten die Scheibenbremsen des Mark III, der bereits überwiegend in Newport Pagnell hergestellt wird. Das Modell hilft seinen Machern, eine weitere Krise zu überdauern. Noch lässt der DB4 auf sich warten, mit dem sich Aston Martin endgültig den Zugang zu der kleinen, aber feinen Loge der Hersteller von Supersportwagen verschaffen wird. Schlimmer noch: David Browns schönste Tochter entpuppt sich als rechtes Sorgenkind und macht hartnäckig Schulden. Man zieht sogar in Erwägung, den Betrieb eine Zeit lang auf die bloße Wartung und Pflege der vorhandenen Aston Martin umzustellen. John Wyer, mild säuselnder Verkaufsrhetorik gänzlich unkundig, wird gar auf eine Promotion-Tour durch die Vereinigten Staaten, Kanada, Australien und Neuseeland geschickt. Er bringt sie mit Bravour hinter sich, abgesehen von drei Tagen bei Windstärke zehn auf der *Queen Mary*. »Gewinnt in Le Mans, und wir verkaufen ein paar von euren Autos«, gibt ihm Kjell Qvale mit auf den Weg, Aston-Martin-Händler in San Francisco. So kommt es in der Tat.

Nach einer Inkubationszeit von vier Jahren macht der DB4 schließlich auf der London Motor Show 1958 seine Aufwartung, eine wirkliche Novität. Die Carrozzeria Touring im fernen Mailand hat ihn mit mediterranem Charme in Maßkonfektion gewandet über einem Plattform-Chassis, das vom Reißbrett von Harold Beach stammt. Für die Maschine, einen Sechszylinder von 3,7 Litern aus Aluminium, zeichnet der Exilpole Tadek Marek verantwortlich. Eine Variante des DB4-Fahrwerks steckt unter dem Aufbau des Lagonda Rapide, der zwischen 1961 und 1964 den Mythos Lagonda am Leben erhält. Ein anderer Mythos wird 1963 erst einmal zu Grabe getragen: dass das Charisma der Marke Aston Martin vor allem durch Erfolge im Sport gespeist

1 000 Kilomètres du Nürburgring en 1959, a coûté très précisément 558 livres.

Entre-temps, les voitures de course et les Grand Tourisme sont devenues deux espèces bien distinctes. La DB2/4, introduite en 1953, est déjà un modèle susceptible d'intéresser un père de famille sportif. Elle lui permet de transporter sur de minuscules sièges d'appoint deux petits enfants qui ne doivent toutefois pas grandir trop vite. La carrosserie est fabriquée chez H. J. Mulliner, à Birmingham. Durant l'été 1954, la cylindrée du moteur est majorée à 2,9 litres. Les deux marques affichent maintenant comme domicile Hanworth Park, Feltham. Pour le reste, on s'engage avec modération dans la décentralisation: moteurs, châssis et trains roulants proviennent d'une autre usine de David Brown, à Farsley, à proximité de Huddersfield, dans le Yorkshire. La même année, Brown rachète le carrossier Tickford Motor Bodies; aujourd'hui encore, le siège d'Aston Martin Lagonda Limited est installé dans cette propriété, où l'histoire est omniprésente. Le terrain appartenait, en effet (depuis 1820), à la société Salmon & Sons, qui se parait de l'épithète «Coachbuilders to the Nobility». Pendant la Seconde Guerre mondiale, Ian Boswell, le manager de Tickford, préside aux destinées de la firme parmi les clients de laquelle figure aussi, depuis 1951, Lagonda.

En 1957, la DB Mark III, nouvel avatar d'un concept original couronné de succès, reprend le flambeau de la DB2-4 Mark II. Les adeptes d'Aston Martin sont de plus en plus nombreux malgré la confusion des genres qui règne dans la dénomination des modèles. Les freins à disques de la Mark III, fabriquée essentiellement à Newport Pagnell, trahissent la parenté avec la voiture de course. Le succès de ce modèle aide ses créateurs à surmonter une autre crise. Pour l'instant, on attend encore la DB4 qui permettra à Aston Martin d'accéder définitivement au club fermé des constructeurs de voitures de sport. Mais il y a plus grave: la plus

proving to be a problem child, causing the company to run up major debts. Serious consideration was even given to suspending production and confining operations to the repair and maintenance of existing stocks of Aston Martins. John Wyer, hardly a master of mellifluous sales rhetoric, was even sent on a promotional tour of the USA, Canada, Australia and New Zealand. He accomplished the chore with some style, apart from three days on the *Queen Mary* spent enduring a force ten storm. Aston Martin's San Francisco dealer Kjell Qvale sent him on his way with the words "We'll buy a few of your cars if you win at Le Mans". And that's just what they did. After an incubation period of four years the DB4 finally took its bow at the 1958 London Motor Show, a genuine novelty. Carrozzeria Touring of Milan had given the body a hefty dose of made-to-measure Mediterranean charm. It surmounted a platform chassis designed by Harold Beach, while the engine, a six-cylinder 3.7 liter aluminum affair, was the work of Polish émigré Tadek Marek. A variant of the DB4 running gear was also to be found concealed under the bodywork of the Lagonda Rapide, which kept the historic Lagonda name alive between 1961 and 1964. In contrast, a time-honored aspect of the company philosophy was laid to rest in 1963: the central tenet that the mystique of the

wird. Natürlich geschieht das mit Stil: Bei der Coppa Inter-Europa, einem Drei-Stunden-Rennen im Rahmenprogramm des Gran Premio d'Italia in Monza, wächst Werkspilot Roy Salvadori am Lenkrad eines sorgfältig vorbereiteten DB4GT über sich selbst hinaus und schlägt Mike Parkes im Ferrari 250 GTO, gegen den damals normalerweise kein Kraut gewachsen ist. Dritter wird der Belgier Lucien Bianchi in einem weiteren Aston Martin. Die volle Aufmerksamkeit seiner Mitarbeiter, so ein Machtwort von David Brown, gebühre von nun an den Produktionswagen. Im Oktober jenes Jahres löst der DB5 seinen allgemein wohlgelittenen Vorgänger ab, einen Vierliter, der auch mit einer Automatik mit drei Fahrstufen an Stelle des üblichen manuell zu schaltenden Fünfgang-Getriebes zu haben ist. Den immer dringlicheren Anfragen aus aller Welt begegnet man mit der Verdoppelung der Produktion. Eines aus der Menge der 1021 produzierten Exemplare bringt es zu Weltruhm: der Streifenwagen des im Auftrag Ihrer Majestät minnenden und meuchelnden Superagenten James Bond in den beiden Fleming-Epen *Goldfinger* und *Feuerball*. Das rasende Requisit ist ausgestattet mit mancherlei militantem Sonderzubehör, das Bonds unglückseligen Verfolgern das Leben schwer und das Sterben einfach machen soll. Nur zwei Jahre später stellt man den DB6 vor, des-

jolie des filles de David Brown ne cesse de contracter des dettes et provoque un désastre financier. La firme envisage même, un certain temps, de se consacrer exclusivement à l'entretien des Aston Martin existantes. John Wyer, qui n'a pourtant rien d'un brillant vendeur, est même envoyé pour une tournée de promotion à travers les États-Unis, le Canada, l'Australie et la Nouvelle-Zélande. Il accomplit sa tâche avec courage, et il lui en faut avec une tempête qui ébranle pendant trois jours le *Queen Mary*. « Gagnez au Mans, cela nous fera vendre quelques-unes de vos voitures », lui conseille Kjell Qvale, un concessionaire Aston Martin de San Francisco. Et c'est ce qui va se passer.

Après une période d'incubation de quatre ans, la DB4 fait finalement son apparition au London Motor Show de 1958. C'est une authentique nouveauté. La Carrozzeria Touring, à Milan, la vêt d'une robe au charme tout méditerranéen qui habille un châssis à plate-forme dessiné par Harold Beach. Le moteur, un six-cylindres en ligne en aluminium de 3,7 litres, est l'œuvre d'un Polonais exilé, Tadek Marek. Une variante du châssis de la DB4 se dissimule sous la carrosserie de la Lagonda Rapide et maintient en vie le mythe Lagonda entre 1961 et 1964.

Un autre mythe disparaît en 1963, selon lequel le succès de la marque Aston Martin devrait être nourri par les succès remportés lors des courses automobiles. Lors de la Coppa Inter-Europa, une course de trois heures organisée en lever de rideau du Gran Premio d'Italia, à Monza, le pilote officiel Roy Salvadori, au volant d'une DB4GT minutieusement préparée, se surpasse et bat Mike Parkes dans sa Ferrari 250 GTO, voiture à cette époque pourtant réputée absolument imbattable. Le troisième est le Belge Lucien Bianchi, au volant d'une autre Aston Martin. Mais toute l'attention du personnel doit désormais se porter sur les voitures de série, tel est le mot d'ordre donné par David Brown. En octobre de cette année-là, la DB5 succède à sa devancière si appréciée. Il s'agit d'une 4-litres, disponible également avec une boîte automatique à trois rapports au lieu de la boîte manuelle conventionnelle à cinq vitesses. La demande du monde entier augmente en permanence et l'on doit doubler la production.

L'un des 1021 exemplaires produits deviendra mondialement célèbre, en tant que voiture de l'illustrissime agent secret James Bond dans les deux épopées de Ian Fleming, *Goldfinger* et *Opération tonnerre*. Véritable forteresse roulante, elle est équipée d'innombrables accessoires issus en droite ligne d'un arsenal militaire et destinés à compliquer la vie, ou plutôt à faciliter la mort, des malheureux poursuivants de l'agent 007. Deux ans plus tard seulement, elle est remplacée par la DB6, dont la version la plus évoluée, la MkII, sera commercialisée de 1967 à 1970. Avec sa version cabriolet baptisée Volante, Aston se

Had it been mass-produced, James Bond's DB5 of Goldfinger fame would surely have found enough buyers. Its special fittings made it the ultimate mode of transport for aggressive driving: Browning machine guns behind the front sidelights, extendable bumpers for ramming purposes, tire slashers, bullet-proof shield, and the rear lights hold oil and nails with which to greet pursuant vehicles.

Wäre er in einer kleinen Serie aufgelegt worden, hätten sich für James Bonds DB5 in dem Streifen Goldfinger gewiss genügend Käufer gefunden. Seine Sonderausrüstung empfahl ihn als ultimatives Transportmittel für den offensiven Fahrer, Browning-Maschinengewehre hinter den Blinkern und verchromte Rammstoßstangen, hinten Reifenschlitzer, Kugelfang, die Rücklichter als Behältnisse für Öl und Dreikantnägel als Gruß an nachfolgende Fahrzeuge.

Construite en série confidentielle, la DB5, réalisée spécialement pour James Bond et le film Goldfinger, aurait certainement trouvé suffisamment d'acheteurs si elle avait été fabriquée en série. Ses équipements spéciaux en auraient fait le moyen de locomotion idéal pour le conducteur agressif: mitrailleuse Browning derrière les clignotants et pare-chocs chromés avec cornes extractibles, « ouvre-boîtes » pour découper les pneus à l'arrière, panneau pare-balles, feux arrière dissimulant des dispositifs de projection d'huile et de clous à trois têtes pour se débarrasser des poursuivants.

THE CONTROL PANEL
The main control console is concealed beneath the armrest between the two front seats. These controls link up with a number of different mechanisms set out below:

DEFENSIVE MECHANISMS
Twin Browning Machine Guns are fitted behind the cars front sidelights. The pressing of the console switch makes the lights hinge forward and fires the guns.

At the back of the car, the nearside lamp cluster hinges back and a hydraulic mechanism ejects oil onto the road.

The offside lamp cluster ejects nails specially designed so that no matter how they fall on the road, spikes always project upwards.

A miniature revolving cutter extends 24" out from the nearside wheel hub, revolving in the opposite direction to the wheel spin. Designed to cut through the tyres of opposition cars. Front and rear bumper extend hydraulically about 18" for ramming purposes.

Operated by a hydraulic ram, a bullet-proof steel plate (profiled to the exact contour of the luggage boot) can be raised to cover completely the rear window.

Aston Martin marque had to be fueled by motorsport success. Naturally, though, they went out in style. At the Coppa Inter-Europa, a three-hour race on the occasion of the Italian Grand Prix at Monza, works driver Roy Salvadori drove out of his skin behind the wheel of his carefully prepared DB4GT to defeat Mike Parkes in the Ferrari 250 GTO, normally an unstoppable force at that time. The Belgian Lucien Bianchi came third in another Aston Martin. Thereafter, though, word came down from David Brown that full attention was to be given to the development of the production cars. In October that year the DB5 replaced its much esteemed predecessor. It was powered by a four liter engine and was also available with an automatic transmission with three drive positions as an alternative to the usual five-speed manual gearbox. Production doubled in response to ever increasing demand from all around the world. One of the 1021 DB5s to be produced was destined for especial fame as the car of choice of the man with the license to kill, super-spy James Bond, in two of the early Bond films, *Goldfinger* and *Thunderball*. Bond's version, of course, was fitted with some unusual accessories in the form of military hardware which made life difficult, and normally short, for his hapless pursuers. Just two years later came the launch of the DB6, Mark II of which remained on the market until 1970. The associated cabriolet, the Volante, broke new ground, its convertible top being the first on a European car to open and close automatically, albeit with a mechanism that creaked and groaned somewhat.
While the models DB4 to DB6 had gradually varied and developed a single design concept, the DBS, launched in 1967, broke new stylistic ground. Being entrusted with that ambitious objective, in-house Aston Martin designer William Towns threw the Italian tradition overboard, as it were. At first the preexisting straight six engine cowered in embarrassment in the wide open spaces beneath the hood of the capacious engine compartment, which had been designed to accommodate Tadek Marek's 5.3 liter V8 power unit. Unfortunately there had been neither enough time nor sufficient resources for the development of the new engine, thus this makeshift interim solution. In 1969 the new unit was finally ready, justifying a new name: the DBSV8. By 1971, however, the cold wind of economic change was blowing over the David Brown Corporation with increasing force. Changes in agricultural methods had led to plummeting demand for tractors, while at the same time Aston Martin Lagonda Limited's losses were running at a ruinous £1.2 million on a turnover of 3.2 million, and in 1972 the company was £450,000 in the red. It was time for David Brown to part company with what had originally been intended as a pleasurable sideline. He sold the firm for the token sum of £100 to Company Developments, a group of Birmingham-based businessmen. He himself remained on the board and became president of the company whose fate had been wound up with his own for so long.

sen Sublimationsstufe MkII bis 1970 am Markt bleibt. Mit dem dazugehörigen Cabriolet namens Volante betritt man entschlossen Neuland: Sein Verdeck – europäische Premiere – öffnet und schließt sich selbsttätig, wenn auch seufzend und knarrend.
Während die Modelle DB4 bis DB6 in sanfter Evolution ein formales Leitmotiv abwandeln und durchspielen, bricht Aston Martin mit dem DBS von 1967 zu neuen stilistischen Ufern auf. Das beginnt damit, dass man gleichsam die italienische Tradition über Bord wirft und mit der Einkleidung des Neuen einen eigenen Designer am Aston-Martin-Dienstort Newport Pagnell betraut: William Towns. Im voluminösen Motorenabteil des DBS kauert verschüchtert der bisherige Reihensechszylinder, eine Interimslösung. Denn noch sind Zeit und Budget nicht reif für Tadek Mareks V8 von 5,3 Litern, den es von Anbeginn an beherbergen sollte. Als Fahrzeug und Triebwerk 1969 schließlich miteinander vereint werden, rechtfertigt dies auch einen neuen Namen: DBSV8.
1971 indessen bläst der David Brown Corporation zunehmend ein kräftiger Gegenwind ins Gesicht. Der Bedarf an Traktoren stürzt auf Grund einer Neuorientierung der Landwirtschaft ab. Bei einem Umsatz von 3,2 Millionen Pfund belaufen sich die Verluste der Aston Martin Lagonda Limited auf jährlich 1,2 Millionen Pfund. 1972 ist man mit ruinösen 450 000 Pfund in den roten Zahlen; Zeit, abzustoßen, was ursprünglich eine vergnügliche Nebenbeschäftigung hatte sein sollen. Für den symbolischen Betrag von 100 Pfund verkauft Brown die Firma an die Company Developments, eine Gruppe von Geschäftsleuten mit dem Sitz Birmingham. Er selbst bleibt im Vorstand und wird Präsident des Unternehmens, dessen Geschicke so lange mit seinen eigenen verwoben waren.

lance avec courage sur des terres vierges: sa capote – une première européenne – s'ouvre et se ferme automatiquement, mais lentement et avec craquements.
Alors que les versions DB4 et DB6 déclinent avec bonheur les différentes versions d'un même concept esthétique, Aston Martin rompt totalement avec la tradition pour la DBS de 1967. Cela commence par l'abandon brutal de la tradition italienne et la décision de confier la mission d'habiller la nouvelle voiture à un designer maison, en fonctions à Newport Pagnell, le siège d'Aston Martin: William Towns. L'ancien six-cylindres en ligne, une solution provisoire, semble complètement perdu dans le vaste compartiment moteur de la DBS. En effet, le temps et l'argent n'ont pas suffi pour y installer le V8 de 5,3 litres de Tadek Marek prévu au départ. Lorsque la voiture et son moteur sont enfin mariés, en 1969, cela justifie le nouveau nom de DBSV8.
En 1971, la David Brown Corporation est confrontée à une tempête économique. En raison de la réorientation de l'agriculture, on a de moins en moins besoin de tracteurs. Pour un chiffre d'affaires de 3,2 millions de livres, les pertes annuelles de la société Aston Martin Lagonda Limited s'élèvent à 1,2 million de livres. En 1972, le déficit, impossible à combler, est de 450 000 livres; il est temps de se débarrasser de ce qui était supposé demeurer une activité secondaire et divertissante. Pour la somme symbolique de 100 livres, David Brown vend la firme à la Company Developments, un groupe d'hommes d'affaires qui a son siège à Birmingham. Lui-même reste au directoire et devient président de la société dont le destin a été si longtemps intimement mêlé au sien.

Officially-sanctioned destruction of a DBS against 200 tons of concrete on the M.I.R.A. site. The date is Friday 13 September 1968. The USA is an important market.

Behördlich vorgeschriebene Zerstörung eines DBS gegen 200 Tonnen Beton auf dem Gelände der M.I.R.A. Der Tag ist Freitag, der 13. September 1968. Die Vereinigten Staaten sind ein wichtiger Markt.

Ainsi en ont décidé les autorités: destruction d'une DBS contre un bloc de 200 tonnes de béton au centre d'essais de la M.I.R.A. (Motor Industry Research Association). Nous sommes le vendredi 13 septembre 1968. Marché important, les États-Unis dictent leur loi.

Blast from the past: John Wyer (right) with Victor Gauntlett at the beginning of the eighties…

Gesichter aus der Vergangenheit: John Wyer (rechts) mit Victor Gauntlett Anfang der Achtziger…

Visages du passé: John Wyer (à droite) avec Victor Gauntlett au début des années 1980…

The art of survival

How ownership of Aston Martin Lagonda passed from hand to hand during the wilderness years from 1972 to 1987

The new chairman William Willson vowed not to meddle with the company philosophy or model policies. The early signs were promising. After a six-week suspension of production, his "effective quality control systems" began to take effect. The workforce was streamlined. Brown's venerable initials DB disappeared from the type designations without replacement and also, more slowly, from the consciousness of the marque's band of devotees. In May 1972 modified versions of the previous ranges appeared in the form of the six-cylinder Aston Martin Vantage with the more powerful Vantage engine and the Aston Martin V8. Two large headlamps now replaced the four smaller lights of the previous design, the waistline was lowered and the spare wheel was fitted horizontally to the floor of the trunk. As part of a rigorous test program with the goal of regaining a foothold on the North American market after two years absence, the engineers also had to cast their eye to the past, and from June 1973 onwards the V8 engine was fed by four Weber downdraft carburetors rather than the previous Bosch fuel injection, in order to comply with the strict exhaust emission laws in place in the US. The room needed for that layout was created by a hefty bulge in the hood. Apart from this the figures tell their own story, with a total of no less than 2750 modifications to design details.

All this proved hugely expensive, and to cap it all the real estate company which had been the main source of income for Company Developments was on the rocks. As a result Aston Martin, after all a flagship British manufacturer, hit the headlines during the October 1974 general election campaign when the company turned to the Wilson government in search of state aid. The effects of this move were disastrous, as creditors and suppliers alike took fright, and by the end of the year production had once again been suspended. On 30th December that year Aston Martin was declared insolvent by Company Developments Limited and William Willson appointed an administrator. Many observers, naturally including a gleeful press, solemnly pronounced that the death knell was finally tolling for the high-class smithy in Newport Pagnell.

However, as on earlier occasions, help was at hand for the company in its hour of need, and once again it was a group of enthusiasts who chose to keep the idea alive and bear the Aston Martin torch into the future. The new men to take over the company on 27th June 1975 were George Minden, a Canadian restaurateur and Rolls-Royce dealer, and Peter Sprague, a young American specializing in the rescue of ailing companies. The two had never met before, but they both shared the same passion for Aston Martin. Symbolically enough, production resumed precisely nine months

Liebe Last, oder die Kunst zu überleben

Wie Aston Martin Lagonda in den schweren Jahren zwischen 1972 und 1987 von Hand zu Hand geht

Der neue Vorsitzende William Willson gelobt, Markenphilosophie und Modellpolitik nach bestem Wissen und Gewissen unangetastet zu lassen. Die Vorzeichen, so scheint es, stehen gut. Nach sechs Wochen Produktionsstopp greifen die »effective quality control systems« der neuen Eigner. Die Belegschaft wird verschlankt, das symbol- und sinnträchtige Kürzel DB verschwindet ersatzlos aus den Typen-Sigeln und allmählich sogar aus dem Bewusstsein der verschworenen Marken-Gemeinde. Im Mai 1972 erscheinen modifizierte Versionen der bisherigen Baureihen, der Sechszylinder Aston Martin Vantage mit dem kräftigeren Vantage-Triebwerk und der Aston Martin V8. Zwei große Lampen ersetzen von nun an die bisherigen vier kleinen Scheinwerfer, die Gürtellinie wurde abgesenkt, das Reserverad lagert horizontal am Boden des Kofferraums. Im Zuge eines rigorosen Testprogramms mit dem Ziel, nach zwei Jahren Pause erneut am nordamerikanischen Markt Fuß zu fassen, richten sich die Visionen plötzlich auch nach hinten: Ab Juni 1973 wird der V8 als Konzession an die strikten Emissionsgesetze in den Vereinigten Staaten durch vier Weber-Fallstromvergaser anstelle der Bosch-Einspritzung gefüttert. Die nötige Kopffreiheit für den Motor gewinnt man durch eine mächtige Erhebung auf der Haube. Im Übrigen fasst man Fortschritt stolz in Zahlen: Zu diesem massiven Eingriff gesellen sich 2750 Retuschen am Detail.

All dies erweist sich als ungemein kostenträchtig und überdies wird das Immobiliengeschäft als tragende Säule im Einkommen der Company Developments brüchig. Im Oktober 1974 gerät die britische Parade-Manufaktur Aston Martin mitten im Wahlkampf in die Schlagzeilen: Man habe sich an die Regierung Wilson gewendet mit der Bitte um eine staatliche Beihilfe. Die Signalwirkung dieser Botschaft ist fatal und vergrämt Schuldner wie Zulieferanten. Gegen Ende des Jahres kommt die Fertigung ein weiteres Mal zum Stillstand. Am 30. Dezember wird Aston Martin von der Company Developments Limited für zahlungsunfähig erklärt und William Willson ernennt einen Konkursverwalter. Viele Beobachter, nicht zuletzt eine hämische Presse, mutmaßen düster, nun bimmle endgültig das Sterbeglöcklein für die Luxusschmiede in Newport Pagnell.

Wie stets in ihrer bewegten Vita jedoch finden sich an dieser Gelenkstelle Helfer, und wie immer sind es Enthusiasten, die wie eine Stafette ein Gut und eine Idee in die Zukunft tragen, die zu erhalten sich lohnt. Mit Unterschrift vom 27. Juni 1975 übernehmen neue Männer die schönen Reste: der kanadische Restaurantbesitzer und Rolls-Royce-Dealer George Minden und Peter Sprague, ein junger Amerikaner, der sich auf die Sanierung kränkelnder Betriebe spezialisiert hat. Die beiden kannten einander vorher nicht. Zusammen führte sie die gemeinsame Passion.

Le poids de l'amour, ou l'art de survivre

Comment Aston Martin Lagonda passe de main en main durant les années difficiles de 1972 à 1987

Le nouveau président, William Willson, fait serment de conserver leur intégrité à la philosophie de la marque et à la politique de modèles. Tout semble s'annoncer plutôt bien. Après six semaines d'interruption de la production, les contrôles qualité (« effective quality control systems ») du nouveau propriétaire commencent à se faire sentir. Les effectifs sont revus à la baisse tandis que la symbolique abréviation DB disparaît des noms et même, peu à peu, de la conscience des fans les plus intégristes. En mai 1972 apparaissent des versions modifiées des gammes précédentes, la six-cylindres Aston Martin Vantage avec le moteur plus puissant de la Vantage et l'Aston Martin V8. Deux gros phares remplacent désormais les quatre anciens petits phares, la ligne de ceinture est abaissée et la roue de secours est placée à l'horizontale au fond du coffre. Dans le contexte d'un sévère programme d'essais qui a pour objectif d'exporter de nouveau la marque sur le marché nord-américain après deux années d'interruption, en juin 1973, une concession est faite aux sévères lois de lutte contre la pollution aux États-Unis et la V8 est équipée de quatre carburateurs Weber inversés à la place de l'injection Bosch. Mais cela impose d'aménager un impressionnant bossage sur le capot pour pouvoir loger le moteur. Pour le reste, les modifications se traduisent aussi par des chiffres : cette profonde remise au goût du jour va de pair avec 2750 retouches de détail.

Tout cela s'avère extrêmement coûteux alors même que les affaires immobilières, principales sources de revenus de la Company Developments, se dégradent elles aussi. En octobre 1974, au plus fort de la campagne électorale, la manufacture de prestige britannique Aston Martin fait les gros titres des journaux : ses managers sont allés mendier des subventions au gouvernement Wilson. Cette information a un effet très néfaste et fait fuir aussi bien les débiteurs que les fournisseurs. Tant et si bien que, vers la fin de l'année, la fabrication est interrompue une nouvelle fois. Le 30 décembre, la Company Developments Limited déclare Aston Martin en faillite et William Willson nomme un syndic. Beaucoup d'observateurs, et surtout la presse, qui en fait des gorges chaudes, s'attendent avec pessimisme à voir définitivement sonner le glas de la manufacture de voitures de luxe de Newport Pagnell.

Comme par le passé, des Saint-Bernard se manifestent en la personne d'enthousiastes cherchant à sauvegarder une idée et une philosophie. Avec la signature du contrat, le 27 juin 1975, les deux hommes qui reprennent l'affaire en main sont George Minden, un Canadien propriétaire de restaurant et de Rolls-Royce et Peter Sprague, un Américain qui s'est spécialisé dans le sauvetage d'entreprises à l'agonie. Réunis par leur passion commune, les deux hommes ne se connaissaient pas auparavant. Neuf mois – quel

later, at a rate of five cars per week. In the meantime the pair who had presided over the first stages of the company's rebirth had been joined by two British businessmen. One was Denis Flather, head of a Sheffield steel business, and the other was the keen flyer Alan Curtis, who had hitherto earned his crust in the real estate business. Flather largely remained in the background, while Curtis dealt with the business side, and Sprague and Minden were responsible for technical questions. On the psychological side, too, there was work to be done: the name of Aston Martin had fallen into disrepute, the old mystique had become tarnished. The spirit of the new era was presented at the 1976 London Motor Show in the form of a four-door Lagonda with an increased wheelbase, but otherwise featuring much the same mechanical components as before. Its fresh and decidedly futuristic lines were once again the work of William Towns. The following year came the powerful Aston Martin V8 Vantage, which stood at the top of the hierarchy of two-door eight cylinder models. In June 1978 this was joined by a convertible version, the Volante, which was available in a standard version like the coupé, reworked from October onwards and offering extra luxury and finesse. Hopes were high that it would help Aston Martin reconquer lost markets. The Lagonda promise did not materialize until 1980, when the model that had been presented four years earlier at Earls Court finally went into production. The ambitious "Bulldog" project, on the other hand, was destined to suffer the sorry fate of remaining a one-off concept car. Presented in March 1980, it was intended as a demonstration of the company's technical skills and innovative daring. The body design was once again the work of freelance stylist William Towns, whose deft pen had produced lines of breathtaking simplicity, an uncompromising wedge bereft of any irrelevant flourishes or curlicues. The power output of the centrally mounted engine was boosted to an impressive 580 horsepower by the two turbochargers, while the doors opened upwards in the style of its Italian and German counterparts. Like the Lagonda, the Bulldog bowed to what was to prove a passing fad by introducing a dashboard populated with digital instruments, an innovation greeted by some as a welcome and forward-looking step, but reviled by others as a tacky Mickey Mouse gimmick. However, the world economy is a fickle mistress: the economic downturn at the end of the 70s and early 80s meant that the useless aristocrats of the upper automobile price segment were facing a hostile environment, as carefully calculating family men condemned them as the epitome of frivolity. The four-man rescue team began to disintegrate, the last to desert being Peter Sprague and Alan Curtis in 1980, having by then wearied of wasting money on the risk-laden Aston Martin venture. This time the changing of the guard was a smooth and efficient process: Victor Gauntlett and Tim Hearley had already invested heavily in Aston Martin earlier that year, gaining themselves places and

Sinnfällige neun Monate verstreichen, ehe man mit fünf Autos pro Woche die Produktion wieder aufnimmt. Inzwischen hat sich das Duo der ersten Stunde nach der Wiedergeburt zum Führungskollektiv erweitert. Dazugestoßen sind die beiden Briten Denis Flather, Chef einer Stahlfirma in Sheffield, und der begeisterte Flieger Alan Curtis, der Brot und Bier bislang mit einer Immobiliengesellschaft verdiente. Flather bleibt eher im Hintergrund, Curtis kümmert sich um die geschäftliche Seite, während sich Sprague und Minden technischen Aspekten zuwenden. Auch psychologisch gibt es manches aufzuarbeiten: Aston Martin ist ins Gerede geraten, der Mythos trägt Beulen und Blessuren. Vom Geist der neuen Zeit zeugt schon auf der London Motor Show 1976 ein viertüriger Lagonda mit größerem Radstand, in dem im Übrigen die bekannten mechanischen Komponenten eingebracht worden sind. Die frische und entschieden futuristisch anmutende Linienführung entstand wiederum auf dem Reißbrett von Williams Towns. Im folgenden Jahr krönt die Muskel-Variante Aston Martin V8 Vantage die Hierarchie der zweitürigen Achtzylinder. Sie erhalten im Juni 1978 Zuwachs in Gestalt der offenen Version Volante, in Standardausführung ebenso wie das überarbeitete Coupé, das ab Oktober mehr Luxus und Raffinesse bietet und damit verlorene Bastionen zurückerobern soll. Das Versprechen Lagonda wird erst 1980 eingelöst, als das Exponat, das vier Jahre zuvor in Earls Court vorgestellt worden ist, schließlich in die Produktion geht. Zum tristen Dasein eines Unikats verdammt ist indessen das Vorzeigeprojekt »Bulldog«, mit dem man nach zwei Jahren Vorarbeit im März 1980 Kompetenz und Mut zur Innovation unter Beweis stellen möchte. Für die visuelle Umsetzung der Sensation ist wie üblich der inzwischen freischaffende Formkünstler William Towns zuständig. Er hat mit kühnen Strichen eine Silhouette von bemerkenswerter Schlichtheit gezeichnet, einen konsequenten Keil ohne Schnörkel und Schnickschnack. Das Triebwerk, von zwei Turboladern zu 580 PS beflügelt, verrichtet mittschiffs seine eindrucksvolle Arbeit. Die Türen öffnen sich wie bei italienischen und deutschen Vorbildern himmelwärts. Eine Verneigung vor einer eher flüchtigen Mode stellt, wie im Lagonda, die digital besiedelte Instrumententafel dar, entweder als Indiz für wahren Fortschritt willkommen geheißen oder aber als Mäusekino geschmäht. Doch die Weltwirtschaft ist eine launische Diva. Und so finden aristokratisch-nutzlose Automobile im oberen Preissegment Ende der Siebziger ein feindseliges Umfeld vor, von pingelig kalkulierenden Familienvätern als Ausgeburten der Unvernunft gebrandmarkt. Die Quadriga der Samariter beginnt zu bröckeln. Als Letzte gehen 1980 Peter Sprague und Alan Curtis von Bord, des Wagnisses Aston Martin überdrüssig. Diesmal vollzieht sich der Wachwechsel in fließendem Übergang: Schon früh in jenem Jahr haben sich Victor Gauntlett und Tim Hearley massiv in Newport Pagnell eingekauft und sich damit Sitz und Stimme im Vorstand verschafft.

symbole! – s'écoulent avant que l'on ne reprenne la production au rythme de cinq voitures par semaine. Entre-temps, le tandem qui a présidé à la renaissance s'est étendu en un collectif de direction. Les deux hommes ont été rejoints par deux Britanniques, Denis Flather, chef d'une firme sidérurgique de Sheffield, et Alan Curtis, aviateur passionné qui gagnait jusqu'ici son pain – et sa bière – en dirigeant une société immobilière. Flather œuvre plutôt en coulisse tandis que Curtis se charge des questions économiques et que Sprague et Minden se consacrent aux aspects techniques. Sur le plan psychologique, aussi, il y a du pain sur la planche : Aston Martin essuie de nombreuses critiques et le mythe est entaché. Au London Motor Show de 1976, déjà, une Lagonda à quatre portes et empattement long qui reprend, pour le reste, des composants mécaniques bien connus fait souffler un vent de nouveauté. Les lignes fraîches et résolument futuristes sont, une fois de plus, l'œuvre de William Towns. L'année suivante, la version « musclée » de l'Aston Martin V8, la Vantage, vient couronner la hiérarchie des huit-cylindres à deux

... and "our Bert" Bertelli (left) in conversation with William Willson during an open day at Newport Pagnell in 1974.

... und »Our Bert« Bertelli (links) 1974 im Gespräch mit William Willson während eines Tages der offenen Tür in Newport Pagnell.

... et « Notre Bert » Bertelli (à gauche) en 1974, en conversation avec William Willson durant une journée portes ouvertes à Newport Pagnell.

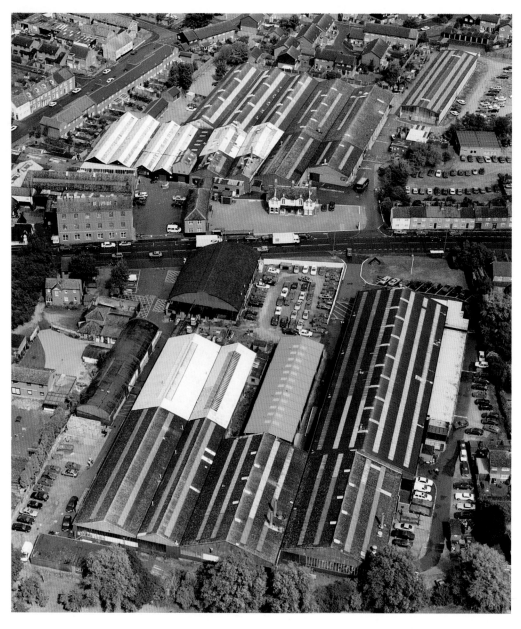

The factory in Newport Pagnell straddling the busy Tickford Street.

Das Werksgelände in Newport Pagnell beiderseits der viel befahrenen Tickford Street.

Les bâtiments de l'usine de Newport Pagnell, des deux côtés de la rue à grande circulation qu'est Tickford Street.

influence on the board. Hearley was owner of C. H. Industrials, a supplier of parts to the car industry, while ex-RAF pilot Gauntlett, as the boss of the private company Pace Petroleum also, in the broadest sense, had a background in the automobile sector. Over Christmas 1980 Gauntlett, now chairman of Aston Martin Lagonda Limited, started to take matters in hand. After the takeover was formalized in January 1981, he embarked on extensive travels on behalf of Aston Martin and Lagonda, taking him to such potential markets as Japan and the Near East. An unconventional thinker, he used sponsorship money from Pace Petroleum to set up a classic Aston Martin race at the Dubai Grand Prix Meeting in December 1981 on the occasion of the celebration of the 20th

Hearleys C. H. Industrials sind Zulieferer der Autoindustrie. Der frühere R.A.F.-Pilot Gauntlett kommt als Boss des Privatunternehmens Pace Petroleum ebenfalls im weitesten Sinne aus der Branche. Schon während der Weihnachtsferien 1980 nimmt er als Vorsitzender der Aston Martin Lagonda Limited die Dinge in die Hand. Eine weitläufige Reisetätigkeit in Sachen Aston Martin und Lagonda führt ihn nach vollzogener Übernahme im Januar 1981 an solch potenzielle Märkte wie Japan und den Nahen Osten. Auch sonst von unkonventioneller Denkungsart, ermöglicht er mit Sponsorgeldern von Pace Petroleum ein historisches Aston-Martin-Rennen beim Dubai Grand Prix Meeting im Dezember 1981 anlässlich der Feiern zum zehnten Jahrestag der Vereinigten Emirate. Eine andere

portes. Elles sont rejointes, en juin 1978, par une version décapotable baptisée Volante, en exécution standard, ainsi que par le coupé réétudié qui, à partir d'octobre, propose encore plus de luxe et de raffinement. La promesse de la Lagonda n'est tenue qu'en 1980 lorsque le prototype dévoilé quatre ans auparavant à Earls Court commence enfin à être produit. Le prototype de salon « Bulldog », présenté en mars 1980 après deux années de travaux et qui devait faire la preuve des compétences techniques ainsi que des capacités d'inno vation de l'entreprise, va en revanche connaître le triste destin de nombreux spécimens uniques. Une fois de plus, c'est William Towns, entre-temps devenu designer indépendant, qui est responsable de la ligne du véhicule. D'un coup de crayon téméraire, il a dessiné une silhouette d'une sobriété ascétique, aux lignes cunéiformes, sans fioritures ni détails superflus. Le moteur, en position centrale arrière, est gavé par deux turbocompresseurs qui lui permettent de développer 580 ch. À l'instar de ses inspiratrices d'origine italienne et allemande, les portes s'ouvrent en ailes de mouette. Comme dans la Lagonda, le tableau de bord, le dernier cri en matière d'affichage à cristaux liquides et de cadrans numériques, est une concession à une mode plutôt éphémère que certains verront comme un signe de véritable progrès et d'autres comme un simple gadget. Mais le cours de l'économie mondiale est imprévisible. Et, à la fin des années 1970, les automobiles de luxe sont confrontées à un environnement hostile, condamnées par les bons pères de famille comme le summum de la déraison. La cohésion commence à s'effriter au sein du quatuor de bons samaritains. Les derniers à quitter le navire seront, en 1980, Peter Sprague et Alan Curtis, définitivement lassés par l'aventure Aston Martin.

Cette fois-ci, la transition s'effectue sans douleur : très tôt déjà, cette année-là, Victor Gauntlett et Tim Hearley avaient massivement investi à Newport Pagnell et, ainsi, s'étaient assuré sièges et voix au directoire. C. H. Industrials, la société de Tim Hearley, est un équipementier de l'industrie automobile. L'ancien pilote de la RAF Victor Gauntlett est, lui aussi, en tant que P.-D.G. de l'entreprise privée Pace Petroleum, un familier de ce secteur, mais dans un sens plus large. Dès les fêtes de Noël 1980, en tant que président d'Aston Martin Lagonda Limited, il prend les choses en main. La reprise est menée à terme en janvier 1981, ses voyages à travers le monde pour Aston Martin et Lagonda le conduisent vers des marchés potentiels comme le Japon et le Proche-Orient. Réputé pour ses idées anticonformistes, il permet l'organisation, grâce au sponsoring de Pace Petroleum, d'une course d'Aston Martin de collection au Dubai Grand Prix Meeting de décembre 1981, à l'occasion des cérémonies du dixième anniversaire des Émirats arabes unis. Un autre acquis dont Gauntlett est à l'origine et qu'il met en pratique est « l'usine à cerveaux » d'Aston Martin Tickford, à Milton Keynes. Elle réalise des exécutions spéciales pour l'industrie automobile telles que la Frazer Tickford Metro à l'équipement pléthorique et

anniversary of the founding of the United Arab Emirates. Another of Gauntlett's achievements was the Aston Martin Tickford concept factory in Milton Keynes, which carried out special orders for the motor industry such as the lavishly fitted Frazer Tickford Metro, the Lancia Hi-Fi and the Toyota Sunchaser.

Gauntlett also revived a tradition that had long lain fallow when in 1982 he reintroduced Aston Martin to motorsport via a joint venture with Nimrod Racing Automobiles. The venture was founded in tandem with Robin Hamilton, an Aston Martin dealer from Burton-on-Trent in Staffordshire and a true devotee of the marque. Aston Martin supplied the engines and provided Hamilton with additional material assistance and personnel. In their first year they achieved a highly respectable third place in Group C of the World Endurance Championship, while a Nimrod driven by privateers Mike Salmon and Ray Mallock came seventh in the fiftieth running of the Le Mans 24 hour race.

In July 1983 North American Aston Martin agents Automotive Investments purchased Pace Petroleum's 55% holding in Aston Martin, the remaining 45% staying in the hands of C.H. Industrials. However, Victor Gauntlett's position as chairman remained unaffected.

Thereafter things started happening thick and fast: after C.H. Industrials sold its holding to Automotive Investments, the latter became 100% owner of Aston Martin Lagonda for ten months of 1984, before Peter Livano, of the famous American shipping family, purchased three quarters of the shares, the remainder being taken up by Victor Gauntlett.

Through all these transactions the product itself had not been neglected, as the Vantage Zagato bore eloquent witness on its launch in March 1986 at the Geneva Motor Show as an answer to such illustrious rivals as the Ferrari 288 GTO. Gauntlett had drawn here on the old business connection with the brothers Elio and Gianni Zagato of Terrazzano di Rho which had first borne fruit a quarter century earlier in the form of the DB4GT Zagato. In price terms this new coproduction occupied a place just one rung below the very top of the automotive ladder, being wedged in between the GTO and the high-tech monster that was the Porsche 959. An open variety of the Vantage Zagato followed a year later. With a total production of just 35, the cabriolet was even more of a rarity than the solid roofed version, of which 50 were made. Two further events put the spotlight on the noble house from Newport Pagnell during 1987. Firstly, in *The Living Daylights* James Bond once again drove an Aston Martin. And in September light could finally be seen at the end of the tunnel, since an end to the years of financial turmoil beckoned as Ford took on Aston Martin, purchasing a 75% majority holding, the remainder of the shares being apportioned on a *pro rata* basis between the Livanos family and Victor Gauntlett. Once again continuity was ensured as Gauntlett retained his position as chairman.

Errungenschaft, die Gauntlett anstößt und in die Tat umsetzt, ist die Denkfabrik Aston Martin Tickford in Milton Keynes. Sie erledigt Sonderaufträge der Motorindustrie wie zum Beispiel den üppig ausgestatteten Frazer Tickford Metro, den Lancia Hi-Fi oder den Toyota Sunchaser.

Darüber hinaus nimmt Gauntlett eine Tradition wieder auf, die lange brachgelegen hat. 1982 meldet sich das Unternehmen im Rennsport durch ein Joint Venture mit Nimrod Racing Automobiles zurück, ins Leben gerufen gemeinsam mit Robin Hamilton, einem treuen Gefolgsmann der Marke und Aston-Martin-Händler in Burton-on-Trent in der Grafschaft Staffordshire. Das Werk liefert die Motoren und unterstützt Hamilton auch sonst materiell und personell. Im ersten Jahr belegt man einen achtbaren dritten Platz in der World Endurance Championship der Gruppe C und ein privat eingesetzter Nimrod unter der Mannschaft Mike Salmon und Ray Mallock wird bei der fünfzigsten Auflage des 24-Stunden-Rennens von Le Mans Siebter.

Im Juli 1983 ersteht die nordamerikanische Aston-Martin-Agentur Automotive Investments die Anteile von Pace Petroleum in Höhe von 55 Prozent, der Rest verbleibt im Besitz von C.H. Industrials. Die Position Victor Gauntletts als Vorsitzender wird gleichwohl nicht in Frage gestellt.

Dann überschlagen sich die Ereignisse: Automotive Investments kontrolliert Aston Martin Lagonda 1984 für zehn Monate zu hundert Prozent, nachdem C.H. Industrials ihre Anteile an den einstigen Partner abgestoßen haben. Anschließend übernehmen die renommierte amerikanische Reeder-Familie um Peter Livanos drei Viertel und Victor Gauntlett den Rest der Aktien.

Dass über all diesen Transaktionen das Produkt und damit die Haupt-Sache nicht zu kurz gekommen ist, dafür legt der Vantage Zagato ein beredtes Zeugnis ab, der im März 1986 in Genf als Antwort auf solche illustren Widersacher wie den Ferrari 288 GTO enthüllt wird. Mit ihm knüpft Gauntlett eine Geschäftsverbindung mit den Gebrüdern Elio und Gianni Zagato in Terrazzano di Rho an, die bereits ein Vierteljahrhundert zuvor erste Früchte mit dem DB4GT Zagato getragen hat. Auch preislich gesehen bezieht die neue Koproduktion ein Luxusappartement im automobilen Oberhaus: Sie ist zwischen dem GTO und dem High-Tech-Monster Porsche 959 angesiedelt. Mit dem entsprechenden Cabriolet sattelt man ein Jahr später noch einmal drauf. Mit einer Verbreitung von 35 Exemplaren bleibt es ein noch rarerer Artikel als die Festdach-Version mit 50. Zwei weitere Ereignisse rücken das noble Haus zu Newport Pagnell 1987 ins Rampenlicht: In *Der Hauch des Todes* fährt James Bond erneut Aston Martin. Und im September ist nach langer Reise auf stürmischer See endlich Land in Sicht, lockt Licht am Ende des Tunnels. Einem Zug der Zeit folgend, wird sich Ford des Problemfalls Aston Martin annehmen, mit einer satten Mehrheit von 75 Prozent. Den Rest teilen die Familie Livanos und Victor Gauntlett paritätisch untereinander auf. Gauntlett bleibt ein weiteres Mal im Amt.

luxueux, la Lancia Hi-Fi ou la Toyota Sunchaser.

Victor Gauntlett fait en outre revivre une tradition qui était longtemps restée sous l'éteignoir. En 1982, l'entreprise fête son retour à la compétition grâce à un joint-venture conclu avec Nimrod Racing Automobiles. Pour cela, il s'allie à Robin Hamilton, un fidèle parmi les fidèles de la marque et concessionnaire Aston Martin à Burton-on-Trent, dans le comté du Staffordshire. L'usine lui fournit les moteurs et vient aussi en aide à Hamilton sur le plan du matériel et du personnel. La première année, l'équipe termine à une respectable troisième place au championnat du monde d'endurance des voitures du groupe C et une Nimrod privée engagée par l'écurie de Mike Salmon et Ray Mallock termine septième à la cinquantième édition de la course des 24 Heures du Mans.

En juillet 1983, la filiale nord-américaine d'Aston Martin, Automotive Investments, reprend les parts de Pace Petroleum, qui représentent 55 %, le reste demeurant la propriété de C.H. Industrials. Cela ne remet pas pour autant en question la position de Victor Gauntlett comme président du directoire.

Puis les événements se précipitent : Automotive Investments contrôle pendant dix mois, en 1984, la totalité d'Aston Martin Lagonda après que C.H. Industrials a cédé ses parts à son ancien partenaire. Ensuite, Peter Livanos, de la célèbre famille d'armateurs américains, acquiert les trois quarts des actions, Victor Gauntlett conservant le reste.

Mais toutes ces transactions ne font pas oublier le produit ni l'essence même de la firme. La Vantage Zagato qui est présentée en mars 1986 à Genève comme réplique à des adversaires aussi illustres que la Ferrari 288 GTO en porte un témoignage sans appel. Avec cette voiture, Victor Gauntlett redonne vie à une relation commerciale avec les frères Elio et Gianni Zagato, de Terrazzano di Rho, qui, un quart de siècle plus tôt, déjà, avait porté de premiers fruits avec la DB4GT Zagato. De par son prix aussi, la nouvelle coproduction peut légitimement prétendre à une place de choix dans la hiérarchie de la noblesse automobile : elle a pour rivales la GTO et la Porsche 959 qui est un monstre de haute technologie. Gauntlett enfonce le clou avec la présentation, un an plus tard, de la version cabriolet. Construite à 35 exemplaires, celle-ci sera encore plus rare que la déjà peu courante version coupé produite à 50 unités. Deux autres événements placent une nouvelle fois le prestigieux établissement de Newport Pagnell sous les feux de la rampe, en 1987 : dans *Tuer n'est pas jouer*, James Bond prend de nouveau le volant d'une Aston Martin. Et, en septembre, après un long voyage sur une mer agitée, la terre est enfin en vue. Une lueur s'annonce au bout du tunnel : Ford se prend de pitié pour la vacillante société Aston Martin dont elle acquiert une solide majorité de 75 %. La famille Livanos et Victor Gauntlett se partagent équitablement les 25 % restants. Et la continuité est assurée : Gauntlett est une nouvelle fois reconduit dans ses fonctions.

Local legislation had to be changed to make the addition to the sign possible.

Um den den Zusatz auf dem Ortsschild zu ermöglichen, musste die lokale Gesetzgebung geändert werden.

Pour permettre ce commentaire sur le panneau, il a fallu modifier la législation locale.

The double-winged company plaque greeting visitors to Tickford Street.

Doppelt beflügelt: das Firmenschild, wie es den Besucher in der Tickford Street empfängt.

Double emblème : le panonceau de la société, tel qu'il accueille les visiteurs Tickford Street.

Glad Tidings
A Satellite of Planet Ford

By the end of the 1980s the existing V8 Saloon, Volante and Vantage were – after 20 years – history, and even the protean term "classic" barely sufficed as a description of how conservative their styling had become. At the 1988 Motor Show at Birmingham Exhibition Centre the Aston Martin Virage heralded the way forward into the 1990s with moderately innovative styling retaining enough typical features and ambience to make its family membership clear. John Heffernan and Ken Greeley were responsible for its smooth and pleasing lines. The V8 was handed over to the American tuners Callaway Engineering for an update and to ensure its compliance with the most stringent emission legislation they could imagine. A team under Tim Good's leadership working to these criteria came up with a beautiful and robust four-valve engine with Weber-Marelli electronic fuel injection, making the Virage a veritable allrounder which would grace the world's most elegant boulevards. 1989 saw a further attempt to repeat the 1959 success in the world sports car championship, this time with the financial support of sponsors Mobil. It met with limited success, however, as a fleet of five Aston Martin AMR1s could only manage a disappointing sixth place.

Victor Gauntlett finally stood down as chairman of Aston Martin in September 1991. The man who replaced him needed little introduction. Walter Hayes, a one-time Fleet Street journalist born in 1924, had already been a vice president of Ford Motor Company and the deputy chairman of Ford of Europe Incorporated. Between 1979 and 1984 he had been in charge of Ford's worldwide PR activities. Motorsport too was deeply indebted to him: Hayes was among the men behind such Ford successes as the legendary GT40 and the triumphant DFV Formula 1 power unit whose sequence of victories commenced with its 1967 debut at Zandvoort in a Lotus 49 with Jim Clark at the wheel. The Hayes era at Aston Martin began equally well. In January 1992 a 6.3 liter, 465 horsepower variant of the Virage was mooted, and in the same year Aston Martin launched the ultimate station wagon in the form of the three-door Shooting Brake, a machine, however, that was highly unlikely ever to become standard equipment for your average forester. The first production version of the Virage Volante Cabriolet was also something of an automotive castle in the air. Its purchase price in Germany of over 390,000 Marks (c. £130,000) suggested that the lucky owner also employed the staff it took to bestow on the beautiful whirlwind the loving care it would need. Then in October 1992 the Vantage shone at the Birmingham International Show, its power boosted to 550 horsepower by its two turbochargers, giving it an alleged top speed of 185 mph. Hayes demonstrated his respect for the past tradition of Aston Martin when he invited David Brown to the Newport Pagnell works on the event of his 89th birthday on 10th May 1993.

Frohe Botschaften
Satellit des Planeten Ford

Geschichte hingegen sind Ende des Jahrzehnts nach zwanzig Jahren die bisherigen Modelle V8 Saloon, Volante und Vantage, bevor nicht einmal mehr der dehnbare Begriff »klassisch« ihre konservative Linie und Konzeption abdeckt. Auf der British Motor Show in Birmingham 1988 weist der Aston Martin Virage den Weg in die Neunziger: mild innovativ und dennoch erkennbar ein Familienmitglied. John Heffernan und Ken Greeley zeichnen für seine glatten und gefälligen Formen verantwortlich. Der V8 wurde beim amerikanischen Tuner Callaway Engineering in stationäre Behandlung gegeben zwecks zeitgemäßem Update und in Hinblick auf die striktesten Emissionsgesetze, die aufzutreiben waren. Ein Team unter Tim Good erarbeitete entlang diesen Parametern einen ebenso schönen wie trotzig-robusten Vierventiler mit elektronischer Einspritzung von Weber-Marelli, der den Virage in der Tat zum Hansdampf in allen Gassen und auf allen Boulevards der Welt macht. Ein weiterer Versuch, an die Erfolge von 1959 bei der Sportwagen-Weltmeisterschaft anzuknüpfen, diesmal mit finanzieller Unterstützung durch den Sponsor Mobil, zeitigt 1989 einen mageren sechsten Platz im Championat der Konstrukteure für die insgesamt fünf Aston Martin AMR1.

Der Mann, der Victor Gauntlett im September 1991 im Kommandostand von Aston Martin ablöst, bedarf keiner ausdrücklichen Empfehlung. Der einstige Fleet-Street-Journalist Walter Hayes, Jahrgang 1924, war bereits Vizepräsident der Ford Motor Company und stellvertretender Vorsitzender von Ford of Europe Incorporated. Zwischen 1979 und 1984 fallen die PR-Aktivitäten von Ford in aller Welt in seine Zuständigkeit. Vor allem der Rennsport steht tief in seiner Schuld: Hayes zählt zu den Männern hinter solchen Ford-Schritten wie dem GT40 und dem Erfolgstriebwerk DFV in der Formel 1, jenem sieghaften Serientäter, dessen erster Einsatz 1967 zu Zandvoort in einem Lotus 49 mit Jim Clark am Lenkrad bereits in seinen ersten Erfolg einmündet. Die Ära Hayes fängt gleich gut an. Im Januar 1992 stellt man eine 6,3-Liter-Variante des Virage mit 465 PS in Aussicht. Mit einem dreitürigen Shooting Brake schafft Aston Martin im gleichen Jahr den ultimativen Kombinationskraftwagen, der gleichwohl niemals zur Grundausstattung für den durchschnittlichen Revierförster gehören wird. Im Bereich der automobilen Luftschlösser angesiedelt ist auch das erste serienmäßige Virage Volante Cabriolet. Sein Anschaffungspreis von über 390 000 Mark in Deutschland legt die Vermutung nahe, dass der glückliche Besitzer über das Personal verfügt, der schönen Windsbraut nun aber auch wirklich die angemessene Zuwendung zuteil werden zu lassen. Und im Oktober 1992 erstrahlt der traditionell nachgelieferte Vantage im Kunstlicht der Birmingham International Show, mit Hilfe zweier Turbolader zu 550 PS erstarkt und nach Aussage des Werks zu 300 Stundenkilometern fähig.

Bonne nouvelle
Le satellite de la planète Ford

À la fin de la décennie, la page est tournée, au bout de 20 ans, sur les anciens modèles V8 Saloon, Volante et Vantage, qui font désormais partie de l'histoire, à tel point que le terme « classique » représente un euphémisme pour décrire leur ligne et leur conception conservatrices. Au British Motor Show de Birmingham, en 1988, l'Aston Martin Virage montre la voie des années 1990 : déja un peu plus novatrice, elle n'en reste pas moins visiblement un membre de la famille. John Heffernan et Ken Greenley, du Royal College of Art, signent sa carrosserie aux lignes fluides et séduisantes. Le moteur V8 est confié au préparateur américain Callaway Engineering de façon à être modernisé et à pouvoir répondre à toutes les législations antipollution, même les plus sévères du monde. Une équipe de spécialistes, sous la direction de Tim Good, conserve le bas-moteur, indestructible, mais le dote d'une nouvelle culasse à quatre soupapes par cylindre qui est équipée d'un système d'injection électronique Weber-Marelli. Forte de ses 330 ch, la nouvelle Virage peut se lancer la tête haute sur les routes du monde entier. Une nouvelle tentative de rééditer le succès de 1959 au championnat du monde des voitures de sport, cette fois-ci avec l'appui financier du sponsor Mobil, se solde, en 1989, par une médiocre sixième place au championnat des constructeurs pour les cinq Aston Martin AMR1.

Il n'est pas nécessaire de présenter l'homme qui remplace Victor Gauntlett, en septembre 1991, aux commandes d'Aston Martin. L'ancien journaliste de Fleet Street, Walter Hayes, né en 1924, était déjà vice-président de Ford Motor Company et adjoint du président de Ford of Europe Incorporated. De 1979 à 1984, c'est lui qui coordonne la totalité des activités de Ford en matière de relations publiques dans le monde entier. Il est de ceux auxquels la compétition automobile doit beaucoup : Walter Hayes est l'un des hommes qui ont permis de concrétiser des projets comme la GT40 et le moteur DFV, le plus titré de la Formule 1, ce récidiviste des podiums dont la première apparition, en 1967 à Zandvoort, dans une Lotus 49 pilotée par Jim Clark, s'est immédiatement soldée par un premier succès. L'ère Hayes commence tout de suite bien. En janvier 1992, on annonce l'arrivée d'une version de 6,3 litres et 465 ch de la Virage. Avec un break de chasse à trois portes baptisé Shooting Brake, Aston Martin présente cette même année le plus luxueux break que l'on puisse imaginer, mais qui ne fera pourtant jamais partie de l'équipement de base du garde-chasse moyen. La première Virage Volante Cabriolet de série appartient à la catégorie des automobiles que bien peu d'amateurs pourront jamais s'offrir. Son prix d'achat, plus de 1 350 000 francs, incite à penser que l'heureux propriétaire dispose du personnel nécessaire pour accorder à cette féline décapotable l'attention qu'elle mérite. Et, en octobre 1992, la version plus puissante, Vantage, découvre la lumière des projecteurs au Birmingham International Show : forte de 550 ch grâce à deux turbocompresseurs, elle est, selon son constructeur, capable de dépasser les 300 km/h.

Still active and enterprising at his advanced age, Brown inspected every square yard of the factory and shook hands with each of the 55 employees who had given Aston Martin sterling service since his own days in charge. He was delighted with the latest model, which was to make its debut at the 1994 Geneva Motor Show. Hayes was only too pleased to take up his suggestion that it should be called the DB7. That designation was not actually entirely new. It had originally been intended for what eventually became the DB6 Mk II, and a draft version of a type badge was even produced on 18th July 1969. However, Brown then decided that the degree of innovation incorporated into the new model did not justify the new name.

In October 1993 two new members were added to the Lagonda family, both using the Virage chassis. These were a four-door saloon and a Shooting Brake, both coming with either 5.3 or 6.3 liter engines. There were also newcomers to the Virage family itself in the form of a 6.3 liter version of both the coupé and the cabriolet.

In February 1994 Walter Hayes finally retired to his beautiful old Shepperton house on the banks of the River Thames. Or nearly. He remained with Aston Martin in the capacity of lifetime honorary president, as the successor to David Brown, who had passed away in September 1993. His successor as chairman was John Oldfield, a former vice president of Ford with responsibility for European product development. Among other things he had been responsible for the planning, design and development of the Mondeo. Aston Martin Lagonda became 100% Ford-owned in the summer of 1994, and was incorporated into the empire of the Dearborn giant as an autonomous subsidiary, ironically a fate that had at one time been intended for its rival Ferrari during the 1960s. The DB7 project received a revitalizing £65 million injection of funds, meaning that the demand that had been stoked up for 18 months at a series of motor shows could finally be satisfied. Jaguar Sport's factory at Bloxham in Oxfordshire was acquired as the production center, where the car to be is pushed on trolleys through 15 stages before finally being sent for road testing. At last in September the DB7 was launched, to the acclaim of an eager and expectant global clientele.

This clientele quickly grew in size, as in 1995 Aston Martin Lagonda produced more than 700 cars in a single year for the first time in its long history. The Vantage also exceeded 100 units for the first time, a small step in absolute terms but a giant leap for the noble house from Newport Pagnell, whose venerable but inconspicuous façade was in stark contrast to its beautiful automotive creations. In October the seriously ill John Oldfield stepped down as chairman to be replaced by David Price. In a symbolic gesture Newport Pagnell demonstrated to visitors the esteem in which the Tickford Street business was held when its town mayor and local MP Peter Butler unveiled a new town sign proclaiming Newport Pagnell "Home to Aston Martin

Dass sich Hayes einen Sinn für das Vergangene, nicht aber Vergessene bewahrt hat, zeigt sich, als er David Brown an dessen 89. Geburtstag am 10. Mai 1993 nach Newport Pagnell einlädt. Der rüstige Greis inspiziert jeden Quadratmeter der Fabrik und begrüßt die 55 Angestellten, die seit seiner eigenen Zeit bei Aston Martin zum lebenden Inventar gehört haben, per Handschlag. Hellauf begeistert ist er vom neuesten Modell, das auf dem Genfer Salon 1994 debütieren wird. Nur zu gerne geht Hayes auf seinen Vorschlag ein, es DB7 zu nennen, als Hommage an sich selbst gewissermaßen. Der Name ist nicht neu: So sollte der DB6 MkII heißen, und es gab am 18. Juli 1969 sogar schon einen Entwurf für das Typen-Sigel. Doch dann befand Brown, das Maß an Innovation rechtfertige keine neue Bezeichnung.

Im Oktober 1993 verästelt sich die Lagonda-Familie in zwei weitere Mitglieder auf dem Chassis des Virage: eine viertürige Limousine und ein Shooting Brake mit Motoren von wahlweise 5,3 oder 6,3 Litern. Und auch beim Virage selbst stellt sich Zuwachs ein in Gestalt einer 6,3-Liter-Version des Coupés wie des Cabriolets.

Im Februar 1994 zieht sich Walter Hayes endgültig in den Ruhestand zurück in das Idyll seines schönen alten Hauses in Shepperton ganz in der Nähe der Themse. Oder fast: Er bleibt Aston Martin erhalten als Ehrenpräsident auf Lebenszeit in der Nachfolge von David Brown, der im September 1993 gestorben ist. Sein Nachfolger wird John Oldfield, früher Vizepräsident bei Ford mit dem Zuständigkeitsbereich Product Development in Europa. Planung, Entwurf und Entwicklung des Mondeo gehen auf sein Konto.

Seit dem Sommer 1994 ist Aston Martin Lagonda zu hundert Prozent Ford-Eigentum und als weitgehend autonome Filiale in das Imperium des Riesen aus Dearborn eingegliedert, ein Status, der pikanterweise in den sechziger Jahren einmal dem Marktgegner Ferrari zugedacht war. Eine belebende Investitionsspritze von 65 Millionen Pfund wird dem Projekt DB7 eingeimpft, damit der Appetit, der 18 Monate lang auf diversen Shows erregt worden ist, nun auch endlich gestillt werden kann. Als Fertigungsstätte erwirbt man von Jaguar Sport eine Fabrik zu Bloxham in Oxfordshire. Dort schiebt man das werdende Auto auf Montagewägelchen durch 15 Stationen, bevor man es einem abschließenden Straßentest unterzieht. Ab September wird der DB7 einer erwartungsvollen und freudig applaudierenden Klientel in aller Welt zugeführt.

Diese weitet sich zügig aus: 1995 produziert Aston Martin Lagonda als Novum in seiner Geschichte mehr als 700 Fahrzeuge in einem einzigen Jahr. Der Vantage überwindet erstmalig die Marke von 100 Einheiten, an absoluten Maßstäben gemessen ein winziger Schritt, ein Riesensprung hingegen für das noble Haus in Newport Pagnell, vor dessen altehrwürdigen und unscheinbaren Fassaden sich seine schönen Geschöpfe in eigentümlichem Kontrast abheben. Im Oktober löst David Price den schwer kranken

Walter Hayes montre qu'il a le respect de ce qui a été accompli dans le passé en invitant David Brown, pour son 89e anniversaire, le 10 mai 1993, à se rendre à Newport Pagnell. Toujours bon pied bon œil, le vieil homme inspecte le moindre mètre carré de l'usine et serre la main des 55 employés qui, depuis l'époque où lui-même présidait aux destinées d'Aston Martin, font désormais partie des meubles. Il se montre enthousiasmé par le tout nouveau modèle qui doit faire ses débuts au Salon de Genève de 1994. Point n'est besoin de forcer la main à Walter Hayes pour accepter la proposition de David Brown de la baptiser DB7, en hommage à lui-même, en quelque sorte. Le nom n'est pas nouveau : il était prévu d'appeler ainsi la DB6 Mk II et il y a même déjà eu, le 18 juillet 1969, une esquisse pour le logo. Mais, ce jour-là, David Brown avait trouvé que le degré d'innovation ne justifiait pas une nouvelle dénomination.

En octobre 1993, la famille Lagonda se voit ajouter deux membres supplémentaires, construits sur le châssis de la Virage : une limousine à quatre portes et un break de chasse Shooting Brake propulsés, au choix, par un moteur de 5,3 ou 6,3 litres. En ce qui concerne la Virage elle-même, la famille s'agrandit aussi sous la forme d'une version de 6,3 litres du coupé et du cabriolet.

En février 1994, Walter Hayes prend définitivement sa retraite dans l'écrin idyllique de sa magnifique vieille maison de Shepperton, à un jet de pierre de la Tamise. Ou presque : il continuera de faire partie d'Aston Martin en tant que président honoraire à vie comme successeur de David Brown, qui est décédé en septembre 1993. Son remplaçant sera John Oldfield, ancien vice-président de Ford où il était chargé du développement de produits pour l'Europe. Il est l'auteur de la planification, du dessin et du développement de la Mondeo.

Summit meeting: after the unveiling of the cairn on 23 May 1997 on Aston Hill, the cheerful Lady Paula Brown, widow of the late David Brown, here framed by the five Aston Martin bosses John Oldfield, David Price, Victor Gauntlett, Bob Dover and Walter Hayes (from left).

Gipfel-Treffen: Nach der Enthüllung des Cairns am 23. Mai 1997 am Aston Hill wird Lady Paula Brown, die fröhliche Witwe des verstorbenen David Brown, gerahmt von den fünf Aston-Martin-Bossen John Oldfield, David Price, Victor Gauntlett, Bob Dover und Walter Hayes (von links).

Rencontre au sommet : après l'inauguration du monument, le 23 mai 1997, à Aston Hill, Lady Paula Brown, veuve de feu David Brown, encadrée par les cinq hommes qui ont présidé aux destinées d'Aston Martin : John Oldfield, David Price, Victor Gauntlett, Bob Dover et Walter Hayes (de gauche à droite) posent pour le photographe.

Tricorn: on the same day the hot-air balloon with the gigantic emblem of the marque made its maiden voyage into a misty sky.

Dreispitz: Am gleichen Tage erhebt sich der Heißluftballon mit dem gigantischen Emblem der Marke zum ersten Mal in einen diesigen Himmel.

Tricorne : le jour même, la montgolfière avec le gigantesque emblème de la marque s'élève pour la première fois dans le ciel brumeux.

Lagonda". Meanwhile, the Aston Martin Owners' Club, which is about to move to spectacular new premises in the 600-year-old Great Barn at Drayton St. Leonard near Oxford, celebrated the Diamond Jubilee of its foundation by the legendary "Mort" Morris-Goodall, with a party to demonstrate that there is life indeed behind the ominous abbreviation AMOC. Not to be outdone, the Lagonda Owners' Club splashed out on a lavish celebration of the marque's Le Mans victory that same year.

The DB7 Volante was launched in January 1996. The choice of date was made for strategic reasons: the Detroit and Los Angeles auto shows were to serve as a bridgehead for a renewed offensive on the hugely competitive US market. Past tempts to penetrate this market had foundered on the cars' failure to comply with US safety and emission regulations. In June the first DB7 coupés and Volantes were shipped to the USA and Canada, and the 1000th DB7, produced in October, was also bound for an American buyer. This round figure itself represented yet another record: it meant that the DB7 had become the most successful Aston Martin ever. At around the same time the Geneva Motor Show saw the introduction of the V8 Coupé, derived from the Vantage and featuring a 350 horsepower engine and automatic transmission. 1996 confirmed what the year before had prefigured: Aston Martin was on a stable high. Demand was easily outstripping supply, which that year once again amounted to more than 700 cars.

December 1996 saw yet another change of top level personnel, as David Price left to become consultant to a group of companies outside the motor industry after a stay of record brevity. In his place came Bob Dover. He took up the post at

John Oldfield an der Spitze des Managements ab. In einer symbolischen Geste zeigt die Gemeinde Newport Pagnell ihren Besuchern, dass das Unternehmen in der Tickford Street ihr zur Zierde gereicht: Ihr Bürgermeister und lokaler Abgeordneter Peter Butler enthüllt neue Ortsschilder, die den Zusatz »Home to Aston Martin Lagonda« enthalten. Der Aston Martin Owners' Club, der demnächst ein neues Domizil im 600 Jahre alten Great Barn zu Drayton St. Leonard unweit Oxford beziehen wird, zeigt mit einer Diamond-Jubilee-Feier zum 60. Jahrestag seiner Gründung durch den legendären »Mort« Morris-Goodall, dass sich hinter seinem Unheil verkündenden Kürzel AMOC tosendes Leben verbirgt. Und der Lagonda Owners' Club mag sich da nicht lumpen lassen und zelebriert seinerseits den Le-Mans-Sieg der Marke aus dem gleichen Jahr.

Der DB7 Volante feiert seine Premiere im Januar 1996. Das hat nicht zuletzt strategische Gründe: Die Auto-Shows von Detroit und Los Angeles dienen als Brückenköpfe für eine neue Offensive auf dem heftig umkämpften Markt in den Vereinigten Staaten. In der Vergangenheit verweigerten sie den Zuwanderern aus Newport Pagnell immer wieder die Einbürgerung, weil sie sich den dortigen Sicherheits- und Emissionsvorschriften nicht fügten. Im Juni werden die ersten DB7 in Gestalt des Coupés wie des Volante in die USA und Kanada verschifft, und auch Exemplar Nummer 1000 macht sich im Oktober auf den Weg zu einem amerikanischen Kunden. Die pralle Zahl zeigt einen weiteren Rekord an: Der DB7 ist der erfolgreichste Aston Martin, den es je gab. Gleichwohl erweitert man das Programm auf dem Genfer Salon um das V8 Coupé, ein Derivat des Vantage mit 350 PS und automatischem Getriebe. Das Jahr 1996 bestätigt, was sich ein Jahr zuvor bereits angedeutet hat: ein stabiles Hoch für Aston Martin. Dabei übersteigt die Nachfrage entschieden das Angebot von wiederum reichlich 700 Exemplaren.

Im Dezember ist ein weiteres Revirement an der Spitze angesagt: Nach einer Verweildauer von Rekordkürze geht David Price, um eine gänzlich neue Herausforderung als Berater einer Firmengruppe außerhalb der Autoindustrie zu suchen. An seiner statt kommt Bob Dover. Er tritt seinen Dienst in einer Phase an, in der frischer Wind die Segel des Unternehmens schwellt, das nun mit den schier unerschöpflichen Ressourcen der Mutter Ford im Rücken endgültig in ruhiges Fahrwasser eingelaufen ist. Denn 1997 werden 712 neue Aston Martin an Kundschaft in 29 verschiedenen Ländern ausgeliefert. Das sind 41 mehr als die gesamte Produktion in dem Vierteljahrhundert zwischen 1915 und 1939. Zwei Neuerscheinungen variieren vertraute Themen: der Alfred Dunhill DB7 in Varianten für Raucher und Nichtraucher sowie der V8 Volante mit 200 Millimetern mehr Radstand, der auch den bislang eher stiefmütterlich behandelten hinten Einsitzenden mehr Knieraum und Komfort verwöhnt. Peter Gethin, umtriebiger Grand-Prix-Pensionär mit einer aktiven Vergangenheit zwischen

Depuis l'été 1994, Aston Martin Lagonda appartient à cent pour cent à Ford et, en tant que filiale pratiquement autonome dans l'empire du géant de Dearborn, elle bénéficie d'un statut qui – ironie du destin – aurait dû revenir, dans les années 1960, à son adversaire d'alors sur les circuits : Ferrari. Une bienfaisante injection de 65 millions de livres permet que le projet DB7 puisse enfin satisfaire la demande des nombreux amateurs auxquels il a mis l'eau à la bouche au cours de ses 18 mois de pérégrinations de salon en salon. Pour la fabriquer, Aston Martin rachète à Jaguar Sport une usine située à Bloxham, dans l'Oxfordshire. Là, la future voiture défile sur un chariot le long de 15 stations de montage avant de subir un test routier de contrôle. En septembre, la DB7 est présentée dans le monde entier à une clientèle impatiente et conquise par avance. Son succès est immense : en 1995, Aston Martin Lagonda produit pour la première fois de son histoire plus de 700 voitures en une seule année. La Vantage dépasse pour la première fois le seuil des cent exemplaires, une production minuscule en chiffres absolus, mais un progrès énorme pour la prestigieuse maison de Newport Pagnell, où ses magnifiques créations constituent un contraste bizarre avec la vénérable et insignifiante façade de briques de l'usine. En octobre, David Price reprend, à la tête de la direction, le flambeau d'un John Oldfield gravement malade. Symboliquement, la commune de Newport Pagnell annonce à ses visiteurs qu'elle est fière d'héberger l'entreprise de Tickford Street : son maire et député Peter Butler dévoile de nouveaux panneaux indiquant le nom de la localité, qui comportent la mention « Patrie d'Aston Martin Lagonda ». L'Aston Martin Owners' Club, qui élira bientôt domicile dans la Great Barn, âgée de 600 ans, à Drayton St. Leonard, non loin d'Oxford, prouve, lors des cérémonies commé moratives du Diamond Jubilee, pour le 60e anniversaire de sa fondation par le légendaire « Mort » Morris-Goodall, qu'il mord la vie à pleines dents, en dépit de son horrible sigle, AMOC. Le Lagonda Owners'Club ne veut pas rester inactif et célèbre, quant à lui, la victoire remportée par la marque au Mans la même année.

La DB7 Volante fête sa première en janvier 1996. Les salons de l'automobile de Detroit et de Los Angeles servent de têtes de pont pour une nouvelle offensive sur le marché, prometteur mais disputé, des États-Unis. Par le passé, son accès avait été interdit aux émigrantes de Newport Pagnell : elles ne respectaient pas les normes de sécurité et de dépollution en vigueur dans ce pays. En juin, les premières DB7 partent à l'assaut des États-Unis et du Canada avec en avant-garde le coupé et la Volante ; l'exemplaire numéro 1000, lui aussi, franchit l'Atlantique en octobre pour faire le bonheur d'un client américain. Ce chiffre rond est synonyme d'un nouveau record : la DB7 est l'Aston Martin qui a remporté le plus grand succès. Simultanément, au Salon de Genève, le programme s'enrichit du coupé V8, extrapolé de la Vantage, de 350 ch et avec une boîte automatique. 1996 confirme ce qui s'esquissait d'ores et déjà un an auparavant : la conjoncture reste favo-

a time when Aston Martin had the wind in its sails, and with the backing of Ford's huge resources seemed to have finally weathered the financial storms of the past. In 1997 a total of 712 new Aston Martins were sold in 29 different countries – 41 more cars than the total production in the quarter century from 1915 to 1939. Two new offerings were variations on familiar themes: the Alfred Dunhill DB7 in versions for smokers and non-smokers, and the V8 Volante, which had an 8 inch greater wheelbase, giving the hitherto disregarded rear passenger somewhat more legroom and comfort. Other novelties included a "Roadcraft" driving course for new Aston Martin owners run by Peter Gethin, an energetic ex-Grand Prix driver who had raced with McLaren, BRM and Lola between 1970 and 1974, and a cleverly designed promotional program for the sale of used Aston Martins.

On 23rd May 1997 a cairn was unveiled on Aston Hill in commemoration of the origins of the firm's name, while overhead a giant triangular hot air balloon bearing the familiar company logo manifested the ever growing self-confidence of the marque. The people behind Aston Martin also showed their community spirit by holding open days in June at both Newport Pagnell and Bloxham, raising £20,000 for charity in the process. Then in July came the launch of a development program in conjunction with Cosworth and Ford AVT, aimed at the perfecting of the next generation of power units.

In August 1998 the Aston Martin Heritage Trust was launched with the brief of presenting the history and cultivating the image of the marque, partly through the annual issue of the journal *Aston*, a publication full of painstakingly researched tidbits and curiosities gleaned from the storehouse of 85 years of history.

From the autumn of that same year a 600 horsepower version of the V8 Vantage has been on offer to people who are looking for that little bit more, though a prohibitive pricetag of 493,750 Marks (c. £160,000) acts as a form of natural selection on potential buyers. By comparison the DB7 Vantage, presented at the 1999 Geneva Spring Motor Show, is a snip at a modest 237,500 DM (c. £75,000). The DB7 Vantage was undoubtedly Aston Martin's star turn for the start of the new millennium. This fabulous creation from Bloxham combines the mystique of the Aston Martin marque with the magic of the twelve cylinder engine. The amount of hand craftsmanship remaining is modest, and it also features other concessions to progress. Gear changing of the manual six-speed transmission is via a Formula 1-style toggle switch on the steering wheel, and the aluminum chassis and carbon fiber body keep the unladen weight down to 3100 lbs. Above all, however, the V12 represents a restoration of the hierarchical principle, having not only more power but also more cylinders than the Prestige. Readers may recall that having 12 of them beneath the hood was in olden days a

1970 und 1974 bei McLaren, BRM und Lola bietet einen »Roadcraft«-Fahrerlehrgang für neue Aston-Martin-Besitzer an. Darüber hinaus gibt es ein clever ausgetüfteltes Förderprogramm für den Verkauf von Gebrauchtwagen des Hauses. Am 23. Mai 1997 wird eingedenk der Ursprünge am Aston Hill in archaisierender Symbolik ein Steinhaufen enthüllt. Über der Szene bläht sich ein riesiger Ballon in ungewöhnlicher Dreiecks-Konfiguration und manifestiert mit den bekannten Emblemen ein stetig erstarkendes Marken-Bewusstsein. Dass darüber hinaus der Gemeinsinn der Männer hinter Aston Martin nicht verkümmert ist, bezeugt ein Tag der offenen Tür im Juni an den Standorten Newport Pagnell und Bloxham, an welchem man 20 000 Pfund für karitative Zwecke einnimmt. Im Juli leitet man gemeinsam mit Cosworth und Ford AVT ein Zukunftsprogramm in die Wege, das auf die Sublimierung künftiger Generationen von Triebwerken abzielt.

Um die Wartung und Pflege der Geschichte des Unternehmens, die Politur seiner Patina gewissermaßen, kümmert sich seit dem August 1998 der Aston Martin Heritage Trust, der einmal im Jahr das Journal *Aston* herausgibt, voll mit sorgfältig recherchierten Schmankerln aus der Fundgrube von 85 Jahren Historie. Seit dem Herbst des gleichen Jahres steht der V8 Vantage mit 600 PS bereit als Angebot an Menschen, für die es gern etwas mehr sein darf, allerdings zum Kostenpunkt von 493 750 Mark, der bereits eine natürliche Auslese schafft. Da liest sich der Anschaffungspreis von 237 500 Mark für die gleichnamige Ausbaustufe des DB7, vorgestellt auf dem Genfer Frühlingssalon 1999, vergleichsweise wie die Bitte um ein Almosen. Der DB7 Vantage war zweifellos das Star-Angebot für das neue Jahrtausend. Mit dem Beau aus Bloxham spannt man nämlich in den Mythos der Marke Aston Martin den Charme des magischen Dutzends ein. Und der zweite Streich folgt sogleich: Derselbe Motor, allerdings unter den kundigen Händen des weitläufigen Ford-Verwandten Cosworth auf knorrige 504 PS erstarkt, sorgt im neuen Topmodell V12 Coupé für ungestümen Drang nach vorn. Es nimmt stilistische und technische Motive der Studie Projekt Vantage von 1998 auf und löst im Herbst 2000 die in Ehren ergraute Baureihe V8 ab. Nur noch moderat ist der Anteil an Handarbeit. Auch sonst fühlt man sich dem Fortschritt verpflichtet: Wie in der Formel 1 wird das manuelle Sechsgang-Getriebe mit Wippen am Lenkrad geschaltet, und ein Chassis aus Aluminium sowie die Karosserie aus Kohlefaser sollen das Leergewicht bei 1400 Kilogramm halten. Vor allem jedoch bringt der V12 die hierarchische Prinzip wieder ins Lot, nach dem Prestige nicht nur aus zusätzlichen Pferdestärken, sondern auch aus einem Mehr an Zylindern erwächst.

Zwölf davon unter der Haube zu haben, man erinnere sich, war in grauer Vorzeit einmal das Privileg eines handverlesenen Fähnleins von Lagonda-Lenkern. Der von Selbstvertrauen strotzende Bob Dover gönnt sich das Privileg, persönlich

rable à Aston Martin. La demande dépasse notablement l'offre, qui est de nouveau largement supérieure à 700 exemplaires. En décembre, une nouvelle direction est annoncée à la tête de la firme : après un séjour d'une brièveté record, David Price quitte Aston Martin pour relever des défis totalement différents comme consultant d'un groupe d'entreprises extérieures à l'industrie automobile. Il est remplacé par Bob Dover, qui prend ses fonctions au moment où un vent arrière gonfle les voiles de l'entreprise qui, maintenant, avec les ressources apparemment inépuisables de la maison mère Ford, s'est définitivement engagée sur un océan de tranquillité. En effet, en 1997, 712 Aston Martin neuves sont livrées à des clients de 29 pays différents. Soit 41 exemplaires de plus que toute la production du quart de siècle qui s'est écoulé de 1915 à 1939. Deux nouveaux modèles déclinent un thème familier : la Alfred Dunhill DB7 en deux versions, pour fumeurs et non-fumeurs, ainsi que la V8 Volante avec un empattement allongé de 200 mm qui permet enfin aux passagers des sièges arrière, jusqu'ici considérés comme quantité négligeable, de bénéficier de plus d'espace pour les jambes et de plus de confort. Peter Gethin, ancien pilote de Grand Prix chez McLaren, BRM et Lola entre 1970 et 1974, désormais à la retraite, propose un stage de conduite baptisé « Roadcraft » aux nouveaux propriétaires d'Aston Martin. Il existe en outre un programme de promotion astucieusement conçu pour la vente de voitures d'occasion avec l'emblème ailé. Le 23 mai 1997, pour commémorer les origines du nom de la firme, un monument de pierre au symbolisme archaïque est dévoilé à Aston Hill. Au-dessus de la scène, un gigantesque ballon à l'inhabituelle forme triangulaire témoigne, avec les fameux emblèmes, de la confiance en soi sans cesse croissante de la marque. Une journée portes ouvertes organisée en juin dans les usines de Newport Pagnell et de Bloxham, au cours de laquelle 20 000 livres sont récoltées à des fins humanitaires, prouve que les hommes qui président aux destinées d'Aston Martin n'ont pas perdu leur esprit de solidarité envers la collectivité. En juillet, de concert avec Cosworth et Ford AVT, un programme de développement est inauguré pour le perfectionnement des générations futures de groupes motopropulseurs.

Depuis août 1998, l'Aston Martin Heritage Trust, qui édite une fois par an le journal *Aston*, mine de détails savoureux et d'anecdotes glanés dans 85 ans d'histoire de la marque, se charge de cultiver et d'entretenir l'histoire de l'entreprise, de lui donner de la patine en quelque sorte. Depuis l'automne de la même année, la V8 Vantage de 600 ch figure au catalogue. Mais elle coûte la bagatelle de 1 700 000 francs, et cela crée déjà une sélection naturelle. Avec un prix d'achat de 830 000 francs, la version correspondante de la DB7, présentée au Salon de Genève au printemps 1999, est (presque) à la portée de toutes les bourses. La DB7 Vantage était incontestablement l'affaire à saisir pour le nouveau millénaire. Avec la belle GT de Bloxham, on ajoute en effet au mythe de la marque Aston Martin le charme des

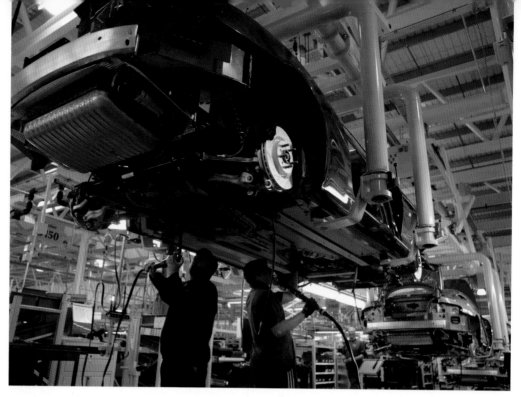

A monumental sandstone complex: the new Aston-Martin headquarters' ensemble of buildings at Gaydon, to the south of Birmingham, is also the production site of the DB9 and its derivatives.

Monumentaler Sandstein-Komplex: Das Ensemble der neuen Aston-Martin-Zentrale in Gaydon, südlich von Birmingham, dient auch der Fertigung des DB9 und seiner Derivate.

Un monumental complexe de grès : l'ensemble architectural de la nouvelle centrale d'Aston Martin, à Gaydon, au sud de Birmingham, héberge aussi les ateliers de montage de la DB9 et de ses dérivées.

privilege reserved for the select ranks of Lagonda drivers.

Bursting with self-confidence, Bob Dover allowed himself the privilege of personally opening the world's 73rd Aston Martin branch on the distinguished Park Lane in London. One has to bring the Aston Martin product a little more into public view, according to Dover. After all, the construction of automobile mass products is being transferred more and more to countries with low wage costs, said the qualified engineer, putting things in a global perspective. One only has to look at the Volkswagen company policy in respect to its Seat and Škoda satellites. Where labor costs are high, the only chance lies in the premium sector. In a way, one had drawn both the best and the worst of cards. "The worst, because financial and other expenditure remains consistently high in order to meet the world's safety and emission regulations. It makes no difference whether ten vehicles are produced, or a million. The best, to the extent that we can count on a homogenous and dependable clientele. We do our best to design and produce exactly that model which will then become the focal point of their lives."

Ford and Jaguar parts are to be found in the successful DB7 model, of which 10,000 vehicles have been built. Purists and notorious moaners who do not look to closely even complain of certain similarities to the Jaguar XK8, the development of which was the responsibility of Bob Dover in the first half of the 1990s. When Ford looks for a new boss for Land-Rover, Dover "finishes" with Aston Martin and takes on this new responsibility. His legacy: a full order book – 900 DB7s alone are planned annually. "This year we can achieve a new sales and production record," Dover

in der vornehmen Londoner Park Lane die weltweit 73. Aston-Martin-Niederlassung einzuweihen. Man müsse, so Dover, das Produkt Aston Martin noch ein bisschen mehr unter die Leute bringen. Schließlich werde sich die Fertigung automobiler Massenware immer mehr in Länder mit niedrigen Lohnkosten verlagern, stellt der diplomierte Ingenieur die Dinge in einen globalen Zusammenhang. Man achte nur auf die Politik von Volkswagen hinsichtlich seiner Satelliten Seat und Škoda. Wo Arbeit teuer sei wie in England, liege die Chance im Premiumsektor. Man habe gewissermaßen die beste und die schlechteste Karte gezogen. »Die schlechteste, weil der finanzielle und sonstige Aufwand immer gleich hoch ist, wenn man den Sicherheits- und Emissionsbestimmungen dieser Welt genügen will. Da macht es keinen Unterschied, ob man zehn oder eine Million Fahrzeuge herstellt. Die beste insofern, als wir auf eine homogene und zuverlässige Klientel rechnen können. Wir tun unser Bestes, genau jene Modelle zu entwerfen und zu produzieren, die dann im Mittelpunkt ihres Lebens stehen.«

Am Erfolgstyp DB7, der in fast 10 000 Exemplaren gebaut worden ist, finden sich noch Fremdteile von Ford und Jaguar. Puristen und notorische Nörgler, die nicht so genau hinschauen, machen sogar gewisse Ähnlichkeiten zum Jaguar XK8 aus, für dessen Entwicklung Bob Dover in der ersten Hälfte der neunziger Jahre verantwortlich zeichnet. Als im Sommer 2000 Ford einen neuen Chef für Land-Rover braucht, ist Dover bei Aston Martin »over« und wird mit der neuen Aufgabe betraut. Sein Nachlass: Volle Auftragsbücher – allein 900 DB7 stehen in der annuellen Planung. »Dieses Jahr können wir einen neuen Verkaufs- und Produktionsrekord erzielen«, prognostiziert Dover vor seinem

douze-cylindres magiques. La proportion de travail fait à la main a régressé et, pour le reste, on se voue corps et âme au progrès : comme en Formule 1, la boîte manuelle à six vitesses est actionnée par des basculeurs au volant tandis qu'un châssis en aluminium et une carrosserie en fibre de carbone permettent de contenir le poids à vide à 1 400 kg. Mais, surtout, le V12 incarne la volonté de respecter de nouveau le principe en vertu duquel on n'accroît pas seulement son prestige avec quelques chevaux supplémentaires, mais aussi avec quelques cylindres de plus.

À une époque antédiluvienne, douze cylindres sous le capot étaient, on se le rappelle encore, le privilège d'un petit nombre de conducteurs triés sur le volet qui avaient la fierté de posséder une Lagonda.

Sûr de lui, Bob Dover s'offre le privilège d'inaugurer personnellement la 73e succursale d'Aston Martin dans le prestigieux quartier londonien de Park Lane. Il faut faire encore mieux pour que les consommateurs connaissent le produit Aston Martin, déclare Bob Dover. En effet, la fabrication d'automobiles en série va de plus en plus être délocalisée vers les pays à bas salaires, constate l'ingénieur diplômé, qui voit les choses dans un contexte global. Regardez donc la politique menée par Volkswagen avec ses filiales Seat et Škoda. Là où le coût de la main-d'œuvre est élevé, comme en Angleterre, il faut tenter sa chance dans le secteur des voitures de luxe. Dans un pays comme celui-ci, on a, en quelque sorte, tiré une bonne et une mauvaise carte. « La mauvaise carte parce que les charges, financières et autres, sont toujours aussi élevées dès lors que l'on veut et doit respecter les normes de sécurité et de dépollution en vigueur. Il n'y a aucune différence, que l'on fabrique dix ou un million de voitures. La bonne carte, c'est une clientèle homogène et fidèle sur laquelle on peut compter. Nous donnons

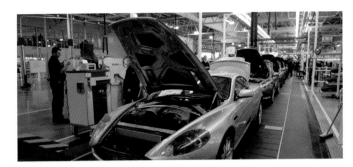
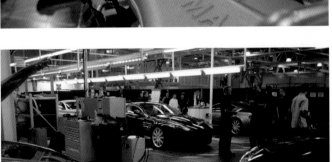

prophesized before his job switch. And almost emphatically compared the importance of Aston Martin for Great Britain with that of the Ferrari image for Italy. It is a Swabian, not a Briton, who takes over the running of the traditional English business. Dr. Ulrich Bez, born in November 1944 in Bad Cannstatt near Stuttgart, is a market insider. The former Porsche development boss, who can also list BMW and Daewoo as steps in his long career in the automobile industry, was most recently an adviser to Ford. He has been able to put this expertise into practice as boss of Aston Martin since 11th July 2000.

Aston Martin is more than a new challenge for Bez, a fan of fast cars and a sportsman whose passions include skiing, tennis, and golf. Before Ian Callum's reworked Vanquish 2001 makes its debut, Bez lets it be stripped of all Ford family standard parts that are not befitting its status. Apart from which, he ordered the same brutally hard program testing for Aston Martin as he was used to during his time at Porsche. High-tech and work done by hand demand a seal of quality, and that is exactly what every customer receives in the form of a badge with the name of the vehicles inspector.

The cooperation between Aston Martin and Zagato has been reactivated under Bez. Dr. Andrea Zagato, the grandson of the firm's founder, Ugo Zagato, suggested in the fall of 2001 a special edition of the DB7, received the green light for the drafts he presented in January 2002 which met with approval. So many orders are made for the Italian Briton with the "double bubble roof," that the edition, strictly limited to 99 vehicles, is soon sold out. The 99 Aston Martin Zagato AR (American Roadster), with their double bubbles as scoops behind the headrests, quickly find their fans.

Stellungswechsel. Und fast emphatisch vergleicht er die Bedeutung von Aston Martin für Großbritannien mit dem Ferrari-Image für Italien.

Kein Brite, sondern ein Schwabe übernimmt die Geschicke des englischen Traditions-Unternehmens. Dr. Ulrich Bez, im November 1944 in Bad Cannstatt bei Stuttgart geboren, ist Branchen-Insider. Der ehemalige Entwicklungschef von Porsche, der auch BMW und Daewoo zu Stationen seiner langen Tätigkeit in der Autoindustrie zählt, fungiert zuletzt als Berater von Ford. Dieses Know-how darf er seit dem 11. Juli 2000 als Aston-Martin-Chef in die Praxis umsetzen.

Für den Liebhaber schneller Fahrzeuge und Sportsmann Bez, zu dessen Leidenschaften auch Skifahren, Tennis und Golf zählen, ist Aston Martin mehr als eine neue Herausforderung. Ehe der von Ian Callum überarbeitete Vanquish 2001 debütiert, lässt ihn Bez von allen Serien-Teilen der Ford-Familie, die nicht standesgemäß sind, entrümpeln. Außerdem verordnet er Aston Martin ein knallhartes Testprogramm, wie er es aus seinen Porsche-Zeiten gewöhnt ist. Hightech und Handarbeit in Vollendung verlangen nach einem Gütesiegel, und das erhält jeder Kunde in Form einer Plakette mit dem Namen des Endkontrolleurs.

Unter Bez wird die Zusammenarbeit von Aston Martin mit Zagato wieder aktiviert. Dr. Andrea Zagato, Enkel des Firmengründers Ugo Zagato, schlägt im Herbst 2001 eine Sonderversion des DB7 vor und bekommt grünes Licht für Entwürfe, die er im Januar 2002 präsentiert und die auf Gegenliebe stoßen. Für den italienischen Briten mit *double bubble roof* gehen derart viele Bestellungen ein, dass die auf 99 automobile Preziosen limitierte Edition bald vergriffen ist. Auch die 99 Aston Martin Zagato AR (American Roadster), bei denen sich die

le meilleur de nous-mêmes pour concevoir et produire les modèles qui correspondent exactement à nos clients. »

Le best-seller, la DB7 construite à quelque 10 000 exemplaires, comporte encore des pièces d'origine « roturière », Ford et Jaguar. Les puristes et les détracteurs notoires, qui n'y regardent pas de très près, déclarent même avoir reconnu certaines similitudes avec la Jaguar XK8 dont Bob Dover, durant la première moitié des années 1990, a assumé la responsabilité du développement. Quand Ford a eu besoin d'un nouveau patron pour Land-Rover, au cours de l'été 2000, Dover est devenu « over » chez Aston Martin et s'est vu confier cette nouvelle mission. Mais il a laissé un héritage : des carnets de commandes pleins à craquer – pas moins de 900 DB7 figurent dans la planification annuelle. « Cette année, nous pouvons battre un nouveau record de vente et de production », pronostique Dover avant de prendre ses nouvelles fonctions. Et, presque avec emphase, il compare la situation d'Aston Martin en Grande-Bretagne à l'image de Ferrari en Italie.

Ce n'est pas un Britannique, mais un Souabe qui prend en mains les rênes de la prestigieuse marque anglaise. Ulrich Bez, né en novembre 1944 à Bad Cannstatt, près de Stuttgart, est un homme du sérail. L'ancien chef du développement de Porsche, qui, lors de sa longue carrière dans l'industrie automobile, a aussi fait étape chez BMW et Daewoo, jouait tout récemment le rôle de consultant pour Ford. Un savoir-faire que, depuis le 11 juillet 2000, il peut mettre en pratique en tant que P.-D.G. d'Aston Martin.

Pour l'amoureux des belles voitures rapides et sportives qu'est Bez, qui a aussi pour passions le ski, le tennis et le golf, Aston Martin est plus qu'un nouveau défi à relever. Avant que la Vanquish revue et

*The Aston Martin Jet 2:
the Bertone designers Roberto Piatti,
Guiliano Biasio, and David Wilkie's
only 4'5"-high study transforms the
Vanquish into a futuristic sports car.
The station wagon rear, the extensive
glass roof, and the masterly
coordination of interior and exterior,
all provide an incentive for a small-
batch series production of the Jet 2.*

*Aston Martin Jet 2:
Die nur 1330 Millimeter hohe Studie
der Bertone-Designer Roberto Piatti,
Guiliano Biasio und David Wilkie
verwandelt den Vanquish in einen
futuristischen Sportwagen. Kombiheck,
großflächiges Glasdach und die
gekonnte Abstimmung vom Interieur
auf das Exterieur reizen zu einer
Kleinserie des Jet 2.*

*Aston Martin Jet 2:
l'étude de style (elle ne mesure que
1330 millimètres de haut) des designers
de Bertone – Roberto Piatti, Guiliano
Biasio et David Wilkie – métamorphose
la Vanquish en une voiture de sport
futuriste. Break de chasse, vaste toit
vitré et harmonie parfaite de l'intérieur
et de l'extérieur justifient une petite
série de la Jet 2.*

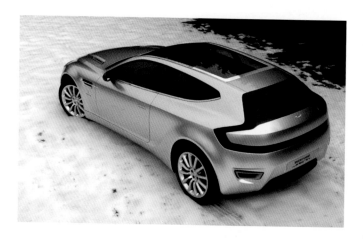

*Following on the success of the AR1,
Dr. Andrea Zagato also transformed
the Vanquish into a roadster, which
debuted at the 2004 Geneva motor
show. While the front remained
untouched, the rear with its double-
bubble glass wind blocker most
definitely bears the Italian bodywork
couturier's signature.*

*Nach dem AR1-Erfolg verwandelte
Dr. Andrea Zagato auch den Vanquish
in einen Roadster, der auf dem Genfer
Salon 2004 debütierte. Während
die Front unangetastet blieb, trägt
das Heck mit Doppelblasen-Glas-
Windschott ganz die Handschrift des
italienischen Karosserie-Couturiers.*

*Après le succès remporté par l'AR1,
Andrea Zagato a aussi créé une version
roadster de la Vanquish, qui a fait ses
débuts au Salon de Genève 2004. Tandis
que la proue a conservé son intégrité, la
poupe avec pare-vent en verre à double
bulbe porte la signature inconfondable
du couturier-carrosserie italien.*

In 2003, Aston Martin itself says good-
bye to the DB7 era and the production
halls in Bloxham, once rented from
Jaguar, with a GT version of the most
successful model of the company's
history. Henrik Fisker, appointed chief
designer, develops the DB9 and, to-
gether with Ian Callum (in the mean-
time with Jaguar), also the Aston Martin
V8 Vantage, which is aimed at the
Porsche section of the market from
2005 onward. The prototype of the
"small" Aston Martin meets with extra-
ordinary resonance at the 2003 Geneva
show – another dazzling success for
Fisker, who is entrusted by Ford with
a few drafts for updating the renowned
Lincoln brand. Even though Lincoln,
with 56,566 Town Cars, put more than
twice the number of vehicles onto the
US market in 2003 than Chevrolet
with the Corvette, the US concern's pre-
mium brand lacks optical attractiveness
to make its mark outside the North
American marketplace.
The production plant and workshops at
Newport Pagnell were also in desperate
need of a facelift, but demolition and
rebuilding would have been too
cost-intensive; apart from which, the
production of the Vanquish would have
been interrupted. However, the much
too cramped works at Bloxham are
given up when the last DB7 leaves the
production line. There is only one alter-

doppelte Blase als Hutzen hinter den
Nackenstützen äußert, finden schnell
ihre Liebhaber.
Aston Martin selbst verabschiedet sich
2003 von der DB7-Ära und den einst von
Jaguar angemieteten Hallen in Bloxham
mit einer GT-Version des erfolgreichsten
Modells der Firmengeschichte. Henrik
Fisker, zum Chef-Designer bestallt, ent-
wirft den DB9 und zusammen mit Ian
Callum (inzwischen bei Jaguar) auch den
Aston Martin V8 Vantage, der ab 2005
auf Porsche-Marktsegmente angesetzt
ist. Der Prototyp des »kleinen« Aston
Martin erfreut sich beim Genfer Salon
2003 außerordentlicher Resonanz – ein
weiterer glänzender Wurf von Fisker,
den Ford auch mit ein paar Entwürfen
zum Aufpolieren der Renommee-Marke
Lincoln betraut. Auch wenn Lincoln 2003
vom Town Car mit 56 566 Einheiten dop-
pelt so viele Wagen auf den US-Markt
geworfen hat wie Chevrolet mit der Cor-
vette, fehlt es der Premium-Marke des
US-Konzerns an optischer Attraktivität,
um außerhalb Nordamerikas Markt-
chancen zu ergreifen.
Neuen Glanz hätten dringend auch die
Produktionsanlagen und Werkshallen
von Newport Pagnell nötig, doch Abriss
und Neubau wären zu kostenintensiv
ausgefallen und außerdem geriete die
Vanquish-Fertigung ins Stocken. Immer-
hin wird mit dem letzten DB7 das viel zu
beengte Werk in Bloxham aufgegeben.

corrigée par Ian Callum ne fasse ses débuts
en 2001, Ulrich Bez l'a fait débarrasser de
toutes les pièces de série en provenance de
la famille Ford, qui ne sont pas « dignes »
d'elle. En outre, il fait procéder Aston
Martin à un impitoyable programme de
tests, comme il y est habitué depuis son
passage chez Porsche. *High-tech* et travail
manuel élevé au rang d'artisanat d'art
exigent un label de qualité, un label que
chaque client obtient sous la forme
d'une plaquette où figure le nom du
contrôleur final.
Sous Ulrich Bez, la coopération entre
Aston Martin et Zagato reprend vie.
Andrea Zagato, le petit-fils du créateur de
la firme, Ugo Zagato, propose, à l'automne
2001, une version spéciale de la DB7 et
obtient le feu vert pour des esquisses qu'il
présente en janvier 2002 et qui sont bien
accueillies. Pour la britannique italienne
avec le *double bubble roof*, Aston reçoit
tant de commandes que l'édition limitée
à 99 pièces se vite épuisée. De même, les
99 Aston Martin Zagato AR (American
Roadster), sur lesquelles le double bossage
se poursuit sous la forme d'un carénage
derrière les appuis-tête, trouvent rapide-
ment preneur.
Aston Martin elle-même met un point
final, en 2003, à l'ère de la DB7 et des ate-
liers de Bloxham, loués jadis de Jaguar,
avec une version GT du modèle le plus
vendu dans l'histoire de la marque. Henrik
Fisker, promu chef styliste, dessine la DB9
et, avec le concours de Ian Callum (qui a
entre-temps rejoint Jaguar), dessine aussi
l'Aston Martin V8 Vantage qui va s'atta-
quer, à partir de 2005, au segment de
marché de Porsche. Au Salon de Genève
2003, le prototype de « petite » Aston
Martin remporte un immense succès –
une autre brillante réussite de Fisker,
auquel Ford a aussi confié quelques
esquisses destinées à redorer le blason de
la célèbre marque Lincoln. Même si, en
2003, Lincoln a, avec 56 566 exemplaires,
commercialisé deux fois plus de Town Car
sur le marché américain que Chevrolet
avec sa Corvette, la marque de prestige
du groupe américain ne possède pas
l'attractivité esthétique qui lui donnerait
des chances sur les marchés extérieurs à
l'Amérique du Nord.
Un bon coup de balai, c'est aussi ce dont
auraient besoin d'urgence les unités de
production et les ateliers d'usine de New-
port Pagnell; mais la démolition et la
reconstruction à partir d'une feuille blan-
che auraient coûté trop cher. En outre,
cela aurait perturbé la fabrication de la
Vanquish. Toujours est-il que l'usine de
Bloxham, beaucoup trop exiguë, est aban-
donnée une fois la dernière DB7 achevée.
Il n'y a qu'une seule alternative à Blox-
ham. Aston fait donc édifier à Gaydon, au
sud de Birmingham, en pleine nature, une
unité de production créée avec le grès à
partir duquel l'on construit les cathédra-
les. Et ce complexe industriel, avec sa
façade tout en galbes derrière laquelle un
atrium accueille les visiteurs, se profile
comme un monument. Derrière la façade :
un ensemble de halls extrêmement com-
pact de seulement 100 mètres de long sur
150 mètres de large. L'art du bâtiment est,
ici, superflu, car il s'édifie est une œuvre
d'art en soi. Le nouvel emblème d'Aston
Martin toise les arrivants depuis un socle

native to Bloxham, and that is built from scratch in Gaydon, to the south of Birmingham, from the material used in building cathedrals. This sandstone complex with a rounded façade, behind which an atrium greets its visitors, rises like a monument. The following, extremely compact hall ensemble measures only 110 x 165 yards. Art for this building complex is superfluous, for it is *per se* an object of art. The new Aston Martin emblem, now with radially aligned feathers, looks down from a 33-foot-high stone pedestal. Moats teeming with newts encircle this well formed industrial plant like a fortress: My home is my castle!

Dr. Bez is pleased with this architecturally successful complex, "the first in our 89 year-long company history to be shaped to the requirements of Aston Martin," in which he has set up his headquarters. Nature receives back more than has been taken from her, for 900 trees and 2000 bushes are planted in the 54 acres of the grounds. A garden landscape outside – artistic ambience inside, totally designed, from the ceiling lighting to the furniture! The first Aston Martin to be built in Gaydon, the DB9, embodies the new era. Despite radical technical change as well, this sports car generation's proportion of hand craftsmanship is still very high. Even the laborious lacquering in several coats is done by hand. The Aston Martin test program is also laborious. No less than 93 DB9 pre-series prototypes had been given a medical examination in extreme conditions, between Death Valley in California and the Arctic Circle in Sweden, while the V8 had to endure the same process.

Aston Martin uses the services of only one robot in Gaydon, to attach the aluminum chassis and body parts. As Prince Charles symbolically tries to begin production in March 2004 (production had started *de facto* in January) by pressing the start button of the production line, nothing happens. Of all possibilities, it is that part of the construction process which does not have the right to strike, that goes on strike!

Für Bloxham gibt es nur eine Alternative, und die wird in Gaydon, südlich von Birmingham, aus der Natur gestampft, errichtet aus dem Material, aus dem man Kathedralen baut. Wie ein Monument erhebt sich dieser Sandstein-Komplex mit seiner abgerundeten Fassade, hinter der ein Atrium den Besucher empfängt. Daran anschließend: ein äußerst kompaktes Hallen-Ensemble von nur 100 x 150 Metern. Kunst an dem Gesamtbau erübrigt sich, denn er ist ein Kunstwerk *per se*. Das neue Aston-Martin-Emblem mit jetzt radial ausgerichteten Federn schaut von einem zehn Meter hohen Steinsockel herab. Wassergräben, in denen sich Molche tummeln, säumen diese wohlgeformte Industrie-Anlage wie eine Trutzburg: *My home is my castle!*

Dieser architektonisch gelungene Komplex »ist der erste unserer 89-jährigen Firmengeschichte, der auf die Bedürfnisse von Aston Martin zugeschnitten ist«, freut sich Dr. Bez, der hier seine Schaltzentrale eingerichtet hat. Die Natur bekommt mehr zurück, als man ihr entriss, denn auf dem gut 22 Hektar großen Betriebs-Grundstück werden 900 Bäume und 2000 Büsche angepflanzt. Gartenlandschaft draußen – künstlerisches Ambiente innen, Design total von der Deckenbeleuchtung bis zum Mobiliar! Der erste in Gaydon gebaute Aston Martin, der DB9, verkörpert die neue Ära. Trotz des Umbruchs auch in technischer Hinsicht ist der handwerkliche Anteil an dieser Sportwagen-Generation noch sehr hoch. Selbst die aufwändige Lackierung in mehreren Schichten erfolgt von Hand. Aufwändig betreibt Aston Martin jetzt auch sein Testprogramm. Nicht weniger als 93 Vorserien-DB9 wurden zwischen dem Death Valley in Kalifornien und dem Polarkreis in Schweden unter Extrem-Bedingungen auf Herz und Nieren überprüft, und der V8 musste sich die gleiche Prozedur gefallen lassen.

Aston Martin bedient sich in Gaydon nur eines einzigen Roboters, der Aluminium-Chassis- und Karosserieteile zusammenklebt. Als Prinz Charles im März 2004 symbolisch die *de facto* schon im Januar erfolgte Fertigung in Betrieb nehmen will und dazu den Startknopf der Montage drückt, rührt sich nichts. Ausgerechnet der, dem ein Streikrecht nicht zusteht, streikt!

de pierre de 10 mètres de haut. Des douves remplies d'eau dans lesquelles s'ébattent des salamandres cernent ce bâtiment industriel aux formes plaisantes comme un château fort : *My home is my castle!*

Ce complexe architectural très réussi « est le premier au cours des 89 ans d'histoire de notre firme qui soit taillé sur mesure pour les besoins d'Aston Martin », déclare, visiblement ravi, Ulrich Bez, qui a installé ici son poste de commande. La nature reçoit plus que ce qu'on lui a pris, car, dans l'enceinte de l'usine qui couvre largement vingt-deux hectares, Aston Martin a fait planter 900 arbres et 2000 buissons. Paysage de jardin à l'extérieur et ambiance artistique à l'intérieur, c'est le règne sans partage du design depuis l'éclairage des plafonds jusqu'au mobilier ! La première Aston Martin construite à Gaydon, la DB9, incarne cette ère nouvelle. Malgré la révolution sur le plan technique, la proportion de travail manuel artisanal dans cette génération de voitures de sport reste encore très élevée. Même la complexe apposition des innombrables couches de vernis s'effectue à la main. Aston Martin réalise maintenant imperturbablement son programme de tests. Pas moins de 93 DB9 de présérie ont été testées jusque dans les moindres détails entre la Vallée de la mort, en Californie, et le cercle polaire, en Suède, dans des conditions extrêmes. Une véritable torture à laquelle la V8 a, elle aussi, dû se plier.

À Gaydon, Aston Martin n'utilise qu'un seul et unique robot, celui qui assemble par collage les éléments en aluminium du châssis et de la carrosserie. Quand le prince Charles a symboliquement mis en service, en mars 2004, la chaîne de fabrication, qui fonctionnait *de facto* depuis janvier déjà, et a appuyé sur le bouton de démarrage de la ligne de montage, rien n'a bougé. Comme par hasard, c'est justement celui qui n'en a pas le droit qui s'est mis en grève !

Aston Martin aims to conquer Porsche terrain – both in motor sport and on the road. The new V8 Vantage, reminiscent of the 911, fits perfectly into this strategy.

Porsche-Terrain – im Motorsport und auf der Straße – will Aston Martin erobern. In diese Strategie passt der neue V8 Vantage, dessen Potential an den 911er erinnert.

Aston Martin veut conquérir le terrain de Porsche – dans le domaine du sport automobile ainsi que sur la route. Le nouveau modèle, le V8 Vantage, dont le potentiel rappelle le 911, s'inscrit dans cette stratégie.

Comeback in Le Mans 2005: the new DBR9 with 600 bhp of which twelve will be built.

Comeback in Le Mans 2005: Der neue DB9R mit 600 PS, von dem zwölf Exemplare aufgebaut werden.

Come-back au Mans en 2005 : la nouvelle DB9R avec 600 ch, qui va être produite à douze exemplaires.

Lionel Martin Series

The two Aston Martins on display at the London Motor Show during the crisis year of 1925 were more than just window dressing for the company, as they showed no discernible trace of timidity or anxiety about the future.

The first of these, available for the ample price of £825, was a boat-shaped sports model, pale yellow with brown wings. Access to the Spartan but elegant cockpit was via a single door, while a hatch over the rear concealed one to two further seats. The power unit, a four-cylinder one and a half liter affair with eight valves and twin overhead cams, impresses even by modern standards.

And then there was a four-seater tourer of equally pleasing lines, available in two attractive shades of red for £725. Its side-valve engine was a familiar design, having been developed in 1921 by the engineer H. V. Robb, previously of Coventry-Simplex, from the very earliest Aston Martin power unit. Robb was not content with a few cosmetic changes, however, increasing the cubic capacity from 1389 to 1487 cc, adding a third bearing to the crankshaft and substituting gearwheels for the camshaft chain of the earlier model. To extract the maximum power from minimum capacity, a high engine speed was called for, and to achieve this particular attention was paid to the lubrication of the massive crankshaft and also to the separately-housed four-speed gearbox as well as the rear axle. For example, before the oil reached the bearings it was forced under high pressure through three interlocking filters. In this form Robb's creation was put rigorously through its paces in two prototype machines before being incorporated into a small production series from 1923 onwards. In other respects not a lot had changed, apart from the fitting of brakes to all four wheels. Huge drum brakes had previously been fitted on the rear wheels only.

The Autocar's issue of 12th March 1921 expresses admiration, describing the Aston Martin as "a carefully designed light car". Among its strengths was the fact that it embodied both the fruit of Lionel Martin's racing exploits and his conservative mindset: the fact that he had cherry-picked the best ideas from a variety of well-known cars meant that little innovative risk was involved. The outcome was a car offering a superb driving experience, a must for the true connoisseur. The magazine cites three things that epitomize the comfort and moderate technological progress that the Aston Martin stood for: the longitudinally adjustable steering wheel, the double compartment fuel reservoir, with a lever permitting access to the reserve tank, and the pads on the axles for the car jack. Naturally, as *The Autocar* wryly noted, all this had to be paid for...

This running-board variant of the company logo helped bring the name Aston Martin to the public eye at the motor shows of the 1920s and 1930s.

Schild-Bürger: Mit dieser Spielart des Firmenlogos auf dem Trittbrett des 11 hp macht Aston Martin zum Beispiel auf den Autoausstellungen der zwanziger und dreißiger Jahre auf sich aufmerksam.

Carte de visite : en apposant le logo de la firme sur la portière de la 11 hp, Aston Martin a trouvé un bon moyen d'attirer l'attention sur elle lors des salons automobiles des années 1920 et 1930.

Die beiden Exponate des Aston-Martin-Standes bei der London Motor Show im Jahr der Krise 1925 gereichen dem Unternehmen nicht nur zur Zierde, sondern sie lassen auch keine Spur von Zaghaftigkeit und Zukunftsangst erkennen.

Da gibt es für den generös bemessenen Preis von 825 Pfund ein bootsförmiges Sportmodell, blassgelb mit braunen Kotflügeln. Zugang zu dem spartanisch, aber nobel ausgestatteten Cockpit gewährt lediglich eine einzige Tür, und unter einer Abdeckung über dem Heck verbergen sich ein bis zwei zusätzliche Sitzgelegenheiten. Vom Feinsten – selbst nach heutigen Maßstäben – ist auch das Triebwerk, ein Vierzylinder mit anderthalb Litern Inhalt, dessen acht Ventile von zwei oben liegenden Nockenwellen zur Arbeit angehalten werden.

Da ist ein viersitziger Tourer von gleichfalls gefälliger Linienführung in zwei attraktiven Rot-Schattierungen, Kostenpunkt 725 Pfund. Sein Motor, dessen Stoffwechsel sich über seitliche Ventile vollzieht, ist ein guter alter Bekannter. Der Ingenieur H. V. Robb, früher einmal zuständig für Produkte von Coventry-Simplex, hat ihn 1921 aus dem Aston-Martin-Triebwerk der ersten Stunde sublimiert. Robb ließ es nicht bei ein paar kosmetischen Retuschen bewenden: Der Hubraum wurde von 1389 auf 1487 ccm aufgestockt. Die Kurbelwelle rotiert in drei Lagern anstatt der bisherigen zwei. Und die Kette, welche die Nockenwelle ursprünglich aktivierte, wurde durch Zahnräder ersetzt. Um aus wenig Hubraum viel Leistung herauszuholen, sind hohe Drehzahlen angesagt. So legte man einen besonderen Schwerpunkt auf optimale Schmierung der massiven Kurbelwelle, aber auch des in einem robusten Gehäuse getrennt untergebrachten Viergang-Getriebes und der Hinterachse. Bevor das Öl die Lager erreicht, wird es zum Beispiel unter hohem Druck durch drei ineinander geschachtelte Filter gepresst.

In dieser Form wird Robbs Kreation im zweiten Prototyp nach Herzenslust gequält, ehe man sie schließlich in die kleine Serie ab 1923 übernimmt. Viel hat man ohnehin nicht geändert, abgesehen von Bremsen an allen vier Rädern, wo

bisher lediglich an der Hinterachse Trommeln von beträchtlichem Querschnitt zu finden waren.

In seiner Ausgabe vom 12. März 1921 zeigt sich *The Autocar* ungemein angetan: Der Aston Martin sei ein sorgfältig konstruiertes leichtes Auto (»a carefully designed light car«). Zu seinem Vorteil flössen in ihm Lionel Martins umfangreiche Rennerfahrung und seine bewahrende Denkungsart zusammen. Da seine Schöpfer nur die besten Ideen hinter einer Vielzahl bekannter Automobile vereinigt hätten, sei man keinerlei innovatives Risiko eingegangen. Herausgekommen sei dabei ein Auto, in dem es sich hervorragend reisen lasse, ein Angebot für den wahren Connaisseur. Drei Dinge nennt das Blatt als Beispiele für die Annehmlichkeiten und den milden Fortschritt, die der Aston Martin verkörpere: die längs verstellbare Lenksäule, den zweigeteilten Tank, der erst nach Umlegen eines Hebels eine Reservemenge Sprit freigibt, und die Widerlager an den Achsen für den Wagenheber. Natürlich, fügt *The Autocar* frisch hinzu, habe das alles seinen Preis …

Les deux modèles exposés sur le stand d'Aston Martin au London Motor Show de l'année de crise 1925 ne font pas seulement honneur à l'entreprise, ils sont bel et bien la preuve que la firme se refuse à temporiser et ne craint pas l'avenir.

Pour 825 livres, on peut s'offrir ce modèle sport à la carrosserie jaune pâle avec des ailes marron et se terminant comme une carène de bateau. Une seule portière donne accès à un cockpit peu spacieux, mais luxueux. Sous un capot à l'arrière se dissimulent un ou deux sièges supplémentaires. Même selon les critères d'aujourd'hui, le moteur est du meilleur cru. Il s'agit d'un quatre-cylindres de 1500 cm³ de cylindrée et dont les huit soupapes sont actionnées par deux arbres à cames en tête.

À ses côtés se trouve une Tourer à quatre places, aux lignes tout aussi séduisantes, avec une carrosserie dans deux jolis tons de rouge, qui coûte 725 livres. Son moteur, où l'échange des gaz s'effectue par des soupapes latérales, est une vieille connaissance. L'ingénieur H. V. Robb, qui a jadis été le père des moteurs Coventry-

Simplex, l'a développé, en 1921, à partir du moteur Aston Martin de la première heure. Mais Robb ne s'est pas contenté de quelques retouches superficielles: il a majoré sa cylindrée de 1389 à 1487 cm³. Le vilebrequin repose sur trois paliers, au lieu de deux normalement. Et la chaîne qui actionnait l'arbre à cames à l'origine est remplacée ici par une cascade d'engrenages. Des régimes élevés sont indispensables si l'on veut obtenir beaucoup de puissance à partir d'une faible cylindrée. Ainsi a-t-on prêté une attention particulière à une lubrification optimale du vilebrequin massif, mais aussi à la boîte à quatre vitesses, logée dans un solide carter séparé, et au train arrière. Avant d'atteindre les paliers, l'huile franchit par exemple, sous une pression élevée, trois filtres successifs.

Dans cette configuration, la création de Robb subit alors de longs tests impitoyables sous le capot du second prototype avant de donner naissance à une construction en petite série à partir de 1923. Les modifications sont des plus réduites. La principale: des freins sur les quatre roues alors que l'on ne trouvait

auparavant des tambours, d'un diamètre imposant, que sur le train arrière.

Dans son numéro du 12 mars 1921, la revue *The Autocar* ne tarit pas d'éloges: l'Aston Martin est une voiture légère et construite avec beaucoup de soin *(a carefully designed light car)*. Elle bénéficie à la fois de la riche expérience de la course de Lionel Martin et de son esprit conservateur. Comme ses créateurs n'ont repris que les meilleures idées caractérisant un grand nombre d'automobiles bien connues à cette époque, il ne leur a pas été nécessaire de courir le risque d'innover. Ainsi ont-ils réalisé une voiture idéale pour les longs voyages, un modèle qui ne pouvait que séduire le véritable connaisseur. La revue cite trois exemples illustrant les avantages et le léger progrès qu'incarne l'Aston Martin: la colonne de direction réglable en profondeur, le réservoir en deux éléments qui ne libère une réserve de carburant qu'après que l'on a basculé un levier, et les renforts ménagés sur les essieux pour le cric. Naturellement, ajoute *The Autocar* avec une franchise désarmante, tout cela a son prix …

A renowned relic from the early years, the Green Pea was known on the continent as the Petit Pois. As the works car of 1922 the Green Pea was intended as Bamford & Martin's answer to the Voiturette formula. The recess to the right of the cockpit created extra room for the braking leg.

Berühmtes Relikt aus den Gründerjahren, zärtlich Green Pea, auf dem Kontinent auch Petit Pois genannt: Als Werkswagen von 1922 ist die grüne Erbse eine Antwort von Bamford & Martin auf die Voiturette-Formel. Die Ausbuchtung rechts des Cockpits schafft mehr Raum für den Bremsfuß.

Relique célèbre des années héroïques, affectueusement surnommée Green Pea, elle a aussi été baptisée « Petit Pois » sur le continent. En tant que voiture d'usine de 1922, elle constitue la réponse de Bamford & Martin à la formule des voiturettes. Le bossage à droite du cockpit permet d'actionner plus librement la pédale de frein.

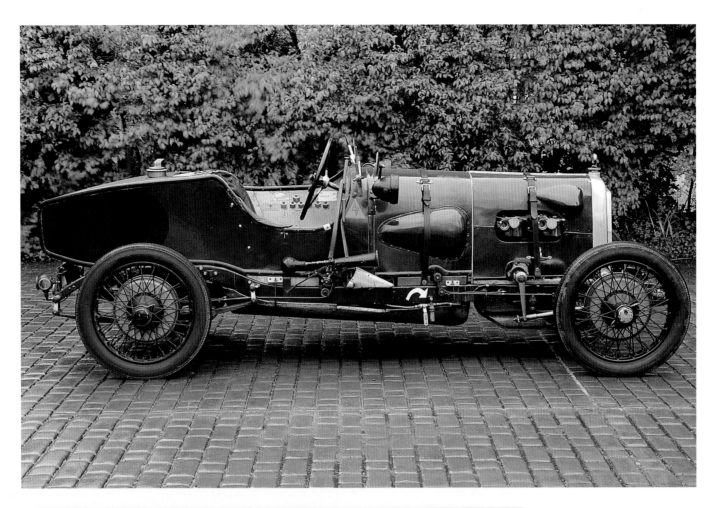

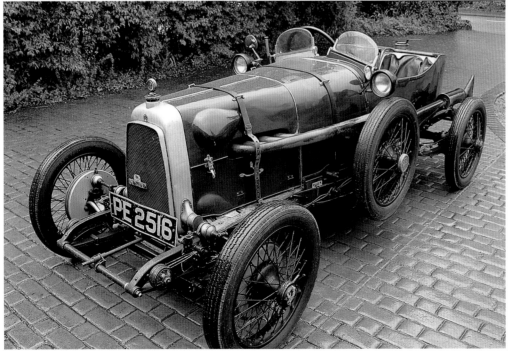

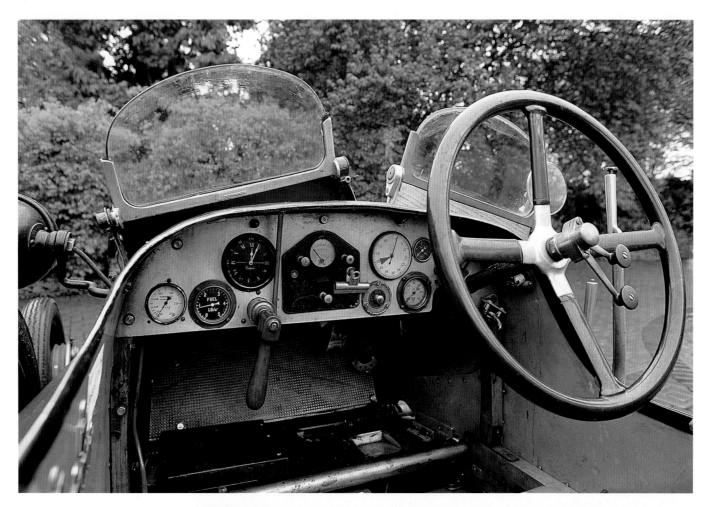

The two handles on the steering column are a manual throttle and ignition point adjuster respectively. Their vertical counterpart was for creating pressure in the gas tank. The step in the form of a stylized company logo is a much later addition. The engine was an eight-valve affair with twin overhead camshafts, designed by the Hon. Roby Benson, later to become Lord Charnwood.

Die beiden Hebel auf der Lenksäule dienen dem Handgas und der Verstellung des Zündzeitpunkts. Mit ihrem vertikalen Pendant lässt sich Druck im Benzintank erzeugen. Das Trittbrett in der Form eines stilisierten Markenzeichens wurde viel später angefügt. Das Triebwerk: ein Achtventiler mit zwei oben liegenden Nockenwellen, entworfen vom Hon. Roby Benson, später Lord Charnwood.

Les deux leviers sur la colonne de direction permettent d'accélérer à la main et de régler l'allumage. Le levier vertical est utilisé pour faire monter la pression dans le réservoir d'essence. Le marchepied avec l'emblème stylisé de la marque a été ajouté beaucoup plus tard. Le moteur est un huit-soupapes à deux arbres à cames en tête dessiné par l'honorable Roby Benson, le futur Lord Charnwood.

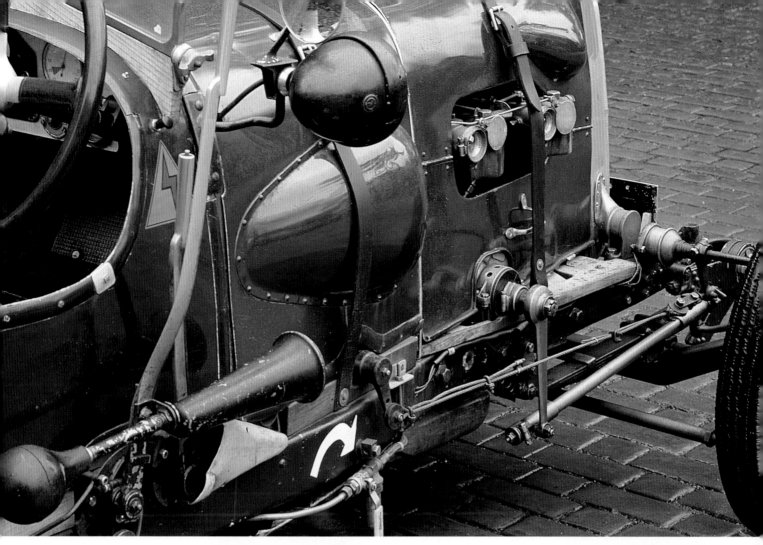

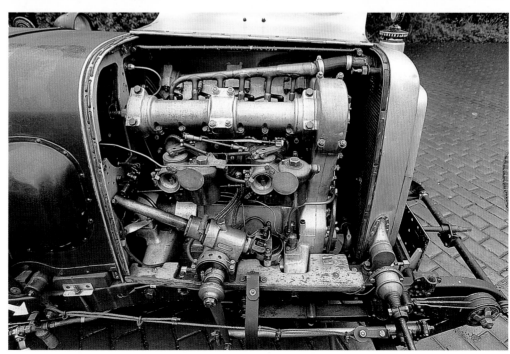

Following double page:
In its simple housing the Green Pea is framed by antiquities far removed from any museum reliability. Ownership alone is not enough. A car of this age needs continual loving care and attention and an ample supply of spare parts.

Folgende Doppelseite:
Höhere Ordnung: In ihrer schlichten Behausung wird die Green Pea von Altertümern fern jeglicher musealen Beständigkeit umrahmt. Der Besitz alleine genügt nicht. Ein Auto dieses reifen Alters verlangt nach Hingabe, ständiger Zuwendung und üppig ausgestatteten Ersatzteillagern.

Double page suivante :
Dans son écrin fruste, le Green Pea est encadré d'antiquités qui n'ont rien à voir avec la solennité d'un musée. La posséder ne suffit pas. Une voiture d'un tel âge demande dévouement, attention de tous les instants et un stock de pièces détachées conséquent.

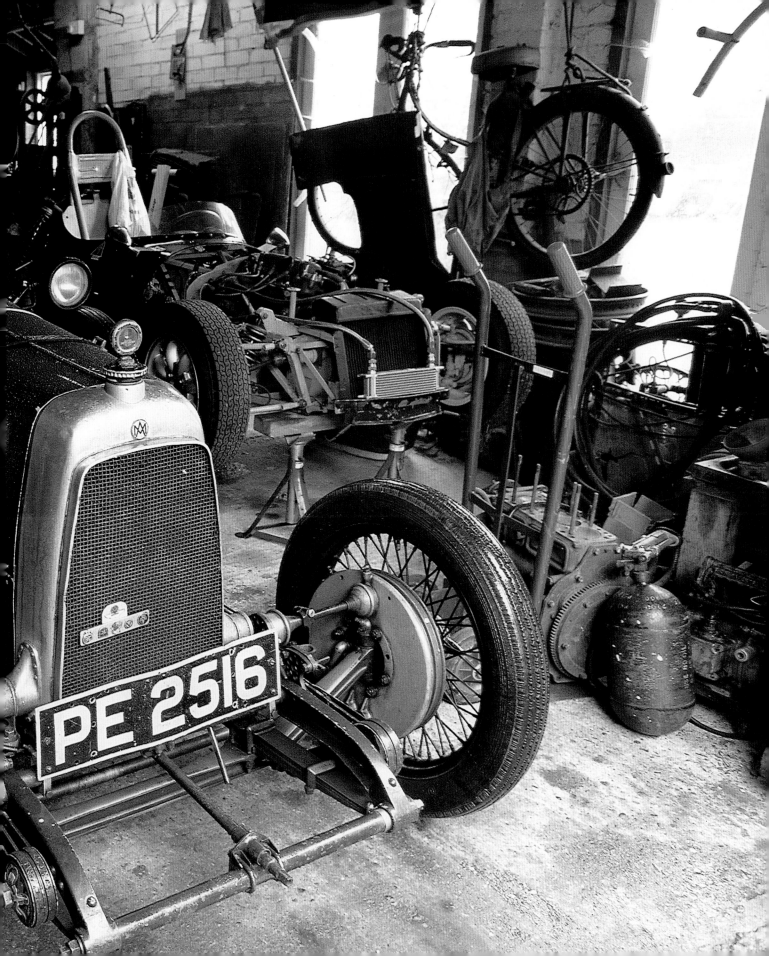

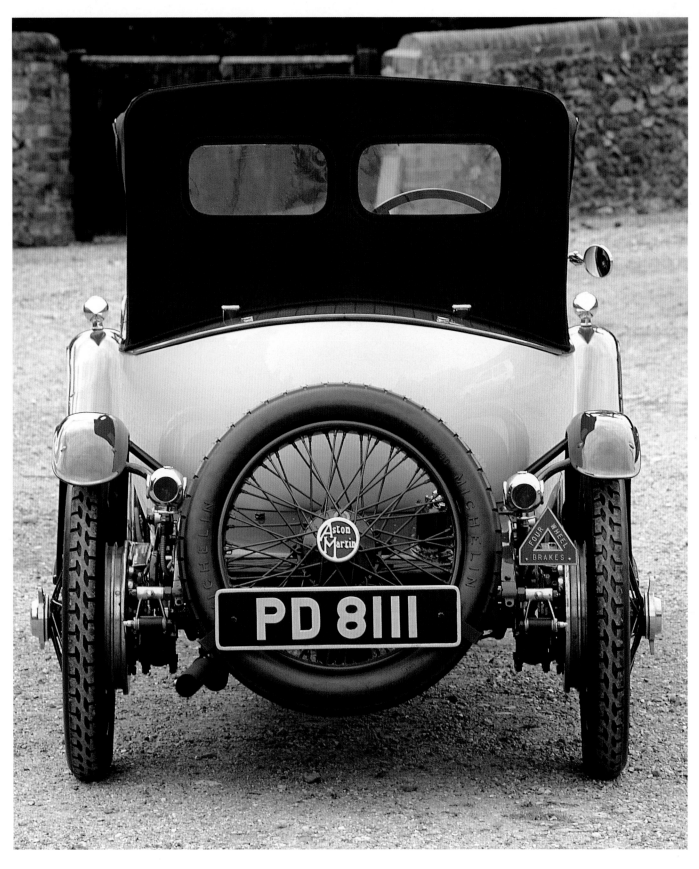

PD 8111

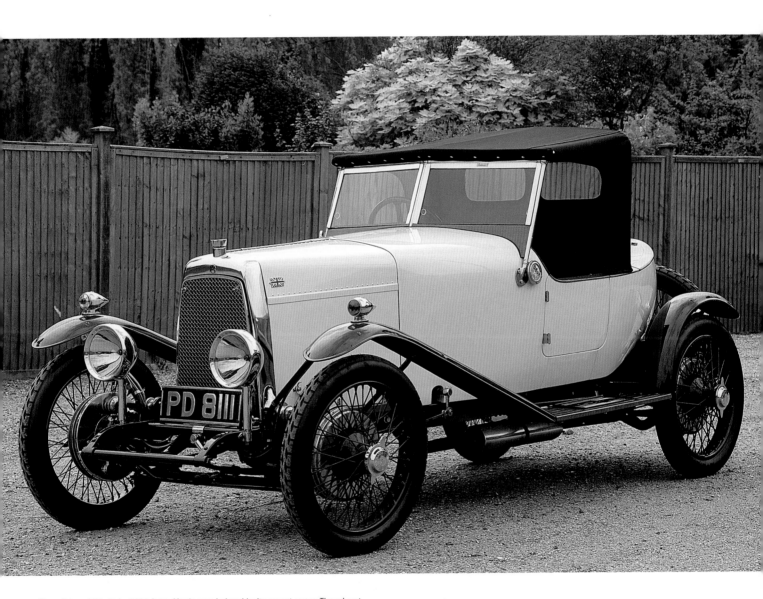

The soft top of this 11 hp 1924 Aston Martin was designed by its current owner. The exhaust system is original apart from its aluminum shielding.

Wohl behütet: Das Verdeck dieses 11 hp Aston Martin von 1924 wurde von seinem jetzigen Eigner entworfen. Die Auspuffanlage entspricht dem Original bis auf eine Aluminiumabdeckung.

La capote de cette Aston Martin 11 hp de 1924 a été dessinée par son actuel propriétaire. Au carénage en aluminium près, le pot d'échappement correspond à celui de l'original.

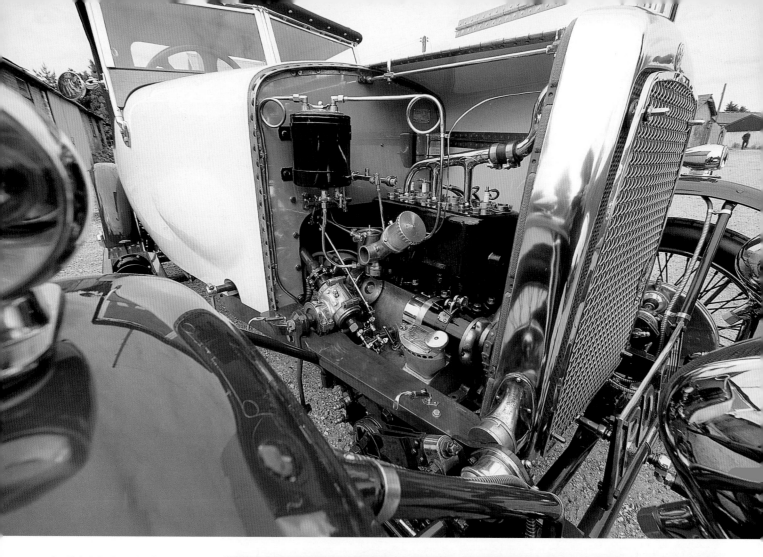

A unified whole: the engine of this early Aston was a four-cylinder side-valve affair of monobloc construction. The steering gear was connected to a multifunction switch operated from the steering wheel. The light alloy plates above the fuse box and on the oil filler neck proudly proclaim that this is an Aston Martin and as such is equipped with unusually efficient brakes.

Wie aus einem Guss: Beim Motor des frühen Aston handelt es sich um einen Vierzylinder mit seitlichen Ventilen in Monoblock-Bauweise. An das Lenkgetriebe schließt sich ein Multifunktionsschalter an, vom Lenkrad her verstellbar. Markenstolz manifestiert sich auf den polierten Leicht-metallplättchen über der Sicherungsbox und auf dem Öleinfüllstutzen.

Le moteur des premières Aston est un quatre-cylindres à soupapes latérales de construction monobloc. Sur le boîtier de direction est greffée une manette multifonctions commandée depuis le volant. De petites plaques d'aluminium poli au-dessus du boîtier de fusibles et sur la goulotte du réservoir d'huile proclament qu'il s'agit d'une Aston Martin, et qu'elle est à ce titre équipée de freins dont l'efficacité n'est plus à démontrer.

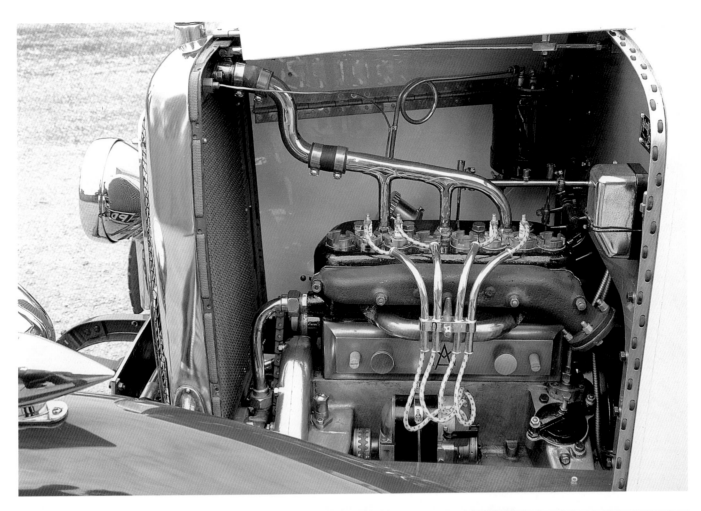

Part of the front suspension with the brake rod leading into the drum and the crank handle. Toward the rear the cap on the spare wheel and a sign make clear that this Aston Martin has four wheel brakes.

Teile der Vorderradaufhängung mit in der Trommel mündender Bremsstange und Handkurbel. Nach hinten warnen die Kappe auf dem Rerserverad sowie ein ausdrücklicher Hinweis, dass es sich um einen Aston Martin mit Vierradbremse handelt.

Éléments de la suspension avant avec la mâchoire de frein mordant sur le tambour et la manivelle. À l'arrière, le couvre-moyeu de la roue de secours et un triangle de signalisation indiquent que cette Aston Martin est dotée de freins sur les quatre roues.

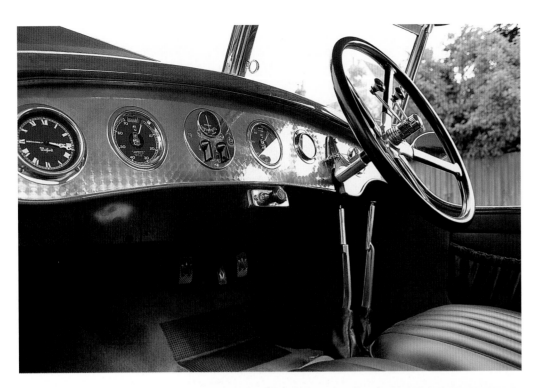

Long-term solutions: the streamlined clearance lamps fitted on the wings are reminiscent of the later T-Type. The two handles on the steering wheel perform the same function as in the Green Pea. The boat-like rear end is unconventional to say the least. It all appears to have been made for eternity, the little plate with the name of the current owner giving the very same impression.

Langfristige Lösungen: Auf den Kotflügeln thronen stromlinienförmige Positionslampen wie am späteren T-Type. Die beiden Hebel am Lenkrad erfüllen die gleichen Aufgaben wie an der Green Pea. Die Interpretation des Bootshecks ist eigenwillig, fast beim Wort genommen. Das scheint alles wie für die Ewigkeit gemacht, und verewigt hat sich auch der gegenwärtige Besitzer.

Des solutions qui perdureront : sur les garde-boue trônent des feux de position aérodynamiques comme sur la future Type T. Les deux manettes sur le volant ont le même but que sur la Green Pea. L'arrière façon bateau est pour le moins anticonventionnel. Tout semble conçu pour l'éternité, et le propriétaire actuel s'y est aussi immortalisé en faisant graver son nom sur une plaque.

International

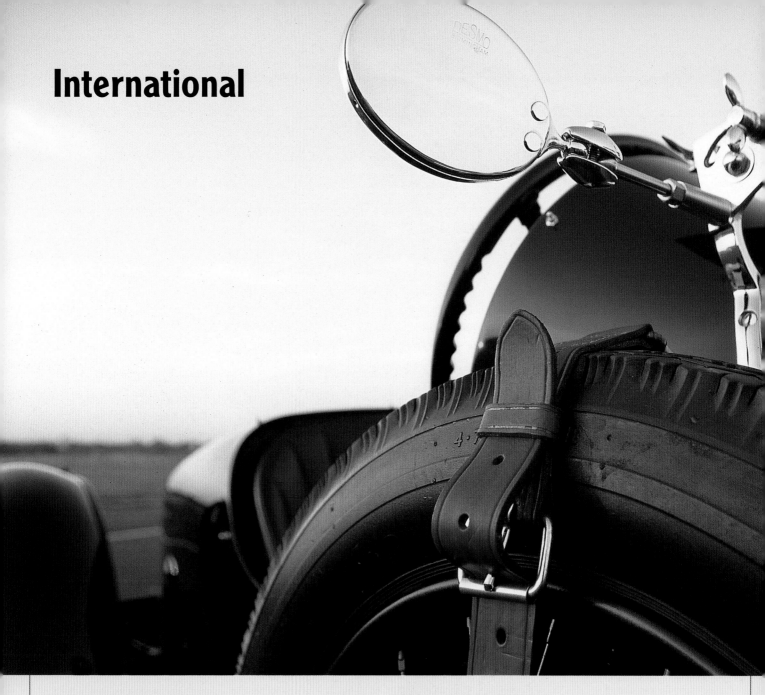

The International was so named because it met the requirements of the international motorsport governing body AIACR (Association Internationale des Automobile Clubs Reconnus).

Seinen weltläufigen Namen erhält der International, weil er den Bestimmungen der Motorsport-Legislative AIACR (Association Internationale des Automobile Clubs Reconnus) entspricht.

L'International doit son nom au fait qu'elle respecte les dispositions de l'Association internationale des Automobile Clubs reconnus, l'AIACR, l'autorité de tutelle de la compétition automobile.

The philosophy brought by Cesare Bertelli to the reformed Aston Martin Motors in October 1926 was simple but daunting: with his kind of car you should be able to motor in comfort to Le Mans, compete unscathed in the 24-hour race and then drive contentedly back home again.

Bertelli brought with him an engine created by his colleague Claude Hill, who was to do Aston Martin long years of service. As if he had anticipated the preferences of his new employer, Hill had opted for the standard one-and-a-half liter engine volume plus a three-bearing crankshaft and a chain-driven overhead camshaft. This unit initially proved its reliability in a used Enfield-Allday chassis before Cesare Bertelli's brother

Enrico added simple, but attractive, bodywork at Feltham.

The first Aston Martins since the change of ownership made their appearance at the London Motor Show in 1927. They comprised a saloon and a tourer with a long chassis plus a sporty short-chassis version. Bertelli now wasted no time in putting his Le Mans doctrine to the test. Sadly, the two works cars LM1 (for Le Mans) and LM2 failed to cover themselves in glory at the 1928 staging of the Sarthe marathon race. The LM1, driven by Bertelli himself in tandem with George Eyston, retired ignominiously after an accident. Despite this they met with a positive reception, probably due to the technical refinements they had to offer, such as the underslung frame

which kept the car low and compact, and the dry sump lubrication. The latter was incorporated in 1929 into the International, available in a Sports version for £475 or as a saloon at £595. Evidence of the direct feedback from the race circuit came in the form of the tuned Ulster engine, available to the keen motorist from 1930 onwards as a £50 optional extra. The hefty aluminum brake drums ensured that this quirky and temperamental compact Aston Martin could quickly be reined in.

The Autocar issue of 18th September 1931 had especial praise for the smooth running of the engine, which lost nothing in comparison with a good six-cylinder power unit, though the magazine went on to note that sensitive souls might object to the cheerful prattling noise emanating from the exhaust. Even from low revs in fourth gear the test car demonstrated satisfactory acceleration and a ready response to the driver's actions. Also excellent were the drive position from the bucket seats, the direct steering and the roadholding, while the short, stubby gearshift was a pleasure to operate, its shifting gate unmistakably mapping out the path of the gears.

A year later the same magazine went still further, proclaiming that the Aston Martin was one of the few cars that makes one's heart beat faster, and noting that its magic resided in the fact that it was the product of painstaking hand craftsmanship rather than soulless mass production.

Die Philosophie, die Cesare Bertelli in die Neugründung der Aston Martin Motors im Oktober 1926 einbringt, ist kurz und inhaltsschwer: Mit einem Auto nach seinen Vorstellungen müsse man kommod nach Le Mans anreisen, das 24-Stunden-Rennen unbeschadet überstehen und sich wieder vergnügt auf den Heimweg begeben können.

Als konkrete Mitgift steuert er ein Triebwerk seines Mitarbeiters Claude Hill bei, der Aston Martin auf lange Zeit erhalten bleiben wird. Gewissermaßen in vorauseilendem Gehorsam hat sich Hill für das Standardvolumen von anderthalb Litern entschieden. Die Kurbelwelle ist dreifach gelagert, die oben liegende Nockenwelle wird vermittels einer Kette aktiviert. Seine Tauglichkeit stellt es zunächst in einem gebrauchten Enfield-Allday-Chassis unter Beweis, bevor es von Cesare Bertellis Bruder Enrico in Feltham schlicht und schön eingekleidet wird.

Ihre Aufwartung machen die ersten Aston Martin nach dem Wachwechsel an der Spitze bei der London Motor Show 1927, ein Saloon und ein Tourer auf einem Langchassis, eine sportliche Version auf einem kurzen. Und schon schickt sich Bertelli an, sein Le-Mans-Diktum in die Tat umzusetzen. Die beiden Werkswagen LM (für Le Mans) 1 und LM2 bedecken sich bei dem Sarthe-Marathon 1928 keineswegs mit Ruhm. Der LM1, abwechselnd von Bertelli selber und George Eyston gefahren, muss sogar nach einem Unfall vorzeitig die Segel streichen. Gleichwohl ist die Rezeption positiv, schon wegen der technischen Appetithäppchen, die sie zu bieten haben: der Unterzugrahmen zum Beispiel, der es gestattet, den Aufbau niedrig und gedrungen zu halten, und die Trockensumpfschmierung. Diese wird in das Modell International von 1929 übernommen, welches für 475 Pfund als Sports und zum Gegenwert von 595 Pfund als Saloon zu haben ist. Von der unmittelbaren Rückkoppelung mit dem Rennsport zeugt der getunte Ulster-Motor, der ab 1930 für den ambitionierten Lenker um 50 Pfund mehr als Option angeboten wird. Große Bremstrommeln aus Aluminium gewährleisten, dass man das quirlige Temperament des kleinen Aston energisch an die Kandare nehmen kann.

The Autocar vom 18. September 1931 lobt besonders die Umgänglichkeit und Laufruhe der Maschine, die einem guten Sechszylinder nicht nachstehe. Unter Umständen könnten allerdings empfindliche Leute Anstoß nehmen an dem freundlichen Gebrabbel seines Auspuffs. Selbst aus niedrigen Drehzahlen im vierten Gang habe sich der Prüfling problemlos beschleunigen lassen. Hervorragend seien die Position, die man in seinen Schalensitzen einnehmen könne, die direkte Lenkung sowie die Straßenlage. Gerne betätige man das kurze, trotzige Knüppelchen, dessen Weg durch eine Schaltkulisse unmissverständlich vorgezeichnet sei.

Ein Jahr später sattelt die gleiche Publikation noch einmal drauf: Der Zauber des Aston Martin bestehe darin, dass er das Produkt altehrwürdigen Handwerks sei und nicht seelenloser Massenfertigung.

La philosophie adoptée par Cesare Bertelli lors de la renaissance d'Aston Martin Motors, en octobre 1926, est claire et nette, mais elle est lourde de conséquences : avec une voiture telle qu'il l'imagine, on devrait pouvoir se rendre au Mans, franchir le drapeau en damier à l'issue de la course des 24 Heures et, ensuite, le cœur en fête, reprendre la route pour rentrer chez soi.

En guise de dot, il dépose dans la corbeille de mariage un moteur conçu par son collaborateur Claude Hill et dont Aston Martin fera son fonds de commerce pendant longtemps. Comme par prémonition, Hill a opté pour la cylindrée classique d'un litre et demi. Le vilebrequin est à trois paliers et l'arbre à cames en tête est entraîné par une chaîne. Il administre la preuve de sa vaillance dans un châssis d'occasion d'Enfield Allday avant qu'Enrico Bertelli, le frère de Cesare Bertelli, ne l'habille plus tard, à Feltham, d'une robe sobre, mais magnifique.

Après la relève de la garde, les premières Aston Martin font leur révérence comme voitures de sport au London Motor Show de 1927, avec une Saloon et une Tourer à châssis long ainsi qu'avec une version sportive à empattement court. Et déjà, Cesare Bertelli veut appliquer sa volonté de courir au Mans. Les deux voitures officielles, les LM1 et LM2 (LM pour Le Mans) sont loin de se couvrir de gloire lors du marathon sur le circuit sarthois en 1928. La LM1, pilotée par Bertelli lui-même et George Eyston, doit même regagner prématurément son garage après un accident. L'accueil qui leur est réservé n'en est pas moins positif, ne serait-ce qu'en vertu des innovations techniques qui les distinguent : le châssis surbaissé qui leur permet de disposer d'une carrosserie basse et compacte, ainsi que la lubrification à carter sec. Le modèle International de 1929, proposé au prix de 475 livres en version Sports et au prix de 595 livres en version Saloon, reprendra ce type de lubrification. Le moteur Ulster, plus puissant, présenté en option à partir de 1930 pour un supplément de 50 livres, est une retombée directe de la course. De grands tambours de freins en aluminium sont la garantie de pouvoir à tout moment juguler le tempérament expansif de la petite Aston.

La revue *The Autocar* du 1er février 1929 loue la souplesse et la douceur de fonctionnement de son moteur. Les gens délicats pourraient toutefois s'offusquer des aboiements trop généreux de son pot d'échappement. Même à bas régime en quatrième, la voiture accélère toujours sans s'étouffer, précise la revue. La position de conduite que l'on peut adopter dans ses sièges baquets est remarquable, tout comme la direction, directe, et la tenue de route. C'est avec grand plaisir que l'on actionne le petit et solide levier de changement de vitesses dont le cheminement dans la grille ne prête jamais à confusion.

Un an plus tard, la même revue enfonce le clou : pour elle, l'Aston Martin figure parmi les voitures qui font battre le plus fort le cœur des amateurs. Sa séduction réside dans le fait qu'elle est le produit d'un travail artisanal traditionnel et non pas un objet de fabrication industrielle anonyme.

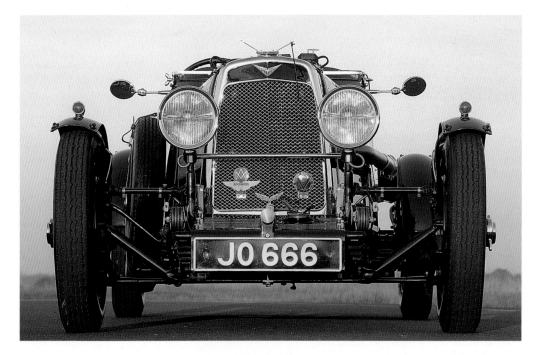

Built for speed: the two-seater betrays its competitive nature with the tapered rear and Brooklands exhaust. Storage space behind the rear seat and in front of the spare wheel is extremely limited.

Für schnelle Zwecke: Vom Wettbewerbscharakter des Zweisitzers zeugen sein Spitzheck und der Brooklands-Auspuff. Hinter den Rücksitzen vor dem Einzugsbereich des Reserverads gibt es nur wenige Ablagemöglichkeiten.

Dédiée à la vitesse : l'arrière pointu et l'échappement Brooklands trahissent la vocation sportive de cette biplace. Entre les sièges arrière et la roue de secours, il n'y a qu'un petit espace de rangement pour de menus objets.

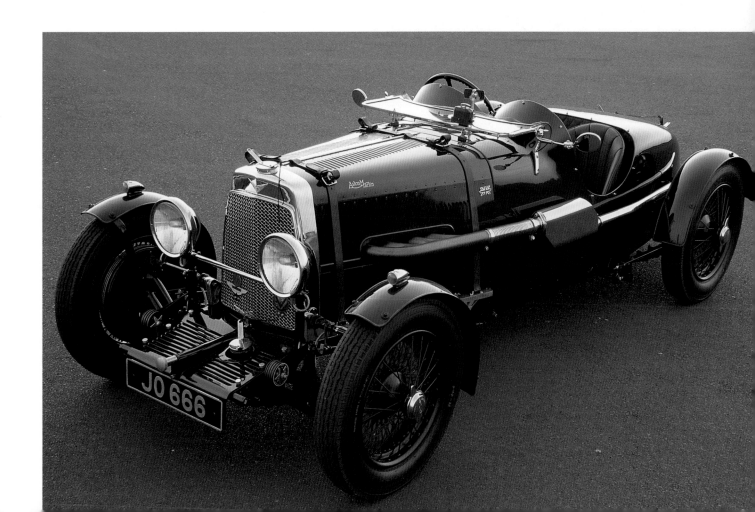

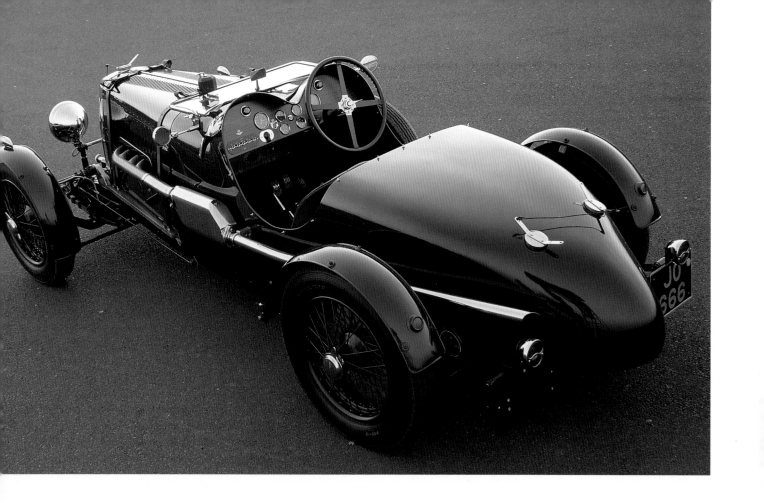

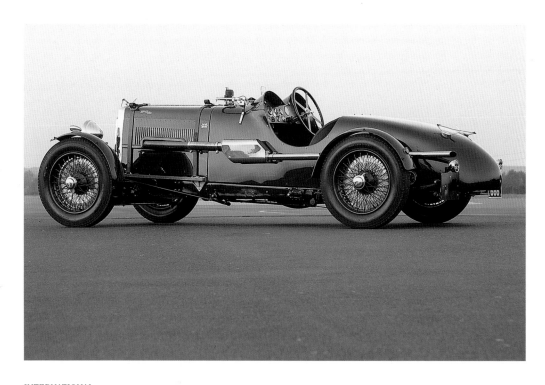

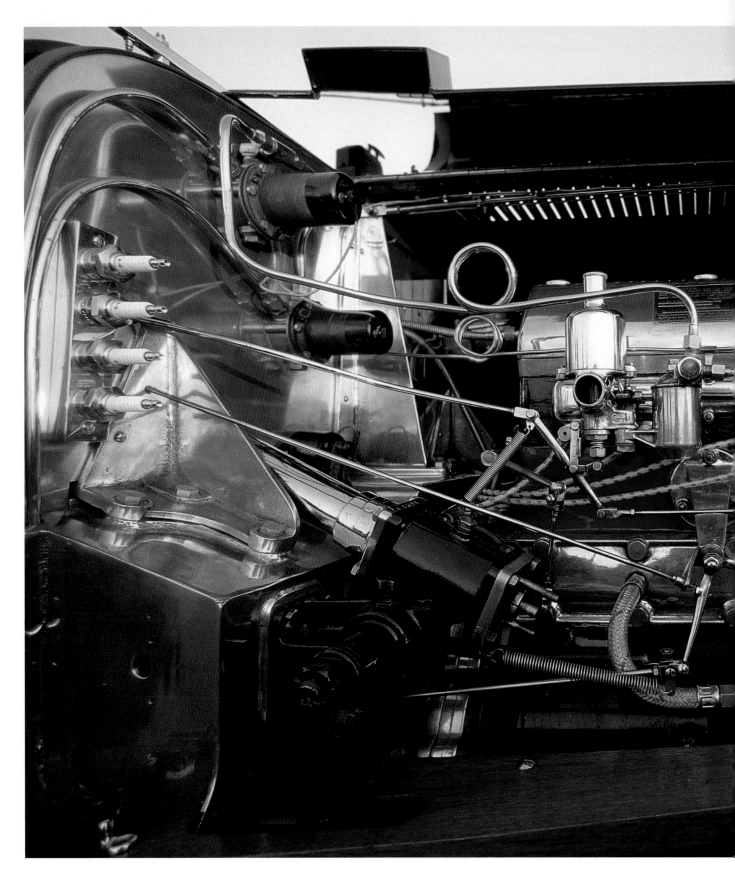

Characteristic of the International:
Claude Hill's four-cylinder engine with
one overhead camshaft and dry-sump
lubrication.

Typisch für den International:
Der Vierzylinder Claude Hills mit einer
oben liegenden Nockenwelle und
Trockensumpfschmierung.

Typique de l'International : le quatre-
cylindres de Claude Hill à arbre à cames
en tête et la lubrification à carter sec.

Le Mans

Cesare Bertelli must sometimes have felt like a sailor aboard a sinking ship. Having become Aston Martin Limited in 1929, the small company was struggling in heavy seas and seemed to be threatened by the inclement weather in the wake of the Wall Street Crash in October of that year. The original management team fell abruptly apart, as first Charnwood father and son stepped down, soon to be followed by W. S. Renwick. However, various more-or-less good Samaritans came to the rescue, such as Frazer-Nash proprietor H. J. Aldington for a period in 1931, or the London Aston-Martin dealer Lance Prideaux-Brune in 1932. And then the show was put definitively back on the road when Newcastle shipping magnate Sir Arthur Sutherland came to the rescue of the sinking vessel. In light of this shaky background a radical restructuring was called for. Just 130 Aston Martins had been sold since 1926, hardly enough to put the company on a solid footing, and on top of that vital resources had been drained off by motorsport, which had always been part and parcel of the creed of the marque, but in economic terms was of little more value than an attractive pub sign: it looks good, but it doesn't bring home the bacon. Prideaux-Brune put his finger on the solution. The production costs had to be cut in order to reduce the asking price, but without compromising the solid quality reputation of the product. Thus for example, for the second generation of Internationals, which appeared in February 1932, Aston Martin dispensed with some expensive in-house components by, for example, going back to the Laycock transmission with its direct connection to the engine. The 60 horsepower New International was available in long- and short-chassis versions. In style it very much resembled its predecessor, but met with little public approbation, selling a mere dozen.

The Le Mans met with greater success. This car, construction of which was initiated by the Sutherlands, developed a hefty 70 horsepower and was available as a long-chassis four-seater, as a 2/4 seater, or as a two-seater costing £595, some £120 more than the International Sports. A striking feature was the small, low-set radiator, presenting a much smaller cross section to the wind. As usual the crankshaft was a heavy, solid affair, while the four pistons were made of a light magnesium alloy which could withstand a higher compression ratio than the customary aluminum. Two electric pumps conveyed the fuel to the engine, while a switch allowed the driver to choose whether one or both of the pumps were in operation. One of them, incidentally, was responsible for the two-gallon reserve tank. The brakes, owing much of their efficiency to voluminous, finned drums, did their job without servo assistance. The steering wheel featured all the latest refinements, providing hand controls for the lights, gas and the ignition.

A Le Mans of the second Bertelli series from February 1932 to December 1933. The large instruments nestle comfortably in voluminous recesses.

Ein Le Mans der zweiten Bertelli-Serie vom Februar 1932 bis zum Dezember 1933. Große Armaturen erteilen ihre Auskünfte in voluminöse Ausbuchtungen eingebettet.

Une Le Mans de la seconde série de Bertelli construite de février 1932 à décembre 1933. Grands cadrans bien intégrés aux galbes du tableau de bord.

Manchmal muss sich Cesare Bertelli wie ein Lotse vorgekommen sein, der an Bord eines sinkenden Schiffs gestiegen ist. 1929 zur Aston Martin Limited umgewidmet, krängt das kleine Unternehmen in schwerer See und wird arg gebeutelt von den Sturmböen im Sog des Wall Street Crash im Oktober jenes Jahres. Das ursprüngliche Führungskollektiv bröckelt rasch ab. Erst steigen Vater und Sohn Charnwood aus, dann W. S. Renwick. Aber auch mehr oder weniger barmherzige Samariter stellen sich ein wie 1931 eine Zeit lang Frazer-Nash-Eigner H. J. Aldington und 1932 der Londoner Aston-Martin-Händler Lance Prideaux-Brune. Einigermaßen Fahrt nimmt man erst wieder auf, nachdem sich Sir Arthur Sutherland, Schiffsmagnat in Newcastle, des stolzen Havaristen erbarmt hat.

Vor diesem düsteren Hintergrund zeichnet sich eine radikale Neuorientierung ab. 130 Aston Martin sind seit 1926 unter die Leute gebracht worden, ohne dass Hand-Werk goldenen Boden gehabt hätte. Überdies hat der Rennsport eine Menge Geld verschlungen, seit jeher unverzichtbarer Bestandteil im Glaubensbekenntnis der Marke, aber von der Wirkung eines attraktiven Wirtshausschilds: Es sieht schön aus, trägt aber nichts ein. Prideaux-Brune gibt die Losung aus, man müsse den Preis und somit die Produktionskosten senken. Die solide Qualitätsanmutung des Produkts dürfe gleichwohl nicht angetastet werden. Folglich greift man zum Beispiel beim International der zweiten Generation im Februar 1932 auf ein Laycock-Getriebe zurück, das unmittelbar an den Motor geflanscht ist, und verzichtet somit auf die entsprechende teurere Komponente aus dem eigenen Hause. Auf einem langen und auf einem kurzen Chassis erhältlich und 60 PS stark, lehnt sich der New International formal an seinen Vorgänger an, erfährt allerdings lediglich eine Verbreitung von einem Dutzend.

Mehr Erfolg beschieden ist dem Typ Le Mans, dessen Bau die Sutherlands angestoßen haben. Er bringt stämmige 70 PS auf die Bremse und kann als Viersitzer auf dem Langchassis und als 2/4-Sitzer geordert werden. Als Zweiplätzer – eine dritte Variante – kostet er 595 Pfund, 120 mehr als der International Sports.

Auffällig ist der kleinere und niedrigere Kühler, der dem Fahrtwind viel weniger Angriffsfläche bietet. Die Kurbelwelle ist wie üblich schwer und solide, das Quartett der Kolben leicht, aus einer Magnesiumlegierung, die eine höhere Kompression aushält als das sonst verwendete Aluminium. Treibstoff wird dem Triebwerk durch zwei elektrische Pumpen zugeführt. Mit einem Schalter können wahlweise beide zugleich beziehungsweise die eine oder die andere aktiviert werden. Eine Pumpe ist überdies für das neun Liter fassende Reservoir zuständig. Die Bremsen, von voluminösen gerippten Trommeln beherbergt, kommen ohne Servohilfe aus, da sie auch so gut ansprechen und kraftvoll zupacken. Den letzten Stand der Dinge verkörpert das Lenkrad – mit Fingerkontrollen für Licht, Gas und Zündung.

Parfois, Cesare Bertelli a pu avoir l'impression de piloter un bateau susceptible de couler à tout moment. Rebaptisée Aston Martin Limited en 1929, la petite entreprise tangue sur une mer agitée et frôle parfois la catastrophe sous les coups de boutoir des vagues déclenchées par le krach boursier de Wall Street de cette année-là. L'équipe directoriale originale voit plusieurs de ses membres la quitter successivement. À commencer par le père et le fils Charnwood, qui lui tournent le dos, puis W. S. Renwick. Mais des samaritains plus ou moins miséricordieux viennent à son secours comme en 1931, pendant un certain temps, H. J. Aldington, le propriétaire de Frazer-Nash et, en 1932, Lance Prideaux-Brune, un concessionnaire Aston Martin de Londres. Le bâtiment ne reprend de la vitesse sur une mer plus calme qu'après que Sir

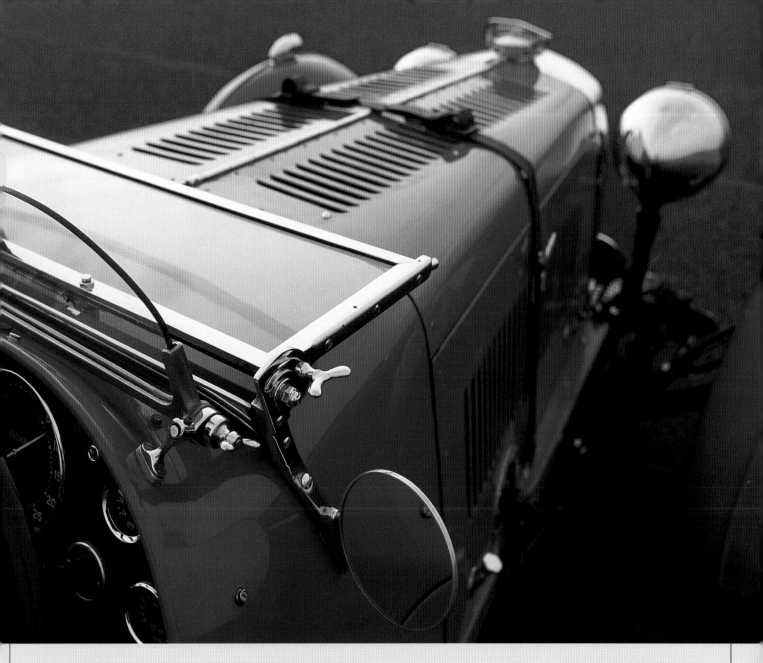

Arthur Sutherland, magnat de l'industrie des chantiers navals à Newcastle, a été apitoyé par le sort du jadis fier navire.

Un changement de cap décisif se produit dans ce contexte peu encourageant. Depuis 1926, 130 Aston Martin ont trouvé preneur sans que la firme ait fait fortune pour autant. En outre, la compétition automobile a englouti des sommes colossales et, si elle est depuis toujours le credo indéfectible de la marque, ses effets sont comparables à ceux d'une belle enseigne à l'entrée d'un bon restaurant. Cela a de l'allure, mais ne rapporte pas grand-chose. Prideaux-Brune énonce un postulat : il faut revoir le prix à la baisse et pour cela réduire les coûts de production. Mais il ne faut pas pour autant nuire à la réputation de qualité du produit. Un exemple en est donné lors de la présentation de l'International de la deuxième génération en février

1932 : on recourt en effet à une boîte de vitesses Laycock qui fait bloc avec le moteur, renonçant ainsi à des composants maison beaucoup plus onéreux. Sur le plan esthétique, la New International, qui est proposée au choix avec un châssis long ou court et un moteur de 60 ch, s'inspire de sa devancière, mais ne sera produite qu'à raison d'une douzaine d'exemplaires.

Le modèle Le Mans, dont les Sutherland ont été à l'origine de la construction, remportera plus de succès. Il ne développe pas moins de 70 ch au frein et peut être commandé en version quatre-places à châssis long ou en une version à 2/4 places. En version deux-places – troisième variante – il coûte 595 livres, 120 de plus que l'International Sports.

Il se distingue par un radiateur plus compact et plus bas, qui diminue donc la résistance à l'avancement. Comme de

coutume, le vilebrequin est lourd et solide alors que le quatuor de pistons est très léger puisqu'ils sont fabriqués dans un alliage de magnésium qui permet un taux de compression plus élevé que l'aluminium généralement utilisé à cette époque. Deux pompes électriques approvisionnent le moteur en carburant. Un basculeur permet au choix d'actionner les deux pompes simultanément ou, au contraire, séparément. Une pompe est en outre reliée à la réserve, dont la capacité est de 9 litres. Les freins, à l'abri derrière de volumineux tambours à rainures, sont démunis de toute assistance, car ils font preuve d'un mordant inné et d'une efficacité suffisante. Le volant, quant à lui, propose tous les perfectionnements techniques possibles – avec des touches que l'on actionne du bout des doigts pour l'éclairage, l'alimentation et le retard ou l'avance à l'allumage.

Following double page: Seen from this perspective the ice-blue Le Mans radiates the poignant charm of a bygone age. However, when the weather is good this grizzled old racer will still deliver pure driving pleasure for two.

Folgende Doppelseite: Aus dieser Perspektive gesehen strömt der eisblaue Le Mans den ganzen Charme der alten Zeit aus. Dennoch: Bei schönem Wetter vermittelt der betagte Renner noch heute pure Freude am Fahren für zwei.

Double page suivante : vue sous cet angle, la Le Mans bleu de France irradie du charme de la Belle Époque. Et pourtant, par beau temps, cette vénérable voiture de course est aujourd'hui encore un gage de pur plaisir pour rouler à deux.

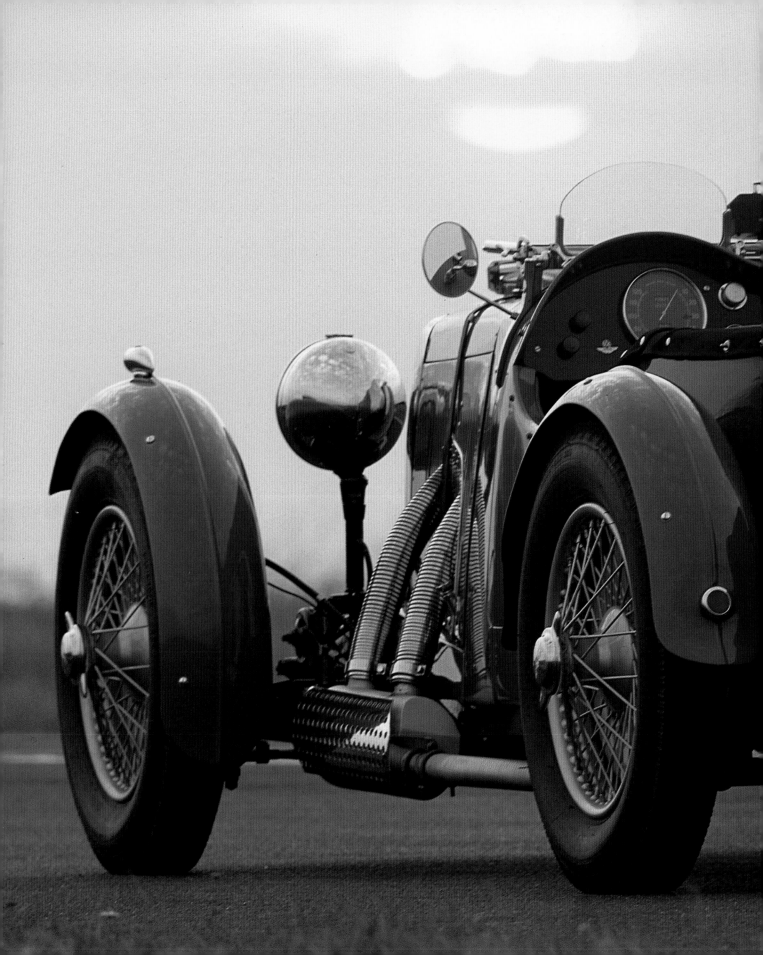

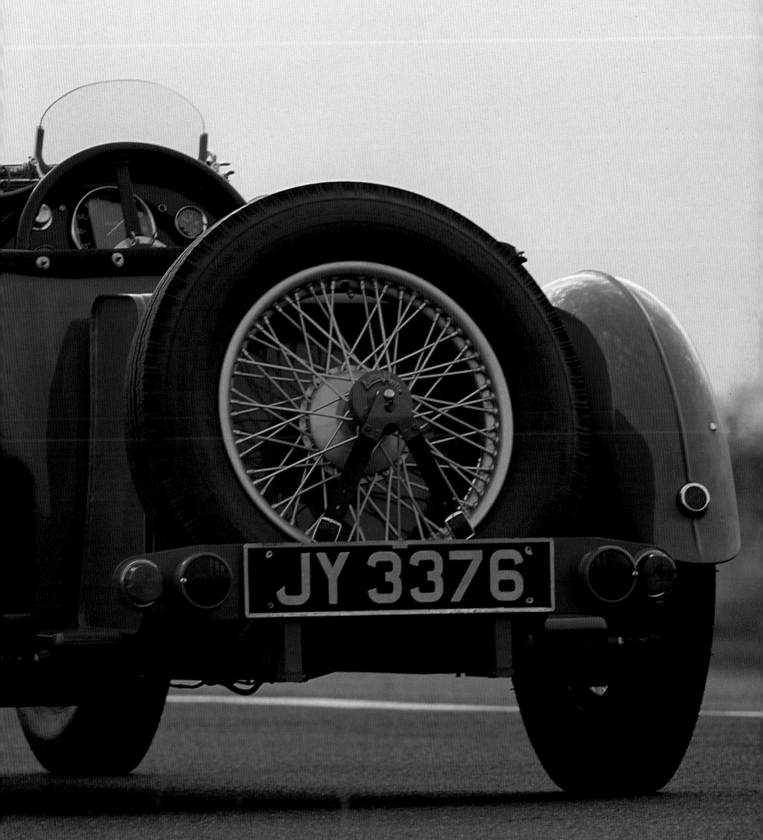

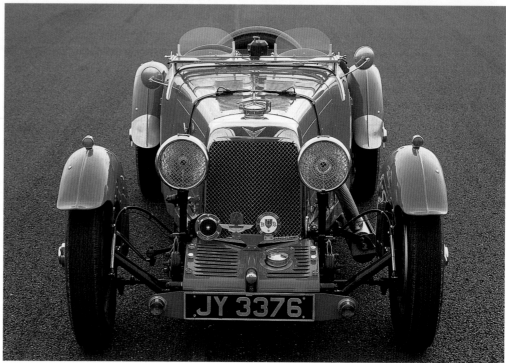

The filling necks for the water, oil and gasoline are sealed by clamps fastened with an ingenious hinged mechanism. The rev counter is in the driver's field of vision, while the less important tachometer is in the co-driver's. Reserve spark plugs stand ready for use next to the four-cylinder engine.

Die Einfüllstutzen für Wasser, Öl und Benzin werden von Bügeln mit einem ingeniösen Klappmechanismus gekrönt. Im Blickfeld des Fahrers liegt der Drehzahlmesser, in dem des Copiloten der weniger wichtige Tachometer. In der Nachbarschaft des Vierzylinders stehen Reservezündkerzen für ihren Einsatz bereit.

Les goulottes des réservoirs d'eau, d'huile et d'essence sont couronnées par des étriers avec un ingénieux mécanisme de fermeture. Dans le champ de vision du pilote, le compte-tours et, dans celui du copilote, le tachymètre, moins important. Des bougies de réserve montent la garde à proximité immédiate du quatre-cylindres.

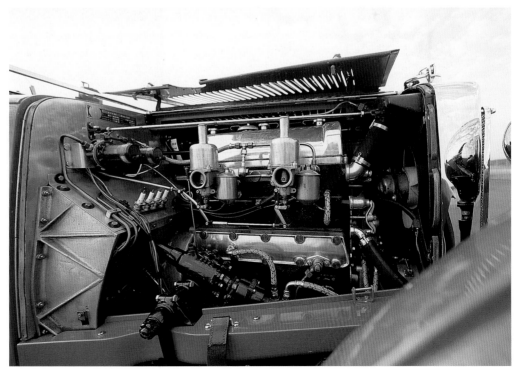

Mark II
& Ulster

After the 1932 takeover, the Aston Martin management divided their responsibilities in accordance with their inclinations, with Bertelli tending to the sports and racing cars, and Arthur and Gordon Sutherland aiming to give the somewhat rough-and-ready Aston Martins rather more refinement and sophistication in an attempt to broaden their market appeal.

Their influence was first felt in the Mark II, and 166 specimens of this product of the new era were sold between January 1934 and December 1935. It featured an open body placed on the short chassis of the Le Mans. Despite the car having the appearance of a four-seater, the rear seats were in reality little more than additional luggage space. It cost £610, while an extra £30 bought you the saloon version, whose unusually long 3048 millimeter wheelbase meant that the passengers in the second row could sit comfortably in front of the rear axle. This feature also allowed the roof line to be lowered, contributing to the car's sleek lines, as did the very slight front and rear overhangs. For £700 a drophead coupé incorporating an intricate roof construction was available on the same chassis.

The frame had been strengthened and stiffened and the two front Hartford frictional shock absorbers were mounted transversely rather than longitudinally so that the outer arms were now directly coupled to the wheel carriers and thus to the extremities of the axles. This markedly improved the road-holding, especially when cornering on bumpy roads.

The tight-fitting motorcycle-style front mudguards which responded to the steering were retained despite the fact that dispensing with them would have reduced the car's unsprung mass. This allowed the car's low nose to be retained, a long-standing design feature which the company was loath to dispense with. As a respectful reviewer wrote in *The Autocar* of 7th September 1934, an Aston Martin never shocked by brutal innovation, rather it was always a link in the chain of a gradual evolutionary process.

The same applies to the Mark II's power unit, which went about its business with the discretion of an English film butler, once the bulky crankshaft had been correctly balanced. *The Autocar* was particularly impressed with the visual beauty of the small four-cylinder engine. The lubrication system was also inspiring, one pump feeding nine liters a minute to the bearings, while a second forced the oil back into the tank. A striking feature was the thermo-statically-controlled radiator louver in place of the usual wire grille. The brakes were still cable-operated, and were as striking in their outward appearance as they were notable for their efficiency, their huge Alfin drums completely filling the 18-inch wheel rims. And they had plenty of work to do: *The Autocar* recorded a top speed of 85 mph for the 2/4-seater with the windscreen folded down, while the saloon reached 81 mph.

The moderating influence of the Sutherland father and son are apparent on the Mark II. It is significantly more comfortable, featuring door handles among other things. The dashboard is no longer topped by bulges and populated with modest-sized instruments. The right-hand door is cut away, enabling the driver to rest his arm comfortably.

Am Mark II lässt sich der besänftigende Einfluss von Vater und Sohn Sutherland nachweisen. Er wartet mit deutlich mehr Komfort auf, zum Beispiel Türgriffen. Die Armaturentafel ist wieder gerade und mit kleinen Instrumenten besetzt. Die rechte Tür ist tiefer ausgeschnitten, damit der Fahrer den Unterarm lässig in die so entstehende Bucht lagern kann.

La Mark II trahit l'influence apaisante des Sutherland père et fils. Elle offre nettement plus de confort avec, par exemple, des poignées de portière. Le tableau de bord est de nouveau rectiligne et héberge des cadrans de plus petites dimensions. La portière du côté droit est plus profondément échancrée. Le conducteur peut ainsi s'en servir confortablement comme d'un accoudoir.

While the Mark II had to incorporate a variety of concessions in order to finally get some money coming in to the Aston Martin coffers, Cesare Bertelli and the men around him had free rein to do as they pleased with the Ulster, which made up just 21 of the total Mark II population. It made an inauspicious start at the 1934 Le Mans race, drawing a total blank as all three works cars retired with apparently trivial technical faults. Bertelli saw red, literally, ordaining that the cars be painted that color rather than the traditional British Racing Green when competing in Northern Ireland's Ulster Tourist Trophy. This seemed to help, as T. S. Fotheringham came third, with two further Aston Martins occupying 6th and 7th places, sufficient to win the team prize, and at the same time providing the new model with its name. At that year's London Motor Show the Ulster was added to the product range, presented as a special offer for amateur racers at an

affordable £750. Its engine was the apotheosis of the 1.5 liter, with a compression of 9.5:1, polished ports and two large carburetors boosting it to 80 horsepower at 5200 rpm.

The low-slung, sleek two-seater Ulster presented a remarkably small cross section to the wind, while the wedge-shaped rear bulged out at the bottom to accommodate the spare tire which is stowed horizontally on the floor. For extra speed, the front windscreen could be folded down and replaced by two wind deflectors. The heavily-populated dashboard extended well into the front passenger's area, and notified him among other things of the time of day and the speed. As a works brochure proudly proclaimed, the top speed is a mighty 100 mph. The horizontal array of airplane switches operated with a satisfying snap. Protruding from the middle of the enormous four-spoke steering wheel was a long lever allowing the driver to set the ignition point.

A flared racing exhaust pipe thickening in a Brooklands silencer protruded from an opening in the hood. Rumbling noises emanated from this similar to those of a a three-liter Bentley engine, and they were accompanied by the gentle nasal whine from the transmission. The front passenger had to be alert: anyone unwittingly supporting himself by grabbing hold beyond the lower door frame while getting in or out of the car would get a burnt hand for his trouble. Although the Ulster's large and powerful Girling brakes provided efficient deceleration from high speeds, when driving at a moderate pace they were rather reluctant to respond.

Modest changes were made to the model in 1935, the radiator being further reduced in size, the previously straight bonnet slightly bent over the mature four-cylinder engine. Now in its prime, it developed an impressive 85 horsepower – but its days were numbered.

Nach dem Revirement von 1932 teilt die Aston-Martin-Doppelspitze das Terrain gemäß ihren Neigungen untereinander auf: Bertelli verlegt sich auf die Sport- und Wettbewerbswagen, Arthur und Gordon Sutherland möchten den eher rauen Naturburschen im Zeichen des Flügels mehr Kultur anerziehen und damit zugleich einen neuen Markt erschließen.

Ihre pädagogische Arbeit fließt zunächst in den Mark II ein, der zwischen Januar 1934 und Dezember 1935 in 166 Exemplaren vom Geist der neuen Zeit kündet. Auf das kurze Chassis des bisherigen Le Mans setzt man einen offenen Aufbau, der wie ein Viersitzer ausschaut, hinten jedoch unter einer Abdeckung lediglich zwei Notunterkünfte beziehungsweise mehr Gepäckraum oder Ablagemöglichkeiten vorsieht. 610 Pfund kostet dieser 2/4-Plätzer, 30 mehr ein Saloon mit dem ungewöhnlich langen Radstand von 3048 Millimetern. Die rückwärtigen Passagiere reisen komfortabel vor der Hinterachse. Überdies kann die Dachlinie auf diese Weise abgesenkt werden, ebenso bekömmlich für die Silhouette wie die ganz geringen Überhänge vorn und hinten. Mit 700 Pfund schlägt ein Drophead Coupé auf dem gleichen Chassis mit einer aufwendigen Dachkonstruktion zu Buche.

Den Rahmen hat man verstärkt und versteift, die beiden Hartford-Reibungsstoßdämpfer vorn quer statt längs eingebaut, so dass die äußeren Arme nun direkt an die Radträger und damit die extremen Enden der Achse angelenkt sind. Das zeigt deutliche Verbesserungen in der Straßenlage, vor allem wenn der Aston Martin mit eingeschlagenen Vorderrädern auf einen Buckel trifft.

Obwohl die ungefederten Massen hätten verringert werden können, behält man die eng anliegenden Motorrad-Kotflügel vorn bei, die den Bewegungen der Lenkung folgen: So lässt sich die Stirnfläche niedrig halten, und auf ein gewachsenes Stückchen Tradition mag man nicht so einfach verzichten. Ein Aston Martin, schreibt der einfühlsame Rezensent in *The Autocar* vom 7. September 1934, schockiere nie durch brutale Neuerung, sondern sei stets ein Glied im Prozess fortwährender Evolution.

Dieser ist auch das Triebwerk des Mark II unterworfen, das seinen Dienst mit der Diskretion eines englischen Filmbutlers versieht. Sehr angetan zeigt sich *The Autocar* davon, wie aufgeräumt sich der kleine Vierzylinder dem Blick darbietet. Für seine Durchblutung ist hervorragend gesorgt: Neun Liter werden pro Minute von einer Pumpe gegen die Lager gepresst und von einer zweiten in den Öltank zurückgedrückt. Auffällig ist die thermostatisch kontrollierte Kühlerjalousie an der Stelle des gewohnten Drahtgeflechts. Die Bremsen werden noch immer über Kabel bedient. Ebenso eindrucksvoll wie die Verzögerung, die sie gestatten, wirkt ihre optische Präsenz: Riesige Alfin-Trommeln füllen die 18-Zoll-Felgen gänzlich aus. Es gibt ja auch viel zu tun: 137 Stundenkilometer Spitze misst *The Autocar* für den 2/4-Sitzer mit heruntergeklappter Scheibe, 130 Stundenkilometer für den Saloon. Pflicht – und Kür: Während mit dem Mark II eine

Menge Konzessionen gemacht werden müssen, damit endlich einmal Geld ins Haus kommt, dürfen die Männer um Cesare Bertelli bei dessen höchster Sublimationsstufe Ulster nach dem Lustprinzip verfahren. Man merkt es dem Auto an, das mit 21 Exemplaren in der Mark-II-Population vertreten ist. Seine Geschichte beginnt 1934 in Le Mans mit einem schmählichen Totalausfall, als die drei Werkswagen scheinbar trivialen technischen Defekten erliegen. Bertelli sieht Rot, und in Rot statt des traditionellen British Racing Green lässt er deshalb die Fahrzeuge für die Tourist Trophy in der irischen Provinz Ulster umlackieren. Das hilft: T. S. Fotheringham wird Dritter, zwei weitere Aston Martin finden sich auf den Plätzen sechs und sieben und verhelfen der Marke zum Teampreis – und zum Namen für das neue Modell. Auf der London Motor Show im gleichen Jahr wird es der Produktpalette angefügt, als Sonderangebot für den Freizeit-Rennfahrer zu erschwinglichen 750 Pfund. Sein Triebwerk ist die Apotheose des 1,5-Liters, der sich nun dank einer Kompression von 9,5:1, polierter Kanäle und zweier großer Vergaser zu 80 PS bei 5250/min aufschwingt. Der Ulster setzt dem Fahrtwind eine bemerkenswert kleine Stirnfläche entgegen, ist niedrig und so schlank, wie es seine zweisitzige Auslegung gestattet. Das keilförmig zulaufende Heck weitet und rundet sich über dem Reserverad, das waagerecht am Boden lagert. Die Frontscheibe lässt sich umlegen und für schnelle Zwecke durch zwei Windabweiser ersetzen. Die üppige Besiedelung des Armaturenbretts erstreckt sich bis vor den Beifahrer, der unter anderem über die Uhrzeit auf dem Laufenden gehalten wird und über die Geschwindigkeit, die der Pilot im Augenblick einzuschlagen für richtig hält. Bis zu 100 Meilen pro Stunde sind zu erzielen, wie eine Werksbroschüre vollmundig verheißt. Die zahlreichen Flugzeugschalter, waagerecht in einer Reihe angeordnet, lassen sich mit sinnlichem Knacken umlegen. Aus der Mitte des gewaltigen Vierspeichen-Lenkrads wuchert ein langer, gekröpfter Hebel hervor, mit dem der Zündzeitpunkt vor- und zurückverlegt werden kann.

Splitternackt geht aus der vielfach durchbrochenen Motorhaube vorn links ein Rennauspuff hervor, verdickt sich in einem Brooklands-Schalldämpfer und mündet in ein weit sich auffächerndes Endstück. Diesem entströmt ein Kollern ähnlich dem Dreiliter-Bentley-Renntriebwerks, wozu sich das zarte nasale Weinen des Getriebes gesellt. Der Beifahrer muss auf der Hut sein: Wer sich beim Grätschen oder Hocken über die niedrige Bordkante noch einmal unbedacht aufstützt, verbrennt sich die Finger. Vermittels seiner großen Girling-Bremsen lässt sich der Ulster aus hohen Geschwindigkeiten glänzend verzögern, während sie bei mäßiger Gangart nur unwillig ansprechen.

Im Zuge sanfter Modellpflege wird 1935 der Kühler noch einmal verkleinert, und die vormals gerade Haube krümmt sich leicht über den Vierzylinder darunter. In der Blüte seiner Jahre leistet er nun 85 PS. Nur: Seine Tage sind gezählt.

Après la redistribution des cartes en 1932, les hommes à la tête d'Aston Martin se partagent le terrain en fonction de leurs goûts respectifs : Bertelli se concentre sur les voitures de sport et de compétition alors qu'Arthur et Gordon Sutherland décident de rendre un peu plus raffinés et sophistiqués les autres véhicules, encore un peu frustes, ce qui, par la même occasion, leur permettra de conquérir un nouveau marché.

Leur zèle se traduit tout d'abord par l'arrivée de la Mark II, qui, produite à 166 exemplaires entre janvier 1934 et décembre 1935, annonce l'esprit d'une ère nouvelle. Le châssis court de l'ancien modèle Le Mans est coiffé d'une carrosserie découverte qui ressemble à celle d'une quatre-places, mais n'héberge cependant à l'arrière, sous un capot, que deux petits sièges d'appoint ou un espace supplémentaire pour les bagages. Cette 2/4 places coûte 610 livres, et 30 de plus pour une Saloon à l'empattement à la longueur inhabituelle de 3048 mm, et où les passagers arrière peuvent voyager confortablement devant le train arrière. Cela permet également d'abaisser la ligne de toit et est tout aussi bénéfique à sa silhouette que les très faibles portes-à-faux avant et arrière. Il faut débourser 700 livres pour s'offrir, sur un châssis identique, un Drophead Coupé au système de toit sophistiqué.

Le châssis a été renforcé et rigidifié et les deux amortisseurs à frictions Hartford sont montés en position transversale avant et non plus longitudinale, si bien que les bras extérieurs attaquent maintenant directement les moyeux de roues et, donc, les extrémités de l'essieu.

Il aurait été possible de réduire les masses non suspendues si l'on n'avait pas conservé les ailes montées sur les tambours de frein et qui suivent les mouvements de la direction. Cela autorise en revanche une vitesse de pointe supérieure, sans oublier qu'il n'est jamais simple de renoncer à ce qui symbolise une tradition profondément enracinée. Une Aston Martin, écrit un journaliste plein de bon sens dans *The Autocar* du 7 septembre 1934, ne choque jamais par une innovation brutale, mais représente toujours une étape dans un processus d'évolution permanente.

Un processus auquel est aussi soumis le moteur de la Mark II, qui accomplit sa tâche avec la discrétion d'un majordome anglais. *The Autocar* ne tarit pas d'éloges tant le petit quatre-cylindres séduit le regard par son architecture. Sa bonne santé thermique est garantie : une pompe fait gicler 9 litres d'huile par minute sur les paliers et une seconde fait revenir le lubrifiant dans le réservoir à huile. La différence extérieure la plus visible consiste en des volets de radiateur à commande thermostatique qui remplacent le grillage de calandre habituel. Les freins possèdent toujours une commande à câble. Leur apparence est aussi impressionnante que la décélération qu'ils autorisent. De gigantesques tambours Alfin remplissent le moindre centimètre des jantes de 18 pouces. Lors d'une série d'essais, *The Autocar* mesure une vitesse de pointe de 137 km/h pour la

2/4 places avec le pare-brise rabattu et de 130 km/h pour la Saloon.

Alors que la Mark II a obligé à faire de nombreuses concessions pour que de l'argent renfloue les caisses, l'équipe de Cesare Bertelli a pu laisser libre cours à son ambition pour l'Ulster, qui en est la forme la plus sophistiquée. Cette voiture ne représente que 21 exemplaires parmi toutes les Mark II. Son histoire débute au Mans en 1934 par une débâcle, des défaillances techniques mineures ayant condamné à l'abandon les trois voitures officielles. Bertelli voit rouge et, pour conjurer le mauvais sort, décide de faire peindre en rouge, à la place du British Racing Green, les voitures qu'il a inscrites au départ du Tourist Trophy, dans la province irlandaise de l'Ulster. Et ça marche : T. S. Fotheringham termine troisième et deux autres Aston Martin arrivent respectivement aux sixième et septième places, ce qui permet à la marque de remporter la coupe par équipe, et de donner un nom au nouveau modèle. Au London Motor Show de cette année-là, il est proposé en offre spéciale destinée aux pilotes de course amateurs pour le prix modique de 750 livres. Son moteur est l'apothéose du 1,5 litre et développe maintenant 80 ch à 5250 tr/min grâce à un taux de compression de 9,5:1, des tubulures polies et deux gros carburateurs.

L'Ulster est très aérodynamique grâce à sa carrosserie plus étroite et plus basse et, également, en vertu de sa conception de pure biplace. L'arrière en forme de carène de bateau s'élargit à la base et dissimule la roue de secours placée à l'horizontale sur le plancher. Le pare-brise est rabattable et peut être remplacé par deux déflecteurs lorsque l'on veut rouler plus vite. Le tableau de bord est couvert de cadrans qui vont jusque devant le siège du passager. Il est possible d'atteindre la vitesse de 100 miles à l'heure, soit plus de 160 km/h, comme le promet fièrement une brochure publicitaire. Les manettes d'avion, alignées à l'horizontale et étiquetées, s'actionnent dans un claquement sec et plaisant. Au centre de l'imposant volant à quatre branches trône un long levier recourbé qui permet d'avancer ou de retarder l'allumage.

Nu comme un ver, un échappement course sort par une ouverture sur le côté avant gauche du capot moteur et rejoint un épais silencieux Brooklands avant de se terminer par une sortie d'échappement en queue de poisson. Celle-ci laisse entendre des borborygmes dignes d'un moteur de course de Bentley 3-litres égayés par le ronronnement à tonalité nasale de la boîte de vitesses. Il est recommandé au passager d'être sur ses gardes : s'il s'appuie trop sur la carrosserie en montant à bord ou en se penchant, il risque de se brûler les doigts. Grâce à d'immenses freins Girling, l'Ulster décélère très efficacement à grande vitesse alors que les freins ont tendance à briller par leur inefficacité à un rythme moins soutenu.

En 1935, le radiateur voit sa taille diminuer une nouvelle fois et le capot est désormais légèrement incliné au-dessus du quatre-cylindres. Dans la fleur de l'âge, il affiche une puissance de 85 ch. Mais ses jours sont comptés.

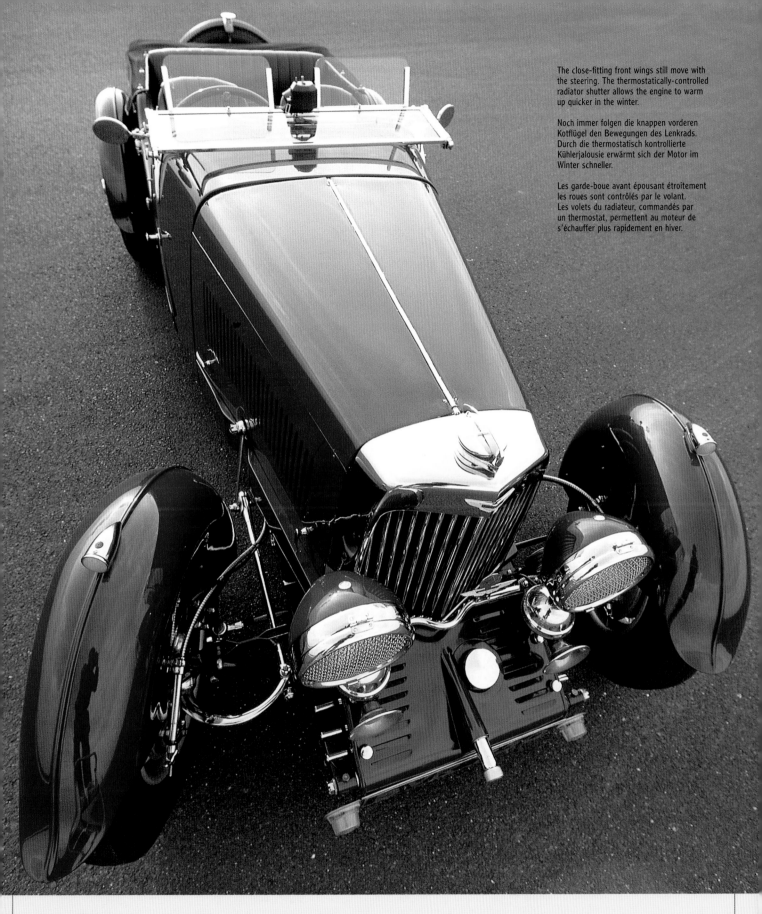

The close-fitting front wings still move with the steering. The thermostatically-controlled radiator shutter allows the engine to warm up quicker in the winter.

Noch immer folgen die knappen vorderen Kotflügel den Bewegungen des Lenkrads. Durch die thermostatisch kontrollierte Kühlerjalousie erwärmt sich der Motor im Winter schneller.

Les garde-boue avant épousant étroitement les roues sont contrôlés par le volant. Les volets du radiateur, commandés par un thermostat, permettent au moteur de s'échauffer plus rapidement en hiver.

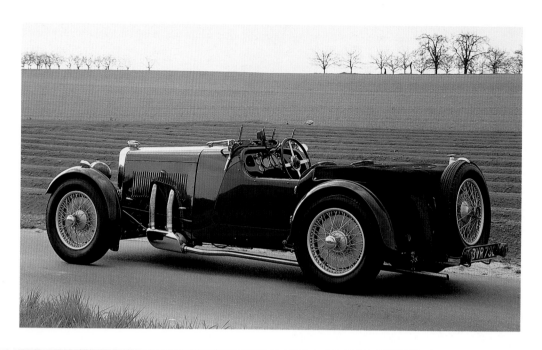

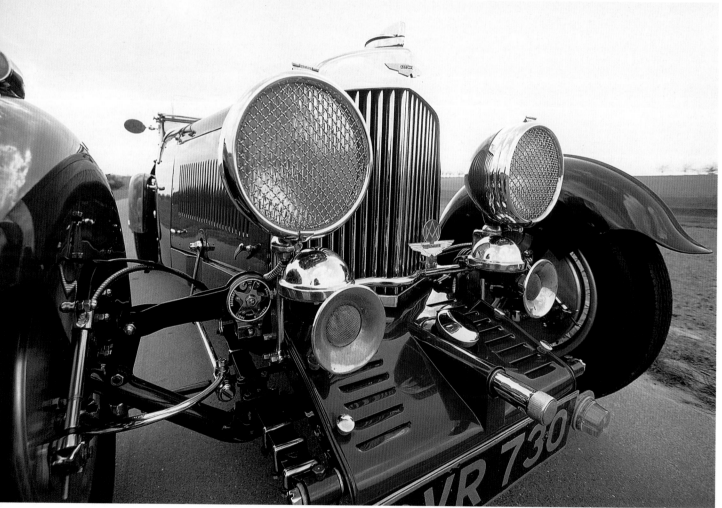

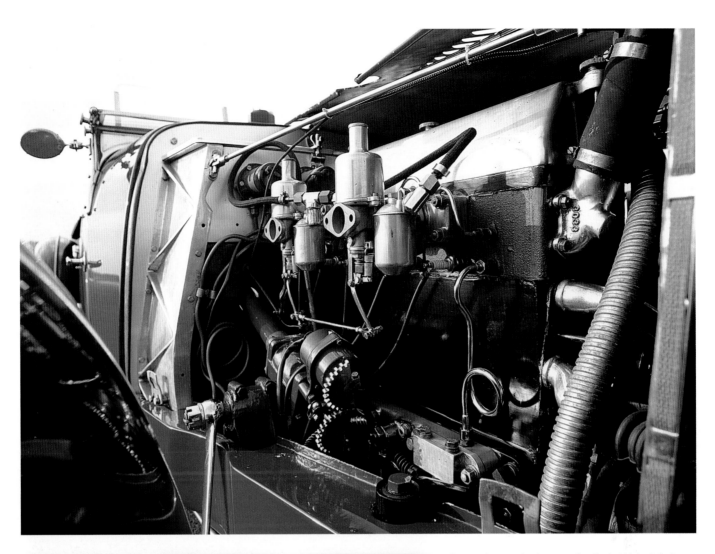

Transversely-mounted and easy-to-adjust Hartford frictional shock absorbers improve the roadholding. The oil gallery has got smaller and the oil filter system has been markedly improved.

Quer zur Fahrtrichtung eingebaute und leicht zu verstellende Hartford-Reibungsstoßdämpfer verbessern die Straßenlage. Kleiner geworden ist die Ölgalerie, spürbar optimiert das Ölfiltersystem.

Des amortisseurs à friction Hartford montés en position transversale et aisément réglables améliorent la tenue de route. Le circuit d'huile est maintenant moins volumineux et le système de filtre à huile a été nettement optimisé.

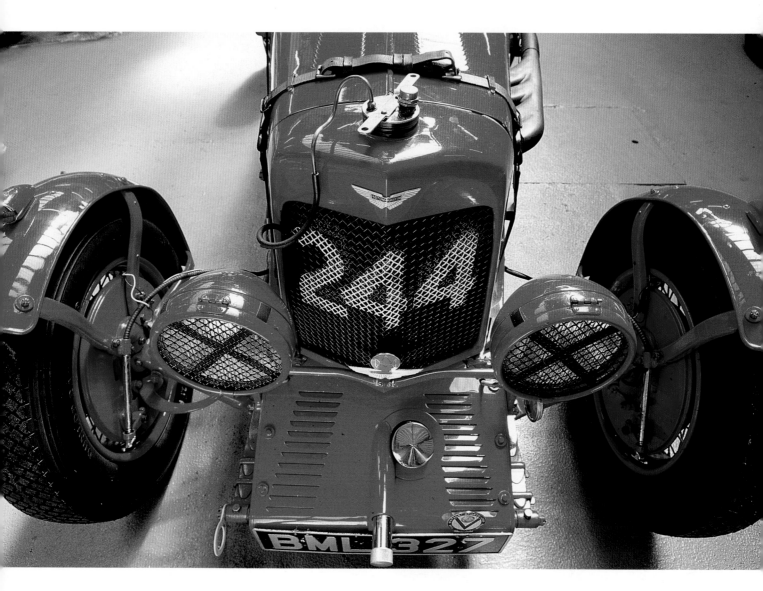

Change of colors: Bertelli's wife Vera was behind the red of the Ulster. British Racing Green had hitherto brought nothing but misfortune, and so Bertelli went for the racing colors of his land of birth, Italy. A distinctive characteristic is the semicircular horizontal recess for the spare wheel.

Farbe gewechselt: Die Anregung für das Rot des Ulster kommt von Bertellis Frau Vera. British Racing Green habe bisher nur Unglück gebracht. Folglich versucht man es mit der Renn-Couleur seines Geburtslands Italien. Typisch: die halbkreisförmige waagerechte Ausbuchtung für das Reserverad.

Changement de décor : la suggestion de peindre l'Ulster en rouge a été faite par Vera, l'épouse de Bertelli. Le British Racing Green n'avait, selon elle, que porté malheur jusqu'à ce jour. On opte donc pour la couleur nationale de son pays natal, l'Italie. Typique : le demi-cercle trahissant la présence de la roue de secours placée à l'horizontale.

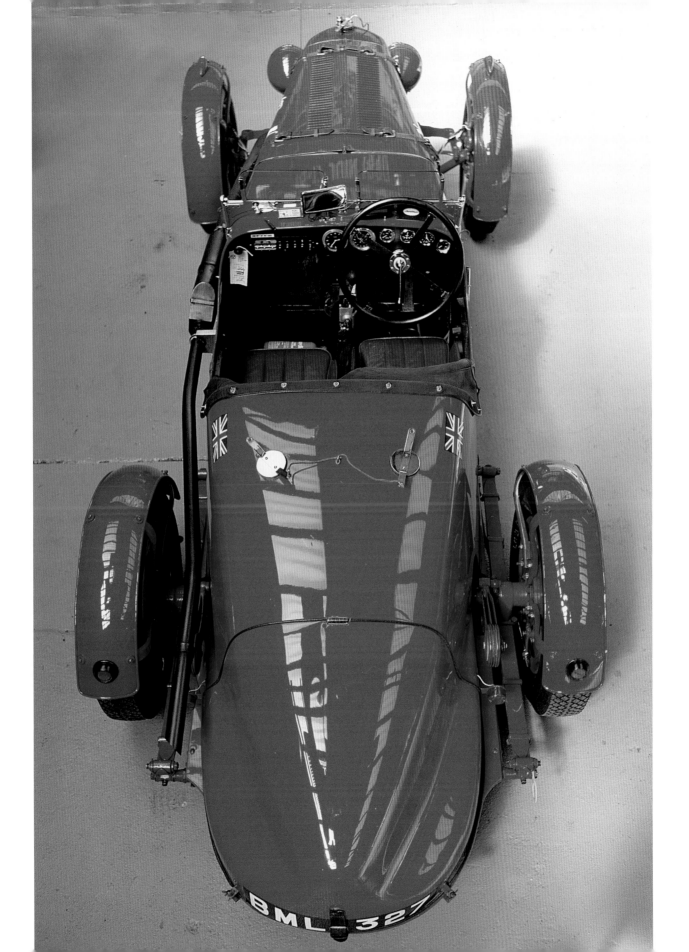

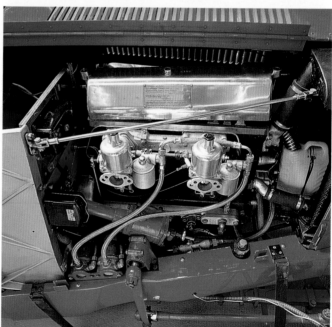

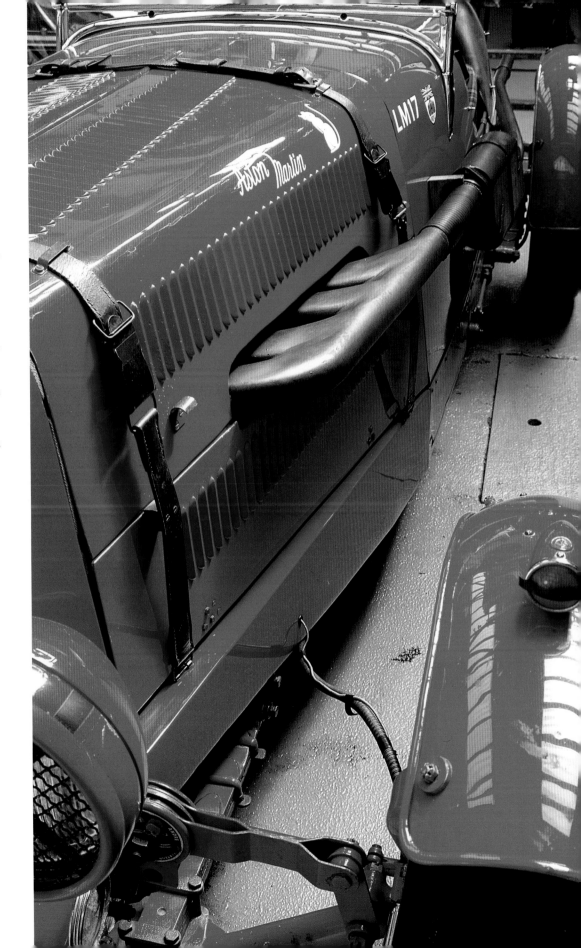

The rear shock absorbers are fitted in the direction of travel. The tank cap overflow leads to somewhere beneath the car. Two carburetors have been standard since the time of the International. The exhaust system with its wide, separate individual pipes prevents exhaust interference due to the firing sequence 1/3/2/4.

Die Stoßdämpfer hinten versehen ihren Dienst in Fahrtrichtung. Der Überlauf auf dem Tankdeckel mündet irgendwo im Souterrain. Zwei Vergaser sind seit dem International Standard. Die Auspuffanlage mit weitgehend separaten Einzelrohren verhindert Abgas-Interferenzen wegen der Zündfolge 1/3/2/4.

Les amortisseurs arrière sont en position longitudinale. Le trop-plein du bouchon de réservoir débouche quelque part sous la voiture. Depuis l'International, deux carburateurs sont de règle. La ligne d'échappement aux sorties spécifiques à chaque cylindre empêche les interférences des gaz brûlés dues à l'ordre d'allumage 1/3/2/4.

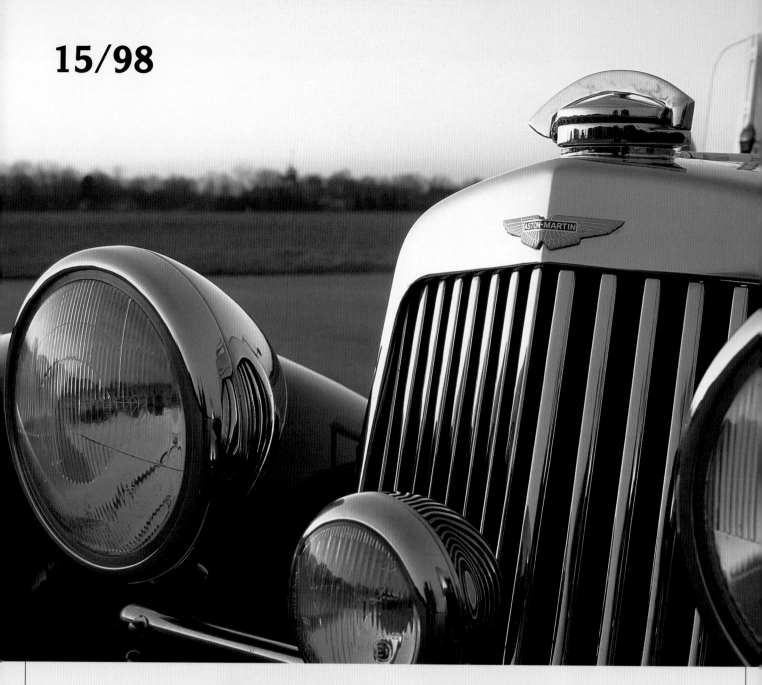

O ver the ten years from 1926 Aston Martin became a watchword for sporting motoring among both its aficionados and a wider public. Even the cars on offer for use by the fast set on public roads were essentially racing machines tempered by a thin veneer of civilization. This coincidence of seemingly incongruous factors was mirrored by a power struggle between the extravagant and flamboyant race fan Cesare Bertelli and the more commercially-minded Sutherland father and son combination.

A sign that things were on the move came with the early entries for that year's Le Mans race, when three Ulsters were joined by two modified two-liter versions on an almost identical chassis intro-

duced by the June 12th issue of *The Autocar* as the Super-Sports or alternatively as the Speed Model. Le Mans was cancelled in 1936 due to strikes, whereas the Speed remained and was offered to sporting motorists at a price of £875, one being driven in the Tourist Trophy by future national hero Dick Seaman, who tried several different cars that season. He led the armada of BMW 328s for some time until a bearing finally gave out on him and he had to retire.

The model was finally offered as the C-Type, clad in bodywork reflecting contemporary notions of streamlining, not exactly beautiful, more of a curiosity and an interesting footnote in the prewar history of the marque. Under the bonnet

lurked Claude Hill's scaled-up engine with the valve positions reversed, inlet port to the left and exhaust port to the right. Apart from this the parameters remained the same: dry-sump lubrication, a transmission system which, as with the later 1.5-liter version, formed a unit with the engine, twin SU carburetor and double camshaft drive chain tensioned by a Weller spring plate.

The type designation 15/98 borne by the 173 examples of this model conveys two items of information about the power of the engine, the 15 standing for the number of taxable ("RAC") horsepower, and 98 for the actual horsepower. This turned out to be "Our Bert's" parting gift to the Feltham company, and it attracted high

In den zehn Jahren seit 1926 hat Aston Martin im Bewusstsein seiner Kunden und auf dem Markt eine Parzelle innerhalb der Grenzsteine Sport und sportlich bezogen. Auch beim Angebot der Marke an den flott verkehrenden Normalbürger handelt es sich ja im Grunde um Wettbewerbswagen, die mit einem dünnen Firnis von Zivilisation überzogen sind.

Im Spannungsfeld zwischen diesen Polen spielt sich zugleich ein Machtkampf ab zwischen dem kostspieligen Renn-Enthusiasmus Cesare Bertellis und den eher kommerziellen Erwägungen von Vater und Sohn Sutherland.

Dass die Dinge in Bewegung gekommen sind, beweist die frühe Nennung für Le Mans in jenem Jahr: Zu drei Ulster gesellen sich zwei Derivate auf fast dem gleichen Chassis mit Zweiliter-Maschinen, von *The Autocar* in der Ausgabe vom 12. Juni als Super-Sports oder auch als Speed Model vorgestellt. Le Mans fällt 1936 wegen Streiks aus, der Speed bleibt, als Offerte an Sportfahrer zum Preis von 875 Pfund. Bei der Tourist Trophy etwa führt der künftige Nationalheros Dick Seaman, der sich in jener Saison an vielen Fahrzeugen versucht, eine Zeit lang vor den BMW 328, bis ein Lager nicht mehr mitmacht.

Am Ende gibt es ihn als C-Type sogar in der zeitgenössischen Interpretation von Stromlinie, nicht schön, aber kurios und eine interessante Fußnote in der Vorkriegs-Historie des Hauses. Unter der Haube jedoch findet sich, wie gehabt, eine strikte Monokultur: Claude Hills maßstabsgerecht vergrößertes Triebwerk mit umgekehrter Anordnung der Ventile, Auslass rechts, Einlass links. Ansonsten sind die Parameter die gleichen: Trockensumpfschmierung, ein Getriebe, das wie bei den späteren 1,5-Litern mit dem Motor eine Einheit bildet, zwei SU-Vergaser, Nockenwellenantrieb per Doppelkette, die durch ein Weller-Federblatt gespannt wird.

Die Typenbezeichnung 15/98 für die 173 Exemplare der Modellreihe erteilt eine Doppelauskunft über die Stärke der Maschine: 15 (»RAC«) Steuer-PS, 98 reale PS. Sie wird zu »Our Bert's« Abschiedsgeschenk an das Unternehmen in Feltham und trägt hohes Lob ein: Hinsichtlich der Spitzengeschwindigkeit habe der Zweiliter nichts gebracht, steht zum Beispiel in *The Autocar* vom 23. Juli 1937 zu lesen, sehr wohl aber, was Laufkultur, Fahrbarkeit und Geräuschpegel anbelange. Die verschworene Marken-Gemeinde brauche sich aber keine Sorgen zu machen: noch immer lasse sich ein Aston Martin am Auspuffton deutlich unterscheiden von den Feld-, Wald- und Wiesenautomobilen ringsum.

Diese Aussage bezieht sich bereits auf den 2/4-Sitzer auf dem Kurzchassis, der 1937 ebenso für 100 Pfund weniger als im Vorjahr angeboten wird wie der Saloon und der viersitzige Tourer auf dem längeren. Die Kotflügel vorn sind nun fest mit dem Fahrwerk verbunden und fließen zumeist mit den hinteren und dem Trittbrett dazwischen zu einer stilistischen Einheit zusammen. Dem 15/98 bekommt es.

Pendant dix ans, de 1926 à 1936, consciente des désirs de ses clients et des exigences du marché, Aston Martin a délimité son territoire dans le domaine de la compétition et des voitures de sport. Les voitures de la marque destinées à l'automobiliste de tous les jours, mais épris de conduite sportive, sont en réalité des voitures de course à peine revêtues d'un vernis de civilisation.

Des tensions s'exercent et une rivalité se développe entre le coûteux enthousiasme pour la course de Cesare Bertelli et les considérations plutôt mercantiles des Sutherland, père et fils.

Mais les choses bougent, comme le prouve l'engagement précoce aux 24 Heures du Mans, l'année où trois Ulster sont soutenues par deux véhicules au châssis pratiquement identique, mais à moteur de 2 litres que, dans son numéro du 12 juin, *The Autocar* qualifie de Super-Sports ou aussi de Speed. Les 24 Heures du Mans de 1936 sont annulées pour cause de grèves, mais la Speed demeure au catalogue à l'intention des conducteurs sportifs auxquels elle est proposée au prix de 875 livres. Au Tourist Trophy, le futur héros national Dick Seaman qui, cette saison-là, s'essaie sur plusieurs voitures, caracole devant les BMW 328 jusqu'à ce qu'un palier casse et l'oblige à abandonner la course.

La version définitive du modèle est la type C dont les lignes aérodynamiques – témoignage de leur époque – plus curieuses que vraiment belles, constituent une parenthèse intéressante dans l'histoire d'avant-guerre de la marque Aston Martin. Sous le capot, règne sans partage le moteur de Claude Hill agrandi à l'échelle, avec une inversion des soupapes, d'échappement à droite et d'admission à gauche. Pour le reste, les caractéristiques sont les mêmes : lubrification à carter sec, une boîte de vitesses qui, comme pour le futur modèle de 1,5 litre, fait bloc avec le moteur, deux carburateurs SU et une prise d'arbre à cames à double chaîne tendue par un ressort à lames de Weller.

La dénomination 15/98 pour les 173 exemplaires de cette gamme est révélatrice pour la puissance du moteur : 15 chevaux fiscaux (« RAC »), soit 98 chevaux réels. Cadeau d'adieu de « Notre Bert » à l'entreprise de Feltham, elle suscite des éloges de toute part : même si en termes de vitesse de pointe, la 2-litre n'apporte rien de plus, peut-on lire dans *The Autocar* du 23 juillet 1937, elle est d'une douceur de fonctionnement, d'une maniabilité et d'un niveau sonore incomparables. On peut encore et toujours distinguer sans hésiter une Aston Martin du commun de l'automobile à la seule sonorité de son pot d'échappement.

Ce constat vaut aussi pour la 2/4 places à châssis court qui, en 1937, coûte elle aussi 100 livres de moins que l'année précédente, à l'instar de la Saloon et de la Tourer à quatre places et châssis long. Désormais, les ailes font partie intégrante du châssis et se fondent harmonieusement avec les ailes arrière et le marchepied, créant une unité esthétique qui sied fort bien à la 15/98.

The two-seater Tourer with its body by Abbey and the now-familiar logo, which had been introduced in 1934.

Zweisitziger Tourer mit einem Aufbau von Abbey und dem seit 1934 verwendeten bekannten Markenzeichen.

Tourer deux places avec carrosserie Abbey. L'emblème désormais célèbre est apparu en 1934.

praise. For example, the 23rd July 1937 issue of *The Autocar* noted that, although its top speed had not changed, it was outstanding in terms of driveability and noise levels. However, sworn Aston Martin devotees had nothing to fear: the car could still be distinguished from the common-or-garden machines surrounding it by its unmistakable engine noise.

The same applied to the 2/4-seater on the short chassis, available from 1937 for £100 less than the previous year, as was the saloon and four-seater tourer on the longer chassis. The front wings were now firmly integrated into the body, forming a single flowing stylistic unit with the running board and rear bodywork. It suited the 15/98 very well.

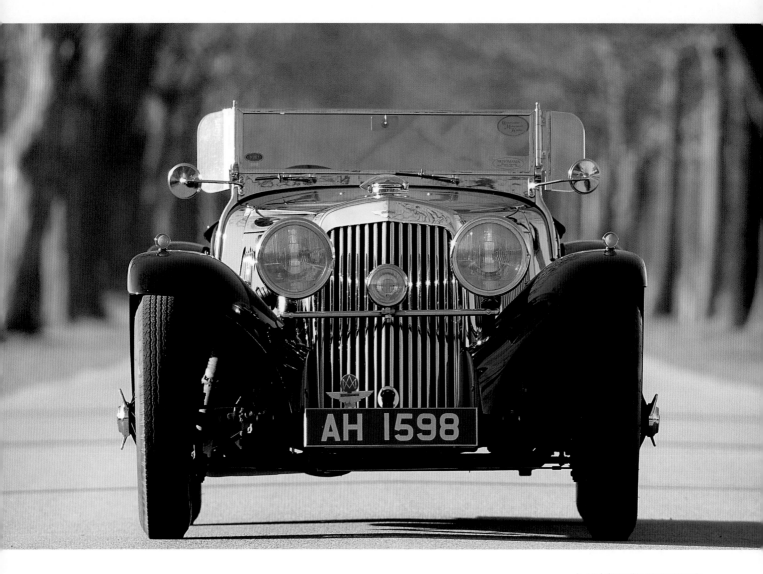

In good shape: this sporting tourer's
proper full-size fixed wings proclaim
the spirit of the new age.

Gut in Form: Richtige feste und voll
ausgearbeitete Kotflügel künden an diesem
sportlichen Reisewagen vom Geist der
neuen Zeit.

Belle prestance : sur cette voiture de
grand tourisme sportive, des ailes dignes
de ce nom, aux galbes élégants, annoncent
l'esprit d'une nouvelle époque.

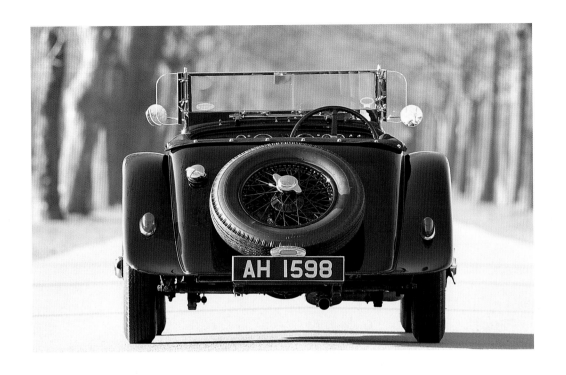

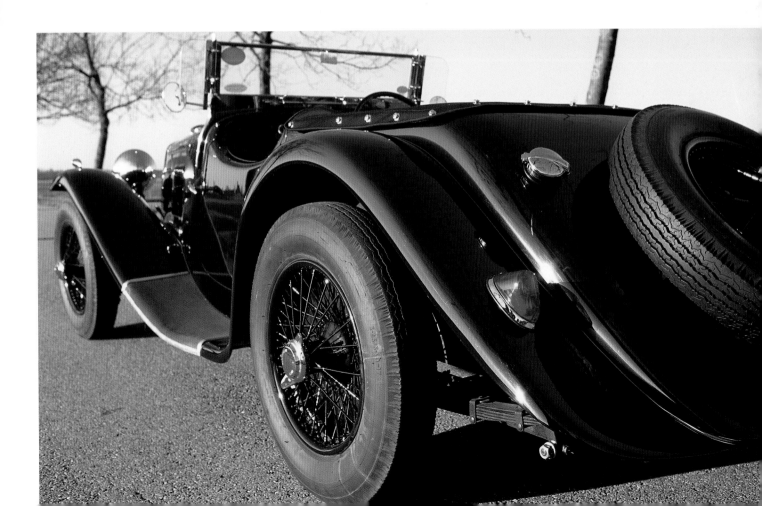

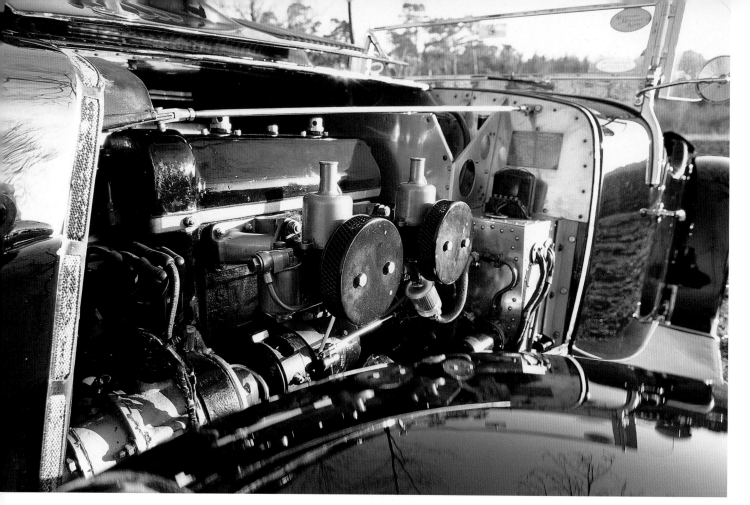

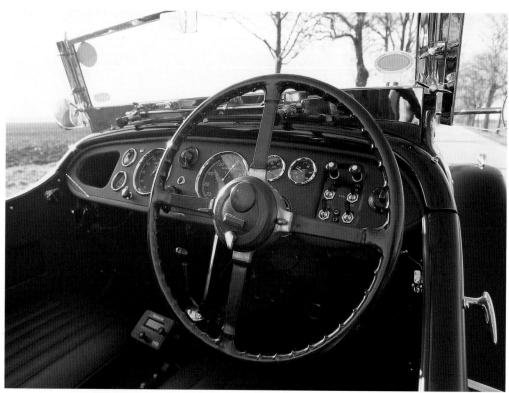

The filters in front of the carburetors have the important auxiliary function of reducing noise on the intake side, which had swapped places in the two liter with the exhaust tract. The frictional shock absorbers are once again fitted longitudinally. The rev counter's shift to the left is indicative of the fact that the information it provides is no longer assigned quite the same importance.

Die Filter vor den Vergasern sorgen nicht zuletzt für weniger Geräuschentwicklung auf der Einlassseite, die ihren Platz am Zweiliter mit dem Auslasstrakt getauscht hat. Die Reibungsstoßdämpfer vorn sind wieder längs angeordnet. Der Linksruck des Drehzahl-messers ist ein Indiz, dass der strikten Beherzigung seiner Information nicht mehr so viel Bedeutung beigemessen wird.

Les filtres placés en amont des carburateurs n'ont pas seulement pour effet de réprimer le niveau sonore côté admission qui, sur le deux-litres, a troqué sa place avec le collecteur d'échappement. À l'avant, les amortisseurs à friction sont de nouveau en position longitudinale. Le décalage vers la gauche du compte-tours indique que l'on n'accorde plus autant d'importance au strict respect de ses informations.

The characteristic sportiness of the Aston Martin has been entirely lost in this 15/98 saloon, whose two-liter engine has a whole lot of car to haul around.

Repräsentativer Auftritt: Dieser Limousine vom Typ 15/98 ist die markenspezifische Sportlichkeit völlig abhanden gekommen. Im Gegenteil: Die Zweiliter-Maschine muss eine Menge Auto mit sich herumschleppen.

Présentation majestueuse : cette limousine 15/98 a perdu tout le caractère sportif spécifique à la marque. Pire : le moteur de deux litres doit composer avec une voiture très lourde.

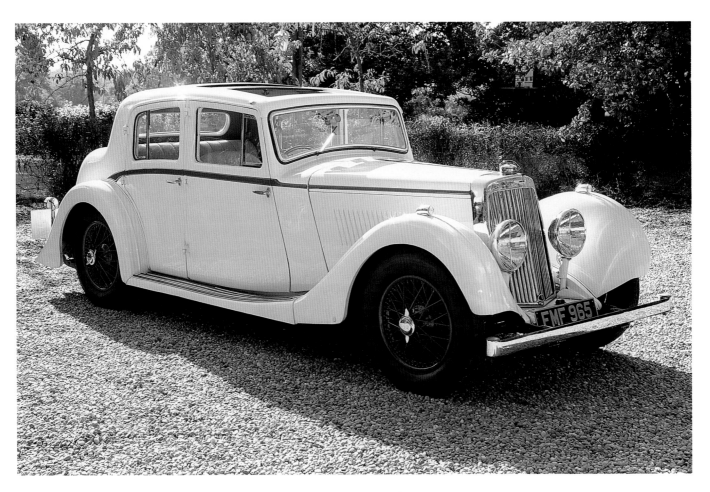

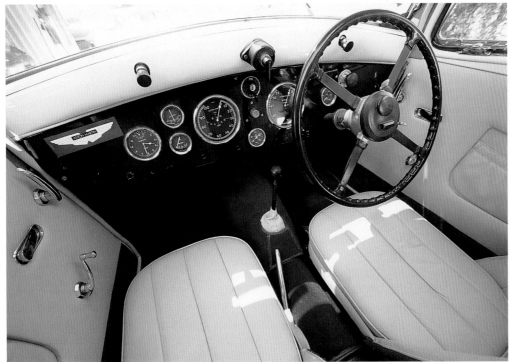

Atom

he Future in the Present" claimed *The Autocar* on 18th July 1941. Aston Martin had hitherto tended to carefully modify and develop existing models, but now, shortly before the outbreak of the Second World War, with the 15/98 model range on the right track, Gordon Sutherland and Claude Hill developed an extravagant vision of the automotive future which found its concrete expression in the Atom. The starting point was its patented skeleton frame along the lines of the Carrozzeria Touring Superleggera philosophy. A structure of square tubes created a rigid cage where even the roof tubes performed a load-bearing function. This gave the rough outline of the bodywork, the aluminum panels of which were either curved around the tubular frame or screwed on to it. It came across as decidedly futuristic, its flat window glass meaning that the front and rear windscreens came in two pieces. The four tall, narrow doors were fastened to the central pillars, while the headlights were sunk into the tops of the wings.

While the rear suspension was a conventional leafspring arrangement, the front featured an unusual independent-wheel suspension system designed by Gordon Armstrong, involving helical springs and large cast trailing arms. The electromagnetic Cotal four-speed gearbox was operated via a tiny lever on the dashboard. Not the least of its attributes was its reliability – always provided the dynamo did not give out or the battery run flat. The engine was a new Hill creation, as ever a two-liter affair, but resorting to a pushrod layout. However, five years were to pass before it would be ready to take its place under the bulky one-piece bonnet of the Atom, and in the meantime the 15/98 engine unit had to do stand-in service.

H. S. Linfield, editor of *The Autocar*, observed from its silky and silent running that Aston Martin must once again have worked intensively on the soundproofing, and that it was no longer possible to tell that the car had a four-cylinder engine. Linfield did however concede that he had done little more than caress the gas pedal when test driving. By 1941, this had become second nature, as the wartime fuel shortage bit deep, despite the cheaper, low octane Pool petrol flowing through the carburetors, reducing the Atom's output by a good 15 horsepower. Nevertheless he drove the car for three wonderful hours, covering 117 miles and turning heads everywhere he went.

On paper the Atom was a prototype forerunner of the production version. However, the Second World War put paid to that, decreeing that it would forever remain a one-off – not the only destiny to be affected.

he Future in the Present« vermutet *The Autocar* vom 18. Juli 1941 in ihm, von Aston Martin bislang eher behutsame Pflege und Entwicklung von Gestandenem gewohnt.

Nachdem die Baureihe 15/98 auf das richtige Gleis gesetzt und angerollt ist, tummeln sich die Herren Gordon Sutherland und Claude Hill kurz vor Ausbruch des Krieges mit dem Prototyp Atom tatsächlich auf einer üppig blühenden Spielwiese von Ideen, wie denn die automobile Zukunft aussehen könnte. Das beginnt mit seinem patentierten Skelett-Rahmen ähnlich dem Superleggera-Prinzip der Carrozzeria Touring. Ein Geflecht von vierkantigen Rohren findet sich zu einem rigiden Käfig zusammen, in dem auch die Dachbalken tragende Funktion haben. Er gibt die ungefähre Silhouette der Karosserie bereits vor, deren Aluminiumpaneele teils über den Rohren gekrümmt, teils an ihnen festgeschraubt sind. Sie wird allgemein als fortschrittlich bis futuristisch empfunden, mit planen Fensterflächen, was die Zweiteilung von Front- und Heckscheiben bedingt. Die vier schmalen, aber hohen Türen sind an den mittleren Säulen angeschlagen, die Scheinwerfer sitzen als Intarsien in den Spitzen der Kotflügel.

Während man hinten auf eine konventionelle Lösung mit Blattfedern zurückgreift, findet sich vorn Einzelradaufhängung gemäß dem ungewöhnlichen System Copyright Gordon Armstrong, in dem Schraubenfedern mit freitragenden Armen zusammenwirken. Die elektromagnetische Cotal-Viergangschaltung wird vermittels eines winzigen Hebelchens am Armaturenbrett betätigt. Sie zeichnet sich nicht zuletzt durch ihre Verlässlichkeit aus – solange die Lichtmaschine nicht ihren Dienst verweigert und die Batterie leer läuft. Als Triebwerk ist eine neue Hill-Kreation vorgesehen, zwei Liter wie gehabt, jedoch mit Stoßstangen. Bis es seinen Weg unter die große einteilige Haube des Atom findet, verstreichen allerdings noch fünf Jahre, in denen der Motor des 15/98 als Stellvertreter herhalten muss.

The Autocar-Redakteur H. S. Linfield streicht dessen seidige und geräuschlose Arbeitsweise heraus, zurückzuführen darauf, dass man sich bei Aston Martin noch einmal sehr intensiv um die Geräuschdämpfung gekümmert habe. Als Vierzylinder sei er nun überhaupt nicht mehr zu identifizieren. Linfield räumt gleichwohl ein, das Gaspedal lediglich gestreichelt zu haben. Dergleichen ist im Kriegsjahr 1941 bereits zur zweiten Natur geworden, selbst wenn durch den Vergaser der billigere und oktanschwache Pool-Sprit fließt, der die Potenz des Atom um etwa 15 PS schwächt. Dennoch habe er mit dem Auto drei wundervolle Stunden und 117 Meilen Fahrtweg verbracht, in denen er aufgefallen sei wie ein bunter Hund.

Laut Lexikon handelt es sich bei einem Prototyp um den Vorläufer einer Serie. Der Zweite Weltkrieg lässt den Atom zum Unikat vereinsamen – aber der bringt ja auch andere Schicksale durcheinander.

he Future in the Present » (l'avenir rejoint le présent) s'exclame *The Autocar* le 18 juillet 1941. Aston Martin avait jusqu'alors habitué à des améliorations et modifications progressives de modèles existants.

Mais aujourd'hui, juste avant le début de la guerre, la gamme 15/98 étant dans la bonne voie et remportant un certain succès, Messieurs Gordon Sutherland et Claude Hill « s'éclatent », avec le prototype Atom, qui regorge littéralement d'idées novatrices, laissant entrevoir ce à quoi pourrait ressembler l'automobile de l'avenir. Cela commence par son châssis-squelette breveté apparenté au principe Superleggera de la Carrozzeria Touring. Un faisceau de profilés de section carrée constitue une cage rigide dans laquelle les longerons de toit assument eux aussi une fonction porteuse. Cette cage préfigure

déjà approximativement la silhouette de la carrosserie dont certains panneaux d'aluminium sont façonnés en galbe sur les tubes et dont certains autres y sont boulonnés. D'une manière générale, on la considère comme ultramoderne et même futuriste avec ses surfaces vitrées planes, ce qui explique que le pare-brise et la lunette arrière soient en deux morceaux. Les charnières des quatre portières étroites mais hautes se trouvent sur le pied central et les phares sont repoussés, tels une marque-terie, jusqu'à la pointe des ailes.

Alors que l'on trouve à l'arrière une architecture conventionnelle avec ressorts à lames, le train avant est plus novateur avec une suspension à roues indépendantes qui reprend un système inhabituel, breveté par Gordon Armstrong, où des ressorts hélicoïdaux sont combinés à un gros bras oscillant

tenant la fusée. Un minuscule levier au tableau de bord permet d'actionner la boîte électromagnétique Cotal à quatre rapports. Cette boîte se distingue notamment par sa fiabilité – tant que l'alternateur fonctionne et que la batterie n'est pas à plat. Le moteur prévu est une nouvelle création de Claude Hill, de 2 litres comme de coutume, mais il s'agit d'un moteur culbuté à soupapes en tête. À cause de la guerre, il faudra encore attendre cinq bonnes années avant qu'il ne s'installe sous le vaste capot d'un seul tenant de l'Atom, l'intérim étant assuré durant ces années-là par un moteur de 15/98.

The Autocar, en l'occurrence son rédac-teur, H. S. Linfield, souligne son fonctionnement doux et silencieux, preuve que, chez Aston Martin, on s'est une fois de plus penché très attentivement sur les mesures d'insonorisation. Il est désor-

mais absolument impossible d'identifier ce moteur comme un quatre-cylindres. Linfield concède toutefois qu'il n'a fait qu'effleurer l'accélérateur en l'essayant. Une telle attitude est devenue une seconde nature pendant cette période de guerre, même si on utilise un carburant à faible taux d'octane, moins coûteux, qui prive l'Atom d'une quinzaine de chevaux. Cela ne l'a pas empêché de passer trois heures merveilleuses en compagnie de la voiture et de couvrir à cette occasion 117 miles au cours desquels il a déclaré que tous ceux qu'il avait croisés tournaient la tête.

À en croire le dictionnaire, un prototype est le modèle précurseur d'une série. Mais la Seconde Guerre mondiale réduira l'Atom au rang de spécimen unique – un destin parmi des milliers d'autres que la guerre aura réduits à néant.

Sign of progress: right down to the bizarre emblem on the radiator, the Atom proclaimed that here was a car where Aston really wanted to do everything differently. It has the appearance of a stylized hand pointing towards the rear.

Zeichen des Fortschritts: Auch an der bizarren Kühlerfigur des Atom lässt sich ablesen, dass man mit diesem Auto nun wirklich alles ganz anders machen wollte. Sie scheint wie eine stilisierte Hand nach hinten zu weisen.

Tout dans l'Atom, jusqu'à la bizarre figure de proue sur le radiateur, porte à croire que l'on a cherché à créer une voiture complètement différente. Telle une main stylisée, elle semble tendue vers l'arrière du véhicule.

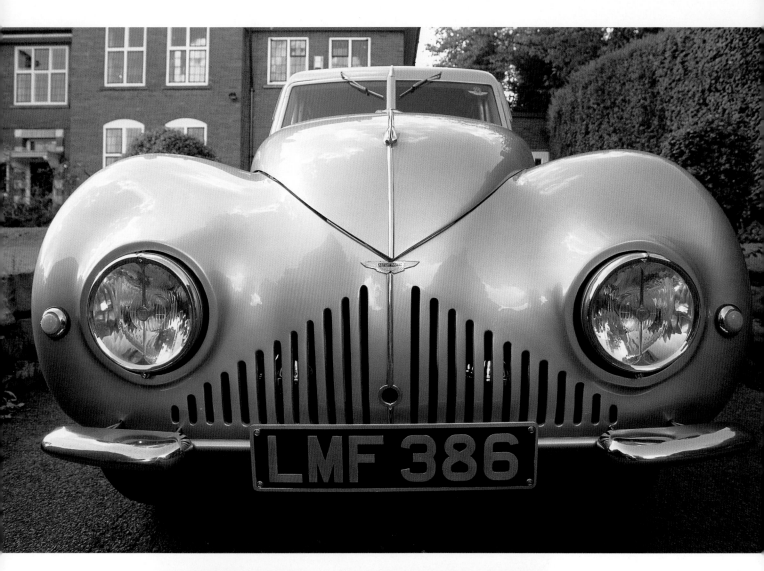

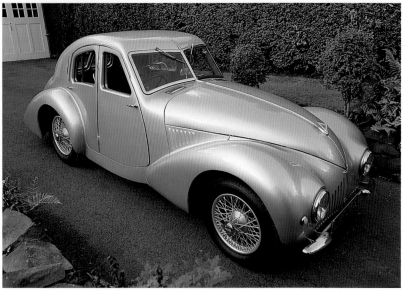

The Atom's rear windows pick up and vary on the theme adopted at the front end of the car. The vehicle is fitted with flat windows all round.

Die Verglasung der Heckpartie des Atom nimmt Motive der Frontansicht wieder auf und wandelt sie zugleich ab. Plane Fenster finden sich überall.

La lunette arrière de l'Atom est le rappel de la face avant, réinterprétée. Toutes les vitres sont planes.

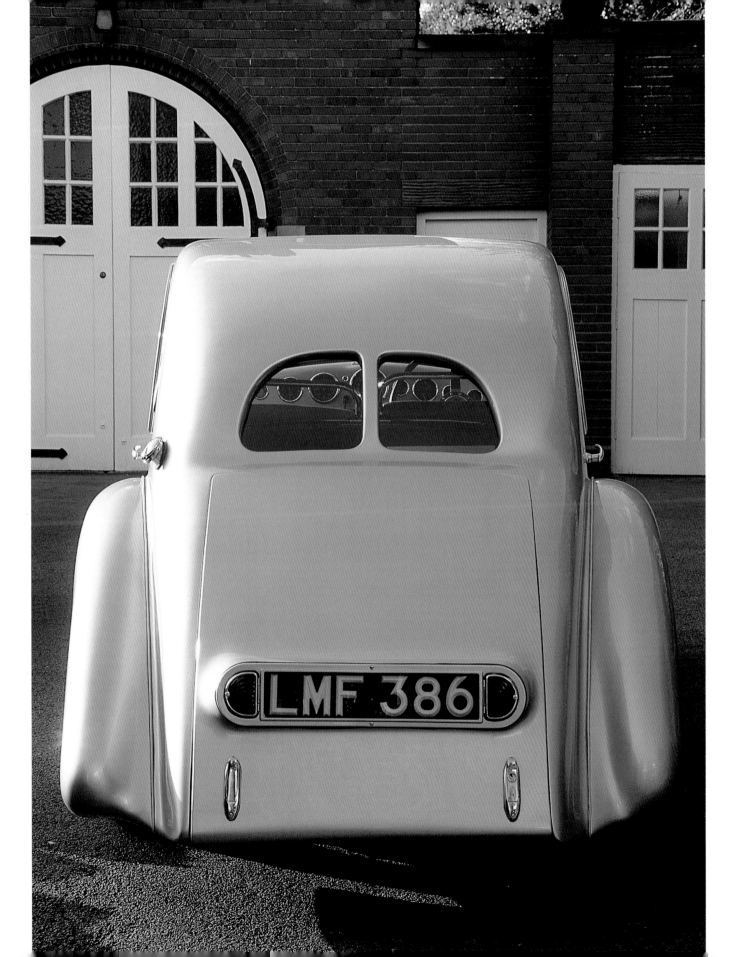

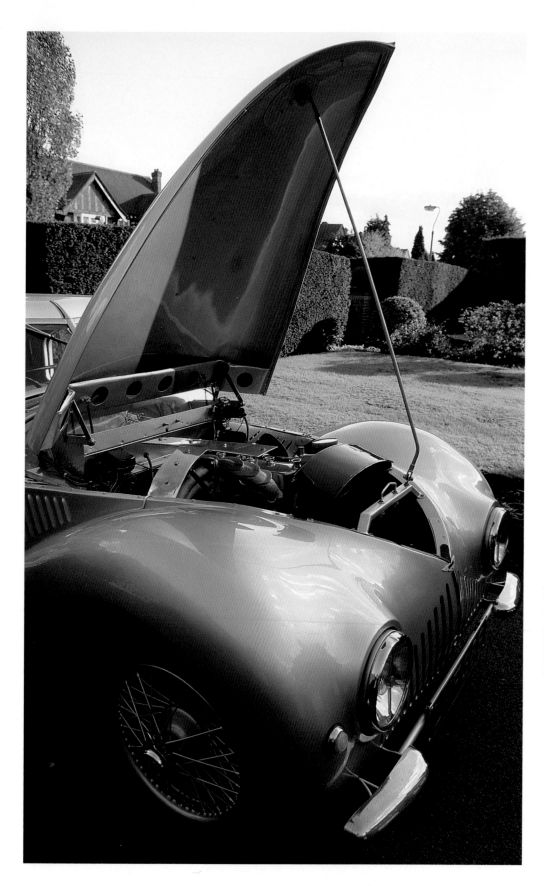

The etymology of the car's name: after an early test Gordon Sutherland observed that the car had loads of power for its size – just like an atom.

Die Etymologie des Namens für den Rundling: Gordon Sutherland äußert nach einem der ersten Ausritte, angesichts seiner Größe habe er eine Menge Kraft – wie ein Atom.

Origine du nom de cette voiture tout en rondeurs : à l'issue de ses premiers essais, compte tenu de sa dimension, Gordon Sutherland déclare qu'elle ne manque pas de force – comme un atome.

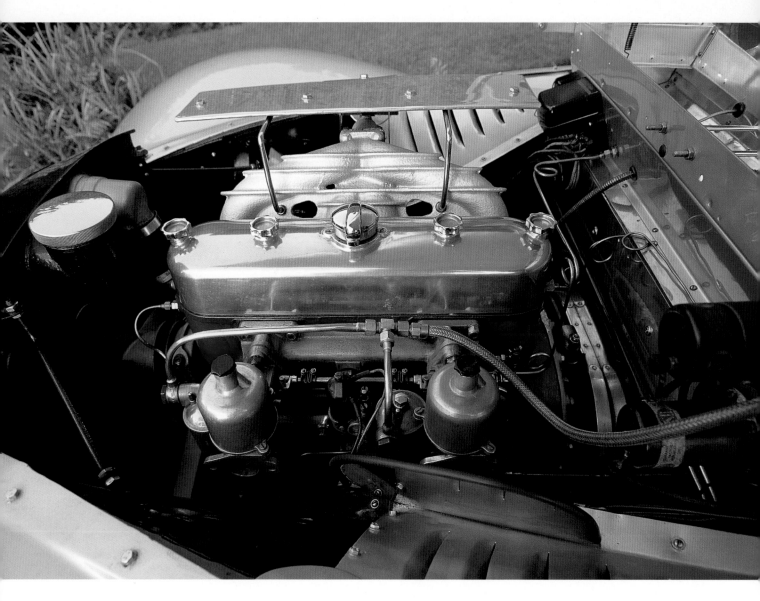

Originally, it was Claude Hill's new two-liter pushrod engine that was intended for use in the Atom. However, all of the development work and the 100,000 miles of testing eventually took place using the 15/98 power unit. Striking features of the car's interior include the electric Cotal gearshift selector lever beneath the dashboard and the cunningly-designed rack supporting the seats. A test drive at the wheel of this machine prompted David Brown to purchase Aston Martin.

Atom-Kraftwerk: Ursprünglich soll Claude Hills neue Zweiliter-Stoßstangenmaschine im Motorraum des Atom einziehen. Die gesamte Entwicklung und 160 000 Testkilometer finden aber dann mit einem 15/98-Triebwerk statt. Markante Einzelheiten im Innenraum: der Wählhebel für die elektrische Cotal-Schaltung in der Bucht unterhalb des Armaturenbretts und das klug ausgedachte Untergestell der Sitze. Die Probefahrt an diesem federnden und justierbaren Lenkrad bewegt David Brown zum Kauf von Aston Martin.

Le cœur de l'Atom : initialement, c'est le nouveau 2-litres culbuté de Claude Hill qui doit propulser l'Atom. Mais le développement et les 160 000 km de tests ont lieu avec un moteur de 15/98. Détails particuliers du cockpit : le levier de changement de vitesses de la boîte électrique Cotal sous le tableau de bord et les astucieuses consoles de sièges. C'est après avoir essayé cette voiture au volant réglable et à ressort que David Brown décide d'acheter Aston Martin.

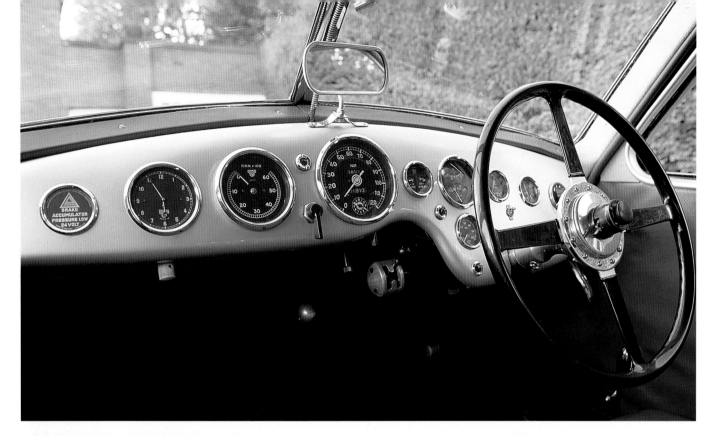

2-litre Sports

In 1939 a vision of the future, by 1947 the Atom had become a fossil. Despite this it did its duty, serving to keep hopes and dreams for the future alive during the privation and stagnation of the war years, and also spurring David Brown to buy the noble but ailing Aston Martin company in the postwar era.

Brown's first car was based on the concept of that prewar creation without being a blatant copy of it. It was an open two-seater which the publication *Motor* described in October 1948 as combining the appearance of a super sports car with the comfort of a drophead coupé. The bench seat was wide enough to squeeze three people in, should one wish to avoid seeking emergency accommodation under the rear hood. The trunk had ample room to stow the owner's no-doubt meager possessions in that immediate postwar era of wall-to-wall rationing. At £2331 the 2-litre Sports, which subsequently came to be known as the DB1 by analogy with later models, was pricey, particularly in comparison to its chief rival, the Jaguar XK120, which was launched that same year at a price of just £998. The DB1's opulent, curvaceous lines recalled past models, while the front grille anticipated the face of future Aston Martins. If necessary, the complete front section of the body could be detached, thus eliminating a major source of wind noise.

The fundamental concept of the Atom frame remained, forming the chassis and body support all in one. The suspension, while less eccentric, was a progressive design quite similar to the system employed by prewar Auto Union racing cars, involving trailing arms and helical springs at the front, while the rear featured a rigid axle with helical springs and a Panhard rod. As in the late Atom the bonnet concealed Claude Hill's new 1970 cc short-stroke engine with a side-mounted camshaft, thus reducing production and maintenance costs.

Large vertical intake valves were fed by two SU carburetors. Sharply angled exhaust valves ensured that exhaust flow was drawn off rapidly and thus improved the mixture intake, which was believed at the time to enhance performance.

The heavy crankshaft now had five bearings and the wet sump was made of light alloy and had fins inside and out. The Atom's Cotal automatic was replaced by a conventional four-speed gearbox brought to the company by David Brown.

The technical details were made public in March 1948, and prototypes rolled off the line that summer, a stripped-down version of which won the Spa 24-hour race for drivers "Jock" Horsfall and Leslie Johnson. The 2-litre Sports was finally launched that autumn. The model was supremely disdainful of the modest needs of that austere postwar era, and the company's hopes were dashed as a grand total of just 15 DB1s were sold by May 1950.

Im Jahr 1939 noch eine Vision, ist der Atom 1947 zum Fossil verkümmert. Dennoch tut er seine Schuldigkeit, als Dream Car in der Tristesse und Stagnation der Kriegszeit und weil er David Brown Appetit auf den Kauf der feinen, aber kränkelnden Manufaktur Aston Martin macht.

Browns Erstling lehnt sich an das Konzept des Vorkriegs-Beaus an, ohne es zu kopieren: ein offener Zweiplätzer, dem die Zeitschrift *Motor* im Oktober 1948 das Aussehen eines Supersportwagens und den Komfort eines Drophead Coupés bescheinigt. Auf der breiten Sitzbank lässt es sich bei Bedarf in inniger Dreisamkeit reisen, falls man das Beziehen einer Notunterkunft hinten unter der Haube vermeiden möchte. Kofferraum ist in jedem Falle reichlich vorhanden für die Habseligkeiten der unmittelbaren Nachkriegszeit. Mit einem Preis von 2331 Pfund ist der 2-litre Sports, später aus Gründen der Analogie auch als DB1 bezeichnet, allerdings manifest teuer, vor allem im Vergleich mit dem Konkurrenten Jaguar XK120 aus dem gleichen Jahr, der das Budget lediglich mit 998 Pfund belastet. Seine üppig rundlichen Linien verweisen eher in die Vergangenheit, während das Triptychon aus Grillstäben vorn die Gesichter künftiger Aston Martin antizipiert. Notfalls lässt sich die komplette Vorderpartie der Karosserie abheben, womit zugleich eine Quelle des Zischelns und Knerzens entfällt.

Geblieben ist im Prinzip der Fachwerkrahmen des Atom, zugleich Chassis und

Variations on a theme: the 2-litre Sports'
three-part front design introduced a motif
that later generations of Aston Martins were
to take up, modify and stylize.

Thema mit Variationen: Mit dem dreiteiligen
Frontdesign des 2-litre Sports wird ein Motiv
angeschlagen, das spätere Generationen von
Aston Martin aufnehmen, abwandeln und
stilisieren werden.

Déclinaisons d'un même thème : avec la
calandre en trois éléments de la 2-litre
Sports s'annonce un motif que les
générations futures d'Aston Martin vont
reprendre, interpréter et styliser.

Karosserieträger. Die Aufhängung der Räder hingegen gibt sich weniger ausgefallen und dennoch fortschrittlich: vorn einzeln an Kurbellängslenkern mit Schraubenfedern ähnlich dem System an den Rennwagen der Auto Union, hinten an einer Starrachse mit Schraubenfedern und einem Panhardstab. Unter der vorderen Haube hat wie im späten Atom Claude Hills neuer Vierzylinder Einzug gehalten, ein Kurzhuber von 1970 ccm mit hoch angesetzter seitlicher Nockenwelle, was sich günstig auf die Fertigungskosten und auf die Wartung auswirkt.
Große senkrecht stehende Einlassventile werden von zwei SU-Vergasern gefüttert. Stark angewinkelte Auslassventile sollen die Verbrennungshitze zügig abführen und damit die Beatmung beschleunigen,

was nach der Auffassung der Zeit zu mehr Leistung führt. Die schwere Kurbelwelle ist nun fünffach gelagert, der nasse Leichtmetallsumpf innen und außen verrippt. Ausgedient hat die Cotal-Automatik des Atom und wird ersetzt durch ein konventionelles Viergang-Getriebe, das David Brown als Morgengabe mitgebracht hat. Die technischen Einzelheiten werden im März 1948 bekannt gegeben. Prototypen laufen im Sommer. Eine abgemagerte Variante gewinnt das 24-Stunden-Rennen von Spa unter »Jock« Horsfall und Leslie Johnson. Präsentiert wird der 2-litre Sports im Herbst. Souverän vorbeigeplant an den Bedürfnissen der Zeit, bringt er es trotz kühner Hoffnungen bis zum Mai 1950 lediglich auf die winzige Auflage von 15 Exemplaren.

Vision futuriste en 1939, l'Atom est déjà un dinosaure en 1947. Elle n'en a pas moins sa raison d'être, d'abord comme «voiture de rêve» au milieu des privations et de la stagnation des années de guerre et, surtout, parce que c'est elle qui incite David Brown à reprendre la petite manufacture à l'agonie qu'est Aston Martin.
La première création de David Brown s'inspire du concept du prototype d'avant-guerre, mais sans le plagier : c'est une biplace découverte à laquelle la revue *Motor,* en octobre 1948, reconnaît le style d'une voiture de sport et le confort d'un coupé Drophead. La large banquette permet, si besoin est, à trois personnes de voyager côte à côte, si l'on veut éviter l'espace exigu sous la capote pour une personne. Figurant au catalogue au prix de 1498 livres, la 2-litre Sports est toutefois beaucoup plus chère que ses concurrentes de la même année, notamment que la Jaguar XK120, qui ne coûte que 988 livres. Ses lignes aux galbes opulents appartiennent déjà au passé alors que la grille verticale flanquée de deux «moustaches» annonce déjà la calandre des futures Aston Martin. Toute la proue de la voiture se rabat vers l'avant, ce qui élimine toute source de craquements et grincements. Le concept de cage en tubes de section carrée est repris de l'Atom. Moins sophistiquée, la suspension est par contre plus moderne : à l'avant, on trouve des bras de manivelle longitudinaux avec ressorts hélicoïdaux

inspirés du système des Auto Union de course et, à l'arrière, un essieu rigide avec ressorts hélicoïdaux et une barre Panhard. Le capot avant héberge, comme les dernières Atom, le nouveau quatre-cylindres de Claude Hill, un moteur à course courte de 1970 cm³ de cylindrée avec un arbre à cames latéral placé très haut dans un souci de facilité de production et d'entretien.
Les grandes soupapes d'admission verticales sont alimentées par deux carburateurs SU. Les soupapes d'échappement, fortement obliques, sont conçues pour évacuer rapidement la chaleur de la combustion et, ainsi, accélérer la respiration du moteur, chose qui – croit-on à l'époque – est censée augmenter la puissance.
Le lourd vilebrequin est maintenant à cinq paliers et la lubrification est assurée par un carter humide en aluminium avec des rainures intérieures et extérieures. La boîte automatique Cotal de l'Atom a été remplacée par une boîte à quatre vitesses conventionnelle que David Brown a offerte en dot. Les caractéristiques techniques détaillées sont dévoilées en 1948 et les premiers prototypes prennent la route au cours de l'été. Une variante allégée gagne les 24 Heures de Spa avec «Jock» Horsfall et Leslie Johnson au volant. La 2-litre Sports est présentée à l'automne. Conçue au mépris total des besoins de l'époque, elle ne sera produite, malgré les espoirs ambitieux de ses pères, qu'au nombre confidentiel de 15 exemplaires jusqu'en mai 1950.

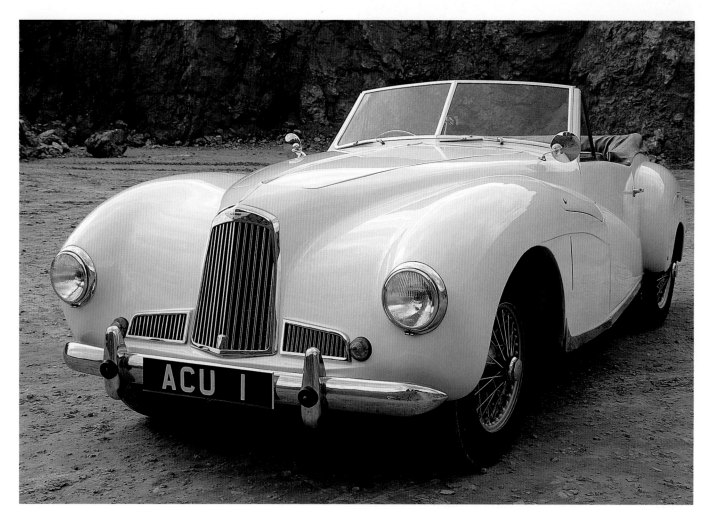

Curvaceous: David Brown's first offering elevated the rounded style to an article of faith. The front bench seat has room for the driver plus two passengers.

Kurven-Star: David Browns Erstling erhebt die konsequente Rundung zum Prinzip. Bis zu zwei Beifahrer werden auf der dreiplätzigen Sitzbank über Wohlbefinden und Betriebsmoral des Triebwerks auf dem Laufenden gehalten.

Tout n'est que galbes et arrondis : la première création de David Brown élève systématiquement les rondeurs au rang de principe. La banquette accueille le conducteur plus deux passagers.

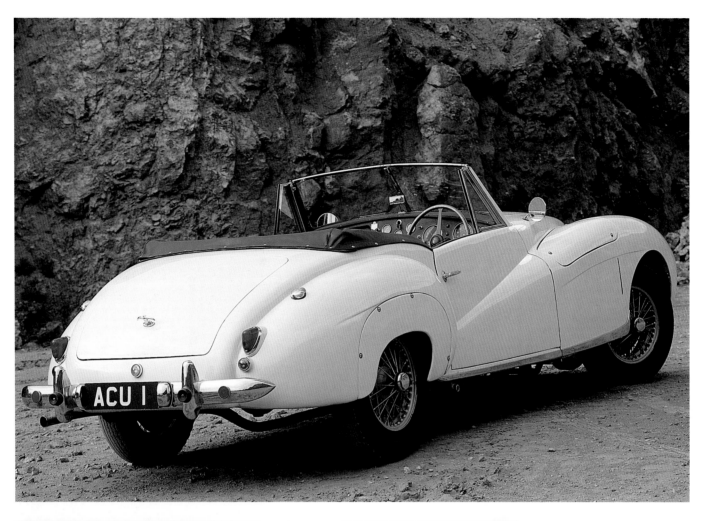

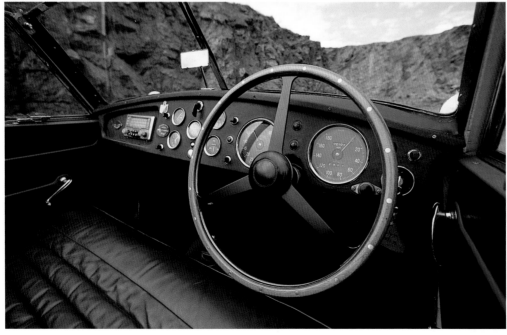

The rear wheels can be completely covered by further panels. The spare wheel is mounted vertically in its own housing in the right-hand wing. The entire front hood can be lifted, but for minor repairs there is an additional narrow opening giving access to the engine.

Unter die Haube gebracht: Die Hinterräder lassen sich durch entsprechend geformte Bleche auch völlig abdecken. Unter einem eigenen Deckel verborgen steht das Reserverad senkrecht im rechten Kotflügel. Zwar lässt sich die gesamte Vorderpartie abklappen, aber für kleinere Reparaturen gibt es einen schmalen weiteren Zugang zum Motor.

Bien chapeautées : des carénages permettent, quand on le désire, de faire disparaître presque totalement les roues arrière tandis que la roue de secours est astucieusement camouflée à la verticale sous un capot spécifique de l'aile avant droite. S'il est aussi possible de rabattre toute la proue, un petit capot donne accès au moteur pour les interventions mineures.

DB2

"One of the most beautiful cars in the world" proclaimed *Motor* in April 1950, while in the July 1952 issue of *Auto Sport Review*, John Wheelock Freeman viewed it as "the apotheosis of British craftsmanship" and recalled its early history, when David Brown sent three prototypes to Le Mans 1949 with streamlined coupé bodywork on the basis of the 2-litre Sports. One of them, registered for road use as was customary at Aston Martin and carrying the number plate UMC 66, contained the monumental six-cylinder engine provided by W. O. Bentley when Lagonda and Aston Martin teamed up.

Bentley's 105 horsepower twin-overhead camshaft creation was also to be found in a fourth coupé, which can to a certain extent be regarded as the forerunner of the DB2 range. This was subjected to an incessant testing program involving thousands of miles of continental roads, before its official press launch on 12th April 1950. At the end of the year 125-horsepower saloon and drophead coupé variants of a Vantage model came out. The separation between the three parts of the radiator grille had now been dropped, a design change which contributed markedly to the simple, clean lines of the DB2. Designer Frank Feeley's pontoon-shaped alloy body was clearly borrowed from the contemporary Italian school. The whole front section could be opened towards the front, providing excellent access to the engine, auxiliary units and tools. Space at the rear was limited to a small compartment for the spare wheel, and any luggage had to be stowed via the car's passenger compartment on a platform located over and behind the rear axle.

The square-tube frame, which formed a kind of skeleton underlying the bodywork, was almost delicate in appearance but in fact proved to be incredibly resistant to torsion. With the rear wheels now featuring twin trailing arms on either side, the chassis and suspension iron out even the bumpiest of road surfaces in a manner quite untypical of English sports cars.

411 DB2s were produced by April 1953, roughly 100 of them Drophead Coupés, giving the Aston Martin a secure niche in the sports car market and positioning the marque well to encroach on the respective German and Italian fiefdoms. As the product of time-honored traditions of hand craftsmanship, the DB2 was not exactly to be had for peanuts, the saloon costing £2724 (plus sales tax) in 1952, and the cabriolet no less than £2879, or over £1000 more than the Jaguar XK120. Meanwhile horizons were broadening as the board identified well-heeled young families as a target group. This strategy led to the DB2/4, a 2+2-seater, 565 of which were sold over the two years from October 1953, 73 of them drophead coupés. Three modifications created extra space. Firstly, the DB2/4 is 178 millimeters longer than the DB2, while secondly, slightly increased headroom in the rear gives the model a somewhat steeper outline without significantly affecting its character. Thirdly, the large luggage platform over the rear axle was turned into two rudimentary seats. The folding rear backrest was probably a world first, while the tailgate, which now allowed access to the trunk from outside, was elegantly integrated into the smooth lines of the DB2/4's bodywork. The central bar in the slightly curved windshield disappeared, further helping Frank Feeley's creation to find its own distinctive identity.

One curiosity of the design was that the car's tool kit was located beneath a padded cover between the two front seats, while passengers of all sizes could position their seats to their own satisfaction. The large, thin three-spoke steering wheel was adjustable in the direction of travel as well. The model's many reviewers also praised the lavish instrumentation which extended well into the passenger's half of the car.

The DB2/4 understeered moderately into corners and the rear end only started to drift if you really carried it to extremes, as works driver Roy Salvadori did for the journal *Autocourse* in May 1955 when gunning the test car to "two-miles-a-minute" status. Salvadori was using the three liter engine with which Aston Martin's "family saloon" was equipped from mid-1954 onwards, a unit developing 140 horsepower at 5000 rpm. Even at 2000 rpm it generated impressive punch. However, steering, clutch and brake operation called for strong biceps and well-developed leg musculature.

A Mark II Version, 199 of which were built between October 1955 and August 1957, involved minor modifications such as slightly increased headroom and small rear fins as a concession to contemporary American tastes, seats with better lateral grip and partial attachment of the front body to the frame so that the entire section no longer had to be removed in order, for instance, to check the oil level. A hardtop variant was added to the existing saloon and drophead coupé versions. This followed the lines of the cabriolet with its hood mounted. A total of 34 were built.

Three chassis were sent to be dolled up as flat spyders by the Milan firm Carrozzeria Touring according to their Superleggera principle, producing elegant and sophisticated chrome creations with oodles of southern flair. However, the standard bodies produced by Tickford of Newport Pagnell, in David Brown's ownership since 1954, were no Cinderellas themselves, so external orders such as this remained a rarity.

For some reason the designation 2/4 got lost in the final and highest version of the DB2, presented to an enthusiastic public at the Geneva Spring Motor Show in March 1957. It immediately became known as the DB Mark III.

This was given the aggressive pointed radiator design of the DB3S racing sports car, which suited it well, but in other respects had the chassis and body of its predecessor. *Road & Track* acknowledged this conservatism in its May 1957 version, noting that it demonstrated that clean aerodynamic lines do not go out of date even after seven years. The cost of so much automotive beauty and quality was entirely reasonable, especially in comparison with its costly Italian rivals. The approval of the leading American motoring magazine was important and possibly conducive to the fact that 350 of the 550 Mark IIIs produced (85 of them drophead coupés, plus a few notchback coupés) were destined to be sold in the USA. The rear quarterlights were now hinged and could thus contribute to the ventilation of the passenger compartment, while the dashboard instruments were gathered together in the driver's field of view under a rounded lip.

The engine had been extensively modified by the Polish émigré Tadek Marek, an Aston Martin employee since 1954 and the man responsible for the DB4 project. A new cylinder head boosted its power to 162 horsepower or, in

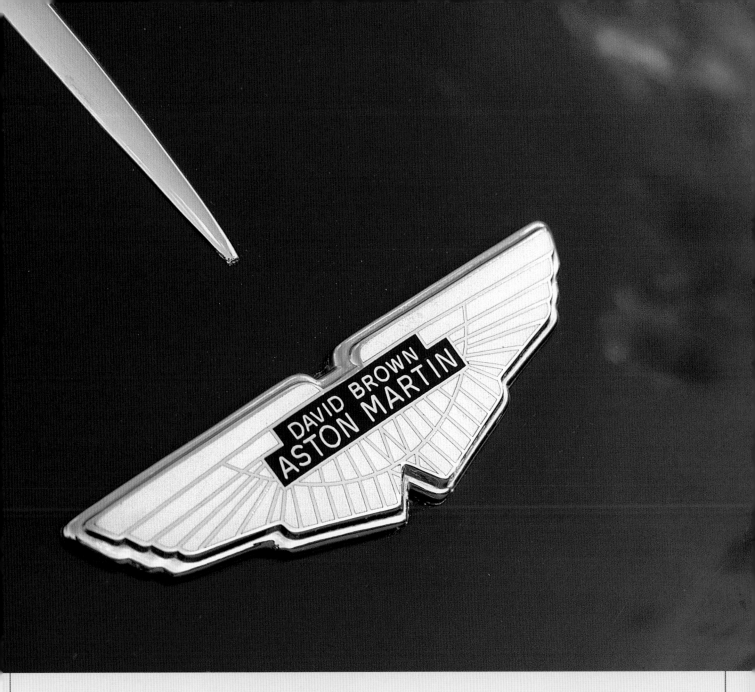

conjunction with a dual exhaust system, to 178 horsepower. And if even that was not enough, a version with high-lift camshafts, an increased compression and three voluminous Weber carburetors pumped the power up still further to 195 horsepower. These were a product of Aston Martin's involvement in motorsport, something which was as much an article of faith for David Brown as for his predecessors. Girling disc brakes were available as an option on the first 100 cars, and later became standard on the Mark III, having proved themselves in the crucible of racing competition. The tried-and-tested four-speed gearbox, *Road & Track* noted with approval, was now somewhat faster and smoother to change. From 1958

onwards overdrive by Laycock de Normanville could be ordered as an optional extra. According to the renowned English car tester John Bolster a gentleman attired in a dinner jacket would not be out of place at the wheel of a Mark III, and if he should find the task of gear changing rather too wearisome, a Borg Warner automatic was available for an extra £150 from 1959 onwards – a development viewed by the purists as an outrageous piece of sacrilege. When the Mark III passed peacefully away in 1959, it had done its duty. The DB4 had been a long time coming, but in the meantime the last and most mature descendant of the legendary Atom had done sterling service for many and proved itself a worthy substitute.

David Brown inserting his own name into the traditional Aston Martin wing shows his pride in the famous marque he has acquired and his own achievements.

Beflügelt: Im Namenszusatz auf dem Markenzeichen des DB Mk III manifestiert sich David Browns Stolz auf seine schönste Tochter.

Des ailes pour l'éternité : en ajoutant son patronyme à l'emblème d'Aston Martin, David Brown exprime combien il est fier de la marque qu'il vient de reprendre, et de ce qu'il en a fait.

»Eines der schönsten Autos der Welt« nennt ihn *Motor* im April 1950. Und: »Die Apotheose britischen Handwerks« frohlockt John Wheelock Freeman in *Auto Sport Review* vom Juli 1952 und erinnert auch gleich an die Vorgeschichte: Zum 24-Stunden-Rennen von Le Mans 1949 schickt David Brown drei Prototypen mit windschlüpfigen Coupé-Karosserien auf der Basis des 2-litre Sports. In einem von ihnen, mit dem amtlichen Kennzeichen UMC 66 nach Gepflogenheit des Hauses für die Straße zugelassen, erhebt sich monumental der Sechszylinder, den W. O. Bentley als Lagonda-Mitgift in die Ehe mit Aston Martin eingebracht hat. Mit zwei Nockenwellen unter einem schimmernd polierten Deckel ist Bentleys Bauwerk, 105 markige PS stark, auch im Motorenabteil eines vierten Coupés anzutreffen.

Bei diesem handelt es sich gewissermaßen um den Ahnherrn der Baureihe DB2. Ihm ist ein rast- und ruheloses Autodasein beschieden, mit unzähligen Testkilometern auf kontinentalen Straßen, bevor das Modell am 12. April 1950 der Presse offiziell vorgestellt wird. Man offeriert es Ende des Jahres in einer Vantage-Version von 125 PS als Saloon und Drophead Coupé und hat inzwischen die Trennung zwischen den drei Teilen des Kühlergrills wegfallen lassen. Diese Retusche ist der Schlichtheit im Erscheinungsbild des jüngsten Aston Martin durchaus zuträglich. Der pontonförmigen Leichtmetallkarosserie des DB2 hat Designer Frank Feeley offensichtlich Elemente der zeitgenössischen italienischen Schule anverwandelt. Die gesamte vordere Partie des Aufbaus lässt sich nach vorn abklappen, was einen exemplarisch großzügigen Zugang zu Motor, Hilfsaggregaten und Werkzeug gestattet. Hinten ist lediglich ein passgerechtes Kämmerlein mit einem eigenen Deckel für das Reserverad vorgesehen. Gepäck muss von innen auf einer Plattform über und jenseits der Hinterachse verstaut werden.

Der Fachwerkrahmen aus Vierkantrohren, die die Karosserie wie ein Gerippe unterbauen, wirkt fast filigran, erweist sich indessen als ungemein verwindungssteif. Das Fahrwerk – die Hinterräder sind inzwischen an jeweils zwei Längslenkern aufgehängt – bügelt selbst rauen Untergrund weitaus geschmeidiger aus, als man dies von englischen Sportwagen gewohnt ist.

Mit Opus 2, bis zum April 1953 in 411 Einheiten auf die schönen Speichenräder gestellt, davon ungefähr 100 Drophead Coupés, bezieht Aston Martin seinen festen Platz auf dem Sportwagenmarkt und bläst zugleich zum Angriff auf deutsche und mediterrane Erbhöfe. Als Produkt altväterisch-redlicher Handarbeit bekommt man den DB2 nicht eben für einen Pappenstiel: 1952 schlägt der Saloon mit 2724 Pfund (einschließlich Kaufsteuer), das Cabriolet mit 2879 Pfund zu Buche, über 1000 Pfund mehr als ein Jaguar XK120.

Doch schon weiten sich die Horizonte, hat man die Vorstände sprießender Familien unter den Jüngern der Marke als Zielgruppe ausgemacht. An diese ist

der DB2/4 adressiert, ein 2+2-Sitzer, der vom Oktober 1953 an in den folgenden zwei Jahren 565 Käufer findet. 73 davon entfallen auf das Drophead Coupé. Zusätzlichen Raum hat man durch drei Maßnahmen geschaffen: Der DB2/4 ist 178 Millimeter länger als der DB2. Ein leichtes Mehr an Kopffreiheit lässt die Silhouette etwas steiler abfallen, ohne dass der Charakter des Modells insgesamt angetastet würde. Und der großen Gepäckplattform wurden zu Häupten der Hinterachse zwei rudimentäre Sitzgelegenheiten abgewonnen. Die Hecklehne – vermutlich eine Weltpremiere – ist umlegbar. Die rückwärtige Klappe, welche nun den Zugang zum Kofferabteil von außen erschließt, wurde gleichermaßen elegant in die Linie und in die Karosserie des DB2/4 integriert. Der mittlere Steg in der sanft gekrümmten Windschutzscheibe entfällt, womit Frank Feeleys Beau für Piste und Boulevard gewissermaßen ein weiteres Stückchen zu sich selbst gefunden hat.

Eine Kuriosität findet sich zwischen den beiden vorderen Fauteuils. Dort wartet unter einer gepolsterten Abdeckung das Bordwerkzeug auf einen der Fälle, die hoffentlich niemals eintreten. Passagiere jeglichen Wuchses können vorne eine zufrieden stellende Sitzposition beziehen, zumal sich das große, dünne Dreispeichenlenkrad in Fahrtrichtung verstellen lässt. Anerkennend äußern sich die zahlreichen Rezensenten des Modells auch zu der üppigen Instrumentierung, deren Ausläufer sich bis weit in den Einzugsbereich des Beifahrers erstrecken.

In Kurven gibt sich der DB2/4 gutmütig untersteuernd und drängt erst dann mit dem Heck nach außen, wenn es der Pilot wirklich zu bunt treibt wie Werksfahrer Roy Salvadori für die Zeitschrift *Autocourse* im Mai 1955, wo der Prüfling als »two-miles-a-minute«-Renner gefeiert wird. Schon bei diesem Test basiert bereits auf dem Dreiliter-Motor, mit welchem der »family saloon« von Aston Martin seit Mitte 1954 ausgeliefert wird, mit 140 PS bei 5000/min. Schon bei 2000/min tritt er kräftig an. Die Betätigung von Lenkung, Kupplung und Bremsen verlangt nach Bizeps und gut ausgebildeter Beinmuskulatur.

Einer Mark-II-Version, von Oktober 1955 bis August 1957 in einer Auflage von 199 Stück gebaut, hat man milde Modellpflege angedeihen lassen, ein bisschen mehr Spielraum für den Kopf und kleine Finnen hinten als Knicks vor dem amerikanischen Zeitgeschmack, Sitze, die besseren seitlichen Halt gewähren, eine teilweise feste Verbindung der Karosserie vorn mit dem Rahmen, so dass nicht mehr das komplette Vorderteil der Verkleidung angehoben werden muss, wenn man zum Beispiel den Ölstand überprüfen möchte. Zu Saloon und Drophead Coupé gesellt sich nun eine Hardtop-Variante, welche die Linie des Cabriolets mit aufgesetzter Haube nachzeichnet und 34 Exemplare der Mark-II-Population insgesamt stellt.

Drei Chassis werden von der Mailänder Carrozzeria Touring gemäß ihrem Superleggera-Prinzip als flache Spyder in Schale geworfen, geborene Salon-

löwen mit viel Chrom und südländischem Flair. Aber da auch die Normalkarosserien von Tickford in Newport Pagnell, seit 1954 im Besitz von David Brown, ja keine Aschenbrödel sind, bleibt ein solcher Fremdauftrag die Ausnahme.

Irgendwie ist der letzten und höchsten Ausbaustufe des DB2, dem staunenden Publikum beim Genfer Frühlingssalon im März 1957 präsentiert, das 2/4 abhanden gekommen: Sie heißt umgehend DB Mark III.

Man hat ihr das aggressiv gespitzte Kühlermaul des Rennsportwagens DB3S verpasst, was ihr gut zu Gesicht steht, und im Übrigen Chassis und Aufbau des Vorgängers übernommen. *Road & Track* nimmt diesen Konservatismus in der Ausgabe vom Mai 1957 wohlwollend zur Kenntnis: Hier sei der Beweis, dass eine saubere aerodynamische Linie selbst nach sieben Jahren ihre Aktualität nicht verliere. Der Preis für so viel automobile Schönheit und Qualität sei durchaus angemessen, vor allem im Vergleich zu der saftig teuren italienischen Konkurrenz. Die Billigung der führenden amerikanischen Publikation ist wichtig. 350 der 550 Mark III (85 davon sind Drophead Coupés, einige wenige Notchback Coupés) werden in die USA ausgeführt. Die hinteren Seitenfenster sind nun ausstellbar und somit der Ventilation des Innenraums dienlich, die Instrumente im Blickfeld des Lenkers unter einem gewölbten Wulst versammelt.

Das Triebwerk wurde gründlich überarbeitet von dem Exilpolen Tadek Marek, Aston-Martin-Kostgänger seit 1954 und eigentlich für das Projekt DB4 zuständig.

Ein neuer Zylinderkopf bläst ihm 162 oder, im Verbund mit einem Doppelauspuff, 178 PS ein. Falls es noch ein wenig mehr sein darf, holt man bis zu 195 PS aus dem Ärmel, mit schärferen Nockenwellen, höherer Kompression sowie drei voluminösen Weber-Vergasern. Der Rennsport lässt grüßen, geheiligter Glaubensartikel auch im Credo David Browns. Girling-Scheibenbremsen vorn werden für die ersten 100 Exemplare noch als Option angeboten und zählen anschließend zur Grundausstattung des Mark III. Auch sie haben sich bewährt im Fegefeuer der Piste. Das bewährte und urgesunde Viergang-Getriebe, stellt *Road & Track* befriedigt fest, lasse sich nunmehr noch einmal eine Idee schneller und angenehmer schalten. Wahlweise steht ab 1958 ein Overdrive von Laycock de Normanville zur Verfügung. Ist der Gentleman am Volant, dort laut dem renommierten englischen Autotester John Bolster auch im Dinnerjacket nicht fehl am Platze, gar des Hand-Werks müde, wird ihm dieser Tort auf Wunsch und zum Aufpreis von 150 Pfund ab 1959 durch eine Automatik von Borg Warner abgenommen. Kein Wunder, dass dieser Zug von den Fundamentalisten unter den Freunden der Marke mit einem wütenden Aufschrei als Verrat an der reinen Lehre gebrandmarkt wird.

Als der Mark III 1959 friedlich entschlummert, hat er fürwahr seine Pflicht getan. Allzu lange ließ der DB4 auf sich warten. Aber eine ganze Reihe von Kunden war mit seinem Statthalter, dem letzten und am Ende voll ausgereiften Abkömmling des legendären Atom, gar nicht schlecht bedient.

The vent in front of the windscreen supplies the heating and demisting system with air.

Der Einlass vor der Windschutzscheibe führt der Heizung und dem Beschlagentfernungssystem Luft zu.

L'ouïe à la base du pare-brise alimente en air le chauffage et le système de désembuage du pare-brise.

L'une des plus belles voitures du monde », tel est le commentaire de *Motor* dans son numéro d'avril 1950. « L'apothéose de l'artisanat britannique », exulte John Wheelock Freeman dans *Auto Sport Review* de juillet 1952, rappelant aussi dans la foulée ses antécédents : pour les 24 Heures du Mans de 1949, David Brown engage trois prototypes avec des carrosseries aérodynamiques de coupé sur la base de la 2-litre Sports. Sous le capot de l'une d'elles, qui, selon les us et coutumes de la maison, est homologuée pour la route et arbore l'immatriculation officielle UMC66, se trouve le six-cylindres que W. O. Bentley a apporté en dot de Lagonda dans le mariage avec Aston Martin. Avec deux arbres à cames sous un couvercle poli comme de l'argent, le cadeau de Bentley, avec ses 105 ch, se retrouve dans le compartiment moteur d'un quatrième coupé.

Celui-ci constitue en quelque sorte l'ancêtre de la gamme DB2. Il connaîtra un destin sans repos pour une automobile, avec d'innombrables kilomètres d'essais sur les routes du continent avant que le modèle ne soit présenté officiellement à la presse le 12 avril 1950. À la fin de l'année, il est offert dans une version Vantage de 125 ch en Saloon et Drophead Coupé et a, entre-temps, abandonné la séparation entre les trois éléments de la calandre. Cette retouche est du plus bel effet, tant la sobriété des lignes sied à la toute nouvelle Aston Martin. Le designer Frank Feeley semble s'être inspiré de l'école italienne contemporaine pour la carrosserie en alliage léger, au style de ponton, de la DB2. Toute la partie avant de la carrosserie se rabat d'un seul bloc et dénude le moteur, ses organes et les outils de bord. À l'arrière, on ne trouve qu'un minuscule compartiment avec son couvercle pour la roue de secours. Quant aux bagages, il faut les placer derrière les sièges.

Le châssis tubulaire en tubes de section carrée qui soutient la carrosserie comme un squelette semble très léger mais s'avère pourtant d'une rigidité étonnante. Les trains roulants gomment les inégalités de revêtement les plus grossières avec beaucoup de douceur.

Avec cette DB2 chaussée de jolies roues à rayons et produite à 411 exemplaires, dont une centaine de Drophead Coupés, jusqu'en avril 1953, Aston Martin s'installe sur le marché des voitures de sport et entre simultanément dans la catégorie supérieure ; elle va pouvoir passer à l'offensive contre ses rivales allemandes et italiennes. La DB2 étant le résultat d'un travail fait à la main dans la plus pure tradition artisanale, il est exclu de se l'offrir pour le prix d'une voiture de sport du tout venant : en 1952, la Saloon est facturée 2724 livres (TVA comprise) et le cabriolet coûte 2879 livres, soit 1000 livres de plus qu'une Jaguar XK120. Mais l'horizon s'éclaircit dès lors que l'on considère que parmi les adeptes de la marque, les jeunes familles aisées sont une cible de choix. C'est en effet à elles qu'est destinée la DB2/4, une 2+2 dévoilée en octobre 1953, qui trouvera 565 acheteurs au cours des deux années suivantes. Soixante-treize optent pour le Drophead Coupé. Deux astuces ont permis d'augmenter son habitabilité : l'empattement de la DB2/4 mesure 178 mm de plus que celui de la DB2 et la garde au toit à l'arrière a été légèrement accrue. La lunette est donc plus verticale, mais cela ne porte aucunement préjudice aux lignes générales de la voiture ou à son équilibre. De plus, deux sièges rudimentaires ont été ménagés au détriment du compartiment à bagages au-dessus du train arrière. Le dossier de ces deux sièges – sans doute une première mondiale – est rabattable. Très en avance sur son temps, le couvercle de malle avec lunette arrière intégrée qui permet d'accéder au coffre de l'extérieur ne nuit pas aux lignes ni à l'élégance de la carrosserie de la DB2/4. Le pare-brise légèrement galbé est désormais d'une seule pièce et affine les lignes tout en affirmant l'identité de la belle création de Frank Feeley, qui a plus que jamais sa place sur les pistes comme sur les boulevards.

Une curiosité se niche entre les deux fauteuils avant. On trouve, en effet, sous un accoudoir capitonné, les outils de bord dans l'hypothèse d'une panne qui, espérons-le, ne surviendra jamais. Les passagers, même de grande taille, peuvent s'installer d'autant plus confortablement à l'avant que le grand volant très mince à trois branches est réglable en profondeur. Les nombreux chroniqueurs qui ont essayé ce modèle ne tarissent pas d'éloges sur la richesse de l'instrumentation dont les cadrans les plus à droite arrivent au niveau du passager.

Dans les virages, la DB2/4 affiche un tempérament sous-vireur sécurisant qui ne laisse décrocher l'arrière que lorsque le pilote pousse la voiture dans ses derniers retranchements, comme l'a fait le pilote d'usine Roy Salvadori pour la revue *Autocourse* en mai 1955, qui a encensé le bolide, le qualifiant de voiture à « two-miles-a-minute ». Salvadori testait le moteur 3-litres avec lequel la « family saloon » d'Aston Martin est livrée depuis le milieu de 1954 et qui délivre 140 ch à 5000 tr/min. À 2000 tr/min, ses reprises sont déjà vigoureuses. Mais pour actionner la direction, l'embrayage et les freins, il faut une musculature d'athlète.

Une version Mark II produite à 199 exemplaires d'octobre 1955 à août 1957 a bénéficié de modifications mineures avec un peu plus d'espace pour la tête et des ailes arrière formant de petits ailerons, concession à la mode américaine de l'époque, des sièges offrant un meilleur maintien latéral, une partie de la carrosserie avant boulonnée au châssis, si bien qu'il n'est plus nécessaire de relever tout le capot pour vérifier le niveau d'huile, par exemple. La Saloon et le Drophead Coupé sont rejoints par une variante à *hard-top* qui reprend la ligne du cabriolet et représentera au total 34 exemplaires parmi les Mark II.

Trois châssis sont envoyés à la société milanaise Carrozzeria Touring, qui les habille selon son principe Superleggera, destinés à séduire les foules des salons grâce à leurs chromes rutilants et leur aura méditerranéenne. Mais les carrosseries normales fabriquées par Tickford à Newport Pagnell, qui appartient depuis 1954 à David Brown, ne sont pas, elles non plus, dépourvues d'élégance, et cette commande passée à un carrossier extérieur restera anecdotique.

On ne sait pourquoi l'ultime évolution de la DB2, présentée à un public étonné au Salon de Printemps de mars 1957, à Genève, a perdu son patronyme 2/4 : elle s'appelle tout simplement DB Mark III. Elle a été dotée du mufle agressif de la DB3S de compétition, ce qui lui sied d'ailleurs fort bien, et pour le reste elle reprend le châssis et la carrosserie de sa devancière. Ces derniers ont fait leurs preuves sur les circuits. *Road & Track*, dans son numéro de mai 1957, prend acte de ce conservatisme avec une grande bienveillance : voilà bien la preuve, écrit la revue, qu'une ligne aérodynamique nette ne perd rien de son actualité, même au bout de sept ans. Le prix est à la hauteur de tant de beauté et de qualité, notamment comparé à celui de ses concurrentes italiennes, qui est astronomique. L'approbation de la revue américaine, qui fait autorité, est capitale : 350 des 550 Mark III (dont 85 sont des Drophead Coupé et une petite poignée, des Notchback Coupé à trois volumes) sont exportées aux États-Unis. Les glaces de custode s'entrebâillent, ce qui améliore la ventilation du cockpit, et les instruments placés dans le champ de vision du conducteur sont bien regroupés.

Le moteur a été revu et corrigé par un exilé polonais, Tadek Marek, un motoriste venu de chez Austin qui a rejoint Aston Martin en 1954 pour retravailler le moteur de la DB4. Différentes modifications – bloc, vilebrequin, arbres à cames et collecteur – permettent d'extraire 162 ch du bloc de 2922 cm³ ou 178 ch en combinaison avec un double pot d'échappement. Le programme d'options offre une puissance de 195 ch grâce à des arbres à cames plus pointus, un taux de compression plus élevé et trois volumineux carburateurs Weber. La compétition, activité sacrée selon le credo de David Brown, n'est jamais loin. Les freins à disque Girling à l'avant sont proposés en option pour les 100 premiers exemplaires puis feront partie de la dotation standard de la Mark III, après avoir fait leurs preuves en compétition. Comme le constate avec satisfaction *Road & Track*, l'indestructible boîte à quatre vitesses a encore gagné en rapidité et en agrément. À partir de 1958, on peut disposer en option d'un overdrive Laycock de Normanville. Si c'est un gentleman qui prend le volant, écrit le célèbre chroniqueur automobile anglais John Bolster, il n'y sera jamais déplacé, même en smoking… Et, s'il est fatigué de changer les vitesses à la main, c'est, en option et contre un supplément de prix de 150 livres, une boîte automatique Borg Warner qui s'en chargera à sa place à partir de 1959. Mais le puriste ne s'étonnera pas que cette décision suscite un tollé parmi les fanatiques de la marque et soit qualifiée de crime de lèse-majesté.

Lorsque la Mark III prend sa retraite en 1959, elle n'a pas démérité, même si la DB4 est attendue depuis longtemps. En effet, nombreux sont les clients qui auront été parfaitement satisfaits de cette dernière descendante – la plus aboutie – de la légendaire Atom.

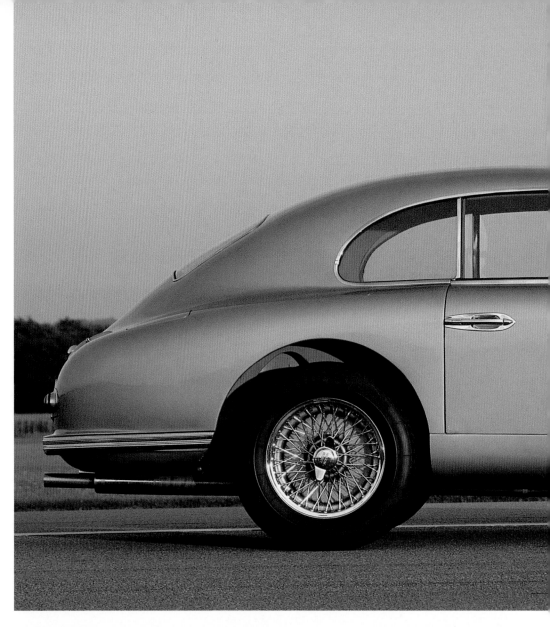

This Vantage version retains the original external appearance of the DB2 with its three-part front grill and two lateral outlets behind the front wheels, allowing hot air from the engine compartment to escape.

Bei dieser Vantage-Version handelt es sich äußerlich noch um DB2-Urgestein mit dreigeteiltem Frontgrill und zwei seitlichen Auslässen hinter den Vorderrädern, durch die heiße Luft aus dem Motorraum entweicht.

Cette version Vantage a l'apparence extérieure d'une ancêtre de la DB2 à calandre en trois éléments avec une ouïe d'aération derrière les roues avant qui sert à évacuer l'air brûlant du compartiment moteur.

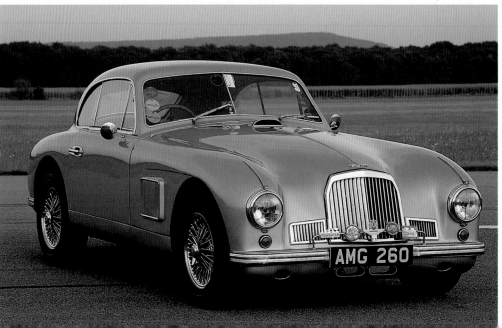

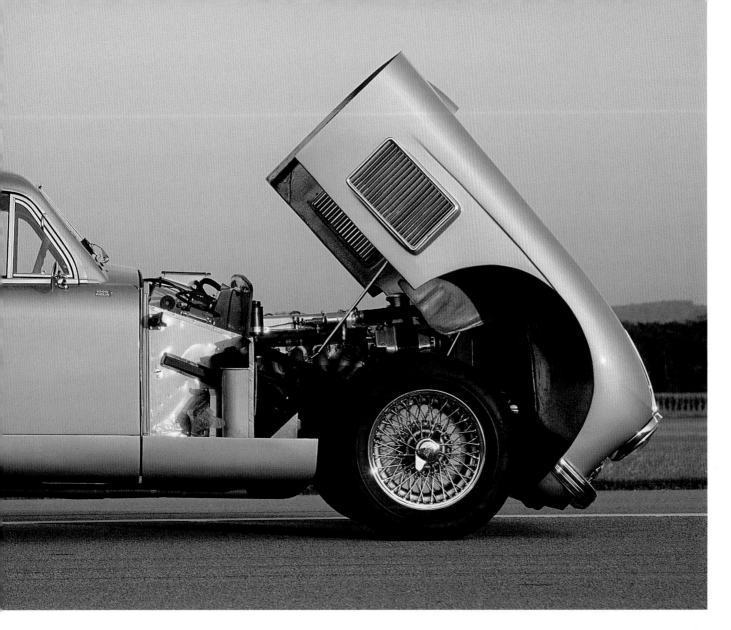

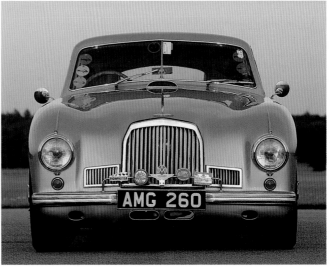

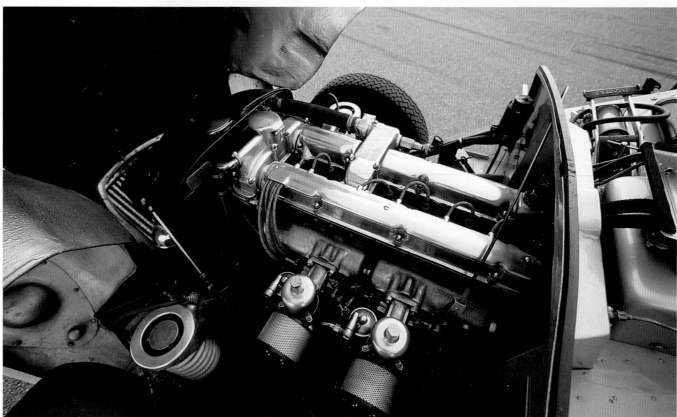

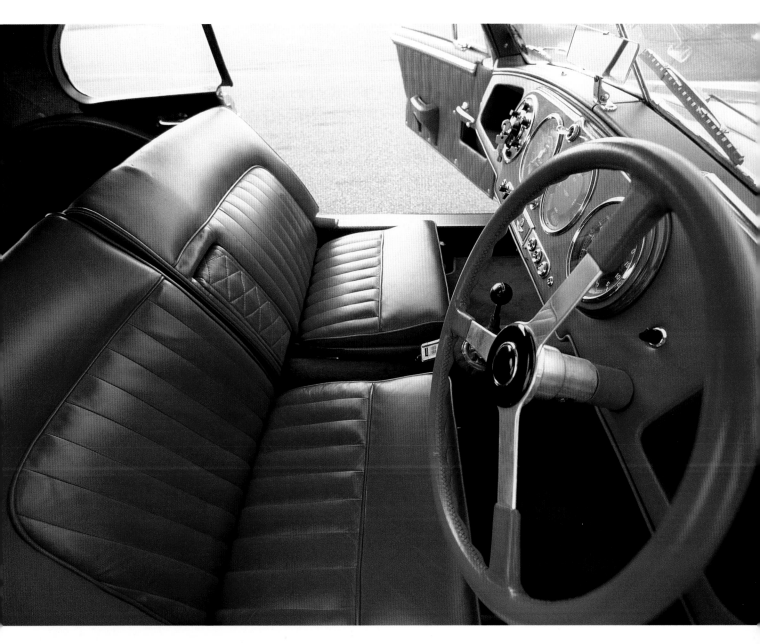

Beneath the upturned hood parts of the heating as well as a tire pump, an air pressure measuring device and a fire extinguisher are visible. A double SU carburetor helps boost the power of the DB2 Vantage to 125 bhp. The massive three-spoke steering wheel is vertically adjustable.

Einblicke: Unter der hochgestülpten Haube werden Elemente der Heizung, Luftpumpe, Luftdruckmesser und Feuerlöscher sichtbar. Ein SU-Doppelvergaser verhilft dem DB2 Vantage zu 125 PS. Das massive Dreispeichenlenkrad lässt sich in Längsrichtung verstellen.

Le capot moteur rabattu laisse entrevoir des éléments du chauffage, la pompe à air, le manomètre et l'extincteur. Un double carburateur SU confère à la DB2 Vantage une puissance de 125 chevaux. Le massif volant à trois branches est réglable en profondeur.

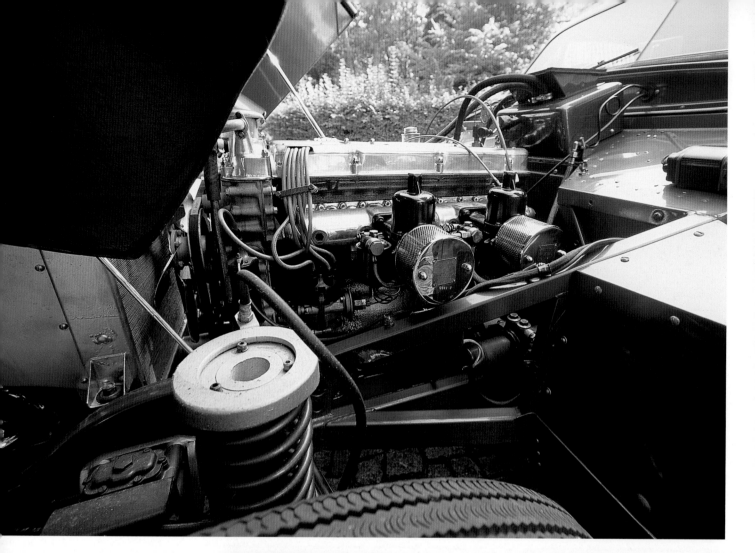

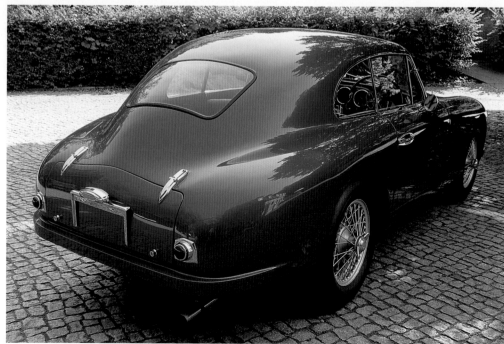

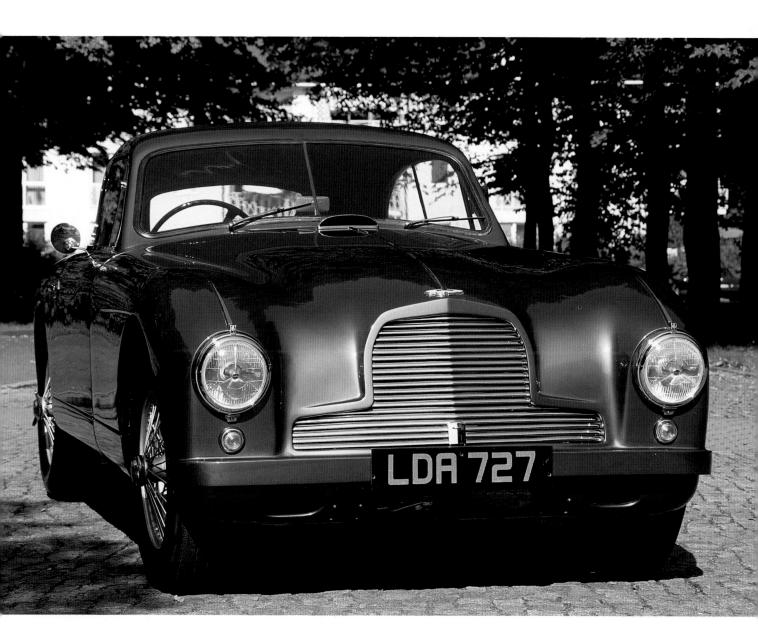

While retaining a high degree of individuality, the flowing lines given the DB2 by designer
Frank Feeley are reminiscent of the Italian automobile styling of the time.

Bei einer hohen Eigenständigkeit seiner flüssigen Linien hat Designer Frank Feeley dem
DB2 gleichwohl Elemente zeitgenössischer italienischer Formensprache anverwandelt.

Tout en lui laissant beaucoup de personnalité, le designer Frank Feeley a dessiné, pour la DB2,
des lignes fluides, caractéristiques des automobiles italiennes de l'époque.

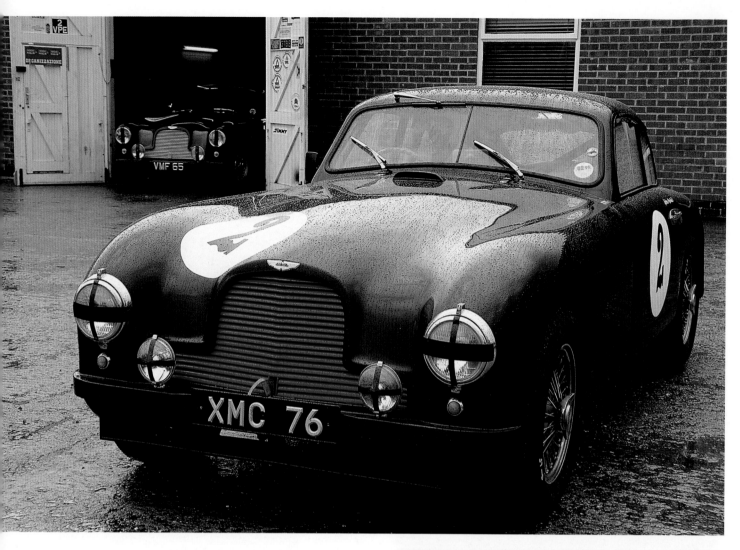

A long career: the DB2 with the XMC 76 number plate came 7th at the 1951 Le Mans 24-hour race as the Aston Martin works car driven by the team of Parnell & Hampshire. Remaining true to its original motorsport purpose, it continues to be raced to this day by its current owner Rowan Atkinson, aka Mr. Bean.

Unruhestand: Der DB2 mit dem Kennzeichen XMC 76 schloss 1951 in Le Mans als Team Car unter der Mannschaft Parnell/Hampshire auf Rang 7 ab. Seiner ursprünglichen Bestimmung, dem Rennsport, wird er noch heute zugeführt durch seinen Besitzer Rowan Atkinson alias Mr. Bean.

À quand une retraite méritée ? La DB2 immatriculée XMC 76 a terminé 7e au Mans en 1951 en tant que voiture d'usine pilotée par l'équipage Parnell/Hampshire. Aujourd'hui, elle court toujours, pilotée par un certain Rowan Atkinson, alias Mister Bean.

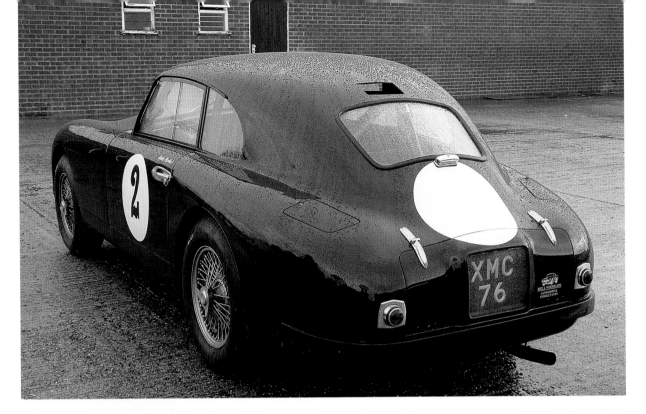

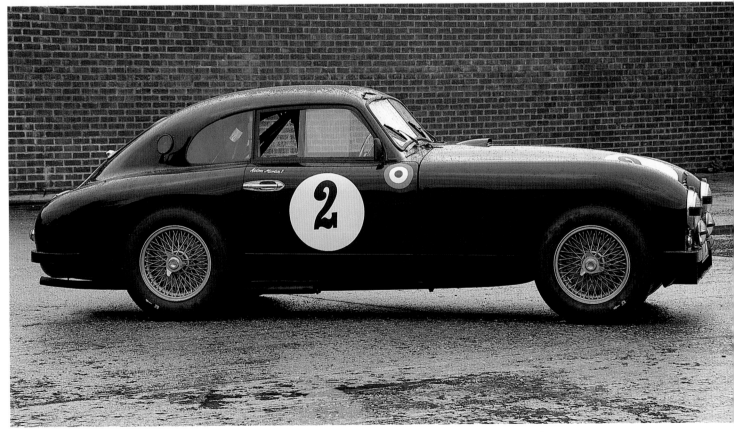

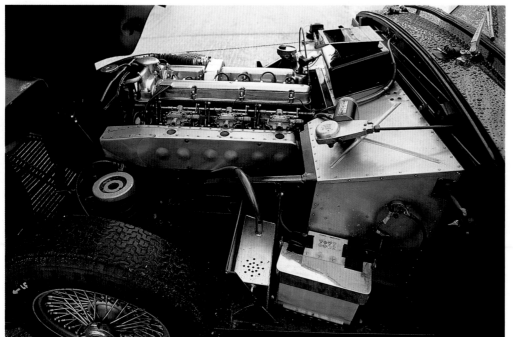

Safety first: modern requirements such as bucket seats and full harness belts may have purists shaking their heads, but do contribute to driver safety.

Safety first: Moderne Requisiten wie Schalensitze und Hosenträgergurte mögen den Puristen bekümmern, dienen jedoch der Sicherheit des Piloten.

Safety first : au grand dam des puristes, le siège baquet et le harnais garantissent une certaine sécurité au pilote.

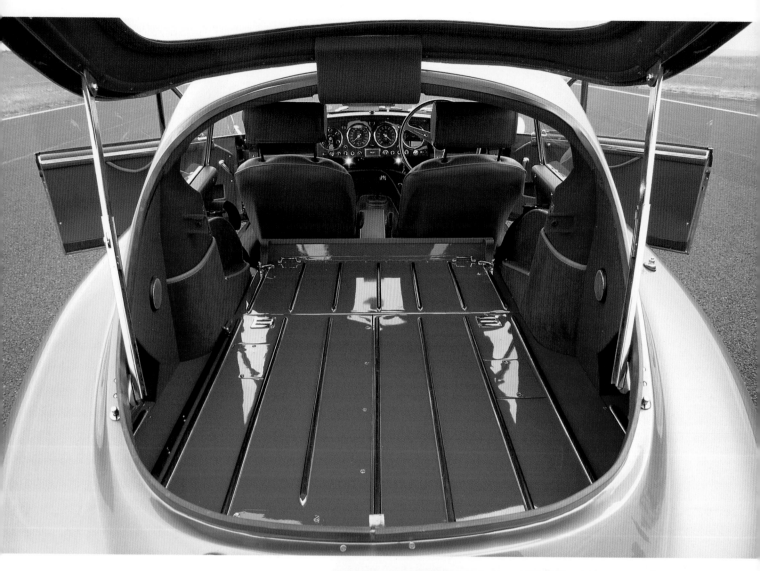

Space vehicle: a reporter at the time called the DB2/4 "the fastest shooting brake in the world". Its large rear door merges harmoniously with the handsome coupé lines. The fitting of a third SU carburetor bespeaks the owner's desire for some extra muscle.

Raum-Fahrzeug: Ein Berichterstatter aus jenen Jahren nennt den DB2/4 »den schnellsten Shooting Brake der Welt«. Seine große Heckklappe fügt sich gleichwohl harmonisch in die schöne Coupéform ein. Die Verwendung von drei SU-Vergasern anstatt der üblichen zwei zeugt vom Wunsch des Besitzers nach etwas mehr Muskel.

Navette spatiale : un journaliste a jadis qualifié la DB2/4 de « shooting brake la plus rapide du monde ». Son grand hayon ne dépare pas le moins du monde ses élégantes lignes de coupé. La présence de trois carburateurs SU, au lieu de deux à l'origine, témoigne que son propriétaire souhaitait un peu plus de punch.

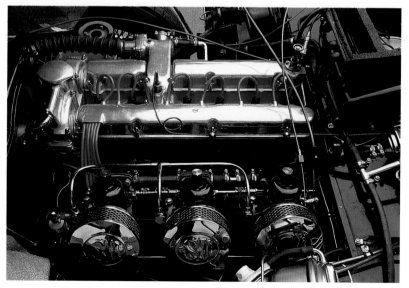

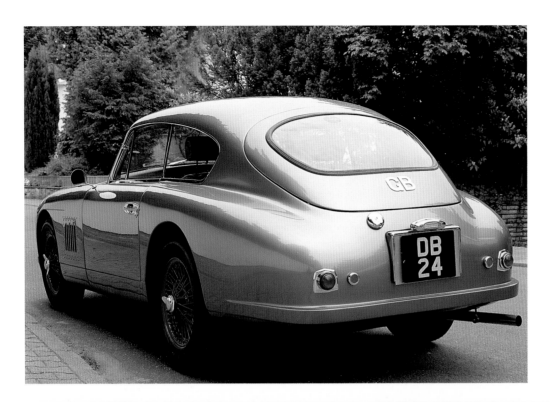

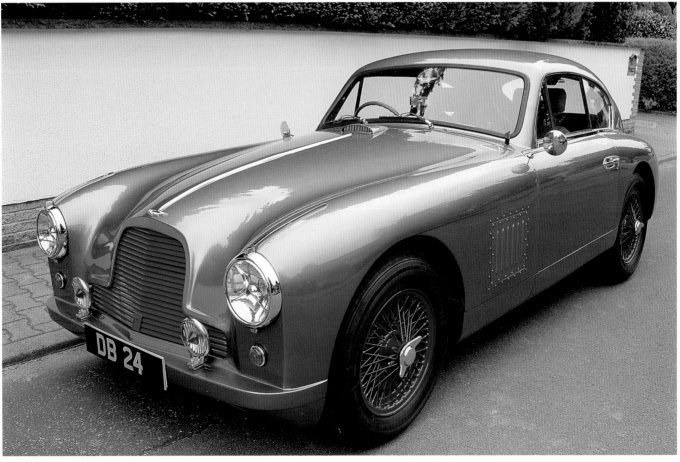

Attractive details include Lucas lamps, air inlets in front of the passenger compartment as well as chrome-plated door handles and winged logo.

Attraktive Details wie Lucas-Lampen, Lufteinlass vor dem Fahrgastraum, mit Chrom unterlegter Türgriff und Flügel-Emblem.

Le tableau de bord truffé d'instruments fait penser à un cockpit d'avion, une caractéristique traditionnelle d'Aston Martin, qui renforce la symbiose entre le conducteur et sa voiture.

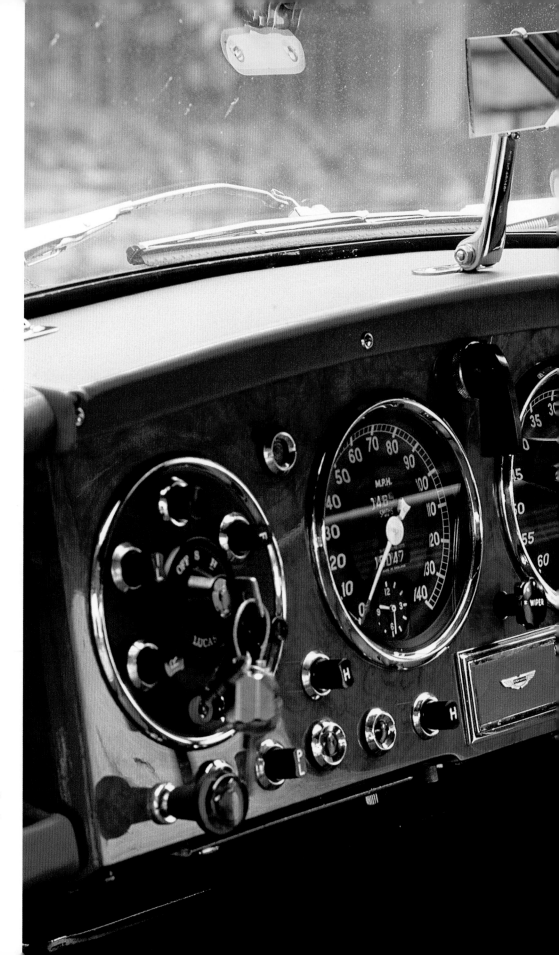

The crowded dashboard almost has the appearance of an airplane cockpit, an old Aston Martin virtue which strengthens the symbiosis between driver and machine.

Informations-Gesellschaft: Fast schon die Anmutung eines Cockpits geht von der reich ausgestatteten Instrumententafel aus, eine alte Aston-Martin-Tugend, die der Symbiose zwischen Fahrer und Fahrzeug dient.

Le tableau de bord truffé d'instruments fait penser à un cockpit d'avion, une caractéristisque traditionnelle d'Aston Martin, qui renforce la symbiose entre le conducteur et sa voiture.

A new face: the grille of the DB Mk III is an unmistakable borrowing from the DB3S, while the instrument ensemble is now designed for the driver's eyes only. Originally intended to fill the gap before the DB4 arrived, the final version of the DB2 possesses considerable individuality in its own right.

Neues Gesicht: Der Grill des DB Mk III ist unverkennbar dem DB3S entlehnt, das Ensemble der Instrumente nunmehr ausschließlich dem Fahrer zugeordnet. Eigentlich als Lückenbüßer vor der Ankunft des DB4 gedacht, besitzt die letzte Ausbaustufe des DB2 eine hohe Eigenständigkeit.

Nouveau visage : la calandre de la DB Mk III s'inspire sans ambiguïté de celle de la DB3S et l'ensemble des cadrans est maintenant regroupé dans le champ de vision du conducteur. Conçue à l'origine pour permettre d'attendre l'arrivée de la DB4, la dernière version de la DB2 se distingue par une grande personnalité.

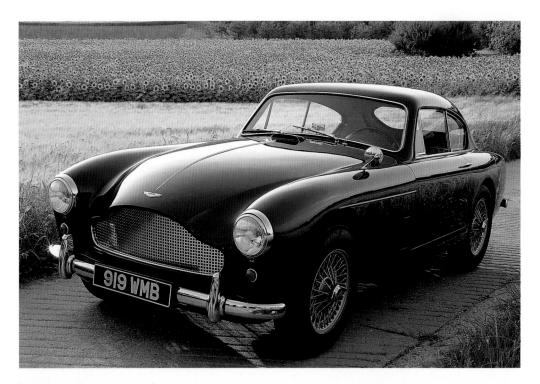

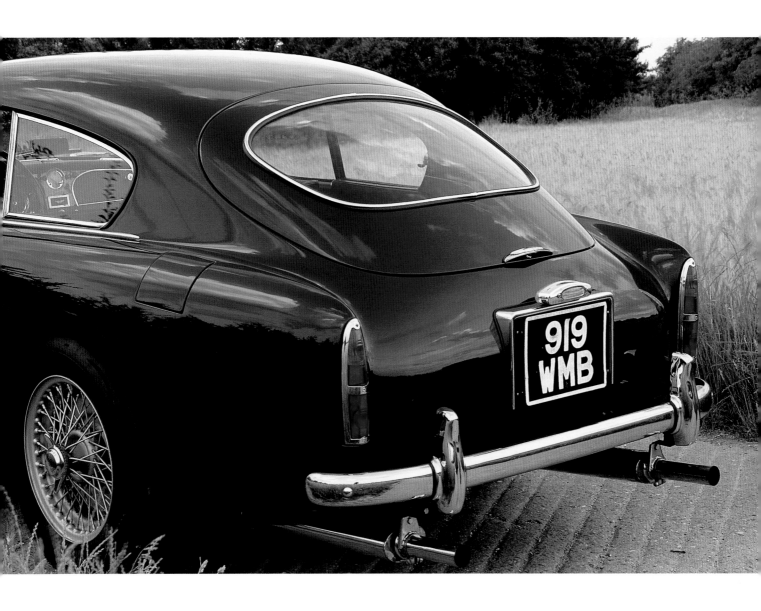

Following double page: Racing improves the breed. The DB Mk III's power unit shows clear influences from Aston Martin's motorsport experience. The majestic six-cylinder engine with its twin exhaust generates an impressive 178 bhp.

Folgende Doppelseite: Racing improves the breed. In das Triebwerk des DB Mk III sind reichlich die Erfahrungen aus dem Rennsport eingeflossen. Mit zwei Auspuffrohren leistet der majestätische Sechszylinder 178 PS.

Double page suivante : «Racing improves the breed». Le moteur de la DB Mk III profite des nombreuses expériences de la compétition automobile. Avec deux sorties d'échappement, le majestueux six-cylindres développe 178 chevaux.

Remodeling of a DB Mark III
Restaurierung eines DB Mark III
Restauration d'une DB Mark III

This DB Mk III was discovered in desperate condition, with some of its outline totally lost. The distinctive hood front was obtained by the Frankfurt restorer from the well-stocked Aston Martin Service of Dorset. He made the remainder, for example the grille's decorative trim, in his own workshop.

Der Zustand, in dem der DB Mk III vorgefunden wird, ist desolat. Die Konturen haben sich teilweise völlig verwischt. Die markante Haubenfront bezieht der Frankfurter Restaurator beim gut sortierten Aston Martin Service Dorset. Den Rest wie etwa den Zierrahmen für das Grill fertigt er in eigener Regie.

L'état dans lequel se trouvait cette DB Mk III n'est guère encourageant. Il ne reste plus grand-chose de la carrosserie. Le restaurateur de Francfort s'est procuré le capot moteur aux lignes marquantes chez le distributeur de pièces Aston Martin Dorset, toujours bien achalandé. Le reste, par exemple le jonc décoratif de la calandre, il le fabrique lui-même.

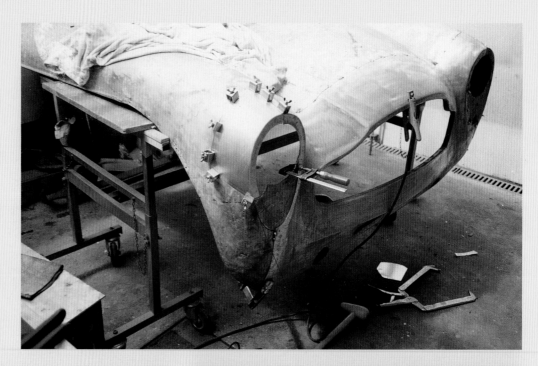

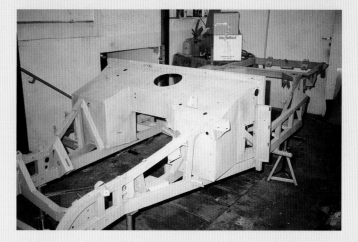

Only an expert would have been able to identify the make and type from this pile of scrap. It was only after a going over with the sand blaster that it became clear that the basic chassis was still usable.

Nur der Kundige hätte aus diesem Gewirr von Teilen und Teilchen noch Marke und Typ herausgelesen. Dass die Substanz etwa des Chassis brauchbar ist, zeigt sich nach der Behandlung mit dem Sandstrahlgebläse.

Seul un initié – et encore! – aurait pu identifier la marque et le type de la voiture à la vue de ce puzzle de pièces et de composants. Après avoir été décapé au sable, le châssis révèle qu'il est encore utilisable.

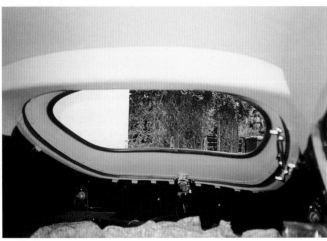

Part of the interior of the Mk III has been quietly rusting and rotting in boxes. Only a few instruments appear to have withstood the ravages of time reasonably well.
The first fruits of the restoration work: a rear window, new felt roof lining, cushions, and finally the completed upholstery for one seat.

Schrittweise Erneuerung: Das Innenleben des Mk III ist sanft modernd und rostend in Kisten ausgelagert. Nur einige Instrumente scheinen die Zerstörung durch die Zeit einigermaßen unbeschadet überstanden zu haben.
Erste Früchte der Aufbauarbeit: ein Heckfenster, ein neuer Filzhimmel, die Kissen, schließlich die komplette Einkleidung eines Sitzes.

Rénover pas à pas : les entrailles de la Mk III ont été stockées dans des caisses où elles ont moisi et rouillé au fil des années. Seuls quelques cadrans semblent avoir résisté un tant soit peu aux outrages du temps.
Les premiers fruits de la reconstruction : la lunette arrière, le nouveau capitonnage du toit, les coussins et, enfin, la garniture complète d'un siège.

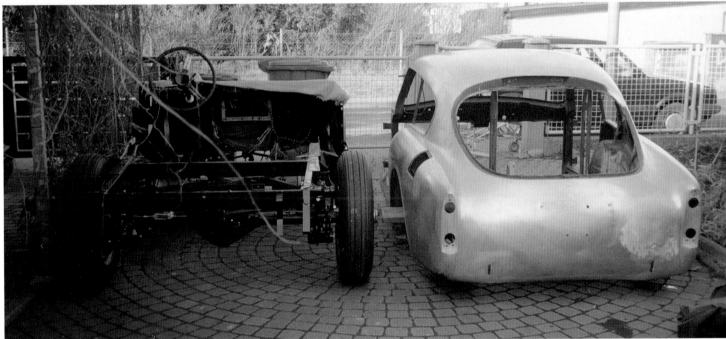

Among other items, the entire timing chain of the Mk III power train had to be replaced before it emerged brand new and gleaming red. The chassis has already been restored, the body is still bare but the outside surface has been treated with paint remover and the inside surface sandblasted.
The final fully-restored Aston Martin was the outcome of two years of dedicated work.

Am Triebwerk des Mk III mussten unter anderem sämtliche Steuerketten erneuert werden, bevor es rot und wie neu erglänzt. Das Chassis ist bereits restauriert, die Karosserie noch blank, außen abgebeizt, innen sandgestrahlt.
In dem neuen alten Aston Martin stecken zwei Jahre hingebungsvolle Arbeit.

Il a fallu notamment rénover la totalité des chaînes de commande du moteur de la Mk III avant qu'il ne puisse de nouveau briller de tous ses feux, rouge et scintillant. Le châssis est déjà restauré, la carrosserie, décapée à l'extérieur et sablée à l'intérieur, n'est pas encore peinte. La « nouvelle vieille » Aston Martin représente deux années d'un travail de bénédictin.

DB3

Leather trim: the straps on both the DB3 and the DB3S ensure that the hood stays on at high speeds. On the later model they are inset, improving the lines and saving space.

Leder-Ausstattung: Die Riemen sowohl am DB3 als auch am DB3S tragen dazu bei, die Fronthaube bei hohen Geschwindigkeiten am Fahrzeug zu halten. Bei dem späteren Modell sind sie bereits formschön und Platz sparend eingelassen.

Équipement en cuir : aussi bien sur la DB3 que sur la DB3S, les courroies empêchent le capot de s'ouvrir à grande vitesse. Sur le modèle suivant, elles seront déjà intégrées à la carrosserie avec plus d'élégance et de compacité.

Though sporty in nature, the DB1, DB2 and derivatives were essentially only capable of racing for class victories. This was not good enough for the ambitious David Brown, and so in 1951 he entrusted ex-Auto Union constructor Robert Eberan von Eberhorst and canny strategist John Wyer with the mission of designing a car capable of taking on and defeating the Jaguars and Ferraris.
However, two problems immediately presented themselves. Firstly, though they were not openly hostile, the chemistry between the two men was not right. And secondly, W. O. Bentley's six-cylinder engine was simply too heavy, and in other respects not necessarily suitable for racing purposes.
In the DB3 clear traces of Eberhorst's glorious past can be discerned, including a double-tube ladder frame, a de Dion axle and a Panhard rod at the rear, plus trailing arms and torsion bars all round. From the start John Wyer saw the model as no more than a stopgap, a view confirmed by its decidedly unpromising debut in the 1951 Tourist Trophy.
In 1952 it was fitted with a three-liter engine. The highpoints of that season came at the start and at the finish with second, third and fourth place at Silverstone behind Stirling Moss' Jaguar C-Type in spring and victory for Peter Collins and Pat Griffith in the nine-hour race at Goodwood in the middle of August in a 2.6 liter model that ended the race running on five cylinders. However, there was little to report between these two achievements,

and the low point came at the Monaco sports car race on 2nd June, which substituted for the Grand Prix that year, when oil from the broken engine of Reg Parnell's DB3 led to a massive mass shunt behind Sainte Dévote.
John Wyer and von Eberhorst's assistant Willie Watson called for a less weighty and more powerful vehicle. The result was the DB3S, which was 75 kilos lighter than its predecessor and developed 160 horsepower, a figure that had been raised to 180 by the time of the 1953 running of Le Mans. The chassis was set lower, the wheelbase reduced by 150 millimeters, and Frank Feeley had created attractive bodywork to round off the design. Due to inadequate preparation time the DB3S failed at Le Mans, but thereafter embarked on a series of victories on British circuits. It was a similar story in 1954, despite the fact that two spark plugs per cylinder had helped boost the power to 225 horsepower. The simultaneous preparation and deployment of a prestigious Lagonda V12 crippled both projects. Despite this, a small run of DB3Ss were released in October for both in-house use and for the private motorist. 1955 saw greater success, in part due to the addition of disc brakes and a further power boost to 240 bhp. The crowning point of this and the following season was a second place at Le Mans.
By 1956, though, Aston Martin was preparing to scale new heights: the exciting DBR1, the machine that would bring the marque its greatest motorsport triumphs, was waiting in the wings.

Obwohl von sportlicher Natur, taugen DB1 und DB2 und ihre Derivate auf den Rennpisten im Grunde genommen lediglich zu Klassensiegen. Dies wurmt den ehrgeizigen David Brown. Und so betraut er 1951 den ehemaligen Auto Union-Konstrukteur Robert Eberan von Eberhorst sowie den gewieften Strategen John Wyer mit der Mission, ein siegfähiges Auto zu bauen und es zum Erfolg zu führen, gegen die Jaguar, gegen die Ferrari.

Doch umgehend sieht man sich einem Doppel-Dilemma gegenüber: Ohne in offene Abneigung umzuschlagen, stimmt die Chemie zwischen den beiden Männern nicht. Und W. O. Bentleys Sechszylinder ist eigentlich zu schwer und auch sonst nicht unbedingt renntauglich.

Im DB3 sind deutliche Spuren der Praxis von Eberhorsts in den ruhmreichen dreißiger Jahren auszumachen, ein Doppelrohr-Leiterrahmen, die de-Dion-Achse und ein Panhardstab hinten, Längslenker und Drehstäbe ringsum. Gleichwohl sieht John Wyer das Modell von vornherein als Lückenbüßer an. Bereits sein wenig verheißungsvolles Debüt bei der Tourist Trophy 1951 gibt ihm Recht.

1952 rüstet man auf drei Liter auf. Die Höhepunkte der Saison liegen am Anfang und am Ende mit den Plätzen zwei bis vier hinter dem Jaguar C-Type von Stirling Moss in Silverstone und einem Sieg beim Neun-Stunden-Rennen von Goodwood Mitte August für Peter Collins und Pat Griffith in einem 2,6-Liter, der am Ende nur auf fünf Zylindern läuft. Über die Zeit dazwischen gibt es wenig Vergnügliches

zu berichten. Bei dem Sportwagenrennen in Monaco am 2. Juni, das in diesem Jahr den Grand Prix ersetzt, löst das Öl aus dem geborstenen Triebwerk von DB3-Pilot Reg Parnell gar einen teuren Auffahrunfall hinter Sainte Dévote aus. John Wyer und von Eberhorsts Adjutant Willie Watson bestehen auf einem leichteren und stärkeren Fahrzeug. Das Ergebnis ist der DB3S, der 75 Kilo weniger als sein Vorgänger auf die Waage und ursprünglich 160 PS, in Le Mans 1953 bereits 180 PS auf die Bremse bringt. Das Chassis ist tiefer gelegt, der Radstand um 150 Millimeter verkürzt, und Frank Feeley hat ihm eine attraktive Karosserie übergestreift. Auf Grund zu kurzer und zu hastiger Vorbereitung scheitert der DB3S in Le Mans, tritt dann jedoch einen Siegeszug über englische Pisten an.

Ähnliches bleibt auch 1954 trotz zweier Zündkerzen je Zylinder und 225 PS verwehrt. Vorbereitung und Einsatz eines prestigeträchtigen Lagonda V12 zur gleichen Zeit zehrt an den Nerven und an den Ressourcen und lähmt beide Projekte. Gleichwohl legt man im Oktober eine kleine Serie des DB3S für den Hausgebrauch und für Privatfahrer auf. 1955 wird ein gutes Jahr, wozu auch Scheibenbremsen und 240 stramme PS beitragen. Diese und die folgende Saison werden von zweiten Plätzen in Le Mans gekrönt.

Doch 1956 schickt man sich bereits an, zu neuen Ufern aufzubrechen. DBR1 heißt die erregende Perspektive für die Zukunft, die dem Hause Aston Martin die schönsten Erfolge seiner Sportgeschichte bringen wird.

Malgré leur nature sportive, les DB1 et DB2 ainsi que leurs cousines ne peuvent guère, en circuit, avoir d'autres ambitions que des victoires par catégories. Cette idée ronge l'ambitieux David Brown. Ainsi confie-t-il, en 1951, à l'ancien ingénieur d'Auto Union Robert Eberan von Eberhorst ainsi qu'au rusé stratège John Wyer la mission de construire une voiture capable de remporter la victoire au classement général et de la mener au succès contre les Jaguar et les Ferrari.

Mais deux problèmes se posent immédiatement : même s'il n'y a pas de conflit ouvert, il n'y a pas non plus d'affinité entre les deux hommes. Quant au six-cylindres de W. O. Bentley, a priori déjà trop lourd, il n'est pas non plus prédestiné pour la course.

On distingue dans la DB3 des traces du glorieux passé de von Eberhorst dans les années 1930 : un châssis en échelle à double poutre, le pont de Dion et une barre Panhard à l'arrière, des bras longitudinaux et des barres de torsion pour les quatre roues. John Wyer est pourtant immédiatement convaincu que cette voiture n'est qu'un substitut temporaire. Ses débuts décevants lors du Tourist Trophy de 1951, déjà, lui donnent raison. En 1952, sa cylindrée est majorée à 3 litres. C'est au tout début de la saison qu'elle connaît son apogée, une saison qu'elle termine avec des deuxième, troisième et quatrième places derrière la Jaguar Type C de Stirling Moss à Silverstone et avec une victoire à la course des Neuf Heures de Goodwood, à la mi-août,

pilotée par Peter Collins et Pat Griffith, équipée d'un moteur de 2,6 litres qui ne tourne plus que sur cinq cylindres. Lors de la course de voitures de sport de Monaco qui remplace le Grand Prix de cette année-là, le 2 juin, l'huile s'écoulant du moteur explosé de la DB3 du pilote Reg Parnell déclenche une collision en chaîne derrière Sainte-Dévote.

John Wyer et Willie Watson, l'adjoint de von Eberhorst, exigent une voiture plus légère et plus puissante. Le résultat en est la DB3S, qui accuse 75 kg de moins et, de 160 ch à l'origine, développe déjà 180 ch au frein pour les 24 Heures du Mans de 1953. Le châssis a été abaissé et l'empattement raccourci de 150 mm. Préparée à la hâte, la DB3S subit un échec au Mans, mais entame une série triomphale sur les pistes britanniques.

Elle ne remportera plus autant de succès en 1954, malgré deux bougies par cylindre et une puissance majorée à 225 ch. La préparation et l'engagement d'une Lagonda V12 au nom prestigieux à la même époque paralyse les deux projets. Ceci n'empêche pas que soit présentée, en octobre, une petite série de la DB3S destinée à un usage maison et à des pilotes privés. 1955 sera une bonne année, surtout grâce aux freins à disques et à la fiabilité de 240 vigoureux chevaux. Cette saison et la suivante seront couronnées par une deuxième place au Mans.

Mais, en 1956, on se prépare à partir à la conquête des étoiles. DBR1 est le nom de la voiture extraordinaire qui permettra à Aston Martin de glaner les plus beaux succès en course de son histoire.

DB3

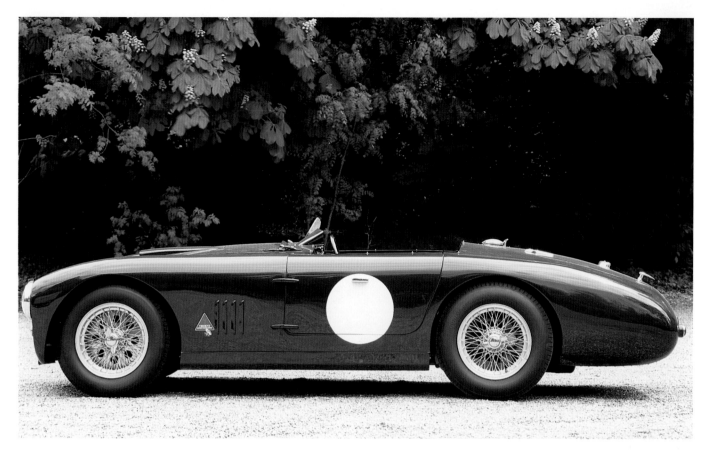

With numerous components, including the slightly modified engine taken from the DB2, and with its simple but elegant lines, the DB3 in the end had not much to offer in terms of success.

Mit zahlreichen Komponenten wie etwa der schwach modifizierten Maschine aus dem DB2 ausgestattet und von eher schlichter Schönheit, hat der DB3 am Ende wenig vorzuweisen.

Reprenant de nombreux éléments de la DB2, par exemple son moteur légèrement modifié, et d'une esthétique sobre, la DB3 ne peut finalement pas se prévaloir d'un palmarès très riche.

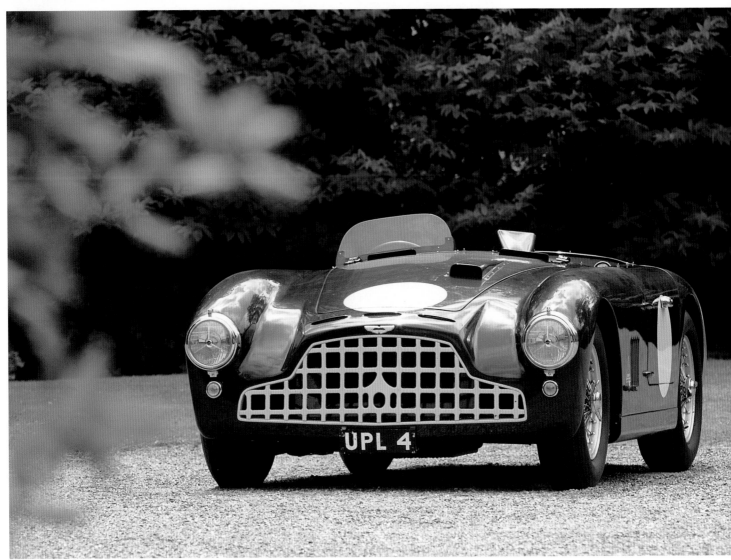

The DB3S bridged the gap to the successful DBR1 in terms
not only of its list of victories and podium finishes but also of design.

Nicht nur was die Liste seiner Siege und guten Platzierungen anbelangt,
sondern auch formal schlägt der DB3S die Brücke zu Erfolgstyp DBR1.

Par le nombre de ses victoires et de ses places d'honneur, mais aussi par son esthétique,
la DB3S est le digne précurseur de la DBR1, qui sera couronnée de succès.

Following double page: The body of the DB3S is a masterpiece from Frank Feeley,
and was the last word in modern design in 1953.

Folgende Doppelseite: Die Karosserie des DB3S ist ein Meisterstück Frank Feeleys.
Sie verkörpert 1953 zugleich den letzten Stand der Dinge.

Double page suivante : la carrosserie de la DB3S est un chef-d'œuvre de Frank Feeley ;
elle représente en 1953 le nec plus ultra du design.

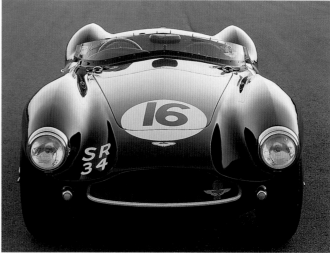

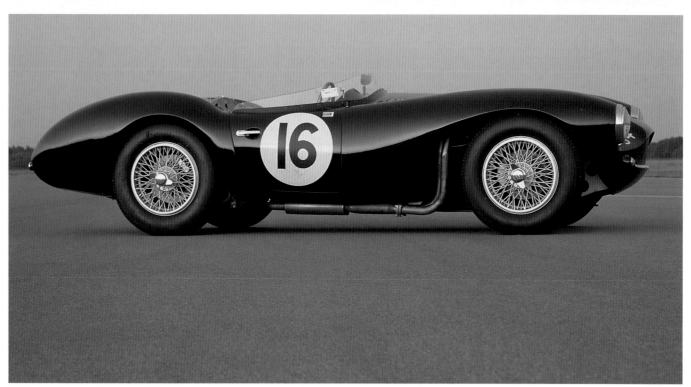

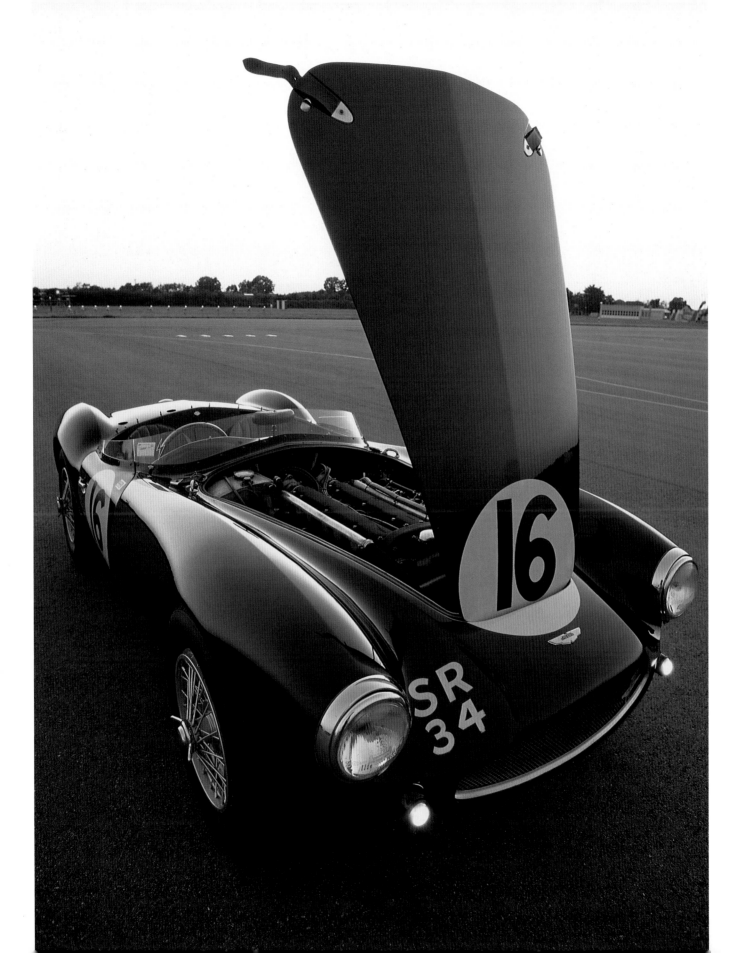

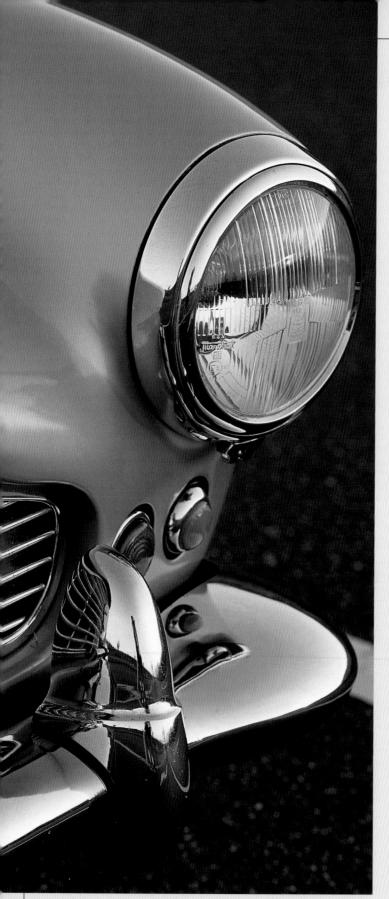

DB4

When *Motor* test driver Christopher Jennings returned in November 1960 to the car he had parked illegally, to his chagrin he found a Welsh policewoman waiting for him. However, it turned out that she was not there to uphold the letter of the law, in fact quite the opposite: the kind-hearted and attractive officer waved him into a nearby parking space and told him: "I could not bear to send away so beautiful a car."

This was typical of the emotions stirred, even among the ranks of officialdom, by the DB4, star turn of the 1958 London Motor Show. It had been a long time coming, with Aston Martin employee Harold Beach commencing work on its platform frame in 1954. When finally complete the car featured a live axle and twin trailing arms at the rear and front wishbone suspension, with lateral support provided by Watt linkage and helical springs all round representing the cutting edge of technology in those years.

The car's flowing lines were courtesy of Carrozzeria Touring, while the chassis was supplied from Farsley and the tubular understructure was welded on in Newport Pagnell. The body took the form of aluminum panels following the Milan company's Superleggera principle.

The engine was designed by Tadek Marek, a Pole who had fled from the Nazis in the Second World War, reaching England via Casablanca in 1941. After a certain amount of squabbling with John Wyer, who always had his eye on Aston Martin's motorsport interests, the two agreed on a six-cylinder aluminum engine with twin overhead camshafts and a capacity of 3670 cc, with "square" cylinders, bore and stroke both being 92 mm. Two SU horizontal carburetors gave it an initial power output of 242 horsepower. Since it did not have to try too hard to achieve this, future owners could look forward to long years of service from the engine, especially as it had already done motorsport duties under the bonnet of the DBR2. As usual the power transmission was entrusted to the in-house four-speed gearbox which always got a good reception.

After a 1959 test drive for *Road & Track* the Aston Martin works driver Roy Salvadori reported that the car had a split personality, being at one and the same time an authentic powerhouse and an obedient family saloon in which four people could readily undertake a long journey in great comfort.

The sitting position was fairly high, meaning that the bulky air scoop on the bonnet would under some circumstances obstruct the driver's view of the road. The five most important instruments were efficiently positioned in the driver's range of vision, and their clear calibration gave reliable information on the machine's condition. Initial understeer gave way progressively to neutral handling.

The DB4's front and rear light ensembles. Simplicity is beauty has always been one of the watchwords of the marque.

Ampel-Koalition: Die Leuchtenensembles am DB4 vorn und hinten. Schlichtheit bedeutet Schönheit, lautet eine der Devisen der Marke.

Voir et être vu : les optiques avant et arrière de la DB4. La sobriété comme synonyme de beauté est l'une des devises de la marque.

Salvadori's rough treatment of racing cars was well known, and true to form he subjected the DB4 to veritable torture: from a standing start to 100 mph and back again in 27.4 seconds, the same procedure to be repeated immediately in precisely the same time. This was testimony to the efficiency of the four hydraulic Dunlop disc brakes and an affirmation of the most sacred principle of the marque's founders Bamford and Martin: racing improves the breed. In contrast to many of their rivals from the magic square around Modena great attention had been lavished on every last detail. Two examples of this care were the tool kit, unparalleled for the variety of its contents, and the comprehensive operating manual bound in finest leather.

Still faster than the DB4 was the DB4GT, presented to a rapturous public at the London Motor Show a year later. That the GT designation was more than just a couple of letters had already been proven in the spring of 1959 by Stirling Moss' victory in a prototype version in the GT race which formed part of Silverstone's International Trophy program.

The wheelbase of the DB4GT had been reduced by 127 mm to 2362 millimeters, turning it into a pure two-seater. It was also 69 kilograms lighter, and the doors were a good deal more slender than those of the basic model, whose solid frame construction could cope well with wide, heavy doors. The two headlights had been recessed into the tops of the wings in the interests of streamlining.

The works literature boasted that the engine's twin-plug ignition plus three Weber dual-barrel carburetors developed no less than 302 horsepower, though this proved to be something of an exaggeration, as closer examination revealed that this figure overstepped the mark by some ten per cent. However, by the standards of the time that was still more than enough, and in December 1961 the renowned English motoring journalist John Bolster registered a reliable maximum speed of 152 mph with the needle of the rev counter hovering around the 6000 rpm mark. And whenever the DB4GT was subjected, to the dismay of its passengers, to the same torture once visited on the DB4 by Roy Salvadori, it passed the test with flying colors, powering to 100 mph in just 15 seconds and taking a further five to return to a standstill. Impressive deceleration was provided by Girling's huge and efficient disc brakes – despite the lack of servo assistance.

The clutch and roadholding of the DB4GT also met with widespread praise. For the hefty price of £4,670, £586 more than for the DB4, the motorist was essentially buying a sporty touring car for road use. In the battle for the top spots in international motorsport only top-class drivers like Stirling Moss or Innes Ireland could hold their own, and once the Ferrari GTO appeared on the scene in 1962, the Aston Martin DB4GT would generally have to be content with fulfilling the noble Olympian ideal that taking part is what counts.

The same applied to the DB4GT Zagato. The crowning glory of the range, it was launched in 1960, and was perhaps David Brown's finest creation for Aston Martin to date. With its gentle echoes of the Ferrari 250 GT Short Wheel Base, it proved to be one of the greatest hits produced by the small and exclusive north Italian manufacturer Zagato. Something like this could hardly come cheap, and at precisely 5469 pounds 19 shillings and ninepence, buyers had to dig deep indeed into their pockets. This sum included the cost of transporting the chassis to Via Giorgini 18 in Milan, where the Zagato brothers clad the tubular frame in a timelessly beautiful aluminum body.

Though no lightweight at 1251 kilograms, about a hundredweight had been taken off the DB4GT Zagato by the tried-and-tested recipe of reducing the trim, fitting plexiglass side and rear windows, which incidentally kept their shape perfectly even at high speed, and dispensing with the fenders, making the model very vulnerable to even the most minor front or rear impacts. The two slight bulges on the hood concealed the cylinder heads, and were evidence of the shortage of space in the engine room. At the rear, too, room was tight, and the horizontally stored spare wheel fought for space with the huge 135-liter petrol tank, sufficient to cover around 350 miles. As *Autocar's* reporter noted wistfully on 13th April 1962, you could drive the car from England to the south of France with only a single refueling stop. The DB4GT Zagato was indeed an agreeable companion even for the longest journey, the Zagato bucket seats, for example, being so comfortable that you could travel in them all day without noticing them, and above a certain speed the wind and tire noise from the Avon Turbospeed Mk II exceeded the sound made by the six-cylinder engine. A slight increase in the compression from 9:1 to 9.7:1 boosted the horsepower by 12, although little difference in performance from the earlier DB4GT press test car could be noted, no doubt due to the especially lively example of the breed with which the press corps was supplied.

Between January 1959 and October 1961 the range was put onto the market in five batches totaling 1103 DB4s, 75 DB4GTs and 19 Zagatos, falling somewhat short of the qualification requirement of 100 for the two GT versions. From 1960 onwards Series II included an overdrive option, Series IV the SS (for Special Series) Vantage variant, which produced an extra 25 horsepower. Then in 1961 the DB4's top was removed to produce one of the most beautiful cabriolets in the world and, with a total production of just 70, one of the rarest.

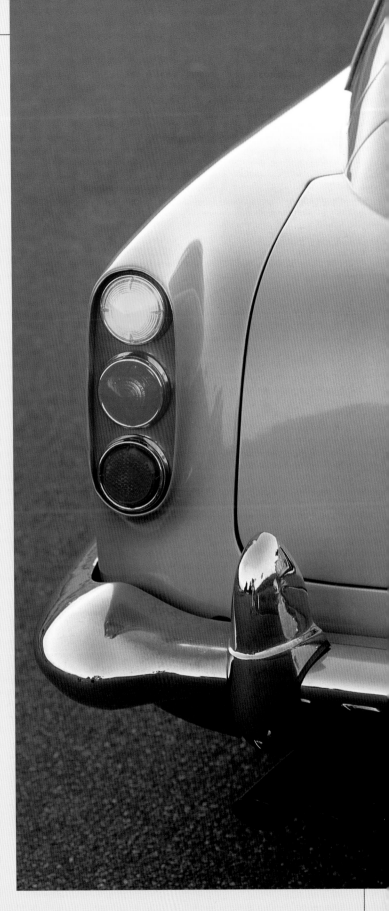

As *Motor*-Tester Christopher Jennings im November 1960 zu seinem im Halteverbot abgestellten Fahrzeug zurückkehrt, erwartet ihn zu seinem Verdruss eine walisische Polizistin. Dienst nach Vorschrift ist indessen nicht angesagt, im Gegenteil: Die ansehnliche Beamtin winkt den Bagatellsünder freundlich in eine Parklücke ganz in der Nähe und spricht dann die geflügelten Worte: »Ich konnte es nicht übers Herz bringen, ein so schönes Auto wegzuschicken.«

Solche herzlichen Emotionen löst er aus, sogar in Behördenkreisen, der DB4, funkelnder Star der London Motor Show 1958. Im Gespräch ist er schon lange. Denn bereits 1954 beginnt Aston-Martin-Mitarbeiter Harold Beach an seinem Plattformrahmen zu werken, der am Ende mit einer Starrachse und Längslenkern hinten und Dreiecks-Querlenkern vorn, der Seitenführung durch ein Watt-Gestänge sowie Schraubenfedern ringsum den letzten Stand der Weisheit darstellt.

Von der Carrozzeria Touring kommen Entwurf und Lizenz für seine flüssigen und schlüssigen Linien. Das Chassis wird aus Farsley angeliefert, in Newport Pagnell das Fachwerkgerippe aufgeschweißt, auf dem gemäß dem Superleggera-Prinzip der Mailänder die Karosserie aus Aluminium-Paneelen gebogen wird.

Für den Motor ist Tadek Marek zuständig, ein Pole, der 1941 über Casablanca nach England geflohen ist. Nach einigem Hickhack mit John Wyer, der immer auch die Eignung für den Rennsport im Auge hat, einigt man sich auf einen Sechszylinder aus Aluminium mit zwei oben liegenden Nockenwellen und 3670 ccm bei »quadratischen« Zylindermaßen: Bohrung und Hub betragen je 92 mm. Zwei SU-Horizontalvergaser befähigen ihn anfänglich zu 242 PS. Weil er sich damit nicht sonderlich anstrengen muss, erfreut er künftige Eigner mit einer hohen Lebenserwartung, zumal er sich vor der Verwendung in der Serie bereits im Renneinsatz unter der Haube des DBR2 bewährt hat. In den Dienst der Kraftübertragung ist wie üblich ein hauseigenes Viergang-Getriebe gestellt, das stets gute Noten erhält.

In einem Fahrbericht in *Road & Track* bescheinigt Aston-Martin-Werkspilot Roy Salvadori 1959 dem schönen Prüfling eine gespaltene Persönlichkeit. Er sei Kraftprotz und gefügiges Familienauto zugleich, in dem man eine Zeit lang durchaus zu viert reisen könne.

Man sitze ziemlich hoch, so dass sich unter Umständen die voluminöse Hutze auf der Motorhaube störend ins Bild schiebe. Lobenswert sei die zentrale Anordnung der fünf wichtigsten Rundinstrumente genau im Blickfeld des Fahrers. Mit kräftigen Markierungen gäben sie zuverlässig Auskunft über Wohlbehagen und Betriebsmoral der Maschine. Anfängliches Untersteuern gehe progressiv in neutrales Fahrverhalten über.

Salvadoris roher Umgang mit Rennwagen ist bekannt, und so unterzieht er auch den DB4 einer veritablen Tortur: vom Stand auf Tempo 160 und wieder

zurück in 27,4 Sekunden, und weil's so schön schrecklich war, sofort noch einmal in genau der gleichen Zeit. Das stellt den vier hydraulischen Dunlop-Scheibenbremsen fürwahr ein treffliches Zeugnis aus und bestätigt den Artikel Nummer eins aus dem Grundgesetz der Heldenväter Bamford und Martin: Racing improves the breed. Im Gegensatz zu so manchem Konkurrenten aus dem magischen Quadrat im Großraum Modena hat man dem Detail liebevolle Zuwendung angedeihen lassen. Zwei Beispiele: Das reichhaltig sortierte Werkzeug sucht seinesgleichen, und die umfassende Betriebsanleitung ist in duftendem Leder gebunden.

Noch eine Idee schneller als der DB4 kann es der DB4GT, einer entzückten Öffentlichkeit auf der London Motor Show ein Jahr später vor Augen geführt. Dass es sich bei dem Zusatz Gran Turismo nicht nur um schmückendes Beiwerk handelt, hat bereits im Frühjahr 1959 beim GT-Rennen im Rahmenprogramm der International Trophy in Silverstone Stirling Moss durch einen Sieg in einem Prototyp unter Beweis gestellt.

Um 127 Millimeter hat man den Radstand des DB4GT auf 2362 Millimeter verkürzt und ihn damit zu einem reinen Zweisitzer mutieren lassen. 69 Kilogramm wurden abgespeckt, die Türen viel schmaler gehalten als beim Basismodell, dessen robuste Rahmenkonstruktion ja grundsätzlich breite und schwere Eingänge zulässt. Die beiden Scheinwerfer leben nun in den Kotflügelspitzen ein relativ zurückgezogenes Dasein, was der Windschlüpfigkeit zustatten kommt.

Mit seiner Doppelzündung sowie drei Weber-Doppelkörpervergasern leiste der Motor 302 PS, prahlt die Werksliteratur und trägt damit im Zuge des allgemeinen Wettrüstens wohl ein wenig zu dick auf: Bei genauerer Überprüfung welken ungefähr zehn Prozent davon schnöde dahin. Übrig bleibt nach den Maßstäben der Zeit immer noch genug: Im Dezember 1961 ermittelt der renommierte englische Fachjournalist John Bolster eine zuverlässige Höchstgeschwindigkeit von 245 Stundenkilometern, wobei die Nadel des Drehzahlmessers just an der Marke 6000/min knabbert. Und wann immer der DB4GT zum Missvergnügen der Mitreisenden der gleichen Folter ausgesetzt wird wie einst der DB4 durch Roy Salvadori, zieht er sich glänzend aus der Affäre: 15 Sekunden von null auf 100 Meilen, fünf weitere zurück zum Stillstand. Für die Verzögerung zuständig sind nun riesige und rigoros zupackende Scheibenbremsen von Girling – wohlgemerkt ohne Servounterstützung.

Mit viel Anerkennung bedacht werden auch die Kupplung und die Tatsache, dass der Proband stets vorbildlich Kurs hält. Gleichwohl erwirbt der Käufer zum deftigen Entgelt von 4670 Pfund, 586 mehr als für einen DB4, in erster Linie einen sportiven Reisewagen für die Straße. Im Kampf um erste Plätze mischen im internationalen Motorsport lediglich erstklassige Piloten wie Moss oder Innes Ireland mit. Und als 1962 der Ferrari GTO auf der Bildfläche und in den Boxen erscheint, lässt sich mit dem

Behind the bold Z of the Carrozzeria on the flanks of the DB4GT Zagato lies an exciting automobile.

Hinter dem kühnen Z der Carrozzeria auf der Flanke des DB4GT Zagato findet sich ein aufregendes Automobil.

Aston Martin DB4GT gewöhnlich nur noch ein hehres olympisches Ideal verwirklichen: Dabei sein ist alles.

Das Gleiche gilt für den DB4GT Zagato, mit dem David Brown der Baureihe und wohl auch seinem bisherigen Schaffen 1960 die Krone aufsetzt. Trotz sanfter Anklänge an den Ferrari 250 GT Short Wheel Base zählt er auch zu den großen Würfen der ebenso kleinen wie exklusiven norditalienischen Manufaktur. So etwas kann nicht billig sein: Penibel kalkulierte 5469 Pfund, 19 Schillinge und neun Pence muss der Kunde auf den Tisch des Hauses blättern. In diesen Betrag fließen unter anderem die Kosten für die umständliche Reise des Chassis zu der Mailänder Via Giorgini 18 ein, wo ihm die Gebrüder Zagato ein zeitlos schönes Aluminium-Habit über sein Rohr-Gerippe streifen.

Obwohl mit 1251 Kilogramm Leergewicht noch immer kein Bruder Leichtfuß, ist der DB4GT Zagato um einen weiteren Zentner abgemagert nach bewährter Rezeptur: weniger Trimm, Plexiglasscheiben seitlich und hinten, die übrigens selbst bei hohen Geschwindigkeiten tadellos in Form bleiben, Verzicht auf Stoßfänger, was das Modell bereits bei kleinen Nasenstübern oder plumpen Annäherungsversuchen von hinten sehr verwundbar macht. Die beiden leichten Höcker auf der Motorhaube zeugen davon, dass man selbst mit der Freiheit der Zylinderköpfe nach oben sparsam umgegangen ist. Qualvolle Enge herrscht auch im Heck, wo dem waagerecht lagernden Reserverad jeder Kubikzentimeter streitig gemacht wird

durch den riesigen 135-Liter-Tank, der für etwa 560 Kilometer Fahrstrecke reicht. Mit einmaligem Nachtanken, merkt der *Autocar*-Berichterstatter am 13. April 1962 sehnsüchtig an, komme damit von der britischen Hauptinsel bis nach Südfrankreich. Sogar bei längeren Exkursionen erweist sich der DB4GT Zagato dabei als verträglicher Geselle: Ein manifester Vorzug der Zagato-Sitzschalen sei zum Beispiel, dass man sie selbst nach langer Fahrt überhaupt nicht spüre. Und von einem bestimmten Tempo an überwögen die Wind- und die Abrollgeräusche der Serienbereifung Avon Turbospeed Mk II eindeutig die Lebensäußerungen des Sechszylinders. Zwölf weitere Pferdestärken wurden durch eine leichte Anhebung der Kompression von 9:1 auf 9,7:1 gewonnen. Mehr Temperament sei dabei kaum herausgesprungen, schon weil es sich bei dem früheren DB4GT-Testwagen für die Presse um ein ungemein munteres Exemplar handelte.

Zwischen dem Januar 1959 und dem Oktober 1961 wird die Modellreihe in fünf Schüben in den Markt eingespeist, 1103 DB4, 75 DB4GT sowie 19 Zagato, so dass die Qualifikationslatte mit 100 Exemplaren für die beiden GT-Versionen eine Idee zu hoch aufgehängt ist. Mit der Serie II wird ab 1960 ein Overdrive als Option angeboten, die Vantage-Variante SS (für Special Series) mit 25 Mehr-PS im Rahmen der Serie IV. Erst 1961 findet die Eröffnung des DB4 statt – zu einem der schönsten Cabriolets der Welt und bei einem Vorkommen von nur 70 auch einem der rarsten.

Derrière le Z volontaire de la Carrozzeria,
sur les flancs de la DB4GT Zagato,
se dissimule une voiture excitante.

Lorsque le pilote et chroniqueur de la revue *Motor,* Christopher Jennings, revient en novembre 1960 vers sa voiture garée en stationnement interdit, il a la mauvaise surprise de voir qu'il est attendu par une aussi belle voiture. Quel n'est son étonnement, lui qui s'attendait à entendre un sermon: la – jolie – fonctionnaire prie aimablement le coupable de garer sa voiture sur un parking tout proche, où elle lui fait alors cette déclaration désarmante: «Je n'ai pas eu le cœur d'envoyer à la fourrière une aussi belle voiture.»
Voilà le genre d'émotions sympathiques que déclenche – et ce, même parmi les fonctionnaires – la DB4, star rayonnante du London Motor Show de 1958. Il faut dire qu'il y a longtemps qu'on en parlait.
En effet, dès 1954, l'ingénieur d'Aston Martin Harold Beach commence à se pencher sur son châssis à plate-forme qui représente alors le *summum* des progrès techniques avec un essieu rigide et des bras longitudinaux à l'arrière ainsi qu'une suspension triangulée transversale à l'avant, le guidage latéral étant assuré par un parallélogramme de Watt avec des ressorts hélicoïdaux pour chacune des roues.
La Carrozzeria Touring signe son dessin et donne une licence pour la fabrication en série de ses lignes fluides et étirées.
Le châssis, des panneaux de tôle soudés à Farsley, est expédié à Newport Pagnell où l'on monte la structure tubulaire sur laquelle, conformément au principe Superleggera du carrossier milanais, l'on façonne la carrosserie en aluminium.
La réalisation du moteur est l'affaire de Tadek Marek, un Polonais réfugié en

Angleterre en 1941 après être passé par Casablanca. Après maintes discussions avec John Wyer qui veut aussi un moteur apte à la compétition, les deux hommes se mettent d'accord pour un six-cylindres en aluminium à deux arbres à cames en tête et d'une cylindrée de 3670 cm³ avec des cotes «carrées»: l'alésage et la course sont de 92 mm. Deux carburateurs horizontaux SU lui confèrent à l'origine 242 ch. Comme il n'a aucun mal à délivrer cette puissance, ses futurs propriétaires peuvent se réjouir d'une grande espérance de vie, et ce, d'autant plus que, avant de faire son apparition en série, il s'est déjà illustré en compétition sous le capot de la DBR2. La transmission consiste comme toujours en une boîte à quatre vitesses de fabrication maison qui est toujours bien accueillie.
Dans un essai réalisé pour *Road & Track* en 1959, le pilote officiel d'Aston Martin, Roy Salvadori, atteste une double personnalité à cette belle GT. Il s'agit à la fois d'une Grand Tourisme et d'une docile voiture familiale dans laquelle on peut fort bien voyager à quatre.
Bien que l'on soit assis assez haut, l'imposant bossage sur le capot moteur peut, dans certaines circonstances, gêner la vue. On peut se féliciter de l'agencement central des cinq principaux cadrans, placés exactement dans le champ de vision du conducteur. D'une excellente lisibilité, ils renseignent sur l'humeur et l'état de la machine. Le sous-virage initial fait graduellement place à un comportement neutre. Salvadori est réputé pour ne pas ménager ses voitures de course et il soumet donc aussi la DB4 à une

véritable torture: de 0 à 160 km/h et retour à 0 en 27,4 secondes et il réitère la procédure en exactement le même temps. Cela constitue un test de fiabilité inégalable pour les quatre freins à disque Dunlop et confirme l'article 1 de la «Constitution» qu'ont donné à leur marque ses pères fondateurs Bamford et Martin: «Racing improves the breed». Contrairement à maints concurrents du triangle magique de Modène, l'amour du détail n'est pas un vain mot chez Aston Martin. Pour preuve: très complet, l'assortiment d'outils est incomparable, et le mode d'emploi très détaillé est présenté dans une reliure cuir.
Mais une autre voiture est un soupçon plus rapide que la DB4, il s'agit de la DB4GT, présentée à un public ravi un an plus tard, lors du London Motor Show. Elle est qualifiée de véhicule de Grand Tourisme et ce n'est pas une simple déclaration d'intention, comme elle l'a déjà prouvé, au printemps 1959, lors de la course de GT organisée en marge de l'International Trophy à Silverstone, où Stirling Moss a remporté la victoire au volant d'un prototype.
L'empattement de la DB4GT a été raccourci de 127 mm à 2362 mm. Il s'agit donc d'une pure biplace. Elle a perdu 69 kg et les portières sont plus étroites que sur le modèle de base dont le solide châssis peut, par principe, supporter des portes plus larges et plus lourdes. Les deux phares sont intégrés aux extrémités des ailes et presque affleurants, ce qui est tout bénéfice pour l'aérodynamique.
Avec son double allumage et ses trois carburateurs double corps Weber, le moteur développe 302 ch, déclare fièrement le catalogue de l'usine, mais cette contribution à la course généralisée aux armements est un peu exagérée: une mesure un peu plus précise révèle que 10% environ relèvent de l'imaginaire. Mais il en reste néanmoins plus qu'assez selon les critères de l'époque: en décembre 1961, le célèbre journaliste spécialisé anglais John Bolster établit une vitesse maximale fiable de 245 km/h, à l'occasion de quoi l'aiguille du compte-tours flirte avec les 6000 tr/min. Et chaque fois que la DB4GT, pour le plus grand désagrément des passagers, est soumise à la même torture que, en son temps, la DB4 par Roy Salvadori, elle se tire brillamment d'affaire: 15 secondes pour atteindre 100 miles à l'heure, plus cinq secondes pour s'arrêter à nouveau. La décélération est maintenant confiée à de gigantesques freins à disque Girling qui mordent impitoyablement – bien que sans assistance.
La voiture suscite beaucoup d'éloges en raison de son embrayage et de sa tenue de cap toujours exemplaire. Quoi qu'il en soit, pour le prix faramineux de 4670 livres, soit 586 de plus que pour une DB4, l'acheteur acquiert une voiture sportive de grand tourisme pour la route. Dans la lutte pour la victoire lors des courses internationales, seuls des pilotes de tout premier ordre comme Stirling Moss ou Innes Ireland peuvent tirer leur épingle du jeu avec un tel véhicule. En 1962, lorsque la Ferrari GTO apparaît sur les circuits, où elle monopolise les succès, l'Aston Martin DB4GT ne permet

généralement plus que de réaliser le noble idéal olympique en vertu duquel l'essentiel est de participer.
Cela vaut également pour la DB4GT Zagato, avec laquelle David Brown couronne sa gamme et, sans doute aussi, l'œuvre de sa vie, en 1960. Malgré certaines similitudes avec la Ferrari 250 GT Short Wheel Base, elle aussi figure parmi les plus beaux dessins de la manufacture d'Italie du Nord, qui est aussi petite que prestigieuse. Et une telle voiture ne peut pas être bon marché: le client doit en effet débourser exactement 5469 livres, 19 shillings et 9 pence pour s'offrir ce bijou. Cette somme comprend notamment les coûts du voyage compliqué qu'a fait le châssis jusqu'au 18 Via Giorgini à Milan, où les frères Zagato habillent son châssis tubulaire d'une robe en aluminium à la beauté intemporelle.
Bien qu'avec un poids de 1251 kg à vide – elle ne brille toujours pas par sa légèreté – la DB4GT Zagato a perdu près de 100 kg selon une recette éprouvée: aménagements intérieurs supprimés, vitres en plexiglas sur les côtés et à l'arrière, lesquelles ne se déforment absolument pas, même à grande vitesse. Elle est aussi démunie de tout pare-chocs, ce qui la rend très vulnérable lors du moindre contact ou lorsqu'on la suit de trop près. Les deux légers bossages sur le capot moteur témoignent que les culasses ne sont pas les seules à disposer d'un espace compté. Grande promiscuité également à l'arrière, où la roue de secours verticale se dispute chaque centimètre cube du coffre avec le gigantesque réservoir de 135 litres qui confère à la voiture une autonomie d'environ 560 km. Il suffit de refaire le plein une seule fois, précise le journaliste d'*Autocar* dans le numéro du 13 avril 1962, pour descendre de l'archipel britannique jusque dans le midi de la France. Même quand on couvre de longues distances, la DB4GT Zagato reste toujours une compagne prévenante: un avantage manifeste des sièges baquet Zagato est par exemple que l'on ne ressent pas la moindre fatigue, même après un long voyage. Et, à partir d'une certaine vitesse, les bruits du vent et du roulement des pneus de série, des Avon Turbospeed Mk II, masquent presque totalement les signes de vie du six-cylindres. Douze chevaux supplémentaires sont obtenus par une légère majoration du taux de compression de 9:1 à 9,7:1, sans que cela fasse une grande différence avec l'ancienne DB4 d'essais destinée à la presse, qui était déjà un modèle des plus sportifs.
Entre janvier 1959 et octobre 1961, la gamme est commercialisée en cinq étapes: 1103 DB4, 75 DB4GT ainsi que 19 Zagato, le chiffre fatidique des 100 exemplaires indispensables pour obtenir l'homologation restant inaccessible pour les deux versions GT. Avec la Série II, un *overdrive* est proposé en option à partir de 1960 et la version Vantage SS (pour Special Series) reçoit 25 ch de plus avec l'apparition de la Série IV. Ce n'est qu'en 1961 qu'est produite une version décapotable de la DB4 – qui devient l'un des plus beaux cabriolets du monde et aussi, parce qu'elle n'a été produite qu'à 70 exemplaires seulement, l'un des plus rares.

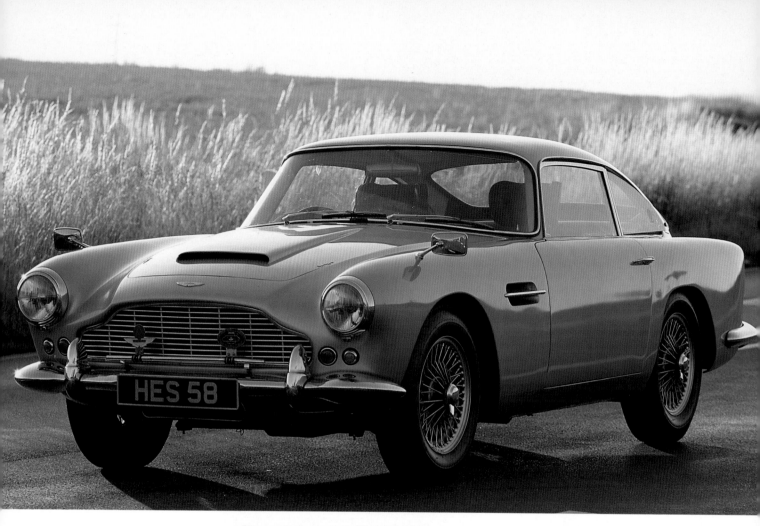

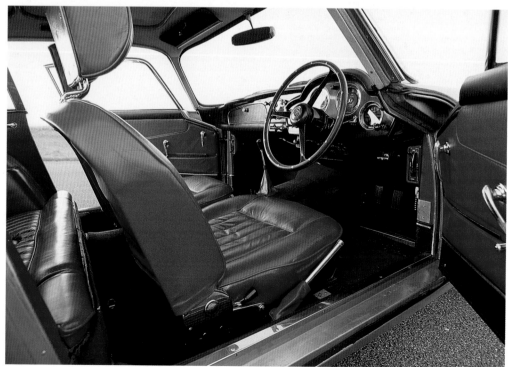

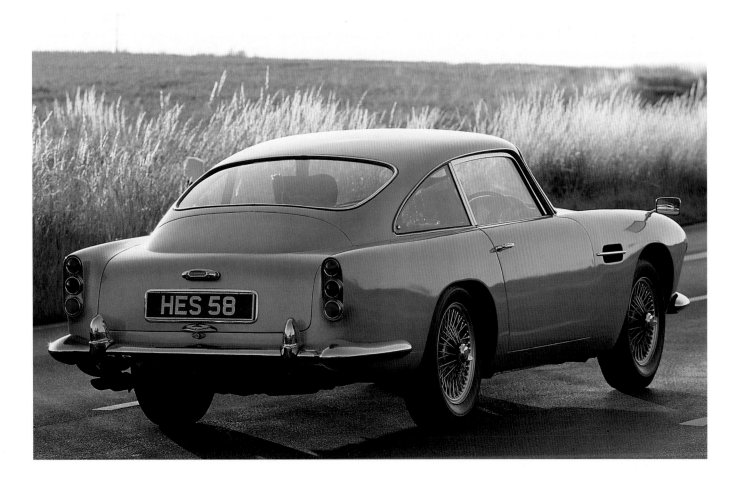

All-round view: the panorama windows of the DB4 plus the oblique A columns ensure good visibility without impeding access to the interior. Spoked wheels with a central nut come as standard.

Voller Durchblick: Die Panoramascheibe des DB4 gewährt zusammen mit geneigten A-Säulen gute Sicht, ohne den Zugang zum Innenraum zu behindern. Speichenräder mit Zentralverschluss zählen zur Standardausrüstung.

Bonne visibilité : conjointement avec les montants de pavillon inclinés, le pare-brise panoramique de la DB4 assure une vision intégrale sans entraver l'accès à l'habitacle. Les roues fil à moyeu central font partie de la dotation de série.

The DB4GT follows the DB4 base version in many essential points and details. The Superleggera logo reveals that the bodywork was by the Milan Couturier Touring, too.

In wesentlichen Punkten und Details folgt der DB4GT der Basisversion DB4. Das Logo Superleggera weist darauf hin, dass auch er von dem Mailänder Couturier Touring bekleidet wird.

Sur des points de détail, mais essentiels, la DB4GT s'inspire de la version de base DB4. Le logo Superleggera indique qu'elle aussi a été habillée par le carrossier milanais Touring.

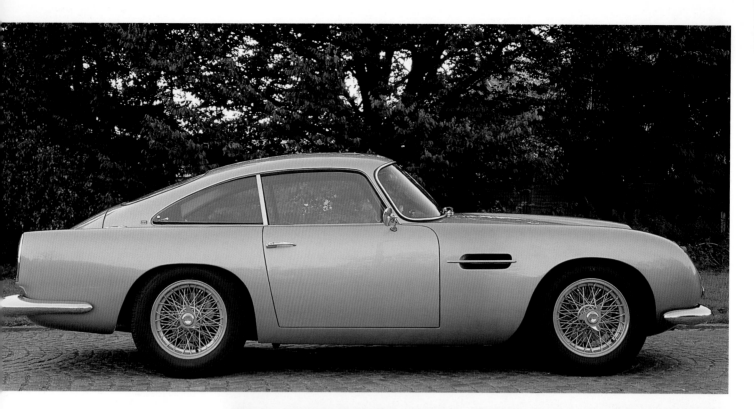

The DB4GT featured a reduced wheelbase, narrower doors, sunken headlights, a new cylinder head with twin-plug ignition and three 45 DCOE Weber twin-choke carburetors. The spare wheel more or less fills the trunk.

Leistungsträger: Weniger Radstand, schmalere Türen, versenkte Scheinwerfer, ein neuer Zylinderkopf mit Doppelzündung und drei Weber-Doppelvergaser 45 DCOE. Der Kofferraum des DB4GT ist mit dem Reserverad gut ausgelastet.

Empattement raccourci, portières plus courtes, phares abaissés, une nouvelle culasse à double allumage et trois doubles carburateurs Weber 45 DCOE. La roue de secours monopolise le coffre de la DB4GT.

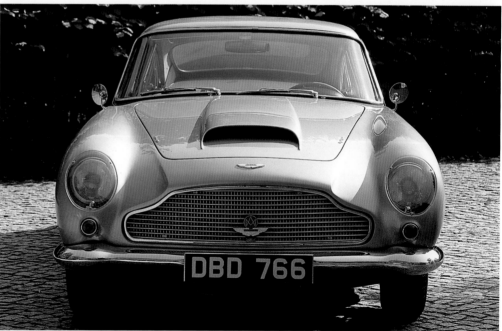

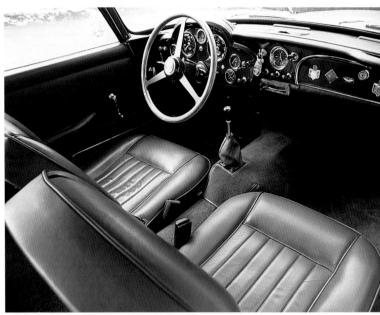

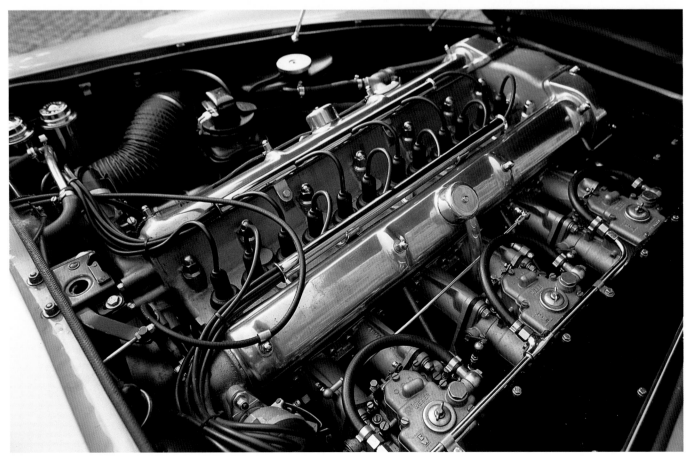

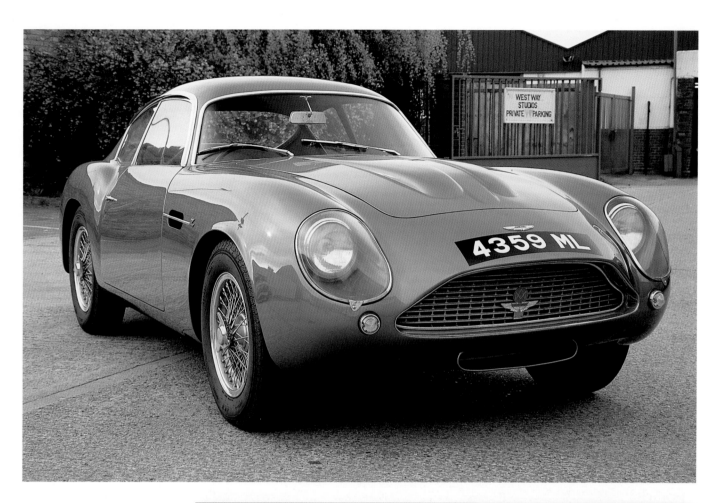

Highly-strung thoroughbred: the DB4GT Zagato was not designed for everyday driving. Its fenderless light alloy body is simply too delicate. And what looks like a trunk, with its striking reversing lights on the hood, is in fact filled by the gas tank and spare wheel. But it is beautiful and it is fast.

Verletzlicher Aristokrat: Für den prosaischen Auto-Alltag ist der DB4GT Zagato nicht geschaffen. Zu verwundbar ist seine Leichtmetallkarosserie ohne jegliche Stoßfänger. Und was ein Kofferraum zu sein scheint mit einer markanten Rückfahrleuchte auf dem Deckel, ist bereits gefüllt mit Tank und Reserverad. Aber schön ist er und schnell.

Vulnérable aristocrate : la DB4GT Zagato n'est pas conçue pour les rudesses de la conduite quotidienne. Sa carrosserie en aluminium dépourvue de tout pare-chocs est trop fragile. Et ce qui est censé servir de coffre, avec un feu de recul au traitement bien personnel sur le couvercle de malle, est déjà rempli avec le réservoir et la roue de secours. Mais elle est belle et rapide.

DBR1

The DBR1 was the embodiment of the ancient Greek philosophers' belief that what is beautiful is also good. However, in terms of its success on the racing circuits figures were not always so convincing: 1957 and 1959 were good years for the Aston Martin DBR1, but 1956 and 1958 were definitely on the lean side.

Designed by engineer Ted Cutting, it was a thoroughbred racing machine. The smooth body was wrapped around a light tubular frame with front trailing arms, a de Dion axle at the rear and torsion-bar suspension all round. As always it was designed with the pilgrimage to the time-honored Aston Martin mecca of Le Mans in mind. In 1956 the organizers of the 24-hour-race restricted prototype capacity to 2.5 liters – a reaction to the tragic accident suffered by Frenchman Pierre Levegh the year before, when more than 80 spectators were also killed. The prompt response from Feltham was a light-alloy cylinder block with a seven-bearing crankshaft and dry-sump lubrication, crowned by the cylinder head from the DB3S, with its twin-plug ignition.

On its debut at the Sarthe circuit in 1956 the DBR1 did not exactly make the headlines, retiring after 20 hours when in 7th place. The two works cars, now equipped with three-liter engines, did little better a year later, soon being restricted to fourth gear only. Both retired early once again, Tony Brooks' car after an accident at Tertre Rouge. However, Brooks was responsible for the marque's greatest successes to date in 1957 as he won two sports car events in Spa and also the 1000-kilometer race on the Nürburgring, where to everyone's surprise his little-known co-driver Noel Cunningham-Reid proved an excellent assistant.

The decision of the sport's governing body in 1958 to reduce the maximum cubic capacity for prototypes of the DBR1's caliber to three liters seemed like a gift for Aston Martin. However, it resulted in just two victories that season. The first came when Stirling Moss shared a borrowed DBR1 he had wheeled out of John Wyer with Jack Brabham, the pair winning with absurd ease at the Nürburgring by a margin of over four minutes. The second was added in the Tourist Trophy at Goodwood when the three DBR1 drivers Stirling Moss, Roy Salvadori and Carroll Shelby occupied places one to three.

Moss was also the man behind the 1959 constructors' championship. At Le Mans the quick Briton ground down his rivals, only to eventually retire himself, leaving the path clear for a double victory by the two Aston Martin teams Shelby/Salvadori and Maurice Trintignant/Paul Frère. However, Moss triumphed once again at the Ring, despite the time lost when his partner Jack Fairman spun off into the Brünnchen ditch and tried to lever the car on to the track again. Moss then rounded things off in perfect fashion at Goodwood, winning in Shelby's and Fairman's car after his own had caught fire during refueling and team boss Reg Parnell ordained the switch.

The irony was that all this success came after Aston Martin had planned only to compete at Le Mans in the 1959 season.

An ihm lässt sich eine Wahrheit nachweisen, mit der bereits die alten griechischen Philosophen Ordnung in die Welt der Dinge brachten: Was schön ist, ist auch gut. Dennoch ist nicht nur eitel Sonnenschein angesagt. 1957 und 1959 sind ertragreiche Jahre für den Aston Martin DBR1, 1956 und 1958 eher magere.

Entworfen von Ingenieur Ted Cutting, ist er ein reinrassiger Rennsportwagen. Die glatte Hülle ruht auf einem leichten Gitterrohrrahmen mit Längslenkern vorn, einer de-Dion-Achse hinten sowie Drehstabfederung ringsum. Wie immer hat man bei seiner Konzeption vor allem die Pilgerfahrt in das uralte Aston-Martin-Mekka Le Mans im Sinn. Das 24-Stunden-Rennen ist 1956 für Prototypen mit 2,5 Liter Hubraum ausgeschrieben – als Reflex auf den schweren Unfall des Franzosen Pierre Levegh im Jahr zuvor, der mehr als 80 Zuschauer mit in den Tod gerissen hat. Die schlagfertige Antwort aus Feltham: ein Leichtmetall-block mit siebenfach gelagerter Kurbel-welle und Trockensumpfschmierung, gekrönt vom Zylinderkopf des DB3S mit Doppelzündung.

Bei seinem Einstand 1956 auf dem Sarthe-Kurs hält sich der DBR1 aus den Schlagzeilen. Und wenig ruhmreich gerät auch der Auftritt der zwei Werkswagen, inzwischen auf drei Liter nachgerüstet, ein Jahr später. Nur noch der vierte Gang tut man bei ihnen am Ende seinen Dienst. Und so scheiden beide erneut vorzeitig aus, das Exemplar mit Tony Brooks am Volant durch Unfall bei Tertre Rouge. Tony Brooks beschert der Marke 1957 ihre schönsten Erfolge bisher mit Siegen bei zwei Sportwagenläufen in Spa sowie beim 1000-Kilometer-Rennen auf dem Nürburgring, wo ihm zu jedermanns Überraschung dem wenig bekannten Noel Cunningham-Reid ein ebenbürtiger Kollege zur Seite steht.

Dass der Hubraum für Prototypen vom Schlage des DBR1 für 1958 behördlich auf drei Liter eingegrenzt ist, scheint wie ein Geschenk an Aston Martin. Doch nur zwei Siege springen heraus. Am Nürburgring teilt sich Stirling Moss einen Leih-DBR1, den er John Wyer abgerungen hat, mit Jack Brabham und gewinnt mit absurder Leichtigkeit und vier Minuten Vorsprung. Und bei der Tourist Trophy in Goodwood belegen DBR1-Piloten in der Reihenfolge Moss, Roy Salvadori und Carroll Shelby die Ränge eins bis drei.

Moss ist letztlich auch der Mann hinter dem Championat der Konstrukteuren 1959. An dem flinken Briten verschleißt sich die Konkurrenz in Le Mans, bis er selber ausfällt und den Weg freimacht für den Doppelerfolg der Aston-Martin-Riegen Shelby/Salvadori und Maurice Trintignant/Paul Frère. Moss herrscht erneut am Ring, trotz eines zeitraubenden Ausflugs seines Partners Jack Fairman in den Graben am Brünnchen. Und Moss macht die Sache in Goodwood perfekt, selbst als sein eigenes Fahrzeug beim Betanken abgefackelt ist und Teamchef Reg Parnell ihn auf das Auto von Shelby und Fairman gesetzt hat.

Ursprünglich eingeplant war von Aston Martin 1959 lediglich der Einsatz in Le Mans.

Elle est l'illustration d'une croyance des philosophes grecs de l'Antiquité: ce qui est beau est bon aussi. Mais tout n'est pourtant pas pour le mieux dans le meilleur des mondes. Si 1957 et 1959 sont des années productives pour l'Aston Martin DBR1, 1956 et 1958 sont plutôt des années de vaches maigres.

Dessinée par l'ingénieur Ted Cutting, c'est une voiture de course sans compromis. Sa carrosserie fluide habille un léger châssis tubulaire avec des bras longitudinaux à l'avant, un pont arrière De Dion ainsi qu'une suspension à barre de torsion pour les quatre roues. Comme toutes les Aston Martin destinées à la course, elle a surtout été conçue pour le pèlerinage traditionnel à la Mecque des Aston Martin, c'est-à-dire Le Mans. La course des 24 Heures de 1956 est réservée aux prototypes de 2,5 litres de cylindrée – en réaction au grave accident du

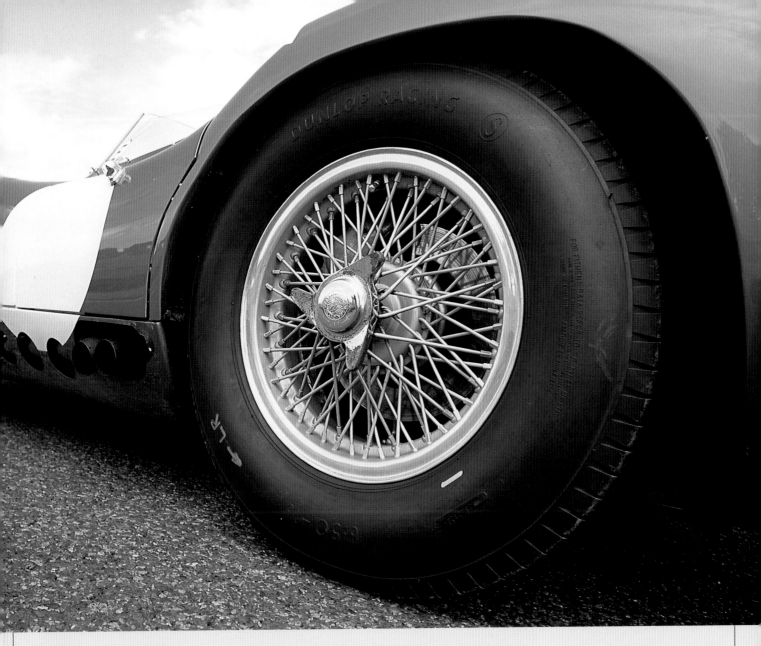

Français Pierre Levegh, l'année précédente, qui a causé la mort de plus de 80 spectateurs. Feltham répond du tac au tac, avec un bloc en alliage léger à vilebrequin à sept paliers et lubrification à carter sec, couronné par la culasse de la DB3S à double allumage.

Lors de ses débuts sur le circuit de la Sarthe, en 1956, la DBR1 ne fait pas les gros titres des journaux: abandon en septième position au bout de 20 heures. Un an plus tard, les deux voitures d'usine, dont la cylindrée a entre-temps été majorée à trois litres, ne s'en tirent pas beaucoup mieux non plus. À la fin de la course, seule la quatrième vitesse est encore utilisable. Les deux bolides jettent donc de nouveau prématurément l'éponge, l'exemplaire piloté par Tony Brooks devant même abandonner à la suite d'un accident au Tertre Rouge. C'est pourtant ce même Tony Brooks qui signera les plus beaux succès de la marque

à ce jour, en 1957, en remportant la victoire lors de deux manches pour voitures de sport, à Spa ainsi qu'aux 1 000 Kilomètres du Nürburgring où, à la surprise générale, un pilote jusqu'à ce jour quasi inconnu, Noel Cunningham-Reid, se révèle tout aussi compétitif que lui.

En 1958, les autorités fédérales ont limité à 3 litres la cylindrée pour les prototypes comme la DBR1. Pour Aston Martin, c'est un véritable cadeau offert sur un plateau d'argent. La marque anglaise ne remportera pourtant que deux victoires. Au Nürburgring, Stirling Moss partage avec Jack Brabham une DBR1 d'emprunt arrachée à John Wyer et remporte la victoire avec une facilité déconcertante et quatre bonnes minutes d'avance. Au Tourist Trophy, à Goodwood, les pilotes de DBR1 monopolisent les trois premières places; Stirling Moss arrive en tête, suivi de Roy Salvadori et de Carroll Shelby. C'est en fin de compte à Moss qu'Aston Martin doit de

remporter le titre de Champion du monde des constructeurs en 1959. Au Mans, ses concurrents s'épuiseront en vain à lutter contre le rapide Britannique avant que lui-même ne doive abandonner et ouvre ainsi la voie à un doublé des Aston Martin signé par Carroll Shelby/Roy Salvadori et Maurice Trintignant/Paul Frère. Moss fait de nouveau régner sa loi au Nürburgring malgré une excursion de son coéquipier Jack Fairman dans le fossé, à Brünnchen, qui coûtera plusieurs minutes aux deux hommes. Et Moss bouclera ensuite l'affaire à Goodwood, même après que sa propre voiture aura été réduite à un tas de cendres lors du ravitaillement en essence et après que le directeur de course Reg Parnell lui aura intimé de reprendre la voiture de Shelby et Fairman.

Sympathique ironie du destin: à l'origine, en 1959, il était prévu de n'engager des Aston Martin qu'au Mans, à l'exclusion de toute autre compétition.

The lines of the DBR1 are largely determined by its function. Aston Martin designer Ted Cutting made skilful use of the remaining room for maneuver to create one of the most beautiful sports cars of its era.

Die Form des DBR1 wird von seinem Zweck bestimmt. Aus dem verbleibenden ästhetischen Spielraum heraus hat Aston Martin-Ingenieur Ted Cutting einen der schönsten Rennwagen seiner Zeit geschaffen.

La forme de la DBR1 est dictée par sa finalité. Exploitant le peu de marge de manœuvre esthétique à sa disposition, l'ingénieur d'Aston Martin, Ted Cutting, a réalisé l'une des plus belles voitures de course de son époque.

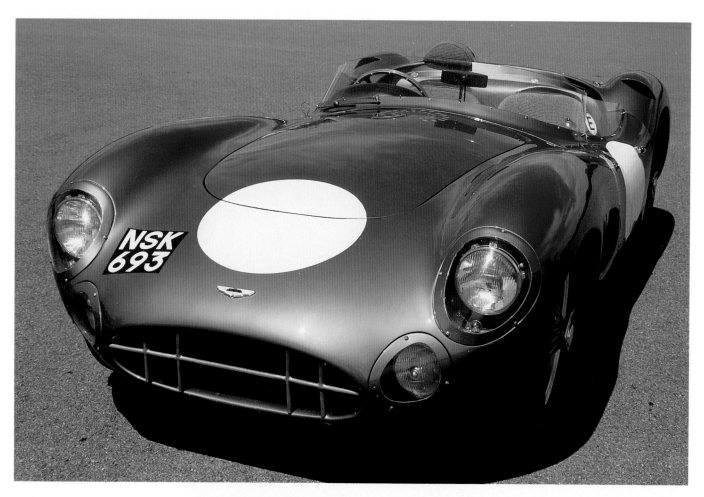

The flowing lines of the DBR1 today still house what was then the latest version of the Aston Martin six-cylinder engine, fed by three Weber twin-choke carburetors.

Dienst-fertig: In die fließenden Rundungen des DBR1 eingebettet lauert damals wie heute die höchste Sublimationsstufe des aktuellen Aston-Martin-Sechszylinders auf ihren Einsatz, ernährt von drei Weber-Doppelvergasern.

Prête à courir : sous les lignes fluides de la DBR1 piaffe d'impatience, aujourd'hui comme jadis, la version la plus poussée du six-cylindres d'Aston Martin, qui attend de prendre le départ, animée par ses trois doubles carburateurs Weber.

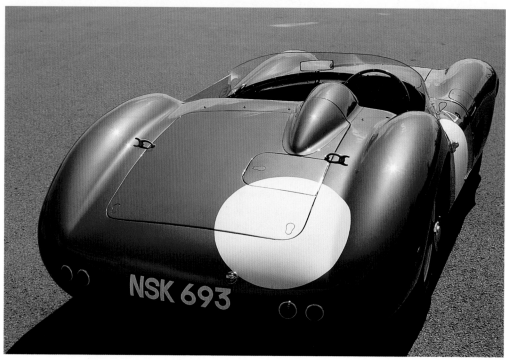

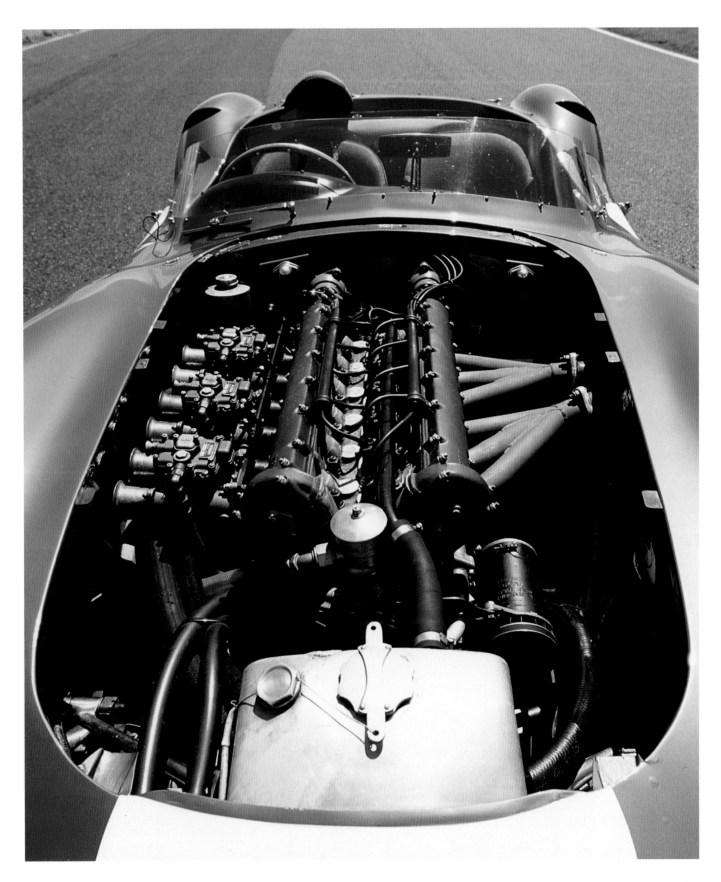

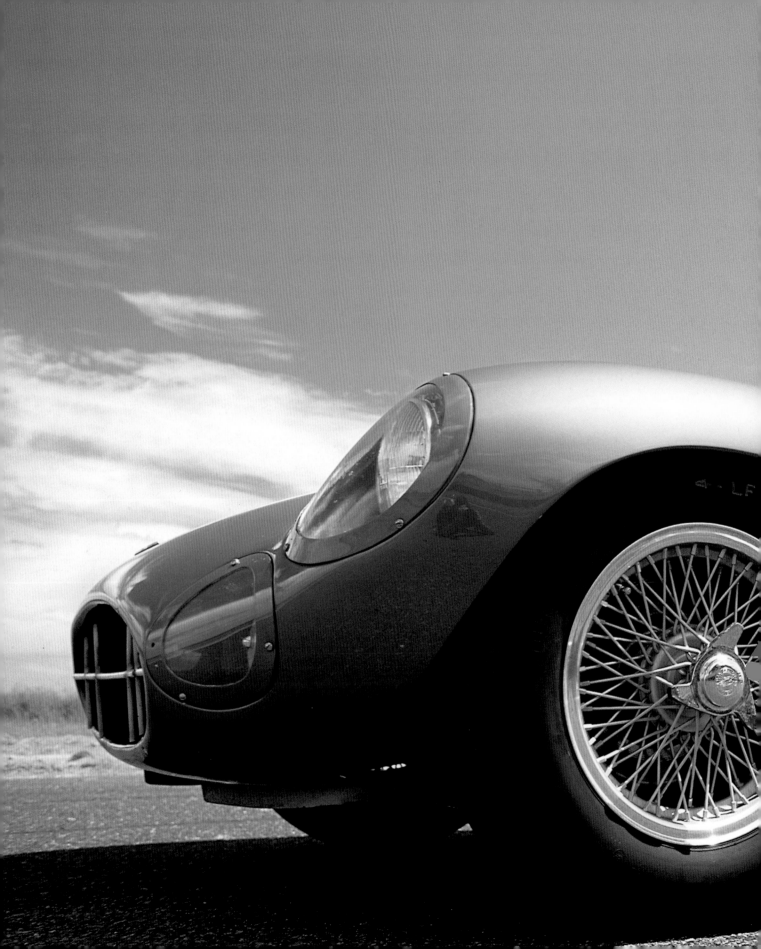

The outcome of a metamorphosis: there is an unusual story behind the DBR1 with the chassis number 4. It began its life in 1958 as a DBR3/1 with a short-stroke three-liter engine, derived from the DB4 power unit.

Ergebnis einer Metamorphose: Hinter dem DBR1 mit dem Chassis Nummer 4 liegt eine ungewöhnliche Geschichte. Er begann sein Dasein 1958 als DBR3/1 mit einem kurzhubigen Dreilitermotor, Derivat des DB4-Triebwerks.

Résultat d'une métamorphose : derrière la DBR1 châssis numéro 4 se dissimule l'histoire extraordinaire d'une vie commencée en 1958 en tant que DBR3/1, avec un moteur de 3 litres à course courte extrapolé du moteur de la DB4.

Like that of its smaller counterpart, the dashboard of the DBR2 is heavily populated. The positioning of the rev counter places the critical area squarely in the driver's field of vision.

Schnörkellos geformt wie sein kleineres Pendant, ist der DBR2 wie dieses reichlich mit Instrumenten ausgestattet. Die Anordnung des Drehzahlmessers rückt den kritischen Bereich voll ins Blickfeld des Piloten.

Tout aussi sobre que sa petite sœur, la DBR2, comme celle-ci, regorge de cadrans. Le compte-tours est placé de telle manière que la zone critique soit parfaitement dans le champ de vision du pilote.

DBR2

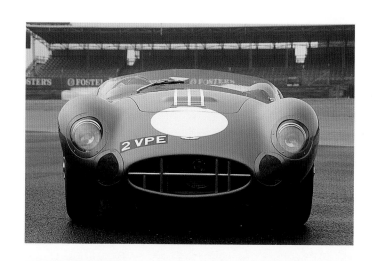

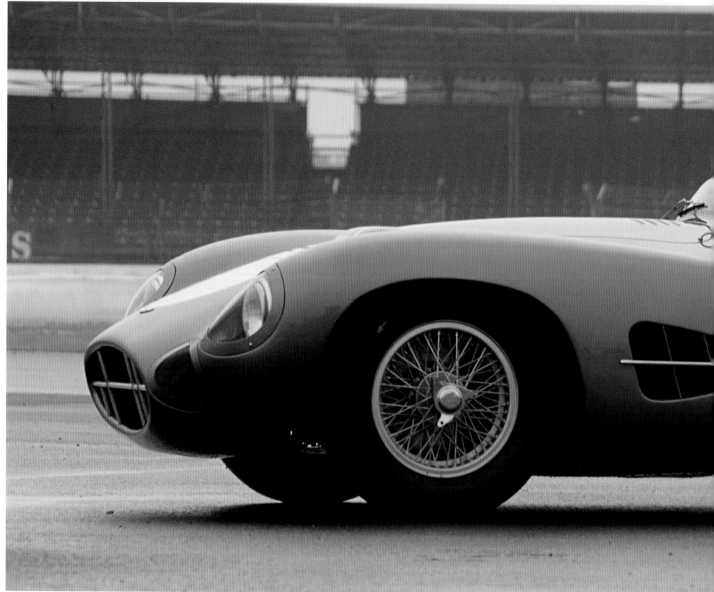

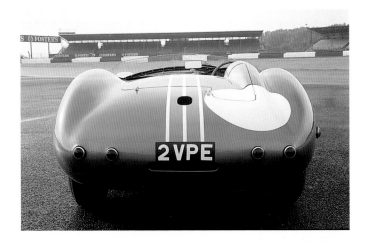

The DBR2 was faster, more powerful, wider and longer than the DBR1 – but far less successful.

Schneller, stärker, breiter und länger als der DBR1 ist der DBR2. Aber längst nicht so erfolgreich.

La DBR2 est plus rapide, plus puissante, plus large et plus longue que la DBR1. Mais elle est loin d'avoir remporté autant de succès.

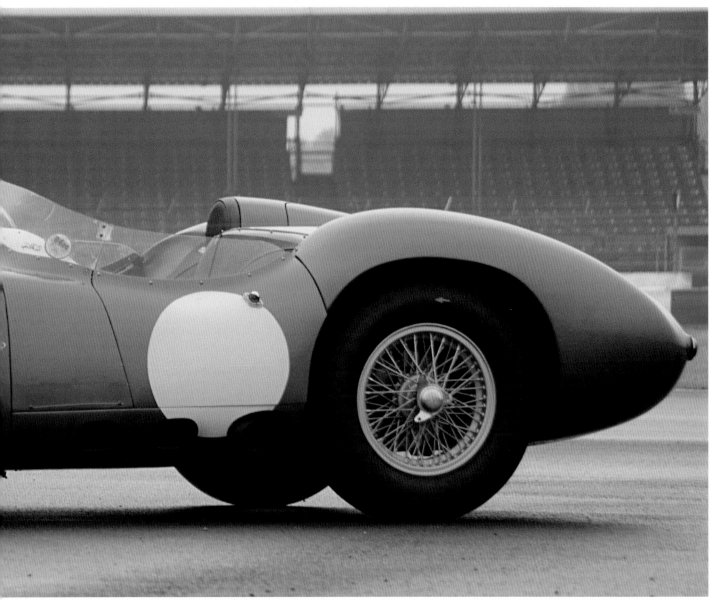

DBR4

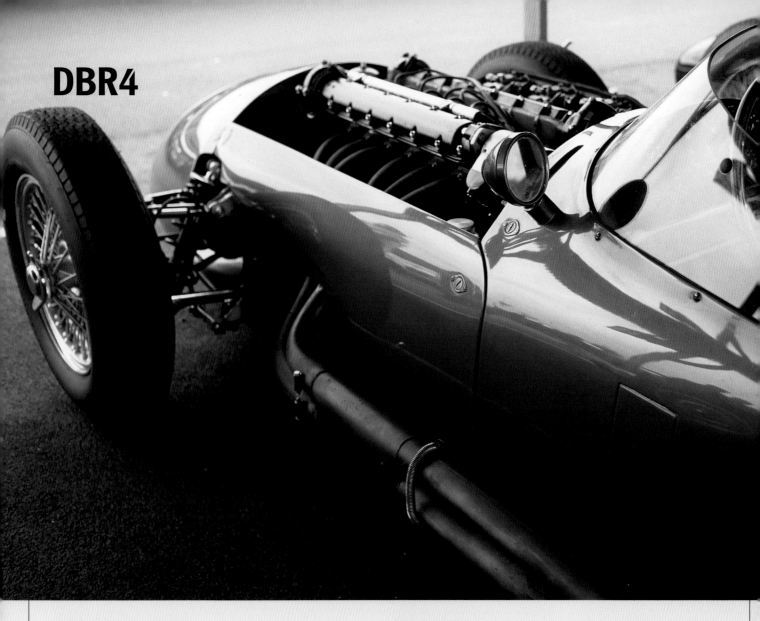

The DBR4's power unit is a well-known quantity, being a development of the 2.5 liter six-cylinder engine from the original DBR1.

Das Triebwerk des DBR4 ist eine bekannte Größe: der weiterentwickelte Sechszylinder aus dem ursprünglichen DBR1 mit 2,5 Litern.

Le moteur de la DBR4 est une vieille connaissance : il s'agit du six-cylindres perfectionné qui propulsait à l'origine la DBR1 avec 2,5 litres de cylindrée.

In his autobiography *The Certain Sound* John Wyer summed up the career of the DBR4 in these graphic terms: "In 1958 it might have won races. In 1959 it was a dying duck, and in 1960 a stinking fish."

David Brown had always dreamed of producing an Aston Martin capable of competing in Formula 1. The DBR4, though, was borne out of his rivalry with one Colin Vanderwell, another English entrepreneur who had been racing his Vanwalls on the world's circuits since 1954, making British Racing Green a force to reckon with.

Aston Martin received some encouragement in 1958 when motorsport's governing body banned alcohol-based fuels. This played into Aston Martin's hand, since their machines ran on standard commercially-available fuel, while other engine constructors were forced to modify their products.

Conversely, the days of the frontal engine were numbered in Formula 1, a fact that was eventually to prove fatal for the DBR4. A development of the DBR1, the model had pleasing lines and was constructed to the marque's customary high standards. Its backbone is provided by a slimmer, lighter tubular frame with front wishbones and a de Dion axle at the rear. It did not take long to come up with a suitable engine, a development of the 2.5-liter unit from the original DBR1. Tests carried out between Christmas and New Year 1957 at the M.I.R.A. (Motor Industry Research Association) test circuit were highly promising, but despite this the project was put on ice for a year, as top priority was given to the development of the sports cars, since they seemed ideally suited to the new three-liter formula decreed by the sport's governing body.

False hopes were raised once again as DBR4 driver Roy Salvadori only just failed to defeat Jack Brabham in his Cooper in a Formula 1 race at Silverstone in spring 1959. However, lubrication problems soon cropped up: at up to 6500 rpm the three-liter sports car vari-

In seiner Renn-Autobiographie *The Certain Sound* fasst John Wyer das Schicksal und damit die Karriere des DBR4 in drastischer Bildhaftigkeit zusammen: »1958 hätte er Rennen gewinnen können. 1959 war er eine sterbende Ente, 1960 ein stinkender Fisch.« Schon immer hat David Brown den Wunsch nach einem Formel-1-Wagen aus eigener Fertigung gehegt. Geboren wird der DBR4 allerdings aus seiner Rivalität mit Colin Vanderwell heraus, einem anderen englischen Unternehmer, dessen Vanwall-Rennwagen seit 1954 die Farbe British Racing Green auf den Pisten der Welt hof- und konkurrenzfähig gemacht haben.

Ermutigt fühlt man sich, als die Rennsport-Legislative für 1958 Kraftstoffe auf alkoholischer Basis verbietet. Das spielt Aston Martin in die Karten, deren Maschinen sich von handelsüblichem Sprit ernähren.

Andererseits sind die Tage des Frontmotors in der Formel 1 gezählt, und das wird sich als fatal für die späte Vision DBR4 erweisen. Das Modell ist wohlgeformt und gemäß dem hohen Standard des Hauses gebaut. Abgeleitet wird es vom DBR1. Als Rückgrat dient ein schmalerer und leichterer Gitterrohrrahmen mit Querlenkern vorn und einer de-Dion-Achse hinten. Nach einem geeigneten Motor braucht man nicht lange zu suchen und bereitet kurzerhand den 2,5-Liter aus dem ursprünglichen DBR1 auf. Tests zwischen Weihnachten und Neujahr 1957 auf dem Versuchsgelände der M.I.R.A. (für Motor Industry Research Association) stimmen durchaus optimistisch. Dennoch wird das Projekt für ein Jahr auf Eis gelegt. Erste Priorität genießen die Sportwagen, denen die neue Dreiliterformel als Reglement nach Maß entgegenzukommen scheint.

Trügerische Hoffnung keimt erneut auf, als sich DBR4-Pilot Roy Salvadori bei einem Formel-1-Lauf in Silverstone im Frühjahr 1959 nur knapp Jack Brabham im Cooper geschlagen geben muss. Aber schon zeichnen sich Probleme mit der Schmierung ab: In seiner Dreiliter-Variante im Sportwagen bei Drehzahlen bis zu 6500/min verrichtet der Sechszylinder klaglos seine Arbeit. Unerwartete Schwächen stellen sich im Monoposto ein, wo der kritische Bereich erst jenseits 8000/min angesiedelt ist. Die Ausbeute bleibt mager: zwei sechste Plätze für Salvadori in seinen vier Grand Prix für die Marke 1959. In Silverstone kann er sich im Glanz der ersten Startreihe sonnen, flankiert von Brabham im Cooper und Harry Schell im BRM.

In Monza bringt die Waage ein anderes Dilemma zu Tage: Der Aston Martin wiegt 636 Kilogramm, der Cooper 540 und der Lotus 490. Dieser Herausforderung begegnet man erstaunlich schnell und speckt 96 Kilogramm ab, allerdings nicht bei den ungefederten Massen – mit verheerenden Folgen für das Handling. Noch schlechter benimmt sich der eilends nachgeschobene und noch einmal erleichterte DBR5. Und so zieht David Brown den Formel-1-Rennwagen von Aston Martin nach dem Großen Preis von England 1960 betrübt aus dem Verkehr.

Dans son autobiographie – *The Certain Sound* – John Wyer résume le destin et la carrière de la DBR4 avec une concision très expressive : « En 1958, elle aurait pu gagner des courses. En 1959, c'était un canard boiteux et en 1960, un poisson puant. »

David Brown a toujours souhaité en secret voir courir des voitures de Formule 1 avec son blason. La DBR4 était toutefois née de sa rivalité avec Colin Vanderwell, un autre industriel anglais dont les voitures de course, les Vanwall, faisaient briller les couleurs *British Racing Green* sur les circuits du monde entier depuis 1954.

David Brown voit un encouragement dans l'interdiction par les autorités fédérales des carburants à base d'alcool durant la saison 1958. En effet, les Aston Martin utilisaient déjà des carburants standard.

À cette époque, les jours du moteur avant sont comptés en Formule 1 et cela va se révéler fatal pour la DBR4. La voiture, construite conformément aux critères de qualité de la maison, a belle apparence. Dérivée de la DBR1, elle a pour épine dorsale un châssis tubulaire plus étroit et plus léger à bras transversaux à l'avant et essieu de Dion à l'arrière. Point n'est besoin de chercher longtemps un moteur approprié, le 2,5 litres de la DBR1 d'origine semble prédestiné. Des essais réalisés entre Noël et le nouvel an 1957 sur le circuit de la MIRA, la Motor Industry Research Association, justifient leur optimisme. Et pourtant, le projet est suspendu pour une année. En effet, priorité est accordée chez Aston Martin aux voitures de sport, dont la nouvelle réglementation avec la formule 3-litres semble taillée sur mesure pour elle.

Un espoir surgit à nouveau lorsque le pilote de la DBR4, Roy Salvadori, lors d'une manche de Formule 1, à Silverstone, au printemps 1959, réussit presque à l'emporter sur Jack Brabham sur Cooper. Mais des problèmes de lubrification s'esquissent déjà : dans sa version 3-litres en voiture de sport avec des régimes de 6500 tr/min au maximum, le six-cylindres fonctionne à la perfection. Une faiblesse inattendue se manifeste avec la monoplace, où la zone critique ne commence qu'au-delà de 8000 tours. Le butin est des plus maigres : deux sixièmes places pour Salvadori lors de ses quatre Grands Prix disputés pour la marque en 1959. À Silverstone, il peut toutefois se flatter de prendre le départ en première ligne aux côtés de Brabham sur Cooper et Harry Schell sur BRM.

À Monza, la balance met au jour un autre problème : l'Aston Martin pèse 636 kg, contre 540 pour la Cooper et 490 seulement pour la Lotus. Ses concepteurs relèvent le défi sans hésiter et lui font perdre 96 kg, mais, malheureusement, ce poids n'est pas retiré des masses non suspendues – ce qui a des conséquences catastrophiques sur sa maniabilité. Les choses s'aggravent encore avec la DBR5 qui la remplace au pied levé et est encore allégée. Et c'est ainsi que, contre son gré, à l'issue du Grand Prix d'Angleterre de 1960 David Brown doit renoncer à engager des Aston Martin en Formule 1.

ant of the six-cylinder engine performed flawlessly. However, unexpected weaknesses emerged in the single-seater race car in the critical area above 8000 rpm. As a result the pickings were slim: two sixth places for Salvadori in the four Grand Prix he contested for the marque in 1959. At Silverstone, however, there was a ray of sunshine as he qualified on the front row alongside Brabham in the Cooper and Harry Schell in the BRM.

At Monza the scales brought a further problem to light: the Aston Martin weighed in at 636 kilograms, the Cooper at 540 and the Lotus at 490. The challenge was met with astonishing speed as 96 kilograms were removed, though unfortunately not from the unsprung mass – with disastrous consequences for the car's handling.

The follow-up DBR5 was further reduced in weight, and handled even worse, and so a crestfallen David Brown withdrew the Aston Martin Formula 1 car from the competition after the 1960 British Grand Prix.

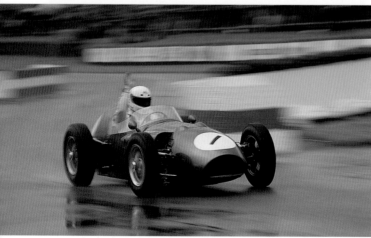

Evergreen: by the end of the 1950s the DBR4 was falling behind the times. However, today it still does good service for its owner in club races.

Evergreen: Ende der fünfziger Jahre hinkte der DBR4 der Entwicklung hinterher. Dafür leistet er heute noch seinem Besitzer auf Clubrennen gute Dienste.

Evergreen : à la fin des années 1950, la DBR4 est déjà totalement dépassée. Aujourd'hui, en revanche, elle rend de bons et loyaux services à son propriétaire lors des courses de clubs.

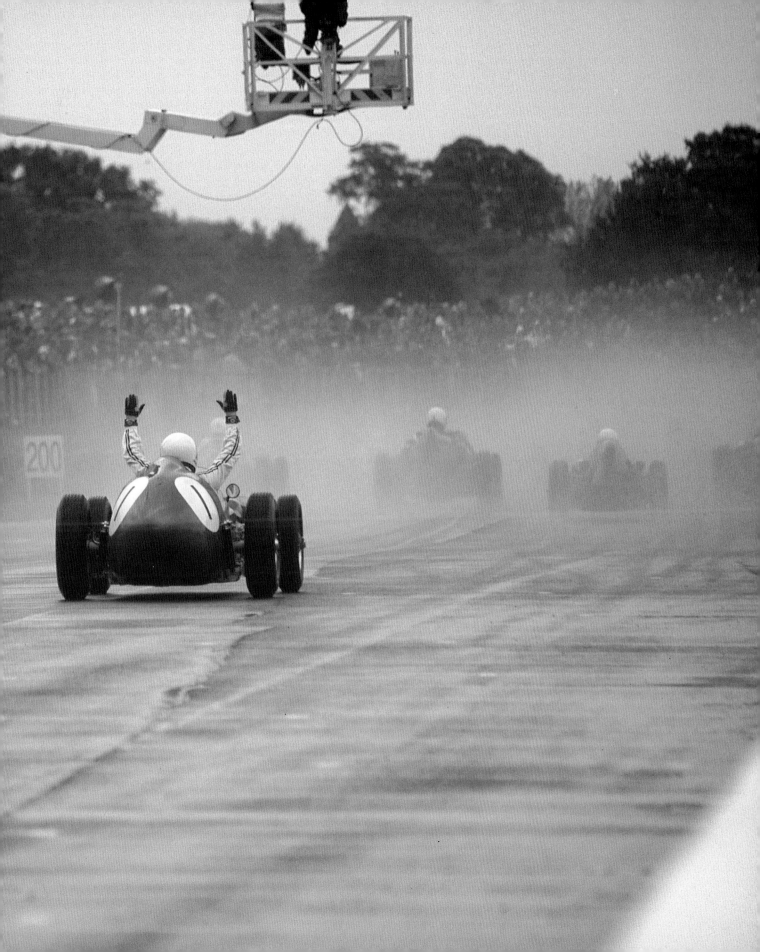

DB5

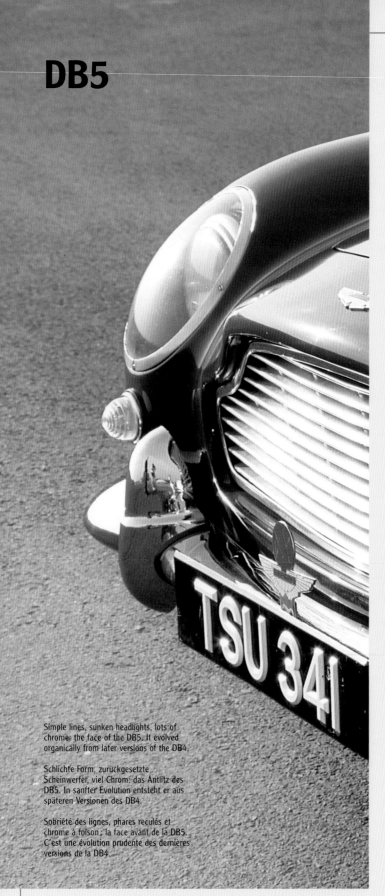

Simple lines, sunken headlights, lots of chrome: the face of the DB5. It evolved organically from later versions of the DB4.

Schlichte Form, zurückgesetzte Scheinwerfer, viel Chrom: das Antlitz des DB5. In sanfter Evolution entsteht er aus späteren Versionen des DB4.

Sobriété des lignes, phares reculés et chrome à foison: la face avant de la DB5. C'est une évolution prudente des dernières versions de la DB4.

In September 1964 *Autocar* pronounced the DB5 a car of many faces, one of which would always match the mood of its driver. And indeed, that is how David Brown and his team had planned it: as a comfortable Gran Turismo with superior drive characteristics and a refined manner, and with no racing pretensions, in line with the marque's more laid-back philosophy for the new decade.

The transition from the DB4 to the DB5 around the middle of 1963 was as seamless as the one from the DB2 to the DB2/4 had once been. The car rocketed to fame as James Bond's choice in the spy thriller *Goldfinger*, although the automobile film star was in fact a Series V DB4 Vantage housing an engine which had been available since September 1961. It featured larger valves and SU carburetors, a higher compression ratio and a generously measured 266 horsepower. An extra 90 mm length provided the occupants with a little more leg room. As in the DB4GT, the dashboard was thick with instruments.

Some major internal changes justified the new DB5 designation. These included a new four-liter engine with bags of torque. The background to this was David Brown's resuscitation of the Lagonda name at the beginning of the 1960s in the form of a longer, more luxurious DB4 variant. The additional weight of the Lagonda Rapide was compensated for by boring out the existing engine to 3995 cc. The DB5 was fitted with a modified 282 horsepower version, the power from which was transmitted by three different systems to the rear axle. The first of these was the standard David Brown transmission with Laycock de Normanville overdrive. Alternatively the customer could opt for a Borg Warner automatic with three drive settings, and from chassis 1340 onwards the DB5 was fitted with a five-speed transmission from the Friedrichshafen gearwheel factory, a system originally designed for the Maserati 5000 GT. The driver's manual specified a maximum of 5500 rpm for high-speed cruising, while brief excursions up to 6000 rpm would not damage the robust six-cylinder engine. Girling disc brakes provided the necessary deceleration. *Autocar* expressed its approval of one optional extra: the Armstrong Selectaride System, whereby a switch on the dashboard allows four different levels of stiffness to be selected for the rear shock absorbers. From 1964 a 325 horsepower Vantage version was available. During the two years of production 1021 DB5s were constructed, 123 of them Volante cabriolets, plus 12 Shooting Brakes for hunting enthusiasts – Harold Radford & Co providing the body of what was the fastest, most luxurious and most expensive estate car in the world.

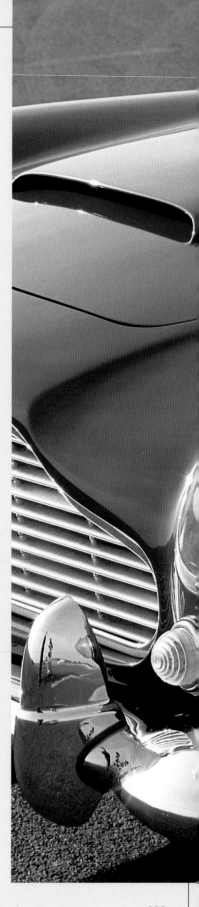

Autocar nennt ihn im September 1964 ein Auto mit vielen Gesichtern. Eines davon passe immer zu der jeweiligen Stimmung seines Fahrers. So ist er in der Tat von den Männern um David Brown angelegt: ein komfortabler Gran Turismo mit überlegenen Fahrleistungen und liebenswürdigen Umgangsformen, gleichwohl ohne Rennambitionen ganz im Einklang mit der sanfteren Philosophie der Marke im neuen Jahrzehnt.

Die Übergänge vom DB4 zum DB5 etwa Mitte 1963 vollziehen sich fließend wie einst vom DB2 zum DB2/4. An der Nahtstelle steht ein automobiler Filmstar, der Dienstwagen des Glamour-Agenten James Bond in dem Minne- und Meuchel-Epos *Goldfinger*. Eigentlich handelt es sich um einen DB4 Vantage der Serie V. Unter der Haube haust folglich ein seit dem September 1961 verfügbares Triebwerk mit größeren Ventilen und SU-Vergasern, höherer Kompression und liberal bemessenen 266 PS. 90 Millimeter mehr Länge schaffen üppigeren Lebensraum für die Insassen. Die Instrumententafel ist wie im DB4GT reich besiedelt.

Dass dem Neuen eine eigene Identität als Opus 5 zuerkannt wird, rechtfertigen massive Eingriffe unter der Haut. Vorn ist nämlich ein Vierliter mit urigem Drehmoment eingezogen. Auch er hat seine Vorgeschichte: Anfang der sechziger Jahre hat David Brown den brachliegenden Namen Lagonda wieder belebt, in Form eines längeren und luxuriösen Ablegers der Baureihe DB4. Das zusätzliche Gewicht des Lagonda Rapide wird dadurch aufgefangen, dass man den real existierenden Motor auf 3995 ccm aufbohrt. In einer evolutionären Stafette wird diese Variante dem DB5 zugänglich gemacht, mit 282 PS, die auf drei verschiedene Arten an die Hinterachse weitervermittelt werden können. Da ist das serienmäßige David-Brown-Getriebe mit einem Overdrive von Laycock de Normanville, dazu wahlweise ein Automat von Borg Warner mit drei Fahrstufen oder – ab Chassis 1340 Standard – ein Fünfgang-Getriebe der Zahnradfabrik Friedrichshafen, das ursprünglich für den Maserati 5000 GT gedacht war. Für zügiges Fahren empfiehlt die Betriebsanleitung den Aufenthalt bei 5500/min, kurze Ausflüge bis zu 6000/min würden dem robusten Sechszylinder aber nicht schaden. An die Kandare genommen wird der DB5 vermittels Girling-Scheibenbremsen. *Autocar* äußert sich anerkennend über ein gelegentlich geordertes Extra: das System Selectaride von Armstrong, mit dem sich über einen Schalter am Armaturenbrett die hinteren Stoßdämpfer in vier Härtegraden verstellen lassen.

Ab 1964 wird eine Vantage-Version mit 325 PS angeboten. Insgesamt entstehen in den zwei Jahren seiner Produktion 1021 DB5, davon 123 Cabriolets namens Volante sowie zwölf Shooting Brakes für die Freunde der Jagd. Harold Radford & Cie kleidet sie ein, die schnellsten, luxuriösesten und teuersten Kombinationskraftwagen auf dem Markt.

Dans son numéro de septembre 1964, *Autocar* la qualifie de voiture aux nombreux visages, dont l'un est toujours en harmonie avec l'humeur de son conducteur. C'est ainsi en effet que l'a conçue l'équipe réunie autour de David Brown : un véhicule Grand Tourisme confortable aux performances supérieures à la moyenne, raffiné, sans ambitions sportives, comme le veut la philosophie adoptée par la marque pour la nouvelle décennie.

Le passage de la DB4 à la DB5, vers le milieu de l'année 1963, s'effectue en douceur, comme jadis la transition de la DB2 à la DB2/4. Elle acquiert une grande notoriété en devenant la voiture vedette du cinéma, la mythique voiture de fonction du sémillant agent secret James Bond dans l'épopée mirobolante de *Goldfinger*. À proprement parler, il s'agit d'une DB4 Vantage Série V. Sous le capot réside un moteur disponible depuis septembre 1961, aux soupapes de plus grandes dimensions et à carburateurs SU, au taux de compression plus élevé et à la puissance évaluée à 266 ch. 90 mm de plus en longueur se traduisent par un plus grand espace pour les occupants. Comme dans la DB4GT, le porte-instruments est plutôt chargé.

Les interventions massives sous la carrosserie justifient que l'on donne à ce nouveau modèle sa propre dénomination. En effet, un moteur de 4 litres au couple exubérant prend ses aises sous le capot. Au début des années 1960, David Brown a fait revivre le nom Lagonda, jusqu'ici « en jachère », sous la forme d'une version plus longue et plus luxueuse de la gamme DB4. Pour compenser le poids supplémentaire de la Lagonda Rapide, il décide de majorer à 3 995 cm³ la cylindrée du moteur existant. Dans une version intermédiaire plus évoluée, cette variante propulse la DB5 avec 282 ch, qui peuvent être transmis au train arrière de trois façons différentes. La première possibilité est la boîte de vitesses de série de David Brown avec un *overdrive* Laycock de Normanville, la deuxième étant une boîte automatique Borg Warner à trois rapports ou – à partir du châssis 1340 standard – une boîte manuelle à cinq vitesses du fabricant allemand Zahnradfabrik Friedrichshafen, qui était conçue à l'origine pour la Maserati 5000 GT. À quiconque veut rouler vite, le mode d'emploi recommande de se cantonner aux alentours de 5 500 tr/min, de brèves montées en régime jusqu'à 6 000 tr/min ne risquant pas de porter préjudice au robuste six-cylindres. Pour juguler la DB5 lorsqu'elle est lancée à grande vitesse, on peut faire confiance aux freins à disque Girling. *Autocar* évoque en termes élogieux une option qui séduira certains acheteurs : le système Armstrong Selectaride qui, à l'aide d'une commande au tableau de bord, permet de choisir parmi quatre degrés de dureté pour les amortisseurs arrière.

Dès 1964, Aston Martin propose une version Vantage de 325 ch. Durant les deux années de sa production, 1021 DB5 sont construites, dont 123 cabriolets, baptisés Volante, ainsi que 12 Shooting Brakes pour les amateurs de chasse. Habillés par Harold Radford & Cie, il s'agit des breaks les plus rapides et les plus onéreux que l'on puisse trouver sur le marché.

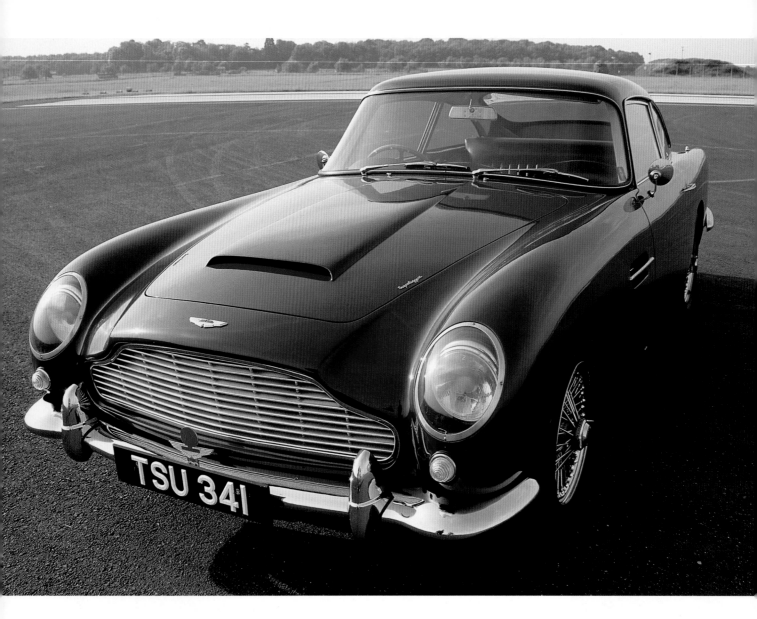

The DB5 is a kind of fastback Coupé, as revealed by the design of the rear end. Beneath the front hood a coupé four-liter power unit with lots of polished aluminum lurks, on the lookout for freedom and adventure.

Der DB5 zählt zur Spezies der Fastback Coupés und so schaut sein Heck in der Tat aus. Unter der vorderen Haube lauert ein Vierliter mit viel poliertem Aluminium auf den Einsatz für Freiheit und Abenteuer.

La DB5 appartient à la race des coupés fastback, dont elle possède l'arrière typique. Sous le capot avant réside un moteur de 4 litres en aluminium poli, impatient de partir à l'aventure en toute liberté.

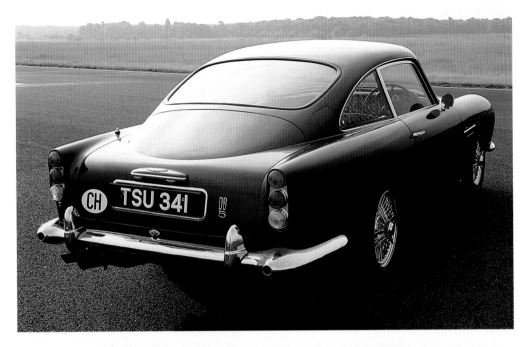

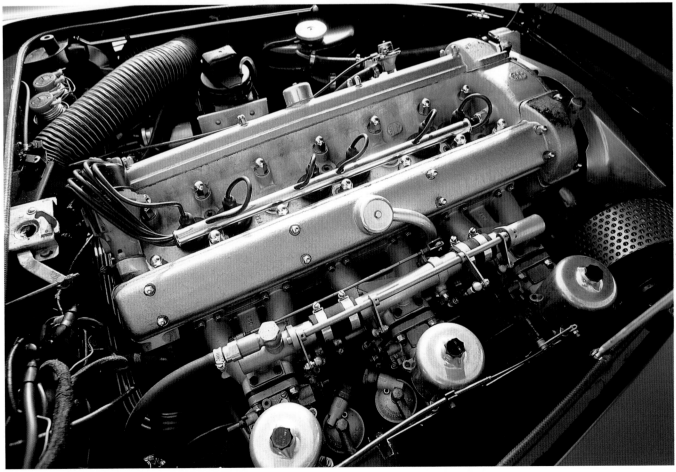

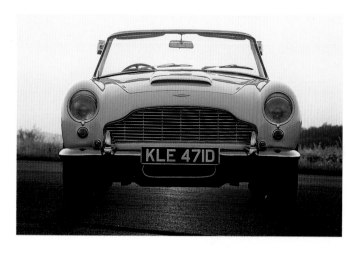

This open version was presented at the Paris Motor Show and then added to the range in May 1964. A total of 123 DB5 Convertibles were eventually produced.

Offen gestanden: Auf dem Pariser Salon vorgestellt und ab Mai 1964 im Sortiment, ist das Convertible mit 123 Exemplaren an der DB5-Produktion beteiligt.

Au Salon de Paris est présentée la version cabriolet de la DB5, appelée Convertible, qui sera commercialisée en mai 1964 et représentera 123 exemplaires dans la production.

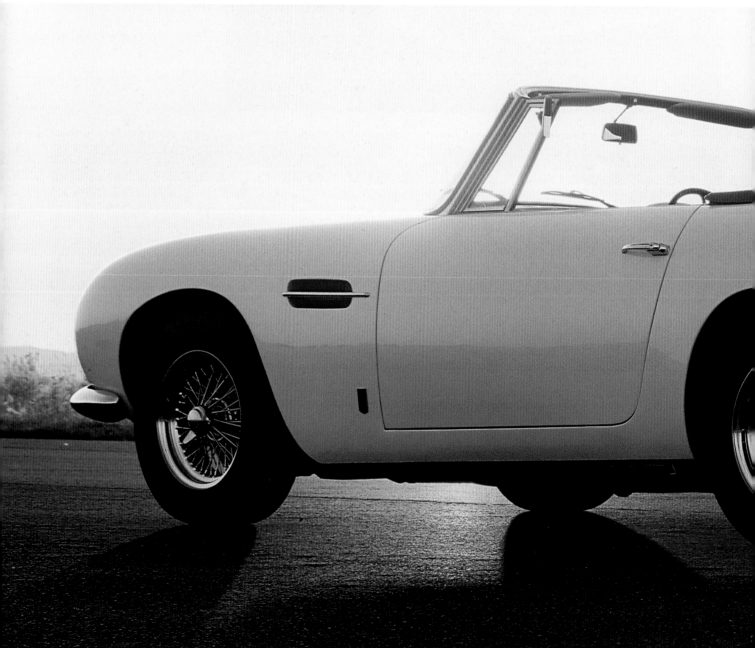

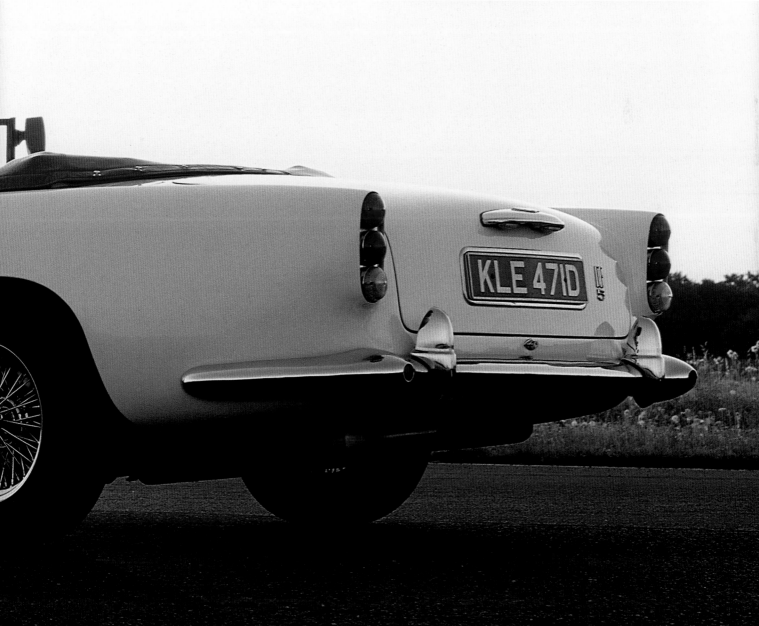

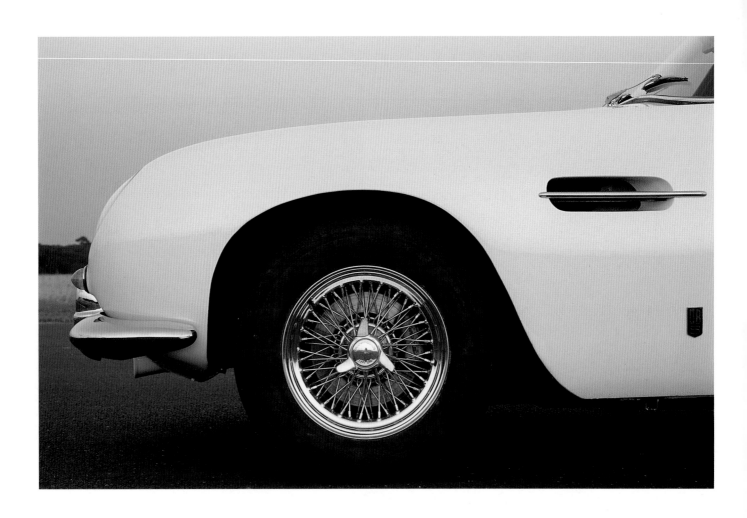

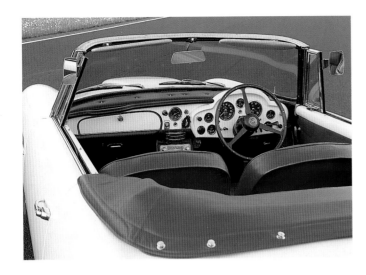

The front windscreen of the Convertible is 3 inches higher than in the saloon version in order to protect against the wind. The well-populated dashboard came in the color of the car.

Die Frontscheibe des Convertibles ist 13 Millimeter höher als am Saloon als Hilfe gegen Fahrtwind. Das umfassend ausgestattete Armaturenbrett gibt es auch in der Farbe des Wagens.

Pour mieux braver les éléments, le pare-brise du cabriolet mesure 13 millimètres de plus en hauteur que celui du coupé. Le tableau de bord richement doté est aussi proposé dans la couleur de la carrosserie.

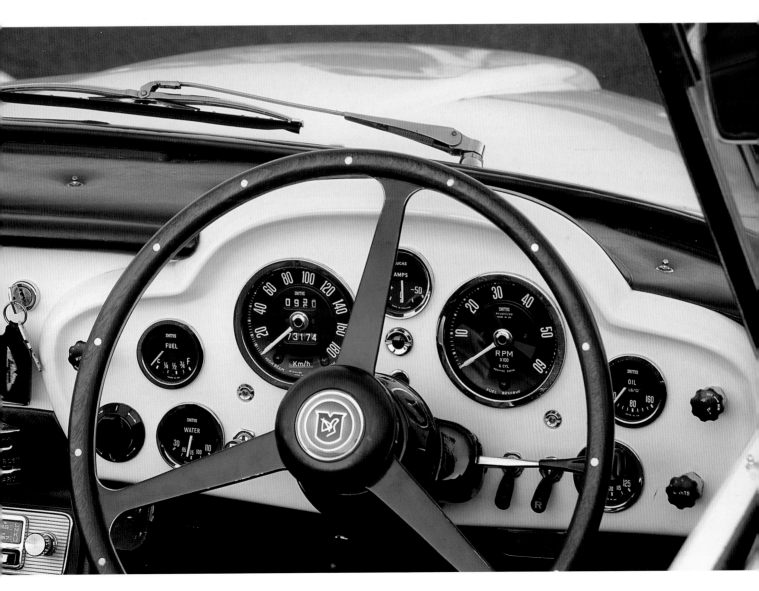

DB6

The third and final variation on the DB4 theme, introduced at the London Motor Show of 1965, is not hard to identify. For example, there are the divided fenders at front and rear, with a coarse-meshed grille beneath the number plate concealing the oil cooler. Then there are the small angular rear quarterlights and the sharply dropping Kamm tail rounding off to a pert bulge. And there is the wheelbase, lengthened by 90 mm, inserted just before the drive wheel cutouts, plus flatter rear seat cushions and an extra 20 millimeters of headroom. The shortening of the upper rear trailing arm served the same purpose of attracting new clientele to Aston Martin by making the DB6 a genuine, comfortable four-seater. The Superleggera-style tubular understructure was removed, the Huddersfield plant responsible for the chassis replacing it with external aluminum body panels mounted on inner steel panels.

The engine was the same as the DB5's, Tadek Marek's famous six-cylinder 282-horsepower unit. Though this figure fell by 42 when the harsh spotlight of the German DIN industrial norms was trained on it, the Vantage's 325 horsepower dwindling in like fashion to 272. Regardless of whether they were fitted with manual or automatic transmission, a unitary £4998 was set for all models. The 1966 increase in purchase tax by the Labour administration of the time plus falling demand in a depressed market led David Brown to take the drastic step in February 1967 of reducing the price by £1000, thus steering the company back into the red figures. The DB6 was produced by the Newport Pagnell plant in two batches: firstly 1327 saloons up to July 1969, followed by 240 of the Mark II until November 1970.

Rationalization meant that the same 6-inch wheels as in the DBS were used, with tires to match. This necessitated fitting the cars with flares above the wheel arches to make room for the tires. The low volume of sales was a clear sign of the fact that this classic was fast losing popularity in favor of the latest DBS generation.

During the same period 215 cabriolets were sold, at first using the chassis of the DB5, then later that of the DB6 saloon.

The US journal *Road & Track* would rather have seen a new model than a facelift on a familiar visage, and viewed the blunt rear as an irritating and unnecessary concession to contemporary tastes, and a crude desecration of the familiar lines. However, the author then came to the conciliatory conclusion that the automotive world would definitely be a grayer place without David Brown's handsome contributions.

Die dritte und letzte Variation zum Thema DB4, vorgestellt auf der London Motor Show 1965, ist unschwer zu identifizieren. Da ist die geteilte Stoßstange hinten und vorn, wo unter dem Nummernschild ein grobmaschiges Gitter den Ölkühler abdeckt. Da sind die eckig endenden rückwärtigen Seitenfensterchen und der Steilabfall des Kamm-Hecks, vor dem sich die Silhouette noch einmal zu einem kecken Hügel aufwirft. Da sind, bei näherem Hinsehen, 90 Millimeter mehr Radstand, gewonnen kurz vor den Ausschnitten für die Antriebsräder, dazu flachere Sitzkissen hinten und auch sonst 20 Millimeter mehr Kopffreiheit. Dass die oberen Längslenker hinten verkürzt wurden, dient dem gleichen Anliegen: Der DB6 soll Aston Martin eine neue Klientel erschließen, die auch im Fond kommod sitzen möchte. Abgerissen wurde im Werk Huddersfield, wo das Chassis hergestellt wird, das Rohrgeflecht à la Superleggera. Statt seiner liegen nun die äußeren Aluminium-Paneelen der Karosserie über inneren aus Stahlblech.

Die Motorisierung ist die Gleiche wie im DB5, Tadek Mareks bekannter Sechszylinder mit 282 PS, von denen im grellen Licht der Deutschen Industrie-Norm 42 wegschmelzen. Von den 325 PS, die für den Vantage angegeben werden, bleiben immerhin noch 272. Ob sie manuell oder per Automatik geschaltet werden: Für alle Modelle wird ein einheitlicher Preis von 4998 Pfund in Rechnung gestellt. Die Erhöhung der Kaufsteuer von 1966 durch die damalige Labour-Regierung sowie sinkende Nachfrage auf dem krisengerüttelten Markt fängt David Brown im Februar 1967 durch eine drastische Maßnahme auf: Er senkt die Gebühr um 1000 Pfund und steuert das Unternehmen damit wieder in die Verlustzone.

Der DB6 verlässt das Werk in Newport Pagnell in zwei Schüben: 1327 Saloons bis zum Juli 1969, 240 Exemplare eines Mark II bis zum November 1970.

Aus Gründen der Rationalisierung gelangen in diesen 6-Zoll-Felgen wie im DBS mit entsprechenden Pneus zum Einbau, so dass mittels nach außen gewölbter Kotflügelkanten Raum geschaffen werden muss. Die geringe Anzahl von Mark II ist ein deutliches Indiz dafür, dass der Klassiker bereits von der jungen DBS-Generation an die Wand gedrückt wird.

In demselben Zeitraum entstehen 215 Cabriolets, erst noch auf dem Fahrgestell des DB5, das später von dem des DB6 Saloons abgelöst wird.

Das amerikanische Blatt *Road & Track* hätte lieber ein neues Modell gesehen. Das stumpfe Heck störe als unnötiger Tribut an den Zeitgeschmack. Dann aber kommt der Autor zu dem versöhnlichen Schluss, dass die Autowelt ohne die schönen Beiträge von David Brown gewiss ein bisschen dunkler wäre.

La troisième et dernière déclinaison de la DB4, présentée au London Motor Show en 1965, est facile à identifier. Elle se distingue par un pare-chocs divisé à l'arrière et à l'avant où, sous la plaque minéralogique, une prise d'air intégrée à la jupe protège le radiateur d'huile. Elle se signale aussi par les petites fenêtres latérales qui se terminent au carré et sa poupe tronquée avec un spoiler de type Kamm, qui vise à mieux plaquer l'arrière de la voiture à la route. Une étude plus attentive révèle également que l'empattement s'est allongé de 90 mm juste devant les arches des roues arrière, que les coussins des sièges arrière sont plus plats et que le pavillon a aussi été relevé, le tout offrant ainsi 20 mm de plus de garde au toit. Les bras longitudinaux supérieurs ont été raccourcis à l'arrière, toujours dans le même objectif: Aston Martin destine sa DB6 à une nouvelle clientèle, qui souhaite aussi être assise confortablement à l'arrière. Le châssis tubulaire sous licence Superleggera disparaît. À l'usine de Huddersfield, où est

construit le châssis, on le remplace par des panneaux extérieurs de carrosserie en aluminium recouvrant une structure intérieure en tôle d'acier.

La motorisation est la même que pour la DB5, en l'occurrence le six-cylindres bien connu de Tadek Marek, de 282 ch, auquel les sévères normes industrielles allemandes en font perdre 42. Des 325 ch revendiqués pour la Vantage, il en reste tout de même encore 272. Que la boîte soit manuelle ou automatique, tous les modèles sont facturés au même prix de 4 998 livres. L'augmentation de la taxe sur la valeur ajoutée par le gouvernement travailliste en 1966, ainsi que la baisse de la demande sur un marché ébranlé par les crises incitent David Brown à prendre une mesure draconienne en février 1967 : il diminue le prix de 1 000 livres et fait ainsi de nouveau sortir l'entreprise du déficit.

La DB6 quitte l'usine de Newport Pagnell en deux étapes : 1 327 Saloon jusqu'en juillet 1969 et 240 Mark II jusqu'en novembre 1970.

Pour des motifs de rationalisation, elles sont équipées de jantes de six pouces aux pneus correspondants, comme la DBS, ce qui nécessite un renflement des ailes, modification qui transforme nettement son aspect. Le nombre réduit de Mark II produites est un indice qui ne trompe pas : cette classique est déjà poussée à la retraite par la jeune génération de DBS. Durant la même période, Aston Martin fabrique 215 cabriolets, au début encore sur le châssis de la DB5 puis, plus tard, sur celui de la DB6 Saloon.

La revue spécialisée américaine *Road & Track* aurait préféré voir apparaître un nouveau modèle plutôt qu'une vieille connaissance remise au goût du jour. Elle voit dans l'arrière tronqué une concession superflue aux modes de l'époque. Selon elle, cela porte préjudice à la ligne unique à laquelle on s'était accoutumé. Mais l'auteur n'en termine pas moins sur une note optimiste car, dit-il, le monde de l'automobile serait sans aucun doute un peu triste sans les belles créations de David Brown.

The new rear of the DB6 translates Professor Wunibald Kamm's doctrine of the aerodynamic virtues of the smallest possible cross-section into reality, in so doing increasing the rear axle downforce by 30%.

Das neue Heck des DB6 setzt die Lehre des Professors Wunibald Kamm von den aerodynamischen Segnungen des kleinsten Abreißquerschnitts in die Tat um und reduziert den Auftrieb an der Hinterachse um 30 Prozent.

Le nouvel arrière de la DB6 met en application la doctrine du professeur Wunibald Kamm qui proclame les bienfaits aérodynamiques de la poupe tronquée avec petit becquet arrière qui réduit de 30 % la portance à hauteur des roues motrices.

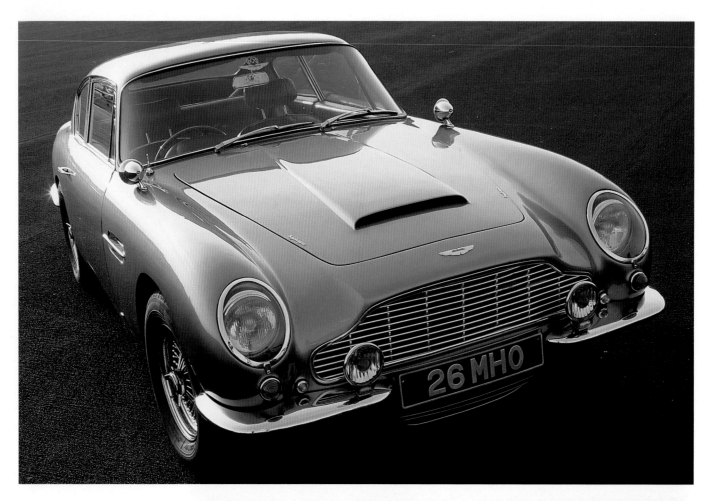

The DB6 is just two inches longer than its predecessor. Its windscreen is more sharply angled, but the interior is nevertheless more spacious, providing occupants with extra headroom.

Der DB6 ist nur 50 Millimeter länger als sein Vorgänger. Seine Windschutzscheibe ist stärker geneigt. Gleichwohl steht den Insassen mehr Raum zur Verfügung, zum Beispiel ein Zuwachs an Kopffreiheit hinten.

La DB6 mesure 50 millimètres de plus que sa devancière. Son pare-brise est plus fortement incliné. Et pourtant, les passagers ont plus de liberté de mouvement, la garde au toit à l'arrière ayant augmenté.

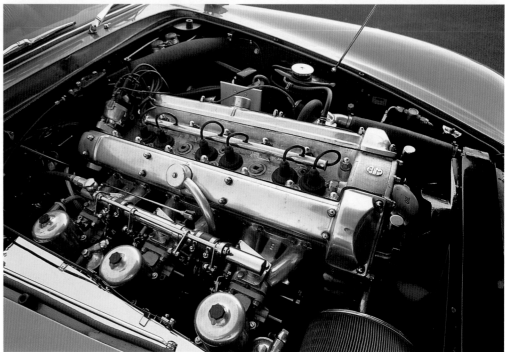

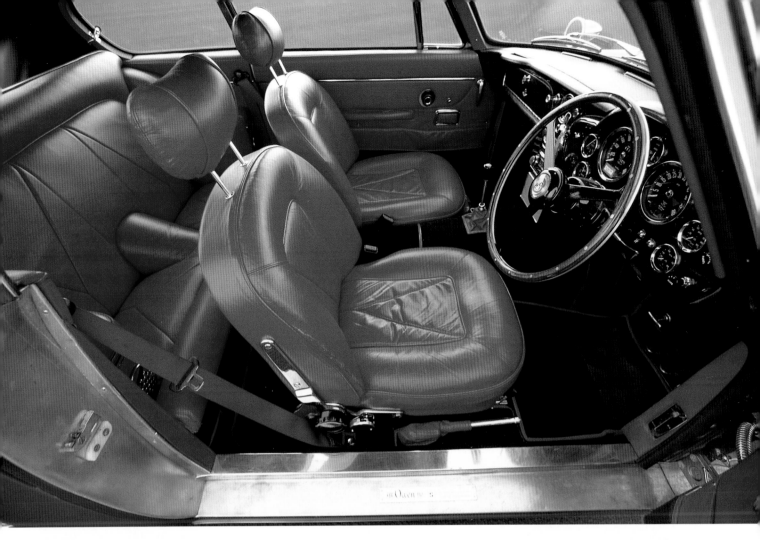

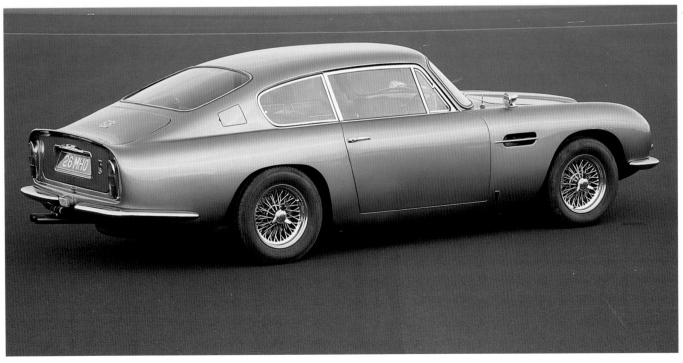

DBS

The first appearance of a two-seater DBS with a Touring body and left-hand drive, at the 1966 London Motor Show at Olympia, also proved to be the last. The company's rocky financial situation, which had worsened after the introduction of a punitive purchase tax by the Wilson administration in July that year, was causing disquiet. And so the Aston Martin DBS opus 1 proved to be a one-off, although in fact two of them had been made, only to be consigned to the scrapheap of history.

At the same time David Brown and other decision-makers got together to consider their options. Their aim was to produce a 2+2-seater with an in-house body, and incorporating as many current production parts as possible. The deadline for the model – surely an impossible goal – was to be the 1967 Motor Show.

William Towns was responsible for the handsome bodywork. He had just recently been hired by Aston Martin, and went on to become a top freelance industrial designer at the end of the 1960s. His design undoubtedly radiated plenty of Italian-style flair, and the body was so smoothly proportioned that the sheer size of the DBS was almost forgotten. Times had changed, and despite the breakneck pace, time was found to perfect the development of a spoiler via testing in the M.I.R.A. wind tunnel, and also to incorporate plenty of passive safety features. As the 28th September 1967 issue of *Autocar* noted, Aston Martin had long since proved itself in the field of active safety.

A team under the engineer Dudley Gershon based their work on the chassis of the DB6, widening it by 114 millimeters and increasing the wheelbase by 30 millimeters. Drawing on a tradition going back through a long line of models including the DB3S, DBR1, DBR4 and the Lagonda Rapide, the rear suspension was supplied by a de Dion axle. This provided better traction on poor surfaces and, in tandem with the disc brakes fitted close to the differential, reduced the unsprung mass from 130 to 80 kilograms.

The whole thing was thrown together somewhat hastily, leading among other things to a 133-kilogram weight increase over the DB6. This would not have detracted from the agility of the DBS too much had it not been powered by the preexisting six-cylinder unit, which looked a little lonesome cowering in the capacious engine compartment. The planned V8, intended to set the standard in this exclusive market niche, was not yet ready.

830 DBSs were built prior to David Brown's retirement. After the takeover by Company Developments in 1972 a further 70 came into existence, curiously now under the name Aston Martin Vantage. The term Vantage had hitherto been reserved for the most powerful model in the range.

Der erste Auftritt eines zweisitzigen DBS mit einer Karosserie von Touring und Linkslenkung auf der London Motor Show 1966 in Earls Court ist zugleich sein letzter. Unbehagen besteht, nicht zuletzt wegen der wenig rosigen Situation des Unternehmens, seitdem die Wilson-Regierung im Juli die Anschaffung von dergleichen Luxusgütern mit einer deftigen Kaufsteuer ahndet. Der Aston Martin DBS opus 1 verkümmert zum Unikum, wenngleich nicht zum Unikat: Tatsächlich sind es zwei Erlkönige, die auf den historischen Müllhaufen wandern.

Zugleich finden sich David Brown und weitere Entscheidungsträger zusammen, um ihre Hausaufgaben neu zu machen. Die Parameter: Ein 2+2-Sitzer, für dessen Einkleidung man selbst zu sorgen gedenkt. Möglichst viele Teile sollen der laufenden Produktion entnommen werden können. Termin – und damit setzt man sich ein wahres Wunder zum Ziel – soll die Motor Show 1967 sein.

Um die schöne Hülle kümmert sich William Towns, der just bei Aston Martin angeheuert hat und sich Ende der Sechziger als Industriedesigner selbstständig machen wird. Zweifellos umfächelt sein Produkt italienisches Flair. So ausgewogen sind die Proportionen, dass die schiere Größe des DBS fast austariert wird. Die Zeiten wandeln sich: Trotz fieberhafter Hast findet man die Muße, einen Spoiler im Windkanal der M.I.R.A. zu optimieren und jede Menge passive Sicherheit in das Konzept einzubringen. Um die aktive Sicherheit hat sich Aston Martin laut *Autocar* vom 28. September 1967 ohnehin schon seit jeher verdient gemacht.

Ein Team um den Ingenieur Dudley Gershon nimmt sich das Chassis des DB6 vor, vergrößert die Breite um 114 Millimeter und den Radstand um 30 Millimeter. Was die Auslegung der Hinterradaufhängung anbelangt, greift man auf eine stolze Tradition des Hauses zurück, bewährt in der Ahnenreihe DB3S, DBR1, DBR4 und Lagonda Rapide: die de-Dion-Achse. Sie stellt bessere Traktion auf schlechtem Untergrund sicher und senkt im Bunde mit Scheibenbremsen, die unmittelbar am Differential angesiedelt sind, die ungefederten Massen von 130 auf 80 Kilogramm.

All das wird ein bisschen hastig zusammengezimmert, woraus nicht zuletzt stramme 133 Kilogramm Mehrgewicht gegenüber dem DB6 resultieren. Diese hätten die Agilität des DBS kaum geschmälert, würde nicht inmitten des geräumigen Motorenappartements gleichsam schüchtern und vereinsamt der bekannte Sechszylinder kauern. Der geplante V8, der zugleich auf dem schmalen Markt in dieser Klasse einen kräftigen Akzent setzen soll, lässt noch auf sich warten.

830 DBS werden bis zum Ausscheiden David Browns gebaut. Nach der Übernahme durch Company Developments 1972 entstehen noch einmal 70 weitere, nun kurioserweise Aston Martin Vantage geheißen.

Diese Edel-Vokabel war bislang stets dem stärksten Stück des Sortiments vorbehalten gewesen.

La première apparition en public d'une DBS biplace avec une carrosserie Touring et conduite à gauche, au London Motor Show de 1966, à Earls Court, est aussi sa dernière. Un certain malaise règne, aussi et surtout en raison de la situation préoccupante de l'entreprise depuis que le gouvernement Wilson, en juillet, pénalise l'achat de biens de luxe d'une lourde taxe sur la valeur ajoutée. L'Aston Martin DBS opus 1 connaîtra le destin d'un modèle unique bien qu'il ne s'agisse pas d'un spécimen unique : en fait, ce sont deux prototypes qui entreront dans les annales d'Aston Martin.

Immédiatement, David Brown et quelques autres décideurs se réunissent en conclave pour se remettre à la tâche. Objectif : une 2+2 qu'il est prévu d'habiller d'une carrosserie maison. Tout comme il est prévu de reprendre le plus grand nombre possible de pièces sur des modèles de production courante. La date butoir – la respecter serait un véritable miracle – est le Motor Show de 1967.

William Towns, qui vient de rejoindre Aston Martin après s'être mis à son compte à la fin des années 1960 comme designer industriel, est chargé de lui dessiner une robe digne d'elle. Celle-ci possède incontestablement un charme qui évoque l'Italie. Les proportions sont si équilibrées qu'elles font presque oublier les dimensions imposantes de la DBS. Comme les temps changent, malgré une hâte fébrile, on a le loisir d'optimiser un aileron dans la soufflerie de la MIRA et d'intégrer au concept quantité de dispositifs améliorant la sécurité passive. Selon la revue *Autocar* du 28 septembre 1967, Aston Martin n'a jamais démérité sur le plan de la sécurité active.

Une équipe entourant l'ingénieur Dudley Gershon se charge du châssis de la DB6, elle l'élargit de 114 mm et en allonge l'empattement de 30 mm. Quant à la géométrie de la suspension arrière, on recourt à une tradition de la maison illustrée par la galerie des ancêtres – DB3S, DBR1, DBR4 et Lagonda Rapide : le pont de Dion. Il se traduit par une meilleure motricité sur mauvais revêtements et, conjointement avec les freins à disque montés à proximité immédiate du différentiel, réduit les masses non suspendues de 130 à 80 kg.

Tout cela est assemblé un peu à la va-vite, et c'est ce qui explique pour une bonne part la prise de poids considérable de 133 kg par rapport à la DB6. Cela n'aurait guère porté préjudice à la vivacité de la DBS si le vaste compartiment moteur n'avait pas hébergé, aussi timide qu'isolé, le célèbre, mais petit six-cylindres. Le V8 projeté qui était destiné à devenir la norme sur le marché de cette catégorie de voitures se fait encore attendre.

830 DBS seront construites jusqu'au départ de David Brown. Après la reprise de la firme par Company Developments, en 1972, il en est encore produit 70, curieusement baptisées Aston Martin Vantage.

Ce surnom prestigieux était, en effet, jusqu'ici réservé exclusivement aux modèles les plus puissants de la gamme.

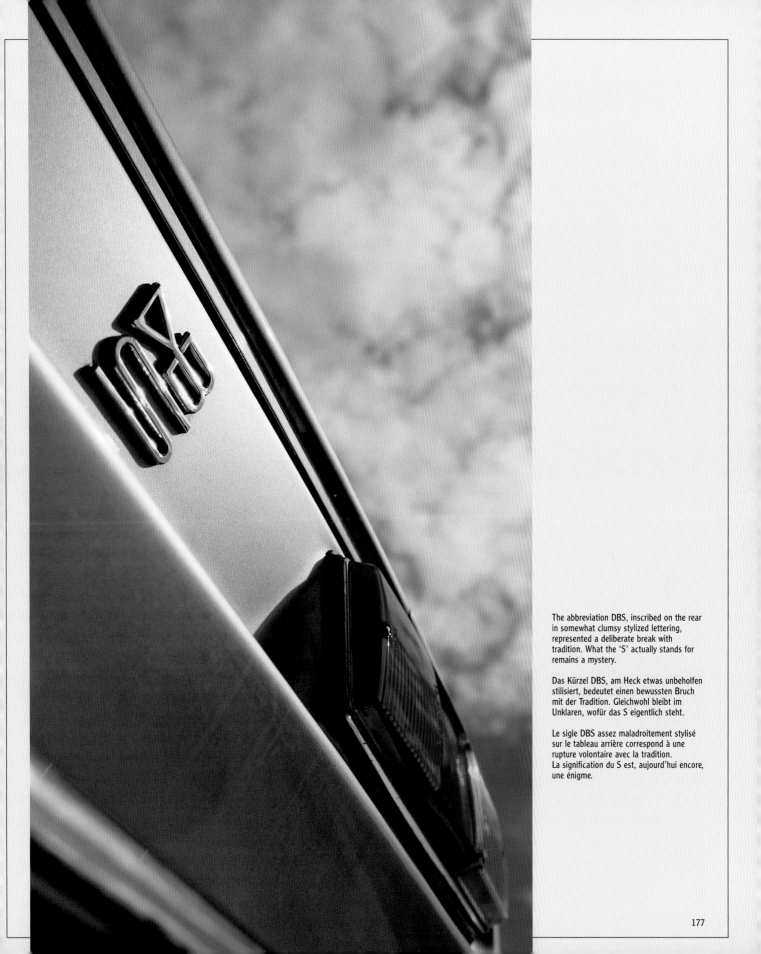

The abbreviation DBS, inscribed on the rear in somewhat clumsy stylized lettering, represented a deliberate break with tradition. What the 'S' actually stands for remains a mystery.

Das Kürzel DBS, am Heck etwas unbeholfen stilisiert, bedeutet einen bewussten Bruch mit der Tradition. Gleichwohl bleibt im Unklaren, wofür das S eigentlich steht.

Le sigle DBS assez maladroitement stylisé sur le tableau arrière correspond à une rupture volontaire avec la tradition. La signification du S est, aujourd'hui encore, une énigme.

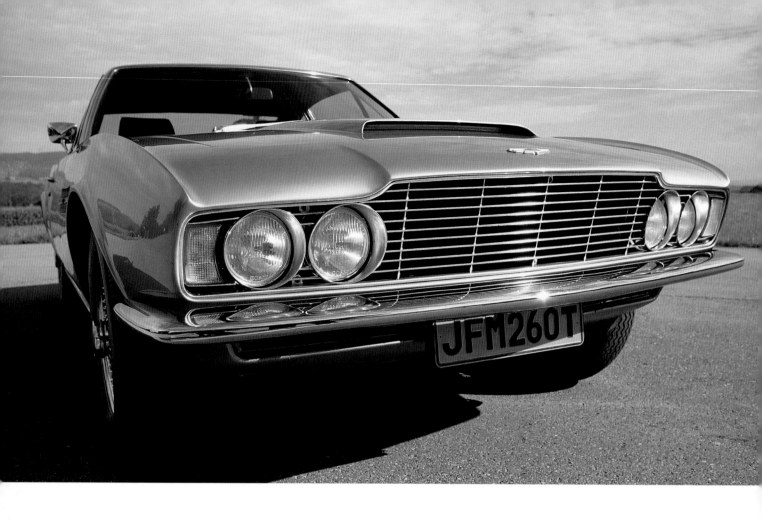

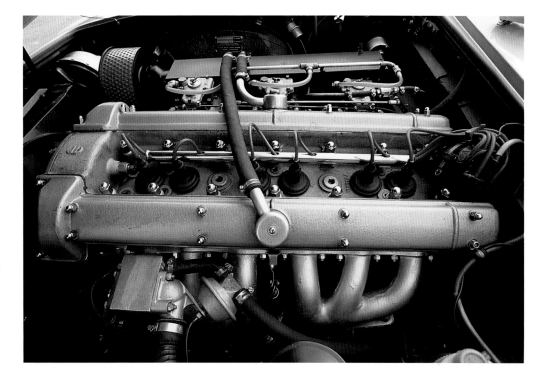

This Vantage version with three Weber Type 45 DCOE carburetors, sharper camshafts and higher compression was available at no extra price.

Ohne Aufpreis ist diese Vantage-Version mit drei Weber-Vergasern vom Typ 45 DCOE, schärferen Nockenwellen und höherer Verdichtung erhältlich.

Sans supplément de prix, cette version Vantage est proposée avec trois carburateurs Weber 45 DCOE, des arbres à cames plus pointus et un taux de compression plus élevé.

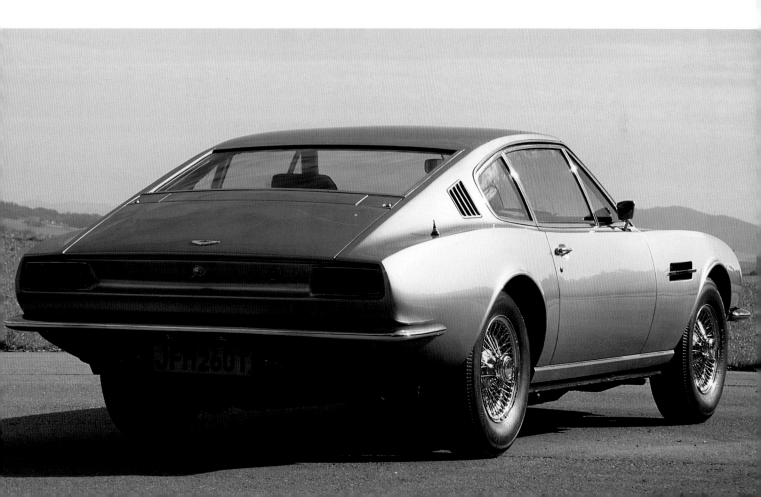

The usual air vents behind the front wheels were in fact a later addition after the initial design was found to lead to overheating in the engine compartment. The original plan was to have single headlights, but contemporary fashions prevailed in the end.

Für den üblichen Luftauslass hinter den Vorderrädern entscheidet man sich erst später, da sich durch die ursprüngliche Lösung die Hitze im Motorraum staut. Einzelscheinwerfer sind frühzeitig im Gespräch, doch dann setzt sich die Zeitmode durch.

On n'optera que plus tard pour les ouïes d'aération usuelles derrière les roues avant, car la solution originelle a pour effet de faire s'accumuler la chaleur dans le compartiment moteur. À l'origine, les phares séparés sont privilégiés, mais la mode de l'époque finira par s'imposer.

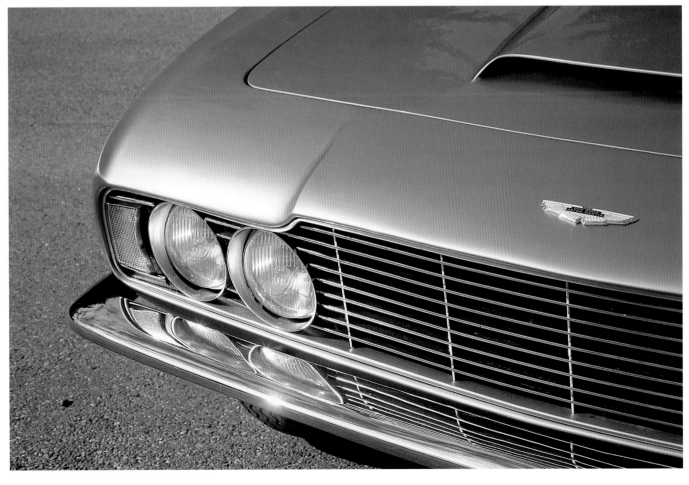

V8

All's well that ends well – in the case of the V8 so well that it was to serve Aston Martin for 20 years and four different owners. It had its origins in 1963 when Tadek Marek and a hand-picked team of 23 started work on a mighty light alloy power unit in this configuration, the cylinder blocks angled at 90°. The project team was hampered by a limited budget and a remit to use as many existing parts as possible, plus major working commitments in other areas. The 240-kilogram V8 was first put to the test in 1967 in the Lola T70 Mk3 GT of ex-Formula 1 champion John Surtees. However, the rumbling coupé generally retired so early in the race that Surtees' co-driver David Hobbs never got a chance to get behind the wheel.

It was not until September 1969 then, that Marek's work reached its actual destination, installed into the DBS V8 in the form of a 315 horsepower, 5340 cc engine with four overhead camshafts and an eight-piston Bosch injection pump which added 20 mph to the speed of the existing DBS. A significant portion of this power was translated into slip and heat by the standard Chrysler Torqueflite automatic transmission, whereas a new lighter and more silent five-speed ZF manual provided more satisfactory results. Aston Martin drew a veil of secrecy over the actual power output in those days, so that rumors and speculation ran wild. At any rate, so much power was available that finding the right tire proved difficult, the company finally opting for the Pirelli CN73 radial. However, the works claim of a top speed of 168 mph seemed somewhat fanciful, as the manual version reached just 150 mph in a 1971 test by *auto motor und sport*, and the automatic just 145 mph in a later 1975 test.

405 of the DBS V8 saw the light of day before the new management dropped the DBS designation in 1972, the top Aston Martin now being known simply as the V8, and, like the Vantage, being distinguished by individual headlights replacing the previous double iodine lamps. In practical terms this meant an improvement in the low beam at the expense of a weaker high beam.

A further 250 second generation V8s rolled off the line before trouble loomed in the form of a 1972 US ban due to excessive emission levels. It was not until October 1974 that the latest Aston Martin – the Vantage, the company's last six-cylinder machine so far, having meanwhile been scrapped – received the OK from the stringent Federal authorities. A large bulge in the hood bore witness to the presence of intricate fuel preparation arrangements below, in the form of four Weber DCNF downdraft carburetors nestling between the cylinder heads of this quiet, but phenomenally thirsty eight-cylinder engine.

However, the carburetors did effect the required reduction in emission levels, while also permitting fierce torque of 398 foot pounds.

Dark days now befell the company. After the disaster of the 1974 miner's strike and the subsequent three-day week, which caused widespread damage to the entire British economy, the Newport Pagnell firm barely had money to pay the milkman. Only a last minute cash injection by good samaritans Peter Sprague and George Minden kept the ailing 175-man company on its feet, a measure followed by a series of profit-oriented economy measures.

After Aston Martin Lagonda Limited had once again found its feet in 1976, the V8 evolved gradually over the years. In February 1977 a Vantage version proclaimed the ambition of the new owners with a dynamic launch at an Aston Martin Owners' Club race meeting. At the head of the eight induction pipes, four 48 IDF2/100 dual-barrel Weber carburetors provided the machine with a Niagaran average of one gallon of fuel every 11 miles. All later generations of Vantages were to rely on this sort of carburation even after fuel injection, this time by Edoardo Weber, was reinstated beneath the now-flat hood of the standard 1986 V8. By the end, estimates of the power of the Vantage hovered around the 485 horsepower mark, though the pernickety German registration procedure once again poured cold water on such wild imaginings, revealing an actual figure of 380, which should after all be adequate for most purposes.

The clean lines of the car were marred by the inevitable rear spoiler, while the air-scoop on the hood had been blanked in and the coolant air now entered via a vent beneath the front fender, modifications which were to be incorporated in all models from October 1978 onwards. Stiffer suspension and wider tires coped with the extra power of the Vantage, while the law-abiding owner, shackled by the statutory 70-mph speed limit, could only marvel at the car's potential performance.

In June that year the cabriolet version of the V8 first saw the light of day, each car requiring, according to the custom of the marque, 90 days of painstaking hand craftsmanship and 22 coats of paint to protect it against the vicissitudes of northern climes. To gain an unrestricted view of the heavens above the driver just had to release a couple of clasps and press a button, and the roof swept smoothly back, folded up without fuss and disappeared into a recess behind the rear seats. As the model range reached the end of the road and the Virage was already looming into sight, the 1986 Volante was fitted with some Vantage elements such as the saloon's power unit and its solid wing extensions. Its arch flares were linked by slanted glassfiber skirts to prevent the

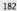

paintwork being damaged by dirt or stones thrown up from the road beneath. These retouches called for a modified front spoiler, while the rear was surmounted by a sort of humpback structure. These alterations were not to everybody's taste, and certainly not to Prince Charles', a dyed-in-the-wool Aston Martin fan, who insisted that his personal specimen be delivered devoid of any such aerodynamic tomfoolery.

The company records show that 849 V8 Volantes were sold in the eleven years of their production from 1978 to 1989. On top of this were 2658 Saloons, including 350 Vantages, over the two decades during which they held the Aston Martin banner high.

Meanwhile, just 85 of the Vantage Zagato were produced, among them 35 Volantes. And a good thing too, in the opinion of

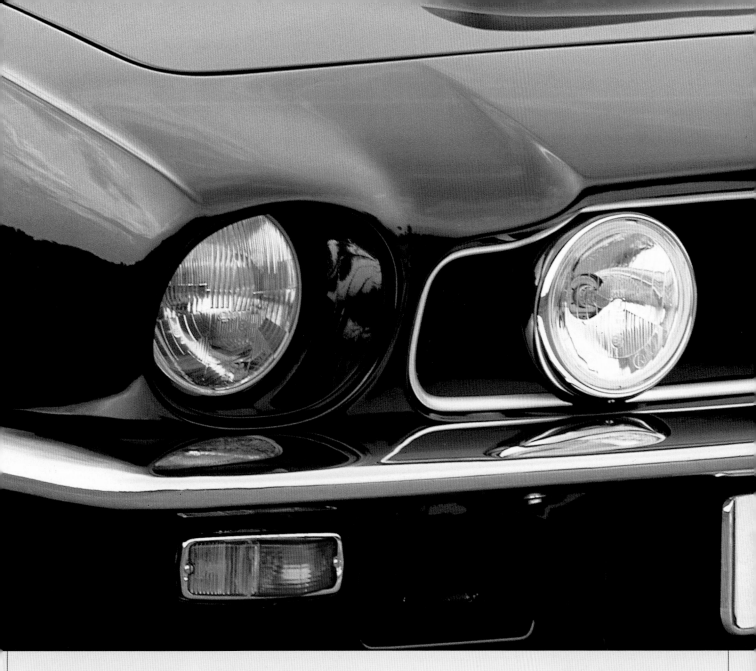

many. Plans for this limited edition were forged at the Geneva Spring Motor Show of 1984 by Victor Gauntlett and Peter Livanos on the one hand, and the brothers Gianni and Elio Zagato on the other. The project was intended as a bold statement by the two parties: both Aston Martin and Zagato are still alive and kicking being the intended message. After all, they had a glorious common past to look back on, the 1959 DB4GT Zagato remaining one of the most sought-after automobiles of all time.

Although there was only an outline plan to go on in Geneva in 1985, and the asking price threatened to exceed that of a Ferrari 288GTO, the English and Italian coproduction was sold out in no time. Only one year later, again in Geneva, it was presented to the world. However, it was not met with like

enthusiasm by critics or fans, being dubbed an ugly extravaganza by some and earning the unflattering nickname Aston Martin Sierra.

As in the past the chain of production was somewhat tortuous, the Vantage chassis being sent after testing to Terrazzano di Rho for assembly, trimming and painting before being returned to Newport Pagnell. A small bulge vaulted on top of the carburetors which fed the 432 horsepower engine, though the open version had to content itself with a less powerful injection engine, having an almost flat bonnet.

The Aston Martin Vantage Zagato just failed to gain entry to the exclusive over-300 kph (186 mph) club, the French Publication *Sport Auto* recording a speed of 299 kph during testing on an unopened stretch of freeway.

Variations on the general V8 theme: in a different light – the front end of a 1989 Vantage...

Variationen zum Generalthema V8: Bei Licht besehen – die Gesichtszüge eines Vantage von 1989...

Variations sur le thème générique du V8 : tous phares allumés – le visage aux traits volontaires d'une Vantage de 1989...

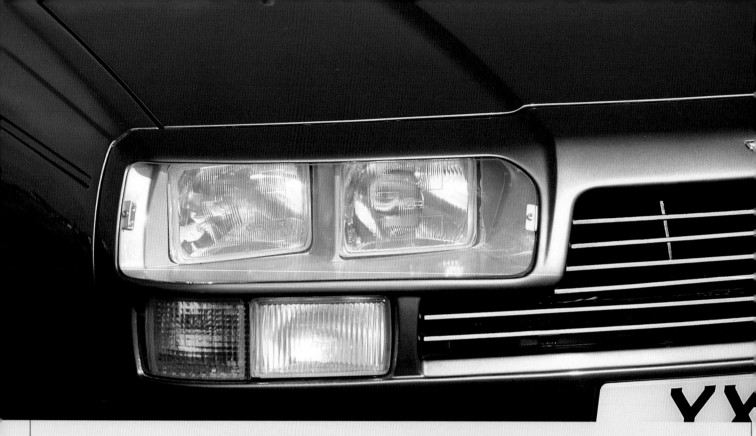

...and a Vantage Zagato's.

... und eines Vantage Zagato.

... et celui d'une Vantage Zagato.

Was lange währt, wird endlich gut, im Falle des V8 so gut, dass er bei Aston Martin über 20 Jahre und vier verschiedene Eigentümer hinweg für Dauer im Wechsel sorgt. Schon seit 1963 befassen sich Tadek Marek und ein Team von 23 handverlesenen Mitarbeitern mit einem majestätischen Leichtmetall-Aggregat dieser Konfiguration, dessen Bänke im Winkel von 90 Grad auseinander klaffen. Behindert wird die Projektgruppe durch ein begrenztes Budget, prallvolle Werktage auch auf anderen Gebieten sowie die Auflage, auf so viele bereits existierende Teile als möglich zurückzugreifen. Seine erste Bewährungsprobe führt den 240 Kilogramm leichten Achtzylinder 1967 nach altem Brauch an die Rennfront, als starkes Herz im Lola T70 Mk3 GT des ehemaligen Formel-1-Weltmeisters John Surtees. Stets fällt das grollende Coupé so frühzeitig aus, dass Surtees' Partner David Hobbs gar nicht zum Zuge kommt.

Erst ab September 1969 wird schließlich vereint, was immer schon zusammengehörte: Mareks nunmehr reife Leistung, mit 5340 ccm Volumen, einer Quadriga von Nockenwellen, der Achtstempel-Einspritzpumpe von Bosch und 315 statusträchtigen PS, und der real existierende DBS, der als DBS V8 umgehend eine Menge an Prestige sowie 32 Stundenkilometer mehr Spitzengeschwindigkeit gewinnt. Einen beträchtlichen Teil dieser Leistung setzt die in der Regel gewählte Chrysler-Torqueflite-Automatik in Schlupf und Wärme um, während ein neues leichteres und leiseres Fünfgang-

Getriebe von ZF mit dem Hubraumriesen eine weniger parasitäre Symbiose eingeht. Über die tatsächliche PS-Zahl breitet man in jenen Jahren werkseitig den Schleier des Geheimnisses, so dass Gerüchte und Spekulationen ins Kraut schießen. In jedem Fall steht noch so viel strotzende Kraft zur Disposition, dass man buchstäblich auf einen geeigneten Pneu warten muss. Mit dem Radialreifen CN73 von Pirelli bietet sich dieser schließlich an. Die vom Werk pausbäckig verheißenen 270 Stundenkilometer sind gleichwohl nachweisbar dem Reich der Legende entlehnt. 241,7 erreicht der Testwagen von *auto motor und sport* 1971 mit Handschaltung und 234 ein weiterer von 1975 mit Automatik.

405 Exemplare sind ihren Besitzern zugeführt worden, da tilgt 1972 neues Management das Kürzel DBS aus der Typenbezeichnung: Der Top-Aston heißt nun schlicht V8 und ist im Übrigen wie auch der Vantage erkennbar an einzelnen Scheinwerfern, wo bisher beide aus Joddampf-Doppellampen in die Welt blickten.

Praktisch bedeutet das einen Zugewinn beim Abblendlicht, während man im Fernbereich Einbußen in Kauf nehmen muss.

Noch einmal 250 V8 der zweiten Generation werden aufgelegt. Doch schon droht Ungemach von wichtigem nordamerikanischen Markt, der dem Exoten aus Newport Pagnell seit 1972 wegen unmäßiger Emissionen die Einbürgerung verweigert. Erst im Oktober 1974 – der Vantage als letzter Sechszylinder des Hauses ist inzwischen verblieben –

erhält dieser wieder Billigung und Stempel der strengen Behörden, allerdings bereits in einer weiteren Ausbaustufe. Ein größerer Buckel auf der vorderen Haube zeugt von der Anwesenheit eines wahren Tempels der Gemischaufbereitung darunter: Vier Doppel-Fallstromvergaser des Typs Weber DCNF im Tal zwischen den Zylinderköpfen verpflegen nun den murmelnden, aber ungemein durstigen Achtzylinder großzügig mit fossiler Nahrung. Sie mildern aber auch den Ausstoß an Schadstoffen. Zugleich ermöglichen sie ein bulligeres Drehmoment von 55 Meterkilogramm.

In diese Phase fallen dunkle Stunden in der Vita des Unternehmens. Nach den Dreitagewochen des Jahres 1974, die der britischen Wirtschaft insgesamt schwere Blessuren schlagen, ist man in Newport Pagnell kaum noch in der Lage, die Rechnung auch nur des Milchmanns zu begleichen. Erst die Scheck-Therapie des Samariter-Duos Peter Sprague und George Minden hilft dem siechen 175-Mann-Betrieb in letzter Minute wieder auf die Beine. Zugleich wird ihm die Schonkost profitorientierten Wirtschaftens verordnet.

Nachdem die Aston Martin Lagonda Limited 1976 wieder Tritt gefasst hat, kommt der V8 in allmählicher Evolution in die Jahre. Seit dem Februar 1977 kündet eine Vantage-Version vom Ehrgeiz der neuen Eigner, dynamisch eingeführt auf einer Rennveranstaltung des Aston Martin Owners' Club. Zu Häupten der acht Ansaugstutzen bereiten vier Weber-Doppelvergaser des Kalibers 48 IDF2/100 via größerer Einlassventile der Mam-

mutmaschine ein wahres Bacchanal von rund 24 Litern je 100 Kilometer im Schnitt. Vergaser bleiben dem Modell selbst in der Schlussphase seines Daseins erhalten, nachdem unter der nunmehr flacheren Haube des Normal-V8 1986 noch einmal eine Einspritzung, diesmal von Edoardo Weber, eingezogen ist. Die Mutmaßungen hinsichtlich der Potenz des Vantage pendeln sich am Ende bei 485 PS ein, werden indes von der peniblen deutschen Zulassungsprozedur widerlegt, die mit 380 Real-PS immer noch reichlich übrig lässt.

Auf dem Kofferraumdeckel stört der unvermeidliche Spoiler eine klare Linie, während der Wulst auf der Motorhaube nach vorn geschlossen wird und die Kühlluft nun durch ein Loch in einem Leitblech unterhalb der vorderen Stoßstange zischt. Diese Änderungen sind ab dem Oktober 1978 an allen Aston Martin zu finden. Eine straffere Aufhängung und breitere Räder fangen das Plus an Vantage-Power auf der Fahrwerksseite auf, wobei sich der vom 70-Meilen-Limit behördlich eingebremste normale Kunde eher an den beträchtlichen Möglichkeiten seines Automobils erfreut, als dass er diese ausreizen würde.

Im Juni jenes Jahres erblickt das Cabriolet des V8 das Licht dieser Welt, nach Brauch des Hauses und ganz gegen den Trend der Zeit Stück für Stück in sorgsamer, 90 Tage währender Handarbeit zusammengesetzt sowie mit 22 Lackschichten gegen die Schikanen nordischer Witterung versiegelt. Will der Pilot ungehindert durch das schwere und solide PVC-Dach den dankbaren Blick

nach oben erheben, hat er lediglich zwei Schnallen zu lösen und einen Knopf zu drücken, und schon schwebt das Hindernis nach hinten, legte sich in Falten und verschwindet knisternd in einem Verlies im Rücken der Fond-Passagiere.

Als sich die Modellreihe ihrem Ende zuneigt und der Virage bereits in Sicht ist, sattelt man noch einmal drauf und rüstet den Volante 1986 mit Vantage-Elementen aus, dem Triebwerk des Saloon ebenso wie stämmigen Kotflügelbreiterungen. Sie sind unten mit schrägen Schürzen verbunden, damit der Lack von aufgeworfenem Schmutz und Steinschlag von unten verschont bleibt. Diese Retuschen verlangen nach einem veränderten Frontspoiler, während dem Heck eine buckelartige Struktur aufgesetzt wird. All dies, so meinen viele, stehe dem Vantage Volante nicht gut zu Gesicht. Und so ordert etwa Prinz Charles, ein treuer Kunde des Hauses, sein persönliches Exemplar ohne dergleichen aerodynamischen Show-Schnickschnack.

849 V8 Volante insgesamt weist die Firmenstatistik für die elf Jahre seiner Fertigung bis 1989 aus. Dazu kommen die 2658 Saloons, unter ihnen 350 Vantage, über die beiden Dekaden, in denen sie die Aston-Martin-Fahne hochhalten. Bei einer qualifizierten Minderheit von 85 Stück, davon 35 Volante, lässt man es hinsichtlich des Vantage Zagato bewenden. Und viele sagen zum Glück.

Die Pläne für diese limitierte Edition werden auf der Genfer Frühjahrsshow 1984 geschmiedet, zwischen Victor Gauntlett und Peter Livanos einerseits und den Gebrüdern Gianni und Elio Zagato andererseits. Das Projekt kommt einer Attacke gegen den Kleinmut gleich: Aston Martin und Zagato leben noch, soll es signalisieren, und wie! Zugleich spannt man eine große gemeinsame Vergangenheit in den Dienst dieser Idee: Der DB4GT Zagato von 1959 zählt immerhin zu den begehrenswertesten Automobilen aller Zeiten. Obwohl man sich 1985 in Genf lediglich an einer Skizze orientieren kann und sich ein Preis oberhalb des Entgelts für einen Ferrari 288GTO abzeichnet, ist die anglo-italienische Koproduktion im Nu vergriffen. Erst ein Jahr später kann sie, wiederum in der Rhone-Stadt, von jedermann besichtigt werden. Sie muss allerdings gelegentlich den Vorwurf kostspieliger Hässlichkeit und den Spitznamen Aston Martin Sierra über sich ergehen lassen.

Wieder sind die Wege umständlich: Das bereits getestete Chassis des Vantage wird nach Terrazzano di Rho geschickt, dort bekleidet, eingerichtet und lackiert und wieder nach Newport Pagnell zurück erstattet. Ein kecker Hügel wirft sich hier auf der Vergaserbatterie auf, die das 432 PS starke Triebwerk füttert. Er entfällt bei der offenen Version, die sich mit dem schwächeren Einspritzer begnügt.

Die Eintrittskarte zu der exklusiven Loge der 300-Stundenkilometer-Autos bleibt dem Aston Martin Vantage Zagato verwehrt: Die französische Publikation *Sport Auto* misst ihn auf einer noch nicht eröffneten Stück autoroute mit Tempo 299.

Tout vient à point à qui sait attendre: c'est ainsi que le V8, pendant plus de vingt ans et malgré quatre propriétaires différents, garantit à Aston Martin une certaine continuité dans le changement. En 1963, déjà, Tadek Marek et son équipe de 23 collaborateurs triés sur le volet se consacrent à un majestueux groupe motopropulseur en alliage léger reprenant cette architecture avec un banc de cylindres de 90 degrés. Selon une bonne vieille tradition, ce V8 qui ne pèse que 240 kg subit son baptême du feu, en 1967, sur les circuits de compétition, en l'occurrence sous le capot de la Lola T70 Mk3 GT de l'ancien champion du monde de Formule 1 John Surtees. Mais la fiabilité n'est pas au rendez-vous et la berlinette abandonne si vite que le coéquipier de Surtees, David Hobbs, n'a jamais l'occasion de la piloter.

Ce n'est qu'à partir de septembre 1969 qu'est consommée une union qui s'imposait entre le moteur de Marek, maintenant au point – d'une cylindrée de 5340 cm³, avec quatre arbres à cames, une pompe d'injection Bosch à huit pistons et 315 ch – et le châssis préexistant de la DBS. Le fruit de cette union, rebaptisée DBS V8, gagne en prestige et peut se prévaloir de 32 km/h de plus en vitesse de pointe. La boîte automatique Torqueflite de Chrysler transforme une partie non négligeable de cette puissance en patinage et chaleur alors qu'une nouvelle boîte à cinq vitesses ZF, plus légère et plus silencieuse, donne de meilleurs résultats en s'accordant mieux avec son moteur à la cylindrée gigantesque. Ces années-là, le constructeur se mure dans le silence quant à sa puissance réelle, si bien que les rumeurs et les spéculations vont bon train. Quoi qu'il en soit, la puissance disponible est telle que l'on doit attendre un pneu approprié. Cela sera le cas avec l'arrivée du pneu radial, le CN73 de Pirelli. La vitesse de pointe de 270 km/h promise orgueilleusement par l'usine relève malgré tout de l'affabulation. Une voiture d'essai d'*auto motor und sport* est chronométrée, en 1971, à 241,7 km/h avec une boîte manuelle et une autre, équipée d'une transmission automatique, à 234 km/h en 1975.

405 exemplaires ont été livrés à leur propriétaire lorsque la direction décide, en 1972, de supprimer le sigle DBS de son nom: la plus élaborée des Aston Martin ne s'appelle désormais plus que V8 et demeure, pour le reste, reconnaissable, à l'instar de la Vantage, à ses phares séparés remplaçant les doubles phares à halogène qui l'équipaient précédemment.

Une nouvelle édition, à 250 exemplaires, de la V8 deuxième génération est lancée. Mais des nuages sombres se profilent déjà à l'horizon du marché nord-américain qui, depuis 1972, refuse l'entrée sur son territoire à l'étalon de Newport Pagnell pour motif de non-respect des normes de dépollution. Ce n'est qu'en octobre 1974 – la Vantage a depuis longtemps disparu en tant que dernier six-cylindres de chez Aston – que celui-ci obtient de nouveau le feu vert et le droit d'entrée des sévères autorités, mais déjà dans une version plus poussée.

Un gros bossage sur le capot avant témoigne de la présence d'un véritable temple édifié au culte de la préparation du mélange: quatre doubles carburateurs inversés Weber DCNF prennent leurs aises entre les culasses d'un huit-cylindres maintenant plus silencieux, mais toujours aussi glouton. Mais ils tempèrent également les rejets de polluants. Tout à fait accessoirement, ils se traduisent aussi par un couple plus généreux de 55 mkg.

C'est une époque à laquelle l'entreprise connaît de nouveau des heures difficiles. Après la semaine de trois jours qui inflige des pertes quasi irrémédiables à toute l'économie britannique en 1974, on n'est pratiquement plus en mesure à Newport Pagnell de payer les factures. Seule l'injection massive d'argent par le tandem de bons samaritains que sont Peter Sprague et George Minden permet à l'entreprise à l'agonie et à ses fidèles 175 collaborateurs de reprendre des couleurs en dernière minute.

Après qu'Aston Martin Lagonda Limited eut repris pied, en 1976, la V8 commence à accuser son âge après sa longue succession d'évolutions. Depuis février 1977, une version Vantage témoigne de l'ambition des nouveaux propriétaires après une présentation dynamique lors d'une journée de compétition organisée par l'Aston Martin Owners'Club. Les huit tubulures d'aspiration sont coiffées par quatre doubles carburateurs Weber calibre 48 IDF2/100 qui, grâce aux soupapes d'admission de plus grand diamètre dont est équipé le moteur, permettent au mammouth d'avaler en moyenne 24 litres de carburant aux 100 km. Ce modèle restera équipé de carburateurs jusqu'à la phase ultime de sa vie alors que, à partir de 1986, on trouvera de nouveau sous le capot, maintenant plus plat, de la V8 normale, une injection, mais cette fois-ci de chez Edoardo Weber. Vers la fin, les rumeurs qui courent au sujet de la puissance de la Vantage font parfois état de 485 ch, chiffre que la tatillonne procédure d'homologation allemande réfute. Avec 380 ch bien réels, il n'en reste pas moins assez puissant pour la plupart des usages.

Sur le couvercle de malle, l'aileron rompt la clarté des lignes alors que le bossage sur le capot moteur est occulté, l'air de refroidissement étant désormais capté par une ouverture ménagée sous le pare-chocs avant, des modifications que l'on retrouvera, à partir d'octobre 1978, sur toutes les Aston Martin. Côté châssis, une suspension plus ferme et des roues plus larges compensent le supplément de puissance de la version Vantage. En raison de la vitesse légalement limitée à 70 miles/h, le conducteur britannique freiné dans son élan n'aura d'autre possibilité que de se réjouir du potentiel de sa voiture qu'il n'aura sans doute jamais l'occasion de pousser dans ses derniers retranchements.

En juin de la même année, la version cabriolet de la V8 voit la lumière du jour, dans la plus pure tradition de la maison et tout à fait à contre-courant de cette époque, assemblée minutieusement en 90 jours de travail manuel et revêtue de 22 couches de peinture pour affronter les rigueurs du climat en Europe. Si le conducteur veut profiter sans entraves de l'immensité de la voûte céleste, il lui suffit de débloquer deux verrous et d'appuyer sur un bouton pour faire s'escamoter derrière lui la lourde capote à l'épais capitonnage. En quelques secondes, elle se lève, se plie et disparaît avec quelques craquements dans un compartiment ménagé derrière le dossier des sièges arrière.

Alors que l'arrêt de la production de ce modèle s'annonce, la Virage étant déjà en vue, Aston fait une nouvelle fois preuve de générosité et équipe la Volante, en 1986, de quelques éléments de la Vantage, du moteur de la Saloon ainsi que de ses proéminents élargisseurs d'ailes. Ces retouches imposent également un nouvel aileron avant alors qu'un becquet trône à l'arrière. Tout cela n'est pas à l'avantage de la Vantage Volante. Ainsi, le prince Charles, fidèle client de la maison, commande sans un exemplaire personnel sans de tels appendices aérodynamiques tape-à-l'œil.

Les archives font état de 849 V8 Volante construites jusqu'en 1989. À cela s'ajoutent 2658 Saloon, dont 350 Vantage. En ce qui concerne la Vantage Zagato, le compteur s'arrêtera à 85 exemplaires, dont 35 Volante.

Les plans pour cette édition limitée sont forgés au Salon de l'Automobile de Genève, au printemps 1984, entre Victor Gauntlett et Peter Livanos, d'une part, et les frères Gianni et Elio Zagato, d'autre part. Le projet équivaut à un défi lancé à la pusillanimité: Aston Martin et Zagato sont bien vivants, veut-on ainsi proclamer à la face du monde. Les quatre hommes font revivre un grand passé commun pour le mettre au service d'une idée: la DB4GT Zagato de 1959 est en effet l'une des voitures de collection les plus recherchées de tous les temps.

Bien que, à Genève en 1985, on doive se contenter d'un croquis et que le prix annoncé soit supérieur à celui d'une Ferrari 288 GTO, la coproduction anglo-italienne se vend en moins de temps qu'il n'en faut pour signer le chèque… confortable. Il faudra attendre un an, pour que chacun puisse enfin admirer la voiture, à Genève cette fois encore. On lui reproche parfois d'être non seulement coûteuse, mais aussi hideuse, raison pour laquelle certains l'affublent du surnom «Aston Martin Sierra».

Une fois de plus, Aston Martin choisit la complexité quand la simplicité se serait imposée: le châssis de la Vantage, une fois testé, est envoyé à Terrazzano di Rho, où il est habillé, aménagé et peint avant d'être renvoyé à Newport Pagnell. Une bosse révélatrice trahit la présence d'une batterie de carburateurs qui alimente le moteur de 432 ch. La version décapotable ne comporte pas ce bossage, car elle se contente du moteur à injection un peu moins puissant.

L'Aston Martin Vantage se voit refuser le billet d'entrée dans le club très fermé des voitures dépassant les 300 km/h: la revue spécialisée française *Sport Auto* la chronomètre, sur un tronçon d'autoroute pas encore inauguré, à la vitesse de 299 km/h.

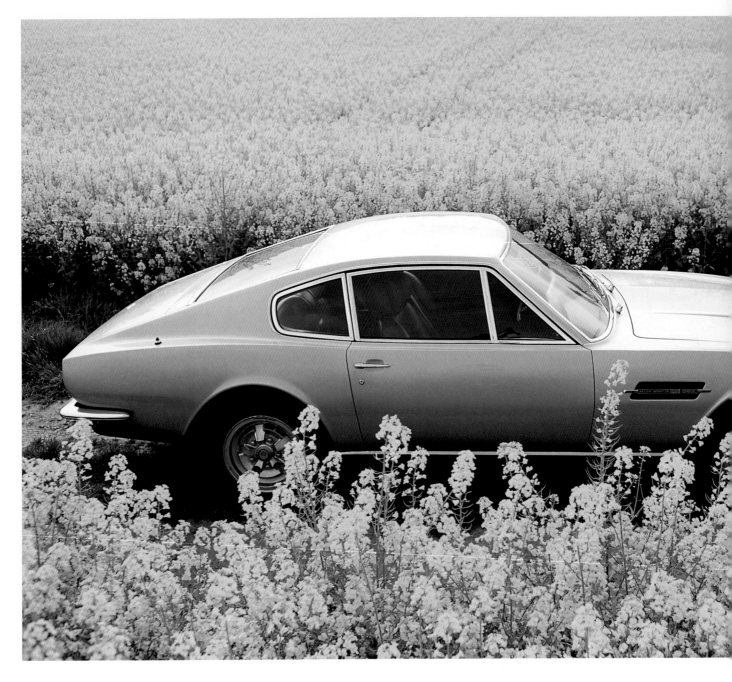

An early Series 2 V8. The light emanating from the deeply sunken single headlights was relatively poor.

Früher V8 der Serie 2. Die Lichtausbeute durch die tief eingebetteten Einzelscheinwerfer ist nur dürftig.

Une ancienne V8 Série 2. Le rendement de l'éclairage des phares séparés placés très bas laisse à désirer.

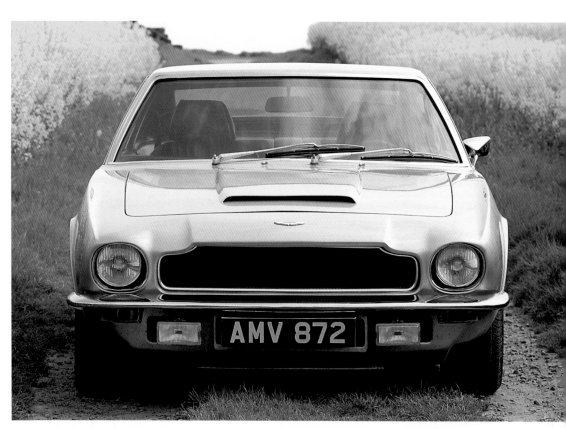

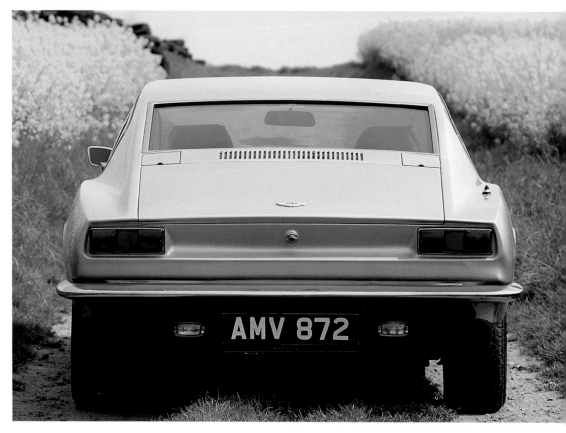

The engine is fed via mechanical Bosch fuel injection. It conveys the power to the rear axle via a Torqueflite automatic transmission system. Obviously there were a few DBS plates going spare after the takeover by Company Developments.

Das Triebwerk wird durch eine mechanische Bosch-Einspritzung in die Ansaugrohre gefüttert und reicht seine Kraft vermittels einer Torqueflite-Automatik an die Hinterachse weiter. Offenbar waren nach der Übernahme durch Company Developments noch ein paar DBS-Schildchen übrig.

Le moteur, alimenté par une injection mécanique Bosch débouchant dans les collecteurs d'aspiration, transmet son couple au train arrière par le biais d'une boîte automatique Torqueflite. Manifestement, lors de la reprise de la marque par Company Developments, on avait encore un stock de plaques DBS inutilisées.

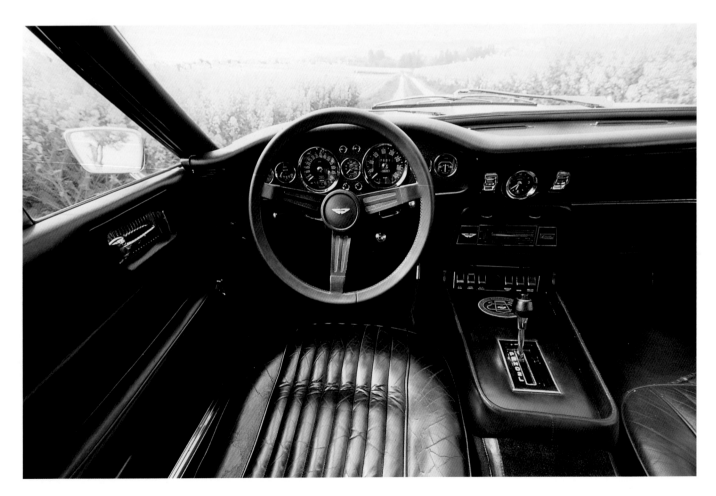

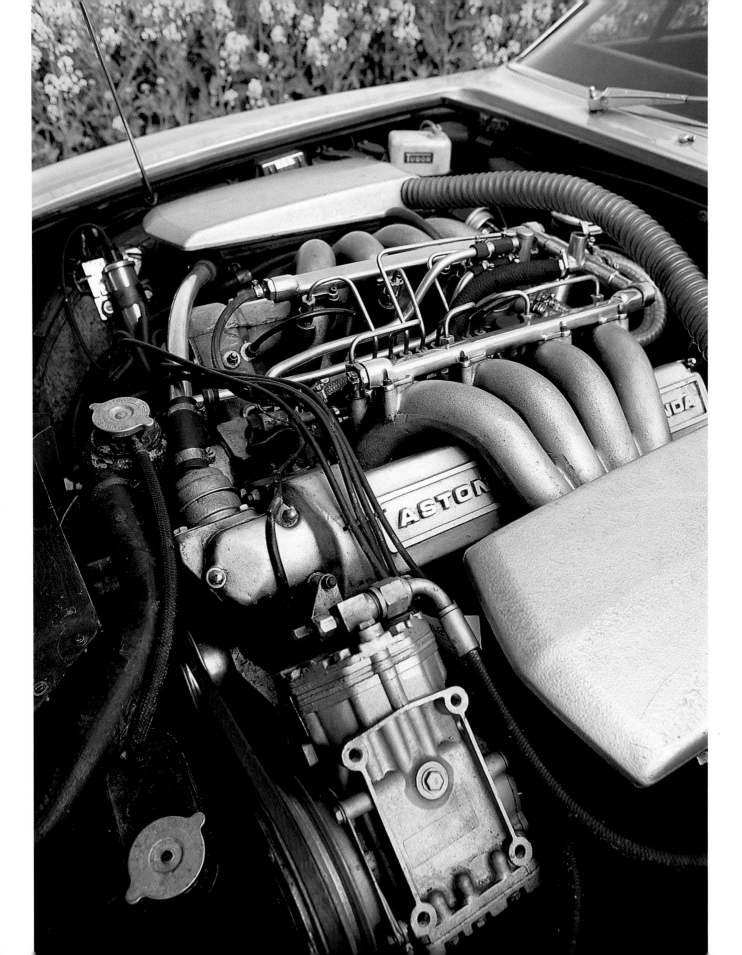

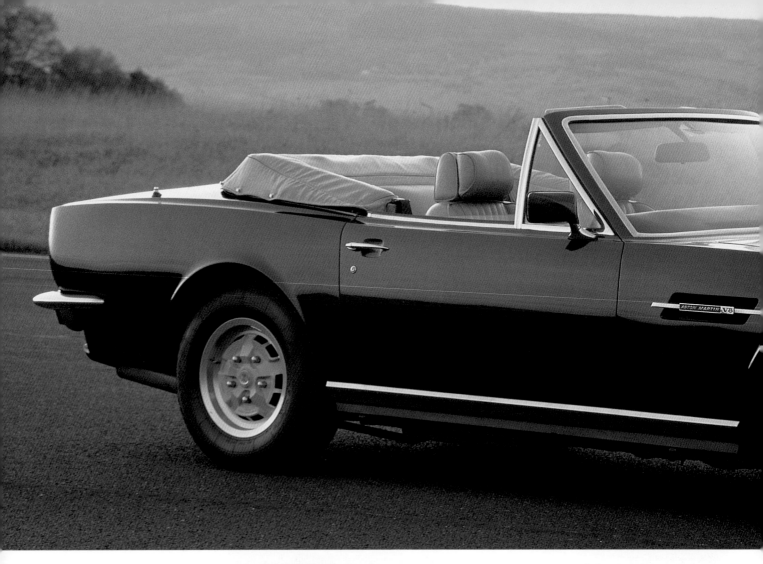

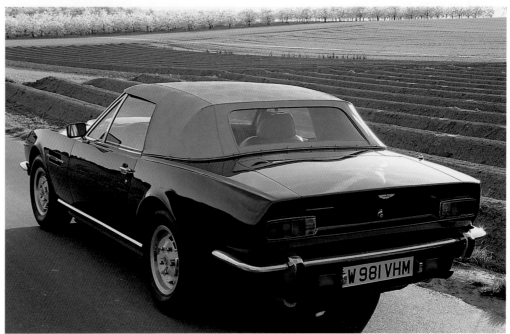

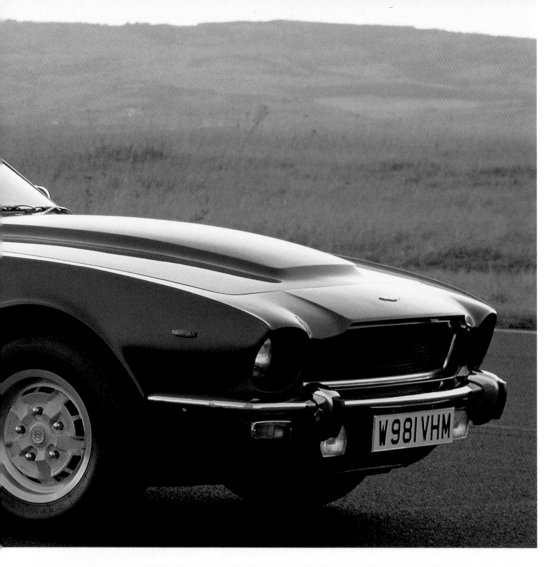

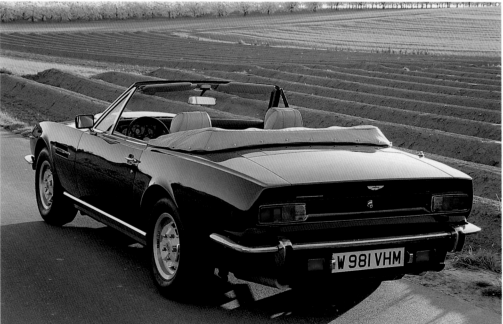

The Volante's revival from 1978 onwards was due to an increase in the demand in the North American market for high-class cabriolets. The softtop, designed by Harold Beach, is operated by an electric-hydraulic system.

Der Volante ab 1978 verdankt seine Renaissance der vermehrten Nachfrage nach hochklassigen Cabriolets auf dem nordamerikanischen Markt. Das Verdeck, von Harold Beach entworfen, wird elektrisch-hydraulisch betätigt.

À partir de 1978, la Volante doit sa renaissance à l'augmentation de la demande de cabriolets de grand luxe sur le marché nord-américain. Dessinée par Harold Beach, la capote possède une commande électrico-hydraulique.

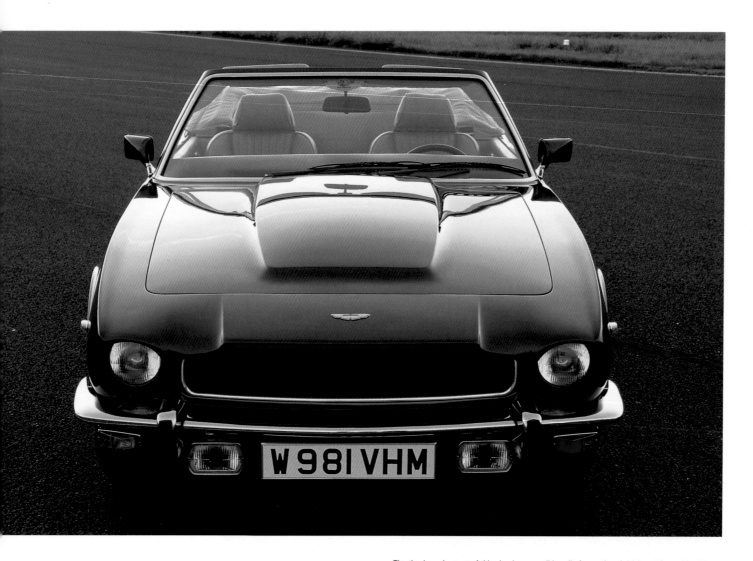

The timeless elegance of this classic convertible calls for a relaxed driving style, and for this the Chrysler automatic transmission is the ideal complement. However, impressive reserves of power are available when needed.

Sanfte Tour: Die zeitlose Eleganz dieses klassischen Convertible verlangt nach gelassenem Chauffieren. Da bietet sich der Chrysler-Automat förmlich an. Gut zu wissen: Bei Bedarf stehen reichlich Reserven zur Verfügung.

Main de fer dans un gant de velours : l'élégance intemporelle de ce cabriolet classique impose une conduite tout en douceur. La boîte automatique Chrysler est idéale pour une telle voiture. Bon à savoir : en cas de besoin, les chevaux ne demandent qu'à s'exprimer.

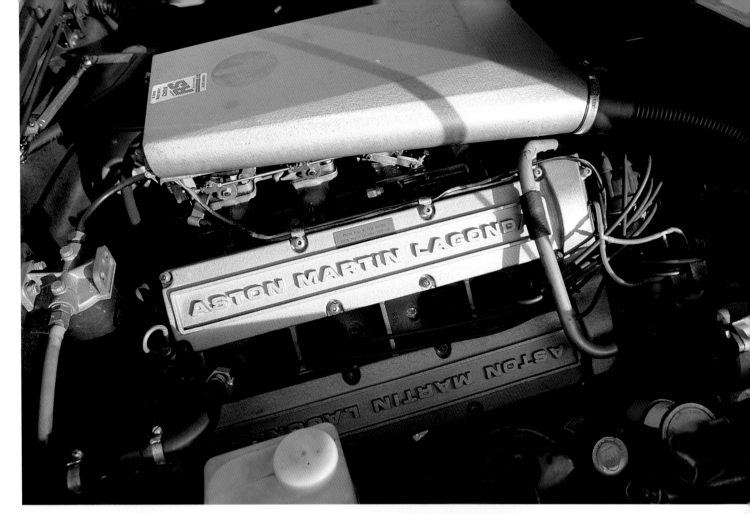

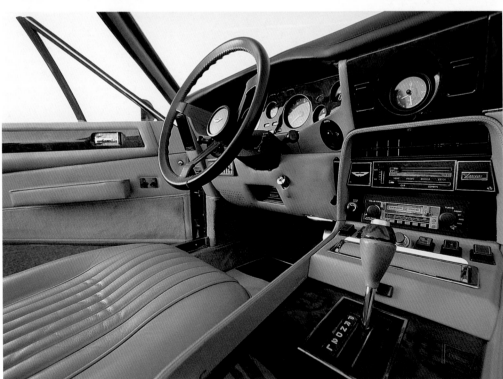

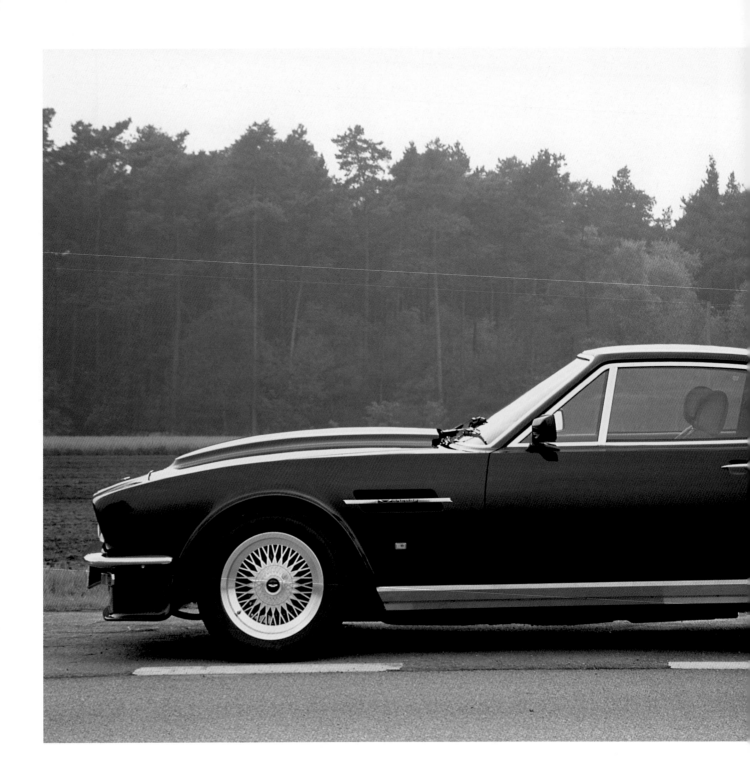

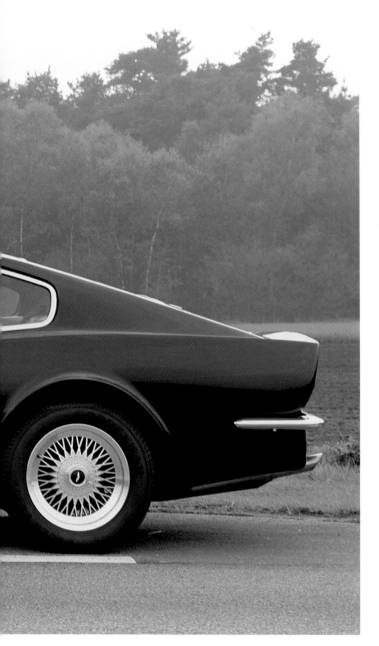

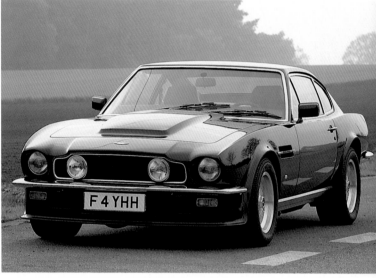

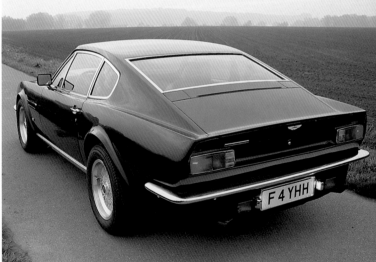

Like the Series 5 Saloon, the body of the V8 Vantage from 1986 onwards presents a slender and aerodynamic profile to the wind. The front paneling serves the purpose of preventing cooling of the engine. The lines of the car reflect the power residing beneath the hood.

Starker Auftritt: Die Karosserie des V8 Vantage ab 1986 schmiegt sich analog zum Saloon der Serie 5 gestreckter in den Wind. Die Abdeckung vorn dient thermischen Zielen: Sie verhindert ein Auskühlen des Motors. Das Auto verkörpert förmlich die Kraft, die in ihm schlummert.

Un style musclé : à l'instar de celle de la Saloon de la Série 5, la carrosserie de la V8 Vantage est plus aérodynamique à partir du millésime 1986. L'occultation de la calandre assure un bon équilibre thermique du moteur. La voiture exprime par ses lignes la force qui sommeille en elle.

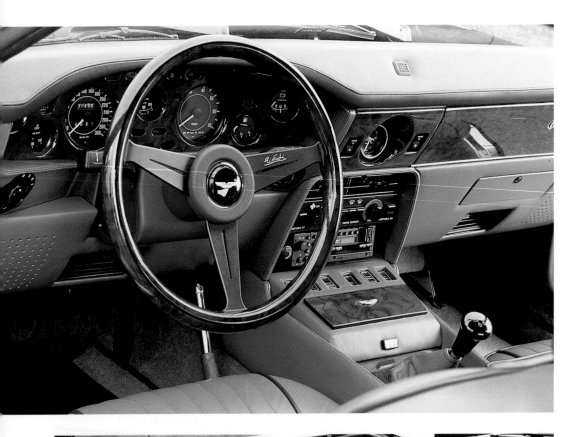

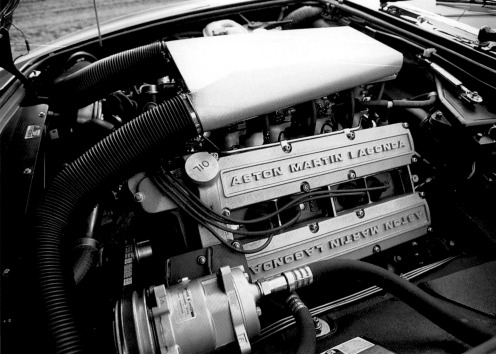

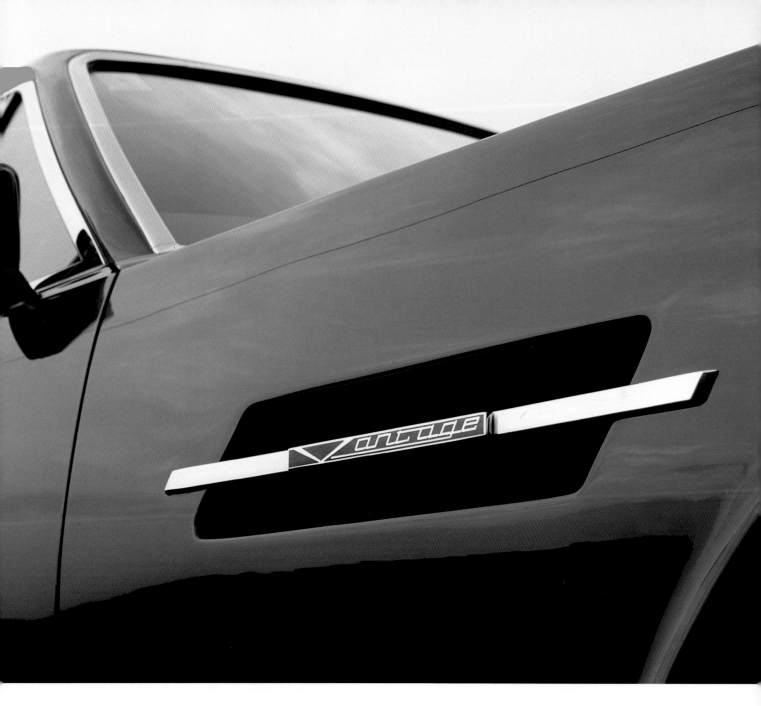

Towards the end of the model's life the interior trim was further refined and the power of the engine boosted to 400 bhp by conventional measures. For those who found that inadequate a 432 bhp version was also available.

Gegen Ende des Modelllebens sind die Innenausstattung noch einmal verfeinert und die Leistung des Triebwerks mit konventionellen Eingriffen auf 400 PS gesteigert worden. Für alle, die es etwas heißer lieben, werden auch 432 PS angeboten.

En fin de carrière, ce modèle reçoit un aménagement intérieur encore plus raffiné tandis que la puissance de son moteur à passe à 400 ch. Ceux pour qui cela ne suffit pas peuvent en commander une version de 432 ch.

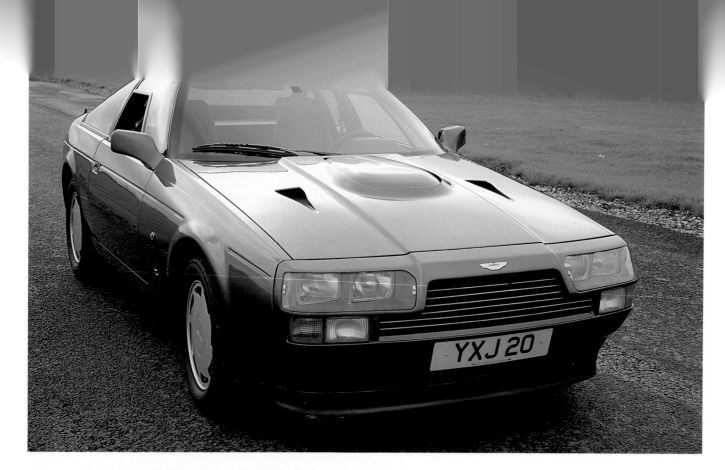

Though admired by some, the angular lines of the V8 Vantage Zagato certainly did not meet with universal praise. The emblem on the trunk hood combines the logos of the two companies.

Bewundert viel und viel gescholten: Die kantige Form des V8 Vantage Zagato löst keineswegs ungeteilte Begeisterung aus. In dem Emblem auf dem Kofferraumdeckel finden sich die Markenzeichen der beiden Unternehmen zusammen.

À la fois admirées et critiquées, les lignes anguleuses de la V8 Vantage Zagato divisent les adeptes de la marque. L'emblème sur le couvercle de malle réunit les logos des deux firmes.

V8 VANTAGE ZAGATO

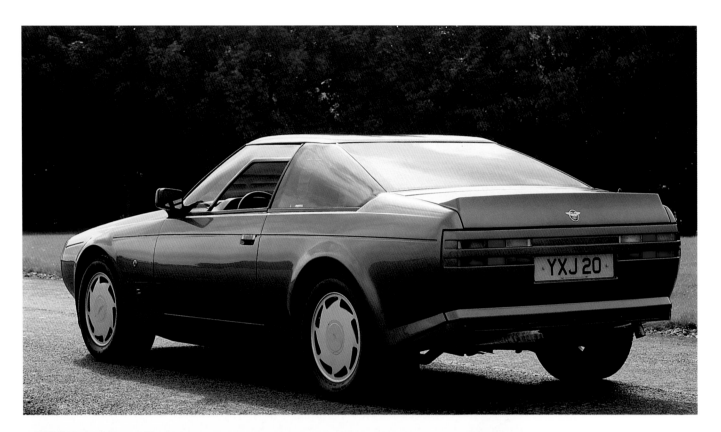

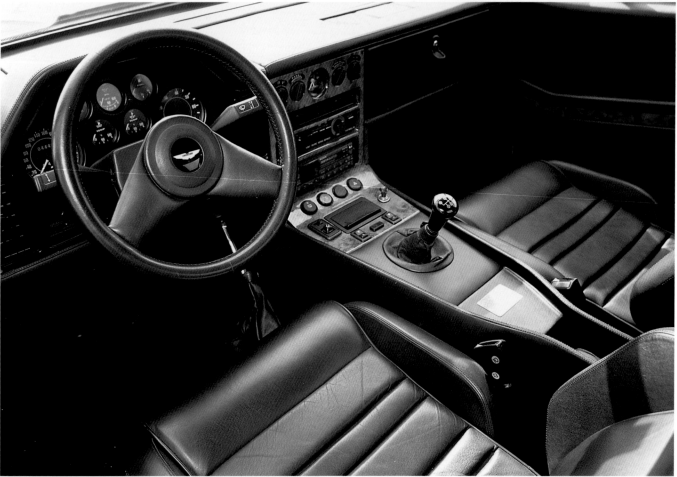

The whole is also the sum of the parts: the angular instrument panel echoes the external appearance of the Zagato. The instruments were made by Lotus, the two levers behind the steering wheel by Vauxhall and the console switches by Jaguar.

Das Ganze ist auch die Summe der Teile: Der winklige Instrumententräger nimmt Motive der äußeren Erscheinung des Zagato auf. Die Instrumente stammen von Lotus, die beiden Hebel hinter dem Lenkrad von Vauxhall und die Schalter auf der Konsole von Jaguar.

Puzzle : anguleux, le tableau de bord rappelle les lignes de carrosserie de la Zagato. Les cadrans proviennent de chez Lotus, les deux leviers derrière le volant, de chez Vauxhall et les manettes sur la console, de chez Jaguar.

Lagonda

Like its 2.6 liter, six-cylinder predecessor, the Lagonda 3-litre (from 1953 onwards) had a good press, aided by the fact that it was chosen as the young Prince Philip's means of transport. Despite this, sales remained sluggish.

Kein Renner: Wie auch sein Vorgänger mit dem 2,6-Liter-Sechszylinder erhält der Lagonda 3-litre (ab 1953) gute Kritiken, zumal einer dem Transport des jungen Prince Philip dient. Die Verkäufe verlaufen indessen schleppend.

Succès mitigé : comme sa devancière à moteur six-cylindres de 2,6 litres, la Lagonda trois-litres (à partir de 1953) reçoit de bonnes critiques, d'autant plus que l'une est utilisée par le jeune prince Philip. Les ventes, par contre, ne seront jamais convaincantes.

After David Brown annexed this moribund marque to his empire in 1947, it was restricted to a shadowy existence until production was discontinued altogether in 1958. Later the Lagonda name was pulled out of the hat periodically with a very special clientele in mind. That applied equally to the Lagonda Rapide of 1961, to the 1969 Lagonda DBS V8, which Brown had produced for his own use, and also to the wildly expensive 1974 V8 Lagonda, all three of which were unmistakably derived from the current Aston Martin models of the time.

In contrast, the 1976 AM V8 Lagonda S2, designed by William Towns, the English counterpart of the daring Italian designer Giorgio Giugiaro, was a declaration of war against any form of conservatism or stinginess. It was put together at great speed, just seven months separating planning from the finished product, which was presented on 12th October 1976 at the richly symbolic locale of Aston Clinton. The car featured a platform chassis by Mike Loasby plus the Aston Martin V8 suspension, to which an automatic rear shock absorber level control system had been added, surmounted by a highly individualistic four-door body with razor-sharp lines incorporating four retractable headlights. Despite the Lagonda S2's 5285 millimeter length the design still had a certain elegant lightness.

The interior also made a virtue of the unusual, with its one-spoke steering wheel, digital instruments and array of no less than 46 switches. The complex electronic system was plagued by endless malfunctions which were finally eradicated by American specialist Brian Refoy's intensive efforts. The Chrysler Torqueflite automatic transmission came as standard. It harmonized perfectly with the existing V8, reduced in power to 280 horsepower in the interests of silent running and flexibility. However, good things only come to those who wait, and the first Lagonda S2 was not ready for delivery until 24th April 1978.

The model was subjected to a steady development process. From 1984 the many instruments and displays were supplemented by spoken messages in English, German, French or Arabic, while the S3, launched at the New York Motor Show 1986, which opened its doors on January 25th, embodied more radical evolutionary advances.

The injection engine of the contemporary Aston Martin V8 now developed 300 horsepower. The S4, presented at Geneva in March 1987, had altogether dispensed with the aluminum panels and rounded off the sharp edges. The front featured six small headlights, fog lamps fitted into the lowslung front spoilers, and similarly lowslung skirts. During the 13 years of its production, which lasted until 1990, the AM V8 Lagonda remained out of reach for the average pocket, costing £24,570 when first launched, and a swingeing £95,000 by the end of its run.

Nachdem David Brown 1947 die marode Marke dieses Namens seinem Imperium einverleibt hat, führt diese eine Zeit lang ein Schattendasein, bis die Produktion 1958 gänzlich eingestellt wird. Später zieht man den Namen Lagonda sporadisch aus dem Köcher wie einen Pfeil, der auf das Herz einer sehr besonderen Klientel zielt. Das gilt für den Lagonda Rapide von 1961. Das gilt erst recht für einen Lagonda DBS V8 von 1969, den sich Brown für seinen eigenen Bedarf hat anfertigen lassen. Das gilt schließlich für den sündhaft teuren V8 Lagonda von 1974, der wie die beiden anderen unverkennbar von den jeweils aktuellen Aston-Martin-Modellen abgeleitet ist.

Mit dem AM V8 Lagonda S2 von 1976 indessen hat sich William Towns jenseits konservativen Taktierens und übrigens auch jeglicher Knauserigkeit der Sensation schlechthin verschrieben. Man handelt rasch: Zwischen gesagt und getan liegen gerade mal sieben Monate. Die Präsentation des Produkts findet am 12. Oktober 1976 auf symbolschwangerem Boden statt, nämlich in Aston Clinton. Auf einem Plattformchassis von Mike Loasby mit der Aufhängung des Aston Martin V8, allerdings um eine selbsttätige Niveauregulierung der hinteren Dämpfer bereichert, ruht eine höchst eigenwillig gestylte viertürige Karosserie mit rasiermesserscharfen Konturen, zu denen nicht zuletzt die vier Klappscheinwerfer beitragen. 5285 Millimeter ist der Lagonda lang und gleichwohl von einer gewissen filigranen Leichtigkeit.

Auch im Inneren wird das Ungewöhnliche zum Prinzip erhoben, mit einem Einspeichenlenkrad etwa, digitalen Instrumenten sowie einer Armee von insgesamt 46 Schaltern. Dieses komplizierte elektronische System wird heimgesucht von zahlreichen Störfällen, die erst der amerikanische Spezialist Brian Refoy in intensiver stationärer Behandlung ausmerzt. Standard ist der Chrysler-Automat Torqueflite. Er versteht sich prächtig mit dem bekannten V8, auf 280 PS heruntergetunt im Interesse von Laufruhe und Flexibilität. Da aber gut Ding Weile haben will, wird der erste Lagonda S2 erst am 24. April 1978 ausgeliefert.

Immer lässt man dem Modell milden Fortschritt angedeihen. Ab 1984 parliert die große Limousine gar multilingual zu ihren Insassen in den Sprachen Englisch, Deutsch, Französisch und Arabisch. Größere Sprünge in der Evolution gibt es mit dem S3 seit dem New Yorker Salon 1986, der am 25. Januar seine Pforten öffnet. Der Einspritzmotor des zeitgenössischen Aston Martin V8 mobilisiert nun 300 PS unter seiner ewig langen Haube. Am S4, vorgestellt in Genf im März 1987, ist kein Aluminium-Paneel mehr wie vorher, sind scharfe Kanten geglättet, sechs kleinere Scheinwerfer vorne fest untergebracht und Nebellampen blicken als Intarsien aus einem wie auch die seitlichen Schürzen tief hängenden Frontspoiler. Für den Normalverbraucher bleibt der AM V8 Lagonda in den 13 Jahren seiner Produktion bis 1990 immer gleichmäßig unerschwinglich. Am Anfang hätte er 24570 Pfund ansparen müssen, satte 95000 Pfund am Ende.

En 1947, David Brown intègre à son empire la marque agonisante Lagonda. Celle-ci demeure insignifiante jusqu'en 1958, année qui marque l'arrêt de la production. Plus tard, il utilise sporadiquement le nom de Lagonda comme une flèche qu'il tire de son carquois pour viser au cœur d'une clientèle très particulière. Cela vaut déjà pour la Lagonda Rapide de 1961. Et cela vaut a fortiori pour une Lagonda DBS V8 de 1969 que Brown s'est fait fabriquer pour son utilisation personnelle. Et cela vaut, enfin, pour la V8 Lagonda de 1974 qui coûte un prix astronomique et, comme les deux autres modèles, est, sans ambiguïté, dérivée des Aston Martin constituant alors le fonds de commerce de la marque.

Avec l'AM V8 Lagonda S2 de 1976, par contre, William Towns, s'est voué corps et âme à la sensation, faisant fi de toute velléité de conservatisme et, d'ailleurs aussi, d'avarice. La présentation de la voiture a lieu, le 12 octobre 1976, à Aston Clinton. Sur un châssis qui est l'œuvre de Mike Loasby avec les suspensions de l'Aston Martin V8 – enrichies d'un correcteur d'assiette automatique pour le train arrière – repose une carrosserie à quatre portes au style jamais vu à ce jour. La Lagonda mesure 5285 mm de long et est, pourtant, d'une légèreté incontestable.

Dans l'habitacle aussi, l'extraordinaire est élevé au rang de principe, par exemple avec un volant à une seule branche, des instruments numériques ainsi qu'une batterie de pas moins de 46 leviers et manettes. Ce système électronique est régulièrement paralysé par de nombreux dysfonctionnements que seul le spécialiste américain Brian Refoy parvient à guérir après l'avoir intégralement disséqué. La voiture est équipée en série d'une boîte automatique Chrysler Torqueflite qui convient à la perfection au V8 dont la puissance a été ramenée à 280 ch. Mais la gestation de toute bonne chose demande du temps et la première Lagonda S2 n'est livrée à son nouveau propriétaire que le 24 avril 1978.

La voiture bénéficie régulièrement d'améliorations mineures. À partir de 1984, la grosse limousine devient polyglotte et s'adresse à ses occupants en anglais, en allemand, en français ou en arabe. Une évolution plus substantielle se produit avec la S3, présentée au Salon de l'Auto de New York en 1986.

Le moteur à injection de la nouvelle Aston Martin V8 développe maintenant 300 ch sous son capot. Sur la S4 présentée à Genève en mars 1987, il n'y a plus aucun panneau d'aluminium, les arêtes acérées ont été assouplies, les six petits phares à l'avant sont désormais fixes et des phares antibrouillards sont insérés dans un aileron avant descendant aussi bas que les jupes latérales.

Pour l'automobiliste moyen, l'AM V8 Lagonda restera toujours d'un prix aussi inaccessible au cours des treize années de sa production, jusqu'en 1990. Au début, il lui aurait fallu économiser 24570 livres pour se l'offrir et, à la fin, pas moins de 95000 livres.

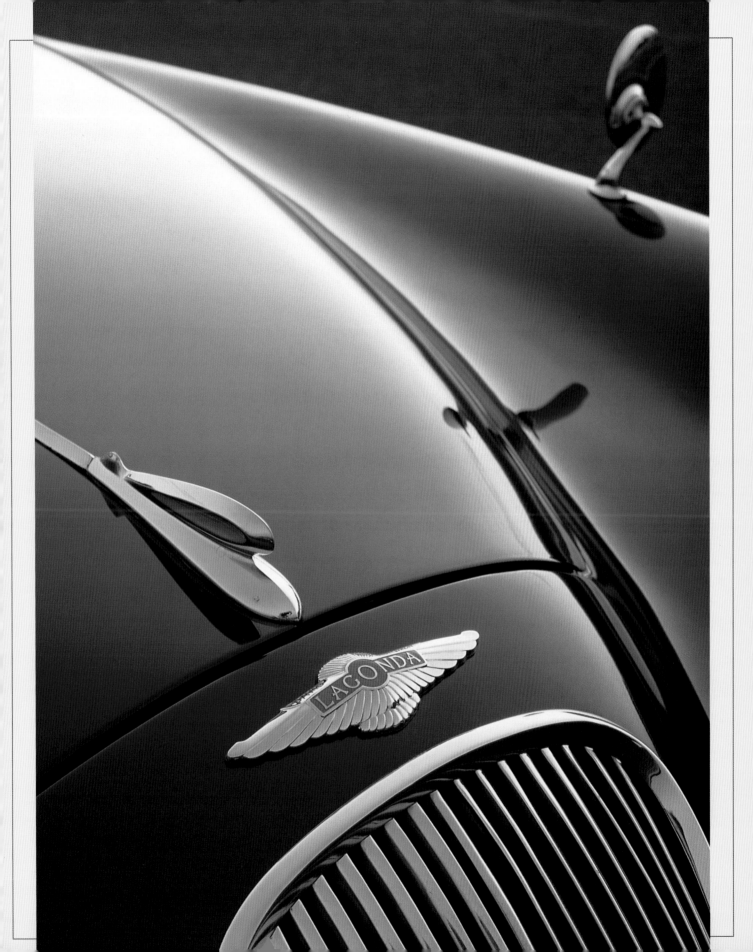

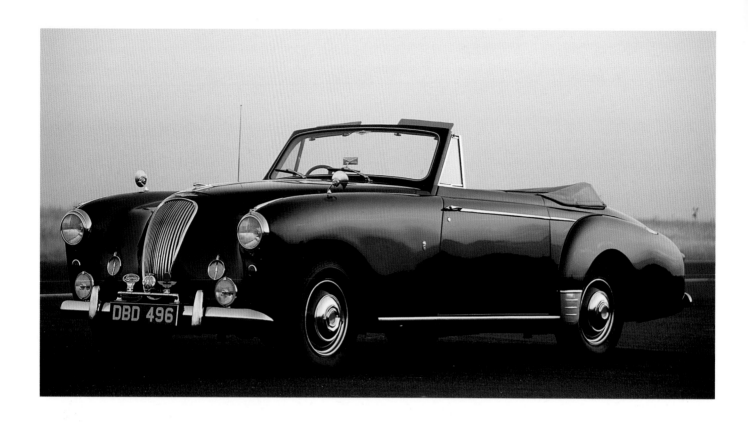

Of impressive appearance, but big, heavy and underpowered. A Tickford drophead coupé of the second series from 1955.

Prächtig, aber groß, schwer und zu schwach: ein Tickford Drophead Coupé der zweiten Serie von 1955.

Majestueux, mais encombrant, lourd et insuffisamment motorisé: un Tickford Drophead Coupé de la seconde série de 1955.

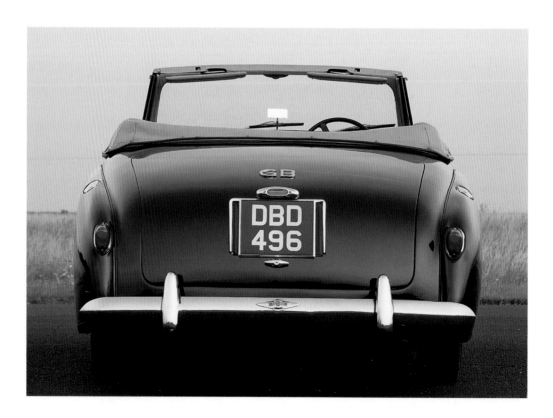

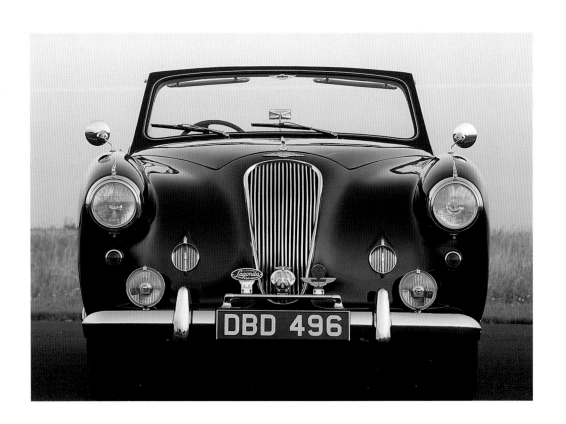

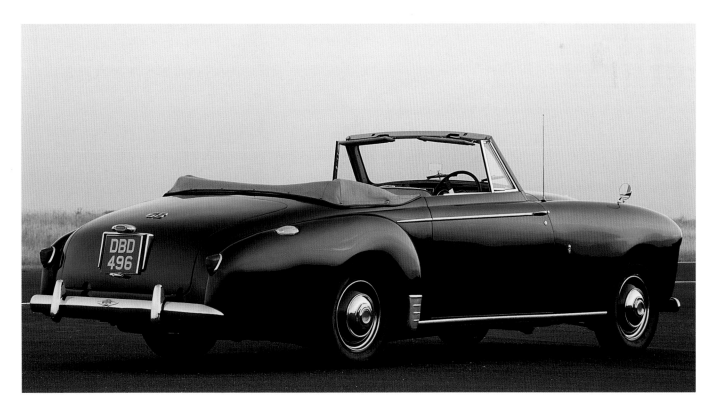

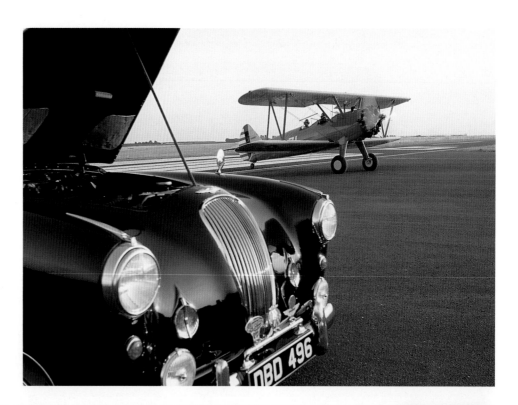

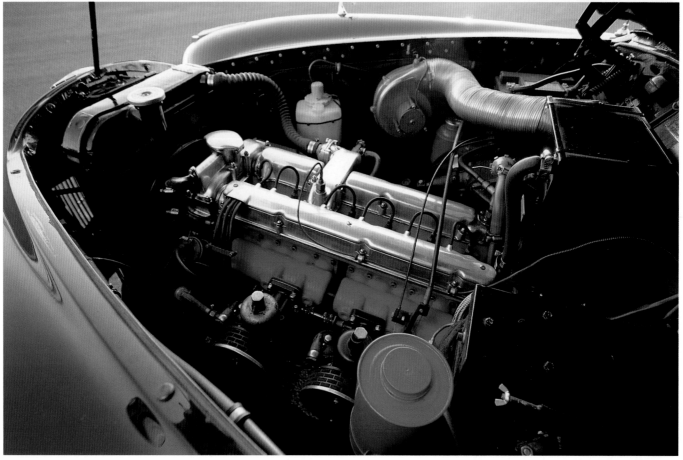

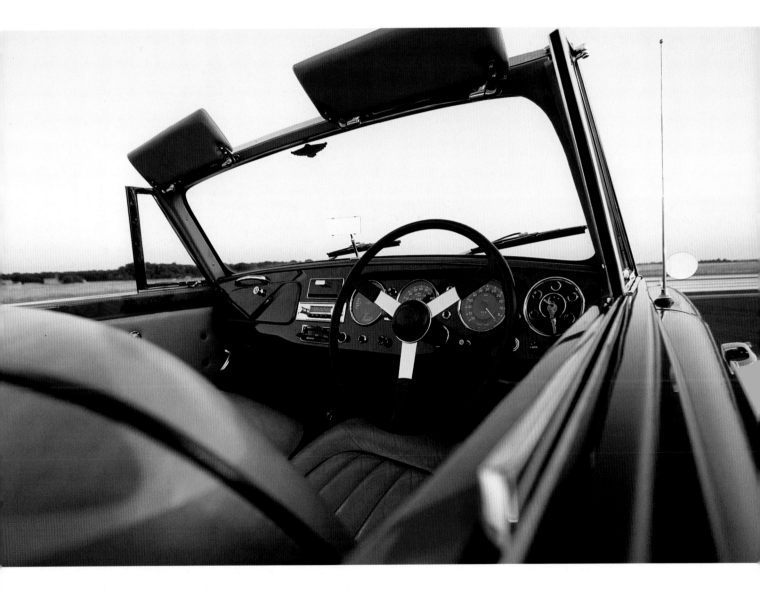

The three-liter version of W. O. Bentleys 140 bhp six-cylinder engine had over 3300 pounds of vehicle to lug around. As a consequence, leisurely travel is the order of the day.

Schweres Los: Die Dreiliter-Variante von W. O. Bentleys Sechszylinder mit 140 PS muss die Trägheit von über 1500 Kilogramm Fahrzeuggewicht überwinden. Folglich ist gemächliches Reisen angesagt.

Tâche ardue : la version de trois litres du six-cylindres de W. O. Bentley de 140 ch doit mouvoir une voiture qui pèse plus de 1500 kg. Par conséquent, il ne faut pas s'attendre à des performances époustouflantes.

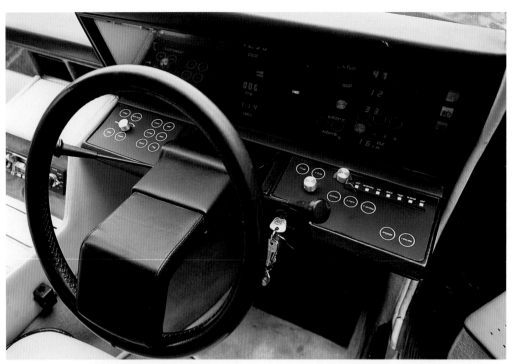

A matter of taste: William Towns' V8 Lagonda also met with a mixed reception, due both to its external appearance and, most especially, its unconventional interior design, featuring a one-spoke steering wheel and digital instruments. Illustrated here is a Series 2 car (from 1976 on).

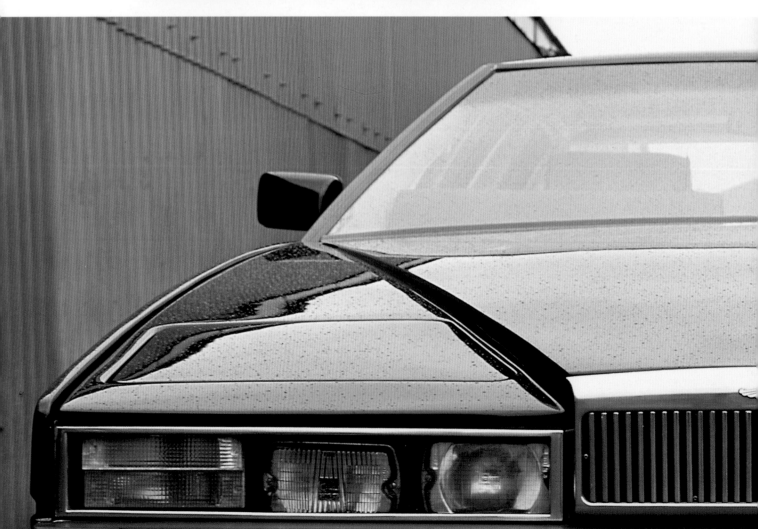

Ansichts-Sache: Auch an der William-Towns-Kreation V8 Lagonda scheiden sich die Geister. Das gilt für die Form, vor allem aber auch die ungewöhnliche Innenarchitektur mit Einspeichenlenkrad und digitaler Instrumentierung. Hier ein Fahrzeug der Series 2 (ab 1976).

Question de goût : la V8 Lagonda dessinée par William Towns reçoit un accueil mitigé, en partie pour ses lignes, et aussi pour le traitement spectaculaire du cockpit avec volant monobranche et instrumentation numérique. Ici, un modèle de la Série 2 (à partir de 1976).

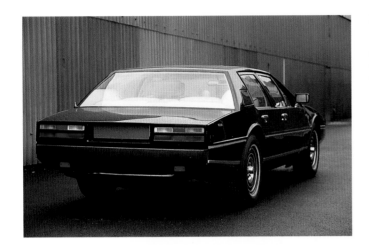

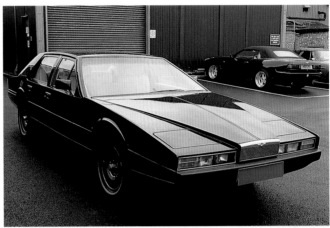

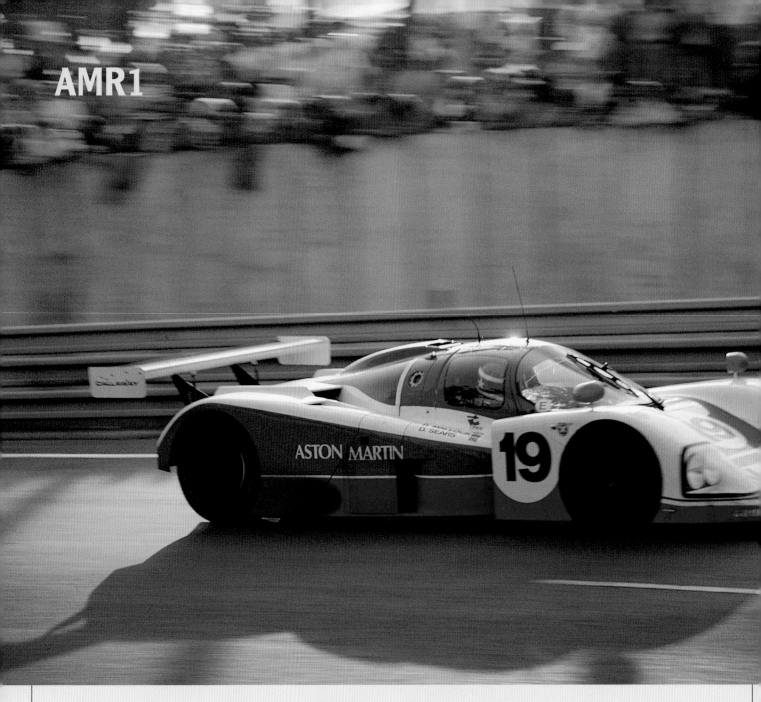

AMR1

The impetus for a Group C racing car to recall Aston Martin's glorious past came from Richard Williams and Ray Mallock, respectively the team boss and constructor of Écurie Écosse, who had already previously used cars fitted with components from the Newport Pagnell works.

The idea fell on fertile ground, both Victor Gauntlett and co-owner Peter Livanos showing a keen interest. Livanos was to finance the design and development of the car with a budget of 26 million pounds spread over a planned six years, while Gauntlett would decide whether the product was worthy to bear the Aston Martin name. Max Boxstrom, an ex-member of the Brabham race

team, produced an outline design for the AMR1 1987, while Ray Mallock turned the idea into reality. Both the technology employed and the materials, such as carbon fiber and Kevlar body and monocoque, were state-of-the-art.

Aston Martin fitted the car with an in-house five-speed gearbox that was accurate changing up, but somewhat sloppy changing down. The company also manufactured the 6-liter engine. It featured four valves per cylinder, as with the Virage which was launched simultaneously in October 1988. Even at low revs the growling V8 was bursting with power, and its torque characteristic was practically flat between 4500 and 7000 rpm. At 7500 rpm the driver received a

warning not to overdo things. Its top speed of 211 mph on the Hunaudières straight of Le Mans, though respectable, was not enough to mix it with the best.

Le Mans 1989 was very much in Aston Martin's sights, exactly 30 years after the triumph of Roy Salvadori and Carroll Shelby in the DBR1. The painstaking preparations included acquiring a patch of sacred French soil complete with farmhouse near the Tertre Rouge part of the circuit. Here Gauntlett and Livanos housed their Protech (standing for Proteus Technology) team with its red, white and blue livery. However, these massive preparations met with a meager return on the 16th and 17th June 1989 as Michael Roe and Costas Ros achieved

Der Anstoß für einen Rennwagen der Gruppe C, der wie in glorreicher Vergangenheit den Namen Aston Martin tragen soll, kommt von Richard Williams und Ray Mallock, dem Teamchef und dem Konstrukteur der Écurie Écosse, die bereits früher Fahrzeuge mit Komponenten aus Newport Pagnell eingesetzt hat.

Er fällt auf fruchtbaren Boden: Victor Gauntlett und Co-Eigner Peter Livanos zeigen sich sehr angetan von der Idee. Livanos wird Entwurf und Entwicklung mit einem Haushalt von 26 Millionen Pfund über die ursprünglich geplanten sechs Jahre finanzieren, Gauntlett entscheiden, ob das Produkt dem Nobel-Namen Aston Martin gut tun wird. Max Boxstrom, früher einmal Angestellter des Brabham-Rennstalls, skizziert den AMR1 1987, Ray Mallock setzt das Konzept in die Tat um. Technologie und Werkstoffe wie Kohlefaser und Kevlar für Karosserie und Monocoque sind auf dem letzten Stand der Wissenschaft.

Ein eigens angefertigtes Fünfgang-Getriebe von Aston Martin, akkurat herauf-, aber etwas latschig herunterzuschalten, wird zusammengespannt mit einer Sechsliter-Maschine vom selben Hersteller. Sie atmet über vier Ventile je Zylinder wie beim Virage, der im Oktober 1988 um die gleiche Zeit seine Aufwartung macht. Schon bei niedrigen Drehzahlen setzt der brotzelnde V8 bullige Leistung frei: Seine Drehmomentkurve verläuft fast flach zwischen 4500 und 7000/min. Bei 7500/min ergeht eine Warnung an den Piloten, die Dinge nicht auf die Spitze zu treiben. Die Höchstgeschwindigkeit von 340 Stundenkilometern auf der Hunaudières-Geraden von Le Mans ist ordentlich, ohne dass man dort mit den Besten mithalten könnte.

Le Mans liegt 1989 denn auch voll im Visier – genau 30 Jahre nach dem Erfolg von Roy Salvadori und Carroll Shelby im DBR1. Zur sorgfältigen Vorbereitung gehört der Erwerb einer Parzelle heiligen französischen Bodens nebst Bauernhaus in der Nähe des Streckenteils Tertre Rouge, wo Gauntlett und Livanos ihr Protech (für Proteus Technology)-Team in den Farben Rotweißblau unterbringen. Dieser Berg gebiert an dem Wochenende vom 16. bis zum 17. Juni 1989 nur ein Mäuschen: Rang 11 für Michael Roe und Costas Ros auf dem Aston Martin AMR1, der in der Weltmeisterschaft auf dem sechsten Platz abschließt. Beim Finalrennen in Mexiko rüstet man noch einmal nach auf 6,3 Liter Hubraum für das Chassis AMR/05, schon um einen Teil der PS-Herde wieder einzufangen, die in der dünnen Höhenluft dort verloren geht.

Für den verbesserten Typ AMR2 hat man unter anderen Formel-1-Designer Tony Southgate verpflichtet, da bimmelt im Februar 1990 das Sterbeglöcklein für das Projekt. Der Unwägbarkeiten sind zu viele: Zum einen ist ungewiss, ob Le Mans in diesem Jahr überhaupt über die Bühne gehen wird. Zum anderen erwirbt Ford den Konkurrenten Jaguar und löst sein Versprechen nicht ein, Aston Martin für 1991 mit dem Cosworth-3,5-Liter-Rennmotor auszurüsten.

L'idée de créer une voiture de course du Groupe C destinée à faire revivre un glorieux passé en faisant briller le nom d'Aston Martin sur les circuits vient de deux hommes : Richard Williams et Ray Mallock, respectivement chef d'écurie et constructeur de l'Écurie Écosse, qui ont déjà autrefois engagé des voitures avec des composants de Newport Pagnell. Et cela ne tombe pas dans l'oreille d'un sourd : Victor Gauntlett et le copropriétaire d'Aston Martin, Peter Livanos, sont emballés par cette idée. Livanos accepte de financer la phase de conception et de développement à hauteur de 26 millions de livres pour une période initialement prévue de six ans, à l'issue de quoi Gauntlett décidera si le produit est digne de porter le nom prestigieux d'Aston Martin. Max Boxstrom, un ancien de l'écurie de Formule 1 Brabham, dessine l'AMR1 en 1987 et Ray Mallock transpose le concept dans la réalité. Sa technologie et ses matériaux, comme la fibre de carbone et le kevlar pour la carrosserie et la monocoque, sont le dernier cri.

Une boîte Aston Martin à cinq vitesses conçue spécialement – brillante en montée de rapports, mais peu docile au rétrogradage – est accolée à un moteur de 6 litres du même constructeur. Il possède une culasse à quatre soupapes comme la Virage, qui fait son apparition en octobre 1988. Dès les bas régimes, le bruyant V8 délivre une puissance énorme : sa courbe de couple est presque plate entre 4500 et 7000 tr/min. Mais, à 7500 tr/min, les pilotes doivent immédiatement passer le rapport supérieur s'ils ne veulent pas « fusiller » le moteur. La vitesse maximale de 340 km/h atteinte sur la ligne droite des Hunaudières au Mans est respectable, mais elle ne suffit pas pour y talonner les meilleurs.

La participation aux 24 Heures du Mans de 1989 est l'objectif – et un moyen de commémorer le trentième anniversaire de la victoire remportée par Roy Salvadori et Carroll Shelby au volant d'une DBR1. Pour se préparer le mieux possible, Aston Martin acquiert un lopin de terrain avec une ferme sur le sol sacré français à proximité du célèbre virage du Tertre Rouge. Gauntlett et Livanos y installent leur écurie Protech (pour Proteus Technology) aux couleurs rouge-blanc-bleu. Le week-end des 16 et 17 juin 1989, Michael Roe et Costas Ros finissent onzièmes avec l'Aston Martin AMR1, qui terminera le championnat du monde au sixième rang. Lors de la finale à Mexico, la cylindrée du moteur équipant le châssis AMR/05 est majorée à 6,3 litres pour compenser la centaine de chevaux qui s'est évaporée dans l'air raréfié d'un circuit à haute altitude.

Au moment même où, pour construire la future AMR2, Aston parvient à obtenir le concours de Tony Southgate, qui a déjà dessiné des Formule 1, sonne le glas du projet en février 1990. Il y a trop d'impondérables : d'une part, il n'est pas certain que les 24 Heures du Mans soient organisées cette année-là et, surtout, Ford, qui vient de racheter Jaguar, la concurrente d'Aston Martin, ne tient pas la promesse faite à cette dernière d'équiper en 1991 ses voitures en moteurs de course Cosworth de 3,5 litres.

11th place in their Aston Martin AMR1, which came sixth in the World Championship as a whole. For the final race in Mexico a larger 6.3-liter engine was fitted to the AMR/05 chassis in an attempt to make good at least part of the car's power deficit in comparison to most of its rivals. Formula 1 designer Tony Southgate had been commissioned for the new improved AMR2, but then in February 1990 the death knell tolled on the project, victim both of the uncertainty over whether the Le Mans race would take place at all that year, and of the fact that Ford took over rivals Jaguar and as a consequence went back on its promise to equip Aston Martin with the Cosworth 3.5-liter race engine for the 1991 season.

Engine failure to their AMR1 was to bring a premature end to Le Mans 1989 for David Lesley, Ray Mallock and David Sears on Sunday morning.

Wenn die Sonne tiefer steht: Ein Motorschaden an ihrem AMR1 wird 1989 in Le Mans der Fahrt von David Lesley, Ray Mallock und David Sears am Sonntagmorgen ein vorzeitiges Ende bereiten.

Quand le soleil est bas : une panne de moteur fera s'achever prématurément, le dimanche matin, la course de David Lesley, Ray Mallock et David Sears avec leur AMR1 aux 24 Heures du Mans de 1989.

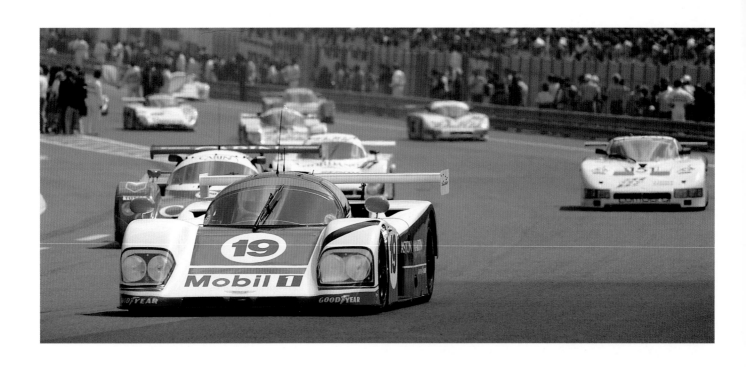

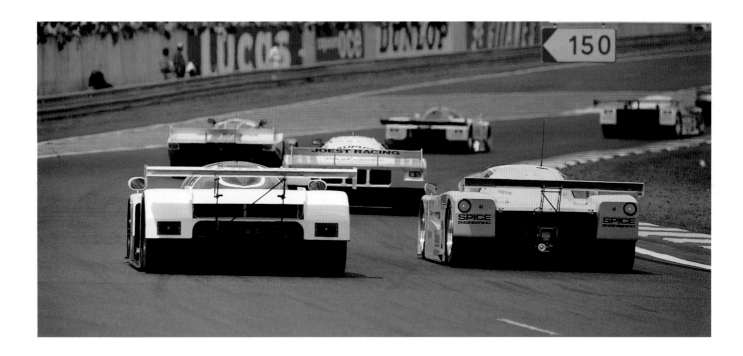

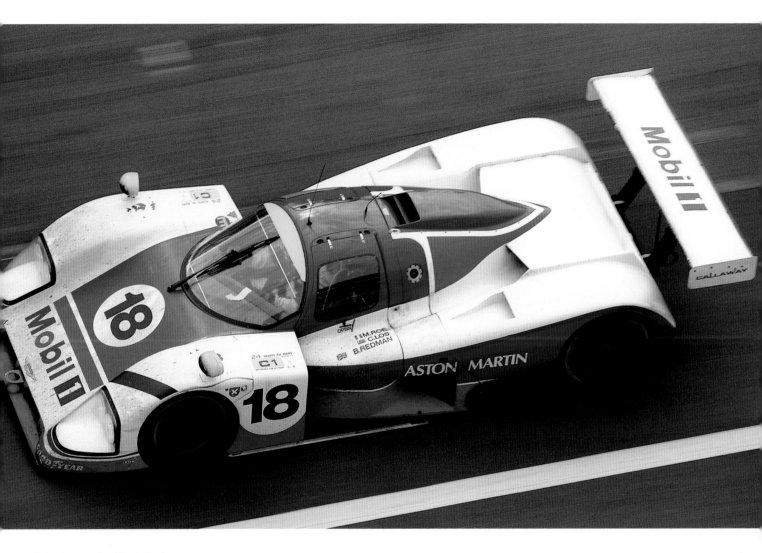

Hindered among other things by its clumsy
aerodynamics, Brian Redman, Michael Roe
and Costas Los' AMR1 with the number 18
ended the same race in 11th position.

Rushhour: Nicht zuletzt von sperriger
Aerodynamik behindert, belegt der AMR1
mit der Startnummer 18 mit den Piloten
Brian Redman, Michael Roe und Costas Los
beim gleichen Rennen Rang 11.

Pas particulièrement avantagée par son
aérodynamique médiocre, l'AMR1 numéro 18
pilotée par Brian Redman, Michael Roe
et Costas Los termine 11e lors de cette
même course.

Virage

By the mid-1980s the V8 had reached the end of the road. It was too familiar, too monumental, too complex and expensive to manufacture, and on top of this it was getting hard to find suppliers for some of the spare parts. A new model, which had repeatedly been promised, was long overdue.

At this point the management at Newport Pagnell discovered the discreet charm of democracy, offering a prize to the workforce and members of the Aston Martin Owners' Club to come up with an attractive new name, which in the tradition of the Vantage and Volante should begin with V. However, in the end it was Victor Gauntlett himself who won his own prize, opting for the euphonious and meaningful French word Virage, completely unaware that this had been an AMOC member's proposal. Strangely, though not without parallel in the company's history, in 1994 the name disappeared from the bodywork, the new model, like the old, now once again becoming the plain V8.

At the end of April 1986 five design teams were commissioned to present a Virage model by 28th August that year. One requirement placed a significant limitation on their design freedom: the basis for the car was to be a shortened Lagonda chassis with slightly modified suspension, the aim being to increase the number of identical parts and reduce costs. William Towns was also called in to lend his tried and tested skills to the project. Finally on 8th October 1986 the Royal College of Arts team of Ken Greenley and John Heffernan got the nod. Their design was the embodiment of elegant simplicity, though its rear did undergo a certain amount of modification after wind tunnel testing at Southampton University: form follows function, as they say in the trade.

Between April 1986 and December 1987 the existing engine underwent a thoroughgoing revamp at Callaway Engineering in Connecticut. The US tuning shop's brief was to ensure that the engine would meet emission regulations all around the world and to convert it for use with unleaded gasoline. Reeves Callaway and his team were aware of the robust qualities of the lower portion of the existing V8 and directed their main efforts on the upper half, adding new cylinder heads, four valves per cylinder and Weber fuel injection, producing a 330 horsepower unit.

At its presentation at the Birmingham Exhibition Centre Motor Show in October 1988 the verdict on this trim two-tonner was highly favorable, and it had already received 54 orders sight unseen. However, the patience of prospective customers was to be put to a severe test, the Virage not finally being ready for delivery until 5th January 1990. The pure two-seater Volante, which had its premiere at the same forum two years later, also met with immediate success. It was followed at the 1992 Geneva show by the first Shooting

As on the Vantage, the V8 Coupé dissipates engine heat via grilles fitted in front of the windscreen.

Ähnlich wie am Vantage entweicht am V8 Coupé Motorhitze durch Grills vor der Windschutzscheibe nach oben.

Comme sur la Vantage, des grilles placées sur le capot devant le pare-brise évacuent, sur le V8 Coupé, la chaleur du compartiment moteur.

1992. This really did give no quarter in the search for extra output. In order to avoid the dreaded turbo lag two Roots compressors had been fitted, a solution first tried way back in the 1930s. The outcome was an engine that could hold its own against the most renowned international competition: a 550 horsepower unit coupled with a six-speed ZF transmission. The Vantage was packed with muscle throughout the rev range, reaching 100 mph in just ten seconds and arriving at a top speed of 185 mph, making it the fastest Aston Martin yet.

The chassis modifications were largely the same as those of the 6.3-liter option. The external similarity was also striking, apart from a changed grille flanked on either side by arrays of three small lights in the area where the headlamps of the Volkswagen Corrado used to be. The Aston Martin V8 Coupé, launched in March 1996 as the successor to the Virage, came across to a certain extent as a slightly watered-down Vantage.

In 1999, to mark the 40th anniversary of the historic victory at Le Mans and the 1959 constructor's championship, a strictly limited special edition of just 40 V8 Vantage Le Mans was produced. They sold like hot cakes. Not so long ago the mighty 600 horsepower generated by their engines would have been a respectable figure for a Formula 1 car. However, the model's days are numbered. When the final car of a final batch of six Vantage Volantes, each lovingly tailored to the requirements of its future owner, leaves the works in August 2000, the era of the V8 from Newport Pagnell will be at an end, a poignant milestone in the history of the marque.

Brake to be produced in-house by Aston Martin, along with a 2+2-seater cabriolet, and in the autumn of 1997 by another four-seater Volante which represented a further open declaration of war on the rest of the convertible world. From 1993 onwards the Virage was available with a four-speed automatic transmission from Chrysler, and standard six-speed manual, the top gear being designed for economical high-speed cruising, from ZF. At the end of the year a longer four-door version was added to the range and also a counterpart to the Shooting Brake, going by the name Vacances, thus resuscitating the hallowed name of Lagonda once again.

Both of these fitted perfectly in with Aston Martin's new policy in favor of tailor-made cars for a demanding and exclusive clientele. The marque's next stroke in October 1994 was a run of just ten Limited Edition coupés, featuring somewhat more power and traditional British Racing Green livery to set against the vulgar red of their great transalpine rival. Since the beginning of 1992 conversion kits had been available to satisfy the demand for more power and individuality by all those who could not wait for the advent of the Virage Vantage. True to the old maxim that the one thing better than a big engine is an

even bigger one, the center point of this was a 6.3-liter version of the V8 generating 465 horsepower. This major power boost was accompanied by attendant changes to the chassis and the addition of massive 285/45 ZR 18 Goodyear tires housed in elegantly-designed wing extensions.

The Virage, then, was a luxurious Grand Touring car, the most civilized and refined yet created by Aston Martin. However, despite its hundreds of horsepower it came across as somewhat too tame for some, a shortcoming put right by the Vantage, which was presented at the Birmingham Motor Show in October

The traditional side vents of the Vantage
also provide ventilation for the engine
compartment.

Auch der traditionelle seitliche Auslass
des Vantage dient der Ventilation des
Maschinenraums.

La sortie d'air latérale traditionnelle
de la Vantage sert elle aussi à ventiler le
compartiment moteur.

Mit dem V8 lässt sich Mitte der Achtziger nicht mehr viel Staat machen, zu vertraut, zu monumental, zu aufwendig und zu teuer in der Herstellung. Überdies ist so manches Ersatzteil bei den Zulieferern allmählich rar geworden. Ein neues Modell ist überfällig, in der Vergangenheit wieder und wieder versprochen.

Zugleich entdeckt man in Newport Pagnell den diskreten Charme der Demokratie: Ein Preis für einen attraktiven Namen wird ausgelobt unter der Belegschaft und dem Aston Martin Owners' Club. Mit V sollte er anfangen in der Tradition von Vantage und Volante. Schließlich setzt sich Victor Gauntlett selber durch mit der wohlgenährten Vokabel Virage, die gleichwohl unterschwellig auf den Vorschlag eines AMOC-Mitglieds zurückgeht. Merkwürdig, aber nicht ohne Parallelen in der Geschichte der Firma: 1994 verschwindet der V8 von der Bildfläche, und der Neue heißt wieder wie der Alte: V8.

Ende April 1986 werden fünf Design-Teams damit beauftragt, am 28. August des gleichen Jahres ein Modell des Virage zu präsentieren. Eine massive Vorgabe schränkt sie ein: Basis wird ein verkürztes Lagonda-Chassis mit einer leicht modifizierten Aufhängung sein. Es soll dazu beitragen, die Schnittmengen in der Produktion zu vergrößern und somit die Kosten zu verringern. Eingebunden ist auch William Towns als bewährte Geschäftsverbindung. Den Zuschlag indessen erhält am 8. Oktober 1986 das Team Ken Greenley und John Heffernan vom Royal College of Arts. Ihr Entwurf ist einfach schön, lässt allerdings im Heckbereich ein paar Federn im Windkanal der Southampton University: Form follows function, besagt eine Binsenweisheit der Branche.

Zwischen dem April 1986 und dem Dezember 1987 wird der bestehende Motor bei Callaway Engineering in Connecticut einer gründlichen Frischzellenkur unterworfen: Er müsse den Emissionsbestimmungen in aller Welt genügen und sich von bleifreiem Sprit ernähren, wird der amerikanischen Tuning-Schmiede mit auf den Weg gegeben. Reeves Callaway und seine Männer sind sich der kernigen Konstitution der unteren Hälfte des bisherigen V8 durchaus bewusst und leisten vor allem gründliche Arbeit in der oberen, mit neuen Köpfen und vier Ventilen je Zylinder. Von einer Weber-Einspritzung mit Treibstoff beschickt, leistet Callaways Kreation 330 PS.

Bei seiner Vorstellung auf der Show in Birmingham im Oktober 1988 hört man viel Gutes über den properen Zweitonner, sehr zum Vergnügen der 54 Kunden, die den Virage bereits unbesehen bestellt haben. Ihre Geduld wird gleichwohl noch ein wenig auf die Probe gestellt. Offiziell ausgeliefert wird der Virage nämlich erst seit dem 5. Januar 1990. Umgehender Erfolg ist auch dem Volante beim gleichen Forum zwei Jahre später beschieden, einem reinen Zweisitzer. Ihm folgen, zusammen mit dem ersten Shooting Brake, der von Aston Martin selbst gefertigt wird, in Genf 1992 ein 2+2-plätziges Cabriolet und im Herbst 1997 noch einmal ein Volante Convertible für vier Reisende als weitere offene Kriegserklärung an den Rest der Welt. Ab 1993 ist der Virage mit einem Viergang-Automaten von Chrysler erhältlich, während das Standard-Getriebe mit sechs handvermittelten Gängen, von denen der sechste als Schon- und Spargang ausgelegt ist, von ZF stammt. Ende des Jahres erweitert man die Produktpalette um eine längere Version mit vier Türen sowie ein Pendant beim Shooting Brake namens Vacances und küsst zugleich den Nobel-Namen Lagonda aus seinem Dornröschenschlaf wach.

Die beiden passen perfekt in eine neue Nischen-Politik des Hauses Aston Martin, das sich nun bevorzugt mit exklusiven Maßanfertigungen einer wählerischen und wohlhabenden Kundschaft zuwendet. Der nächste Streich: zehn Exemplare eines Limited Edition Coupés im Oktober 1994, etwas stärker und in British Racing Green als vaterländischangemessene Antwort auf das Rot gewisser Konkurrenten jenseits der Alpen. Schon seit Anfang 1992 begegnet man dem Wunsch nach mehr Kraft und Individualität mit Conversion Kits, für alle, welche die Ankunft des Virage Vantage nicht erwarten können. Getreu der klassischen Devise, besser als viel Hubraum sei noch mehr Hubraum, steht dabei eine 6,3-Liter-Version des V8 mit 465 PS im Mittelpunkt. Dieser urige Zuwachs an Kraft wird begleitet von entsprechenden Veränderungen am Fahrwerk und Goodyear-Walzen des Formats 285/45 ZR 18, für die durch gefällig geformte Kotflügelverbreiterungen Ellbogenfreiheit geschaffen wird.

Beim Virage handelt es sich um einen kommoden Reisewagen, den zivilisiertesten Aston Martin bislang. Wem er trotz wohlgenährter PS-Hundertschaften zu handzahm daherkommt, dem kann ab der Birmingham International Show im Oktober 1992 mit dem Vantage geholfen werden. Diesem ist nun wirklich alles Sanfte abhanden gekommen. Auf der Suche nach mehr Pferdestärken hat man diesmal den Weg über zwei Roots-Kompressoren gewählt wie einst in den Dreißigern, um dem Piloten den Absturz in das berüchtigte Turbo-Loch zu ersparen. Das Ergebnis kann sich auch im internationalen Vergleich der stärksten Stücke sehen lassen: 550 PS, von dem ZF-Sechsgang-Getriebe kongenial an die Hinterachse weitergegeben. Schon ganz von unten heraus tritt der Vantage stark an, erreicht die 100-Meilen-Marke in zehn Sekunden – schneller als irgendein Aston Martin vor ihm – und erschlafft erst zwei Stundenkilometer vor der magischen Ziffer 300.

Die Modifikationen am Chassis entsprechen weitgehend der 6,3-Liter-Option. Auch die äußere Ähnlichkeit ist auffällig, abgesehen von einem anderen Grill, der von Ensembles von jeweils drei kleinen Leuchten flankiert wird, wie früher die Lampen des VW Corrado angesiedelt waren. Das Aston Martin V8 Coupé, im März 1996 als Nachfolger des Virage vorgestellt, wirkt in mancher Hinsicht wie ein visuell verharmloster Vantage. Anlässlich des 40. Jahrestages der historischen Siege auf dem Sarthe-Kurs und beim Championat der Marken legt man 1999 eine strikt auf 40 Stück limitierte und rasch vergriffene Sonderedition V8 Vantage Le Mans auf. Dieser ist 600 solide PS stark – vor noch nicht allzu langer Zeit eimal ein guter Formel-1-Wert. Da sind die Tage der Baureihe bereits gezählt: Mit dem letzten Exemplar einer finalen Auflage von sechs Vantage Volante, jeder von Ihnen liebevoll auf die Bedürfnisse des künftigen Besitzers zugeschnitten, endet im August 2000 die Ära der V8 aus Newport Pagnell, fürwahr ein Markstein auf dem Wege der Firma im Zeichen des stilisierten Flügels.

La V8 produite au milieu des années 1980 arrive en bout de course : elle est trop familière, trop monumentale, mais aussi trop sophistiquée et trop coûteuse à fabriquer. En outre, de nombreuses pièces de rechange ont, peu à peu, commencé à se faire rares chez les sous-traitants. Il faut absolument un nouveau modèle, comme cela a régulièrement été promis au cours du passé. Accessoirement, à Newport Pagnell, on découvre le charme discret de la démocratie : un prix est promis à celui qui, parmi le personnel ou au sein de l'Aston Martin Owners'Club, découvrira un nom attrayant pour le nouveau modèle. Seule condition : il doit commencer par V, pour respecter la tradition du Vantage et de Volante. Finalement, c'est Victor Gauntlett lui-même, sur la proposition d'un autre membre de l'AMOC, qui imposera ses vues avec un vocable à la sonorité ronflante : Virage. Chose étonnante, mais qui n'est pas nouvelle dans l'histoire de la firme, en 1994, le nom disparaît du paysage et la nouvelle version s'appelle comme l'ancienne, V8.

Fin avril 1986, cinq équipes de designers sont chargées de présenter, le 28 août de la même année, une maquette de la Virage. Un cahier des charges impitoyable jugule leur créativité : la base en sera un châssis de Lagonda raccourci avec des suspensions légèrement modifiées. Le but de cette décision consiste à rationaliser la production et, ainsi, à réduire les frais. Williams Towns est aussi

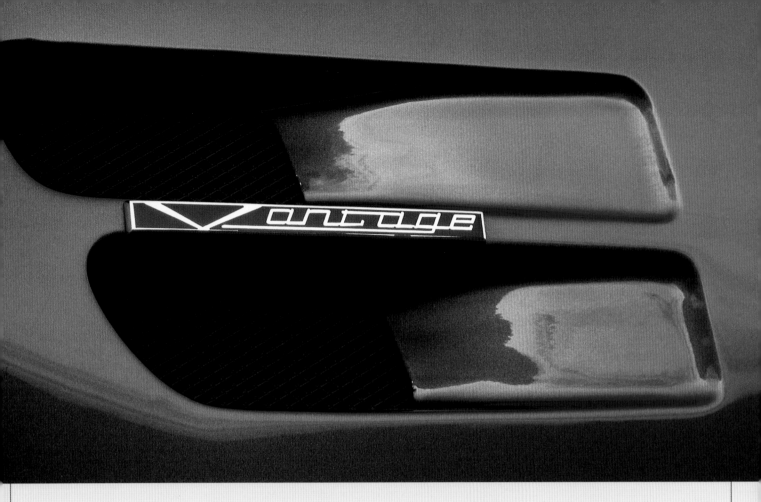

de la partie en tant qu'homme de liaison qui a fait ses preuves. Finalement, c'est l'équipe de Ken Greenley et John Heffeman, du Royal College of Arts, qui est choisie, le 8 octobre 1986. Son dessin est tout simplement beau, même s'il laisse quelques plumes, pour sa partie arrière, après des tests dans la soufflerie de l'Université de Southampton: *form follows function* (la fonction crée l'organe), comme le veut un vieux dicton qui a cours dans l'industrie automobile.

Entre avril 1986 et décembre 1987, le moteur existant bénéficie d'une cure de vitamines systématique chez Callaway Engineering, dans le Connecticut: il doit respecter les normes de dépollution du monde entier et pouvoir consommer de l'essence sans plomb, telles sont les instructions données au préparateur américain. Reeves Callaway et ses hommes sont parfaitement conscients de la bonne constitution du bas moteur de l'actuel V8 et consacrent donc essentiellement leurs soins au haut moteur, qu'ils dotent de nouvelles culasses et de quatre soupapes par cylindre. Alimentée en carburant par une injection Weber, la création de Callaway développe 330 ch.

Lors de sa présentation au Salon de l'Auto de Birmingham, en octobre 1988, cette imposante voiture de deux tonnes suscite bien des éloges, pour le plus grand plaisir des 54 clients qui ont déjà commandé la Virage sans même l'avoir vue. Leur patience va toutefois être mise à rude épreuve. La commercialisation

officielle de la Virage n'interviendra, en effet, que le 5 janvier 1990. Lors de sa présentation au même endroit, deux ans plus tard, la Volante, une pure biplace, remporte un succès immédiat. Elle est suivie, en même temps que le premier Shooting Brake réalisé par Aston Martin elle-même, à Genève en 1992, par un cabriolet 2+2 et, à l'automne 1997, par une nouvelle Volante Convertible qui permet de partager en famille les plaisirs du cabriolet. À partir de 1993, la Virage est disponible avec une boîte automatique à quatre rapports de Chrysler ou avec une boîte manuelle standard à six vitesses de ZF dont le sixième rapport est une surmultipliée. À la fin de l'année, la gamme s'enrichit d'une version allongée à quatre portes ainsi que d'une exécution identique au Shooting Brake, portant le nom de Vacances; Aston profite de l'occasion pour célébrer la renaissance du prestigieux label Lagonda.

Toutes deux s'inscrivent à la perfection dans la nouvelle politique de la manufacture Aston Martin qui, désormais, se consacre surtout à des créations exclusives et sur mesure pour une clientèle aisée qui peut et sait se montrer difficile. Le prochain «coup» ne se fait pas attendre avec les dix exemplaires d'un coupé Limited Edition, en octobre 1994, un peu plus puissant et de couleur *British Racing Green* – réplique patriotique et appropriée au rouge de certaines concurrentes transalpines. Dès 1992, déjà, des kits de conversion offrant plus

de puissance et d'individualité sont proposés à quiconque n'a pas la patience d'attendre l'arrivée de la Virage Vantage. Selon la maxime classique selon laquelle rien ne vaut la cylindrée, Aston propose une version propulsée par un V8 de 6,3 litres et 465 ch. Ce surcroît de puissance impose naturellement des modifications *ad hoc* des trains roulants, qui comprennent de larges gommes Goodyear de 285/45 ZR 18 pour lesquelles il a fallu redessiner les ailes, pourtant déjà larges à l'origine.

La Virage est une voiture de grand tourisme idéale, l'Aston Martin la plus civilisée qui ait pris la route à ce jour. Celui qui, malgré les centaines de chevaux piaffant d'impatience sous le capot, lui reproche d'être trop docile trouve chaussure à son pied avec la Vantage dévoilée au Birmingham International Show d'octobre 1992. Celle-ci a vraiment jeté par-dessus bord tout ce qui lui restait de douceur. À la recherche de chevaux supplémentaires, Aston a, cette fois-ci, choisi de greffer deux compresseurs Roots, méthode déjà appliquée dans les années 1930 pour éviter à son pilote le fameux – et si redouté – temps de réponse des turbos. Avec ses 550 ch que la boîte ZF à six vitesses transmet sans le moindre problème au train arrière, ses concurrentes dans la production automobile mondiale se comptent sur les doigts des deux mains. Même à bas régime, la Vantage fait l'effet d'une catapulte et franchit le mur du son des

100 miles/h au bout de 10 secondes – temps jamais réalisé par aucune Aston Martin auparavant – et ne donne des signes de faiblesse que 2 km/h avant le seuil fatidique des 300 km/h.

Les modifications apportées au châssis sont pratiquement les mêmes que pour la version de 6,3 litres. La similitude extérieure, elle aussi, est frappante, abstraction faite d'une calandre différente qui est flanquée par trois petits phares à la place des anciennes optiques de la VW Corrado. L'Aston Martin V8 Coupé qui succède, en mars 1996, à la Virage fait penser, à plus d'un titre, à une Vantage esthétiquement adoucie. À l'occasion du 40e anniversaire des victoires historiques sur le circuit de la Sarthe et au championnat du monde des constructeurs, Aston Martin présente, en 1999, une édition spéciale de V8 Vantage Le Mans limitée à 40 exemplaires – pas un de plus – qui trouvent instantanément preneur et offrent la puissance respectable de 600 ch – ce qui, encore tout récemment, était un chiffre flatteur pour une bonne Formule 1. Mais les jours de cette gamme sont d'ores et déjà comptés: avec l'ultime exemplaire d'une dernière édition de 6 Vantage Volante, chacune réalisée avec beaucoup d'amour du travail bien fait selon les désirs de leur futur propriétaire, l'ère des V8 à Newport Pagnell se termine en août 2000, date à marquer d'une pierre blanche dans l'histoire de la firme à l'emblème des ailes déployées stylisées.

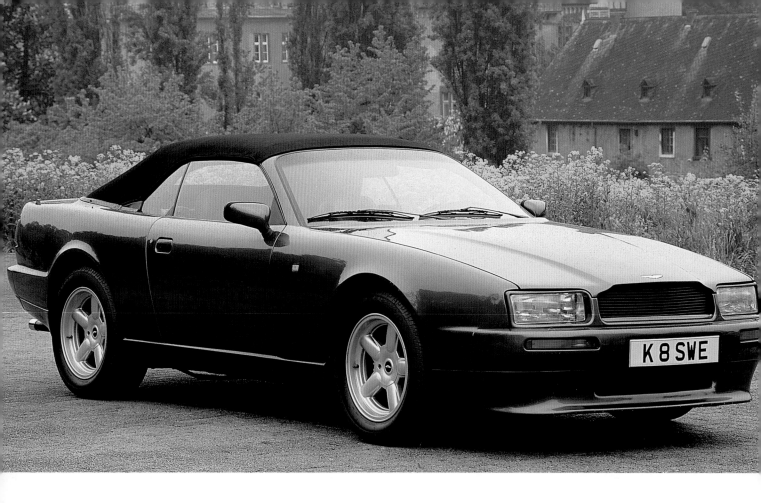

The Virage Volante in its original pre-airbag guise: 17-inch wheels, front lamps from the VW Corrado, rear lights from the VW Scirocco, and wing mirror, from the Citroën CX. Ever since the early days of the V8 the mechanic who built the engine has left his visiting card in the form of a small name plate.

Der Virage Volante in seiner Urform noch ohne Airbag: 17-Zoll-Felgen, Frontlampen vom VW Corrado, Heckleuchten vom VW Scirocco, Außenspiegel vom Citroën CX. Seit den frühen Tagen des V8 hinterlässt der Mitarbeiter, der den Motor zusammengebaut hat, auf einem Schildchen seine Visitenkarte.

La Virage Volante dans sa forme originelle encore sans airbag : jantes de 17 pouces, phares de VW Corrado, feux arrière de VW Scirocco, rétroviseurs extérieurs de Citroën CX. Une longue tradition veut que l'ouvrier qui a monté le moteur V8 s'immortalise en gravant son nom sur une plaque signalétique de la culasse.

Lots of character: numerous modifications make the Vantage a very individual automobile: 18-inch wheels, new lights – produced in-house – all round, a new front spoiler and a new lipped rear.

Charakter-Sache: Zahlreiche Modifikationen machen den Vantage zu einem sehr eigenständigen Auto: 18-Zoll-Räder, neue Lampen aus eigener Produktion ringsum, ein neuer Spoiler vorn sowie ein anderes Heck mit eingearbeiteter Lippe.

Un caractère affirmé. De nombreuses modifications donnent une personnalité indéniable à la Vantage : roues de 18 pouces, nouveaux phares de production maison à l'avant et à l'arrière, nouvel aileron et nouveau dessin de la poupe avec becquet intégré.

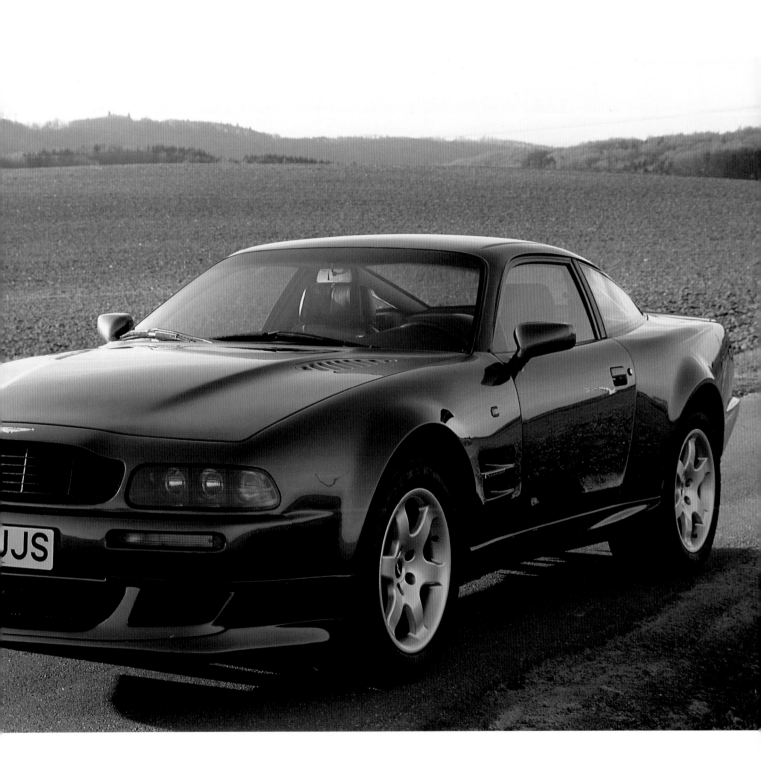

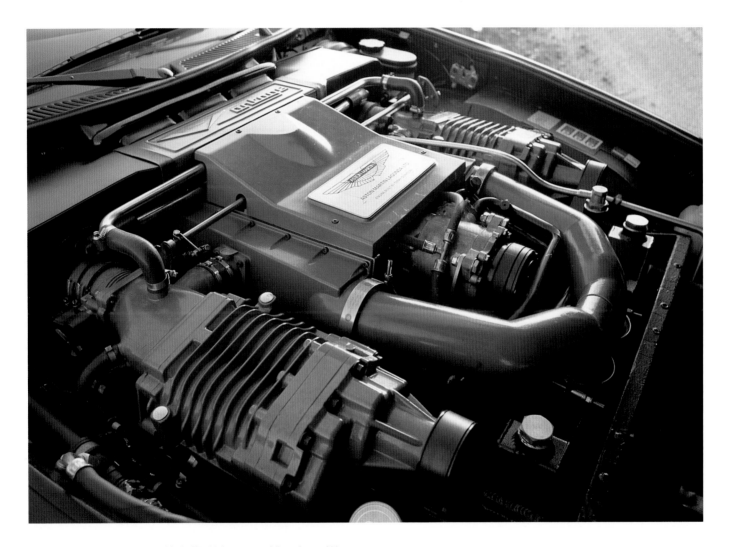

Two belt-driven Eaton compressors provide the V8 with better power delivery than could be achieved via turbochargers. The manual six-speed gearbox is from ZF.

Zwei riemengetriebene Eaton-Kompressoren führen zu einer besser kontrollierbaren Kraftentfaltung des V8, als Turbolader dies bewirken könnten. Das handgeschaltete Sechsgang-Getriebe stammt von ZF.

Deux compresseurs Eaton entraînés par courroie permettent de mieux contrôler la montée en puissance du V8 que ne pourraient le faire des turbocompresseurs. La boîte manuelle à six vitesses provient de chez ZF.

Metamorphosis: the incorporation of Vantage elements into the Virage led to the V8 Coupé. Closer inspection reveals that the lights, spoiler and wheels are new. The steering wheel (plus airbag) can also be found on modest Ford models, while the blowers are from BMW.

Metamorphosen: Die Evolution des Virage mit Hilfe von Vantage-Elementen führt zum V8 Coupé. Bei genauerem Hinsehen entdeckt man, dass Lampen, Spoiler und Felgen neu sind. Das Lenkrad (nebst Airbag) wird man in biederen Ford-Modellen wiederfinden, die Lüftungsdüsen an BMW-Armaturentafeln.

Métamorphoses : l'introduction chez la Virage d'éléments de la Vantage donne naissance au coupé V8. Si l'on regarde attentivement, on constate que phares, aileron et jantes sont nouveaux. Le volant (avec airbag) est celui qui équipe les roturières Ford et les ouïes d'aération proviennent en droite ligne des tableaux de bord de BMW.

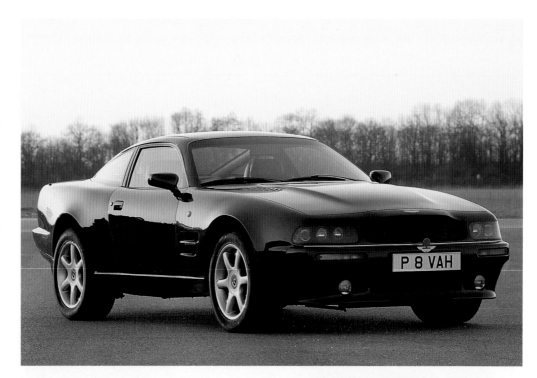

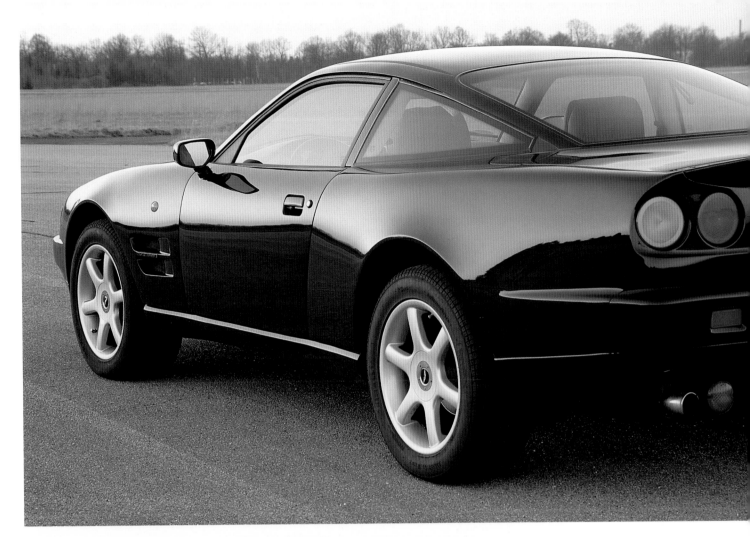

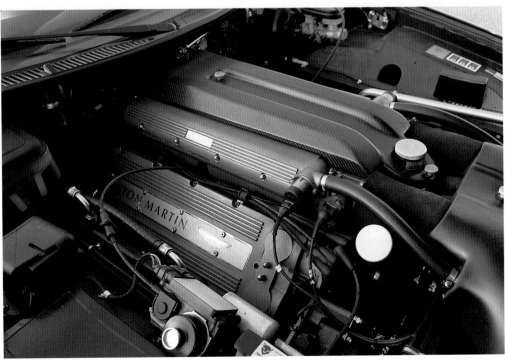

Crafted by Hand in Newport Pagnell
Hand-Werk in Newport Pagnell
Fabrication artisanale à Newport Pagnell

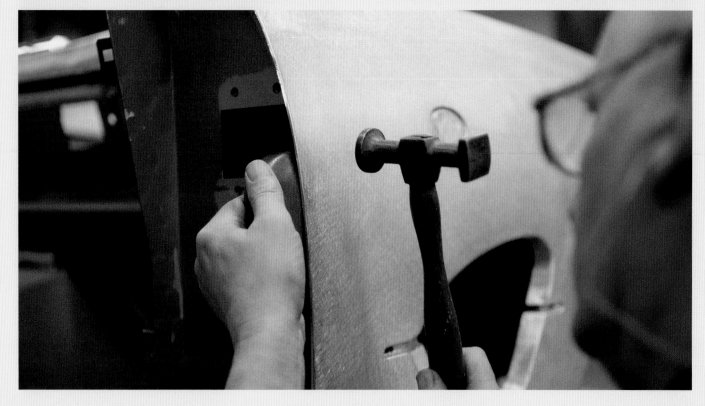

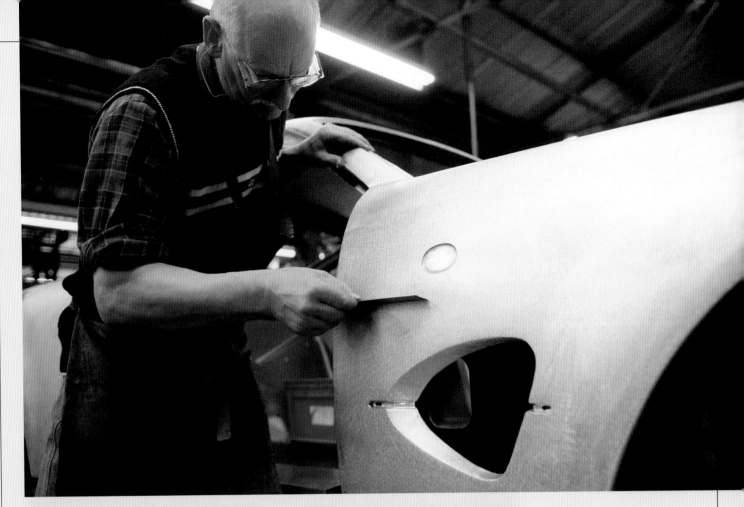

Every member of the body shop personnel has his own tried and trusted set of hardwood and metal hammers, in this illustration being used to conjure forth the lines of a Vantage Le Mans. All traces of unevenness are unerringly removed in the process. Made to measure: the recess for the door handle.

Für das Formen und Glätten der Karosserieteile, hier eines Vantage Le Mans, verfügt jeder Mitarbeiter im Body Shop über seinen vertrauten Satz Hämmer aus Hartholz und Metall. Verbleibende Unebenheiten werden mit Sicherheit aufgespürt. Passgerecht ausgekehlt: die Vertiefung für den Türgriff.

Pour modeler et lisser les panneaux de carrosserie, ici ceux d'une Vantage Le Mans, chaque collaborateur de l'atelier de carrosserie (le Body Shop) possède son propre jeu de marteaux en bois dur et métal. Les moindres aspérités sont décelées avec un flair de limier. La cavité pour la poignée de la portière, réalisée sur mesure, est martelée avec précision.

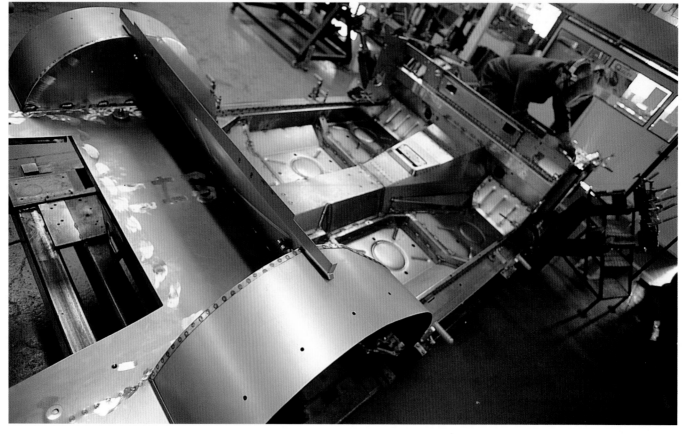

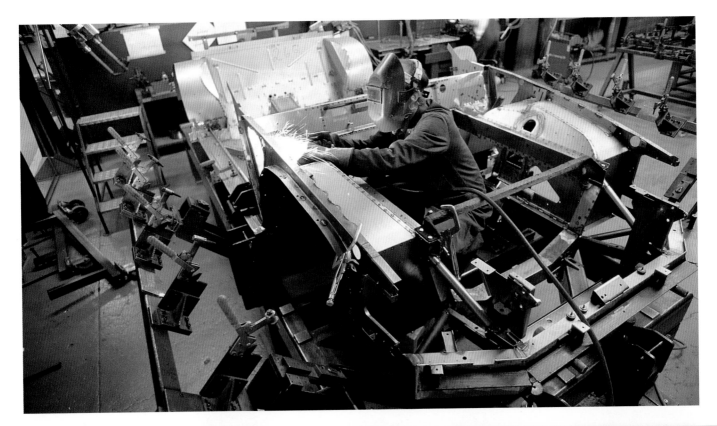

The construction of the chassis frame takes up to three weeks, from the assembly of the stamped and pre-shaped minor parts to the joining of the chassis to the substructure of the body.

Bis zu drei Wochen nimmt der Aufbau eines Rahmens in Anspruch, vom Sammelsurium gestanzter und vorgeformter Kleinteile bis hin zur Vereinigung von Chassis und Unterstruktur der Karosserie.

Il faut jusqu'à trois semaines pour assembler un châssis à partir du puzzle de petites pièces estampées et préformées que l'on monte pour marier le châssis et la structure supportant la carrosserie.

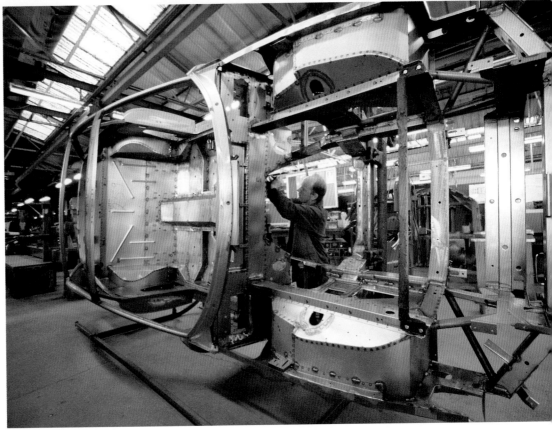

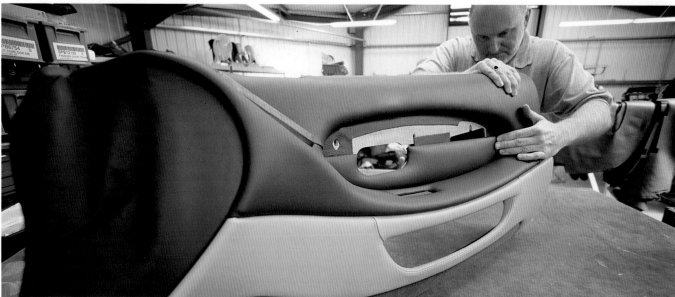

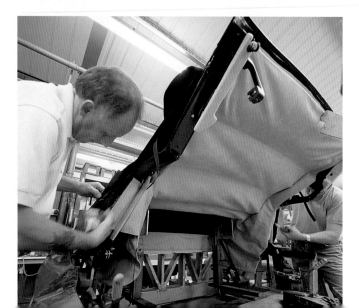

Tailoring work in the trim shop: fragrant Connolly leather is carefully inspected for the tiniest imperfection, while high-grade synthetic materials like Alcantara are also precision hand-cut from patterns and fitted over their corresponding parts, in this case the door paneling of a DB7. The heavy fabric roof of the Volante is composed of six layers.

Maß-Arbeit auch im Trim Shop: Duftendes Connolly-Leder, noch einmal sorgfältig untersucht auf kleinste Unregelmäßigkeiten hin, aber auch edle Kunststoffe wie Alcantara werden anhand von Vorlagen akkurat zugeschnitten und den entsprechenden Teilen wie etwa der Türverkleidung eines DB7 angezogen. Aus sechs Schichten besteht das schwere Stoffdach eines Volante.

Travail sur mesure à l'atelier d'habillage (le Trim Shop) : le cuir Connolly, à l'odeur enivrante, minutieusement examiné pour déceler les moindres irrégularités, mais aussi de luxueuses matières plastiques comme l'Alcantara sont découpés avec précision à la main, à l'aide de patrons, puis mis en place sur la DB7. Il s'agit ici du capitonnage d'une portière. La lourde capote d'une Volante se compose de six couches de matériau.

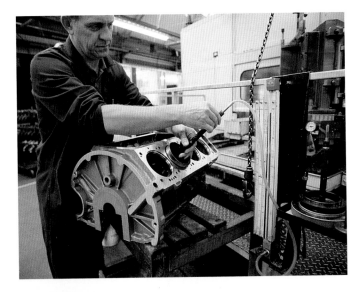

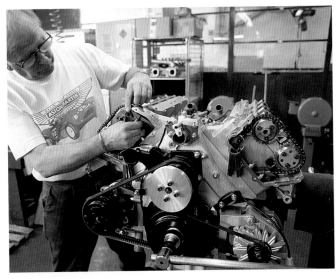

70 man hours are invested in a Vantage power unit, each one of which is the personal responsibility of a single employee. The V8 depicted on the right is nearing completion. The eagle eyes of a specialist with his neon tubes and the expert hands of one of his colleagues do not allow the slightest detail to escape their attention.

70 Arbeitsstunden müssen beispielsweise in ein Vantage-Triebwerk investiert werden, und zwar in der Verantwortung je eines Mitarbeiters. Der rechte V8 steht kurz vor seiner Fertigstellung. Dem Argusauge des Spezialisten bei der Endabnahme und seiner Neonröhre sowie der kundigen Hand seines Kollegen entgeht nicht die kleinste Scharte.

Il faut 70 heures de travail pour fabriquer un moteur de Vantage et chaque tâche est placée sous la responsabilité d'un seul collaborateur. Le V8 de droite est pratiquement terminé. Pas le moindre défaut n'échappe à l'œil d'aigle du spécialiste lors du contrôle final effectué avec les tubes au néon ni à la main experte de son collègue.

Seventh heaven: to go with a design reminiscent of past glories, the DB7's name revives a long-dormant tradition.

Siebtes Sigel: Neben Anleihen bei früheren Formen nimmt der DB7 durch seinen Namen eine lange rostende Tradition wieder auf.

Le septième sceau : rappel d'un passé glorieux, mais aussi retour à une longue tradition.

First made possible by the coming together of Ford's Jaguar and Aston Martin subsidiaries under the aegis of the cosmopolitan Walter Hayes, the DB7 marked a return to the names based on the iconic David Brown's initials, a tradition which had fallen into disuse in 1972. The DB7 brings together tradition and high-tech, in-house workmanship and external sourcing to create a dyed-in-the-wool Aston Martin. The car had its premiere at the Geneva Motor Show in March 1994, where its breathtaking lines met with an enthusiastic response from the visiting crowds. The idea of encroaching on the territory of the Porsche 928, Mercedes SL and Ferrari 328 by producing a smaller model in larger numbers first came to Victor Gauntlett in the mid-1980s, but at that time the company simply did not have the funds to implement it, a reality with which Aston Martin had so often had to live.

Hayes chose a dramatic method of inspiring his designer, the 35-year-old Ian Callum. He simply wheeled a DB4, a DB5 and a DB6 into the design studio, slapped Callum on the back and said: "Do me another one like these!" Callum had previously worked for Ford and Ghia and was now employed by race enthusiast Tom Walkinshaw's conglomerate. His favorite Aston Martin: the DB4GT Zagato.

His design was undoubtedly pleasing on the eye, combining steel bodywork with composite elements such as the hood and trunk lid, the front wings and the bumper covers, which were produced in collaboration with Astec, another company in the TWR (Tom Walkinshaw Racing) group. Apart from this, free use was made of Jaguar parts and equipment, this providing the source, for example, of the chassis and suspension components such as lower wishbones with driveshafts acting as upper links at the rear. The power unit was likewise derived from the Jaguar, and by a stroke of good fortune this allowed the dormant Aston Martin tradition of the straight six engine to be revived in the form of a 3.2-liter version of the AJ6 engine featuring four valves per cylinder and twin overhead camshafts. However, before this was deemed worthy to reside beneath the hood of the DB7, it was thoroughly modified by the engineer Geraint Castleton-White and fitted with an Eaton compressor which boosted its output to 340 horsepower. A water-cooled intercooler controlled the high temperatures thus produced.

Production of the DB7 was at the Bloxham plant which until shortly before had produced the Jaguar XJ220, and which now, after some structural alterations, became Aston Martin Oxford Limited. As with the Virage, as a parallel to the coupé an equally attractive Volante version had been developed. This had a simultaneous premiere at the Detroit and Los Angeles Motor Shows of January 1996, thus paying due deference to the all-important North American market.

In its issue of 30th June 1999 the journal *auto motor und sport* declared the DB7 Vantage, which had had its debut at the Geneva Spring Motor Show that same year, to be simply the best Aston Martin of all time. Given the alarming cost of the time-honored and time-consuming hand craftsmanship that goes into the V8 models, they were almost a giveaway at a price of DM 237,000 (£72,000) for the coupé and DM 257,500 (£78,000) for the Volante, just DM 20,630 more than the basic model, not a sum to frighten off the average DB7 purchaser.

And this all the less so given that, in place of the supercharged straight six of the base model, the Vantage boasted a V12 engine which was a veritable work of art. The 48-valve light-alloy power unit, which was scarcely any heavier than the six-cylinder engine, was developed in close cooperation with Ford and Cosworth Technology's vehicle research and development unit. The engineers' specifications stipulated that the car must not sound like a shrinking violet, and so a rich, creamy and aggressive sound emanated from the double exhaust pipes. The refined Visteon engine management system monitored and controlled the fuel injection, ignition, traction control, alarm system, exhaust and engine diagnostics. External evidence of the powerful cooling system came in the form of Ian Callum's somewhat different nose design incorporating wide vents and a new radiator grille of highly-polished metal.

The massive 410 horsepower generated by the engine meant that the suspension system also had to be modified, with new front wishbones connected to new trailing arms, while an additional horizontal bar structure at the rear contributed to the Vantage's superb roadholding. Powerful deceleration was provided by huge Brembo discs with four-piston calipers. Apart from a few cheap components taken from the Ford range, the DB7's passenger compartment offered the luxury to be expected of a vehicle in this price range, including such features as Connolly leather upholstery with adjustable seats, backs and headrests. The instruments were also newly designed. A high-quality stereo system was concealed discreetly behind a folding panel. A particularly eye-catching feature which harked back to earlier times was the red starter button on the midconsole next to a handsome analog timepiece.

If desired, and if the purchaser could afford the swingeing extra charges involved, each Vantage could be individualized via virtually unlimited paint and upholstery options, and the buyer could even have the traditional hardwood paneling replaced by other materials.

Per aspera ad astra – through night to the light. The Aston Martin DB7 Vantage was proof positive that unremitting stubbornness in the name of a worthwhile idea will pay off in the end.

Möglich wird er erst durch das familiäre Miteinander der schönen Ford-Töchter Jaguar und Aston Martin, mit dem Weltmann Walter Hayes als väterlichem Moderator. Und die Ikone David Brown spendet ihren Segen dazu und ihre Initialen DB, die seit 1972 unbenutzt herumgelegen haben. Im DB7 fließen Überliefertes und Fortschrittliches, Eigenes und Fremdes ineinander zu einer Identität aus einem Guss, zu einem in der Wolle gefärbten Aston. Die Besucher des Genfer Salons im März 1994 stellen das staunend und aufatmend fest, sofern ihnen das Wohl der Edel-Manufaktur mit Sitz in Newport Pagnell am Herzen liegt. Die Idee, mit einem kleineren und in größerer Stückzahl hergestellten Modell in den Fanggründen der Porsche 928, Mercedes SL und Ferrari 328 räubern zu können, kommt in den Achtzigern bereits Victor Gauntlett. Aber die Mittel fehlen, wie üblich.

Hayes wählt eine drastische Form der Inspiration. Er lässt dem 35-jährigen Designer Ian Callum einen DB4, einen DB5 und einen DB6 in ein Studio rollen mit einem herzhaften Klaps auf den Hintern und der programmatischen Aufforderung: Weiter in diesem Stil! Callum war früher bei Ford und Ghia angestellt und arbeitet jetzt für das Firmenkonglomerat des umtriebigen Rennmenschen Tom Walkinshaw. Sein Lieblings-Aston: der DB4GT Zagato.

Kein Zweifel, sein Entwurf schmeichelt sich ins Auge und Herz, diesmal in Stahl gewandet, aber mit Kompositelementen wie dem Motor- und dem Kofferraumdeckel, den Kotflügeln vorn oder den Auflagen auf den Stoßfängern. Sie werden beigesteuert von Astec, einem anderen Unternehmen der TWR (für Tom Walkinshaw Racing)-Gruppe.

Im Übrigen bedient man sich freizügig aus den Jaguar-Regalen, entnimmt ihnen etwa das Chassis mit Aufhängungsteilen, die von den Gepflogenheiten der früheren Konkurrenten zeugen wie zum Beispiel die unteren Querlenker mit mittragender Halbachse hinten. Auch hinsichtlich des Triebwerks wird man fündig, kann sogar an die brachliegende Tradition der Reihensechszylinder anknüpfen mit einer 3,2-Liter-Version des AJ6-Motors mit vier Ventilen pro Verbrennungseinheit und zwei oben liegenden Nockenwellen. Bevor dieser allerdings für würdig erachtet wird, unter der Haube des DB7 einzuziehen, wird er vom Ingenieur Geraint Castleton-White gründlich überarbeitet und mit einem Eaton-Kompressor zusammengespannt, der ihm 340 PS einbläst. Ein wassergekühlter Intercooler mäßigt die auftretenden Temperaturen. Angeschoben und ausgeführt wird die Produktion des DB7 zu Bloxham in jenem Werk, das bis vor kurzem die Wiege des Jaguar XJ220 gewesen ist und nun mit einigen baulichen Veränderungen zur Aston Martin Oxford Limited umgewidmet worden ist. Das Volante, wie schon beim Virage parallel zum Coupé entwickelt und kaum weniger attraktiv als dieses, stellt man im Januar 1996 gleichzeitig in Detroit und in Los Angeles vor und zollt damit dem wichtigen nordamerikanischen Markt die gebührende Achtung.

Den besten Aston Martin, den es je gab, nennt das Fachmagazin *auto motor und sport* in der Ausgabe vom 30. Juni 1999 den DB7 Vantage. Seine Aufwartung hat er auf dem Genfer Frühlingssalon des gleichen Jahres gemacht. Gemessen an den Schwindel erregenden Preissphären für die betagten und in zeitraubender Handarbeit in die Welt gesetzten V8-Modelle sei er fast geschenkt, mit DM 237 000 für das Coupé und DM 257 500 für das Cabrio namens Volante. Nur DM 20 630 trennten ihn vom Basismodell, ein Betrag, den kein DB7-Interessent scheuen solle.

In der Tat: Anstelle des aufgeladenen Sechszylinders residiert im Motorenabteil des Vantage ein V12, ein veritables Prachtstück zumal. Der 48-Ventiler aus Leichtmetall, kaum schwerer als jener, wurde in enger Zusammenarbeit mit der Fahrzeugforschungs- und Entwicklungsgruppe von Ford und Cosworth Technology entwickelt. Im Lastenheft der Ingenieure stand geschrieben, er solle kein Säusler werden, und so entströmt dem Doppelauspuff des schönen Briten ein cremig-aggressiver Sound. Ein ausgefeiltes Visteon-Motorenmanagement überwacht und regelt Einspritzung, Zündung, Antriebsschlupfregelung, Alarmanlage, Abgas und Motordiagnose. Das leistungsstärkere Kühlsystem des Neuen findet auch rein äußerlich seinen Niederschlag: Ian Callum entwarf eigens für ihn ein etwas anderes Gesicht mit breiteren Luftansaugöffnungen sowie einem veränderten Kühlergrill aus hochglanzpoliertem Metall.

Bei satten 410 PS konnte die Aufhängung nicht unangetastet bleiben. Neue Querlenker vorn sind mit einem ebenfalls neuen Längslenker verbunden, und hinten trägt zusätzlich ein Horizontalgestänge zur exzellenten Straßenlage des Vantage bei, der sich vermittels riesiger Scheiben mit Vierkolben-Sätteln von Brembo brutal verzögern lässt.

Abgesehen von einigen wenigen billigen Zutaten aus dem Ford-Sortiment verwöhnt der Wohnbereich des DB7 den Passagier mit dem Ambiente, das von einem Fahrzeug seiner Preisklasse zu erwarten ist, zum Beispiel mit duftendem Connolly-Leder bezogenen Schalensitzen, deren Polster, Rückenlehnen und Kopfstützen einstellbar sind. Die Instrumente erscheinen ebenfalls in neuem Design. Eine hochkarätige Stereoanlage verbirgt sich diskret hinter einer ausklappbaren Blende. Besonderer Blickfang: der uralte Zeiten erinnernde rote Anlasserknopf in der Mittelkonsole in der Nachbarschaft einer hübschen Analoguhr.

Auf Wunsch und gegen wenig zimperlich berechnete Aufpreise wird jeder Vantage zum Auto-Individuum. Der Glückliche, der ihn sich dann noch in die beheizte Garage zu stellen vermag, hat die Qual der Wahl aus einer schier unbegrenzten Palette von Farben für Lack und Sitzbezüge und kann sogar die traditionellen noblen Holzverkleidungen durch andere Werkstoffe ersetzen lassen.

Per aspera ad astra – durch Nacht zum Licht. Anhand des Aston Martin DB7 Vantage lässt sich nachweisen, dass sich Hartnäckigkeit in Namen einer Idee, die es wert ist, am Ende auszahlt.

Elle doit sa naissance à l'association entre la marque Jaguar, appartenant à Ford, et Aston Martin, sous l'égide du mondain Walter Hayes. L'icône David Brown a la générosité de lui donner sa bénédiction et ses initiales DB, restées inutilisées depuis 1972. La DB7 allie tradition et progrès, savoir-faire « maison » et apports extérieurs dans une Aston grand teint. Présentée au public au Salon de Genève, en mars 1994, elle reçoit un accueil enthousiaste du public, séduit par ses lignes époustouflantes. L'idée consistant à marcher sur des brisées des Porsche 928, Mercedes SL et Ferrari 328 avec un modèle de plus petite taille et fabriqué en plus grand nombre est déjà venue à Victor Gauntlett dans les années 1980. Mais il souffrait d'une pénurie d'argent chronique.

Hayes a une façon bien à lui de susciter l'inspiration. Il fait rouler dans le studio, à l'intention du designer Ian Callum, âgé de 35 ans, une DB4, une DB5 et une DB6. Puis, avec une tape amicale sur l'épaule, il lance au jeune homme : « Continuez dans ce style ! » Après avoir été autrefois chez Ford et Ghia, Ian Callum travaille maintenant pour le conglomérat de firmes du très actif ancien pilote de course Tom Walkinshaw. Son Aston préférée est la DB4GT Zagato.

Et à n'en pas douter, la création de Ian Callum est un régal pour l'œil, avec son matérialisé dans l'acier, mais avec des éléments en matériaux composites, par exemple le couvercle de malle et du compartiment moteur, les ailes avant ou les pare-chocs. Ils sont fournis par Astec, une autre entreprise du groupe TWR (abréviation de Tom Walkingshaw Racing).

Pour le reste, on pioche de bon cœur dans la banque d'organes de Jaguar, où l'on prélève par exemple le châssis avec certains éléments de suspension, notamment les bras inférieurs transversaux et demi-arbres porteurs à l'arrière – témoignage des coutumes en vigueur chez l'ancien concurrent. C'est également là que l'on trouve le moteur, à l'occasion de quoi l'on peut même faire revivre la tradition du six-cylindres en ligne avec une version de 3,2 litres du moteur de l'AJ6 à quatre soupapes par cylindre et deux arbres à cames en tête. Avant que ce moteur ne soit toutefois jugé digne de prendre place sous le capot de la DB7, l'ingénieur Geraint Castleton-White le revoit complètement et le dote d'un compresseur Eaton qui lui assure 340 ch. Un échangeur d'air à refroidissement liquide tempère les écarts de température.

La production de la DB7 débute à Bloxham, l'usine même qui, peu de temps auparavant, avait été le berceau de la Jaguar XJ220 et qui, maintenant, après quelques modifications architecturales, a été rebaptisée Aston Martin Oxford Limited. Le cabriolet Volante, développé parallèlement au coupé, comme cela s'était produit pour la Virage, et tout aussi attrayant que le cabriolet de cette dernière, est présenté simultanément, en janvier 1996, à Detroit et Los Angeles. Aston Martin rend ainsi à l'important marché américain l'hommage qui lui revient. Dans son numéro du 30 juin 1999, la revue spécialisée *auto motor und sport* qualifie la DB7 Vantage de meilleure Aston Martin de tous les temps. Elle a été présentée au Salon de Genève, au printemps de la même année. Compte tenu du prix astronomique des modèles V8, la revue allemande la qualifie de cadeau avec 237 000 DM pour le coupé et 257 500 DM pour le cabriolet, baptisé Volante. La différence par rapport au modèle de base est de seulement 20 630 DM, une somme qui ne fera naturellement pas sourciller le véritable amateur de DB7.

En effet, à la place du six-cylindres suralimenté, on trouve dans le compartiment moteur de la Vantage un V12 et, qui plus est, un joyau de moteur. Le 48 soupapes en aluminium, à peine plus lourd que celui qu'il remplace, a été mis au point en étroite coopération avec le groupe de recherche et de développement automobile Ford Cosworth Technology. Le cahier des charges donné aux ingénieurs précisait qu'ils devaient laisser s'exprimer librement le tempérament du moteur. Une gestion moteur Visteon sophistiquée contrôle et gère l'injection, l'allumage, la régulation antipatinage, l'alarme antivol, la dépollution et le système de diagnostic du moteur. Le système de refroidissement de ce moteur est plus performant et cela se voit immédiatement de l'extérieur : Ian Callum a créé spécialement pour lui un dessin légèrement différent avec des prises d'air plus larges ainsi qu'une calandre modifiée en métal poli.

Avec une puissance de 410 ch, la suspension devait impérativement être revue et corrigée. Les nouveaux bras transversaux avant sont reliés à un bras longitudinal et, à l'arrière, une timonerie horizontale supplémentaire contribue à l'excellente tenue de route de la Vantage.

Abstraction faite d'un petit nombre d'accessoires bon marché provenant de la banque d'organes Ford, le cockpit de la DB7 comble ses passagers avec l'ambiance que l'on est en droit d'attendre d'une voiture de cette gamme de prix, par exemple avec des sièges revêtus d'odoriférant cuir Connolly aux coussins, dossiers et appuie-tête réglables. Un détail rappelle une époque depuis longtemps révolue : le bouton de démarreur rouge sur la console médiane, qui côtoie une jolie pendulette analogique. Sur demande, et si l'on est prêt à payer un supplément de prix calculé généreusement, il est possible de personnaliser chaque Vantage jusque dans les moindres détails. L'homme heureux qui pourra ensuite la conserver dans son garage chauffé aura l'embarras du choix dans une palette quasiment illimitée de coloris pour la carrosserie et le capitonnage de sièges, et il pourra même faire remplacer la luxueuse ronce de noyer traditionnelle par d'autres matériaux.

Per aspera ad astra – à travers la nuit vers la lumière. L'Aston Martin DB7 Vantage est bien la preuve de l'entêtement envers et contre tout au nom d'une idée qui en vaut la peine finit toujours par être récompensé.

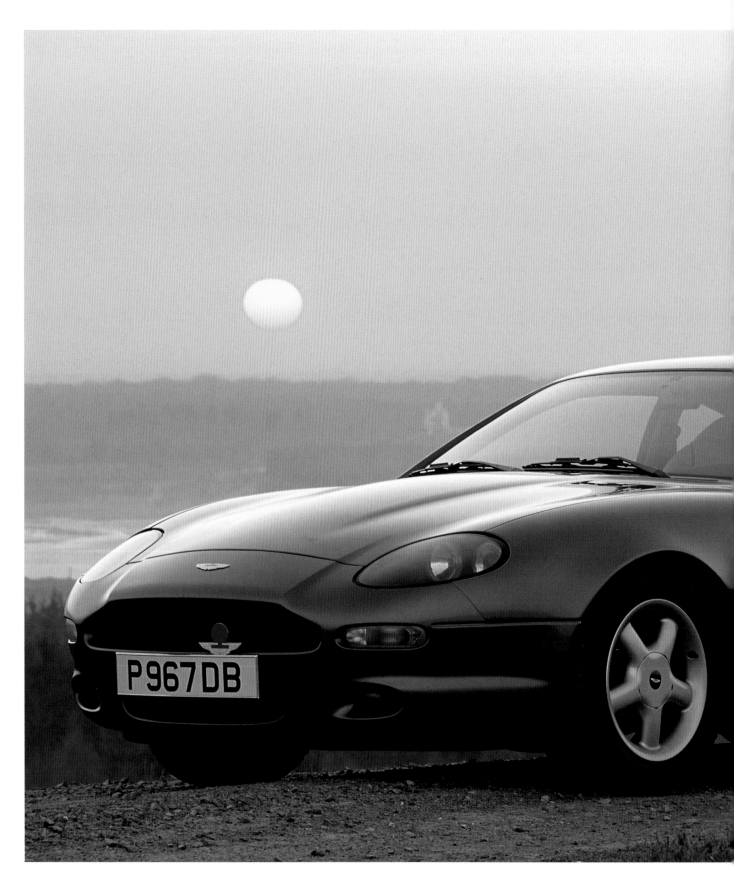

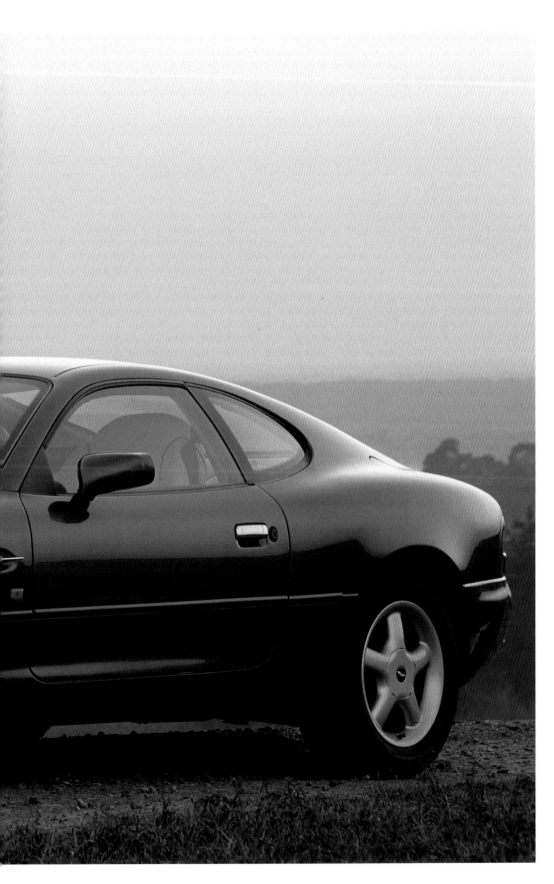

These attractive five-spoke wheels are an optional extra.

Diese Felgen in einer attraktiven Fünfspeichen-Version stammen aus den Regalen mit der Sonderausstattung.

Ces jantes à l'attrayant design à cinq rayons figurent dans la liste des options.

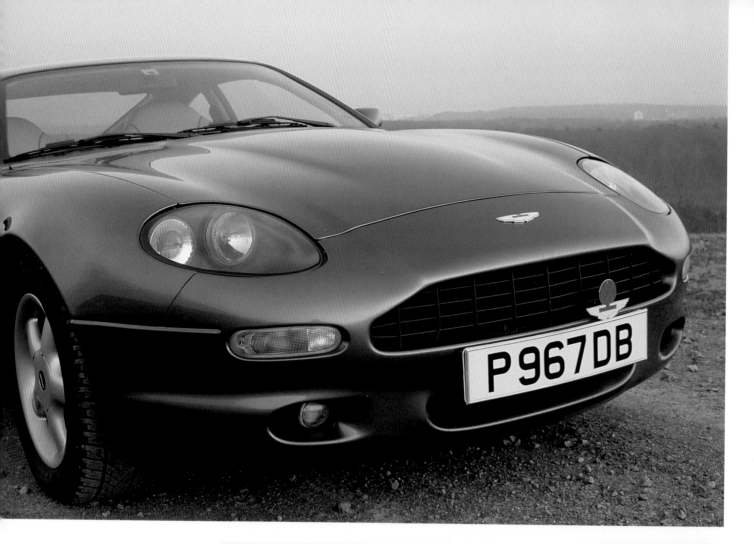

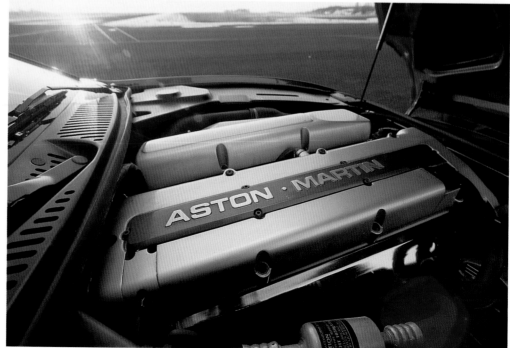

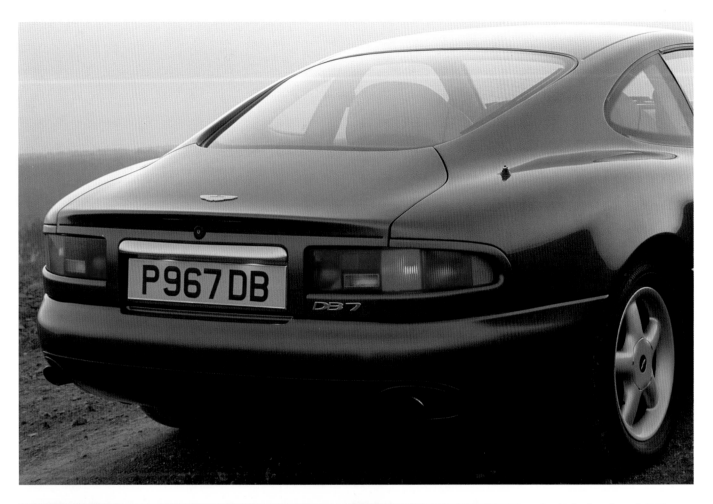

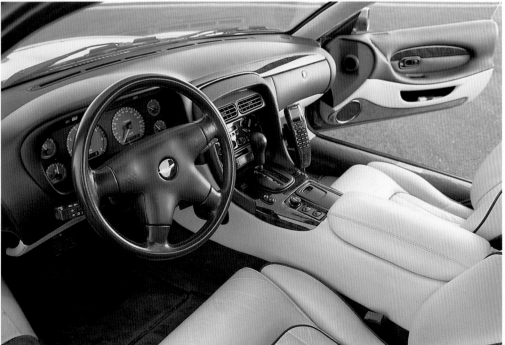

A multicultural experience: the DB7's straight-six engine is a composite, containing, for instance, a Jaguar block and a compressor developed by Ford. The sumptuous leather, walnut and wool equipment of the interior contrast with simple switches and handles provided by parent company Ford.

Multikulturelles Ereignis: Der Reihen-sechszylinder des DB7 ist eine Komposition aus einem Jaguar-Block und einem von Ford entwickelten Kompressor. Im Inneren kontrastieren Leder, Walnussholz und edle Wolle mit simplen Schaltern und Hebeln der Mutter Ford.

Événement multiculturel : le six-cylindres en ligne de la DB7 est le fruit de l'assemblage d'un bloc Jaguar et d'un compresseur mis au point par Ford. Dans l'habitacle, le cuir, la ronce de noyer et la laine peignée de luxe font contraste avec les manettes et leviers de la roturière maison mère Ford.

DB7

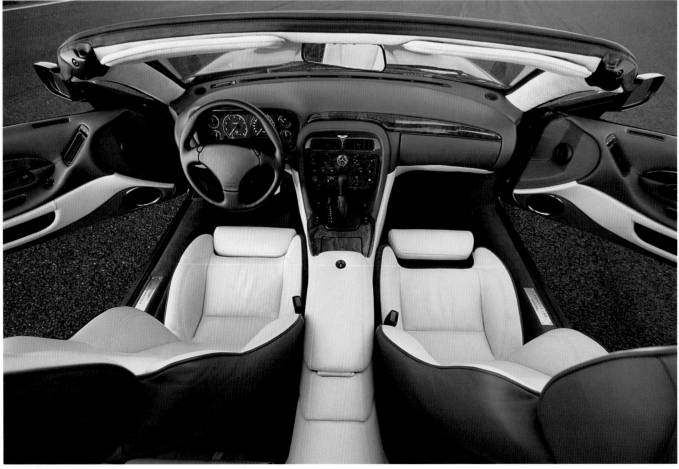

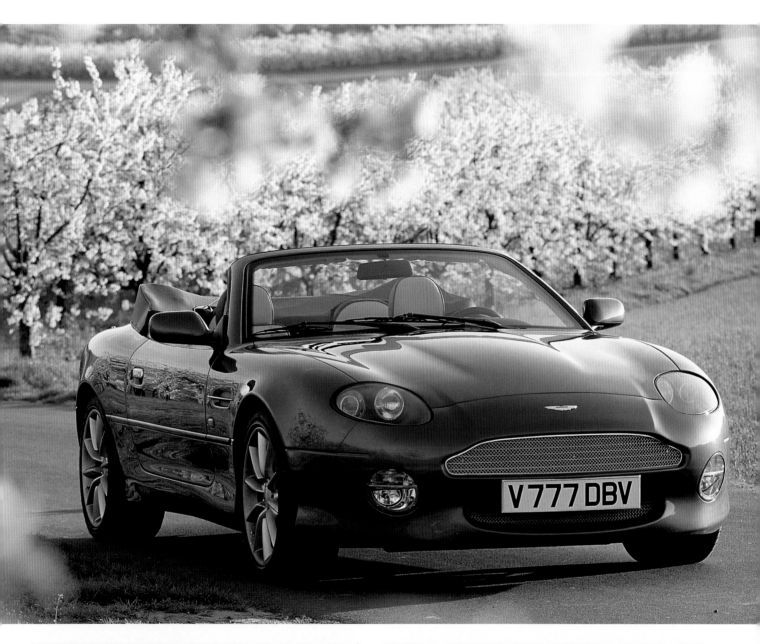

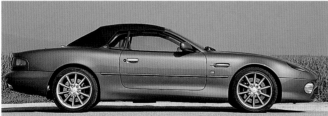

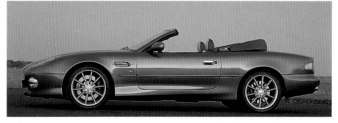

Open to the elements: the DB7 Vantage is distinguished by its larger grille, additional front lights and newly-designed 18-inch wheels. The V12, developed with assistance from Cosworth, barely weighs any more than the six-cylinder engine.

In schöner Offenheit: Den DB7 Vantage erkennt man an seinem größeren Grill, zusätzlichen Frontleuchten und 18-Zoll-Rädern in neuem Design. Der neue V12 wiegt kaum mehr als der Sechszylinder und entstand mit Cosworth als Entwicklungshelfer.

Quand on n'a rien à cacher : on distingue la DB7 Vantage à sa calandre de plus grandes dimensions, à ses feux avant supplémentaires et aux roues de 18 pouces d'un nouveau design. À peine plus lourd que le six-cylindres, le nouveau V12 a été réalisé en coopération avec Cosworth.

Understatement: the prestigious label V12 is nowhere to be found on the DB7 Vantage, a case of saying a lot by saying nothing at all.

Understatement: Den prestigeträchtigen Schriftzug V12 wird man am DB7 Vantage nirgends finden. Somit besteht die Information im Ausbleiben der Information.

Sur la DB7 Vantage, le prestigieux graphisme V12 brille par son absence. L'information est donc donnée par l'absence d'information.

Vanquish

There is something of the predatory animal about the Aston Martin Vanquish's appearance, as if it were just about to pounce, overpower, and devour its prey. Additional headlights and indicators flank the gigantic radiator grille jaws, the last variation for the time being of a theme struck up by the 2-litre Sports.

Vom Auftritt des Aston Martin Vanquish geht etwas Animalisch-Raubtierhaftes aus, so als sei er auf dem Sprung, seine Gegner zu überwältigen und zu verzehren. Das riesige Kühlermaul, vorerst letzte Variation eines Themas, das einst durch den 2-litre Sports angeschlagen wurde, wird flankiert von Zusatzscheinwerfern und den Fahrtrichtungsanzeigern.

Il émane de l'Aston Martin Vanquish quelque chose d'animal et de félin, comme si elle s'apprêtait à bondir pour capturer ses adversaires et les dévorer. La gigantesque gueule de la calandre, pour l'instant l'ultime déclinaison d'un thème qui a été inauguré, jadis, par la 2-litre Sport, est flanquée de phares additionnels et de clignotants.

The original impression was that Aston Martins engineers – used to the constant refinement of revered concepts – had been allowed to play around with their creativity: a series product is not planned, declares the company's boss at the time, Bob Dover, as he introduces the Vantage study project at the Detroit North American Auto Show in January 1998. But this eye-catcher from Buckinghamshire is simply too beautiful not to be true.

A few things are to be settled before the vehicle with the aggressive un-British name of "Vanquish" makes its official appearance at the spring Geneva show in 2001, and before the first production vehicle rolls from the antiquated Tickford Street works in Newport Pagnell on 15th June. Its form truely verges on perfection, a tight fitting suit with a bewitching cut, exuding power, as it were.

Secondly, Dover's successor Ulrich Bez feels uneasy about several weaknesses in the interior fittings, such as the ventilation rosettes derived from Ford's rational Ka model. Thirdly, 50 prototypes are tortured and ravaged over one million miles of testing.

However, the prospects for an exam summa cum laude are excellent. Newport Pagnell needs eight weeks for a single Vanquish, although the proportion of work done by hand has been reduced. Its main structure is formed by a tub of glued and riveted aluminum sheets, fixed to a center tunnel of carbon fiber. This precise material is also to be found in the A column and the front section, where, combined with elements of steel and aluminum, it should contribute to an exemplary reaction in the case of a crash The rear is mainly of plastic reinforced with fiberglass. The Vanquish is veiled in aluminum panels, no longer beaten by hand, but warm-pressed.

The same six-liter V12 as in the DB7 Vantage, albeit strengthened by an extra 49 bhp to 469 bhp by knowledgeable hand in Ford's Cosworth branch, whips the 3970-lbs-heavy coupé to 62 mph in 5.4 seconds and, when desired, and on an empty freeway, manages a top speed of 190 mph. The comprehensive electronic management of this top Aston includes the individual monitoring of tire pressure and temperature. Giant ventilated disk brakes from Brembo have this steed unyieldingly by the bit at all times.

The Vanquish is available as a two-seater or in the 2+2 configuration. The 300 models produced annually can just about satisfy the most urgent demand, despite an introductory price of 240,000 Euros in Germany. One thing is sure: as has often been the case in the past, the inheritor of the Aston Martin will have to be stipulated in the last will and testament.

Au premier coup d'œil, on a l'impression que les ingénieurs d'Aston Martin – habitués à affiner sans relâche des concepts vénérables – n'ont pas pu laisser libre cours à leur créativité : une fabrication en série n'est pas prévue, déclare celui qui était alors le patron de la marque, Bob Dover, lors de la présentation du *concept-car* Project Vantage, à l'occasion du North American Auto Show de Detroit, en janvier 1998. Et pourtant : la belle du Buckinghamshire est tout simplement trop belle pour ne pas devenir une réalité.

Mais, avant qu'elle ne puisse faire officiellement sa révérence lors du Salon de Genève, au printemps 2001, avec un nom martial dont l'agressivité n'a rien de britannique – Vanquish signifie en effet vainqueur – et avant que le premier exemplaire ne sorte des antiques ateliers de la Tickford Street, à Newport Pagnell, le 15 juin, il faut bien évidemment régler quelques détails. Certes, sa forme frise la perfection, avec un smoking bien ajusté et une élégance enivrante qui semble laisser transparaître toute son énergie. De son côté, Ulrich Bez, qui a repris le flambeau de Bob Dover, ressent un certain malaise à la vue de quelques défauts de l'aménagement intérieur, par exemple les grilles d'aération inspirées de la Ford Ka. Ainsi ordonne-t-il spontanément de revoir la copie de l'imposante console médiane habillée d'aluminium. Enfin, 50 prototypes sont testés et torturés sur 1,6 million de kilomètres d'essais.

Les préalables à un examen avec la mention *summa cum laude* sont toutefois brillants. À Newport Pagnell, on ne consacre pas moins de huit semaines à l'assemblage d'une seule et unique Vanquish bien que le degré de travail manuel ait régressé de façon notable. Sa structure principale consiste en un bac en tôles d'aluminium collées et rivetées qui épouse les contours du tunnel de transmission en fibre de carbone. Un matériau précieux que l'on retrouve également dans la baie de pare-brise et la proue de la voiture où, en combinaison avec des éléments en acier et en aluminium, il est censé contribuer à un comportement exemplaire en cas de collision. À l'arrière, c'est la matière plastique renforcée de fibre de verre qui prédomine. La Vanquish est habillée d'une robe en aluminium qui n'est plus martelée à la main, mais emboutie à chaud.

Un V12 de six litres identique à celui de la DB7 Vantage, mais qui a vu sa puissance majorée de 49 ch, à 469 ch, sous les mains expertes des motoristes émérites de Cosworth (une filiale de Ford), catapulte le lourd coupé de 1800 kg en 5,4 secondes de 0 à 100 km/h et jusqu'à une vitesse maximale de 306 km/h lorsque le conducteur en a envie et que les autoroutes sont vides. Les 300 exemplaires fabriqués chaque année devraient tout juste satisfaire la demande la plus pressante malgré un prix d'achat de 240 000 euros en Allemagne. Une chose est sûre : comme cela a déjà fréquemment été le cas par le passé, nombreux seront les propriétaires qui devront préciser dans leur testament qui, après leur décès, héritera de leur Aston Martin Vanquish.

Ursprünglich sieht es aus, als hätten sich die Ingenieure von Aston Martin – gewöhnt an die unablässige Verfeinerung von ehrwürdigen Konzepten – nur ein wenig auf der kreativen Spielwiese tollen dürfen: Eine Serienfertigung, erklärt der damalige Firmenchef Bob Dover bei der Vorstellung der Studie Project Vantage anlässlich der North American Auto Show zu Detroit im Januar 1998, sei nicht geplant. Dennoch: der Blickfang aus Buckinghamshire ist einfach zu schön, um nicht wahr zu sein.

Bevor er indessen auf dem Genfer Frühlingssalon 2001 mit dem unbritisch-aggressiven Kriegernamen Vanquish (zu Deutsch: Sieger sein) offiziell seine Aufwartung macht und der erste Produktionswagen am 15. Juni aus den antikischen Werkhallen an der Tickford Street zu Newport Pagnell rollt, sind noch ein paar Dinge zu erledigen. Gewiss grenzt seine Form an Perfektion, ein knapp sitzender Anzug von betörendem Zuschnitt, durch den gewissermaßen seine Kraft hindurchatmet. Zum Zweiten empfindet Dovers Nachfolger Ulrich Bez Unbehagen angesichts einiger Schwächen der Inneneinrichtung wie etwa Lüftungsrosetten aus dem Vernunftmobil Ford Ka. Zum Dritten werden 50 Prototypen auf 1,6 Millionen Testkilometern gequält und geschunden.

Die Voraussetzungen zu einem Examen *summa cum laude* sind allerdings glänzend. Acht Wochen benötigt man in Newport Pagnell, einen einzigen Vanquish auf die Räder zu stellen, obwohl das Maß an Handwerk entschieden zurückgegangen ist. Seine Hauptstruktur wird gebildet von einer Wanne aus verklebten und genieteten Aluminiumblechen, die sich einem Mitteltunnel aus Kohlefaser anlagert. Dieser preziöse Werkstoff findet sich auch in den A-Säulen und im Vorderwagen, wo er im Verbund mit Stahl- und Aluminiumelementen zu vorbildlichem Verhalten bei einem Crash beitragen soll. Hinten über-wiegt glasfaserverstärkter Kunststoff. Gehüllt ist der Vanquish in Aluminiumblech, nicht mehr von Hand gedengelt, sondern warm gepresst.

Der gleiche 6-Liter-V12 wie im DB7 Vantage, allerdings in der Ford-Filiale Cosworth unter kundigen Händen mit vorsichtigen Eingriffen um 49 auf 469 PS erstarkt, wuchtet das 1800 kg schwere Coupé in 5,4 Sekunden auf Tempo 100 und bei Lust, Laune und leeren Autobahnen auf 306 Stundenkilometer Spitze. Riesige, innen belüftete Scheibenbremsen von Brembo nehmen ihn stets unnachgiebig an die Kandare.

Es gibt den Vanquish als Zweisitzer oder in der Konfiguration 2+2. Die 300 Exemplare pro Jahr konnten die dringendste Nachfrage gerade eben befriedigen, trotz eines Einstandspreises von 240 000 Euro in Deutschland. Eines ist sicher: Wie schon häufig in der Vergangenheit wird ein Erblasser in seinem Testament festhalten müssen, wer nach seinem Ableben den Aston Martin bekommt.

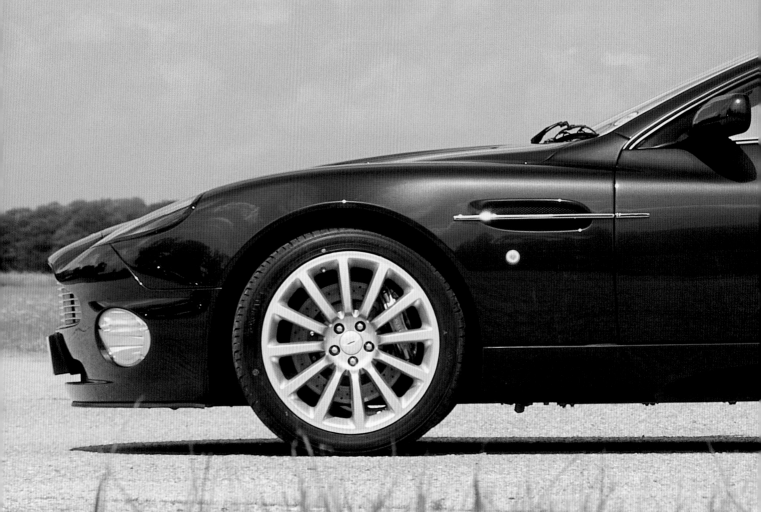

Traditional elements are united with the up-to-date style features of a super car, with a plethora of allusions to earlier products of this renowned company, in the silhouette of the Aston Martin flagship of its time. The short overhang at the rear, and the subtly pronounced spoiler lip integrated into the trunk lid, are striking. White instrumentation monitor the well-being of the powerful V12, whose increased strength in comparison with the DB7 Vantage stems from new exhaust and intake manifolds, among other things.

In der Silhouette des ehemaligen Aston-Martin-Flaggschiffs vereinigen sich in einer Fülle von Anspielungen auf frühere Produkte des hohen Hauses traditionelle Elemente mit zeitgemäßen Stilmerkmalen eines Supercars. Auffällig sind der kurze Überhang hinten und die in den Kofferraumdeckel integrierte, dezent ausgeprägte Spoilerlippe. Weiße Instrumente überwachen das Wohlbefinden des mächtigen V12, dessen Zuwachs an Stärke gegenüber dem DB7 Vantage unter anderem aus neuen Einlass- und Auspuffkrümmern erwächst.

La silhouette de l'actuel navire amiral d'Aston Martin associe, en une multitude de réminiscences de modèles antérieurs de cette prestigieuse manufacture, des éléments traditionnels et des caractéristiques de style contemporaines de supercar. Frappants sont le court porte-à-faux arrière et la lèvre d'aileron d'une grande discrétion intégrée au couvercle de malle. Des cadrans à fond blanc donnent des informations sur l'imposant V12 dont le gain de chevaux, par rapport à la DB7 Vantage, s'explique notamment par de nouveaux collecteurs d'admission et d'échappement.

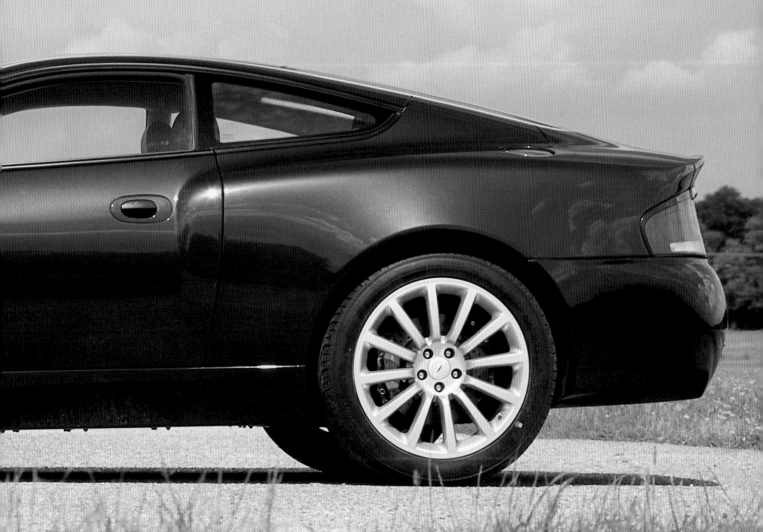

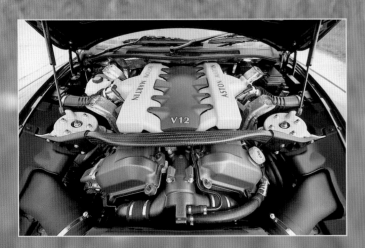

DB7 Zagato & AR

In the view of the present-day company boss Dr. Andrea Zagato, it was now time to put a new joint project with Aston Martin on the road, to follow in the tracks of the super-light DB4 Zagato of 1961 and the Gianni and Elio Zagato brothers' V8 Coupé and Volante, controversial because of the modern appearance. Presenting this view to Dr. Ulrich in the fall of 2001, he met with the approval of Aston Martin's chief. The design is agreed upon in all its details by the following January, so that it can be jointly presented at the 2002 Geneva motor show.

In contrast to the "Superleggera" of those days – designed for racing, and only 19 examples built – the two-seater DB7 Zagato is no thoroughbred racing car. Hiding behind its large "snout," the dimensions of which exceed those of the DB4 GT Zagato's and almost resemble those of the 1952 Ferrari 250S Berlinetta, lies a Granturismo on the basis of a DB7 Vantage chassis shortened by 2½ inches. Faced with 147 seriously interested customers willing to dig deep into their pockets to the tune of almost 260,000 Euro, the producers agreed upon the construction of 99 Zagato coupés. Coupés because, in view of this welcome situation, it is intended to offer an open-topped variation – also 99 vehicles – for sale as well.

The most striking characteristic of the closed Zagato is its "double bubble" roof, a steel roof with two domed bubbles, the separate contours of which are consequentially followed through to the rear windshield. The roadster expresses this element of design with two humps behind the headrests that tail off to the vehicle's rear. Much aluminum is used in the vehicle's construction, apart from the coupé's roof, to ensure a weight advantage of at least 130 lbs over the conventional Vantage, in total 3836 lbs – 1100 more than the legendary "Superleggera"! More power – then 270 bhp, today 440 bhp – easily restores the balance of the scales. In those days, a Zagato owner could not even dream of 185 mph; this however, has become reality with the DB7 Zagato, not to mention an acceleration from 0 to 60 mph in under five seconds. The driving performance is in keeping with Aston Martin's own sporting counterpart, the DB7 GT. The 6-gear transmission with Quickshift belongs to the sport package for the Vantage, as does the chassis and the 4.09 differential. The aluminum wheels designed by Zagato, 8 x 18 inch at the front and 9 x 18 at the rear, allow a corresponding 0.8- and 1.2-inch increase of track width, respectively. In this way, the format of the wheel houses of the 1.2-inch wider Zagato is fully utilized. The braking system has also been made more pithy by little but nonetheless effective modifications.

Nach dem superleichten DB4 Zagato von 1961 und dem – wegen seiner modernen Optik umstrittenen – V8 Coupé nebst Volante der Gebrüder Gianni und Elio Zagato sei es nun an der Zeit, so befindet der heutige Firmenchef Dr. Andrea Zagato, wieder einmal ein gemeinsames Projekt mit Aston Martin auf die Räder zu stellen. Dieses, im Herbst 2001 Dr. Ulrich Bez vorgetragen, findet sofort ein offenes Ohr beim Aston-Martin-Obersten. Im Januar darauf ist das Design in allen seinen Details abgesegnet, so dass es beim Genfer Salon 2002 gemeinsam präsentiert werden kann.

Im Gegensatz zum damaligen »Superleggera« – in nur 19 Exemplaren gebaut und auch für Renneinsätze konzipiert – ist der zweisitzige DB7 Zagato kein reinrassiger Sportler. Hinter seiner großen »Schnauze«, deren Dimensionen die des DB4 GT Zagato noch übertreffen und fast dem Ferrari 250S Berlinetta von 1952 ähneln, verbirgt sich ein Granturismo auf der Basis eines um sechs Zentimeter verkürzten DB7-Vantage-Chassis. Angesichts von 147 ernst zu nehmenden Interessenten, denen der Griff in die Schatulle zum Berappen von knapp 260 000 Euro auch nicht weh tut, wird der Bau von 99 Zagato in Coupé-Form beschlossen. Coupé deswegen, weil man angesichts dieser erfreulichen Lage auch eine offene Variante – ebenfalls 99 Fahrzeuge – anbieten will.

Markantestes Merkmal des geschlossenen Zagato ist das »double bubble roof«, ein in zwei Blasen gewölbtes Stahldach, dessen geteilte Kontur konsequent durch die Heckscheibe fortgesetzt wird. Beim Roadster äußert sich dieses Design-Element in zwei Hutzen, die von den Kopfstützen zum Wagenheck auslaufen. Abgesehen vom Dach des Coupés wird viel Aluminium verbaut, um gegenüber dem herkömmlichen Vantage wenigstens ein Gewichts-Advantage von 60 Kilo zu erzielen, insgesamt 1740 Kilo – 500 mehr als beim legendären »Superleggera«! Mehr Kraft – damals 270 PS, heute 440 PS – gleicht die Differenz auf der Waage locker aus. Von 300 Stundenkilometern wagte ein Zagato-Besitzer seinerzeit nicht einmal zu träumen, im DB7 Zagato sind sie Realität, ganz zu schweigen davon, dass er unter fünf Sekunden von 0 auf 100 km/h beschleunigt. Die Fahrleistungen entsprechen also dem sportlichen Pendant von Aston Martin selbst, dem DB7 GT. Das 6-Gang-Getriebe mit Quickshift stammt aus dem Sport-Paket für den Vantage, ebenso das Fahrwerk und das 4.09-Differenzial. Die von Zagato entworfenen Alu-Räder, 8 x 18 Zoll vorn und 9 x 18 hinten, ermöglichen entsprechende Spurverbreiterungen von 20 und 30 Millimetern. So werden die Radkästen des insgesamt 31 Millimeter breiteren Zagato formatfüllend genutzt. Auch die Bremsanlage wird durch kleine, aber wirkungsvolle Modifikationen griffiger gemacht.

Après l'ultralégère DB4 Zagato de 1961 et la V8 Coupé – très contestée en raison de son esthétique moderne – sans oublier la Volante des frères Gianni et Elio Zagato, l'actuel patron du constructeur italien, Andrea Zagato, estime que le moment est venu de mettre en chantier, une fois de plus, un projet commun avec Aston Martin. Présenté à l'automne 2001 au P.-D.G. Ulrich Bez, ce projet retient immédiatement l'attention de la direction d'Aston Martin. Plus tard, en janvier, le design est approuvé dans ses moindres détails, si bien qu'il peut faire l'objet d'une présentation commune au Salon de Genève en 2002.

Contrairement à la « Superleggera » de jadis – construite en 19 exemplaires

seulement et conçue aussi pour la course –, la DB7 Zagato biplace n'est pas une voiture de sport pure et dure. Derrière sa grosse « gueule », dont les dimensions surpassent encore celles de la DB4 GT Zagato et atteignent presque celles de la Ferrari 250S Berlinetta de 1952, se dissimule un véhicule de grand tourisme sur la base d'un châssis de DB7 Vantage raccourci de six centimètres. Vu le nombre de clients qui n'hésitent pas longtemps avant d'ouvrir leur portefeuille pour débourser une somme proche de 260 000 euros, il est décidé de construire 99 Zagato à carrosserie de coupé. Carrosserie de coupé car, dans ce contexte réjouissant, Aston a aussi l'intention de proposer une variante décapotable – également à 99 exemplaires.

La caractéristique la plus frappante de la Zagato à toit fixe est le *double bubble roof*, un toit avec deux bossages dont les contours de chacun mordent sur la lunette arrière. Dans le cas du roadster, cet élément du design s'exprime par deux bossages se prolongeant derrière les appuie-tête en direction de la poupe. Abstraction faite du toit du coupé, l'aluminium est omniprésent, car l'on veut au moins obtenir un avantage de poids de 60 kg par rapport à la Vantage conventionnelle, soit au total 1740 kg – 500 de plus que pour la légendaire « Superleggera » ! Le surcroît de puissance – 270 ch jadis, 440 ch aujourd'hui – compense aisément cette surcharge pondérale. En son temps, jamais un propriétaire de Zagato n'aurait osé rêver atteindre les 300 km/h sans oublier que,

avec la DB7 Zagato, l'accélération de 0 à 100 km/h en moins de cinq secondes est bel et bien une réalité. Les performances sont donc tout à fait à la hauteur de son homologue sportive de chez Aston Martin elle-même, la DB7 GT. La boîte à six vitesses avec fonction Quickshift provient du pack Sport de la Vantage, de même que les liaisons au sol et le différentiel de 4,09. Les roues en aluminium dessinées par Zagato, de 8x18J à l'avant et 9x18J à l'arrière, se traduisent par un élargissement des voies correspondant, de respectivement 20 et 30 millimètres. Ainsi les arches de roue de la Zagato, globalement plus large de 31 millimètres, sont-elles parfaitement remplies. De même, le circuit de freinage est devenu plus mordant avec des modifications mineures, mais efficaces.

The Zagato origin is subtly hidden in the interior, with a "Z" embossed in the rear of the well-formed seats. On the exterior this image-laden letter is to be found below the air vents on the front wing.

Dezent verbirgt sich im Innenraum die Zagato-Herkunft auf den wohlgeformten Sitzen, in die das »Z« eingeprägt ist. Außen findet man diesen imageträchtigen Buchstaben im vorderen Kotflügel.

Discrètement, l'origine Zagato se dissimule dans l'habitacle, sur les sièges de forme ergonomique où est gravé le fameux « Z ». Sur la carrosserie, on retrouve cette lettre sur les ailes avant.

Typically Zagato: The double-bubble roof's contours are consistently carried through to the rear windshield. Like Pininfarina, Zagato prefers round rear lights.

Typisch Zagato: das Doppelblasen-Dach, dessen Konturen sich konsequent durch die Heckscheibe fortsetzen. Wie Pininfarina präferiert Zagato runde Heckleuchten.

Typiquement Zagato : le toit à double bulbe dont les contours mordent généreusement sur la lunette arrière. Comme Pininfarina, Zagato donne la préférence à des feux arrière circulaires.

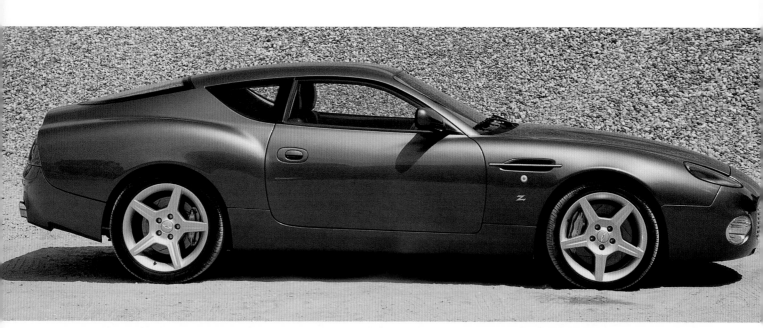

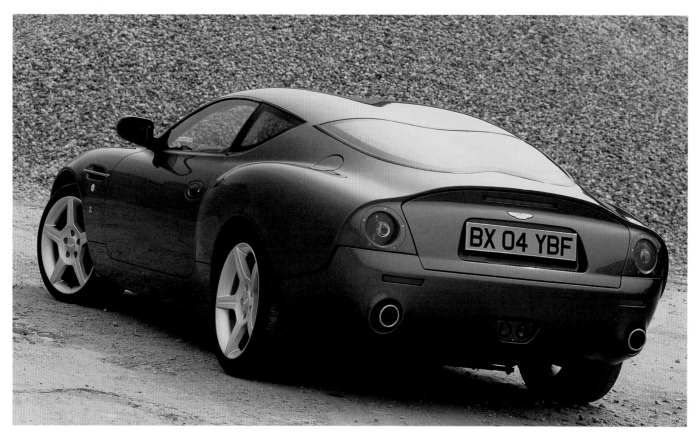

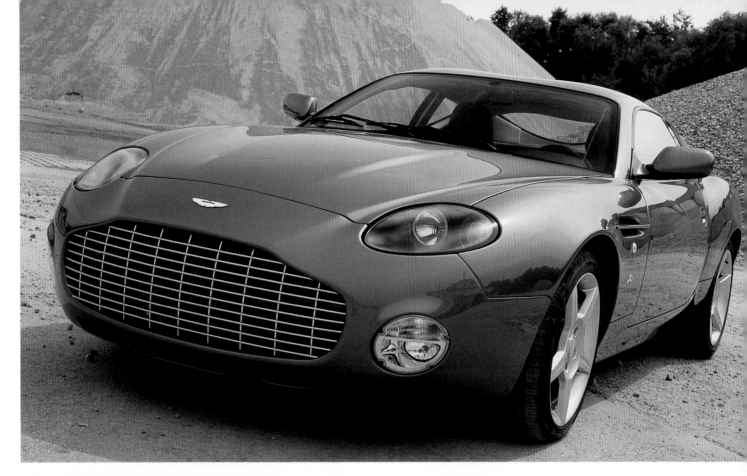

A limited edition of 99 vehicles, quickly distributed among its fans, is the reality behind the DB7 Zagato's large "snout." Zagato declined to include auxiliary seats as in the DB7 in favor of more storage space.

Hinter der großen »Schnauze« des DB7 Zagato verbirgt sich eine limitierte Auflage von 99 Exemplaren, die sich schnell auf ihre Liebhaber verteilte. Auf Notsitze wie im DB7 hat Zagato zu Gunsten von mehr Stauraum verzichtet.

Derrière la grosse « gueule » de la DB7 Zagato se dissimule une édition limitée de 99 exemplaires, qui a vite été distribuée entre ses amateurs. Dans la DB7, Zagato a renoncé à des strapontins en faveur de plus d'espace de rangement.

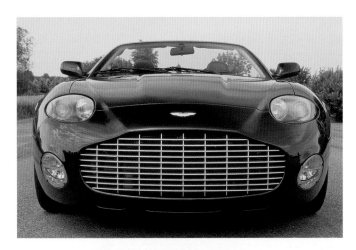

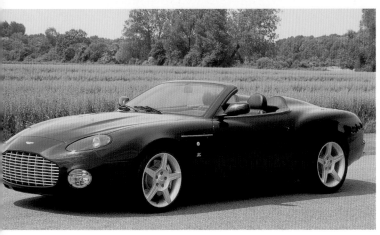

Zagato's American Roadster based on the DB7 – also a 99-vehicle limited edition – are characterized by the "double bubble" design bulges behind the headrests. The cockpit of the AR1 also bears the signature of Zagato design, suiting the thoroughbred roadster well. The 440-bhp engine accelerates the beefy Zagato to 62 mph in less than five seconds.

Zagatos American Roadster auf DB7-Basis – ebenfalls als Edition von 99 Fahrzeugen – deutet das »double bubble«-Design als Ausbuchtungen hinter den Kopfstützen an. Auch das Cockpit des AR1 trägt die Handschrift des Zagato-Designs und passt zu dem reinrassigen Roadster. Das 440-PS-Triebwerk beschleunigt den bulligen Zagato in weniger als fünf Sekunden auf 100 Stundenkilometer.

L'American Roadster de Zagato sur une base de DB7 – encore une autre édition limitée de 99 exemplaires – interprète différemment le design « double bubble » en tant que bossages derrière les appuie-tête. Le cockpit de l'AR1, aussi, arbore la signature de Zagato et convient à la perfection à ce roadster racé. Le groupe motopropulseur de 440 ch catapulte en moins de cinq secondes la musculeuse Zagato de 0 à 100 km/h.

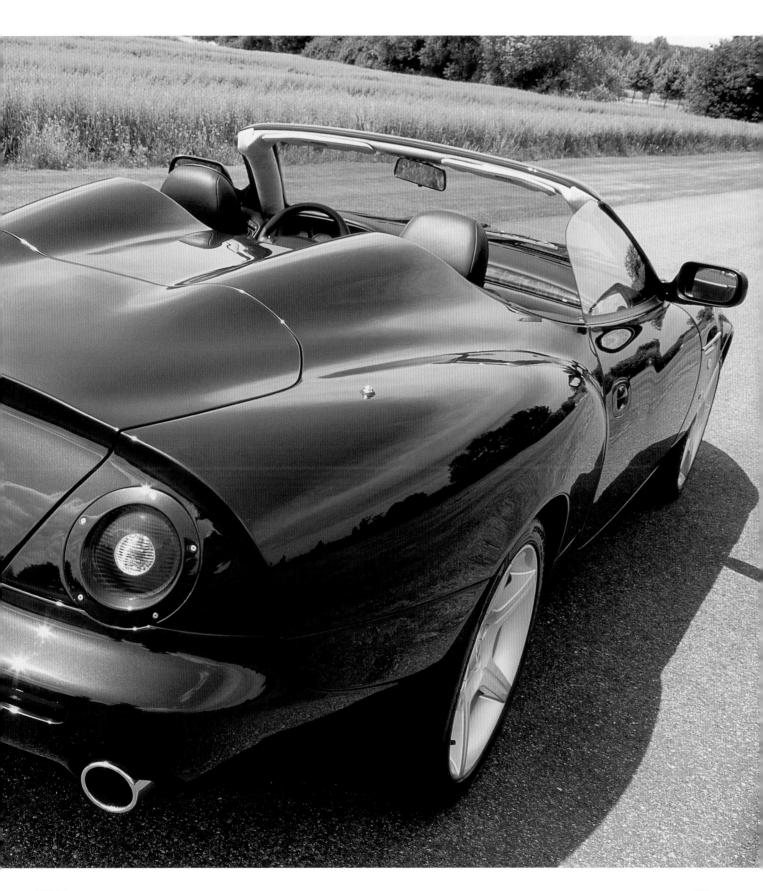

DB7 GT4

It sings the swansong of the DB7 and the old Bloxham entablature with a muffled rumble from its exhaust: the sonorous DB7 GT, the last and most powerful of its kind. Since the spring of 2004, it is confronted with a new era dedicated to its descendants at Gaydon, south of Birmingham.

The last DB7 knight has armed himself well, and coaxes a further reserve of 22 bhp from his warhorse. Long forgotten his younger days when the DB7 had to make do with a straight 6-cylinder engine, for the Vantage's 12-cylinder V60 – nurtured from 420 to 442 bhp – sets its enemies in alarm. That he is no ordinary warrior from the DB7 family is graphically displayed by his helmet crest in the form of two bulges for hot air extraction on the hood. The suit of armor, made of sturdy, heavy steel, finishes with an edge that is meant to prevent him being thrown from the saddle when in a rage – at 185 mph that is – at a joust. This nobleman from the house of Aston Martin, in which a representative of the Swabian knighthood holds sway since July 2000, possess abilities that are not discernable at first sight, and that can only be properly expressed with a modern turn of phrase. Apart from the already mentioned tail edge at the rear that clearly reduces lift at high speeds, the underbody has also been the object of a drastic aerodynamic cure, eradicating air turbulence to a great degree. The chassis specialists have carefully tuned the vehicle to meet Aston Martin's general maxim of smooth directional stability up to its own speed limit.

The entire interior of 2+2 coupé, with its well formed, plush leather upholstered, and comfortable seats, suitable for almost any body size, displays the same tidied appearance as the engine compartment under the hood. The switching distances are short and precise, and the AP double disk clutch also used in motor sport makes short work of carrying out the switching process. The Brembo brake system, fitted with four piston disk brakes and disks with a diameter of 14 inches at the front and 13 inches at the rear, reacts just as well. The DB7 GT's liter performance of 73.3 bhp compares favorably with that of the Vanquish (79.0 bhp per liter engine capacity), and the top speed difference of 14 mph is of no relevance in normal road traffic anyway. The princely sum of 242,000 Euros for the Vanquish stands in comparison to "only" 146,000 Euros for DB7 GT. The DB7 GT would most definitely be one of the victors in a joust for the best super sports car price to performance ratio. In this respect, it is anything but a down at heel knight.

Mit dumpfem Grollen aus seinen Auspuffrohren intoniert er den Schwanengesang auf den DB7 und das alte Gebälk in Bloxham: Der sonore DB7 GT, Letzter und Kräftigster seines Standes. Er wird konfrontiert mit einer neuen Ära, die sich seit dem Frühjahr 2004 in Gaydon, südlich des Birminghamer Ballungsgebietes, ganz seinen Nachfolgern widmet.

Als letzter DB7-Ritter hat er sich gut gerüstet und seinem Streitross eine Kraftreserve von 22 PS entlockt. Vergessen die Jugendzeit, in der sich ein DB7 noch mit einem 6-Zylinder-Reihenmotor bescheiden musste, denn im GT bringt der 12-Zylinder V60 des Vantage die Gegner in den Harnisch, zumal er von 420 auf 442 PS aufgepäppelt worden ist. Dass er kein gewöhnlicher Recke der DB7-Familie ist, dokumentiert schon seine Helmzier in Form von zwei Wülsten mit Heißluft-Abführungen auf der Motorhaube. Die Rüstung aus solidem, ergo schwerem Stahl schließt mit einer Kante ab, die verhindern soll, dass es ihn aus dem Sattel hebt, wenn er bei einer Tjoste – sprich Tempo 300 – so richtig in Rage geraten

ist. Der Edle aus dem Geschlecht Aston Martin, in dem seit Juli 2000 ein Vertreter der schwäbischen Ritterschaft den Ton angibt, besitzt Fähigkeiten, die man ihm nicht auf den ersten Blick ansieht und die sich nur mit neuzeitlichen Formulierungen gar trefflich ausdrücken lassen.

Neben der bereits erwähnten Abrisskante am Heck, die den Auftrieb bei hohen Geschwindigkeiten deutlich reduziert, wurde auch der Unterboden einer aerodynamischen Rosskur unterzogen und Luftverwirbelungen wurden größtenteils ausgemerzt. Ruhiger Geradeauslauf bis

Les vrombissements en provenance de son pot d'échappement entonnent le chant du cygne de la DB7 et des ateliers ancestraux de Bloxham : la caverneuse DB7 GT, l'ultime et la plus puissante de sa série, sait se faire entendre. Elle va être confrontée à une ère nouvelle où on se consacre intégralement, depuis le printemps 2004, à sa « descendance » née à Gaydon, au sud de Birmingham.

En tant qu'ultime chevalier de la lignée DB7, elle possède une magnifique armure et a extirpé de son destrier une réserve de puissance de vingt-deux chevaux. Qu'elle est loin l'époque où la DB7 devait se contenter d'un six-cylindres en ligne ! En effet, sous le capot de la GT, c'est le douze-cylindres en V à 60 degrés de la Vantage qui fait mordre la poussière à ses adversaires. Et ce, d'autant plus facilement que sa cavalerie a été majorée de 420 à 442 chevaux. Cette voiture, de la famille des DB7, n'est pas banale et elle le prouve par la décoration de son casque sous la forme de deux bosses sur le capot avec une ouverture destinée à évacuer l'air brûlant du compartiment moteur. L'armure en acier solide et lourd se termine par une arête censée l'empêcher de se voir désarçonnée quand, au plus fort de la bataille – lorsqu'elle flirte avec les 300 km/h –, elle risque de laisser son tempérament s'emballer. Le noble étalon du haras Aston Martin, aux destinées duquel, depuis juillet 2000, préside un membre de la chevalerie souabe, possède des aptitudes dont on ne le croirait guère capable au premier coup d'œil. Seule l'utilisation du vocabulaire moderne serait capable de le qualifier.

Outre, à l'arrière, l'arête de décrochement déjà mentionnée qui réduit considérablement la portance à grande vitesse, le soubassement a, lui aussi, subi un traitement approfondi selon les impératifs de l'aérodynamique. Ainsi la très grande majorité des tourbillons indésirables a été éliminée. Une tenue de cap imperturbable jusqu'à la vitesse maximum autorisée est, pour une Aston Martin, une maxime qui doit toujours être vraie et à laquelle doivent se plier aussi avec la plus grande minutie les spécialistes des liaisons au sol.

On retrouve dans l'ensemble de l'habitacle du coupé 2+2 la même bonne ordonnance que sous le capot moteur, avec de somptueux capitonnages de cuir dans le cockpit et des fauteuils ergonomiques remarquablement confortables, qui peuvent accueillir des occupants de toutes statures. Les débattements du levier sont courts et précis et l'embrayage bidisque AP, utilisé aussi en compétition, ne prend pas de gants pour changer les rapports à la volée. Avec une puissance au litre de 73,3 ch, la DB7 GT ne s'en tire pas mal par rapport à la Vanquish (79 ch au litre) ; quant à la différence de 22 km/h en pointe, elle risque fort d'être négligeable dans les conditions de circulation normales. La différence vient du billet d'entrée puisque la Vanquish exige que l'on débourse la somme princière de 242 000 euros alors que la DB7 GT, plus chevaleresque, se « contente » de 146 000 euros. Dans un tournoi pour le meilleur rapport prix/prestations entre voitures de sport élitaires, la DB7 GT figurerait sans aucun doute parmi les vainqueurs. De ce point de vue, elle n'a vraiment rien d'un simple chevalier itinérant.

zum eigenen Tempolimit ist bei Aston Martin eine generelle Maxime, auf die sich auch die Fahrwerkspezialisten sorgfältig abgestimmt haben. Aufgeräumt wie unter der Motorhaube wirkt der gesamte Innenbereich des 2+2-Coupés mit üppigen Lederpolsterungen rundum und hervorragend geformten, bequemen Sitzen, die fast jeder Körpergröße Rechnung tragen. Die Schaltwege sind kurz und präzise, und die auch im Motorsport verwendete AP-Doppelscheiben-Kupplung macht bei der Umsetzung der Schaltvorgänge kurzen Prozess. Mit einer Literleistung von

73,3 PS liegt der DB7 GT gemessen am Vanquish (79,0 PS pro Liter Hubraum) nicht schlecht, und die Differenz von 22 km/h bei der Höchstgeschwindigkeit dürfte im normalen Verkehr ohnehin bedeutungslos sein. Der fürstlichen Summe von 242 000 Euro für den Vanquish stehen »nur« 146 000 Euro für den DB7 GT gegenüber. In einer Tjoste um den besten Preis-Leistungs-Vergleich der Super-Sportwagen würde der DB7 GT gewiss zu den Turniersiegern gehören. In dieser Hinsicht ist er alles andere als ein armer Ritter.

Long forgotten the days when a DB7 had to make do with a straight 6-cylinder engine, for the Vantage's V12 delivers 442 bhp.

Vergessen die Zeit, in der sich ein DB7 noch mit einem 6-Zylinder-Reihenmotor bescheiden musste, denn im GT bringt der V12 des Vantage 442 PS.

Qu'elle est loin l'époque où la DB7 devait se contenter d'un six-cylindres en ligne ! Sous le capot de la GT, c'est le V12 de la Vantage qui fait 442 chevaux.

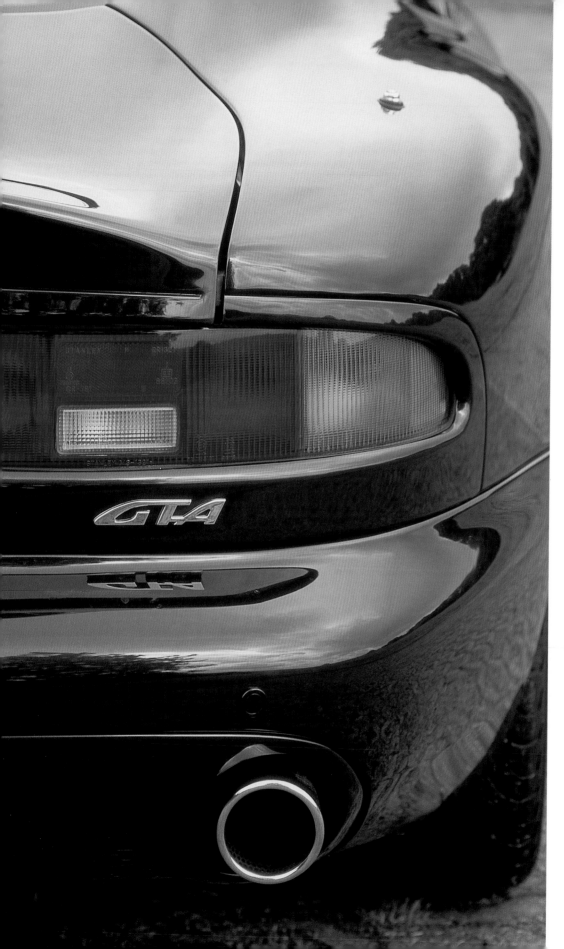

The radiator grille's "fly screen" and well-polished aerodynamic details such as the air trailing edge at the rear betray the GT at first sight.

Das »Fliegengitter« des Kühlergrills und aerodynamisch ausgefeilte Details wie die Luftabrisskante am Heck verraten den GT auf den ersten Blick.

Le « grillage à moustiques » de la calandre et les détails aérodynamiques raffinés tels que l'arête de décrochement à l'arrière trahissent la GT au premier coup d'œil.

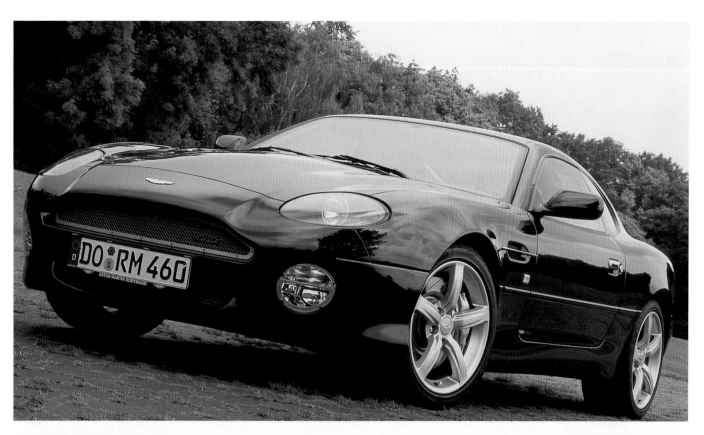

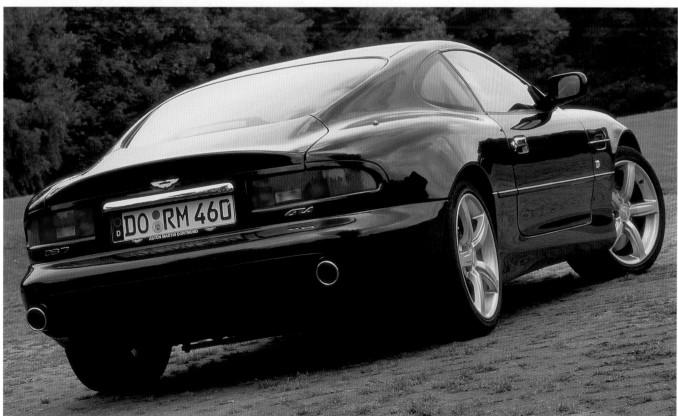

DB9

The latest interpretation of the Aston Martin tradition has a pronounced aesthetic appearance with its flowing curves, few angles, and harmonious interaction between the vehicle's proportions and the undisturbed flow of design lines stretching from the hood, over the roof, to the subtle suggestion of a tail end edge at the rear. The flanks appear less beefy than those of the Vanquish, nevertheless, this 2+2-seater emanates an aura of power. "It displays well-proportioned muscles – not the ugly bloated biceps of a bodybuilder," as the director of design, Henrik Fisker, describes his creation.

The body is constructed with modern production methods, but the rest is done by hand. The Aston Martin engineers resort to the immense know-how of their Volvo colleagues, especially concerning safety, when fitting vertical and horizontal structural sections together to form a whole that is extremely resistant to torsion. The aluminum struts, including the massive cross-brace of the engine compartment, are proof that the static for a Volante has been taken into consideration from the very start. Future models are also to be based on this chassis.

The engine, a Vanquish's V12, further developed by Aston Martin in cooperation with the engine specialists of Ford's RVT

(Research and Vehicle Technology), has a somewhat weaker heart (456 instead of 469 bhp), but delivers the better spectrum of performance. The Maximal torque of 570 Newton meters (542 for the Vanquish) is reached at 5000 rpm. 80 percent of this torque is already achieved at 1500 rpm. This early deployment of the powerhouse's potential – by the way, the engine is 26 lbs lighter than that of the Vanquish – results in a respectable sprint time of 0 to 62 mph in 4.7 seconds, when manually switched using the steering wheel's rocker switches. The process takes two tenths longer when the starting acceleration is left to the automatic ZF 6-gear transmission. The propulsion power is transferred to the rear by a carbon-fiber drive shaft as the transmission and torque converter operate directly in front of the rear axle. A positive side effect of this transaxle principle is the exact 50:50 weight distribution over the DB9's axles. The DB9's optimal weight distribution, in contrast to the slightly overloaded front of the Vanquish, expresses itself in correspondingly neutral handling properties – even with a brisk driving style – supported at all times by a dynamic stability control. The DB9 was fine tuned in the wind tunnel at Volvo and at the Cranfield University, with the priority of high-speed directional stability to the fore.

The DB9, the first offspring to come out of Aston Martin's new domicile in Gaydon, captivates with its no-frills clarity of line.

Elegant geschwungene Kurven, kaum Ecken, harmonisches Zusammenspiel von Proportionen und ein ungestörter Linienfluss von der Haube übers Dach bis zur dezent angedeuteten Abrisskante des Hecks: Die jüngste Interpretation der Traditionsmarke Aston Martin wirkt ausgesprochen ästhetisch. Die Flanken sind weniger bullig ausgefallen als beim Vanquish, dennoch verströmt dieser 2+2-Sitzer einen Hauch von Kraft. »Er zeigt wohlproportionierte Muskeln – keine hässlich aufgeblähten Bizeps eines Bodybuilders«, beschreibt Design-Direktor Henrik Fisker seine Kreation.

Mit modernen Fertigungsmethoden entsteht die Karosserie, doch der Rest ist Handarbeit. Im Zusammenfügen vertikaler und horizontaler Profilstrukturen zu einen äußerst verwindungssteifen Ganzen bedienen sich die Aston-Martin-Ingenieure des immensen Know-hows ihrer Volvo-Kollegen, besonders in Sachen Sicherheit. Alle Crash-Tests werden bei den Schweden durchgeführt. Auch die

Aluminium-Verstrebungen, einschließlich einer gewaltigen Domstrebe im Motorraum, belegen, dass man von vornherein auch die Statik für einen Volante einbezogen hat. Künftige Modelle sollen ebenfalls auf diesem Chassis basieren.

Der zusammen mit Motorenspezialisten von Ford RVT (Research and Vehicle Technology) von Aston Martin weiterentwickelte V12 des Vanquish ist oben heraus zwar etwas schwächer auf der Brust (456 statt 469 PS), liefert aber die bessere Leistungsbandbreite. Das maximale Drehmoment von 570 Newtonmetern (542 beim Vanquish) wird bei 5000 Umdrehungen pro Minute erreicht. 80 Prozent dieses Drehmoments stellen sich bereits bei 1500/min ein. Das früh einsetzende Potential dieses Kraftwerkes – übrigens 11,8 Kilo leichter als beim Vanquish – resultiert in einem respektablen Sprint-Wert von 0 auf 100 Stundenkilometer in 4,7 Sekunden, manuell über Lenkradwippe hochgeschaltet. Überlässt man die Anfangsbeschleunigung dem automatischen ZF-6-Gang-

Der DB9, erster Spross das neuen Aston-Martin-Domizils in Gaydon, besticht durch seine klare Linienführung ohne jegliche Schnörkel.

La DB9, premier modèle sorti du quartier général d'Aston Martin à Gaydon, s'avère irrésistible par la clarté de ses lignes sans les moindres fioritures.

Getriebe allein, dauert der Vorgang zwei Zehntel mehr. Bei diesem Wagen wird die Automatik per Knopfdruck selektiert. Über eine Kohlefaser-Kardanwelle wird die Kraft nach hinten übertragen, denn Getriebe und Drehmomentwandler arbeiten direkt vor der Hinterachse. Positiver Nebeneffekt dieses Transaxle-Prinzips ist die exakte 50:50-Gewichtsverteilung auf die Achsen des DB9. Im Gegensatz zum leicht frontlastigen Vanquish äußert sich die optimale Ausbalancierung des DB9 in einem entsprechend neutralen Fahrverhalten – auch bei eiliger Gangart –, immer unterstützt durch eine dynamische Stabilitäts-Kontrolle. In Windkanal-Tests bei Volvo und der Cranfield University erhielt der DB9 seinen aerodynamischen Feinschliff mit der Priorität Richtungsstabilität im Hochgeschwindigkeitsbereich.

Des galbes élégants, pratiquement aucun angle vif, un jeu harmonieux des proportions et la fluidité sans césure des lignes depuis le capot et jusqu'à la discrète ébauche de becquet sur l'arête du coffre en passant par le toit : la toute dernière interprétation de la marque traditionnelle Aston Martin est un parangon de réussite esthétique. Les flancs sont moins « musculeux » que ceux de la Vanquish. Et pourtant, cette 2+2 diffuse, elle aussi, une sensation réelle de vigueur et de tonicité. « Elle affiche des muscles bien proportionnés – mais non les biceps hypertrophiés de tant d'amateurs de bodybuilding », déclare Henrik Fisker, le directeur du style, pour décrire sa création.

La carrosserie est fabriquée en recourant à des méthodes d'assemblage modernes, mais tout le reste relève du travail manuel. Pour assembler les profilés structurels verticaux et horizontaux en un squelette d'une extrêmement grande rigidité, les ingénieurs d'Aston Martin ont mis à profit l'immense savoir-faire

de leurs collègues de chez Volvo, notamment sur le plan de la sécurité. C'est d'ailleurs en Suède qu'ont été réalisés tous les tests de collision. Les renforts en aluminium, y compris une grosse barre anti-rapprochement dans le compartiment moteur, prouvent que l'on a, aussi, d'emblée tenu compte de la statique d'une prochaine Volante. Il est également prévu que les futurs modèles reprennent ce châssis.

Le V12 de la Vanquish encore perfectionné par Aston Martin avec le concours des motoristes éminents de Ford RVT (Research and Vehicle Technology) est, à haut régime, certes un peu plus faible (456 au lieu de 469 ch), mais il offre la meilleure plage de régime utile. Son couple maximum de 570 Nm (contre 542 pour la Vanquish) est obtenu à 5000 tr/min. Le potentiel de cette usine à gaz qui se fait sentir instantanément – ce moteur pèse d'ailleurs 11,8 kg de moins que celui de la Vanquish – se traduit par un temps des plus respectables pour le 0 à 100 km/h : soit 4,7 secondes,

avec les rapports changés à la main par les basculeurs au volant. Si l'on abandonne l'accélération initiale exclusivement à la boîte automatique ZF à six vitesses, la procédure demande deux dixièmes de plus.

Un arbre de transmission en fibre de carbone canalise le couple vers l'arrière, car la boîte de vitesses et le convertisseur de couple font bloc avec l'essieu moteur. Effet secondaire bienvenu du principe transaxle : la répartition du poids entre les deux trains de la DB9 est absolument symétrique. Contrairement à la Vanquish, qui est affectée par une certaine lourdeur du train avant, l'équilibre optimal de la DB9 se traduit par un comportement d'une neutralité exemplaire – même en cas de conduite (très) rapide – avec en permanence, servant d'ange gardien, le contrôle dynamique de la stabilité. Au fil des innombrables heures passées en soufflerie chez Volvo et à la Cranfield University, la DB9 a vu son aérodynamique affinée avec une priorité : la stabilité directionnelle à grande vitesse.

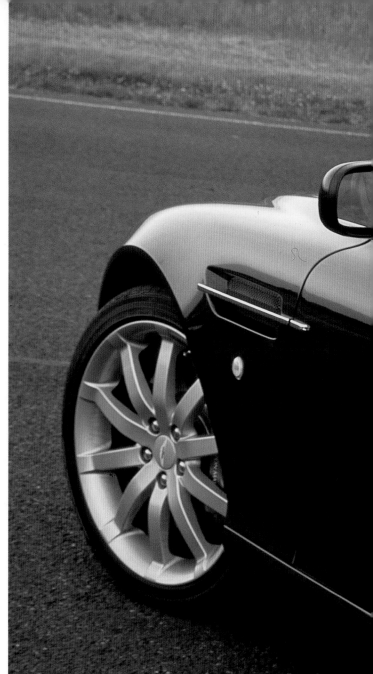

The aluminum outer skin's elongated roof contours underline the elegance of the DB9. Natural wood, aluminum, finest Scottish leather, and even a glass ashtray bestow a special ambience on the DB9's interior. The sole retrospective of this most modern touring sports car: the rev counter moves in an anti-clockwise direction, as in earlier years.

Die gestreckte Dachkontur der Aluminium-Außenhaut unterstreicht die sportliche Eleganz des DB9. Naturbelassenes Holz, Aluminium, feinstes schottisches Leder und sogar ein gläserner Aschenbecher verleihen dem DB9-Innenraum ein besonderes Ambiente. Einzige Retrospektive dieses hochmodernen Reise-Sportwagens: Der Drehzahlmesser bewegt sich wie in früheren Jahren gegen den Uhrzeigersinn.

Les contours de toit étirés de la carrosserie en aluminium soulignent l'élégance sportive de la DB9. Bois à l'état naturel, aluminium, cuir écossais très fin et même un cendrier en verre confèrent à l'habitacle de la DB9 une ambiance très particulière. Seule touche néo-rétro dans cette sportive grande routière : comme aux tout débuts d'Aston Martin, le compte-tours se déplace dans le sens contraire des aiguilles d'une montre.

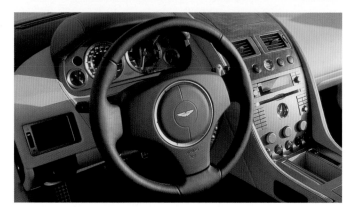

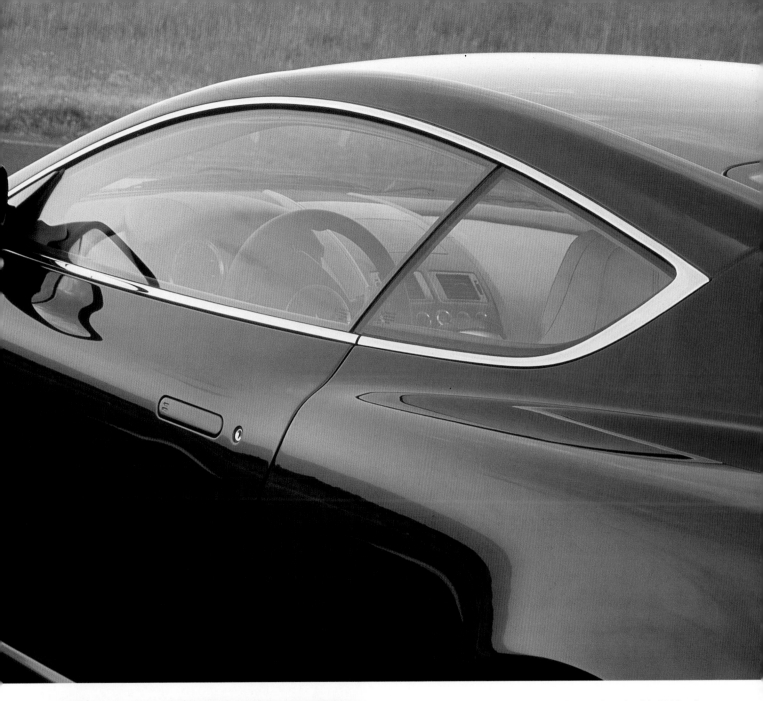

Side struts and a cross brace arching over the V12 also serve the statics of the DB9-based Volante.

Seitliche Verstrebungen und eine Domstrebe, die sich über dem V12 wölbt, dienen auch der Statik eines Volante auf DB9-Basis.

Les renforts latéraux et une barre antirapprochement galbée au-dessus du V12 favorisent aussi la rigidité de la Volante sur base de DB9.

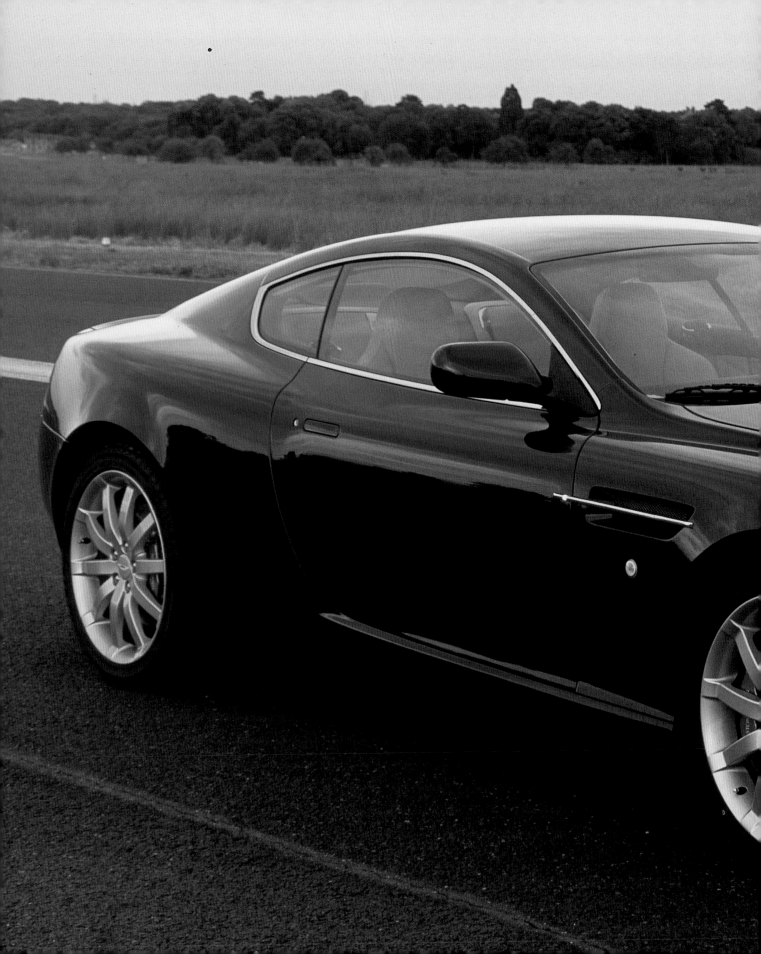

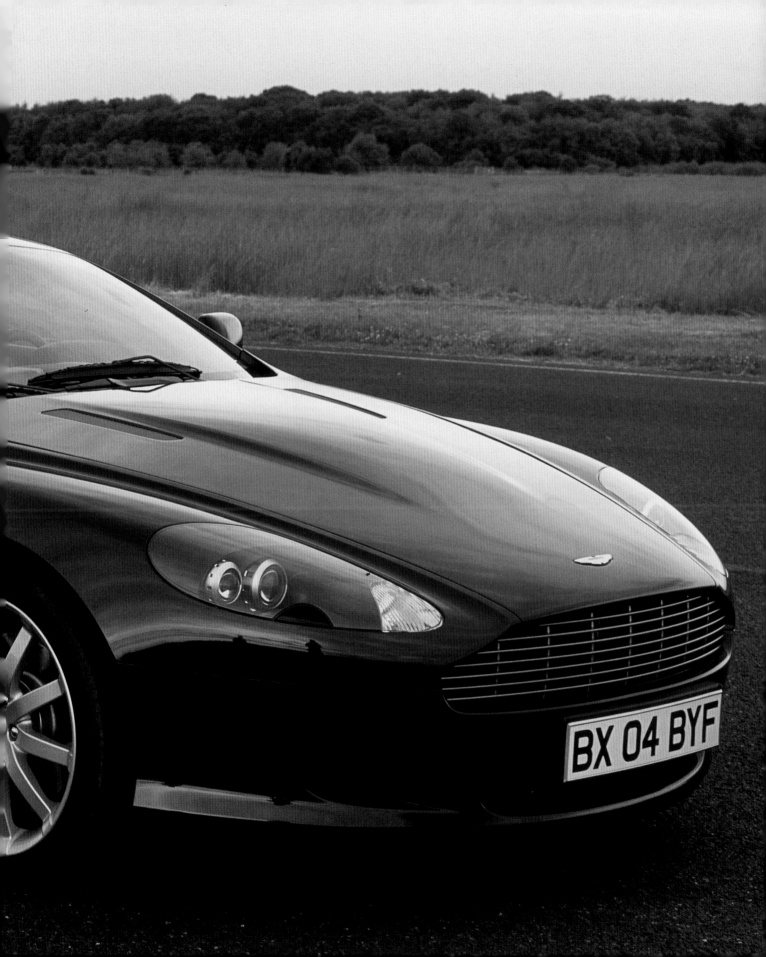

Back to the Future
Zurück zur Zukunft
Retour vers le futur

by Walter Hayes

As you know, from the very beginning Aston Martin was a company like many others. The automotive culture we are living in today owes a lot to Aston Martin-type companies. To start with there were competent gentlemen who loved motorcars. One man wanted to go motor sporting, built a car for himself, and then his friends asked if he would build one for them as well.

Some very special people kept coming in and saving Aston Martin, such as Count Zborowski of Chitty-Bang-Bang fame. Like so many other companies, they had a very difficult time coming back after WW II. They just managed to creep along. And David Brown really sold the company because of problems with his other businesses. He was losing far too much money and his bankers told him he could not afford such an expensive hobby. Frankly, he seemed to have had all the enjoyment he could get out of it. He was a good friend of mine so I knew that. Then Aston was taken over by a sort of consortium. They did the V8s. Eventually it was bought by the Livanos family with Victor Gauntlett as a minor shareholder. The Livanoses are very rich and powerful in shipping, I think Peter Livanos has the largest liquid carrier fleet in the world today. He got to know Gauntlett who was selling oil supplied by the Livanoses in a little chain of petrol stations called Pace. They got to a point when things became impossible. The costs, for instance, of meeting American federal regulations, emissions, safety standards and so on were more than any small company could cope with. You had to crash a couple of cars, and that alone caused enormous costs if you think of how expensive the cars were and are.

And then something really strange happened. In 1987 I went down to the Mille Miglia, which I liked very much, and I stayed at Calino on the estate of the Maggi family, which was very much a home for British teams. Count Aymo Maggi had been one of the founders of the original 1000-mile-race. Gordon Wilkins, the journalist, had a small palazzo there. He invited me to stay there with my wife. So we went down with Prince Michael of Kent and Victor Gauntlett, and I had a really wonderful

Bekanntlich war Aston Martin von Anbeginn eine Firma wie all diese Firmen. Die Autokultur, in der wir heute leben, verdankt solchen Unternehmen eine Menge. Ursprünglich waren da Männer, die Autos liebten und etwas von der Sache verstanden. Jemand wollte Rennen fahren mit einem Wagen, den er selbst auf die Räder gestellt hatte, und dann kamen Freunde und sagten, er solle ihnen gleich einen mitbauen.

Einige der Leute, die Aston Martin am Leben erhalten haben, stellten schon etwas Besonderes dar wie etwa der Graf Zborowski, der sich mit dem Chitty-Bang-Bang einen Namen gemacht hat. Nach dem Zweiten Weltkrieg tat sich die Firma besonders schwer, wie so viele andere auch. Irgendwie hat man sich dann doch durchgeschlagen. Der eigentliche Grund, weshalb David Brown Aston abstieß, lag in seinen Problemen mit seinen anderen Unternehmen. Er verlor viel zu viel Geld und seine Banker warnten ihn, ein solch teures Hobby könne er sich nicht leisten. Andererseits hatte er alles an Vergnügen aus der Sache herausgeholt, das sich aus ihr herausholen ließ. Ich wusste das, weil er ein guter Freund von mir war.

Dann wurde Aston Martin von einer Art Konsortium übernommen. Die Produktion bestand aus dem V8 und seinen Varianten. Schließlich nahm sich, neben Victor Gauntlett als kleinerem Aktionär, die Familie Livanos der Firma an. Sie sind sehr reich und eine erste Adresse in der Schifffahrt. Peter Livanos, damals die treibende Kraft hinter der Übernahme, besitzt heute wahrscheinlich die größte Tankerflotte der Welt. Er und Gauntlett lernten sich kennen, weil dieser eine kleine Kette von Tankstellen besaß, die unter dem Namen Pace firmierte. Sie wurde von der Livanos-Dynastie beliefert. Gleichwohl erreichte man einen Punkt, an dem es unmöglich erschien, weiter zu machen. Die Kosten, die zum Beispiel aufgewendet werden mussten, um den amerikanischen Bestimmungen hinsichtlich der Emissionen und der Sicherheit zu genügen, waren viel zu hoch, als dass sie ein kleines Unternehmen hätte aufbringen können. Schon allein die Crashtests, denen selbst in dieser Preisklasse mehrere Autos geopfert werden müssen, waren enorm teuer.

Bien évidemment, Aston Martin a été dès le début une firme comme beaucoup d'autres. Mais la civilisation de l'automobile dans laquelle nous vivons aujourd'hui doit énormément à de telles entreprises. À l'origine, il s'agissait d'hommes qui aimaient les voitures et savaient de quoi ils parlaient. Il arrivait que l'un d'entre eux veuille courir avec une voiture fabriquée par sa propre entreprise. Et, souvent, des amis ou connaissances lui disaient de profiter de l'occasion pour leur en fabriquer une à eux aussi.

Certaines des personnes qui ont contribué à la pérennité d'Aston Martin étaient bel et bien uniques en leur genre : par exemple le comte Zborowski, qui s'est fait un nom avec la Chitty-Bang-Bang. Après la Seconde Guerre mondiale, la firme a traversé une phase extrêmement difficile, comme beaucoup d'autres entreprises de cette époque. Mais, d'une façon ou d'une autre, elle est parvenue à survivre. La raison pour laquelle David Brown s'est séparé d'Aston Martin est qu'il était confronté à des problèmes avec ses autres sociétés. Il perdait beaucoup trop d'argent et ses banquiers l'avaient mis en garde en lui disant qu'il ne pouvait se payer le luxe d'une « danseuse » aussi chère qu'Aston Martin. Au moins en aura-t-il tiré le maximum de plaisir. Je le sais parce que c'était un de mes bons amis.

Puis Aston Martin a été reprise par une espèce de consortium. La production se composait de la V8 et de ses dérivées. Enfin, aux côtés de Victor Gauntlett comme petit actionnaire, la famille Livanos s'est intéressée à la firme. Richissime, cette famille jouissait d'une réputation flatteuse dans la navigation maritime. Peter Livanos, cheville ouvrière de l'opération de reprise, est sans doute aujourd'hui à la tête de la plus grande flotte de pétroliers du monde. Gauntlett et lui ont fait connaissance parce que ce dernier possédait une petite chaîne de stations-service qui arborait le panonceau Pace. Elle était approvisionnée par la dynastie des Livanos. À un moment donné, on en est arrivé à un stade où il était impossible de continuer. Les investissements à consentir, par exemple pour respecter les dispositions de dépollution américaines et les normes de sécurité, étaient beaucoup trop élevés pour qu'une

time. Prince Michael took my wife to the airport in a Volante. She said to me that I ought to buy that company, what a wonderful car, and I said how funny because I had been talking to Gauntlett and he had told me that they were really struggling. Although their engineering was excellent the modern world seemed far away from them.

By this time Henry Ford II had retired and he had a house not far from here in a place called Henley. In retirement he spent more than four months a year in this country because he loved the place. I used to go there in the morning and have coffee with him and talk. One day he asked what we could do and I suggested buying a sports car factory. I said it quite lightheartedly, just banter. He was retired and no longer chairman, but he was Henry Ford. George Livanos, Peter's uncle, had also told him that they had to pass on responsibility for Aston Martin. Would he be interested? So we talked about it for a very short time and he said why don't we do it. And then he telephoned the new Ford president, as well as Alex Trotman, who later became chairman of the company and had run Ford of Europe until then. They were a bit surprised but there was a lot of sense in the project. Ford had always been frustrated when it came to having a small volume car. It was said that Ford could build a quarter of a million cars but didn't know how to handle a thousand. Big companies still have a lot to learn from small companies because small companies can do things very quickly without any of that huge discipline that surrounds mass manufacturing.

Ford liked cars very much and was always interested in the ones I took to him. And on top of that he had a great sense of the heritage of the motor industry as well as being a great friend of David Brown's. When they were young they used to see a lot of each other. We got on with it and had talks with Gauntlett and Livanos, coming to an agreement in autumn '87. The exceptionally unhappy part of it was that Henry died a couple of weeks earlier, so he was never able to enjoy it. The arrangement was really very simple. We would own three quarters because I had

Dann aber passierte etwas Bemerkenswertes. 1987 stattete ich der Mille Miglia, die mich immer wieder magisch anzieht, einen Besuch ab. Ich wohnte in Calino auf dem Anwesen des Grafen Aymo Maggi, einem der Gründerväter des ursprünglichen 1000-Meilen-Rennens, der für die englischen Teams immer ein reizender Gastgeber war. Der Journalist Gordon Wilkins hatte einen kleinen palazzo auf dem Grundstück, wohin er mich und meine Frau einlud. Also fuhren wir hin, zusammen mit Prinz Michael von Kent und Victor Gauntlett, und amüsierten uns königlich. Am Ende brachte Prinz Michael meine Frau in einem Volante zum Flugplatz. Sie schwärmte mir von dem wundervollen Auto vor und sagte, wir sollten doch Aston Martin kaufen. Ich antwortete, es gebe sonderbare Zufälle im Leben – ich hätte gerade mit Gauntlett gesprochen und der hätte angedeutet, dass es um Aston Martin mal wieder nicht zum Besten stehe. Der technische Standard sei ungemein hoch, aber man lebe doch in einer anderen Welt – gemessen an modernen Maßstäben.

Um die gleiche Zeit hatte sich Henry Ford II zur Ruhe gesetzt. Er besaß ein Haus ganz in meiner Nähe in einem Ort namens Henley. Dort verbrachte er vier Monate im Jahr, da er den Platz liebte. Manchmal fuhr ich vormittags auf eine Tasse Kaffee und ein Schwätzchen zu ihm. Einmal scherzte er: »Und was machen wir heute?« Ich antwortete mit einer Gegenfrage: »Warum kaufen wir nicht einfach eine Sportwagenfabrik?« Das war so dahin gesprochen, eigentlich nur zum Scherz. Im Übrigen saß er mir als Pensionär und nicht mehr als Vorstandsvorsitzender gegenüber. Aber er war eben Henry Ford. George Livanos, Peters Onkel, hatte ihn mit demselben Anliegen angesprochen. Nach kurzer Zeit sagte er: »Warum eigentlich nicht?« Und dann rief er den neuen Ford-Präsidenten an und Alex Trotman, der später Vorsitzender wurde und bislang Ford Europa geleitet hatte. Die beiden waren schon ein bisschen überrascht, aber die Sache machte Sinn. Ford war stets frustriert, wenn irgendein Auto in kleiner Auflage gebaut werden sollte. Es gab da eine Redensart: Eine Viertelmillion Autos zu machen ist kein Problem. Aber mit ein paar Tausend können wir nicht

petite entreprise puisse relever un tel défi. À eux seuls, les tests de collision, pour lesquels il fallait sacrifier plusieurs voitures, coûtaient des sommes astronomiques, surtout dans cette catégorie de prix.

C'est à ce moment-là que s'est produit quelque chose de très intéressant. En 1987, je me suis rendu aux Mille Miglia, une course qui m'a toujours attiré par sa magie. Je résidais à Calino, dans la propriété du comte Aymo Maggi, l'un des hommes qui mirent sur pied la course originelle des 1 000 Miles et qui avait toujours été un hôte exquis pour les écuries anglaises. Sur son terrain, le journaliste Gordon Wilkins avait un petit palazzo où il nous invita, mon épouse et moi-même. Nous nous y sommes donc rendus, accompagnés du prince Michael of Kent et de Victor Gauntlett, et nous nous sommes amusés royalement. À la fin, le prince Michael a conduit mon épouse à l'aéroport dans une Volante. Dès lors, elle n'a plus tari d'éloges sur cette merveilleuse voiture, ne cessant de me répéter que nous devrions acheter Aston Martin. Je lui répondis qu'il y avait des hasards vraiment bizarres dans la vie – que je venais de m'entretenir avec Gauntlett et qu'il avait laissé entendre à demi-mot qu'une fois de plus, la santé d'Aston Martin était des plus fragiles. Son niveau technique était extrêmement élevé, me dit-il, mais on vivait finalement dans un monde qui avait changé, et dont Aston Martin restait très éloigné.

À la même époque, Henry Ford II avait pris sa retraite. Il possédait une maison tout près de chez moi, dans une localité appelée Henley. Il y résidait quatre mois de l'année, car il adorait cet endroit. Il m'arrivait de passer chez lui le matin boire une tasse de thé et bavarder quelques instants. Un jour, il me demanda en blaguant : « Qu'est-ce qu'on fait aujourd'hui ? » Je lui répondis du tac au tac : « Pourquoi n'achèterions-nous pas tout simplement une usine de voitures de sport ? » Ce n'étaient là que quelques paroles jetées en l'air, en manière de plaisanterie. D'ailleurs, il s'adressait à moi en tant que retraité, et non plus en tant que président et supérieur hiérarchique. Mais il s'agissait tout de même encore de Henry Ford. De son côté, George Livanos, l'oncle de Peter, avait déjà pris contact avec lui pour lui parler des problèmes

argued quite strongly that Gauntlett should remain chief executive, the reason being that big companies do not understand small companies. If you are going to take over any kind of company you must support but not dominate them. Many failures are due to mistakes that have been made in this respect. You must understand the soul of the company you are taking over. You want to have Aston Martin and not just the badge with a Ford behind it.

I didn't really have to do anything with the company after the purchase. After about six months I was asked to come on board. Gauntlett had been running it and I was very much a non-executive listening to the discussions. They were serious: could we increase production from 5 to 6 a week? But then in 1989 and '90 the bottom really fell out for them, within weeks. There had been an enormous boom before that with young executives being given £85,000 Ferraris as bonuses. They couldn't keep them so there were these used cars on the market for less than half the price, for example Rolls-Royces with 1000 miles on the clock for one sixth of their original value. Gauntlett thought that the time had come for him to go and take up something else. I had retired at sixty-five. Then Red Poling, who was chairman at that time, asked me if I would go in as executive chairman of Aston Martin. As I felt a responsibility for it I said I would do it until the age of 70, but not beyond. I also said I did not want to preside at a funeral. He said of course not, and added that they would give me three months, until March 1992, to map out a strategy. It seemed fairly obvious to me what had to be done. The company had to go back

umgehen. Große Firmen können da von kleinen eine Menge lernen. Die kleinen können nämlich rasch etwas auf die Beine stellen, ohne sich der strengen Disziplin unterwerfen zu müssen, die zur Massenproduktion gehört.

Ford liebte Autos sehr und interessierte sich stets für die Modelle, die ich ihm vorstellte. Überdies hatte er sich einen Sinn für die historischen Feinheiten der Fahrzeugbranche bewahrt und war ein großer Freund David Browns. In ihrer Jugend sahen die beiden einander häufig. Nach zahlreichen Gesprächen mit Livanos und Gauntlett gelangten wir im Herbst 1987 zu einer Entscheidung. Leider starb Ford kurz vorher, so dass er nichts mehr davon hatte. Die Grundzüge des Deals waren ganz einfach: Wir würden uns mit 75 Prozent bei Aston Martin einkaufen. Ich hatte mich nämlich dafür stark gemacht, dass Gauntlett weitermachen sollte aus dem genannten Grunde. Große Firmen verstehen nichts von kleinen. Wenn man ein Unternehmen übernimmt, muss man ihm unter die Arme greifen, ohne es zu dominieren. Viele Fehlschläge gehen auf falsches Verhalten in dieser Hinsicht zurück. Man muss sich in die Seele des Unternehmens einfühlen, das einem anvertraut wird. Man will Aston Martin haben und nicht das Firmenlogo mit einem Ford dahinter.

Zunächst hatte ich nach dem Kauf nicht viel mit der neuen Ford-Tochter zu tun. Gauntlett führte sie wie bisher und den Diskussionen der Geschäftsführung wohnte ich als bloßer Zuhörer bei. Man sprach beispielsweise sehr ernsthaft darüber, ob man die Produktion von fünf auf sechs Einheiten pro Woche erhöhen sollte. Nach sechs Monaten war ich darum gebeten worden, in den Vorstand

d'Aston Martin. Quelques instants plus tard, il me répondit: «Après tout, pourquoi pas?» Il passa alors un coup de téléphone au nouveau président de Ford et à Alex Trotman, qui allait par la suite être nommé président du directoire et avait jusqu'ici dirigé Ford Europe. Les deux hommes se montrèrent un peu surpris, mais la démarche n'était pas dénuée de sens. Ford se montrait toujours un peu jaloux des marques qui fabriquaient des voitures en éditions limitées. Ainsi, il disait: construire 250 000 voitures n'est pas un problème. Mais nous ne sommes pas capables d'en fabriquer quelques milliers seulement. À ce point de vue, les grandes firmes peuvent apprendre énormément des petites. Les petites sont, en effet, capables de mener rapidement quelque chose à bien sans devoir se soumettre à la sévère discipline qu'implique la production industrielle.

Ford adorait les voitures et s'intéressait toujours aux modèles que je lui présentais. Il avait, en outre, toujours conservé un penchant pour les anecdotes historiques sur l'industrie automobile et c'était un grand ami de David Brown. Dans leur jeunesse, on les voyait souvent ensemble. Après de nombreux entretiens avec Livanos et Gauntlett, nous avons pris une décision à l'automne 1987. Malheureusement, Ford décéda quelques semaines avant la signature de l'accord, si bien qu'il ne put prendre connaissance de l'aboutissement du projet. Les grandes lignes de la transaction étaient très simples: nous voulions acquérir une participation de 75 % d'Aston Martin. J'avais chaudement recommandé que Gauntlett reste aux commandes de l'entreprise pour les motifs mentionnés plus haut. Les grandes firmes ne comprennent pas grand-chose aux petites. Quand on reprend une entreprise, on doit lui venir en aide sans la dominer. Beaucoup d'échecs sont la conséquence d'une erreur de jugement à cet égard. Il faut savoir se transposer dans la mentalité de l'entreprise qui vous est confiée. Nous voulions avoir Aston Martin, et non le logo de cette firme avec Ford derrière.

Dans un premier temps, après la transaction, je n'ai pas eu grand-chose à faire avec la nouvelle filiale de Ford. Au bout de six mois, on m'a proposé un poste au directoire. Gauntlett a continué de diriger l'entreprise comme auparavant et je n'étais qu'un simple auditeur lors des discussions concernant les grandes orientations à adopter. Nous nous demandions, par exemple, le plus sérieusement du monde si nous devions augmenter la cadence de production de cinq à six exemplaires par semaine. Et puis, en 1989 et 1990, Aston Martin a été littéralement prise de court par les événements. Un boom sans précédent s'était produit sur le marché des voitures de luxe. Celles-ci devinrent de véritables objets de spéculation. Partout dans le monde, yuppies et autres jeunes managers comblés de succès se voyaient offrir comme primes des Ferrari ou des Lamborghini coûtant 85 000 livres. Personne ne pouvait évidemment entretenir des voitures aussi chères, tant et si bien qu'elles se retrouvaient un peu plus tard sur le marché pour la moitié de leur prix ou moins

Success has many fathers: in their different ways, Keith Duckworth, Walter Hayes (center), Colin Chapman and Jim Clark (from left to right) all had a hand in the Ford Cosworth DFV's debut triumph at Zandvoort on 7 June 1967.

Der Erfolg hat viele Väter: Am Premierentriumph des Ford Cosworth in Zandvoort am 7. Juni 1967 auf unterschiedliche Weise beteiligt sind Keith Duckworth, Walter Hayes (Mitte), Colin Chapman und Jim Clark (von links).

Chacun se dispute le succès: lors de la première triomphale du moteur Ford Cosworth, à Zandvoort le 7 juin 1967, Keith Duckworth, Walter Hayes (au centre), Colin Chapman et Jim Clark (de gauche à droite) ont contribué à ce succès mémorable chacun à sa manière.

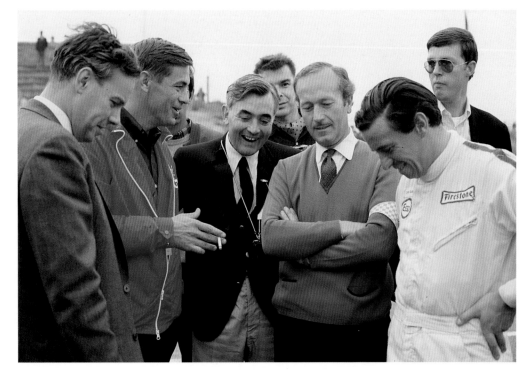

to David Brown. The V8 had been successful and they had sold more than 600 Lagondas. Sales had always been one half in the UK, one quarter in America and one quarter in the rest of the world. The half sold in England often went abroad as well because customers liked to come by and pick up their Aston. The trouble was you could design a new car in Newport Pagnell but you couldn't make it there because there was no room. You would have to stop doing what you were doing. That meant sustaining the factory for three years without producing anything.

Then I had another huge piece of luck because Ford really needed a marque for the luxury market, quite different from Aston, so they took over Jaguar. They had a little factory in Oxfordshire especially put up for the XJ220. It had been a huge barn completely modernized for that specific purpose. It was run by racing entrepreneur Tom Walkinshaw for Jaguar. Ford put a new chairman at Jaguar, Bill Hayden, a good friend of mine with whom I had worked since 1962. I was looking for somewhere to make the Aston, an old Rolls-Royce factory, maybe even Lotus or a continental factory. In the end I decided Astons had to change character a little. So I asked him what would happen to Bloxham once production had finished and he told me I could have it. Then I went to Walkinshaw and again had enormous luck because he had that brilliant young designer Ian Callum, who has just been appointed director of the styling department of both Jaguar and Aston within the Ford Premier Automotive Group. And so I had all the propositions I needed to make my strategy acceptable. All this happened in 1991. I had until March 1992 to come up with something. I talked to Poling about it and got the million dollars to build a prototype car which I had asked for. The problem was going to be the price of the vehicle, which had to be under £80,000. That seemed about the right place in the market. And it would be very difficult to make a handbuilt car for £80,000.

But we worked hard and went to see the chairman of Vickers who agreed that they would paint the body at the Crewe works where the Rolls Royces were painted. They had a brand-new facility. I found a very good outside company to do the bodies, and for some production parts I thought I could go to Jaguar. At the same time I wanted to carry on where we had left off. So I took some historic Astons and pictures to Callum's studio and told him that I didn't want anything sensational looking, like a dart or anything like that. I didn't want anything that frightens women because they have to show their underwear getting in or out. I wanted a very elegant, user-friendly, fast sports car, the kind of car you would design if you were to design a DB7. I had already told David Brown that I would like to bring back the DB. He was really enthusiastic about it and promised me his help.

Then there was the engine. I wanted to have a straight six and didn't want any

einzutreten. Dann aber, 1989 und 1990, wurde Aston Martin förmlich der Teppich unter den Füßen fortgezogen. Vorher war ein enormer Boom ausgebrochen. Wertvolle Autos wurden zu Spekulationsobjekten. Tüchtigen jungen Managern hatte man allenthalben als Bonus 85 000 Pfund teure Ferrari oder Lamborghini in die Hand gedrückt. Kein Mensch konnte so etwas unterhalten, und so erschienen diese Fahrzeuge für den halben Preis oder weniger wieder auf dem Markt. Ich weiß von einem Rolls-Royce mit tausend Meilen auf dem Zähler zu einem Sechstel von dem, was er einmal gekostet hatte. Gauntlett begann sich nach neuen Herausforderungen umzuschauen. Ich hatte mich mit 65 aufs Altenteil zurückgezogen. Dann aber bat mich Red Poling, zu diesem Zeitpunkt Ford-Vorsitzender, ob ich Victors Nachfolge übernehmen wolle. Ich fühlte mich verantwortlich für das, was ich da mit eingefädelt hatte, und sagte: Bis 70, aber keinen Monat darüber hinaus. Ich fügte hinzu, ich sei nicht bereit, ein Begräbnis zu organisieren. Er beruhigte mich, so etwas sei nicht beabsichtigt, und setzte den März 1992 als Termin fest, bis zu dem ich eine Strategie der Sanierung vorlegen solle.

Worin diese bestand, war mir sofort klar. Die Firma musste zurück zu den Ursprüngen, zu David Brown. Der V8 war ein Erfolg gewesen, und man hatte mehr als 600 Lagonda verkauft. Die Hälfte der Produktion war stets im Vereinigten Königreich abgesetzt worden, ein Viertel in den Vereinigten Staaten, das restliche Viertel im Rest der Welt. Ein Teil der englischen Hälfte ging ebenfalls nach Übersee, da viele Kunden gerne vorbeikommen und ihren Aston selber abholen. Das Problem bestand darin, dass man ein neues Modell in Newport Pagnell planen, aber nicht herstellen konnte, weil dort keine Kapazitäten frei waren. Man hätte mit dem aufhören müssen, was dort im Augenblick getan wurde, im Klartext: Die Fabrik hätte drei Jahre irgendwie durchgepäppelt werden müssen, ohne etwas zu produzieren. Dann aber hatte ich enormes Glück. Ford brauchte eine Marke auf dem Markt für Luxuswagen, allerdings von einem anderen Kaliber als Aston Martin, und übernahm Jaguar. Jaguar aber besaß eine kleine Fabrik in Bloxham, Oxfordshire, die eigens für den XJ220 hergerichtet wurde. Früher einmal eine riesige Scheune, war sie für diesen Zweck auf den letzten Stand der Dinge gebracht worden. Tom Walkinshaw war mit der Leitung des Ganzen betraut. Mit dem neuen von Ford eingesetzten Jaguar-Vorsitzenden Bill Hayden hatte ich seit 1962 zusammengearbeitet. Ich suchte nach einem Standort, vielleicht einer ausgedienten Rolls-Royce-Fabrik, vielleicht sogar Lotus oder irgendeinem Werk auf dem Kontinent. Folglich fragte ich ihn, was er mit Bloxham vorhabe, wenn das Projekt XJ220 beendet sei, und er sagte, dass ich das Werk haben könne. Anschließend sprach ich mit Walkinshaw und hatte wieder Glück. Denn da gab es den brillanten jungen Designer Ian Callum, der gerade zum Chef der Abteilung Styling für Jaguar und Aston Martin im Rahmen der Ford Premier Automotive Group befördert worden ist.

encore. J'ai entendu parler d'une Rolls-Royce avec 1 800 km au compteur qui était bradée pour un sixième de ce qu'elle avait coûté à l'origine. À ce moment-là, Victor Gauntlett s'était mis en quête de nouveaux défis à relever. Quant à moi, à 65 ans, j'avais pris ma retraite. C'est alors que Red Poling, qui était alors président de Ford, me demanda si je ne voulais pas prendre la succession de Victor. Je me sentais une responsabilité envers Aston Martin, et je lui ai dit : jusqu'à mes 70 ans, mais pas un mois de plus. Et j'ajoutai que je n'étais pas disposé à organiser un enterrement de première classe. Il me tranquillisa en me disant que telle n'était pas son intention, puis me donna le mois de mars 1992 comme date butoir à laquelle je devais lui présenter une stratégie d'assainissement.

Ce en quoi celle-ci devait consister m'était parfaitement clair. La firme devait revenir à ses origines, à David Brown. La V8 avait été un succès et l'on avait vendu plus de 600 Lagonda. La moitié de la production avait toujours trouvé preneur au Royaume-Uni, un quart aux États-Unis et un quart dans le reste du monde. Une bonne partie de la moitié anglaise prenait d'ailleurs également la direction d'outre-mer, car de nombreux clients se faisaient un grand plaisir de venir eux-mêmes ici prendre possession de leur Aston Martin. Le problème était que, si l'on pouvait concevoir un nouveau modèle à Newport Pagnell, il était hors de question de l'y construire, car l'on ne disposait pas de la place nécessaire dans cette usine. Il aurait fallu arrêter tout ce que l'on y faisait d'autre à ce moment-là ; autrement dit, il aurait fallu maintenir d'une façon ou d'une autre l'usine en vie pendant trois ans sans produire quoi que ce soit.

Et c'est alors que j'ai eu un énorme coup de chance. Ford avait besoin d'une marque sur le marché des voitures de luxe, mais d'un tout autre calibre qu'Aston Martin, et elle a repris Jaguar. Or Jaguar possédait, à Bloxham, dans l'Oxfordshire, une petite usine qui avait été construite spécialement pour la XJ220. Il s'agissait à l'origine d'un gigantesque hangar que l'on avait transformé à cette fin précise. Tom Walkinshaw s'était vu confier la direction des opérations. À partir de 1962, j'ai coopéré avec Bill Hayden, le nouveau président de Jaguar installé par Ford. J'étais à la recherche d'un emplacement, peut-être une ancienne usine Rolls-Royce, peut-être même Lotus, ou une quelconque usine sur le continent. Par conséquent, je lui ai demandé quelles étaient ses intentions concernant Bloxham, une fois que le projet XJ220 arriverait à son terme, et il me déclara que je pouvais avoir l'usine. Ensuite, j'ai pris contact avec Walkinshaw et, une fois de plus, j'ai eu de la chance. En effet, il y avait là un jeune et brillant designer, Ian Callum, qui venait d'être promu chef du département Style pour Jaguar et Aston Martin dans le cadre du Ford Premier Automotive Group.

Et, ainsi, je disposais de tous les ingrédients pour rendre mon projet viable aux yeux des directeurs de Ford. Tout cela se passait en 1991. J'avais encore du temps jusqu'en mars 1992. Je m'entretins avec Poling et reçus, pour un prototype, le

Thirty years on, Cosworth Director and one-time chief mechanic of Lotus, Dick Scammell celebrates Cosworth's 30th anniversary at Donington accompanied by Walter Hayes, Jackie Stewart OBE, and Keith Duckworth. The passage of time appears to have left scarcely a mark on the Lotus 49.

Gereift, aber kaum gealtert: Cosworth-Direktor und ehemaliger Lotus-Chefmechaniker Dick Scammell, Walter Hayes, Jackie Stewart OBE und Keith Duckworth 30 Jahre später bei der Cosworth-Geburtstagsfeier in Donington. Am Lotus 49 scheint die Zeit völlig spurlos vorübergegangen zu sein.

Mûris, mais pas vieillis : Dick Scammell, directeur de Cosworth et ancien chef mécanicien chez Lotus, Walter Hayes, Jackie Stewart et Keith Duckworth, trente ans plus tard, lors de la cérémonie d'anniversaire de Cosworth à Donington. Le temps ne semble pas avoir laissé sa trace sur la Lotus 49.

turbo so it had to be supercharged. I don't believe in turbos because then an engine is added to an engine. Jaguar had a good block which was going out of production anyway. It was substantially redesigned for our purpose. We did the head, superchargers and so on. In March 1992 we had a meeting in London, and I took Poling to our showroom opposite Harrod's and unveiled the car which we had built in 16 weeks, a metal prototype with seats, leather interior, the engine in. The original Callum design was virtually unchanged. It came out of the cradle perfect. The Ford senior management thought this a viable proposal and I got $49 million. At the same time we did the big Vantage, which was important because you have the ultimate car in your range.

We got a lot of assistance from Ford. Down at Dagenham they would build test rigs for us which we could not afford, also helping us with the emission program. When we needed equipment they gave it to us, as well as quality control equipment etc. We designed the factory and the parts store.

We were going to build 600 DB7s a year. When I joined Aston Martin they had made 12,000 cars altogether, so that was a fairly big step up. We had only 40 dealers so we set about increasing the dealer force to about a hundred. And then in spring 1994 when I was 70 I retired and a new chairman took over. I introduced the DB7 myself, long before the launch in Geneva, being still with the company at that time. I wanted to show it to the public because it is difficult to go around and get new dealers if they don't know what they are going to sell. I also wanted to show, with the Shooting

Und somit verfügte ich über alle Voraussetzungen, die meinen Plan für die Ford-Spitze attraktiv machen würden. All dies passierte 1991. Ich hatte noch Zeit bis zum März 1992, redete mit Poling und bekam für einen Prototyp die Million Dollar, um die ich gebeten hatte. Die Schwierigkeit war, dass der Preis des Wagens unter 80 000 Pfund liegen sollte. Dieses Marktsegment hatten wir angepeilt. Für ein per Hand gebautes Fahrzeug war er natürlich utopisch. Aber wir legten uns wirklich in die Riemen, suchten zum Beispiel den Vickers-Vorsitzenden auf. Er sagte uns zu, dass die Lackierarbeiten im ultramodern ausgerüsteten Rolls-Royce-Werk Crewe vorgenommen werden konnten.

Hinsichtlich der Karosserie fand ich einen hervorragenden Lieferanten. Was etliche Teile anbelangte, wusste ich, dass ich bei Jaguar gut aufgehoben war. Zugleich stand mir die Bedeutung des Mythos Aston Martin vor Augen. Also brachte ich einige historische Astons sowie Bilder in Callums Studio und sagte ihm, ich strebte nichts Sensationelles in der Form eines Pfeils oder dergleichen an. Auch wollte ich nichts, was Frauen erschreckte, weil sie darin ihre Unterwäsche zeigen mussten. Ich wollte einen sehr eleganten, verbraucherfreundlichen, schnellen Sportwagen, der an die DB-Baureihen anknüpfte. Das hatte ich bereits David Brown vorgetragen. Er war begeistert von der Idee und versprach jede Unterstützung.

Dann war da die Maschine. Ich entschied mich für einen Reihensechszylinder und kein Turbo-Aggregat. Folglich mussten wir auf einen Kompressor zurückgreifen. Das Turbo-Prinzip mag ich nicht, da es bedeutet, dass eine Maschine mit einer Maschine zusammengespannt wird. Jaguar hatte einen guten Block, der ohnehin aus der Produktion genommen wurde. Für unseren Zweck wurde er gründlich überarbeitet. Wir sorgten für den Zylinderkopf, den Kompressor und so weiter.

Im März 1992 kam es zu einem Treffen in London. Ich ging mit Poling zu unserem Ausstellungspavillon gegenüber dem Kaufhaus Harrod's und enthüllte den Wagen, den wir in 16 Wochen gebaut hatten, einen Prototyp in Metall, mit Sitzen, Ledereinrichtung und einem Motor unter der Haube. Der ursprüngliche Entwurf Ian Callums war buchstäblich unverändert, perfekt, so wie er aus der Wiege gekommen war. Die Ford-Spitze fand meinen Vorschlag akzeptabel und sagte mir 49 Millionen Dollar zu. Zur gleichen Zeit brachten wir den dicken Vantage heraus. Das war wichtig, da man stets das ultimative Modell in seiner Palette haben muss. Ford unterstützte uns nach Kräften. Im Werk Dagenham bauten sie Prüfstände für uns, die wir uns niemals hätten leisten können, und halfen uns auch bei dem Emissionsprogramm. Wir bekamen alles an Ausrüstung, was wir brauchten, wie zum Beispiel die Vorkehrungen für die Qualitätskontrolle. Wir hingegen entwarfen die Fabrik und das Teilelager nach unseren Vorstellungen. 600 DB7 pro Jahr wurden ins Auge gefasst. Als ich zu Aston Martin kam, hatte man insgesamt 12 000 Fahrzeuge hergestellt. Das lief also auf

million de dollars que je lui avais demandé. Le problème était que le prix de la voiture devait être inférieur à 80 000 livres. Tel était le segment de marché que nous avions visé. Nous nous sommes vraiment donné du mal et avons, par exemple, rendu visite au président de Vickers. Il nous promit que les travaux de peinture pourraient être exécutés dans l'usine ultramoderne que Rolls-Royce possède à Crewe.

En ce qui concerne la carrosserie, j'ai trouvé un fournisseur remarquable. Pour bon nombre de pièces, je savais que j'étais logé à bonne enseigne chez Jaguar. En même temps, j'étais parfaitement conscient de la signification du mythe Aston Martin. J'ai donc amené quelques Aston historiques ainsi que des photos dans le studio de Callum et lui ai déclaré que je ne souhaitais rien de sensationnel, avec une forme de fusée ou quoi que ce soit de ce genre. Je voulais une voiture de sport très élégante, conviviale, rapide, une voiture qui s'inspire de l'histoire de DB. J'en avais déjà parlé à David Brown. Il était emballé par mon idée et me promit tout son soutien.

Mais il y avait encore la question du moteur. J'ai opté pour un six-cylindres en ligne et non pas pour un moteur suralimenté. Il nous fallait donc logiquement recourir à un compresseur. Je n'aime pas le principe du turbo, car cela signifie que l'on accole une machine à une autre machine. Jaguar possédait un excellent bloc dont la production devait être arrêtée. Il a été complètement repensé à notre intention. Nous nous sommes chargés de la culasse, du compresseur, et ainsi de suite.

En mars 1992, une rencontre était projetée à Londres. Je me suis rendu avec Poling jusqu'à notre pavillon d'exposition, juste en face du grand magasin Harrod's, pour lui dévoiler la voiture que nous avions construite en 16 semaines, un prototype en métal, avec des sièges, une sellerie cuir et un moteur sous le capot. Le dessin original de Ian Callum était littéralement inchangé, parfait, exactement comme il avait jailli sous son crayon. La direction de Ford trouva ma proposition acceptable et me promit 49 millions de dollars. À la même époque, nous avons commercialisé la grosse Vantage. Ce détail est important, car l'on doit toujours posséder à son catalogue le modèle le plus prestigieux de la gamme. Ford nous soutenait de son mieux.

À l'usine de Dagenham, ils ont construit à notre intention des bancs d'essais que nous n'aurions, sinon, jamais pu nous offrir et ils nous ont aussi aidés pour le programme de dépollution. Nous avons reçu tous les équipements dont nous avions besoin, par exemple les dispositifs pour le contrôle de la qualité. Quant à nous, de notre côté, nous avons dessiné l'usine et le magasin de pièces détachées selon nos propres conceptions. Nous envisagions de produire 600 DB7 par an. Lorsque je suis arrivé chez Aston Martin, l'entreprise avait construit au total 12 000 voitures. L'augmentation de rythme était donc considérable. Nous disposions de quarante concessionnaires. Nous nous sommes alors mis en demeure de majorer à cent le nombre des succursales. Au printemps 1994, j'ai fêté mon 70e anniver-

Brake we introduced in Geneva, that we were carrying on in a much more expensive field, partly because, unlike the DB7, those cars are still completely handmade. We had retained an essential craft, and on the other hand the world markets began to recover. I have sometimes thought that there really is somebody up there who wanted to save Aston Martin. The change would possibly not have occurred without that 1989/1990 recession, because we were busily working on the future at that time and came out with a wonderful motorcar. The quality is remarkably high. These classics are not aging at all, unlike some new sports cars that somehow look dated after two years. But the DB7 doesn't look dated at all.

Other takeovers, like the BMW/Rover one, have been difficult because two cultures have to be reconciled. But having Big Brother in America has worked quite well for Aston Martin. The difference between us and Ferrari? We are James Bond, and they are Miami Vice! There never was any clash of interests with me being a Ford man since Aston Martin had to be left discreet and separate. We were not required to make any money, but were expected not to lose any. When I first went to Aston Martin I asked them to give me the costs of a basic motorcar. What did every item going into a car cost? The engine cost £15,500. The builder has his name on the engine (on the big cars). They will always be built by one man. Sometimes when there's a problem we send a man to the exact location, even overseas. When BMW introduced the Mini they knew that the costs were below the price, but when an Aston Martin became too expensive the price was raised regardless of the market situation. When I came to Aston Martin I told everyone that nobody would get a wage increase until we had saved the company. And we did sell the car at £79,500, as I had promised.

Prince Charles was given an Aston by the Queen on his 21st birthday. His two little boys used to have a baby Aston Martin. Some people specify in their wills who will get the Aston. An Aston was the first English sports car to win the World Championship, and the Owners' Club was the first club in the world to have its own private pit at Le Mans. An Aston Martin still appeals to the young who tend to consider things like Cortinas and MGBs as classic cars. Up to 35,000 people turn up at Aston Martin race meetings. These things show me that it has all been worthwhile.

eine erhebliche Steigerung hinaus. Wir verfügten über 40 Händler. So machten wir uns daran, die Anzahl der Niederlassungen auf 100 aufzustocken. Im Frühjahr 1994 wurde ich 70 und zog mich wie vereinbart zurück. Den DB7 hatte ich der Öffentlichkeit lange vor der offiziellen Premiere in Genf 1994 vorgestellt. Schließlich müssen neue Händler ja wissen, was sie verkaufen werden. Mit dem Shooting Brake, den wir ebenfalls in Genf zeigten, wollte ich demonstrieren, dass wir auch in einem viel teureren Marktbereich die Flinte nicht ins Korn zu werfen gedachten. Das kam einem Bekenntnis zu bester Handwerkertradition gleich, und außerdem begann sich die Nachfrage erfreulich zu stabilisieren. Manchmal denke ich, dass da oben wirklich jemand ist, dem das Wohl von Aston Martin am Herzen liegt. Der Aufschwung hätte allerdings ohne die Rezession von 1989 und 1990 vielleicht nie stattgefunden, weil wir mit vollem Einsatz für die Zukunft gearbeitet haben und dabei ein wirklich wundervolles Auto herausgekommen ist. Die Qualität ist erstaunlich hoch. Zudem altern diese Klassiker nicht, im Gegensatz zu einigen anderen Sportwagen, die nach zwei Jahren irgendwie antiquiert aussehen.

Andere Übernahmen wie etwa die von Rover durch BMW waren schwierig, da sich zwei verschiedene Kulturen miteinander vertragen mussten. Aber mit Big Brother in Amerika haben wir gut zusammengearbeitet.

Als Ford-Mann kam ich nie in Gewissenskonflikte, weil man mit Aston Martin ungemein behutsam umgegangen ist. Wir brauchten keinen Gewinn einzufahren, sollten aber auch keine Verluste machen. Als ich das erste Mal in Newport Pagnell die Runde machte, fragte ich nach den nackten Kosten eines Wagens beziehungsweise der Teile, aus denen er bestand. Die Maschine zum Beispiel schlug mit 15 500 Pfund zu Buche. Bei den V8 steht jeweils der Name des Mitarbeiters drauf, der sie gebaut hat. Als BMC den Mini herausbrachte, wusste man, dass die Kosten unterhalb des Preises lagen. Wenn die Fertigung eines Aston Martin zu kostspielig wurde, hat man einfach den Preis erhöht, egal wie die Marktsituation gerade war. Ich machte auch keinen Hehl daraus, dass niemand eine Gehaltserhöhung bekommen würde, bis wir das Unternehmen gerettet hätten. Und in der Tat verkauften wir den DB7 wie versprochen für 79 500 Pfund.

Prinz Charles bekam von seiner Mutter, der Königin, zu seinem 21. Geburtstag einen Aston Martin. Seine beiden Jungs besaßen einen Baby-Aston als Spielzeug. Einige Leute legen in ihrem Testament fest, wer den Aston erben wird. Ein Aston Martin war der erste englische Sportwagen, der die Weltmeisterschaft gewann. Der Aston Martin Owners' Club hatte als erster Club in der Welt seine eigene Box in Le Mans. Ein Aston Martin spricht noch immer die jungen Leute an, die sonst Autos wie den Cortina oder den MGB als Klassiker ansehen. Bis zu 35 000 Zuschauer erscheinen bei Rennveranstaltungen der Marke Aston Martin.

All das zeigt mir, dass die Sache, für die ich gekämpft habe, eine gute Sache ist.

saire et, comme convenu, je me suis retiré. J'avais présenté la DB7 au grand public longtemps avant sa première officielle au Salon de Genève de 1994. En effet, les nouveaux concessionnaires devaient savoir ce qu'ils allaient vendre. Avec le Shooting Brake, que nous avions également exposé à Genève, je voulais montrer que nous n'avions pas pour autant l'intention de faire une croix sur un autre segment du marché représenté par les véhicules de luxe. C'était une espèce de profession de foi envers la meilleure tradition artisanale – ces véhicules étaient fabriqués à la main – et, en outre, la demande commençait à se stabiliser à un niveau satisfaisant. Ce redressement n'aurait toutefois peut-être jamais eu lieu sans la récession de 1989 et 1990, parce que nous avons alors travaillé de toutes nos forces pour l'avenir et, à cette occasion, avons produit une voiture vraiment merveilleuse. Sa qualité est d'un niveau étonnamment élevé. De plus, de telles classiques ne vieillissent pas, contrairement à de nombreuses autres voitures de sport qui, au bout de deux ans, commencent déjà à sembler archaïques.

Certaines fusions, par exemple la reprise de Rover par BMW, se sont révélées difficiles parce que deux cultures différentes devaient composer. De notre côté, avec Big Brother, en Amérique, nous avons coopéré harmonieusement.

En tant qu'ancien de chez Ford, je n'ai jamais eu de conflits d'intérêts parce que nous avons traité Aston Martin comme une entité à part. Nous n'avions pas besoin de faire des bénéfices, mais nous ne devions pas non plus subir de pertes. Lorsque j'ai fait ma première inspection à Newport Pagnell, j'ai demandé quel était le prix de revient d'une voiture ou, en l'occurrence, des pièces qui la composaient. Le moteur, par exemple, revenait à 15 500 livres. Le V8 arbore le nom du collaborateur qui l'a construit, et c'est toujours une seule personne qui fabrique un moteur. Lorsque BMC a commercialisé la Mini, on savait très bien que les coûts seraient inférieurs à son prix. Lorsque la fabrication d'une Aston Martin devenait trop coûteuse, on se contentait d'en augmenter le prix, sans tenir compte de la situation économique. Je n'ai pas fait mystère que personne ne recevrait d'augmentation de salaire tant que l'entreprise ne serait pas sauvée. Et, de fait, nous avons vendu la DB7, comme promis, pour 79 500 livres.

Le prince Charles a reçu de sa mère, la reine, une Aston Martin en cadeau pour son 21e anniversaire. Ses deux garçons possédaient une Aston miniature comme jouet. Il y a des gens qui précisent dans leur testament qui doit hériter de leur Aston Martin. Une Aston Martin a été la première voiture de sport anglaise à remporter le championnat du monde. L'Aston Martin Owners' Club a été le premier club du monde à posséder son propre stand au Mans. Aston Martin séduit encore et toujours les jeunes gens qui considèrent comme classiques des voitures telles que la Cortina ou la MGB. Jusqu'à 35 000 spectateurs affluent aux courses auxquelles participe la marque Aston Martin.

Tout cela me prouve que la cause que j'ai défendue était une bonne cause.

Swimming in the Rain

by Robert Leyba

The price of an Aston Martin includes a long life, and many vintage Astons are now older than their owners. Undeterred, many old stagers are attracted to the events put on by the Aston Martin Owners' Club. This poses a dilemma for the driver: he naturally wants to preserve his classic vintage machine, but car races generate their own dynamic. President of the German AMOC, Robert Leyba, deals with this here.

Im Preise eines Aston Martin ist von jeher ein langes Leben einbegriffen. Viele historische Fahrzeuge sind bereits betagter als ihre gegenwärtigen Besitzer. Dennoch wird so mancher alte Kämpe auf den Veranstaltungen des Aston Martin Owners' Club unermüdlich dem Rennsport zugeführt. Der Pilot steht dann vor einem Dilemma. Einerseits will er sich und der Nachwelt seinen wertvollen Klassiker erhalten. Andererseits entfalten Autorennen ihre eigene Dynamik. Auch davon handelt der folgende Bericht des deutschen AMOC-Präsidenten Robert Leyba.

Une vie très longue a, de tout temps, été incluse dans le prix d'une Aston Martin. Beaucoup de voitures de collection sont déjà plus âgées que leur propriétaire actuel. Et pourtant, lors des manifestations de l'Aston Martin Owners' Club, on fait appel à ces nobles vétérans. Le pilote est alors confronté à un dilemme. D'un côté, il veut préserver, pour lui-même et les générations futures, sa précieuse automobile. Mais, d'un autre côté, les courses automobiles sont fort tentantes. C'est cette alternative qu'évoque l'article du président de l'AMOC allemand, Robert Leyba.

Since 1950 the Aston Martin Owners' Club has been staging the St. John Horsfall Race Meeting at Silverstone in memory of the legendary racer St. John ("Jock") Horsfall. He was one of the best-known and most successful Aston Martin drivers of his era, achieving his greatest successes in a 2 liter Speed Model at Brooklands and Donington in 1938. During 1947 and 1948 he assisted Aston Martin with the development of the DB1. He died in 1949 at Silverstone, aged just 39, when his ERA crashed and rolled over on the 13th lap of the International Trophy Race.

The Horsfall Meeting is the biggest race meeting in the world for Aston Martin cars. It normally takes place in June, and represents a unique opportunity to admire large numbers of Astons, including dozens of prewar cars, every model from the DB1 to the DB6 and also, of course, more recent models such as the DBS, V8, Virage and Lagonda. These are to be found not only among the racing cars gathered in the Paddock, but also in the special car park for AMOC members and at the Concours competition put on by the Club simultaneously. Depending on the weather, each year anything from 300 to 500 Astons gather at Silverstone to do fitting homage to the memory of St. John Horsfall. It was only natural then, that in 1999 the AMOC sent out its invitations to Silverstone for the 50th staging of the 1999 with especial pride. The unusual date (8th August) was due to a clash of fixtures. Our Hamburg troupe once again set about preparing some of our most interesting vehicles for the event. To make sure the trip to England would be worthwhile, we put together a small team and took the ferry to Harwich. For the 1999 event we registered a DB2 team car (VMF 65), a DB3S (SR 34) and a DB4GT (BE 40100).

Seit 1950 führt der Aston Martin Owners' Club das St. John Horsfall Race Meeting in Silverstone durch, ein Memorial zu Ehren der Rennfahrer-Legende St. John (»Jock«) Horsfall. Er war der bekannteste und erfolgreichste Aston-Martin-Rennfahrer seiner Zeit. Die größten Erfolge erzielte er mit einem 2-litre Speed Model in Brooklands und Donington 1938. In den Jahren 1947 und 1948 half er dem Werk bei der Entwicklung des DB1. Mit nur 39 Jahren starb »Jock« Horsfall 1949 in Silverstone, als er sich in der 13. Runde des International Trophy Race mit seinem ERA überschlug.

Das Horsfall-Meeting ist weltweit die größte Rennveranstaltung mit Fahrzeugen des Hauses Aston Martin. Es findet normalerweise im Juni statt und es gibt keine Gelegenheit, bei der eine größere Anzahl von Astons bewundert werden kann, unter ihnen Dutzende von Vorkriegswagen und alle Modelle vom DB1 bis zum DB6 und natürlich auch die jüngeren Fahrzeuge wie DBS, V8, Virage und Lagonda. Das gilt nicht nur für den Paddock mit den Rennwagen, sondern auch für den Sonderparkplatz der AMOC-Mitglieder und den Concours-Wettbewerb, den der Club gleichzeitig durchführt. Abhängig von der Witterung finden sich jährlich 300 bis 500 Astons in Silverstone ein, um dem Gedächtnis an St. John Horsfall den richtigen Rahmen zu geben.

Da war es nur natürlich, dass der AMOC 1999 mit besonderem Stolz zum 50. Geburtstag des Meetings nach Silverstone einlud. Das Datum, der 8. August, war allerdings etwas ungewöhnlich und hing mit Terminüberschneidungen zusammen. Jedenfalls fühlte sich auch unsere Truppe aus Hamburg erneut aufgerufen, die interessantesten Fahrzeuge für dieses Ereignis vorzubereiten. Damit

Depuis 1950, l'Aston Martin Owners' Club organise traditionnellement le St. John Horsfall Race Meeting à Silverstone, une course disputée en la mémoire d'une légende de la course automobile, St. John («Jock») Horsfall. Il était le pilote d'Aston Martin le plus connu et le plus brillant de son époque. Il a remporté ses plus grands succès avec une 2-litres Speed à Brooklands et Donington en 1938. En 1947 et 1948, il a aidé l'usine à mettre au point la DB1. Âgé de 39 ans seulement, «Jock» Horsfall s'est tué en 1949 à Silverstone lorsque, au 13e tour de l'International Trophy Race, son ERA est partie en tonneaux.

Le Horsfall-Meeting est le plus grand week-end de course automobile du monde dédié aux voitures de la marque Aston Martin. Il est normalement organisé au mois de juin et il n'y a aucune autre occasion où l'on puisse admirer un plus grand nombre de voitures, dont des dizaines de voitures d'avant-guerre et tous les modèles de la DB1 à la DB6 ainsi que, naturellement, les millésimes plus récents comme la DBS, la V8, la Virage et la Lagonda. Cela ne vaut pas seulement pour le paddock où se côtoient les voitures de course, mais aussi pour le parking spécial réservé aux membres de l'AMOC et pour le concours d'élégance que le club organise simultanément. Selon le temps qu'il fait, entre 300 et 500 Aston font, chaque année, le déplacement à Silverstone pour donner le cadre qui convient à la commémoration de St. John Horsfall.

Il était donc naturel que, en 1959, l'AMOC lance ses invitations pour le cinquantenaire du meeting de Silverstone avec une fierté toute particulière. Le jour choisi, le 8 août, n'était toutefois pas coutumier et était dû à des problèmes de dates. Quoi qu'il en soit, notre troupe de Hamburg estimait de son devoir de préparer pour cet événement les voitures les plus inté-

Despite the poor weather forecast we were in good spirits as we loaded everything onto the ferry, and immediately started plundering our picnic baskets, knowing from experience that the coming days at Silverstone would have little to offer on the culinary front. We arrived in England under overcast skies, but at least it was warm and dry. A pleasant surprise was awaiting us at Silverstone, as Richard Culverhouse of the AMOC, who has been organizing this event for years with great efficiency and commitment, had assigned us our own pit (No. 5). This had been lavishly done up for the Grand Prix just a few weeks previously by McLaren Mercedes and fitted with a new floor. Preparations were soon complete, with everything unloaded, tires changed, tanks filled, air pressure and all fluid levels checked. The official acceptance was also no problem, as we knew from the previous year what was and was not allowed. Then we had to sort out the registration, hand in our papers and so forth. One of the top drivers, entering his 1951 DB2 team car, was none other than Rowan Atkinson, aka Mister Bean. He waited patiently in line along with the rest of us to register for his race. This all took about half an hour, and as we left the office it started to rain heavily. So fierce was the downpour that after just ten minutes the circuit was under half an inch of water. The worried owners of open prewar cars attempted to protect the interiors of their vehicles with tarpaulins and all manner of makeshift covers, including umbrellas. The organizers had assigned them to an open area so that they could honor the memory of St. John Horsfall unimpeded. We were somewhat better off in our pit, although a slope in the wrong direction from the pitlane meant that water came streaming through our area. The circuit was obscured by spray and you could see

sich die Reise nach England auch lohnte, packten wir jeweils ein kleines Team zusammen und auf die Fähre nach Harwich. Für 1999 hatten wir ein DB2 Team Car (VMF 65), einen DB3S (SR 34) und einen DB4GT (BE 40100) gemeldet. Trotz der mäßigen Wettervoraussagen für England luden wir alles gut gelaunt auf die Fähre und begannen schon frühzeitig mit der Plünderung unserer Picknickkörbe. Aus Erfahrung wussten wir, dass für die kommenden Tage ernährungsmäßig im Raum Silverstone keine Höhepunkte zu erleben waren. Bei der Ankunft in England fanden wir einen bedeckten Himmel vor, aber es war warm und regnete nicht. In Silverstone erwartete uns eine freudige Überraschung, da Richard Culverhouse vom AMOC, der die englischen Rennen seit Jahren liebevoll und mit großem Einsatz organisiert, uns eine Box (No. 5) zugewiesen hatte. Diese war wenige Wochen zuvor für den Grand Prix von McLaren Mercedes aufs Feinste dekoriert und mit einem neuen Fußboden ausgestattet worden.

Schnell waren die Vorbereitungen getroffen, alles abgeladen, Reifen gewechselt, getankt, Luftdruck und alle Flüssigkeiten geprüft. Auch die technische Abnahme war kein Problem, da wir vom Vorjahr her schon wussten, was erlaubt und was verboten ist.

Dann hatten wir uns um die Registrierung, die Abnahme der Papiere usw., zu kümmern. Ein Topfahrer mit seinem DB2 Team Car aus dem Jahre 1951 ist Rowan Atkinson, allseits bekannt als Mister Bean. Er wartete geduldig wie wir alle, bis er sich für sein Rennen anmelden konnte.

Diese Prozedur dauert etwa eine halbe Stunde und als wir das Büro verlassen, fängt es an kräftig zu regnen. Der Niederschlag setzt so vehement ein, dass schon nach zehn Minuten Fingerbreit

ressantes possibles. Pour que le voyage en Angleterre en vaille vraiment la peine, nous avions constitué une petite équipe avant de nous embarquer sur le ferry de Harwich. Pour 1999, nous avions inscrit une DB2 Team Car (VMF 65), une DBS3 (SR 34) et une DB4GT (BE 40100). Malgré des prévisions météorologiques peu encourageantes pour l'Angleterre, nous avons chargé, l'humeur légère, toutes nos voitures sur le ferry et avons commencé très tôt à piller nos corbeilles de pique-nique. Forts de notre expérience, nous savions que nous ne devions pas nous attendre à trouver un paradis culinaire dans les environs de Silverstone au cours des prochains jours. À notre arrivée en Angleterre, le ciel était couvert, mais il faisait chaud et il ne pleuvait pas. À Silverstone, une heureuse surprise nous attendait : Richard Culverhouse, de l'AMOC qui organise l'événement depuis des années avec efficacité et engagement, nous avait réservé un stand, le n° 5. Quelques semaines plus tôt, McLaren Mercedes l'avait aménagé avec le plus grand luxe en prévision du Grand Prix et avait fait poser un nouveau revêtement au sol. Nos préparatifs ont vite été terminés, nous avons tout déchargé, changé les pneus, fait le plein, contrôlé la pression des pneumatiques et le niveau de tous les liquides. Le contrôle technique n'a pas posé de problème non plus, car nous savions déjà, depuis l'année précédente, ce qui était autorisé et ce qui était interdit. Il nous a fallu nous occuper de l'enregistrement, de la réception des papiers, etc. Un pilote émérite avec sa DB2 officielle de 1951 était présent : Rowan Atkinson, célèbre dans le monde entier sous le nom de Mister Bean. Il a attendu patiemment, comme chacun de nous, avant de pouvoir s'inscrire pour sa course. Cette procédure dure environ une demi-heure et, au moment où nous avons

A question of transfer: even for the short transition between the chilly protection of the resplendent tourers from the Bertelli era and the cosy hospitality of the marquees a good umbrella is needed.

Frage des Transfers: Schon für den kurzen Übergang zwischen der frostigen Geborgenheit der Tourer aus der Bertelli-Ära und der Gastlichkeit der Zelte tut ein Schirm gute Dienste.

Capacité d'adaptation : un parapluie est le bienvenu pour sauter du froid cockpit des voitures de l'ère Bertelli à la chaleur des tentes accueillantes.

nothing, even as a spectator, and the first Type 4, 5 and 6 Astons soon span off. We were standing right by the finishing line as a DB4 crashed into the barrier for no apparent reason, removing the sign indicating the braking point for the next corner, which thus became a matter of sheer guesswork. Despite everything the mood in the pits was cheerful. Our English hosts had grown up with heavy rain. They know the course and with their old-timers in race trim, they can perform well even on a wet track. However, I cannot say the same. Our DB2 team car had been newly restored over the winter and was scheduled for its first serious challenge at Silverstone. However, with its 1950s profile Dunlop racing tires, racing it on a wet surface is like driving on an oil slick. Meetings like this are a first-class opportunity for finding out if your adrenaline levels still hit the roof when the occasion demands. The rain got still heavier, the number of retirements in other groups multiplied, and concern for the safety of the cars was widespread. A loudspeaker announcement reverberating down the pitlane called on participants in the Feltham Class to take up their start positions. I plucked up my courage, switched on the small windscreen wiper (which made precious little difference) and drove off to the starting grid. Alongside me I could see grim-faced professionals, some of whom had been racing at Silverstone for decades come rain or shine. I, on the other hand, was toying with the idea of feigning some small mechanical fault which would allow me to push my priceless team car back into the dry pit area. The rain drummed down on the huge hood, which had by now warmed up nicely, so that clouds of steam rose from it.

Finally the lights went green and practice was on. I could make out nothing in front of me. Then I started in alarm as fast-moving cars came into view immediately

das Wasser auf der Rennstrecke steht. Die besorgten Eigentümer der offenen Vorkriegswagen versuchen, das Innere ihrer Fahrzeuge mit Planen, Abdeckungen aller Art und Regenschirmen zu schützen. Die Veranstalter haben ihnen einen offenen Platz zugewiesen, damit sie sich ungehindert an St. John Horsfall erinnern können. In unserer Box haben wir es da schon etwas besser, obwohl das Gefälle vom Vorplatz her falsch angelegt ist und das Wasser in Strömen hereinläuft.

Mit Spannung verfolgen wir das Training der anderen Gruppen. Der Kurs wird von Spray überlagert. Man sieht nichts, nicht einmal als Zuschauer, und die ersten Astons des Typs 4, 5 und 6 rutschen ins Aus. Wir stehen gerade an der Ziellinie, als ein DB4 ohne ersichtlichen Grund in die Leitplanke kracht und damit zugleich das Schild mit dem Hinweis auf die nächste Kurve abräumt. Es diente als Hinweis auf den Anbremspunkt, den man jetzt nur noch erahnen kann.

Die Stimmung an den Boxen ist gleichwohl ausgelassen. Unsere englischen Freunde sind in heftigem Regen aufgewachsen. Sie kennen den Kurs und können mit ihren Oldtimern im Renntrimm auch auf nasser Strecke sehr gut umgehen. Für mich gilt das allerdings nicht. Unser DB2 Team Car haben wir im Winter frisch restauriert und es soll in Silverstone erstmals zu ernsthaftem Einsatz gelangen. Überdies fährt es sich mit den Dunlop-Racing-Reifen mit einem Profil aus den fünfziger Jahren auf feuchter Fahrbahn wie auf Schmierseife. Rennveranstaltungen dieser Art gelten eine erstklassige Übung, wenn man feststellen will, dass der Adrenalinpegel noch immer kräftig ansteigt, wenn die Umstände danach verlangen. Der Regen nimmt weiter zu, es häufen sich die Ausfälle in den anderen Gruppen und Sorgen um das eigene Auto machen sich breit. Durch die Boxengasse schallen mit grausamer Härte Lautsprecher, die alle Teilnehmer der Feltham Class zur Aufstellung am Start auffordern. Ich nehme meinen ganzen Mut zusammen, schalte die kleinen Scheibenwischerchen ein, was allerdings nichts bringt, und fahre zum Startplatz. Neben mir stehen mit grimmigen Mienen die Profis, die zum Teil schon seit Jahrzehnten in Silverstone mit oder ohne Regen fahren. Ich aber mache mir Gedanken, ob ich nicht vielleicht einen kleinen Defekt simulieren soll, um mein Team Car wieder in die trockene Box schieben zu dürfen. Der Regen prasselt auf die riesige Motorhaube, die sich inzwischen auch im Stand gut aufgeheizt hat, so dass sich Wolken aus verdampfendem Wasser darüber kräuseln.

Endlich springt die Ampel auf Grün und es geht auf die Strecke. In der Gischt der Vorausfahrenden ist nichts zu sehen. Erschrocken stelle ich fest, dass unmittelbar rechts und links neben mir schnellere Autos auftauchen, für Bruchteile einer Sekunde zu sehen sind und dann an mir vorbeiziehen. Kleine Seelandschaften bilden sich auf dem Asphalt, in die das Team Car mit Getöse einschlägt. Durch die Windschutzscheibe spritzt mir Wasser ins Gesicht und aus einem

quitté le bureau, il commence à tomber des hallebardes. L'ondée est si violente que, à peine dix minutes plus tard, la piste est noyée sous plusieurs centimètres d'eau. Au bord de la panique, les propriétaires de voitures d'avant-guerre découvertes s'efforcent de protéger l'habitacle de leurs véhicules avec des bâches, feuilles de plastique en tout genre et parapluies. Les organisateurs leur ont réservé un emplacement en plein air en souvenir de St. John Horsfall. Dans notre stand, nous sommes logés à bien meilleure enseigne bien que la voie d'accès aux stands soit inclinée dans le mauvais sens et que l'eau pénètre à flots dans notre box.

La piste est noyée dans un véritable brouillard. Personne n'y voit goutte, pas même les spectateurs, et les premières Aston du type 4, 5 et 6 sortent de la piste. Nous nous tenons juste à hauteur de la ligne d'arrivée lorsque, sans raison apparente, une DB4 percute les glissières de sécurité et rase par la même occasion le panneau indiquant la prochaine courbe. Ce panneau servait de repère pour le point de freinage, que l'on ne peut maintenant plus que deviner.

L'ambiance n'en reste pas moins décontractée. Les gènes de nos amis anglais sont habitués à la pluie. Ils connaissent le tracé du circuit et n'hésitent pas à cravacher leur voiture de collection en course, même sur une piste détrempée. Mais ce n'est pas mon cas. Durant l'hiver, nous avons totalement restauré notre DB2 d'usine et la course de Silverstone est en quelque sorte son baptême du feu. En outre, équipée de pneus Racing Dunlop avec le profil des années 1950, elle donne l'impression d'être au volant d'une savonnette sur la piste humide.

Les courses de ce genre sont un exercice idéal si l'on veut constater que le niveau d'adrénaline augmente vraiment très vite lorsque les circonstances s'y prêtent. La pluie se fait de plus en plus violente et les abandons se multiplient dans les autres groupes. Dans la voie des stands résonnent les haut-parleurs qui, impitoyables, invitent tous les participants de la Feltham Class à s'aligner sur la grille de départ. Je saisis mon courage à deux mains, actionne les lames de rasoir qui servent d'essuie-glaces et prends place sur la grille. Je suis entouré de pros dont certains, le visage empreint de détermination, courent depuis des dizaines d'années déjà à Silverstone, qu'il pleuve ou non. Je me demande un instant si je ne ferais pas mieux de simuler une petite panne qui me servirait de prétexte pour pouvoir rentrer au stand, bien au sec avec ma voiture. La pluie tambourine sur le gigantesque capot moteur qui, entre-temps, s'est tellement échauffé à l'arrêt que les gouttes qui le martèlent se transforment en volutes de vapeur d'eau.

Le signal du départ passe enfin au vert et nous nous élançons sur la piste. Dans le brouillard provoqué par la voiture qui me précède, je n'y vois absolument rien. Effrayé, je constate que me frôlent, à gauche et à droite, des voitures plus rapides que je ne distingue que pendant quelques fractions de seconde avant qu'elles ne disparaissent devant moi. À travers le pare-brise, la pluie me fouette le visage et, par une ouïe d'aéra-

Not even the Atom in its dignified uniqueness is exempted from the chicanes of the climate.

Selbst dem altehrwürdigen Atom bleiben die Schikanen der Witterung nicht erspart.

Même la vénérable Atom ne se voit pas épargnée par les caprices de la météorologie.

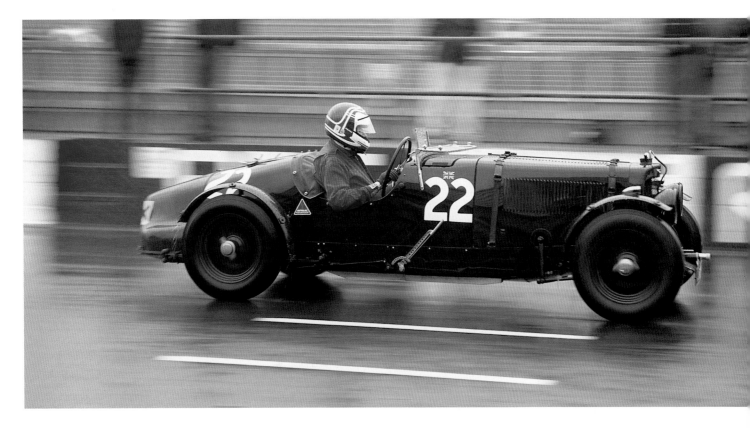

to my right and left for a fraction of a second before whizzing past me into the mist. The team car thundered through the miniature seascapes that were forming on the tarmac. Water from the windscreen was splashing onto my face, while beneath the dashboard water was streaming through an air vent onto my legs. Was this the romance of the racetrack that we hear so much about, or would it perhaps have been a better idea to pass the session enjoying the facilities of the AMOC's VIP lounge? Nonetheless, I drove VMF 65 ever onward through the spray. Built to be a team car for Le Mans 1951, like the meeting itself it would soon be celebrating its 50th birthday. By the time the session finally came to an end, I had lost count of the number of laps I had done. I realized with relief that I had got my DB2 safely home. The race itself always takes place after lunch. This gave me the opportunity to check up on the others in the Concours marquee. Our DB4GT had managed fifth place, a very respectable achievement from a car which had seen action several times at Brands Hatch and Silverstone over the past two years. For lunch Aston Martin had provided a splendid marquee. Making our way there through increasingly heavy rain we all agreed that a rubber dinghy was the only way of getting around that day. Not long after the competition was called off by the organizers due to the waterlogged circuit. We passed on without complaint to the social side of the meet, unpacking our picnic baskets in pit No. 5. The undisputed favorite among our English hosts was the Landjäger smoked sausage.

Lüftungsloch unter dem Armaturenbrett strömt Wasser auf meine Beine. Ist das die Rennfahrerromantik, von der so viel zu lesen ist, oder hätte ich das Training nicht doch lieber in der VIP-Lounge des AMOC genießen sollen? Immer weiter treibe ich VMF 65 durch die Nässe, das 1950 für Le Mans gebaute Team Car, das wie das Meeting selbst in wenigen Monaten seinen Fünfzigsten feiern wird. Nach Runden, die ich nicht gezählt habe, ist alles zu Ende und ich stelle fest, dass ich meinen DB2, der in Silverstone seit Jahrzehnten nicht mehr zum Einsatz kam, unversehrt nach Hause getragen habe.

Das Rennen selbst findet immer erst nach der Mittagspause statt. Das gab mir die Gelegenheit, bei den anderen im Concours-Zelt vorbeizuschauen. Der DB4GT hatte immerhin noch den fünften Platz belegt, was durchaus beachtlich ist, da er in den letzten beiden Jahren häufig in Brands Hatch und Silverstone in Rennen eingesetzt wurde. Aston Martin hatte zum Lunch ein sehr schönes Zelt aufgebaut, in dem wir uns stärken konnten. Auf dem Wege dorthin bei zunehmendem Regen waren wir uns alle einig, dass ein Schlauchboot an diesen Tagen das einzig angemessene Fortbewegungsmittel gewesen wäre.

Wenig später kam das Aus. Die Veranstalter sagten den nassen Wettkampf ab. Wir gingen dann ohne Groll zum geselligen Teil des Treffens über und packten in der Box Nummer 5 unsere Picknickkörbe aus. Renner bei unseren englischen Freunden waren ohne Zweifel die Landjäger.

tion du tableau de bord, l'eau asperge mes jambes. Est-ce là le fameux romantisme de la course automobile qui a fait couler tant d'encre ou n'aurais-je pas mieux fait de suivre tranquillement les essais bien à l'abri dans le VIP-Lounge de l'AMOC? Sans désespérer, je gouverne à travers les flots la VMF 65, la voiture officielle construite en 1950 pour Le Mans qui va, comme la manifestation elle-même, fêter son cinquantième anniversaire dans quelques mois. Après un nombre de tours que je n'ai pas comptés, tout est terminé et je constate que je vais pouvoir ramener ma DB2 indemne à la maison. La course elle-même n'a toujours lieu qu'après la pause déjeuner. Cela me laisse le temps d'aller jeter un coup d'œil aux autres équipes dans l'attente du concours d'élégance. La DB4GT est arrivée cinquième de ce concours, ce qui est un résultat respectable quand on sait que, ces deux dernières années, elle a fréquemment couru à Brands Hatch et Silverstone en course. Pour le déjeuner, Aston Martin a monté une très belle tente dans laquelle nous pouvons reprendre des forces. Un peu plus tard, les organisateurs doivent se rendre à l'évidence et décident d'annuler la course pour cause de pluie diluvienne. Sans rancune, nous passons alors à la partie mondaine de la manifestation et déballons nos corbeilles de pique-nique dans le stand n°5. Et nos saucisses sont sans conteste les favorites de nos amis anglais.

Rain man: racing obeys its own rules. This Ulster driver seems completely unaffected by the wet chaos surrounding him.

Rain Man: Rennen entwickeln ihre eigene Dynamik. Dieser Ulster-Pilot scheint völlig unbeeindruckt von dem feuchten Inferno um ihn herum.

Rain Man: ce pilote d'Ulster ne semble pas le moins du monde impressionné par le chaos et le déluge ambiants.

Getting to the Point
Auf die Pointe gebracht
Anecdotes du bon vieux temps

The Newport Pagnell workforce's reaction to disparaging comments emanating from the new Aston Martin plant at Bloxham.

Not surprisingly, Aston Martin's long and winding road through the 20th century has been liberally sprinkled with anecdotes bespeaking both human folly and greatness in equal measure, and casting light on the state of the company at that time. Some of them have become common currency, being part of a repertoire of stories wheeled out by the fireside or at AMOC meetings whenever the Aston Martin legend is reverentially touched upon.

For example: when Bamford and Martin were looking for more power in 1922, Count "Lou" Zborowski sent Clive Gallop off to the automobile manufacturer Ballot to consult his friend Marcel Gremillon. In this case good advice came cheap, as Gremillon summarily sliced in half a design drawing for an eight cylinder three liter Ballot engine, thus producing a design for a powerful four cylinder engine with two overhead camshafts for a total development cost of just £50!

Here's another one: the slump in sales in 1967 was so severe that one employee, getting somewhat carried away, claimed that unsold Astons were being stored everywhere from cupboards to fields around Newport Pagnell, to barns, and even in garages in the center of the town.

Here's a third one, perhaps the most famous of all: at a party a friend asked David Brown to build him an Aston Martin at cost price. Brown replied that he would be delighted to, as it would be the first time he had sold a car without losing money.

The following anecdote, verified by the illustration above, is of more recent vintage. During a meeting at the new facility in Bloxham, an employee there publicly made disparaging comments about the "decrepit" working conditions at Newport Pagnell. The Newport Pagnell workforce was indignant about this, and their feelings were graphically expressed by the artistically gifted wife of a panel beater. The message: out of dirt comes brilliance.

The outstanding camaraderie of the Aston Martin team during the second half of the 1950s proved the ideal breeding ground for all manner of pranks. While the drivers of teams such as the Écurie Écosse or the Scuderia Ferrari first met up during practice, the men from Feltham traveled and lodged together between races as well. This meant that no-one was safe from the practical jokes of the others, as Roy Salvadori, himself one of the chief culprits, remembers with pleasure. Tony Brooks was often the butt of his comrades' jokes, despite the fact that they then had to face his implacable vengeance: "He was so innocent when he first came to us, a superb driver, but still very wet behind the ears." Before a race at Sebring everyone was provided with three new sets of overalls. Only Brooks appeared to have been denied this benefit, which annoyed and upset him. "Look," said Salvadori, "I've got a spare set. Maybe it'll fit." And indeed it did. This scene was then repeated twice as Peter Collins and Carroll Shelby also offered Brooks apparently superfluous overalls of mysteriously perfect fit, until finally the penny dropped.

When traveling to and from races it became a point of honor not to be the one to drive, and there was always a rush for the back seats. Among other things this had the advantage that, when visiting the pub or restaurant you could go in and snap up the best seats while the chauffeur was busy parking the car. And of course Brooks always ended up doing the driving, fobbed off by team manager Reg Parnell's threadbare praise that he was the safest driver of the lot of them.

However, not even Parnell was spared the mockery of the fun-loving crowd around him. "It was as if we were back at school. Like in a public school we lived in two- or three-bed rooms. Reg normally got the biggest one," recalls Salvadori. On one occasion they placed a cupboard in front of the door to his adjoining room so that it was nowhere to be seen and suddenly seemed not to exist at all. Parnell was informed breezily that he had been given another one. He complained furiously to the baffled hotel manager: "So the two of them came storming in. In the meantime we had put everything back in its place and feigned ignorance. Naturally they were very puzzled." That night at three Salvadori woke up to find his bed unpleasantly damp, and suspected a leaking ceiling. But then he noticed Reg Parnell, who was on the top of a ladder, drenching him and Peter Collins with water from a hose.

The ideal location for their fun and games was their Le Mans headquarters at La Chartre: "Especially when we retired early like in 1957, we had some fantastic parties in a small bar opposite the Hôtel de France, where we always put up." A favorite pastime was a race in which the winner was the one to drink three glasses in the fastest time. The catch was that they were continually refilled, so that alcohol consumption tended towards the infinite.

A stroll through the high-security installation that is a modern paddock will quickly convince anyone that this kind of fun is a thing of the past in top-level motorsport. At best, the laughter of bygone days has been replaced by the manufactured smiles of the photo opportunity.

Natürlich ist der lange, dornige Weg von Aston Martin durch das 20. Jahrhundert gesäumt von Anekdoten, die menschliche Schwäche oder Größe gleichermaßen aufspießen oder auch ein Schlaglicht auf die jeweilige Befindlichkeit des Unternehmens werfen. Manche sind gängige Münze, zählen gewissermaßen zum Erzählrepertoire, wenn an heimischen Kaminen oder bei AMOC-Meetings die Legende Aston Martin raunend beschworen wird. Eine davon: Als sich Bamford und Martin 1922 nach mehr Kraft für ihre Wagen umsehen, schickt Graf »Lou« Zborowski Clive Gallop in die Auto-Manufaktur Ballot. Er soll seinen Freund Marcel Gremillon konsultieren. In diesem Fall ist guter Rat billig: Gremillon halbiert kurzerhand die Konstruktionszeichnung eines Dreiliter-Achtzylinders der französischen Marke. Das Ergebnis, zu Gesamtkosten von 50 Pfund, ist der Bauplan für einen potenten Vierzylinder von anderthalb Liter Volumen mit zwei oben liegenden Nockenwellen.

Eine andere: So schlimm wirkt sich die Absatzflaute 1967 aus, dass sich ein Mitarbeiter später zu der Aussage hinreißen lässt, überall seien unverkaufte Astons verstaut gewesen, in Schränken, auf den Feldern rings um Newport Pagnell, in Scheunen und sogar in Garagen mitten in der Stadt.

Eine dritte, vielleicht die berühmteste von allen: Auf einer Party wird David Brown von einem Freund gebeten, ihm einen Aston Martin zum Selbstkostenpreis zu bauen. Browns Antwort: »Sehr gerne. Denn das wäre das erste Mal, dass ich mit einem Auto kein Geld verliere.« Neueren Datums ist folgende Episode, die von obiger Illustration belegt wird: Während einer Versammlung am neuen Standort Bloxham macht ein dortiger Angestellter in aller Öffentlichkeit ätzende Bemerkungen über die »gammeligen« Arbeitsbedingungen in Newport

Pagnell. Die alte Belegschaft ist empört
und die zeichnerisch begabte Frau eines
Karosseriespenglers setzt ins Bild um,
was jedermann denkt. Die Botschaft:
Out of dirt comes brilliance.
Zum idealen Nährboden für Streiche
unterschiedlicher Härtegrade wird die
ausgeprägte Kameradschaft im Aston-
Martin-Team während der zweiten Hälfte
der fünfziger Jahre. Während etwa die
Piloten der Écurie Écosse oder der Scude-
ria Ferrari einander erst beim Training
begegnen, reist und lebt das Aufgebot
aus Feltham auch im Umfeld der Rennen
zusammen. Dabei ist niemand vor den
Späßen des anderen sicher, wie ihn Roy
Salvadori, zugleich einer der Haupttäter,
gerne erinnert. Vor allem Tony Brooks
sei eine ständige Zielscheibe gewesen,
obwohl man sich vor seiner unerbitt-
lichen Rache habe hüten müssen: »Er
war so unschuldig, als er zu uns kam, ein
hervorragender Fahrer, aber den Kopf
noch voller Zahnmedizin.« Vor einem
Rennen in Sebring seien alle mit drei
neuen Overalls ausgestattet worden. Nur
Brooks schien von dieser Einkleidung
ausgespart zu sein, was ihn geärgert
und beunruhigt habe. »Schau«, habe er
(Salvadori) gesagt, »ich habe noch einen
übrig. Vielleicht passt er.« Das war in der
Tat so. Noch zweimal wiederholte sich die
Szene, als auch Peter Collins und Carroll
Shelby Brooks großherzig scheinbar
überzählige, aber maßgeschneiderte
Overalls anboten, ohne dass der Gefoppte
es merkte.
Bei der An-und Abreise sei es stets ganz
wichtig gewesen, den Wagen nicht fahren
zu müssen. Es habe förmlich einen
Ansturm auf die Rücksitze gegeben.
Das habe zum Beispiel den Vorzug
gehabt, dass man eher in ein Lokal gehen
und sich die besten Plätze hätte sichern
können, während sich der Chauffeur
noch um das Auto kümmern musste.
Der aber sei immer Brooks gewesen, von

Teammanager Reg Parnell mit dem
fadenscheinigen Lob ermutigt, er sei der
Vertrauenswürdigste von allen.
Nicht einmal vor Parnell macht die Spott-
lust der fröhlichen Schar um ihn herum
Halt. »Es war, als gingen wir wieder zur
Schule. Wie im Internat wohnten wir in
Zwei-oder Dreibettzimmern. Reg bekam
meistens das größte«, entsinnt sich Sal-
vadori. Einmal habe man ihm mit einem
Schrank den Zugang zu seinem eigenen,
dem Nachbarraum, versperrt, der deshalb
plötzlich unauffindbar gewesen sei. Ihm
sei ein anderer zugewiesen worden, teilte
man ihm gleichmütig mit. Parnell habe
sich wütend beim verdutzten Hotelmana-
ger beschwert. »Dann kamen die beiden
hereingestürmt. In der Zwischenzeit hat-
ten wir alles rückgängig gemacht und
heuchelten Erstaunen. Natürlich war die
Verwunderung groß.« Nachts um drei
wachte Salvadori auf, als sich ungemüt-
liche Feuchtigkeit in seinem Bett ver-
breitete. Er vermutete ein Loch im Dach.
Doch dann entdeckte er Reg Parnell,
der ihn und Peter Collins von einer Leiter
aus mit einem Schlauch besprengte.
Der ideale Schauplatz für solche Lust-
barkeiten ist der Le-Mans-Standort La
Chartre: »Vor allem, wenn wir früh aus-
gefallen waren wie 1957, folgten die
schönsten Parties in einer kleinen Bar
gegenüber dem Hôtel de France, wo
wir immer abstiegen.« Ein beliebter
Zeitvertreib sei ein Wettbewerb gewesen,
in dem es darum ging, drei Gläser in
kürzester Zeit auszutrinken. Nur: Sie
wurden ständig wieder aufgefüllt, so dass
der Alkoholkonsum mit den bekannten
Folgen unendlich tendierte.
Ein Gang durch den Hochsicherheits-
trakt, der sich heute Fahrerlager nennt,
wird einen rasch davon überzeugen, dass
dem Rennsport diese Art von Humor
inzwischen abhanden gekommen ist.
Bestenfalls ist an die Stelle des herzhaften
Lachens das fotogene Lächeln getreten.

Naturellement, le parcours d'Aston
Martin à travers le XXᵉ siècle a été
ponctué d'innombrables anecdotes
qui mettent en lumière les différentes
facettes des hommes qui ont fait son his-
toire ou jettent un éclairage révélateur
sur la santé de l'entreprise à telle ou telle
époque. Certaines histoires sont entrées
dans les annales et on se les raconte le soir
au coin du feu ou à l'occasion des mee-
tings de l'AMOC lorsque l'on veut faire
revivre la légende Aston Martin.
En voici une : en 1922, Bamford et Martin
sont conscients de la nécessité de donner
plus de puissance à leurs voitures ; le comte
« Lou » Zborowski envoie donc Clive
Gallop chez le constructeur automobile
Ballot. Avec une mission, consulter son
ami Marcel Grémillon. Dans le cas pré-
sent, la solution est vite trouvée : sans
hésiter, Grémillon coupe en deux le cro-
quis d'un huit-cylindres de 3 litres de la
marque française. Le résultat, pour le prix
total de 50 livres sterling, est un plan de
construction pour un puissant quatre-
cylindres d'un litre et demi de cylindrée
avec deux arbres à cames en tête.
Autre anecdote : le marasme de 1967 est
si grave qu'un collaborateur à la langue
trop bien pendue raconte plus tard que
des Aston invendues sont stockées par-
tout, dans des hangars, dans les champs
tout autour de Newport Pagnell, dans des
granges et même dans des garages du
centre ville.
Troisième anecdote, peut-être la plus
connue de toutes : lors d'une fête, David
Brown s'entend demander par un ami
de lui vendre une Aston Martin au prix
coûtant. La réponse de Brown fuse : « Mais
très volontiers. Ce sera bien la première
fois que je ne perdrai pas d'argent avec
une voiture. »
Une anecdote plus récente est l'épisode
dont témoigne l'illustration ci-dessus.
Lors d'une réunion au nouveau site de
Bloxham, un employé de cette usine fait
en public une remarque déplacée sur
les conditions de travail « déplorables »
de Newport Pagnell. Les vieux membres
du personnel sont indignés et la femme
d'un tôlier carrossier doué pour le
dessin couche sur le papier ce que pense
chacun en catimini. Légende : *Out of dirt
comes brilliance* (De la poussière jaillit
la lumière).
L'esprit de camaraderie caractérisé qui
régnait au sein de l'équipe Aston Martin
dans la seconde moitié des années 1950
était un humus fertile pour les plaisante-
ries et farces plus ou moins avouables.
Alors que les pilotes de l'Écurie Écosse
ou de la Scuderia Ferrari, par exemple, ne
se retrouvaient que pour les essais, les
mercenaires de Feltham voyageaient et
vivaient aussi ensemble pendant les week-
ends de course et entre les courses. À cette
occasion, personne n'était à l'abri des
blagues des autres, comme se le rappelle
avec plaisir Roy Salvadori, qui en était
souvent l'un des instigateurs. Tony Brooks,
notamment, était une cible fréquente de
leurs plaisanteries, même s'il fallait faire
attention à s'éviter sa vengeance impi-
toyable : « Il était d'une innocence inima-
ginable lorsqu'il nous a rejoints, c'était
un excellent pilote, mais la tête encore
encombrée par ses études de médecine. »
Avant une course à Sebring, tous les

pilotes avaient reçu trois nouvelles com-
binaisons. Seul Brooks semblait avoir
été oublié au moment de la distribution,
ce qui l'avait considérablement vexé.
« Regarde, lui dit Salvadori, j'ai une com-
binaison en rab'. Peut-être t'irait-elle. »
Et, de fait, elle lui allait bien. La scène
se répéta deux autres fois lorsque Peter
Collins et Carroll Shelby, eux aussi, pro-
posèrent généreusement à Brooks des
combinaisons apparemment superflues,
mais taillées sur mesure, sans que leur
victime ne se doutât un seul instant de
la supercherie.
Lorsque les pilotes se rendaient au circuit
ou en revenaient, il était toujours de la
plus haute importance de ne pas devoir
conduire la voiture soi-même. Ils se
ruaient donc sur les sièges arrière. Cela
avait notamment l'avantage de leur per-
mettre de sortir en premier et de s'assurer
les meilleures places dans les cafés et res-
taurants tandis que le conducteur devait
encore s'occuper de la voiture. Et c'était,
une fois de plus, le plus souvent Tony
Brooks qui se retrouvait au volant, le chef
d'équipe Reg Parnell prétextant toujours
avec conviction que c'était à Brooks que
l'on pouvait faire le plus confiance.
Le goût de la plaisanterie des joyeux
lurons n'épargnait même pas Parnell lui-
même. « C'était comme si nous étions
retournés à l'école. Comme à l'internat,
nous dormions dans des chambres à deux
ou trois lits. Et c'est Reg qui recevait
la plupart du temps la plus grande
chambre », se rappelle Roy Salvadori. Un
jour, la bande de farceurs avait dissimulé
derrière une armoire l'accès à sa chambre,
la pièce contiguë était, soudain, devenait
donc impossible à trouver. Une autre
chambre lui avait été affectée, lui dirent-
ils d'un air innocent. Parnell tourna les
talons pour se plaindre, furieux, auprès du
gérant de l'hôtel, stupéfait. « Puis les deux
hommes surgirent dans la pièce. Entre-
temps, nous avions tout remis en place
et avons feint de n'être au courant de
rien. Naturellement, leur stupéfaction
fut totale. » À trois heures du matin,
Salvadori se réveille avec une désagréable
impression d'humidité. Il pensa qu'il y
avait un trou dans le toit. Mais, en ouvrant
les yeux, il découvrit Reg Parnell qui,
juché sur un escabeau, les douchait, Peter
Collins et lui, avec un tuyau d'arrosage.
La petite ville de La Chartre, près du Mans,
se révéla l'endroit idéal pour telles plai-
santeries : « C'est surtout lorsque nous
abandonnions très vite, comme en 1957,
qu'avaient lieu les plus belles parties de
rigolade, dans ce petit bar situé en face de
l'Hôtel de France où nous descendions
toujours. » Un passe-temps très apprécié
était un concours qui consistait à vider
trois verres en un minimum de temps.
Mais, naturellement, ces verres étaient
systématiquement remplis de nouveau
à ras bord, si bien que la consommation
d'alcool ne s'arrêtait jamais, avec les
conséquences que l'on imagine. Il suffit
de déambuler quelques minutes dans la
zone à haute sécurité qu'est aujourd'hui
le paddock pour se convaincre que ce
genre d'humour est devenu totalement
étranger à la compétition automobile.
Dans le meilleur des cas, les éclats de
rire ont fait place aux sourires pour les
caméras de télévision.

Specifications
Technische Daten
Caractéristiques techniques

Series		Lionel Martin Series	International
Production		1923–1925	1929–1932
Model		11 hp Sports 1924	International 1930
Engine	Configuration	4 cylinders in-line	4 cylinders with single overhead camshaft
	Displacement	1486 cc	1494 cc
	Bore x stroke	66.5 x 107 mm	69 x 99 mm
	Fuel supply	1 carburetor SU	2 horizontal carburetors SU
	Output	45 bhp at 4000 rpm	56 bhp at 4250 rpm
Transmission		4-speed	4-speed
Chassis	Frame	Steel U-channels	Steel U-channels
	Suspension front	Rigid axle and leaf springs	Rigid axle and leaf springs
	Suspension rear	Fully floating live axle and leaf springs	Live axle and leaf springs
Dimensions	Wheelbase	2657 mm	2590 mm
	L x W x H	3658 x 1530 x 1530 mm	3900 x 1640 x 1300 (with windshield up) mm
	Weight	813 kg (dry)	860 kg
Maximum speed		115 km/h	125 km/h

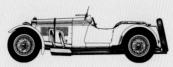
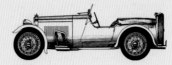

Series		Le Mans	Mark II
Production		1932 and 1933	1934 and 1935
Model		Le Mans 1933	Mark II 1934
Engine	Configuration	4 cylinders in-line with single overhead camshaft	4 cylinders with single overhead camshaft
	Displacement	1494 cc	1494 cc
	Bore x stroke	69 x 99 mm	69 x 99 mm
	Fuel supply	2 horizontal carburetors SU	2 horizontal carburetors SU
	Output	70 bhp at 4750 rpm	73 bhp at 4750 rpm
Transmission		4-speed	4-speed
Chassis	Frame	Steel U-channels	Steel U-channels
	Suspension front	Rigid axle and leaf springs	Rigid axle and leaf springs
	Suspension rear	Live axle and leaf springs	Live axle and leaf springs
Dimensions	Wheelbase	2630 mm (short chassis)	2630 mm (short chassis)
	L x W x H	4050 x 1680 x 1230 mm (with windshield up)	3850 x 1630 x 1200 (up to top edge of racing windshields) mm
	Weight	1020 kg (empty)	870 kg (dry)
Maximum speed		135 km/h	147 km/h

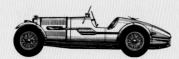

Series		Ulster	15/98	Individual specimen
Production		1934 and 1935	1936–1939	1939 (further development until 1946)
Model		Ulster 1934	Open Sports Tourer 1939	Atom
Engine	Configuration	4 cylinders with single overhead camshaft	4 cylinders with single overhead camshaft	4 cylinders in-line
	Displacement	1494 cc	1950 cc	1970 cc
	Bore x stroke	69 x 99 mm	78 x 102 mm	82.55 x 92 mm
	Fuel supply	2 horizontal carburetors SU	2 carburetors SU HV 3	2 horizontal carburetors SU
	Output	85 bhp at 5250 rpm	98 bhp at 5000 rpm	80 bhp at 4760 rpm
Transmission		4-speed	4-speed	Electr. Cotal 4-speed
Chassis	Frame	Steel U-channels	Steel U-channels	Square-section tubular frame
	Suspension front	Rigid axle and leaf springs	Rigid axle and leaf springs	Trailing arms and coil springs
	Suspension rear	Live axle and leaf springs	Live axle and leaf springs	Live axle and leaf springs
Dimensions	Wheelbase	2603 mm	2061 mm (short chassis)	2670 mm
	L x W x H	3987 x 1600 x 1168 mm	4000 x 1590 x 1400 mm	4430 x 1540 x 1500 mm
	Weight	1040 kg	1150 kg	1220 kg
Maximum speed		164 km/h	135 km/h	169 km/h

Glossar der technischen Begriffe und Abkürzungen S. 279 · Glossaire des termes techniques et des abréviations p. 279

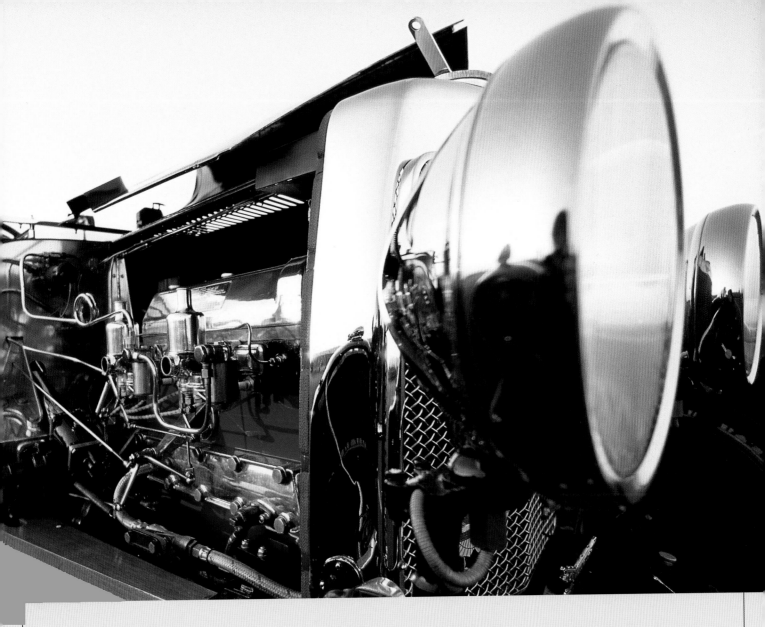

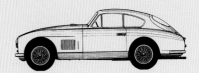

Series		2-litre Sports	DB2	DB2/4
Production		1948–1950	1950–1953	1953–1955
Model		2-litre Sports 1950	DB2 Vantage 1950	DB2/4 1955
Engine	Configuration	4 cylinders in-line	6 cylinders in-line with twin overhead camshafts	6 cylinders in-line with twin overhead camshafts
	Displacement	1970 cc	2580 cc	2922 cc
	Bore x stroke	82.55 x 92 mm	78 x 90 mm	83 x 90 mm
	Fuel supply	2 carburetors SU TH 4 spec. 485	2 horizontal carburetors SU HV6	2 horizontal carburetors SU HV6 (series)
	Output	90 bhp at 4750 rpm	125 bhp at 5000 rpm	140 bhp at 5000 rpm
Transmission		4-speed	4-speed	4-speed
Chassis	Frame	Square-section tube frame	Square-section tube frame	Square-section tube frame
	Suspension front	Trailing arms and coil springs	Trailing links and coil springs	Trailing links and coil springs
	Suspension rear	Live axle, parallelogram linkage and coil springs	Live axle, trailing links, coil springs and Panhard rod	Live axle, trailing links, coil springs and Panhard rod
Dimensions	Wheelbase	2740 mm	2511 mm	2511 mm
	L x W x H	4470 x 1710 x 1410 mm	4130 x 1650 x 1360 mm	4300 x 1650 x 1360 mm
	Weight	1145 kg (dry)	1180 kg (dry)	1179 kg (dry)
Maximum speed		127 km/h	185 km/h	193 km/h

SPECIFICATIONS

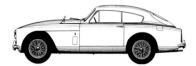
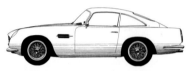
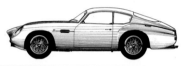

Series	DB Mark III	DB3	DB3S
Production	1957–1959	1951–1953	1953–1956
Model	DB Mark III 1958	DB3 1952	DB3S 1955
Engine Configuration	6 cylinders in-line with twin overhead camshafts	6 cylinders in-line with twin overhead camshafts	6 cylinders in-line with twin overhead camshafts
Displacement	2922 cc	2580 cc	2922 cc
Bore x stroke	83 x 90 mm	78 x 90 mm	83 x 90 mm
Fuel supply	2 horizontal carburetors SU HV6	3 Weber 36 DCF5 twin-choke carburetors	3 Weber 45 DCO twin-choke carburetors
Output	164 bhp at 5500 rpm	140 bph at 5200 rpm	225 bhp at 6000 rpm
Transmission	4-speed	5-speed	4-speed
Chassis Frame	Square section tube frame	Twin-tube ladder frame	Twin-tube ladder frame
Suspension front	Trailing links and coil springs	Trailing links and torsion bars	Trailing links and torsion bars
Suspension rear	Live axle, parallel radius arms, coil springs and Panhard rod	De Dion axle, trailing links and torsions bars	De Dion axle, trailing links and transversely installed torsion bars
Dimensions Wheelbase	2515 mm	2363 mm	2210 mm
L x W x H	4356 x 1651 x 1360 mm	4026 x 1562 x 1016 mm	3906 x 1492 x 1054 mm
Weight	1270 kg (dry)	915 kg (with 40 l fuel on board)	978 kg (with 160 l fuel on board)
Maximum speed	192 km/h	212 km/h	235 km/h

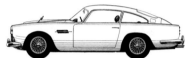
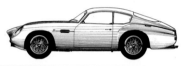

Series	DB4	DB4GT	DB4GT Zagato
Production	1958–1963	1959–1963	1960–1963
Model	DB4 1961	DB4GT 1960	DB4GT Zagato 1962
Engine Configuration	6 cylinders in-line with twin overhead camshafts	6 cylinder in-line with twin overhead camshafts	6 cylinders in-line with twin overhead camshafts
Displacement	3670 cc	3670 cc	3670 cc
Bore x stroke	92 x 92 mm	92 x 92 mm	92 x 92 mm
Fuel supply	2 horizontal carburetors SU HD8	3 Weber 45 DCO E 4 horizontal twin-choke carburetors	3 Weber 45 DCOE 4 twin-choke carburetors
Output	243 bhp at 5500 rpm	270 bhp at 6000 rpm	270 bhp at 6000 rpm
Transmission	4-speed	4-speed	4-speed
Chassis Frame	Platform with tubular framework	Platform with tubular framework	Platform with tubular framework
Suspension front	Twin wishbones and coil springs	Twin wishbones and coil springs	Twin wishbones and coil springs
Suspension rear	Live axle, trailing links, coil springs and Watt linkage	Live axle, trailing links, coil springs and Watt linkage	Live axle, trailing links, coil springs and Watt linkage
Dimensions Wheelbase	2489 mm	2362 mm	2362 mm
L x W x H	4480 x 1680 x 1310 mm	4440 x 1680 x 1320 mm	4267 x 1657 x 1270 mm
Weight	1296 kg (dry)	1227 kg (dry)	1251 kg (with tank half-full)
Maximum speed	225 km/h	245 km/h	247 km/h

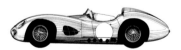
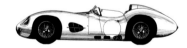
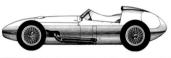

Series	DBR1	DBR2	DBR4
Production	1956–1959	1957	1959
Model	DBR1 1958	DBR2	DBR4
Engine Configuration	6 cylinders in-line with twin overhead camshafts and twin spark plugs per cylinder	6 cylinders in-line with twin overhead camshafts	6 cylinders in-line with twin overhead camshafts, twin spark plugs per cylinder
Displacement	2992 cc	3670 cc	2493 cc
Bore x stroke	84 x 90 mm	92 x 92 mm	83 x 76.8 mm
Fuel supply	3 Weber 45 DCO twin-choke carburetors	3 Weber 50 DCO twin-choke carburetors	3 Weber 50 DCO
Output	250 bhp at 6000 rpm	287 bhp at 5750 rpm	250 bhp at 7800 rpm
Transmission	5-speed	5-speed	5-speed
Chassis Frame	Twin-tube ladder frame with smaller tubes to support body	Twin-tube ladder frame with smaller tubes to support body	Multi-tubular spaceframe
Suspension front	Trailing links and torsion bars	Trailing links and torsion bars	Twin wishbones with coil spring/damper units
Suspension rear	De Dion axle, trailing links and transversely installed torsion bars	De Dion axle, trailing links and transversely installed torsion bars	De Dion-axle, trailing links and transversely installed torsion bars
Dimensions Wheelbase	2290 mm	2360 mm	2286 mm
L x W x H	4030 x 1630 x 980 mm	4064 x 1676 x 978 mm	4100 x 1630 x 1000 mm
Weight	801 kg (dry)	915 kg	680 kg
Maximum speed	254 km/h	264 km/h	exceeding 260 km/h

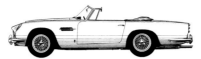
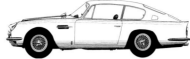
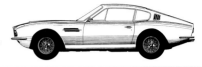

Series	DB5	DB6	DBS
Production	1963–1965	1965–1970	1967–1972
Model	DB5 Convertible 1964	DB6 1967	DBS Vantage 1968
Engine Configuration	6 cylinders in-line with twin overhead camshafts	6 cylinders with twin overhead camshafts	6 cylinders in-line with twin overhead camshafts
Displacement	3995 cc	3995 cc	3995 cc
Bore x stroke	96 x 92 mm	96 x 92 mm	96 x 92 mm
Fuel supply	3 horizontal carburetors SU HD 8	3 horizontal carburetors SU HD 8	3 Weber 45 DCOFF twin-choke carburetors
Output	286 bhp at 5500 rpm	286 bhp at 5500 rpm	330 bhp at 5750 rpm
Transmission	4-speed	5-speed	3-speed Borg-Warner automatic gearbox
Chassis Frame	Platform with tubular frame	Platform with tubular frame	Platform frame
Suspension front	Twin wishbones and coil springs	Twin wishbones and coil springs	Twin wishbones and coil springs
Suspension rear	Live axle, trailing links, coil springs and Watt linkage	Live axle, trailing links, coil springs and Watt linkage	De Dion axle, trailing links, coil springs and Watt linkage
Dimensions Wheelbase	2490 mm	2580 mm	2610 mm
L x W x H	4570 x 1680 x 1320 mm	4620 x 1680 x 1360 mm	4585 x 1830 x 1330 mm
Weight	1465 kg (empty)	1475 kg (empty)	1588 kg (empty)
Maximum speed	230 km/h	238 km/h	246 km/h

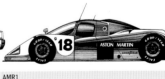

Series	V8	V8 Vantage	V8 Vantage Zagato
Production	1972–1989	1977–1989	1986–1989
Model	V8 Volante 1979	V8 Vantage 1989	V8 Vantage Zagato 1988
Engine Configuration	V8 with 4 overhead camshafts	V8 with 4 overhead camshafts	V8 with 4 overhead camshafts
Displacement	5340 cc	5341 cc	5341 cc
Bore x stroke	100 x 85 mm	100 x 85 mm	100 x 85 mm
Fuel supply	4 Weber 42 DCNF twin-choke downdraft carburetors	4 Weber 48 IDF 3/150 twin downdraft carburetors	4 Weber 48 IDF 3/150 twin downdraft carburetors
Output	304 bhp at 5500 rpm	438 bhp at 6000 rpm	438 bhp at 6200 rpm
Transmission	3-speed Chrysler Torqueflite automatic gearbox	5-speed	5-speed
Chassis Frame	Platform with frame to support body	Platform with frame to support body	Platform and frame to support body
Suspension front	Twin wishbones and coil springs	Twin wishbones and coil springs	Twin wishbones and coil springs
Suspension rear	De Dion axle, trailing links, coil springs and Watt linkage	De Dion axle, trailing links, coil springs and Watt linkage	De Dion axle, trailing links, coil springs and Watt linkage
Dimensions Wheelbase	2610 mm	2610 mm	2610 mm
L x W x H	4585 x 1830 x 1325 mm	4665 x 1890 x 1325 mm	4390 x 1860 x 1295 mm
Weight	1780 kg (empty)	1820 kg (empty)	1650 kg (empty)
Maximum speed	241.7 km/h	289 km/h	299 km/h

Series	Lagonda 3-litre	AM V8 Lagonda	AMR1
Production	1953–1958	1976–1990	1988 and 1989
Model	Lagonda 3-litre DHC 1955	AM V8 Lagonda S2 1977	AMR1
Engine Configuration	6 cylinders in-line with twin overhead camshafts	V8 with 4 overhead camshafts	V8 with 4 overhead camshafts and 4 valves per cylinder
Displacement	2922 cc	5340 cc	5998 cc
Bore x stroke	83 x 90 mm	100 x 85 mm	85 x 105.4 mm
Fuel supply	2 horizontal carburetors SU HV 6	4 Weber 42 DCNF twin downdraft carburetors	Zytec electronic engine management
Output	142 bhp at 5000 rpm	280 bhp at 5000 rpm	670 bhp at 7500 rpm
Transmission	4-speed	3-speed Chrysler Torqueflite automatic gearbox	5-speed
Chassis Frame	Cruciform construction, coachwork around ash frame	Platform frame	Monocoque made out of carbon fiber/Kevlar
Suspension front	Twin wishbones and coil springs	Twin wishbones and coil springs	Twin wishbones, spring/damper units
Suspension rear	Semi-trailing links and longitudinal torsion bars	De Dion axle, trailing links, coil springs and Watt linkage	Twin wishbones, spring/damper units
Dimensions Wheelbase	2880 mm	2915 mm	2900 mm
L x W x H	4980 x 1760 x 1570 mm	5285 x 1815 x 1300 mm	4770 x 1980 x 1010 mm
Weight	1613 kg (dry)	1725 kg (empty)	980 kg (at Le Mans)
Maximum speed	158 km/h	225 km/h	351 km/h

SPECIFICATIONS

Series		Virage	Virage Vantage	V8 Coupé
Production		1989–1994	1992–2000	1996–2000
Model		Virage Volante 1993	Vantage 1996	V8 Coupé 1996
Engine	Configuration	V8 with 4 overhead camshafts and 4 valves per cylinder	V8 with 4 overhead camshafts and 4 valves per cylinder	V8 with 4 overhead camshafts and 4 valves per cylinder
	Displacement	5340 cc	5340 cc	5340 cc
	Bore x stroke	100 x 85 mm	100 x 85 mm	100 x 85 mm
	Fuel supply	Electronic Weber-Marelli gasoline injection	Electronic Ford EECIV injection, 2 superchargers Roots (Eaton)	Electronic injection
	Output	330 bhp at 5300 rpm	550 bhp at 6500 rpm	354 bhp at 6000 rpm
Transmission		5-speed	6-speed	5-speed
Chassis	Frame	Platform and frame to support body	Platform and frame to support body	Platform and frame to support body
	Suspension front	Twin wishbones and coil springs	Twin wishbones and coil springs	Twin wishbones and coil springs
	Suspension rear	De Dion axle, trailing links, coil springs and Watt linkage	De Dion axle, trailing links, coil springs and Watt linkage	De Dion axle, trailing links, coil springs and Watt linkage
Dimensions	Wheelbase	2610 mm	2610 mm	2610 mm
	L x W x H	4745 x 1855 x 1400 mm	4745 x 1945 x 1320 mm	4745 x 1920 x 1330 mm
	Weight	2000 kg (empty)	1990 kg (empty)	1950 kg (empty)
Maximum speed		253 km/h	298 km/h	268 km/h

Series		DB7	DB7 Vantage	Vanquish
Production		1994 until today	From 1999	From 2001
Model		DB7 1995	DB7 Vantage Volante 2000	Vanquish
Engine	Configuration	6 cylinders in-line with twin overhead camshafts and 4 valves per cylinder	V12 with 4 overhead camshafts and 4 valves per cylinder	V12 with 4 overhead camshafts and 4 valves per cylinder
	Displacement	3239 cc	5933 cc	5935 cc
	Bore x stroke	91 x 83 mm	89 x 79.5 mm	89,0 x 79,5 mm
	Fuel supply	Electronic injection, 1 supercharger Roots (Eaton)	Electronic injection	Electronic injection
	Output	317 bhp at 5500 rpm	420 bhp at 6000 rpm	469 bhp at 6800 rpm
Transmission		GM Hydra-Matic 4-stage automatic gearbox	6-speed	6-speed, automatic, autoshift or select shift using paddles
Chassis	Frame	Self-supporting body	Self-supporting body	Self-supporting aluminium bonded body frame
	Suspension front	Twin wishbones and coil springs	Twin wishbones and coil springs	Double wishbones, coil springs, anti-roll bar
	Suspension rear	Lower wishbones with upper halfshaft links and coil springs	Lower wishbones with upper halfshaft links and coil springs	Double wishbones, coil springs, anti-roll bar
Dimensions	Wheelbase	2591 mm	2591 mm	2690 mm
	L x W x H	4645 x 1830 x 1238 mm	4666 x 1830 x 1270 mm	4665 x 1923 x 1330 mm
	Weight	1700 kg	1847 kg	1835 kg
Maximum speed		258 km/h	286 km/h	322 km/h

Series		DB7	DB7	DB9
Production		2002–2003	2003	From 2003
Model		DB7 Zagato	DB7 GT	DB9 2004
Engine	Configuration	V12 with 4 overhead camshafts and 4 valves per cylinder	V12 with 4 overhead camshafts and 4 valves per cylinder	V12 with 4 overhead camshafts and 4 valves per cylinder
	Displacement	5935 cc	5935 cc	5935 cc
	Bore x stroke		89,0 x 79,5 mm	89,0 x 79,5 mm
	Fuel supply	Electronic injection	Electronic injection	Electronic injection
	Output	440 bhp at 6000 rpm	442 bhp at 6000 rpm	456 bhp at 6000 rpm
Transmission		6-speed, quickshift gear lever	6-speed, manual gear lever (5-speed automatic, GTA)	6-speed, conventional, automatic, autoshift or select shift using paddles
Chassis	Frame	Self-supporting body of aluminium, steel and composite parts	Self-supporting body	Self-supporting aluminium bonded body frame
	Suspension front	Twin wishbones and coil springs, anti-roll bar	Twin wishbones and coil springs, anti-roll bar	Double wishbones, coil over monotube dampers, anti-roll bar
	Suspension rear	Twin wishbones and coil springs, longitudinal swing arm, anti-roll bar	Twin wishbones and coil springs, longitudinal arm, anti-roll bar	Double wishbones, coil over monotube dampers, anti-roll bar
Dimensions	Wheelbase	2531 mm	2591 mm	2740 mm
	L x W x H	4481 x 1861 x 1244 mm	4692 x 1830 x 1243 mm	4697 x 1875 x 1318 mm
	Weight	1740 kg	1800 kg	1710 kg
Maximum speed		300 km/h	300 km/h	308 km/h

SPECIFICATIONS

Glossar

Glossaire

General	Allgemein	Généralités
above	oben	en haut
adjustable	verstellbar	réglable
below	unten	en bas
electric	elektrisch	électrique
electronic	elektronisch	électronique
external(ly)	außen	extérieur (-ement)
for	für	pour
front	vorn	avant
internal(ly)	innen	intérieur (-ement)
made of	aus	en
no	keine	aucun(e)
on	auf	sur
per	je	par
rear	hinten	arrière
reinforced	verstärkt	renforcé
since	ab	à partir de
steel	stählern	en acier
supplementary	Zusatz-	supplémentaire
twin	Doppel-	double
with	mit	avec

Series	Baureihe	Gamme
individual specimen	Einzelexemplar	spécimen unique

Production	Baujahr	Millésime
further development	weiter entwickelt	extrapolation
until today	bis heute	jusqu'à aujourd'hui

Model	Modell	Modèle

Engine	Motor	Moteur

Configuration	Konfiguration	Configuration
camshaft	Nockenwelle	arbre à cames
cylinder	Zylinder	cylindre
in-line	in Reihe	en ligne
overhead camshaft	oben liegende Nockenwelle	arbre à cames en tête
valves	Ventile	soupapes

Displacement	Hubraum	Cylindrée
cc	ccm	cm³

Bore x stroke	Bohrung x Hub	Alésage x course

Fuel supply	Kraftstoffversorgung	Alimentation en carburant
carburetor	Vergaser	carburateur
downdraft carburetor	Fallstromvergaser	carburateur inversé
horizontal carburetor	Horizontalvergaser	carburateur horizontal
injection	Einspritzung	injection
intake manifolds	Ansaugrohre	tubulures d'aspiration
supercharger	Kompressoren	compresseurs
twin-choke carburetor	Doppelvergaser	double carburateur

Output	Leistung	Puissance
at …rpm	bei .../min	à … tr/min
bhp	PS	ch

Transmission	Antrieb	Transmission
3-speed	3-Gang	3 vitesses
4-speed	4-Gang	4 vitesses
5-speed	5-Gang	5 vitesses
6-speed	6-Gang	6 vitesses
automatic gearbox	Automatik	automatique
gearbox	Getriebe	boîte de vitesses
semi-automatic gearbox	Halbautomatik	semi-automatique

Chassis	Chassis	Châssis

Frame	Rahmen	Cadre
bodywork	Karosserie	carrosserie
box frame	Kastenrahmen	cadre à caissons
carbon fiber	Kohlefaser	fibre de carbone
coachwork around ash frame	auf Eschenholz ruhende Karosserie	carrosserie reposant sur un cadre en frêne
cruciform construction	kreuzförmige Konstruktion	construction en forme de croix
ladder frame	Leiterrahmen	cadre à échelle
multi-tubular spaceframe	Gitterrohrrahmen	châssis tubulaire

platform and frame to support body	Plattform und Rahmen zur Unterstützung der Karosserie	plate-forme et cadre supportant la carrosserie
platform frame	Plattformrahmen	cadre à plate-forme
self-supporting	selbsttragend	autoporteuse
square section tube frame	Rohrrahmen mit Rohren von quadratischem Querschnitt	châssis tubulaire avec tubes de section carrée
tubular frame	Rohrrahmen	structure tubulaire
twin-tube ladder frame with smaller tubes to support body	Doppelrohr-Leiterrahmen mit Rohren kleineren Querschnitts zur Unterstützung der Karosserie	cadre à échelle à tubes doubles avec tubes de plus petite section pour soutenir la carrosserie
U-channel	U-Träger	support en U
wood	Holz	bois
wood frame	Holzrahmen	cadre en bois

Suspension front/rear	Aufhängung vorn/hinten	Suspension avant/arrière
coil spring	Schraubenfeder	ressorts hélicoïdaux
damper	Dämpfer	amortisseurs
De Dion axle	De Dion Achse	essieu de Dion
fully floating live axle	Schwebeachse	essieu à bras obliques oscillants
leaf spring	Blattfeder	ressorts à lames
live axle	Starrachse	essieu rigide
lower wishbones with upper halfshaft links	untere Querlenker und mittragende Halbachsen	bras transversaux inférieurs et demi-arbres porteurs
Panhard rod	Panhardstab	barre Panhard
parallelogram linkage	Aufhängung mit Rechteck-Querlenkern	suspension à bras transversaux parallélépipédiques
rectangular transverse arm	Rechteck-Querlenker	bras transversaux
rigid axle	Starrachse	essieu rigide
semi-elliptic spring	Halbelliptikfeder	ressorts semi-elliptiques
spring/damper units	Feder-/Dämpfer-Einheiten	unités d'amortisseurs
torsion bar	Drehstab	barre de torsion
trailing links	Schräglenker	bras obliques en travers
transverse	quer	en travers
transverse arms	Querlenker	bras transversaux
transversely installed	quer eingebaut	en position transversale
twin wishbones	Doppel-Querlenker	doubles bras transversaux
Watt linkage	Watt-Gestänge	timonerie de Watt
wheel	Rad	roues
wishbone	Querlenker	triangles/bras transversaux

Dimensions	Maße	Dimensions

Wheelbase	Radstand	Empattement
L(ength) x W(idth) x H(eight) 100 mm = 3.937 in up to top edge of racing windshields	Länge x Breite x Höhe mm bis Oberkante Rennscheiben	Longueur x largeur x hauteur mm jusqu'à l'arête supérieure du coupe-vent course
with windshield up	mit hochgestellter Scheibe	avec pare-brise relevé

Weight	Gewicht	Poids
1 kg = 2.205 lb	kg	kg
dry	trocken	à sec
empty	leer	à vide
with … fuel on board	mit … Treibstoff an Bord	avec … carburant à bord

Maximum speed	Höchstgeschwindigkeit	Vitesse maximale
1 km/h (kph) = 0.621 mph	km/h	km/h
exceeding	über	plus de

Acknowledgements
Danksagung
Remerciements

I would like to express my sincere thanks to the following people
for making their cars available:
Für die Bereitstellung ihrer Fahrzeuge bedanke ich mich bei:
Pour la mise à disposition de leurs voitures, je tiens à remercier :

Rowan Atkinson, Wolfgang Buchholz, Simon Draper, Dirk Ebeling, Herbert Engel,
Jorge Ferreyra-Basso, Maggie Farmer, Wolfgang Friedrichs, Jean-Pierre Frottier,
Miriam Geisler, Tilman Gregor, Dieter Haack, Axel Holler, Heinz Hüve,
Alexander C. Knapp-Voith, Heino Landsberg , Robert Leyba, Peter Livanos, Nick Mason,
Horst Minden, Jerry Moore, Neil Murray, Daniel Paulus, Thomas C. Rollason,
Beat Roos, Dr. Manfred Schlick, Ulrich Schödel, Rainer M. Thurau, Stan Milton White,
Stefan Wierz, Chris Woodgate, Johannes Woskowski, Peter Zizka

Special thanks go to
Mein besonderer Dank gilt
Je remercie tout particulièrement

Aston Martin Lagonda Ltd: Dr. Ulrich Bez, Bob Dover, Harry Calton, Barbara Prince,
Roger Stowers; Walter Hayes (Chairman of the Aston Martin Heritage Trust),
Dr. Manfred Schlick (Vice President Aston Martin Owners Club), Robert Leyba
(Chairman AMOC German Section), John Godley (Assistant Secretary of the AMOC),
Roy Salvadori, Ulrich Schödel and Johannes Woskowski (members and experts of the
AMOC German Section) and John Atkins.

Further thanks go to Oliver Hessmann and Thomas Lindner for their layout, Beate Jung
for assisting with the organisation, Hartmut Lehbrink for his text, Jochen von Osterroth
for the drawings, Thomas Weber for documenting his remodeling work and the
Könemann team for their hard work in realizing this book.

Danke auch Oliver Hessmann und Thomas Lindner für ihr Layout, Beate Jung für
Organisationsassistenz, Hartmut Lehbrink für seine Texte, Jochen von Osterroth für die
Zeichnungen, Thomas Weber für die Dokumentation seiner Restaurierungsarbeiten
sowie dem Könemann-Team für sein Engagement bei der Realisation.

Tous mes remerciements aussi à Oliver Hessmann et Thomas Lindner pour leur
maquette, à Beate Jung pour son assistance lors de l'organisation, à Hartmut Lehbrink
pour ses textes, à Jochen von Osterroth pour les dessins, à Thomas Weber pour la
documentation de ses travaux de restauration ainsi qu'à l'équipe Könemann pour son
engagement lors de la réalisation.

I would also like to express my gratitude to the Egelsbach, Karlsruhe-Forchheim,
Michelstadt and Siegerland airports, the Luftfahrtverein Mainz and the management of
the Silverstone Circuit for their kind cooperation.

Ebenso danke ich für hilfreiche Kooperation den Geschäftsleitungen der Flugplätze
Egelsbach, Karlsruhe-Forchheim, Michelstadt und Siegerland, dem Luftfahrtverein
Mainz sowie der Direktion des Silverstone Circuit.

Je souhaite remercier également, pour leur fructueuse coopération, les directions des
aérodromes d'Egelsbach, de Karlsruhe-Forchheim, de Michelstadt et de Siegerland, le
club d'aviation de tourisme de Mayence ainsi que la direction du circuit de Silverstone.

Rainer W. Schlegelmilch

Bibliography
Bibliografie
Bibliographie

Alan Archer: The Aston Martin, Shire Publications Ltd, Aylesbury 1989

Michael Bowler: Aston Martin V8, Cadogan Publications Ltd, London 1985

Michael Bowler: Aston Martin, The Legend, Parragon 1997

Paul Chudecki: Aston Martin and Lagonda, Volume 2, V8 models from 1970,
Motor Racing Publications, Croydon 1990

R.M. Clarke: Aston Martin 1948–1971, Gold Portfolio, Brooklands Books

R.M. Clarke: Aston Martin 1972–1985, Gold Portfolio, Brooklands Books

R.M. Clarke: Aston Martin 1985–1995, Gold Portfolio, Brooklands Books

Peter Garnier: Aston Martin, compiled from the archives of *Autocar*,
Hamlyn Publishing Group Ltd, London etc. 1982

Dudley Gershon: Aston Martin 1963–1972, Oxford Illustrated Press, Oxford 1982

Roger Gloor: Nachkriegswagen 1945–1960, Hallwag AG, Bern 1981

Mike Lawrence: A to Z of Sports Cars 1945–1990, Bay View Books Ltd, Bideford 1991

Hartmut Lehbrink/Frank Oleski, Seriensportwagen 1945–1980,
Könemann Verlagsgesellschaft, Köln 1993

Chris Nixon: Racing with the David Brown Aston Martins,
Transport Bookman Publications Ltd, Isleworth 1980

Anthony Pritchard: Aston Martin, The Postwar Competition Cars,
Aston Publications, Bourne End 1991

Road & Track on Aston Martin 1962–1990, Brooklands Books

Michael Schäfer: Die Aston Martin Lagonda Ltd in Newport Pagnell,
Verlag Michael Schäfer, Fürth 1999

John Wyer: The Certain Sound, Automobile Year, Edita 1981

Kataloge der *Automobil Revue,* Hallwag AG Bern, von 1958 an

Motor Revue, Motor Presse Verlag, Stuttgart

auto motor und sport, Motor Presse Verlag, Stuttgart

Aston Martin Register, published by the Aston Martin Owners' Club

Photographic credits
Bildnachweis
Crédits photographiques

All photographs by Rainer W. Schlegelmilch except:
Alle Fotos von Rainer W. Schlegelmich außer:
Toutes les photos sont de Rainer W. Schlegelmilch sauf:

Archiv Aston Martin/Archiv Aston Martin Owners' Club: P./S. 6–20, 22, 27–32,
35–36, 41; Bertone: P./S. 40 top/oben/haut; Zagato: P./S. 40 bottom/unten/bas

Thomas Weber: P./S. 126–129

Louis Klemantaski: P./S. 23

© 2008 Tandem Verlag GmbH
h.f.ullmann is an imprint of Tandem Verlag GmbH

Photography: Rainer W. Schlegelmilch
Text: Hartmut Lehbrink, Jochen von Osterroth (pp. 38–41, 240–261)

Drawings: Jochen von Osterroth
Design and typography: Agentur Roman Bold & Black, Oliver Hessmann
Cover: Oliver Hessmann
Translations into English: Stephen Hunter, Russell Cennydd
Translation into French: Jean-Luc Lesouëf

Printed in China

ISBN 978-3-8331-5137-8

10 9 8 7 6 5 4 3 2 1
X IX VIII VII VI V IV III II I

www.ullmann-publishing.com